Policing Provincial England, 1829-1856

Dedicated to the memory of our fathers

NEHEMIAH PHILIPS SIDNEY STORCH
1909–1988 1911–1987

POLICING PROVINCIAL ENGLAND, 1829-1856

The Politics of Reform

David Philips and Robert D. Storch

Leicester University Press
London and New York

Leicester University Press
A Cassell imprint
Wellington House, 125 Strand, London WC2R 0BB
370 Lexington Avenue, New York, NY 10017-6550

First published 1999

British Library Cataloguing-in-Publication Data
A catalogue record for this book is available from the British Library.

ISBN 0-7185-0112-8

Library of Congress Cataloging-in-Publication Data
Philips, David, 1946–
 Policing provincial England, 1829–1856 : the politics of reform /
David Philips and Robert D. Storch
 p. cm.
 Includes bibliographical references and index.
 ISBN 0-7185-0112-8 (hardcover)
 1. Police—England—History—19th century. 2. Police, Rural—
England—History—19th century. 3. Constables—England—
History—19th century. I. Storch, Robert D., 1940- .
 II. Title.
 HV8196.A2P48 1999
 363.2'0942'09034—dc21 98-26883
 CIP

Typeset by BookEns Ltd, Royston, Herts.
Printed and bound in Great Britain by Cromwell Press Ltd, Trowbridge, Wilts.

CONTENTS

TABLES

ACKNOWLEDGEMENTS

Collaboration can be a risky business. One throws one's lot in with someone whose work habits, ideas or even interpretations of what one is doing may turn out to be at variance with one's own. For middle-aged scholars like ourselves, trained in the same school of individual historical craftsmanship, it can be especially difficult. At the beginning, we agreed to a guiding rule for the project: we are two horses hitched to the same cart, so we cannot afford to bite. With the exception of a few nips from time to time, we have kept to it. We saw the project through to the end, and our respect and friendship for each other, which predated the collaboration, remains. Our first acknowledgement, therefore, must be to each other.

Robert Storch was aided by a summer grant from the University of Wisconsin Colleges, an American Council of Learned Societies Grant in Aid of Research and a National Endowment for the Humanities Travel to Collections grant. I would like to thank Professor Paul Boyer, Director of the University of Wisconsin-Madison Institute for Research in the Humanities, who provided a stimulating and welcoming atmosphere during my stint as a fellow. Dean Jane Crisler and Dr David Huehner, my department chair, have helped to grease the wheels on a number of occasions. Two members of my family, my wife Anne Strong Storch and my son Kendall B. I. Storch, consented on occasion to be dragooned into service at the Public Record Office, where, purely out of love for me, they subjected themselves to reading the leavings of nineteenth-century magistrates and Poor Law Guardians.

David Philips, living thousands of miles from both the sources in England and his collaborator in Wisconsin, was greatly aided by the generous study leave of the University of Melbourne, which made possible the necessary time in the English archives, as well as face-to-face consultations with Bob Storch. I would like to acknowledge the very supportive atmosphere of my History Department here, which has provided an excellent environment for research and mental stimulation; grants from the Department and the Arts Faculty have also provided useful material support for the project. I am very grateful to the Australian Research Council for a more substantial grant for 1989 and 1990, which was invaluable in getting the bulk of the empirical evidence-collecting done for the project. Carolyn Rasmussen, Alison Forrest and Zoe Laidlaw gave excellent service as research assistants. A Messecar Visiting Professorship at McMaster University in 1991 enabled me to spend

a semester in North America and to try out my ideas on the historians there. I would particularly like to record my debt to John Weaver, with whom I co-taught a course in this area, and discussed policing histories. Finally, to many of my colleagues and students, who indulged my strange interest in, not just police history, but the English county police (!), and whose responses were frequently stimulating and suggestive of new ideas, I would like to record a sincere thank you.

Over the years, we have both benefited greatly from being part of an international group of historians of crime, criminal justice, policing and punishment. Not only did their conferences enable us to meet initially, and to agree on the joint project which eventually became this book, but they also gave us the opportunity to expose our research and ideas to a well-informed and generous group of scholars, who provided a very supportive academic environment for a project like ours. There have been many such good conferences over the past two decades; but perhaps the best – and also influential in planting the very early seeds of this book – was that on 'History of Labour, Law and Crime', organized by Doug Hay and Francis Snyder at the University of Warwick in August 1983. In addition, we have been fortunate in the individual colleagues and friends who were willing to read and criticize draft sections, or to discuss the issues: John Archer, John Beattie, Tony Brundage, David Eastwood, Mark Finnane, Norman Gash, Vic Gatrell, Doug Hay, Joanna Innes, Jim Jaffe, the late David Jones, Peter King, John Lack, René Lévy, Iain McCalman, Randy McGowen, Peter Mandler, Ruth Paley, Jim Sharpe, Simon Stevenson and John Styles. To Clive Emsley we both owe special thanks, for his constant encouragement, his assistance and his hospitality. And we acknowledge our gratitude to Janet Joyce at Cassell for her interest in the book and her efforts to see it published as we wished; Merilyn Bourke, who produced an immaculate manuscript from many separate fragments of American–Australian drafts; Roger Ruston, our editor, for his skill and patience; and Sandra Margolies, Senior House Editor at Cassell, for her valuable assistance.

We are deeply appreciative of the help rendered by archivists in numerous County Record Offices around England. We gratefully acknowledge the gracious permission of Her Majesty Queen Elizabeth II to make use of material from the Melbourne Papers in the Royal Archives. Material from the Duke of Richmond's papers appears by courtesy of the Trustees of the Goodwood Collections and with acknowledgements to the West Susssex Record Office and the County Archivist. The Marquis of Normanby kindly sent us photocopies of items in the Normanby Papers. We also wish to thank Mr F. E. B. Witts of Upper Slaughter, Gloucestershire, for permission to work on the Witts Diaries, and Peter King for permission to cite an unpublished paper.

Finally, we should also note our debt to modern technology – without the word processor, faxes and in particular e-mail, with its ability to whisk whole drafts back and forth intercontinentally as attachments, it would have been very difficult to hold this far-flung project together.

ABBREVIATIONS

AN	*Aylesbury News*
BC	*Berkshire Chronicle*
BG	*Buckinghamshire Gazette*
BH	*Buckinghamshire Herald*
CC	*Chelmsford Chronicle*
CCo	*Chester Courant*
CFC	Constabulary Force Commission
CFC Report	Report of Commission to inquire as to the Best means of Establishing an Efficient Constabulary Force in ... England and Wales, Parliamentary Papers 1839, XIX (169)
DC	*Derbyshire Courier*
DM	*Derby Mercury*
DWG	*Devizes and Wiltshire Gazette*
GC	*Gloucestershire Chronicle*
HO	Home Office
HPD	*Hansard's Parliamentary Debates*
HT	*Hereford Times*
IJ	*Ipswich Journal*
JOJ	*Jackson's Oxford Journal*
KG	*Kentish Gazette*
KH	*Kent Herald*
LC	*Leicester Chronicle*
LI	*Leeds Intelligencer*
LM	*Leeds Mercury*
MG	*Maidstone Gazette*
MGu	*Manchester Guardian*
MH	Ministry of Health
MOP	*Mirror of Parliament*
NC	*Norfolk Chronicle*
NJ	*Nottingham Journal*
PC	*Preston Chronicle*
PP	Parliamentary Papers
PRO	Public Record Office
QS	Quarter Sessions
RM	*Reading Mercury*

SA	*Staffordshire Advertiser*
SC	*Shropshire Chronicle*
SCh	*Suffolk Chronicle*
ShC	*Shrewsbury Chronicle*
SAd	*Sussex Advertiser*
UCL	University College London
WFP	*Western Flying Post*
WC	*Worcestershire Chronicle*
WG	*Worcestershire Guardian*
WGS	*Wiltshire and Gloucestershire Standard*
WI	*Wiltshire Independent*
WC	*Wolverhampton Chronicle*

Place of publication throughout the notes is London, unless otherwise indicated.

CHAPTER 1

INTRODUCTION: 'A WELL-ORGANIZED POLICE ESTABLISHMENT': POLITICS AND THE TRANSITION TO A POLICED RURAL SOCIETY

I consider the Village Constables or Tithing men wholly incompetent and almost entirely useless ... The generality of them are men imbecile both in body & mind, & in many instances devoid of integrity & moral character. This has naturally led to neglect, lack of duty and conniving at crime, and a resultant increase in crime ... There is nothing that the Constables do that could not be better done by a well-organized police establishment. (Sir Thomas Baring to Constabulary Force Commissioners, 28 December 1836, PRO HO 73/3)

Historians and the police

Anyone who writes about English policing history in the 1990s owes a substantial intellectual debt to many fine historians who have written on the subject. The earliest attempt at a comprehensive history was published in 1901.[1] Charles Reith, between the 1930s and 1950s, wrote no fewer than five books on British police history, which took a highly teleological approach, celebrating the British police forces as the best possible form of police in the world.[2] Sir Leon Radzinowicz, in his magisterial *A History of English Criminal Law and Its Administration from 1750*,[3] devoted considerable space (especially in vols. 3 and 4) to the struggle over reforming policing in England from the late eighteenth century to the mid-nineteenth century. F. C. Mather, in his account of the machinery for the repression of disorders in the Chartist period, included two important chapters on the 'old' and 'new' police.[4] More recently, T. A. Critchley has offered a general history of policing in England and Wales; Clive Emsley has published a number of books which greatly illuminate the social history of policing in England and its reform from the late eighteenth century; and Robert Reiner has offered some pungent historiographical analysis on the 'Birth of the Blues'.[5] Stanley Palmer has examined the development of policing in England and Ireland in this period in relation to issues of protest and public order,[6] and V. A. C. Gatrell has provided some incisive

analysis of the 'new police' and their effectiveness.[7] There have also been numerous important articles which have addressed aspects of police reform in England in the early nineteenth century.[8] The most recent account of these developments draws upon the works cited above to offer a brief synthesis.[9]

The Metropolitan Police of London have naturally occupied a prominent position in these histories[10] – both because of the size and importance of London, and because the Metropolitan Police, on its establishment in 1829, was the first 'new police' force in England, and thus became the most powerful model for contemporary thinking about 'new police' reform. There have also been some studies of the borough police forces of important provincial cities and towns.[11] Less attention has been paid to the development of the county forces of England. The main study – by Carolyn Steedman[12] – deals with the county forces *after* they became compulsory in 1856. There has been far less attention paid to the complex and important period of negotiation – involving central government, county Quarter Sessions, the gentry in general, and even the ratepayers – over the period 1829–56, which eventually led to the Act making county police forces compulsory over the whole country.

The general histories find some difficulty in dealing fully with the development of the county forces. Stanley Palmer's superb book, for instance,[13] deals much more effectively with the Metropolitan Police and with the Royal Irish Constabulary than with the English county forces. This is predominantly because the records for the Metropolitan force and the RIC are held in central archives, whereas the records of each county force – if they have survived at all – are scattered and time-consuming to consult. To find and use the records of each separate county force requires a great deal of work for relatively little return. There do exist published histories of most of the individual county forces, but few of these rise above the local and parochial approach. None of them gives an adequate historical context for the national moves for policing reform which occurred in this period, nor are they able to explain how the developments in their own particular county fit into the wider national changes in the society, economy and polity of Britain in the first half of the nineteenth century.

One of the tasks taken on in this volume is to trace the emergence of a new structure of law enforcement and order keeping in the provinces, above all in rural areas. Except insofar as it constituted a model to imitate, or loaned or transferred its trained personnel to areas outside London, we do not deal with the Metropolitan Police, nor with the borough forces which developed following the Municipal Corporations Act of 1835. Despite the fact that English county police legislation also extended to Wales, we have limited ourselves to the English counties alone.[14] Ireland and Scotland, of course, developed quite separate policing systems under different authorities and different structures: we are not concerned with them here.

The advent of a policed rural society

The County Police Acts of 1839-1840, though initially adopted piecemeal, would prove over the longer term to have been a significant milestone in the history of English rural society. By 1856, across all social groups from the landed classes down through the ranks of paupers, both the idea and experience of policing had undergone a dramatic transformation from what had been (and had been accepted as) the norm in the 1820s, as the following vignettes from Essex illustrate.

On 16 March 1820, Sarah Scott, a farmer at Copford in Essex, discovered that she had been robbed of about four bushels of the wheat which was being threshed in her barn. William Perry, a labourer employed by her to do the threshing, reported to her the loss, and that two strangers had visited the barn the previous day and talked to him for a considerable time while he was engaged in the threshing. Scott and her son John, also a farmer, raised the alarm locally about the loss, and made inquiries in the surrounding area about the two suspicious strangers. Copford is near the border of Suffolk, and a butcher from Bures, on the Suffolk-Essex border, responded to the inquiries; John Webber said that on 16 March he had seen two men he knew from Bures, James Hum and James Cardy, with an ass laden with two half-full sacks on the road from Copford to Bures. John Scott reported this to Thomas Gray, a farmer who was also the local parish constable. Gray applied to the local justice of the peace for a warrant to search the houses of Hum and Cardy, where they found two sacks and a quantity of the wheat. Scott prosecuted Hum and Cardy for larceny at the Easter Quarter Sessions for Essex in April 1820.[15]

The working of the local policing system in this prosecution was typical of the cases which came to Essex Quarter Sessions in 1820. When farmer Robert Willes suspected that his labourer Golden Bridge was stealing the wheat which he threshed, his sons caught and searched Bridge and found some wheat. When Henry Abrey, an upholsterer, suspected that his journeyman was stealing raw materials, he went to the local constable (a shopkeeper) to get a warrant to search the journeyman's home. When Sarah Candler found clothes missing from her washing line, she raised the alarm. One of her neighbours caught a man carrying a bundle of clothing and handed him over to the local constable (a labourer). Rebecca Cutler missed her shawl in a pub: she went in search of the man she suspected of stealing it, found him in another pub, and then sent for the local constable, who found the shawl hidden inside his hat. Amelia Tilewood saw a man carrying a goose, and suspected it was one of hers; she reported it to the constable who arrested the man. William Lake, a draper and tailor, and Ferdinand Bridge, a glover, had both suffered thefts from their shops; they told the local constable that they suspected James Downs and John Rippingale of being responsible, and he searched their houses with a warrant and found the stolen goods.[16]

These simple cases were typical of those coming to Quarter Sessions,

and they illustrate the normal workings of the agencies of law enforcement in provincial England in 1820. Note that, in all of them, the initiative was taken by the owner of the property stolen: in one case they managed without any reference to a constable at all; in the other cases the constable was only brought in to arrest or search the suspected persons. In all cases the injured party had to bear a large part of the burden of searching for the property and the offender, and then of arresting and prosecuting the likely culprit. The local parish constable was generally a part-time officer, following some other trade or occupation, who could, at best, react to requests for his services (if the injured parties could find him). There could be no expectation that he would take a proactive role, patrolling the parish looking for trouble to deal with.[17]

In the cases which came to Essex Quarter Sessions in 1820, depositions and recognizances record the activities of 33 parish constables: 11 of these were artisans or tradesmen; 8 were farmers; 3 were labourers; and 11 were simply recorded as 'constable'. Among these 11 were some long-serving or 'perpetual' constables. A very few of these, in turn, might have had no other occupation.[18] In this, the Essex constables were typical of those of the whole country. In 1820, there were no regular, full-time, paid police forces in England – not even in London, where the Metropolitan Police force was not established until 1829. London in 1820 did possess some paid police, in the form of the 'Bow Street Runners' and similar small groups of police attached to the offices of the stipendiary Police Magistrates, and horse and foot patrols. Most provincial cities and towns of any size, and the London parishes, had paid night watches of some form. But most small towns, villages and rural parishes continued to rely on the parish constables. These were drawn from the ratepayers of the parish – usually farmers, tradesmen or artisans – who were appointed annually to serve as constable. Appointments were normally made by local courts leet and parish vestries, and in some special cases by the magistrates in Petty Sessions. By 1820, it was not uncommon for parishes to employ paid deputies or substitutes to do the actual policing work – men who performed the role for much longer than the one year laid down for the constable, and thus acquired a degree of permanence and experience in the job. However, they were still normally expected to have another trade or occupation to support themselves; they received fees and expenses for serving warrants and going in pursuit of suspects, but they were not normally paid a regular wage to serve exclusively as policemen.

We shall examine many aspects of the parish constable system in more detail in Chapter 2, but for the moment let us glance at a snapshot of the old police system at work – a return of the number of peace officers in the county, made by the Essex Quarter Sessions to the Home Office in 1832.[19] The return lists 399 parishes with a total of 771 acting peace officers – an average of almost two per parish. Most of the parishes were recorded as each having either one or two constables; a small number employed more than two constables. Overwhelmingly, the police were unpaid, except for

the payment of basic expenses and fees when on official business. Only three parishes recorded the employment of paid forces – two under the Lighting and Watching Act of 1830, and the third a force of two men supported by voluntary subscription; twelve more recorded making regular payments to a constable from local parish Poor Rates. To a modern reader, a notable feature of this return is the *age* listed for the constables: 66 per cent of them were in their thirties or forties; another 24 per cent in their fifties, sixties or even seventies; and only 10 per cent were in their twenties or younger. Most of the county – outside the large towns – relied for their basic law enforcement on unpaid, part-time constables aged 30 or over.

Contrast this with the situation in Essex twenty years later in 1853.[20] By then, the county had been under the authority of a regular, paid, uniformed police force since 1840.[21] The size of the county force was 202 men, far fewer than the total number of parish constables appointed in the county in the 1820s, but it possessed a county-wide command structure (which rested on highly professional and competent divisional superintendents linked intimately with the office of the chief constable at Chelmsford), and it functioned around the clock, 365 days a year.

The Essex Constabulary did not (and could not) station a man in each parish, but relied on its full-time force, centralized structure and permanent installations to patrol constantly and enable the public to communicate with it easily. The county was divided into divisions, the divisions into detachments, and the detachments into guards or beats. The Essex chief constable, Captain McHardy, claimed that the county force could respond to the needs of the inhabitants more quickly and effectively than the old parish constables had ever done. The new police, McHardy claimed, could prevent the commission of crime by regular patrolling, disseminate information about offences and offenders quickly throughout the county, and detect and arrest offenders when crimes were committed. McHardy was a great publicist for his Essex force, which he called 'a permanent and perfect police force'.[22] He took advantage of a leading question from the chairman of the committee to emphasize the virtues of his new police force over the old parish constables:

Chairman. Do you not think, under the old system, the parochial constables must have had an interest in the increase of crime? – That is the principal evil of the parochial constable system; there are many other evils, but that is particularly the evil of any system which does not remove an interest in crime; I think a great recommendation of the county constabulary is, that the poor man is protected, and the same interest is taken to follow up any injury he may receive as in the case of the rich man; whereas, in the other system, unless the party can produce the funds the parochial officer will not follow up the case, and it cannot be expected that he should at his own expense.[23]

These changes in Essex were replicated to a greater or lesser degree in most counties between 1839 and the mid-1850s. In 1840–41, half of the English counties established new, regular, uniformed police forces under permissive legislation; by 1856 between 65 and 70 per cent had done so;

from 1856 county forces became compulsory. Allan Silver described what happened in England in this period as the transition from an 'unpoliced' to a 'policed' society.[24] Silver's important article was largely concerned with the policing of London, and most of the writers who have followed him have also tended to focus mostly on the capital, the large provincial cities such as Liverpool, Manchester and Birmingham, and the corporate towns with municipal government. This emphasis is understandable, since the metropolitan and urban story was the most important and obvious in its effect, and it tends to be the easiest to research. But the period also saw the coming of a 'policed society' to the counties *outside* the urban areas. This transition was slower than in the cities, but it was equally significant over the long term. It was also highly charged politically. It raised a delicate question about the future shape of local government and posed a threat to the status and power of parish élites, and an apparent threat to the gentry and the justices of the peace drawn from it.

Provincial policing, politics and the state

The critique of the old constabulary and the elaboration of schemes and plans for a new one were initially elaborated by intellectuals. By the 1830s the critique (but hardly all the details) had been fully taken on board by much of the National Governing Class.[25] It has been recently and correctly pointed out that the last defence of the old constabulary issuing from the (central) English state on the grounds of the primacy of the need to protect the liberty of the subject came in 1822.[26] From that point on, every select committee and Royal Commission of Inquiry on the police, poor laws or related subjects did not fail to recommend a reformed police structure – initially for London and then for provincial England.

The propaganda of the early nineteenth-century intellectuals and government ministers who provided or retailed the rationales and chief arguments for creating a policed society was exceedingly powerful.[27] It is still difficult to avoid coming under its spell,[28] but we have attempted to avoid the dangers which have beset many accounts of the origins of policing: teleology and what Edward Thompson, in a different context, called 'the enormous condescension of posterity'.[29] Since regular police forces have long been the norm in the West, it is hard to imagine a workable society in which that was not the case. The natural tendency is to think that the establishment of paid, embodied forces was sensible, obvious and inevitable, and that people who resisted or argued against it were foolish, reactionary, wicked or all three.[30] We shall observe that the old system of parish constables was not nearly as hopeless as those who beat the drum for a 'new police' made out, but the former came to look more and more obsolete – even 'shambolic' – as metropolitan intellectuals, government ministers and commissions of inquiry hammered away at its deficiencies.

By the 1830s, rural élites, those we term the Provincial Ruling Class,[31]

began to find the substance of the critique of the old system more and more irrefutable. Gentlemen, magistrates and provincial clergymen in increasing numbers began to write to London to complain about the inadequacy of their existing constables, demand new legislation to reform the police of rural England, and report on the new policing initiatives that they had undertaken on their own account.[32] The papers of the Royal Commission on a Constabulary Force for England and Wales (1836–9)[33] are full of such correspondence and provide great insight into the degree to which the critique of the old constabulary had been absorbed by key elements of the gentry, but also the extent to which there would be disagreement over any concrete plan proposed by government – or anyone else for that matter. The growing volume of such material in the 1830s shows conclusively, not that the old police was in fact always inadequate, but that it was increasingly being perceived as such by the Provincial Ruling Class. Those who complained and/or tried to attract the government's attention to their pet reform projects or ideas were, to some extent, a self-selecting group. There were others who wrote in, or, if magistrates, spoke and voted in important Quarter Sessions debates in opposition to a 'new police' and in defence of existing policing agencies, but they constituted a diminishing proportion of rural gentlemen. There was great opposition in the provinces in the early 1840s to the particular police *legislation* rammed through by the Whigs; but, as we shall see, not all of it, among the gentry at least, signified rejection of the main principles of new policing.

Perhaps the greatest defect of teleological police history was its inability to convey adequately the fact that the great debates about policing did not simply pit against each other those who favoured a new police and those who did not. There were many camps and a great cacophony of voices. Keen police reformers in both London and the provinces often did not agree among themselves on key issues of size, control and financing. Therefore, the debates over rural policing, which involved the government, Parliament, rural élites in the counties (and even the representatives of the substantial ratepayers), were very complex and highly textured. We have attempted to capture as much as possible of this in our account.

The policing issue was one element in a wider struggle over the distribution of power within various elements of the English state. The transformation of English rural policing was drawn out and complex because it appeared to threaten a major *bouleversement* of social and power relationships both within rural society and between its rulers and the central state. In the early nineteenth century, these lines of power and authority were beginning to shift. All parties, and not least the gentry, the traditional ruling/ administrator class of the counties, were asking themselves what their future place was to be in the new order of things and struggling to ensure the preservation of their status and authority. A further object of this book is to examine these political battles and how they were fought out in Parliament, within county Quarter Sessions, the provincial press and other forums.

It was a constant complaint of the justices of the peace that they lacked

sufficient control over the old constabulary. Whether a new rural police were to be placed under the control of the government or the gentry through county Quarter Sessions or Petty Sessions, the immediate losers were bound to be the old parish élites. Owing to their influence over local courts leet and their control of the vestries, the older policing structures had been largely their preserve. For obvious reasons, the parish élites, the farmers and substantial tradesmen who controlled the vestries, the constabulary, poor relief and much more at the level of the parish pump never took kindly to the creation of a national police of the sort recommended by Edwin Chadwick and supported by some members of the National Governing Class. This threat never materialized. Instead, under the legislation of 1839, 1840 and 1856, authority over the new police was vested in an unelected and 'irresponsible' body, county Quarter Sessions, which was empowered to levy county rates upon them, forcing them to pay for their own political diminution. Even the Tory alternative police legislation of the 1840s – the Parish Constables Acts of 1842 and 1850 – and other schemes with a Tory provenance, did not treat them much more kindly.[34] The power of parish aristocrats had been dealt a blow by the New Poor Law arrangements of 1834; the reform of the rural police, besides being expensive (and galling on that account alone), was yet another instalment in their disempowerment.[35]

Our story of the politics of provincial police reform has four chief protagonists: 1) London-based intellectuals who propounded and publicized a set of increasingly compelling rationales for revamping the old constabulary arrangements; 2) The National Governing Class; 3) The Provincial Ruling Class; 4) The parish élites and the substantial ratepayers. We observed that the latter group would end up a major loser in the struggle, but for a time in the 1840s they demanded of the gentry and magistrates that they be negotiated with. Because the Provincial Ruling Class faced not only upwards towards Parliament and government, but also downwards towards tenants, the ratepayers and the parishes, it could not afford to appear too crassly willing to shove aside completely the concerns of the ratepayers. It had, at the least, to make a show of considering the ratepayers' interests if only to maintain its local legitimacy as a self-constituted, unelected élite with broad judicial and taxing powers. Therefore, in a number of counties the ratepayers were able to achieve some (temporary) success, either by helping to block adoption of a rural police or by extracting formal or informal commitments from the magistrates to hold force levels down. Finally, we might mention a fifth protagonist largely missing in our account: the agricultural labourers and the poor of the countryside, the element in society from which proceeded the disorder and crime which the police were designed to check and repress. Some radical politicians distant from the key levers of power and decision-making and a few maverick Tories such as Disraeli and Richard Oastler spoke on their behalf. In the debates that swirled around the issue, it is hard to hear their voices. Whatever resistance they engaged in *after* the

implantation of the police,[36] it was a reaction to a *fait accompli* whose terms had been decided by others.

The reform of the English provincial police rested finally on prolonged and complicated transactions between the National Governing Class and the Provincial Ruling Class. It was one thing for ministers to draft bills and commission Royal Commission reports. It was another to make such schemes acceptable to Parliament and to the squires and justices of the peace in the countryside, some of whom were themselves MPs or tied by friendship, interest or blood to members. Much of the story lies in how our issue was negotiated within a complex web of commonality of interest/view and mutual mistrust and suspicion between and within the National Governing and Provincial Ruling classes.[37] The rural police issue was an especially fraught one during the 1830s – the years of Whig ascendancy – because it became entangled in a wider and quite sensitive contemporary debate about the viability of the forms and processes of county government, and the relationship of all local government to the centre.[38]

The magistracy was acutely aware that government's faith in its ability to preserve the peace and maintain order and in the administrative competence of Quarter Sessions had been shaken. They feared an assault on their local power by the centre, which would, of course, have constituted an attack on their status and prestige as well. The diminution of gentry administrative power did, of course, take place, but it was a slow collapse and occurred much later in the nineteenth century. In our period, whatever the degree to which Whig ministers might have been attracted to out-and-out utilitarian prescriptions or other more 'modern' modes of administration, it was impossible for them not to take the interests of the Provincial Ruling Class into account. As a practical matter, any police measure that did not do so would have experienced grave problems in Parliament. The trick for the Whigs in presenting any measure for the policing of the provinces was to discover what the outer limits of gentry tolerance were and craft legislation accordingly.

Ministers well understood that the matter of rural policing had, ultimately, to be *negotiated* with the politically active elements of the landed class in the counties (and, in 1856, with the boroughs as well), and that this bore a relationship to the extent to which backbench support could be mustered. This is what Lord John Russell meant in a frequently quoted letter to Edwin Chadwick. Russell admitted that English local administration was obsolescent, and he shared Chadwick's object of introducing 'system, method, science, economy, regularity and discipline'. However, it was essential not to lose the 'cooperation of the country ... some faults must be indulged for the sake of carrying improvements in the mass'.[39] He, therefore, would propose nothing that would trench overmuch upon the social power, status and prestige of the Provincial Ruling Class. The latter remained a crucial component of the English state, essential in this period to its functioning. The English central state increased its power and competence in the first half of the nineteenth century, but only by

undertaking the negotiations and making the bargains that had to be made with a still self-confident and far from passive landed élite. Our account of the transition to a policed rural society is also offered as a case study of the transactions within and inner workings of the late Hanoverian and early Victorian English state.

'THE WRECK ONLY OF AN ANCIENT SYSTEM'? THE OLD PROVINCIAL CONSTABULARY ON THE EVE OF REFORM

The police establishment for the country consists in general of a constable for each parish or township, elected to serve for the year. He is most commonly an uneducated person from the class of petty tradesmen or mechanics, and in practice is usually nominated by his predecessor on going out of office. No inquiry takes place into his qualifications or fitness for the office, and indeed he is said to be often the person in the parish the most likely to break the peace. . . . Entirely ignorant of his duties when first appointed, the parish constable is often displaced at the end of the year, when his acquaintance with them is, perhaps, beginning to improve. Even when suited in other respects to the employment, his efficiency is always in a great manner impaired by the nature of his position with regard to those among whom he is called upon to act. Belonging entirely to their class, and brought into constant contact with them by his ordinary occupations, he is embarrassed in the discharge of his duty by considerations of personal safety, interest or feeling, and by an anxiety to retain the good will of his neighbour.

(*Second Report of the Commissioners on County Rates*, PP 1836, XXVII, pp. 8–9)

'Dogberry' and his critics

Oddly, we now possess a more rounded picture of the constables and their relations to the state and the local communities in which they functioned at the time of the Stuarts,[1] but much less is known about the state of the constabulary on the eve of its decline. Since it is important to understand the key institution that came under attack, this chapter examines the appointment and changing social status of constables, how they functioned, the variety of forms which they took, and some recent innovations in their use. The 1830s was the last decade in which parish constables remained the sole instruments of law enforcement in the countryside. This period saw the first significant deployments of modern policemen in country districts under a plethora of local initiatives: the Lighting and Watching Act (1833), local Acts, Associations for the Prosecution of Felons, or by private subscription undertaken by country gentlemen.[2]

The County Rates Commission presented in a nutshell all the elements

of a critique of the old constabulary that had become common by this time. Reformers, government ministers, justices, and sometimes even parish authorities and Poor Law Guardians, stigmatized the constables as lazy, recalcitrant, illiterate, officious, aged, bumbling, mercenary and corrupt, often perfect 'Dogberries'.[3] Since the old constabulary varied so considerably in efficiency and quality, it is not difficult to find Dogberries (or worse) among them. A Somerset constable had arrested a man for stealing pork and secured him in a public house. The suspect managed to slip away, and the constable went off in pursuit, but when he returned, 'he found the pork was gone too; he had lost the property as well'.[4] A Norfolk guardian spluttered: 'our constable is good for nothing but to eat drink and Sleep he has a Son a Poacher'.[5] Wolborough lamented that their constable-cum-captain-of-the-watch 'can be neutralised by a pint of beer'.[6] The Winkleigh guardian lamented that the constables were themselves publicans or beerhouse keepers and more interested in 'encouraging than detecting crime'.[7] The Sheppey Union complained of the constables' ignorance of the law and their duties, calling the entire parish constable system 'a mockery of protection'.[8]

But our sources, and even the late-nineteenth-century literature of reminiscence,[9] often summoned up, not Dogberry but a quite different figure: a local man who, by dint of his physical prowess and other personal qualities, could command enough respect to conciliate people at odds, break up petty village brawls, deal with disputes before the parties resorted to the courts, and preserve the peace under normal circumstances. They also reveal another type of constable: a man determined to make a trade of it, tough – even brutal at times – interested in turning the office to account, active (sometimes too active for many), responsive to the magistrates, but often partial and sometimes even corrupt.

The criticisms of the magistrates had great potency. Reformers and 'moral entrepreneurs' such as Edwin Chadwick and government ministers such as Peel, Melbourne and Russell well understood that whatever they wished to do about the rural constabulary, little would be possible without the co-operation of the gentry from whose ranks the justices were drawn. The responses of the magistrates to the queries sent by the Constabulary Force Commission (CFC) demonstrated the degree to which the gentry had lost confidence in the unreformed constabulary. A majority of all English petty sessional benches proclaimed the parish constables inefficient in 1836.[10] Influential magistrates, such as Sir Thomas Baring, called the generality of Hampshire constables 'imbecile in body and mind and [in] many instances devoid of integrity and moral character'. The chairman of Gloucestershire Quarter Sessions spoke of them as being 'the wreck only of an ancient system'.[11]

A Kent justice, frustrated at his inability to get the constables to monitor the beerhouse, complained: 'I have ordered them to go – one did – the other did not – the one who went, sat himself down ... and called for beer.'[12] The justices of Bingham (Nottinghamshire) called their constables

negligent and indifferent to their duty: 'In many cases the constables wish to screen the offences and misconduct of their neighbours, and have ... a dread of making themselves unpopular.'[13] A Staffordshire magistrate complained that a constable, ordered to hold a suspect in custody pending further examination, 'very improperly took the prisoner's word for his [future] appearance', went to his father's house to chase away crows and shot himself in the hand with a gun.[14] His behaviour was irregular, indeed outrageous; no policeman would have failed to respond to a justice's order.

Elsewhere they were accused of corruption. The Thanet magistrates had no complaints about the activity of the entrepreneurial constables of St Peter's and Margate, who, dependent on the emoluments of office, served warrants with alacrity, but they were also viewed as corrupt, taking payoffs from professional beggars and conniving at beerhouse irregularities.[15] In some coastal areas, JPs and the Coast Guard reported the constables to be 'open to bribery' by smugglers;[16] in others they were themselves fishermen-cum-wreckers.[17]

Justices' complaints about the constabulary were nothing new, but in the past the remedy had always been considered: increasing the quality of the constable, increasing his immunities, subjecting him to firmer discipline by authorities external to the village and binding him more closely to the reforming projects of the justices of the peace or the state.[18] By our period, a significant portion of the magistracy could view the entire constabulary system – or non-system, as it was increasingly labelled – as definitively hopeless. Many of them were willing to join government ministers, many liberal Tories, parliamentary Radicals such as Joseph Hume, and other reformers, in calling for its abolition and replacement by something entirely new: by a proper *system* – that is to say policemen in place of the constables. The Suffolk parson J. S. Henslow concluded, in the 1840s, that:

> The possibility of a policeman being stealthily on the watch . . . will often prevent the first step from being taken on the downhill path to infamy, whilst the certain conviction that the village constable is snoring in bed, is apt to inspire the most timid of our would-be offenders with a hope that he shall go undetected . . .[19]

These groups did not always see eye-to-eye, except on the need to make significant changes in the constabulary.[20] But even many justices and magnates, who would fight against the creation of a rural police between 1839 and 1856, did not necessarily think that the old constabulary could go on without a healthy admixture of *professional* direction and greater responsiveness to the magistracy.

In search of greater efficiency, justices themselves were encouraging more semi-professionalism, or even outright professionalism, resorting to the creation of paid so-called 'Office', 'County' or 'Riding' Constables. Magistrates and gentlemen began to organize rural district police forces, effectively professionalizing some active local men, or hiring policemen from the Metropolitan force to do the work or supervise the locals. Sometimes this was accomplished through the adoption of the Lighting and

Watching Act (1833), but more often the men were paid through some form of private, voluntary subscription organized by local gentlemen. The appearance and spread of reformed policing arrangements as a result of such local initiatives, as well as the model of the Metropolitan force (and Metropolitan-model corporation forces such as Liverpool or Hull) threw into still bolder relief the perceived deficiencies of the old constabulary.

The appointment and payment of constables

The magistrates had little say in this business.[21] Constables were appointed largely by manorial courts leet, parish vestries and (in parts of the North) township meetings. Even parish authorities had less formal control over appointments than might be supposed. Constables were originally officers of the manor, and the majority of early-nineteenth-century constables were still chosen by the courts leet. Table 2.1 was compiled from magistrates' returns in 1836 for 285 petty sessional divisions in 28 English counties.[22]

In 64 per cent of reporting divisions, constables were still chosen exclusively or predominantly by courts leet. No clear regional pattern is discernible. In counties such as Essex, Cornwall, Bedfordshire, Devon and Leicestershire, the leets had largely ceased to function in this area; where they continued it was generally for town jurisdictions. By contrast, in Surrey, Hampshire, Somerset, Gloucestershire, Wiltshire and Kent, and in the Northern counties of Lancashire and the West Riding, the leets still acted.

The old practice of parishioners taking their turn at service by rota or house-row still survived – quite strongly in parts of the North. It was universal in Cumberland and very widespread in Westmorland. It was also found in pockets of Durham, Northumberland, all three Ridings of

Table 2.1 Appointment of constables (1836) in sample of 285 petty sessional divisions

Source of appointment	Percentage of those divisions reporting
Courts leet	48
Predominantly by courts leet	15
Parish vestry	5
Predominantly by vestry	17
Magistrates	7
Predominantly by magistrates	5
Other	3
Total	100

Source: PRO HO 73/5/1 & 2, JPs' returns to Constabulary Force Commission
Note: 'Other' comprises appointments by township meetings in a few divisions of the East and North Ridings of Yorkshire, and unusual appointments by the overseers of the poor in one Cornwall division.

Yorkshire, Lincolnshire (Parts of Lindsey), Warwickshire, Lancashire, Wiltshire, Somerset, Sussex, Devon and Buckinghamshire.[23] Constables chosen in this manner did not necessarily serve in person. In the Kirby division of Warwickshire, the rota included only the principal farmers, who never acted, yet retained control over the office by having their sons or bailiffs serve as substitutes. Elsewhere, the chosen constable always employed a substitute of lower social status to do the duties at a fee of £10 per annum. In parts of Wiltshire, magistrates complained that the farmers included in the rota passed on the office to 'illiterate labouring men' or even paupers. In Cumberland, where the rota remained both universal and strictly observed, 'it sometimes happens that the rural police officer is represented in the person of a female'![24] Other, somewhat rarer, methods of appointing constables were at township meetings in parts of the North and East Ridings of Yorkshire; in one division of Cornwall, the overseers of the poor designated them in the name of the parish.[25] Procedures thus varied considerably, and substitution was frequent.

The precise details of appointments by leets and vestries are obscure; often they reflected the outcome of vestry or village politics. In the normal procedure for a leet appointment, the nomination emanated from the leet jury, generally composed of respectable and substantial farmers and tradesmen and was accepted by the manor steward. There were considerable variations on this practice and both hidden and open agendas might operate. In some places, the leet jury nominated twice the number of constables required and the steward then chose half the men on the list. In Byfleet parish (Surrey), the jury dictated the name of the constable and 'the steward knows nothing of them'. In yet others, the leet jury operated unofficial rotas, to the annoyance of the magistrates. Leet juries, they complained, paid no attention to the fitness of the man, but simply to when a person had served before 'or whether it is his turn to serve again, so that the Old, the Cripple and the Man who can neither sign his name nor read the warrant . . . are chosen equally with others when their turn arrives'. The Farnham magistrates' clerk said that the court leet jury 'are vulgarly called Tom-fool's Men', and considered their appointments a 'matter of joke'.[26] But leet appointment did not necessarily connote inefficiency – some of the best long-serving country constables and active town constables were appointed by courts leet.[27]

Appointments made by the vestry were frequently the nominees of the overseers and churchwardens, the parish élite. Often, the incoming constable was named by the outgoing officer. Thomas Dyer, a Surrey magistrate, reported:

> Constables are usually chosen at the tourn or leet. The constable going out of office gives in the name of some person, as his successor, belonging to the parish for which he is acting. *In some parishes the name sent in is fixed upon at a vestry*, but being an office much wished to be avoided, and one for which the parish is not answerable for the manner in which the duties are performed, no trouble is taken in the selection, except to avoid giving offence to personal friends. It is

almost a matter of course the name is accepted ... without any inquiry into his fitness ... and often the person cannot write or read.[28]

We suspect that the hand of the vestry was at work in many such proceedings, but since it was hidden behind a formal leet appointment it is impossible to say precisely how prevalent it was. In the small town of Kettering (Northamptonshire), the select vestry determined in 1834 to appoint a salaried 'standing constable', and sent its nominee's name to the court leet, which appointed him along with the two regular constables; the latter continued to be appointed but became inactive.[29] In Bromsgrove (Worcs.), on the other hand, two of the three constables were appointed by the leet and the third by the vestry.[30]

How a particular individual came to be nominated is difficult to determine. Each locality had its own idea of the social strata and range of occupations appropriate for the office. There was scope for malice and settling scores by lumbering a fellow villager with the office for a year. A Buckinghamshire magistrate reported that the person designated was always someone who was not present at the court leet, and that it was 'as a punishment'. If he belonged to the 'better class of tradesmen', the punishment consisted in being forced to pay a substitute.[31] Lord Radnor thought that, in Wiltshire, appointments were often being made more 'from motives of pique or in joke'.[32] Such practices indeed took place, but they cannot be taken as typifying the entire system.

Magistrates appointed the constables in only 12 per cent of our sample divisions. By the 1830s justices of the peace were loudly deploring the fact that the system was beyond their control,[33] stating that a minimum requirement of any reform programme was an increased magisterial role. The magistrates' relative impotence became a sore point for them,[34] and their attempts to extend their control to appointment of the constables became a source of jealousy and friction between them and the appointing authorities. In the eighteenth century, the justices had created a powerful administrative machine for the domination and regulation of local administration.[35] By the 1830s many were calling for an end to leet and vestry appointments. Defenders of the parish protested mightily against what they considered the imperialism of the justices.[36] But even the more conservative magistrates supported *some* measure of reform – especially by giving the justices power over all appointments and the ability to impose uniform scales of fees.[37]

Calculating the annual worth of the position to the average constable is almost impossible, since portions of his income came from private sources and were not recorded. Some parishes paid the constable a small retainer.[38] Where there was no such arrangement, the constable's annual income from the parish was made up of payments for tasks such as serving precepts, attending the stocks, or surveillance of public houses and beerhouses on Sundays. Other income was derived from work on militia lists, serving summonses for non-payment of rates, executing warrants,

compiling jury lists (up to 1825), and attending distress sales. Some of these duties had to do with criminal justice; others were merely parochial. For some of them, above all public-house surveillance, the constable would not have chanced moving on his own initiative, which would have incurred the risk of having his accounts disallowed. But regarding duties related to jury or militia lists or executing warrants he had to be assiduous, as he could be fined for neglect.

Constables were paid from the county rate for conveyance of prisoners to the county gaol (extra if they had their own vehicle), and for travel, witness and other expenses after a committal to trial in a criminal case.[39] But if an offender were remanded in custody for further examination before committal took place, the constable would have to hope that these costs would be reimbursed by the parish or someone else, since he would not yet have a claim on the county rate. Parish officers acting in good faith would do this, and perhaps ensure the constable something extra for his time and trouble. The account book of the constable of Steeple Claydon, Buckinghamshire shows that, in a local domestic violence case, the parish paid him 2s. 6d. for taking the accused man before a local justice, and then 10s. for a trip to Buckingham for another examination before a full Petty Sessions.[40] He may also have received some private compensation from the prosecutrix, which would not have appeared in his accounts. Daily rates of service varied from 2s. 6d. in rural parts of Kent in the 1830s, to 5s. in Essex. Usually a mileage rate was paid, ranging from 3d. to 10d. per mile if extensive travel was involved. Generally the remuneration was calculated to replace what the man might have earned at his trade on a given day, plus a bit extra.[41]

Some vestries had explicit policies regarding the payment of prosecution expenses from the Poor Rate.[42] In 1791, the township authorities of Pudsey had mounted a campaign against garden thievery and fence breaking, and authorized the constable to prosecute at the expense of the town if the victim was willing to proceed according to law.[43] But there was always the risk that the parish authorities might refuse to pay – for instance if they were opposed to a particular prosecution or the victim was a stranger. A constable's safest course was always to do nothing until one had an assurance of payment from some source(s).[44]

A part of a constable's income, as we observed, was derived from private payments – money to indemnify them for time and trouble for detective work or searching for suspects, and 'fees' levied on parties for settling local quarrels and brawls, or for the restoration of stolen property – activities which occurred within local village mechanisms of self-regulation and dispute settlement and outside the formal criminal justice system. Other sources of income were substitute payments received from a principal, gratuities or rewards from Associations for the Prosecution of Felons,[45] and presents from gentlemen. From 1836 the legality of remunerating constables from parish funds for duties which were not strictly parochial was thrown into doubt. The 1836 reform of parish finances, a direct result

of the advent of the New Poor Law, profoundly disturbed long-standing local arrangements for ensuring reasonable compliance from these amateur officers and produced something of a crisis in the system.[46]

The status of nineteenth-century constables

In the seventeenth century, constables had been drawn from the more propertied and substantial members of the village community.[47] The prestige of the office appears to have been on a par with that of churchwardens and overseers of the poor, and many village worthies held all three offices in rotation. Joan Kent views seventeenth-century constables as 'headmen', persons of high status in the village context, who discharged a mediating role in-between the village and external authorities and functioned (or tried to function) as both royal officials and village representatives.[48]

By the nineteenth century, there were still constables from respectable stations in life to be found,[49] but, overall, the office had declined greatly in prestige. In the Witham division of Essex in the 1820s, farmers constituted 63 per cent of the overseers of the poor, but only 16 per cent of the constables.[50] The great change in the relative prestige of village offices occurred in the eighteenth century. Peter King has pinpointed this for eighteenth-century Essex, demonstrating that these changes had occurred sometime before 1760. The association of constables with less affluent sections of the village population increased. The proportion drawn from labourers and those just above that level rose toward the end of the eighteenth century.[51] It is clear that, by our period, this decline in the status of the constable was rendering the institution less credible in the eyes of those who had the power to reform or abolish it.

Our data from the 1830s (Table 2.2), culled from magistrates' returns to the Constabulary Force Commissioners for seven sample counties, present a picture similar to that of Essex in the last quarter of the eighteenth century, and differing from that reported for Stuart times. The data are extensive and cover all parts of the country. Unfortunately, they do not offer a parish-by-parish breakdown, nor list the precise occupations of the constables. Some ambiguity also results from the fact that some benches may have reported on the status of the men officially designated 'constable', while the actual work of the office may have been done by a deputy. Given this situation, the overall social status of those *acting* as constables might have been even lower, since substitutes were normally drawn from a lower stratum than principals.

Table 2.2 Occupational status of constables (1836) in seven English counties

County	Occupation	No. of divisions
Bedfordshire	Labourers (rural) and tradesmen (towns)	3
Essex	Tradesmen/small tradesmen	7
	Tradesmen/small farmers	4
	Labourers/small tradesmen	3
	Labourers/'lower ranks'	2
	Total	16
Hampshire	Tradesmen/small farmers	6
	Tradesmen/small artisans	4
	Tradesmen/artisans	1
	'Inferior grades'	1
	No data	1
	Total	13
Kent	Farmers/tradesmen	3
	Tradesmen	2
	'Respectable householders'	1
	'Yeomen'	1
	Small farmers/labourers	1
	Not specific	1
	Total	9
Staffordshire	Small farmers/small tradesmen	5
	Farmers/'yeomen'	2
	Total	7
Wiltshire	Farmers/tradesmen	3
	Small tradesmen	1
	'Middle class'/ 'resident householders'	2
	Illiterate labourers/'inferior sort'	2
	Total	8
Yorkshire (East Riding)	Farmers/tradesmen	5
	Farmers	3
	Not specific	1
	Total	9

Source: PRO HO 73/5/1 & 2 justices' returns to Constabulary Force Commission

Table 2.3 Constables' occupations in five Surrey districts (1842)[52]

District	Constables' occupation		Number
Farnham	Farmers		3
	Shoemakers		2
	Gardeners		1
	Blacksmiths		1
	Labourers		2
	Unknown		1
		Total	10
Frimley	Shopkeepers		1
	Labourers		1
		Total	2
Elstead	Farmers		1
	Unknown		1
		Total	2
Frensham	Farmers		1
	Labourers		2
		Total	3
Seal	Sawyers		1
	Bricklayers		1
	Blacksmiths		1
		Total	3

Source: Surrey County Record Office, QS/5/3/A

Table 2.3 represents data from 1842 in five Surrey districts, for which the occupational categories are somewhat more specific.

By 1836, constables generally came from the ranks of smaller farmers and tradesmen. In the countryside, the most substantial farmers, those most likely to be overseers of the poor or churchwardens, rarely acted as constables. In early-nineteenth-century Oxfordshire, constables were 'firmly under the control of village elites'.[53] The justices of Bassetlaw (Nottinghamshire) stated that some farmers served, but 'upper farmers avoid the office'.[54] 'Upper farmers' continued to be appointed in Lincolnshire and Shropshire, but controlled the office either by pressing their sons into service, or, more frequently, by paying a substitute – often one of their own employees.[55]

In the 1830s, the bulk of parish constables were still drawn from the middling strata and many were quite respectable. But the office was now being held by lower grades of the rural middling class; and there were country districts where constables came from the ranks of labourers,[56] something presumably rare a century before. The magistrates of a Hereford division complained that constables were now taken from a class 'the lowest above paupers'. Poor Law Guardians also deplored this trend. The guardian of Bledlow parish (Buckinghamshire) lamented that

the constables were 'ignorant and uneducated day labourers'. The guardians reported that, in the Woburn Union, it was the practice to 'appoint persons constables who are only just one degree beyond the Day Labourer', with nothing 'at stake', and urged the justices to swear in only 'men of substance'. In counties such as Cornwall, Devon, Kent, Leicestershire, Sussex, and the East and North Ridings of Yorkshire, labourers were never appointed, although they served as substitutes.[57] Labourers were reported as being appointed as principals: in Hertfordshire in 18 per cent of all divisions; in Essex (where substitution was discouraged by the justices) in a quarter of the divisions; in Hampshire, Somerset, Cambridgeshire and Herefordshire in about a third of the divisions; and in Bedfordshire in all divisions.[58] They by no means dominated the constabulary, but the increase in the representation of labourers was indicative of the direction in which the office was going by the 1830s.

Both justices and guardians worried that the lower the class from which the constables were taken, the closer their affinities were likely to be with poachers and frequenters of beerhouses, and the more sympathy they were likely to have with anti-Poor Law demonstrators and those who engaged in village petty theft and pilfering.[59] Labourers were not necessarily inefficient constables, but many uneasy gentlemen perceived the increasing proportion of labourers acting as constables as a symptom of growing inefficiency and unreliability. Some justices were concerned that even respectable men did not guarantee efficiency:

> The more respectable they are the worse they are ... for I have had the good fortune to have a respectable man constable in my parish, and on a robbery being committed ... he went to the house and condoled with the person who lost the goods, but where was the robber? He could not go after him, for if he did he would be paid nothing if he did not take him, and if he did take him he would get 5s. a day when he could earn 10s. at home.[60]

Such utterances reflected the bemusement of the rural élite, in which, apparently, both respectability and its opposite produced the same result: inefficiency and torpor.

An important part of the 'Dogberry' stereotype was that constables tended to be aged and broken down, and therefore ineffective. It is true that some constables were old, and some of these decrepit. The parish of Tivetshall St Margaret (Norfolk), with a population of 376, had two constables. One did his duty 'fearlessly', but the other was 'an old man, nearly 70, quite incapable'.[61] Essex in 1832 contained a number of constables in their sixties, in parishes such as Old Sampford, Landon, Little Leigh, Stock, Great Warley and Orsett; and men in their seventies at Sutton, High Ongar and Childerditch – even one aged 77 at Streethall! However, the average age of the Essex constables was 41.3,[62] higher certainly than that of a new police force, but including many healthy and active men.

A related complaint, heard most often from police reformers and justices, was that constables were appointed from parish paupers or to keep certain men from becoming paupers. There was indeed the occasional

case,[63] but the evidence does not support this as a general proposition. The main beneficiaries tended to be the more marginal of those groups that dominated the constabulary – small farmers and tradesmen.[64] Typical was the Copthorne and Effingham division of Surrey, where the substitute system was used to pass the office from the more prosperous to 'others of the same class but needier'; or the Pershore division (Worcs.), where small farmers paid 'artisans with little business' to serve. The incentive money, which could be as high as £10 per annum, and paid directly to the substitute, might have been welcome to such individuals.[65]

The rural constable

We do not doubt the basic passivity of the average rural constable; it was inherent in the very nature of the office. But the constable was only one cog in a criminal justice and prosecutorial system that placed primary responsibility for the prosecution (and often the detection as well) of crime in the hands of individual victims.[66] We should also not forget that, by the mid-1830s, critics had a brand-new standard against which to measure the adequacy of the parish constable – the *new policeman*, who had recently made his appearance in the capital and other big cities, and was penetrating into a number of country districts.[67] A basic distinction began to be drawn between 'constable' and 'policeman': the policeman was paid, proactive and (supposedly) preventive; the constable unpaid, annually rotating and reactive. 'New police' were full-time paid employees, who had no other jobs, wore uniforms and engaged in patrolling, with a view (in theory at least) to both preventing crimes and catching malefactors after their commission. Parish constables were part-time officers, unpaid in principle, drawn from the body of ordinary ratepayers and occupied primarily with other business or trade pursuits. Generally, they acted only when appealed to by a citizen or instructed to do so by a magistrate.

In country districts, the usual procedure in offences against property was for the victim to seek the offender and the missing property – at the cost, usually, of some time and money. The constable would be called after the major detective work was done, a warrant would be procured and the suspect's premises could then be legally searched and an arrest made. Alternatively, and less frequently, the loss could be reported immediately to the constable. The latter would (and could) do little on his own initiative towards finding the guilty party unless the victim could suggest a likely offender or produce some relevant evidence. Armed thus, the constable and victim could gather more evidence, seek a local magistrate, get a warrant and proceed to search the suspect's house. In the Witham division of Essex in the 1820s, for offences other than assaults, only 60 per cent of victims made use of parish constables in this way. In half of these cases the victim did all the work of search and detection, with the constable only being called in at the point of an arrest.[68] This appears to have been typical of the countryside.

Ludlow Bruges, chairman of Wiltshire Quarter Sessions, remarked that the true extent of what the constable did 'was, it appeared, on receiving certain information, to go and search the house of a suspected thief, and in 99 cases out of 100 that information was received from the prosecutor himself'. The local press agreed with Bruges, stating that 'in point of fact the prosecutor was ... his own constable'.[69] The Revd Thomas Spencer stated

> that we are as it were without the pale of the law; that every man that would be safe must be his own watchman, his own constable and his own magistrate; that unless he himself takes all the precautions to make his house and property secure, there is no other remedy; and that, unless he himself shall watch his property, and shall take up the offender, shall take him to the constable, shall order the constable to go with him to the next town, and be put at the expense of the constable doing that, and shall promise the constable to be responsible for putting the man into custody until he can be brought before a magistrate, shall appear before the magistrate, and reason with the magistrate, and in fact, do all the work, the man will escape, whatever be his crime ...[70]

What is noteworthy about these observations and complaints is that the situations they criticize are presented as old-fashioned, lax, even outrageous.[71] Previously, it had been taken for granted that victims would (and should) have to exert themselves greatly if intent on a prosecution. It could even be praised as part of the necessary price which Englishmen paid for the preservation of their liberties.[72] These remarks show clearly the degree to which new and different expectations were coming into play, making what had been the normal, accepted procedures appear increasingly absurd. Although neither Bruges nor Spencer used the word, what they were demanding was a level of performance associated with the *new policeman*. The changed expectations of the criminal justice system among the landed classes is a critical factor in explaining provincial police reform; it is a theme to which we shall return throughout this book.

In fact the more active constables, in both town and country, did more than Bruges or Spencer reported. They played a role in local dispute-settling mechanisms, acting as intermediaries in compromising petty offences. Occasionally this might amount to the compounding of felonies.[73] Assessing the extent of this activity is impossible, since the entire purpose of such transactions was to keep matters out of the criminal justice system where results were uncertain and the costs high, and much of it was illegal. The usual procedure was for the offender to move out of the area and the jurisdiction of its constable. From this safe haven, composition with the victim would then take place 'by the constable's interposition', the latter getting something for his work.[74] The entrepreneurial Cheshire town deputy William Smith, known for his relentless activity and mercenary approach to the job, interposed himself between some victims of a swindle and two thimble riggers, located the perpetrators in a pub, got the money back and took two sovereigns to hush up the business. No doubt the victims paid him as well.[75]

Constables were kept within clear bounds by the pressures and demands

of their fellow villagers who dreaded busybodies and knew how to bring their man up short if he seemed to acquire a swelled head. The Watlington (Norfolk) guardian stated that a constable 'does not like to render himself odious ... by what would be regarded ... as officious interference'. A Sussex constable who arrested a man on his own initiative, 'got so much ill will from his own class of people that for a length of time he was designated the Thief Catcher' – a dishonourable trade.[76] A former Gloucestershire constable, observing new policemen freely laying informations against the beershops, remarked that 'he was glad they [the police] were appointed as he would not in his situation think of complaining of the irregularities of his neighbours' to the magistrates.[77]

Rural constables had to walk a fine line within their communities; for good reason, many avoided using their own powers of arrest for assaults and affrays. The wisest policy was often one of 'see no evil, hear no evil' – above all when it might involve surveillance of, or interference with, alehouses, beershops and other elements of a village's recreational life.[78] Often the constable was himself a regular patron of local drinking establishments and would have seen no reason at all to put official pressure on them. Occasionally, constables showed overt solidarity with other villagers – as at Hadleigh (Suffolk), where they joined the crowds resisting policemen brought in from London who were attempting to stop the celebration of Guy Fawkes Day.[79] Informers of any kind were not appreciated in villages and small parishes. A Derbyshire bench reported a near riot on the conviction of two beersellers in 1836: 'the informers were near losing their lives and would have died had not a young farmer by great personal exertion saved them'.[80] Such odium would particularly attach to constables who acted as informers. Where there were personal connections between a constable and suspect, it was sometimes difficult to coax the constable to act, even with a warrant. A Kent justice reported:

> orders had been given to a publican, the constable of his village, against a man who worked for the constable's father, and it was found impossible to get the constable to execute it. He had . . . called at the constable's house to know the reason of this difficulty, when he saw the very man against whom the warrant was issued walking in front of the constable's house, and sent him to the constable to have the warrant executed ... (a laugh).[81]

On the one hand, remarked a group of Nottinghamshire justices, 'they act under the observation of their neighbours to whom they are accountable at vestry', and this keeps them honest; on the other, 'they are deterred from giving information for fear of private injury from malicious neighbours'.[82]

Being neither professional policemen nor lawyers, constables were often unsure of their immunities and 'diffident of their powers', and they had to be wary of overstepping the latter. The Teignbridge justices reported a 'dread lest they go beyond their duty and thus be liable to a prosecution'.[83] Courts leet, vestries and justices did not provide new constables with handbooks[84] – a lamented fact – nor were they given any formal instruction

regarding their legal powers. The knowledge was traditional, rough-and-ready, acquired on the job, from previous stints of service, outgoing constables and other villagers. There were more refined legal areas where constables must often have been at a loss. How many could quote the legal authorities who opined that they could take up 'nightwalkers' and persons suspected of felony after dark? Or the statutes enjoining the arrest of reputed thieves, or those suspected of conveying stolen goods at night? How many could be sure when it was legal to break down doors and when not?

It was simple prudence to wait for a complaint or a justice's warrant before acting. Chitty, whose treatise on the criminal law few constables could read and fewer still afford, himself recommended this course in most cases.[85] But even then, it might be safer to resist or retire. In Bedfordshire in 1834, a man who refused to let poachers cross his land was shot by a man standing at a beerhouse door. The justices complained that the perpetrator 'was at or about his house ... all the rest of the day unmolested – the constable ... in excusing himself ... said he did not know he might [apprehend the suspect] until he had obtained a warrant!'[86] The shooter was seen around the district for some weeks and then safely decamped to London.

How far could one expect a local farmer, tradesman or artisan, with a farm or business, a family and his health to worry about, to risk life and limb on constable's business, warrant or no warrant? A Surrey constable, having done nothing to apprehend a horse-thief, asked a magistrate: 'If I had my head broke who is to indemnify me? I might have been a cripple and beggar for life.'[87] A Kent justice reported that a few nights previously:

> a constable had gone to a house with a search warrant, and the occupier . . . had loaded his gun, placed himself at the door and threatened to shoot the constable through the head, if he had dared to approach. The constable had become alarmed, and had failed to execute the warrant. Had the warrant been entrusted to . . . police officers, who were sure to execute their duty at any risk . . . the man would never have thought of offering such a violent opposition.[88]

Note the point of the magistrate's story. When confronting horse-thieves (who were frequently not mere casual criminals), smugglers, firearms, cases in which gunplay was involved, or where physical violence was almost sure to be offered, ordinary country constables understandably felt that discretion was the better part of valour.

Constables were unclear about the circumstances under which they could arrest persons *ex officio*, especially in the case of assault or affray.[89] Sometimes, acting to preserve the peace, as they were obliged to do, got them into trouble. At Liverpool Assizes in 1839, two rural constables were successfully sued for false arrest. They had taken up a man for assaulting them while they were breaking up an alehouse disturbance. He sued them for keeping him overnight in a substandard lockup, a common enough circumstance before the new police. They had to pay £10 plus costs from

their own pockets, since no one was willing or able to indemnify them.[90] Had they made an arrest with a warrant, or on a complaint from a third party, they would have been protected; acting, however, on their own authority to arrest for an offence committed within their sight – an assault on themselves! – they were without protection.[91]

Generally, arrests *ex officio* for assaults (being misdemeanours) did not assure the constable reimbursement of expenses unless the constable himself was assaulted in the execution of his duty – and even this had only come in under Peel's Criminal Justice Act of 1826.[92] This constituted another brake on their activity, and perhaps contributed to their 'corruption' – extortion of money from perpetrators in return for not proceeding before a justice of the peace, or, after 1826, making false claims of being assaulted in order to ensure payment from the county.

But there were further inducements for constables to stay out of things. Who was to compensate them if they were injured? What if no commitment took place, a suspect was discharged and one had not taken the precaution of securing compensation or promises of such from the prosecutor? Or if the victim did not pay? Before 1836, parishes, at their discretion, *could* cover these costs, and vestries interested in good order would have been well advised not to abandon their constables lightly. But they did not always do so:

> A hawker was robbed; the two constables, after considerable difficulty secured the offender, who was brought before a bench. The prosecutor did not appear, having been heard to say he was alarmed at the probable trouble and expense . . . Of course the offender was discharged. The constables could not be reimbursed their expenses, amounting to about 40s, which were, on investigation, very reasonable.[93]

Here the constables, anticipating a prosecution for felony, probably failed to get the proper guarantees from the victim. Why did the parish refuse to pay when the prosecution collapsed? Perhaps out of simple niggardliness, which was hardly unknown. But the victim was a hawker, and could have been an outsider. The vestry may have balked at paying 40s. for a stranger's problems. If the constables were inexperienced, they would have learned a painful lesson about the need to negotiate with the victim and about whom the parish expected them to protect.

Passivity was the ordinary country constables' safest policy. 'Wait for a warrant' was their watchword, since they possessed substantial immunities when acting with a warrant in hand. We observed in the Kent case that this could be personally hazardous, but there were legal perils as well.[94] Until the mid-eighteenth century, constables could be sued for trespass for execution of a warrant in an area where the magistrate had no jurisdiction.[95] A constable had to comply *exactly* with the precise terms of a warrant or be liable to an action. If he arrested the wrong person, he would be a trespasser; if the warrant specified the seizure of a certain type of goods supposed to be stolen, and other things, not meeting the precise

description, were taken, he was vulnerable. Legal authorities such as Chitty warned about these dangers.[96] New and inexperienced constables had to act in a fog of uncertainty. The rule, therefore, had to be: act only when one was reasonably certain that the community supported or demanded it – in which case one might hope that legal defects in one's actions might be conveniently ignored – or when specifically ordered to act by a justice, in which case there would be no choice in the matter.

Finally, a constable's level of activity depended on the compensation he could expect. In the mid-1830s (as we shall see[97]), this suddenly became more uncertain than ever, owing to an important ruling of the Poor Law Commission. Country constables, drawn from the humbler strata of society, normally received no salary and were technically not supposed to profit from the office. But unlike the magistrates, who served under a similar principle of amateurism, farmers, craftsmen and labourers compelled to discharge the office possessed neither the fortune nor the leisure to give themselves over too much to it. In small towns or densely populated parishes there were ways and means to put together a full or partial living by 'constabling'. Even in some country parishes vestries occasionally tried to make it worthwhile for someone to hold the office continually, and thus acquire a certain experience and expertise.

Town constables

Town constables, whether principals or deputies, were often of the long-serving type. Examples could be found at Trowbridge, Calne and Chippenham, Truro, Newport Pagnell, Barton-on-Humber, Ashby de la Zouch, Market Drayton, the industrial towns of the Black Country,[98] Malton, Whitby and many other places. They tended to be local men. Some were semi-professionals, like the Bedford constable J. H. Warden, and drew salaries or retainers from parishes or voluntary subscriptions or, very occasionally, from an Association for the Prosecution of Felons. Some ultimately forsook their previous trades entirely. Others were technically unpaid, but, in towns and parishes with a high population density, they made a living on piecework: from process serving, execution of warrants, other fees and payments from individuals, portions of fines in misdemeanour cases and other payments from the county rate. The Chippenham and Corsham constables, for example, received no salary, but could earn, the magistrates reckoned, up to £30 per annum.[99]

Others drew a small retainer from the parish.[100] Some were salaried, usually under some local Act, the Lighting and Watching Act (1833) or a private subscription. The township constable of Brigg (Lincolnshire) was paid £20 per annum from the rates, plus the emoluments.[101] One of the Croydon constables also served as lockup-keeper and drew £60 per annum from the Poor Rate.[102] Another way of assuring decent remuneration, found primarily in Lancashire,[103] was to combine the office with that of overseer or assistant overseer of the poor, an arrangement that prevailed

even in some of the rural districts of the Blackburn hundred. In Clitheroe the salary for the combined offices was £60. Similarly, a town constable could be made inspector of weights and measures, or the office could be combined with a number of other parish, township or manorial duties.

Stourbridge (Worcs.) had two leet-appointed constables, who were, effectively, supplanted in 1829 by William Craig, a paid, standing constable. His income of £100 per annum was made up of payments from several parishes within the petty sessional division, plus fees and payments for conveyance and a house attached to the prison. It was a handsome living until the Poor Law Commission forced an end to parish payments in 1836. By 1839 Craig was reduced to receiving nothing 'except what he could get by serving the processes of the court'.[104] Bromsgrove had James King, first appointed by the parish vestry some time before 1820. The court leet appointed others, but they became unimportant after his advent. The latter made his living from informations against beersellers, executions of warrants, summonsing coroners' juries, fees from service to crime victims, and annual 'presents' of a few pounds a year from local gentlemen.[105] In Doncaster the justices' office constable received a monopoly of the warrant business, plus a retainer of £20 per annum from an Association for the Prosecution of Felons.[106]

A reputation for assiduity and fearlessness, and a willingness to execute warrants and summonses with alacrity would solidify one's reputation among both justices and townspeople. A man who made town 'constabling' his sole trade could become widely known for efficiency and promptness, and thus attract custom; ordinary parish constables in the district were frequently only too willing to stand down. At Barton-on-Humber, the permanent town constable engrossed the business of the surrounding rural parishes; the constables of Horncastle and Market Drayton similarly served neighbouring rural areas. In densely populated northern townships, 'the civil processes ... afford a constant and profitable source of income – that is mileage on summonses for rates and assaults, etc.' The Knottingley constable was paid by subscription, but also earned regular money on summonses for failure to pay Poor and Highway Rates.[107]

Some towns made the full transition to the hiring of full-time policemen in the 1830s. A number of unincorporated towns created little police forces in the 1830s, making use of a local Act or the general Lighting and Watching Act of 1833. Whitehaven, under a local Act, appointed a force of three, put them in uniforms similar to those of the Metropolitan Police and paid them each 35 guineas per annum plus fees.[108] Croydon appointed a uniformed force of a superintendent and five constables, also under a local Act.[109] Horncastle used the Lighting and Watching Act, in 1838, to establish a police force of two paid and uniformed local men.[110]

Lancashire and the West Riding had long-serving 'hired' constables and township deputies long before our period.[111] In the nineteenth century, they seemed more prevalent in these two northern counties than elsewhere – although they came in a bewildering variety of types. In the Kirkdale

division near Liverpool, each township provided a constable plus assistants paid from the rates at £1 to £1-10s. a week, sums strongly suggesting full-time work.[112] The Chorley vestry appointed an active constable, paid him £60 per annum and provided him with assistants;[113] at Burnley, the constable was respectable and salaried, but paid a deputy to do the actual work.[114]

In Wakefield, the constable was similarly respectable and salaried, and paid two deputies who acted as, in effect, 'regular police officers'.[115] There was also a night watch under street commissioners appointed under a local Act. The magistrates, after 1836, were aware that paying the deputies from parish funds was impermissible, and tried to find legal ways of doing so.[116] Huddersfield had a respectable, largely honorific, constable, with two active vestry-paid officers doing the work, and a night watch under local Act commissioners. In the 1830s, the mode of payment of the deputies was declared illegal, and the appointment and payment of the officers was then transferred to the Lighting and Watching Commissioners who levied a legal rate.[117] In the 1820s, Sheffield had three constables, each with active assistants (or 'runners'). By the mid-1830s, although still not incorporated, it had effectively a twenty-man police force under Lighting and Watching commissioners, plus a 56-man night watch, both under the same head officer.[118] The 36 townships of the Skyrack division, forming an arc to the northwest of Leeds, all had township deputies who acted for the small farmers and shopkeepers appointed as constables. Much of the detective work and the execution of warrants had been concentrated, by the mid-1830s, in the hands of a 'Riding Constable' appointed by the justices.[119]

The urbanized areas of the West Riding were largely well covered with full-time and paid constables and deputies by the mid-1840s. In 1840–41, the Quarter Sessions bitterly debated adoption of the County Police Acts of 1839–40. Although there was concern about the state of the out-townships, it rejected, by a narrow margin, a county police force.[120] Enough of the justices felt confidence in the existing structure of paid township constables and deputies and municipal police in Leeds and other towns with municipal government – supplemented, in the 1840s, by salaried super-intending constables – to keep law and order in the Riding.

Although the North had better arrangements than elsewhere before the national police legislation of 1839–40 or 1856, they were often exceedingly complex and cumbersome. Policing was often split between a number of different authorities (sometimes dominated by different political parties), making change frustrating and creating a fertile field for political conflict.[121] At Halifax, for example, the constables (respectable well-to-do men) were appointed by the court leet of the Duke of Leeds. Noting the increase of population, they applied to the vestry for another salaried deputy. Once approval was obtained, they then had to apply to the trustees under the Town's Act, 'and with great difficulty succeeded against the spirit of economy'. The trustees also paid a night watch, but these were under separate management and thus outside the control of the Head Deputy, a

professional officer hired from Manchester. In Bolton, the constables were appointed by the court leet, but their salaries had to be approved by the vestry, which had the power to reject the quarterly accounts. If the ratepayers refused approval, the Tory county magistrates, who had the power to reinstate the charges, were dragged in to the dispute.[122]

All this was far from what police reformers considered desirable: uniformity of system; sometimes uniforms themselves; intercommunicating beat systems; standardized information collection and distribution procedures; training and drill; hierarchy of ranks; and (for some of them) links to a central, national command structure. But it would be quite wrong to think that there was no serious law enforcement before the appearance of police forces.

Deputies and substitutes

The employment of substitutes or deputies to do the actual work was more prevalent in our period than it had been a hundred or so years previously. There may well have been a considerable increase in the practice during the eighteenth century.[123] If a constable appointed a substitute, then he was legally relieved of his duties; this was not the case if he just employed assistants.[124] There had once been doubts about the permissibility of substitution, but by the early nineteenth century its legality was settled. If the substitute was duly accepted by the justices and sworn, the principal was not liable for miscarriage; the substitute was then the constable.[125]

The extent of use of substitutes varied among the counties, according to custom and the justices' policies, for in this area the magistrates had absolute discretion. It was frequent in Hampshire, Hertfordshire, Kent, Nottinghamshire, Shropshire, Somerset, Sussex, and Wiltshire; it was rare, or not permitted at all, in Buckinghamshire, Cornwall, Devon, Essex, Herefordshire, Leicestershire, Suffolk and Warwickshire.

Early-nineteenth-century reformers cited the prevalence of substitution in country districts as a sign of the bankruptcy of the system, as it supposedly reinforced the passage of the office into less and less respectable hands. Certainly, substitutes were almost inevitably of lower status than the principals they replaced – either members of the lower end of the latter's class or drawn from another, lower class entirely: mechanics or labourers. Assistant Poor Law Commissioner William Voules, a confidant of Edwin Chadwick, wrote:

> Should he be a hired substitute? He is from his still inferior situation, utterly worthless as a public functionary, and ... from whatever class chosen, he may be a near relative of the keeper of the tavern or beer shop ... a daily frequenter of it – or ... its owner ... Thus drunkenness-poaching-riots-breaches of the peace ... may be indulged in with impunity.

The situation was both more complex and less alarming than Voules suggested. Substitutes could embody the very worst, but also the very best, of law enforcement before the coming of the police.

The procedure was as follows: where substitution was allowed by the

justices, principals paid inducement money, generally ranging from £5 per annum or less in many southern agricultural areas, to about £10 elsewhere. In parts of Hampshire, principals anxious to escape service at the lowest possible cost, sold the office to the lowest bidder.[126] Substitutes in some country districts could be every bit as bad as the accusations against them claimed: 'idle men tempted by a premium ... low men who connive at illegal practices'.[127] But the preponderance of the evidence is in favour of the deputies. Where farmers' sons or employees served as deputies, our sources generally express a feeling of confidence. Substitutes often took their duties seriously. Being less bound up with their own business affairs than were their principals, they tended to be available and active, and more prepared to act out of their districts.[128] In town jurisdictions, deputies could be entrepreneurial, with a sharp eye out for whatever profit there was to be made.[129] Such men viewed their duties as a kind of small enterprise; many parish and small town authorities accepted it as such, and thought themselves lucky to have an active man, whatever his faults might be.

The police reformer Patrick Colquhoun believed that the substitutes were *the* key to better town policing. Everything depended on 'finding *respectable, able*, and *intelligent* men as substitutes ... because through no other medium can they be sufficiently remunerated'.[130] He suggested that, were

> the remuneration for substitutes more adequate, it is not improbable ... that men of intelligence, who have preserved their integrity, under the frowns of fortune, would be found who would offer themselves as substitutes, and ... devote their time and attention to the various duties of the office ... It is therefore ... from police officers and respectable substitutes only, that vigour and energy ... are to be looked for, and therefore the improvement of the system with respect to Deputy Constables becomes a most important desideratum [in] every populous community in the kingdom.[131]

'Perpetual', 'standing' and 'office' constables

Some constables served for long periods as 'permanent', 'standing' or 'perpetual' constables, acquiring a certain expertise and cunning in their business, above all in the small towns and larger parishes. Some of them were also deputies. At Wingham (Kent), the parish reported in 1832 that 'Beal is generally Imployed [sic] – he has served ... for the parish for the last 15 year [sic]'; at Great Mongham, 'John Rigden ... served for himself in the year 1826 and has been in the office ever since, serving at present for Joseph Paramore'.[132] In Essex, in addition to larger places such as Waltham or Braintree, which had their own particular arrangements, eleven parishes reported having standing constables.[133] Although primarily a town phenomenon, long-serving, frequently quite competent, men were not absent from the countryside.

Often, these posts were combined with other public offices or a private trade or business. J. H. Warden of Bedford was an auctioneer; William Magill of Chepstow a saddle and harness maker; Thomas Smith of

Sheffield doubled as keeper of the gaol; Joe Green of Bingley combined the offices of constable, pinder and bellman, much like the Cheshire deputy William Smith. There was a healthy complement of butchers and blacksmiths, trades requiring strength, and of other types of artisan; but there were also many farmers, schoolmasters and shopkeepers. In larger towns or manufacturing areas, the designated constables were usually quite respectable middle-class men, but their assistants were drawn from the 'manufacturing class' – as at Dudley.[134] Some long-serving town constables were upwardly mobile, such as the active constable of Witham in the 1820s, who aspired to farming, or James Little, the perpetual constable of Patrington, who rose to become clerk to the Board of Guardians.[135] A few later surfaced in new county police forces as inspectors or superintendents.

These characters are met with everywhere: some were rascals, drunkards or both; some were rough men who made themselves feared. Some were intelligent, literate men aspiring to greater professionalism who occasionally developed and communicated police reform schemes to the authorities.[136] Often they were known for their robustness. John Hollings of Morley relied on his physical prowess, stout blackthorn stick and good sense. His approach was sometimes enough to quell local rows, and in minor cases he smoothed 'the troubled waters, by speaking kindly to the offended ones, and terrifying the wrongdoers into making amends, rather than to "make a case" for the magistrates'. [137] Charles Shaw recorded of his childhood in the Staffordshire Potteries town of Tunstall in the 1830s:

> We had only two constables in the town then, and they were both cobblers as well as constables. They always stuck to their 'last' till they were sent for, whenever there was a row or fight ... If not engaged elsewhere, he [the constable] would come hurriedly ... as soon as he was seen there was a cry raised, 'The constable is coming.' That cry never failed to disperse a crowd ... There was a potency in the word 'constable' which I have never seen in the word 'policeman'.[138]

But even they were overwhelmed when anything out of the ordinary took place. Hollings could not cope with the hordes of navvies who descended on the town to build the Morley railway tunnel in 1846–7, and a group of special constables had to be sworn in to assist him.[139] James Little was reduced to impotence at fairtimes when the population suddenly doubled: 'What could we do?' he lamented. 'Just what we could do and that was all.'[140] It could be a dangerous job, and some had second thoughts about continuing. In Alton, a local tradesman got £30 by voluntary subscription to clear up local crime and was furnished with handbolts and a brace of pistols. He succeeded in catching or driving away 'all the notorious thieves'; some of them were transported. A meeting of delighted subscribers met to consider his reappointment, but he refused, saying he would not 'serve the office under double the salary'.[141]

Police reformers were suspicious of permanent constables, fearing that they might lose their respectability by devoting too much time to their duties, that their motives were too mercenary, or both. W. A. Miles,

Chadwick's associate, was convinced that such a career path led to ruin. A respectable tradesman proves active and efficient as a constable, so local gentlemen take up a subscription to make it worth his while to continue in the role. His new office 'raises him in his own estimation, for a time causes him to wear his Sunday coat every day and take his ... Spirits in the Bar Parlour of the principal inn ...' He begins to neglect his own trade, preferring to run about on magistrates' business. His trade decays. He 'is now thrown entirely on his office', loses all objectivity and becomes a 'penalty hunter', a petty tyrant and a drunkard. He loses his respectability, and the subscribers, increasingly embarrassed, withdraw their money, leaving him destitute. Creating such constables, thought Miles, was 'the surest way to ruin a respectable man in middle station'.[142] Men such as Miles or Chadwick also feared that justices and local authorities would become satisfied with such half-measures.

The Castleford justices thought the permanent constables corrupt. They took 'money or drink to make up cases. They are sent for to stop a fight or assault, and take the party into custody, and in the morning let him go upon paying ... Expenses, and thus often levy heavy fines.'[143] They were also the constables most suspected of compounding offences. But many justices were willing to tolerate some 'corruption', drink or a bit of brutality in return for having a man willing to inspect the local drinking establishments, lay informations and risk wading, on occasion, into the midst of brawls.[144] An East Sussex magistrate conceded that 'when we meet with an active intelligent officer it is usually in the larger parishes, and where some individual ... acts as Deputy, and thereby becomes acquainted with the duties of his office'. [145] 'In the smaller towns [of Sussex and Surrey] are to be found very respectable, active and intelligent constables,' reported an assistant poor law commissioner; he nevertheless would have preferred a proper police.[146]

The conversion of an active local man into a semi-professional was sometimes formalized as a result of a decision by local justices to appoint an 'office' constable,[147] and give him a monopoly of all magistrates' business. A decent living could be made in districts sufficiently populous. The Retford bench gave 'preference to an active individual who gives his whole time ...'. 'I use the assistant constable of Howden exclusively, who lives by it,' wrote an East Riding justice. In Suffolk, the Woodbridge magistrates dealt exclusively with the Woodbridge constable and thief catcher Robert Barnes. By the mid-1830s, office constables were found in many parts of the country.[148]

The Whitchurch bench appears to have appointed a combination process-server-cum-detective in 1835, and took the major step of recruiting an outright professional from the Metropolitan Police. He was paid 30s. per week, half from the county rate and half from a private subscription.[149] Shropshire Quarter Sessions displayed a strong and continuing interest in police reform from the early 1830s, and adopted office constables as a matter of county policy in 1837. By 1839 every Shropshire Petty Sessions

was a little Bow Street, each with its own (but lone) 'runner'.[150] The Bow Street Runners, and the other officers attached to the London police offices, had placed heavy emphasis on detection and prosecution of offences; the new county office constables, though on a much smaller scale, were starting to move in the same direction.

There were the usual wide local variations. Some were semi-professionals, some outright professionals as in Whitchurch. Some were appointed directly as special constables by the justices, as in Shropshire, and had nothing to do with the constables appointed by leets or vestries; others were active deputies or constables, appointed by those bodies but used exclusively by the justices. Either way, there were considerable advantages for the magistrates.

Where arrangements were formalized, the statutory basis appears to have been an 1801 Act (41 Geo.III c.78) which allowed justices in Petty Sessions to appoint a special constable to execute warrants in cases of felony, and to apply to Quarter Sessions to compensate the man for time, trouble and expense from the county rate. This could constitute a way around the notorious and long-standing defect in the law which denied a constable payment from the county rate if no one was committed for trial for a case on which he might have expended a lot of time and effort.[151]

In view of the widespread complaints of justices regarding their inability to control parish constables, this mode of proceeding would have been congenial, as it made a constable responsive to Petty Sessions and to the policies of its magistrates. Office constables often engrossed much of the constable business of the neighbourhood by offering locals the services of a man who was always available and willing to respond to calls for service like a proper tradesmen and in whose skills one might have confidence. This had the effect of reducing the activity of other constables in the district, sometimes, no doubt, to their delight.[152]

The old constabulary and new expectations

The seventeenth-century constable, a member of the village élite, had been taken seriously enough by the state to be assigned an important role in the enforcement of its moral reform and crime control plans. In the 1780s, justices energized by the activities of the Proclamation Society still assigned the constable a significant role, but the latter could never be mobilized or pressurized sufficiently to do their bidding.[153] At the turn of the century, even Patrick Colquhoun, a major prophet of nineteenth-century police reform, whose Police Revenue scheme of the 1790s proposed the admixture of professional magisterial and police functionaries, came to think that 'it would be neither expedient nor proper to disturb this ancient [constabulary] system'. He only hoped that 'intelligent individuals' would be chosen and that 'men of property' would take an interest and be of assistance.[154] Within a few decades, however, governments had ceased to take the old constabulary seriously; parliamentary select committees and

royal commissions uniformly denigrated it, and even provincial magistrates themselves were canvassing new alternatives.

The age of modern police reform, which began at this time, produced a powerful and convincing rationale of modern policing whose rhetoric can still capture us. It is only too easy to agree that the old constabulary was 'the wreck only of an ancient system'. It was far from a *system*, the chief desideratum of reformers and the main source of perceived inefficiency, but it had its virtues. Recently, a good case has been made that the much-maligned eighteenth-century London watchmen who preceded Peel's 'new police' were more competent and efficient than had been thought; nearly twenty years ago a similar verdict was pronounced on the constables of the non-incorporated industrial towns of the Black Country.[155] There is much evidence to show that late-eighteenth and early-nineteenth-century English town authorities made determined efforts to upgrade their policing.[156] Many small towns and unincorporated manufacturing areas outside London enjoyed a standard of policing considerably higher than is suggested by the 'Dogberry' stereotype. By the 1830s, a number of rural districts, as well, had begun to improve their policing, quite independently of state compulsion or direction.[157] In many areas, magistrates and local communities were able to adapt the old office to suit their needs – and were happy with the results – or thought it might be successfully improved by superimposing upon it closer magisterial control and/or a thin layer of professional police supervision.

But a growing number of justices and influential gentlemen came to doubt that mere tinkering with the old system would remedy the perceived problems of law enforcement and order keeping outside London. Many came to think that the cure was a new police of some kind. A great number of them were still prepared to resist government attempts to specify the type, number and structure of a rural police on various grounds, but it is clear that the gap between them and the concepts of the police reformers and governments of the period had narrowed. In the next chapter, we shall explore further the developing critique of the old constabulary among the gentry and the reasons for it.

THE GENTRY AND LAW ENFORCEMENT IN THE COUNTRYSIDE: CHANGING VIEWS, 1820–35

I am decidedly of opinion that a *preventive* police, on an extended ... scale, is the only means now left to prevent increasing crime, and ... reestablish order and safety to society. (Thomas Dyott, Staffordshire JP (Tory), 1836)[1]

If any man had told me 25 years ago that such a force as this would be necessary, I should have held it was not necessary in this district, being an entirely Agricultural one; but such has been the alteration of the times ... that we must feel such a force is required. (Peter Wright, Essex JP (Liberal), 1839)[2]

A country village deserves better treatment at the hand of Government; the least its inhabitants have a right to require in return for the taxes they pay is that a respectable, well-paid officer should be stationed among them; a stranger to the people, and having no other dealings with them, than to administer even-handed justice in their local disputes, to enforce every law not by the wretched system of common informers, but their own vigilance and oversight. [The object is to] prevent crime, rather than to punish it, and to bring speedily to justice those who deserve punishment. (The Revd Thomas Spencer, Somerset parson, 1836)[3]

Re-evaluating order and policing in the countryside

The three quotations above represent startlingly novel sentiments among provincial gentlemen. The disengagement of elements of the provincial ruling élite from the traditional system of law enforcement occurred quite suddenly: between the mid-1820s and the mid-1830s. Before this time, public discussions of problems of crime and order in the countryside never placed at the centre a paid, organized, uniformed rural police. Discussion of the deficiencies of the constabulary were carried out within the framework of an older reform perspective which revolved around the related objectives of improving the quality and pay of the parish constables; restricting leet appointments; and increasing the role of the justices in appointments. As for establishing a rural police, the magistrates hardly discussed it, nor did the press. There is little to be found in gentlemen's diaries, and there was no pamphlet literature. In short, it was not an issue.

After 1830, an abundance of sources of all these types becomes available, reflecting the launching of a debate within the landed classes over the policing of the countryside. The determination of Whig governments to alter the old constabulary, telegraphed to provincial gentlemen via the recommendations of a series of Whig-inspired Royal Commissions in the 1830s, was surely a stimulus. However, we shall see that plans of 'new police' reform not only percolated out and down from the centre, they also began to bubble up from the provinces. The request of Cheshire Quarter Sessions for an act enabling them to create county policemen in 1829, and the ongoing discussions in the 1830s within Shropshire Quarter Sessions regarding the need for a constabulary responsible to Quarter Sessions (neither of them directly government-inspired) were indications that local élites were moving on their own.[4] What was previously not a major concern had become an agenda item for discussion and debate among landed gentlemen.[5]

This had great political implications. Rural police reform depended ultimately on the landed class's assessment of the adequacy of the old constabulary.[6] The landed élite dominated parliament and were the actual rulers of the provinces through the institutions of Quarter and Petty Sessions.[7] This is why law enforcement in the countryside could not have been transformed by the simple fiat of government, much less by the mere suasion of Metropolitan intellectuals, Benthamite or otherwise.[8] At the end of the day, any government plan of rural policing was subject to a veto of the landed classes; so, it is crucial to understand how and why a large part of the gentry which, twenty years earlier, would have reacted with bemusement or horror to the very idea of policemen patrolling England's villages and broad acres, was uttering statements such as those of Dyott, Wright and Spencer in the 1830s. The gentry would never accept a red-coated standing army, but, under the right circumstances and safeguards, a portion of it now came to accept the need for a blue one.[9]

More evidence lies in what gentlemen actually began to *do* in their localities in the 1830s. We shall observe that, quite independently of government, the gentry began setting on foot local police experiments that went well beyond the traditional casual watch.[10] Many such schemes imported Metropolitan personnel and set them to patrol rural areas. Some kept written records from which crude local crime statistics were derived and reports to superiors made. This activity reflected the diffusion of a new model of order keeping and crime repression among the provincial gentry and the absorption of the views and prescriptions of police reformers.

The correspondence of the Royal Commission on a Constabulary Force (1836–9) constitutes further evidence of the degree to which the gentry had begun to rethink constabulary reform. The Royal Commission received a flood of suggestions, advice and model constabulary plans penned by landed gentlemen, justices and parsons from all over the country. Some of them were cranky, but many were remarkably elaborate, reflecting the degree of careful thought that went into them.

We do not say that all, or even a majority, of country gentlemen were transformed into ardent proponents of a professional rural police. Some became enthusiastic supporters. Others accepted the need for a police reluctantly, as a result of concrete experience: the increase in rural disorder and perceptions of a major rise in rural crime and the insubordination of the lower orders. Others resisted on various grounds, constitutional and otherwise. But a large percentage of them came to think a rural police necessary.[11] Exactly how big this group was is impossible to say, but within it were many of the opinion leaders of rural society: Quarter Sessions chairmen; Lords Lieutenant;[12] county MPs (some of whom were also Quarter Sessions chairmen or magistrates); and a bevy of parsons and clerical justices who were active on the bench and hyperactive in their localities.[13] During this period, an ideological 'civil war emerged within the landed élite'[14] over the issue of law and order in the countryside which would culminate in the extraordinary policing debates at Quarter Sessions between 1839 and 1841.[15]

One section of the gentry wished to preserve the old constabulary.[16] Generally (but not exclusively) right-wing Tories such as Disraeli, Sir Edward Knatchbull and a host of backwoods clergy, they viewed the landed gentleman as the glue that held together the increasingly fragile English rural idyll. They argued that the combination of the New Poor Law and a new police would degrade the magistracy, rupture the old ties that bound, cripple the parish system of self-government, institutionalize an impersonal professionalism that could threaten the unpaid magistracy, and open the way for the meddling of the state in local affairs. They held that a rural police would inject a new toxin into the cohesion of rural life. These men would attempt to take a stand behind paternalism, the virtues of local self-regulation and the autonomy of Petty Sessions. In our period, they were a declining breed, but they had their own modest constabulary reform programme: to minimize the role of vestries and leets in determining appointment criteria and remuneration, with a view to the consolidation of constabulary appointments in the hand of the local magistrates themselves.[17]

The background to the gradual acceptance of the need for rural policing by an important section of the gentry lies in their response to the consequences of the profound agricultural and social crisis of rural England after the Napoleonic Wars: the plight of the labourers,[18] the intensification of friction between and within all social classes,[19] the fraying of paternalistic relations, a heightened sensitivity to rural crime and apprehensions regarding the effects of the change in the Poor Law. In the early-nineteenth-century southern countryside, social relations deteriorated, men's hands began to be turned against each other and paternalism suffered a major breakdown.[20] The advent of the New Poor Law removed the most important prop of rural paternalism, depersonalizing relief administration,[21] and, by creating the new Boards of Guardians, changing the balance of power in favour of the ratepayers.[22] This was the overall

context for the spread within gentry circles of new·ideas regarding order, crime control and policing.

At the level of the government, the vulnerability of the countryside and the fragility of the social order revealed by the 'Captain Swing' phenomenon accelerated a rethinking of rural order keeping. It jolted the new Whig Home Secretary Lord Melbourne into an abortive effort to devise a national policing bill that might pass parliamentary muster.[23] During the 'Swing' episode, the government was alarmed by what it viewed as the supineness of the magistrates in treating with mobs, making concessions or panicking and prematurely calling for troops.

Government discounted the constables as a factor to rely upon in riot suppression and crowd control.[24] Through the 1840s, the military remained the last line of defence in this area, and on some occasions the first,[25] but Home Secretaries hated to use it. As Russell put it, 'it has the appearance of governing by military force; it harasses the troops, and ... puts the temper both of officers and men to the most severe trials' – in other words it called the legitimacy of government into question and demoralized the army.[26] The practical problem faced by the government was that it was impossible to sideline the military in the absence of a civil force. Despite some reforms in the system of selecting, mustering and remunerating special constables in the early 1830s, few were convinced that this represented the solution. For Home Secretaries, Horse Guards and field commanders alike, the preferred remedy came to be a combination of active magistrates and a proper police.[27]

Captain Swing was equally disturbing to reform-minded provincial gentlemen because 'overseers and magistrates ... had been held personally responsible for the general distress of the ... labourers'.[28] Farmers had egged on labourers to mob the clergy, and the machinery of repression immediately available to the justices proved so unreliable (or absent) that concessions could not be avoided.[29]

They had to admit that the performance of both parish constables and drafts of special constables left much to be desired: 'The wretched inefficiency of the police in those agricultural districts which suffered ... from the visitations of SWING was the main cause of the frightful extent to which that invisible incendiary carried his excesses.'[30] Lord Wodehouse, Tory Lord Lieutenant of Norfolk, came to think that a root and branch change in rural policing had become mandatory. In 1830, magistrates were

> forced to act the part of police officers for want of assistance ... there was no one to take these men from the houses and hedges where they were secreted, unless the Magistrates acted also the part of constables. He would ask was it right that the state of our law should be such as to place the Magistrate in such a situation?[31]

In Norfolk, discussions among the justices about the desirability of rural police reform first cropped up in the late 1820s in the context of concern over what was interpreted as rising criminality, a 'stiffening attitude towards

"petty" crime' and a 'new willingness to redefine certain behaviours previously considered mischievous as specifically criminal ...'.[32] But the spread of favourable attitudes toward 'new policing' was 'given a critical boost by the [Swing] revolt'.[33]

The 1830 disturbances also increased the determination of both the government and reforming landlords to change a system of poor relief that was considered to be an encouragement to riot and an amplifier of generalized insubordination and rural crime.[34] This called up more resistance, which took many forms ranging from overt disturbances in Suffolk, Devon, Sussex, Kent, Bedfordshire, Hertfordshire and Essex[35] to assaults on unpopular individuals and attacks on their property. Desperation, according to Archer, 'drew away the veil of deferential behaviour'.[36]

The implementation of the New Poor Law once again drove home the idea that, in turbulent periods, there was no force on which magistrates could rely to suppress overt violence. In Suffolk, the justices were deserted by the local constables – several were reported dead drunk – and drafts of London policemen were imported to re-establish order.[37]

Even gentlemen dubious of (or opposed to) the New Poor Law became enthusiastic or reluctant converts to the need for new rural policing measures, either on account of the immediate shock of disturbances or because the long-term effects of the new system were perceived or expected to be criminogenic.[38] Peter Wright JP, an Essex opponent of the New Poor Law, stated:

> Now what is the working of the Poor Law ...? The first thing a parent says to his son when he gets 15 or 16 is 'Now you must go and find your own maintenance'. The consequence is that we have ... 40 or 50 of the idlest young men ... committing the most horrid robberies ... I do not believe there has been a night within the last six months in which a robbery has not been committed in my parish ... Therefore my opinion is that we must have the rural police to protect us, for if we are not to have it in my parish I cannot live there at all.[39]

Sir George Crewe accused those engaged in an outcry against 'Demoralized, degraded Pauperism' of doing it 'not for the protection of the poor, but for the protection of the rich'.[40] He deplored the 'rapid demoralization of our country Villages,' which manifested itself in drunkenness, unsupervised beershops, 'nightly riots' and a 'great Increase of Petty Crime'. Like Wright, he came to feel that 'there is not ... a more dangerous evil existing to the Peace and Welfare of the Kingdom than the want of a Proper and Efficient Constabulary Force in the Rural Districts'.[41]

But even before the effects of the New Poor Law manifested themselves, there was unease about its effects on rural criminality and a debate on its implications. For some, the harsh measures it contained seemed logically to point to an increase in vagrancy, widely associated with petty criminality.[42] One JP predicted that raising the honest labourer, by more clearly differentiating the respectable from the unrespectable poor, would drive the idle and worthless to live by crime.[43]

The expectation that the incidence of food theft, sheep stealing and petty crime of all descriptions would increase was held, not only by opponents, but also by some proponents, of the New Poor Law. Thomas Dyer, an active, reforming Surrey justice,[44] stated that crime was indeed on the increase in his locality. His fellow parishioners said that although Poor Rates had gone down, they 'were now in a worse condition through losses sustained by those . . . driven to steal by the severity of that measure'.[45] Dyer concluded that 'if the benefits which it [the New Poor Law] has conferred are to be secured, it must be supported by the establishment of a Police Force, for the dislike manifested to it by many of the Poor . . . and the impunity with which crime is now committed will attract many to that course of life'.[46]

Sir George Stephen, a keen supporter of the New Poor Law, thought that the sullen and despairing submission to the new regime did not promise tranquillity. Those who will not be helped by it 'will seek subsistence by robbery or fraud'. Its overall effects would be to release labour, make it more mobile and, therefore, more dangerous. The 'face of the country will in a few years be covered with straggling, able-bodied mendicants, of drunken habits [who] will beg . . . till charity is tired, and will then steal . . .'. And why not? Since the 'workhouse is a purgatory to the labourer', why would theft *not* be more attractive?[47]

At the time of its implementation, many of its supporters feared that the New Poor Law would be likely to have criminogenic consequences,[48] but it is worth recalling that, just a few years before, the *Old* Poor Law had been deemed to have produced the same effects. The Old Poor Law supposedly produced 'lack of due subordination of the labourer,' and the 'degradation of the moral character of the labouring classes' – which 'tend to the promotion of crime!'[49] Concerns about rural order, crime and social cohesion were projected – or even displaced – on to the relief system, whatever form it took.

Rural England, no Arcadia

Turbulence and rural crime were linked to the 'demoralization'[50] and insubordination of the rural population. After 'Swing', Wellington used almost apocalyptic language, privately confiding to a friend in 1831 that 'the People are rotten to the core. You'll find that it is true. They are not bloodthirsty, but they are desirous of Plunder. They will plunder, destroy and annihilate all Property.'[51] 'It is very apparent', as the Hampshire visiting justices put it in 1832, 'that the estrangement between the higher and lower grades of society has been gradually, and is now rapidly increasing; the natural consequence of which is disrespect on the part of the latter for their superiors and insecurity for property'.[52] The Revd J. S. Henslow saw in the rural lower classes a 'degeneracy of the moral principle'. With no depth of morals 'to controul [sic] and steady them . . . the wild cry of havoc rises through the land . . .'[53] Wiener has observed that

Liberals as well as Conservatives saw in the post-war 'crime wave' 'a message of moral decay' closely linked to 'fears of working class insubordination'.[54] What has, perhaps, not been stressed enough, is the degree to which the countryside came to be considered a locus of moral decay in the early nineteenth century.

The overheated rhetoric of both national figures such as Wellington and reforming provincial gentlemen such as Henslow was increasingly suffused with anti-Arcadian images of the English countryside. In the debates among the gentry of the 1830s and 1840s on crime, order and policing, two incompatible rural Englands were conjured up. One was essentially quiet and peaceful, where crime and disorder, though not absent, were largely of an innocuous nature. Such men were likely to say that 'Expanding the reach of the criminal law,'[55] would needlessly place in the hands of a body of strangers the decision to extrude members of the village community, extend the back-hand of the law to a host of minor offenders, cram the gaols, clog the courts and involve everyone in unnecessary expense.[56] The other was portrayed as increasingly disorderly, crime-ridden, subject to periodic waves of popular fury, infested with rogues and vagabonds controlled by nobody and therefore well beyond the ability of the old constabulary to cope with.

Consider the following contrasting portrayals of the same rural districts in the East and West Ridings:

1. *Magistrate A* (Name Unknown): In this quiet and peaceable division I do not consider any preventive force needful.
 Thomas Clark: Two or three determined rogues might levy contributions on almost any village, and carry off all the inhabitants along with them, if they felt disposed to do so. In fact, we have no rural police. The worst of characters have lived for years on the plunder of the community, a fact known to every body ... With a proper police, such characters would not have remained at large a month ...

2. *Mr Fawkes*: ... in this little strip of Wharfedale ... there was nothing but a very quiet, very small ... population. There was no inducement ... for the thieves to ... commit depredations on the Alps of Rumblemoor. They had there no railroads ... and nothing convertible into cash except ... scotch sheep and long-horned cattle.
 Mr Wood: Why in the neighbourhood of Harewood, which Mr. Edwin Lascelles and Mr. Fawkes [consider] a district in which crime was almost entirely unknown ... within a very few weeks, the house of Mr. A. Lascelles had been broken into, besides two other burglaries and a highway robbery in the immediate neighbourhood. At Hickleton ... there were four persons living there who subsisted by plunder, a system which they carried on without the slightest check, for no constable ... dare interfere, lest he should have his stacks burnt.[57]

Proponents of rural policing denounced the English rural idyll as a fond myth. R. N. Shawe JP ridiculed Mary Russell Mitford at Suffolk Quarter Sessions. Perhaps his colleagues had read:

'Our Village' ... in which there were very charming poetical descriptions of rural scenes and rural life. These individuals might have read this work, which pointed out to them rural simplicity in all its charms, and those other attractions given to a country life ... but he was sadly afraid when they came to examine the reality, to go through a statistical account of those rural districts, it would be a question whether they were superior to many large and populous towns, with regard to morality ... Now he had gone over the particulars of thirty parishes in the county just as they stood – entirely without choice ... taking the parishes exactly as he found them ... he never could get 3,000 in population of the rural districts, and find a less amount of robberies than in the town of Woodbridge with 5,000.[58]

It is hard not to agree with Clark, Wood and Shawe. 'No year in the first half of the nineteenth century,' wrote A. J. Peacock, 'was a quiet year [in East Anglia]. Every year was violent, and the amount of violence that took place was very great indeed.'[59] Outbreaks of rural turbulence and the perception of the countryside as crime-ridden undercut the force of the arguments that serious disorder and crime were mainly urban phenomena, and that professional policing had no application to the countryside.

Reforming gentlemen and magistrates claimed that rural England was engulfed in a crime wave. National statistics of serious crime had been published from 1805, and these series would grow in comprehensiveness and sophistication. These figures show a large increase in indictable committals to trial, reflecting a notable increase in prosecutions which could be taken to mean a similar increase in offences.[60] The steep rise in commitments concerned contemporaries, contributed to a heightened sensitivity to crime and its projection as a serious problem.[61]

The fine distinctions which preoccupy contemporary researchers – 'social crime, 'protest crime', 'crime as protest,' poverty-driven crime, etc.[62] – naturally did not concern them much. What preoccupied them – apart from the occasional atrocious crime – was a vast (and, they thought, increasing) volume of theft carried out by the lower orders: poultry theft, theft of turnips and other produce, wood theft and fencebreaking, the theft of iron railings – the theft of anything that was not chained down or guarded by one's servants[63] or gamekeepers.

The fruits of such theft were either consumed, or resold in a market whose terminus was often a provincial centre, such as Brighton,[64] or even London. Consider the case of Thomas Parsall, interviewed in prison. Parsall lived by robbing gardens near Tottenham. His *modus operandi* was to operate after midnight, hide the stolen produce temporarily in a dung-heap and sell it to little greengrocers who were willing to take off his hands whatever he brought.[65]

This constituted the eternal *basso continuo* of rural illegality; but in the early nineteenth century there was an increased sensitivity to this type of low-level criminality. It was often taken as a symptom of social decomposition and demoralization of the lower orders. A permanent police would place the latter (and, above all, their places of resort) under a wholesome and constant surveillance.

J. S. Henslow, Cambridge Professor of Botany and a clerical justice, was startled at the sheer extent of such petty criminality in West Suffolk, taking it as a sign of the 'degeneracy of the moral principle'. To prefer 'living outside the workhouse by such disreputable resources as picking and stealing ...' was incompatible with the profession of the Gospel. He became convinced that a police would serve as 'a moral engine', deterring and restraining the young and unpractised in crime.[66] The inquiries of the 1830s cast a spotlight on the centres of rural disorder and crime: East Anglian poaching villages, open villages, and extra-parochial Alsatias, such as the communities that grew up in the wake of the enclosures of Middlesex commons:

> The inclosures [sic] of Hounslow Heath, Hampton and Twickenham Commons has led to the growth of a population ... with no parochial system of superintendence, no churches ... no police, but many beershops. From ... these places decent persons are actually driven by the disorderly habits of the lower orders ... It is from these parts that the poachers and thieves ... issue, and to which they retire ... None but an organized police can cope with places of this description.[67]

Reforming gentlemen complained that the entire system of law enforcement was unequal to the task of coping with a crime problem that was not only increasing, but was characterized by an increasing degree of organization among rural criminals.[68] Such gentlemen came to worry about the extent of prosecutorial discretion placed in the hands of individuals. And they saw the parish constables as inadequate for the task. The constabulary was reactive by its nature, and the day-to-day repression of crime was neither a major consideration nor a professional duty; the constables were seen increasingly as a mainstay of an archaic, decrepit, amateurish system whose main products were the fostering of impunity and the widespread failure of justice. There appeared to be an increasing divergence between a far more mobile, urban and commercialized society, and a criminal justice system designed for an earlier era. Deep in the Cotswolds, the Revd F. E. Witts put it this way:

> It is a sense of insecurity, as well as actual insecurity to person and property which has led in many [rural] districts to the establishment of police officers. The habits of the Country are changed; the population immensely increased, the facilities of moving from one place to another greatly augmented, and in like proportion the ease of removing stolen property is greater ... Hence our Police Association ...[69]

The willingness of the gentry to set aside powerful, traditional ideological objections to policing is a sign of how far the gentry felt that they faced a quite novel situation; for the crime (or prosecution) wave was, if anything, more palpable in the rural counties. David Jones pointed out that 'rates in the ... agricultural areas of Suffolk and Dorset were often higher than in selected manufacturing towns, and violence against persons and property formed an important element (up to 25 per cent) of the rural crime rate until the 1860s'.[70] Table 3.1 cannot prove that 'crime' in Wiltshire or

Table 3.1 Population/committal ratios (1805–39)

County	Population increase (%)	Committal increase (%)	Ratio of committal to population
Lancashire	+118	+475	4.0
Durham	+ 93	+362	3.9
Bedfordshire	+ 60	+457	7.6
Norfolk	+ 46	+349	7.6
Dorset	+ 45	+417	9.3
Berkshire	+ 39	+390	10.0
Wiltshire	+ 39	+403	10.3
Herefordshire	+ 24	+299	12.5

Source: B. R. Mitchell and P. Deane *Abstract of British Historical Statistics* (Cambridge, 1962)

Herefordshire was increasing more rapidly than in Lancashire or Durham, but it does show why we might forgive rural gentlemen for thinking that they had a big problem on their hands.[71]

In fact, the large rise of crime rates after the Napoleonic Wars shows that the Hanoverian criminal justice system actually had a considerable capacity to cope, given: (1) the increased determination of victims to resort to it; and (2) the increased willingness of the state to cheapen prosecution by reimbursing some prosecutors' costs. While the criminal justice system was incurring increasing ridicule in ever-widening circles, it was quietly succeeding in greatly multiplying prosecutions, and processing those proceeded against without collapsing under the strain.

Of great importance by the 1830s was the simple existence of the Metropolitan Police, which became a compelling model that guided the thinking of provincial gentlemen. It provided them with a clear idea of what a modern police looked like and how it functioned, enabling them then to consider its adaptability to rural circumstances. Whether or not the Metropolitan Police was in fact so new,[72] landed gentlemen believed that it was. On their visits to London, they remarked its omnipresence, discipline, uniforms, and general bearing, and were greatly impressed. They also viewed Metropolitan policemen in action in the provinces. London police were sent down to deal with disturbances, organize provincial forces and solve atrocious crimes, and gentlemen drew on them for professionals to staff the voluntary subscription or other police schemes they set on foot.[73] The old constabulary was increasingly judged against this new standard and was found wanting

A certain mystique rapidly attached itself to the Metropolitan Police. Their putative effectiveness had almost a magical quality to it.[74] Incredible feats of detective work were attributed to them, and their courage and fierceness in order-keeping situations were impressive. During the Durham pitmen's disturbances of 1832, Lord Durham's agent reported delightedly:

> The seven London Police Men which I applied to Lord Melbourne for to send to Hetton have done most essential service indeed – they organized a large constabulary force and have effectively prevented riots. The magistrates now advocate the appointment of ... efficient police in these districts.[75]

In 1838, during anti-Poor Law and agricultural trades union agitation in the Battle district of Sussex, Frederick North, JP and MP, fearing that 'we have something like the business of 1830 coming on,' asked Lord John Russell to send London police, as he believed that one London policeman was 'better than 50 dragoons'.[76] From Codicote near Welwyn, a gentleman reported the breaking up of a local gang by a Metropolitan officer:

> A regular gang of marauders was established there for some years; the ordinary village police was utterly useless against them; they had become the terror, not only of the parish of Codicote, but of all the surrounding country. By the active exertions of Francis Sapte, Esq. a subscription was collected last spring and a London policeman procured to reside in the village. The results have been most satisfactory; the gang is completely broken up; and though so short a time has elapsed since we commenced operations against them, no less than seven have been transported for various terms of years ...[77]

In Durham and Suffolk the temporary presence of Metropolitan policemen was deemed to have had a lasting impact on the minds of the justices,[78] disposing them in favour of professional policing.[79] Local gentlemen noted the fearlessness, discipline and efficiency of the London police, and contrasted this with the hesitancy, timidity and unreliability of their local constables.

Even some of the new borough forces[80] were regarded as producing a greater measure of preceived security. Lord Radnor thought that property and person were much safer in Salisbury than in the surrounding countryside, and for a time advocated the extension into the hinterland of the Salisbury police;[81] the Revd F. E. Witts was similarly impressed with the Cheltenham police, which he considered followed Metropolitan principles. A Somerset gentleman expressed it in these somewhat overheated terms. When he lived in the countryside:

> my property was injured and stolen. My house was broken into and other times attacked by robbers. Villains under the disguise of beggars apply'd at my house [and] insulted me and my family. My nights ... were times of careful ... watching to guard against the midnight Robber. I now live in ... Bath. A Day and Night Police is continually passing around my house. I am not annoyed with insolent Beggars. I sleep securely undisturbed by Robbers ... The contrast between the two residences I feel to be as if I were removed from the abodes of Savage Society to live among a highly civilized and intellectual People.[82]

The diffusion of the gospel of prevention

In attempting to account for the turning away of a key segment of the gentry from the old constabulary, we have set out as background a long period of threats to rural order, a severe social crisis and the projection of crime as a

threat to social stability. But it was by no means predetermined that the remedy should be seen to lie in a modern, costly, uniformed police composed of salaried public servants, exercising a constant surveillance, divorced from ties to the community, acting (in theory) impartially, hierarchically structured and keeping and generating written records.

To view the abandonment of the old constabulary merely as a response to particular problems and events is insufficient. In the past, there had been no shortage of social crises and periods in which élite sensitivities to crime and concern about order were elevated. In those cases, governments had tried to mobilize the magistrates and the latter had tried to mobilize the constables and the village élite.[83] Never before had a police been considered part of the solution; neither a fully developed intellectual rationale nor concrete models existed. One must also look to the realm of changing ideological fashions and perceptions generated far from the country seats of the gentry, and the degree to which they were integrated into the crime/order thinking and rhetoric of the landed class.

By the mid-1830s, the language of the reforming section of the magistracy more closely mirrored that of the Metropolitan reformers. The former were now as keen as the latter to expose the 'defects of the old, worn out, and inefficient system'. The Cuckfield, Sussex, Petty Sessions stated that the present constabulary was 'calculated for an earlier stage of society,' and cited increased population density, facility of locomotion, and diffusion of wealth – all of which called for a different constabulary.[84] Other gentlemen recited the standard litany of criticism of the parish constable[85] before outlining their own reform proposals.

Sir George Stephen confided to Edwin Chadwick that 'between ourselves [the magistrates] are a set of boobies'.[86] This was probably a matter of deep belief in the pamphlet, book, and official report-writing circles in which men such as Stephen moved. But the gentry were not wholly stupid and included people of wide education who were among the shapers of new ideas.[87] Others kept themselves fully in contact with, and responsive to, Metropolitan currents of thought about all social and political matters. Some of the latter were MPs and circulated in Metropolitan political circles while at the same time functioning as conscientious magistrates at home.[88] On the issue of police reform, Poor Law reform and many others, these men constituted a species of intellectual leaven in the country houses and at county Quarter Sessions. In addition, there was a section of the clergy (some of them quite influential in Quarter Sessions) and a group of active, local landowners who read widely and kept in contact with the latest intellectual fashions.

Provincial discussions on order, crime and policing in the 1830s show that many of the principles and axioms of criminal law reformers were being absorbed by provincial gentlemen. In the 1820s, the Norfolk justices complained of 'the uncertainty of punishment,' and the inability of the constables to do what they thought was required. Their modest reform plan was accompanied, significantly, by a lengthy quotation from the London

stipendiary magistrate and police reformer Patrick Colquhoun.[89] An early-nineteenth-century Quarter Sessions was, in short, a less parochial place than might be supposed. On the issue of rural policing, the arguments and rhetoric employed by reformist members of the landed class more and more closely echoed the most advanced thinking in London.

By the mid-1830s the gospel of prevention had made many provincial converts. Their language was replete with its key words: 'impunity,' 'system,' and 'prevention' itself. The responses of the justices of the peace to the queries of the Constabulary Force Commissioners were studded with references to the desirability of a 'preventive police' and statements regarding the good results they could produce. By reducing impunity, deterring potential thieves through ceaseless surveillance, pursuing and detecting in response to all complaints, collecting and diffusing criminal information, increasing the rate of prosecution by making it cheaper to the victim, raising the conviction rate by expert marshalling and presentation of evidence, a police could actually reduce crime.[90]

Provincial gentlemen who espoused the gospel of crime prevention by means of a paid 'stranger-police', divided on the issue of whether the preventive effect would so diminish crime that the ultimate costs to society would be permanently lowered, or whether one had to prepare for an increased (and perpetual) public charge;[91] but all agreed that the apparently cheap, amateur parish constable system was more expensive than might appear. It placed large burdens on the individual victim, but little on the public;[92] its cheapness was only apparent, the costs being well disguised.[93] A Buckinghamshire justice said that the true expense of non-reform 'consist[s] in the value of the depredations committed, in the injuries sustained, and in the general demoralization of the lower classes ... which an ineffective system of police ... occasion[s]'.[94] Sir William Heathcote, MP, JP and chairman of Hampshire Quarter Sessions, describing the situation in counties without police forces (including his own county in the 1830s), put it this way:

> The position of parochial constables would appear to be this, that they must either be inert, or in proportion to their activity they must be expensive. If they do nothing there are no allowances to be made to them; but if you have occasion to employ them in cases of real intricacy, they must be paid more than you would give to a policeman; you must pay them at a higher rate per day; you can only escape from their being expensive by not employing them at all.[95]

Crime victims had to engage in a complex cost-benefit analysis which all too often led to a decision not to pursue a matter. 'There is a common saying among the farmers, tradesmen and lower classes', wrote a Kent vicar, 'that the first expense viz the loss of their property is the last'.[96] Reformers argued that the result was rampant, under-reported, undetected and unprosecuted crime. A police would reduce frustration and cost by being readily available, charging the complainant nothing and presenting evidence in court in a coherent and professional manner, thus ensuring a successful prosecution.

Reforming gentlemen grasped the concept of the 'dark figure' of crime and linked it to the problem of the reluctant prosecutor. They maintained that the extent of unreported crime was enormous, and that the lack of a police resulted in an unacceptable degree of impunity and consequent large losses to the public. A Shropshire justice who had organized a gentry subscription for the hundred of Ford and hired William Baxter, a London policeman, wrote that Baxter's work had shown:

> an extent of depredation of which none of us were before aware, for as the tracing offenders occasioned formerly a great loss of time and ... often an expenditure of money, for the parish constable had to be paid, [farmers] seldom took any steps to find out the offender but quietly put up with their loss.[97]

An attempt to plumb the extent of criminal acts which never entered the official record in his own parish impelled Thomas Dyer to begin keeping his own record of undetected criminal acts in Chobham.[98] Not unexpectedly, he found that there were many.

Another article of faith projected by Metropolitan reformers and taken on board by provincial gentlemen was the notion that better policing in the Metropolis and large towns tended to propel criminality outward into the countryside. Thomas Dyer carefully compiled a record of unprosecuted crime in his Surrey parish of Chobham. Most of it consisted of typical small crimes invariably committed by locals: thefts of Swede turnips, potatoes, fuel, a set of hurdles, etc. A number of more serious crimes such as the theft of five sheep from one field, a burglary that netted some silver plate and a robbery resulting in the loss of a watch and some silver could well have been the work of local criminals operating within a small radius of their residences. Yet Dyer, against his own evidence, fervently persisted in maintaining that the increase of crime in Chobham was primarily a result of London villains plundering rural Surrey.[99]

But if one believed this, something beyond the parish constable was required to drive out the criminals evicted from London or other towns. The logic was irresistible. The Essex justice John Disney believed that the Metropolitan Police 'drives all the thieves to us, and a [Suffolk] gentleman said to me ... "you will drive them to us ..." to which I observed, "then you must drive them into Norfolk ..." '[100] A Kent gentleman, Thomas Law Hodges, at once a strong police reformer and opponent of government measures, thought that if Surrey and Sussex created police forces, Kent would have no choice but to do likewise to keep it from becoming a 'cul de sac for the reception of all the thieves and vagabonds who might be driven from these ... counties'.[101] Like Disney and Law Hodges, most gentlemen were preoccupied with the well-being of their own counties, but their awareness of the consequences of improved policing arrangements in neighbouring counties might lead them to accept the need for a universal police network.

In urging the necessity of the Metropolitan Police, Peel had grounded his arguments before Parliament on the criminal statistics.[102] Arguing 'from

the numbers' became a standard feature of the criminal discourse of the national political élite from the 1820s. The availability of criminal statistics enabled rural gentlemen to do the same, and we find that, by the 1830s, discussions among them regarding crime and policing featured appeals to the numbers as rhetorical strategies.

One of the foundation principles of Chadwick's 'Preventive Police' was that it 'should ... be conducted on the principle of an association of the public to insure each other from loss by depredation'.[103] Reformist gentlemen took precisely this line, arguing that a police was a mechanism for socializing the risks of crime and disorder. A Suffolk justice thought it sensible that every ratepayer pay a little against the possibility of incurring large costs should he be touched by the hazard of theft.[104] A Somerset gentleman complained of damage to his woods. A police would cost far less than the expense of a private watchman. The extent of impunity under the parish constable system added 'to the expenses of property, and I think by *mutual insurance we should be able to defend each other*'.[105] Gentlemen advocating police reform argued that it was a kind of insurance scheme that would cut the costs of pursuit and detection and encourage higher rates of prosecution by lowering the cost of a prosecution to the individual. They argued that there was a choice between the old notion that individuals (or parishes) should depend upon themselves and the idea of a wider socialization of the costs of crime and disorder in the interest of better system, efficiency and fairness to the respectable poor.

Indeed a rural police was presented by reforming provincial gentlemen as a poor man's measure. Because a police was thought of as a moral engine, the poor waverer would be dissuaded from resorting to crime by being subjected to a ceaseless surveillance. By rooting out the poachers and thieves and watching the beerhouses, the chief source of contamination of the youth of the labouring class would be removed.[106] Because a police was conceived as a universal preventive machine that would decrease crime not only by 'preventing' it, but by increasing the prosecution rate, the individual of small property and the respectable poor would be relieved of the disincentives to prosecution: the costs of detection and pursuit, and the uncertainty about whether they would ever be reimbursed in the end. A poor man would be placed on the same footing as the rich man as to the recovery of his property. The Norfolk clerical justice Robert Wilson asked:

> when a poor man's cottage was robbed 'who was to look after the offender? The constable often declined unless he was paid for doing so, and this the poor man was unable to do ... but if they had a paid constabulary force it would be their duty to attend to all complaints'.[107]

The progressive collapse of confidence in the old constabulary among provincial gentlemen had less to do with the individual constable's own qualities and capabilities and more to do with the growth of a powerful and increasingly persuasive critique of the criminal justice system at large. As Beattie has pointed out, as the latter became more and more persuasive,

the enactment of new measures believed to ensure certainty of detection, prosecution and punishment took on an unassailable logic.[108] Whatever could be said for the parish constable, it was increasingly difficult to argue that the system within which he functioned ensured these things. The defence of the parish constable 'had always been tied to the old law'.[109] Once the latter was subjected to a powerful critique (and government actually began the process of changing it in the 1820s) the old constabulary looked increasingly out of place and became more difficult to defend.

'It is impossible to imagine,' wrote de Tocqueville in 1833, 'anything more detestable than the criminal investigation police in England'. He considered its lack of co-ordination, absence of mechanisms to diffuse criminal information, lack of hierarchy among officials, and its amateurism to be major demerits. In short there was a total absence of system, conducing to a lax and haphazard application of the criminal law and the placing of justice 'out of reach of the poor'.[110] At the very time Tocqueville was visiting England, many English gentlemen were coming to similar conclusions. The chief defect of the old constabulary was increasingly considered its lack of system,[111] its haphazard mixture of competence and incompetence, activity and torpor and its inability to be controlled by the magistrates. The virtues of amateurism and parish self-regulation were increasingly seen as the buttresses less of liberty, than of licence and gross inefficiency. In short, for the reforming element of the landed class, the old constabulary was bankrupt and unreformable.

Rural police reformers rested their case on much more than the supposed increase in serious crime since the end of the French Wars. Crime control was important, but what was wanted above all (and what a police would bring) was *order*. An active justice on the border between the West Riding and Lancashire put the case clearly:

> The police question has ... been argued upon the hypothesis that crime, properly so called, was all that required repression or detection. It is convenient to the opponents of a rural police thus to narrow the ground, because the number of committals, being the only obtainable criterion of the amount of crime, is made the single test of the necessity for establishing the force. There are many offences against law and order which have not been taken into account, which, though called petty offences, nevertheless seriously affect the security both of person and property. Many of the offences of this class would be entirely prevented ... by the mere presence of [a] well organised police ... For instance ... during the summer season tramps abound, who, watching their opportunity, enter the houses when the men are absent and demand money and food under threats of violence ... Assaults, fights, disturbances, and outrages, sometimes violent and frequently disgusting are of frequent occurrence ... I have done constable's work both by night and by day, but I cannot make much impression with such aid as the parochial constables afford me.[112]

Reforming rural gentlemen came to take it as axiomatic that social cohesion itself depended on the degree to which the lower orders could be taught to restrain themselves. For this reason, they endowed turnip stealing, poultry theft and other forms of small-time pilfering with great symbolic

significance. As Henslow put it: 'the pilferer of to-day becomes the plunderer to-morrow; the discontented is rapidly metamorphosed into the destroyer, and the lurking Incendiary steps out the scarcely more dreaded murderer'.[113] Poaching was bad because it violated the law and reinforced habits of idleness; but more serious was the fact that it was a launching pad for a full-blown criminal career. Henslow called a rural police 'a moral engine'[114] because the ceaseless surveillance of the lower orders they would pursue would reinforce an individual's own best moral impulses and restrain 'the unskilled in crime, wherever they are wavering . . .' They would therefore 'prevent the first step from being taken on the downhill path to infamy . . .' The amateur, part-time village constable would be snoring in bed while the human predators of the village were out shooting rabbits, pinching chickens and tearing up the fenceposts.[115]

By the 1820s, government had come to regard the constable as woefully inadequate for the tasks of daily order keeping, efficient criminal investigation, the proper presentation of criminal cases in court, the service of process and execution of warrants, the watching and regulation of drinking establishments, and so forth. These appeared to be performed too ineffectually and sporadically, and sometimes not at all. They asked: if parish constables were irrelevant to riot control and inefficient for crime control, why not limit them to the few routine, administrative tasks they performed for the parish – such as the compilation of jury and militia muster lists,[116] notifying coroners, and serving precepts for Poor Rates – or get rid of them entirely? This came to be the view from Westminster. By the 1830s the same sentiments were liberally issuing from the mouths and pens of provincial gentlemen. Another active, reforming clerical magistrate, the Revd Robert Wilson of Norfolk, summed it all up:

> Had we better not improve that which is now existing? His answer would be that, from the nature of the present force, it would be quite impossible . . . In the first place, there was no responsible person for these appointments . . . how appointed and by whom, or whether fit for the office were matters never enquired about . . . They often found, too, that the parish constable was living among his friends and relations and . . . customers . . . could it be supposed that he would take such means to prevent crime . . . as persons from a distance . . .? It might be urged that if every parish took care to have proper persons appointed . . . they might have a much better . . . force . . . Be it so, but even then . . . they would still be unpaid, and no one would gratuitously do that which a paid officer would be bound to do . . . This . . . was quite sufficient to prove . . . that the constables . . . could not be made an efficient body.[117]

Government, we observed, could do little until these notions had taken hold within the provincial ruling class. For this reason, whatever ministers wished to do, whatever schemes of national police reform they devised, they were obliged to be cautious. Because it was inconceivable that Parliament would ram a sweeping measure of rural police reform down the throats of provincial gentlemen, ministers had to wait for the opinion of provincial leaders to catch up. By the 1830s this was proceeding very quickly.

The constable had always been a butt of the criticisms, often even the contempt of the landed classes.[118] But, by the 1830s, the criticisms were set in a powerful new framework unavailable a century before; one, moreover, that projected a powerful and effective *alternative*. We observed[119] that, by our period, constables were much less likely to be drawn from the village élite, and were thus considered less reliable as implementers of the policies of the centre or the Quarter Sessions. This in itself was a factor in the new willingness of a significant sector of the magistracy to cast about for a substitute.

The substance of the critique of the old constabulary emanating from London reformist circles and that of many provincial gentlemen were converging by the mid-1830s;[120] but the precise remedies prescribed by one were not necessarily the same as those recommended by the other. Those landed men who had become convinced of the need for a rural police did not necessarily favour their proposals or those of government, and they would disagree among themselves about how extensive the police should be, the auspices under which it would operate and whether or not the parish constabulary should be completely abolished.

Justices and Poor Law officials report to the government

A considerable section of the landed class lost faith in the adequacy of the old constabulary; the exact proportion is unknowable, but a contemporary survey – the queries sent to the justices in the autumn of 1836 by the Constabulary Force Commission – offers a crude estimate. Question 6 asked the justices the reasons for failure to bring offenders to justice. The degree to which the constables were blamed is striking, considering the range of other factors which could have been cited.[121] Responses were made by petty sessional divisions, not individual justices. In our sample[122] 35 per cent of all divisions held the constables alone accountable; 58 per cent held them responsible alone or in part.

Table 3.2 Justices' ascription of responsibility for failure to bring offenders to justice (1836)

Ascribed responsibility	No. of divisions	Percentage
No failure	31	22
Parish constables alone	50	35
Constables and prosecution defects	33	23
Prosecution defects alone	19	13
Other	1	1
No response	8	6
Total	142	100

Source: Justices' Responses to Queries of the Constabulary Force Commission (1836), PRO HO 73/5/1 & 2

Table 3.3, based on Questions 47–8, summarizes the percentage of petty sessional divisions who responded favourably to the idea of permanent, paid rural policemen. Question 47 asked what additional means justices thought necessary for increasing the security of person and property; Question 48, the final one, requested any additional information the justices wished to append. Table 3.3 places in the first category benches that recommended paid permanent police, ranging from a demand for professional divisional superintendents to the stationing of elaborated county or national forces; and in the second category those recommending using parish constables only – even if certain reforms were also suggested – and ambiguous responses. Divisions numbering 368, covering all English counties, were tabulated.[123] A regional breakdown follows, showing that the extent of professed dissatisfaction with the parish constabulary was highest in the South,[124] the least industrialized, urbanized part of the country. In view of the deep suspicions of professional policing known to have been recently entertained by the social group to which the magistrates belonged, the results lend force to our notion of a rapid evolution in the climate of opinion of the landed class.

In view of the later split within rural society over the rural policing issue after the passage of the County Police Acts (1839–40),[125] it may be useful to contrast to the opinions of the justices in 1836 those of the farmers and tradesmen who served as parish Poor Law Guardians. The latter were

Table 3.3 Percentage of petty sessional divisions favouring a permanent paid police (1836)

	Number	Percentage
1. England as a whole (368 divisions)[126]		
Favour permanent paid policemen	183	50
Parish constables alone sufficient	162	44
No response	23	6
2. Midlands (79 divisions)		
Favour permanent paid policemen	32	41
Parish constables alone sufficient	41	52
No response	6	7
3. North (82 divisions)		
Favour permanent paid policemen	38	46
Parish constables alone sufficient	39	48
No response	5	6
4. South (207 divisions)		
Favour permanent paid policemen	113	55
Parish constables alone sufficient	82	40
No response	12	5

Source: Justices' responses to queries of Constabulary Force Commission (1836), PRO HO 73/5/1 & 2

taken by us as proxies for parish élites generally, and may be characterized roughly as the 'Ratepayer View' of the matter.

A separate questionnaire was sent to local Poor Law authorities containing many of the same queries appearing on the magistrates' forms. Queries 33 and 34 were identical to those used to compile Table 3.3 on justices' attitudes. Data for the North and Midlands were too sparse to be useful. However, we were able to get results based on 936 parish responses in seventeen southern counties. These may be compared with the results of the magistrates' queries for the southern region. Overall, 31 per cent of the parish Poor Law Guardians responding professed themselves favourable to a paid permanent police. Three years before the public debates associated with the first national legislation, below the Wash-Severn line, a considerable gulf already divided these representatives of the rural middle classes from the gentry respondents who returned the magistrates' queries.[127] We presume that results for the North and Midlands, had we been able to obtain them, would have conformed to the same pattern.

Parish guardians' views diverged from those of the justices in more respects than on the question of favourability to a paid permanent police. Viewing criminal justice from a different angle, they were more apt to point

Table 3.4 Parish Poor Law Guardians favouring a permanent paid police compared to petty sessional divisions in the same counties (17 southern counties – 936 parishes)

County	Percentage of guardians favourable	Percentage of petty sessions divisions favourable	Difference (divisions – guardians)
Hertfordshire	53	82	+29
Buckinghamshire	51	43	−8
Sussex	50	71	+21
Middlesex	44	50	+6
Kent	42	50	+8
Hampshire	39	77	+38
Surrey	38	50	+12
Bedfordshire	37	100	+63
Norfolk	35	No data	–
Northamptonshire	29	57	+28
Berkshire	26	57	+31
Gloucestershire	26	68	+42
Devon	22	65	+43
Essex	18	47	+29
Wiltshire	16	63	+47
Huntingdonshire	13	50	+37
Cambridgeshire	0	50	+50

Sources: Poor Law Guardians' returns to CFC, PRO HO/73/6-9; magistrates' returns to CFC, PRO HO/73/5

to the deficiencies of the justices in its administration: the costs to them of attempting to locate a justice when needed, and the insufficiency of justices in some districts. Some were favourable to the creation of local courts and professional, stipendiary magistrates.[128] They were less likely than justices to view parish constables as corrupt or inefficient and, when in favour of reformed policing, were more apt to favour local forces responsible in some way to the ratepayers. The passage of the County Police Acts in 1839-40 created a new source of conflict between the rural middle classes and the justices, forcing the latter to confront directly the question of their relationship with the ratepayers.[129]

A blow to the old constabulary

Finally, we must discuss an important and completely unanticipated effect of the New Poor Law which had important consequences for both the functioning of the old constabulary and the attitudes of rural gentlemen. An administrative ruling of the Poor Law Commissioners, in March 1836, instructed Union officials to presume illegal all constables' charges relating to the administration of justice; no charges not sanctioned 'in plain words' by a statute or regulation of the Poor Law Commission were to be paid.[130] At a stroke, this stopped the formation of rural police schemes under the auspices of local Poor Law Unions,[131] and threw constables and parish authorities everywhere into disarray. It also shook the confidence of the magistrates in the whole system – during a period in which they were bombarded with the reports of a number of Whig Royal Commissions critical of the old constabulary, and were strongly encouraged to accept police reform by a government determined to legislate.

The arcane rules governing reimbursement of constables' expenses had always dictated that the constable not invest too much time and effort when compensation might not be forthcoming. Now, constables, more uncertain than ever whether parishes would pay their charges, increasingly refused to move unless victims positively underwrote their efforts. Justices complained that constables were now more apt to sit on warrants, executing them only just before a Petty Sessions in order to avoid detaining a prisoner in custody and incurring expenses which might never be reimbursed.[132] Many parishes had willingly paid their constables' bills, or even knowingly overpaid padded ones, to compensate the men properly for trouble and time lost at their regular occupations. The Rector of Little Oakley, Essex, stated that his parish would always pay the constable if no apprehension took place and the constable became ineligible for reimbursement from the county rate – a policy especially valuable to poor victims.[133] All such items in constables' bills now came under intense scrutiny by Union auditors.

Constables' willingness to search for offenders plummeted, 'as now in most cases the parishes refuse to pay'.[134] In those rare jurisdictions where constables prosecuted for offences against morals, prosecutions ceased entirely, as did inspections of vagrants' lodging houses.[135] Parishes which

used to pay a small stipend or retainer out of the rates were compelled to discontinue them.[136] Where there had been watchmen or constables' assistants paid by the parish without the sanction of a local Act or the Lighting and Watching Act, there was general confusion[137] – as at Croydon, where the gaol-keeper had been paid from the Poor Rate and was suddenly cut off. The worthy Stourbridge constable, Mr Craig, found his regular payments from the surrounding parishes stopped; Mr King of Bromsgrove lost his annual retainer.[138] Justices reported that leets and vestries were having difficulty finding trustworthy people, and that beerhouse supervision, intervention in brawls and affrays, and detection of trespassers were in total suspension.[139]

A Buckinghamshire justice reported 'the whole rural police in a state of abeyance', and wondered if it were legal for Petty Sessions to levy constables' charges on the Poor Law authorities by distress![140] Some vestries went on strike, refusing to appoint constables at all.[141] Those most affected were often those long-serving men who generally provided the best service. Some resigned.[142] In some southern counties, the pool of men willing to serve as substitutes declined, resulting in an inflation of the substitute-price.[143] In parts of Sussex, it was even proposed 'that ... the higher Classes ... be appointed in order to compel them to pay the substitutes'![144] 'You see,' said a Witney farmer, 'the constables cannot get their expenses. The Poor Law Commissioners have been so particular ... that these constables soon get very tired of their office; they now say D[am]n this office, I wish I was out of it'.[145]

This ruling placed conservative advocates of the notion of parish self-regulation on the defensive; it provided ammunition to ideologues anxious to implant a modern bureaucratic police structure; and it further eroded the declining confidence of the landed class in the old system of provincial law enforcement – precisely at the time at which the Whigs decided that the time was ripe to legislate.

METROPOLITAN PERSPECTIVES: MINISTERS, MPs AND MORAL ENTREPRENEURS

Early policing schemes

We have been discussing the evolution of the thinking of the 'provincial ruling class' regarding law-and-order matters in the 1820s and 1830s. In this chapter we wish to look largely at the views of members of the 'national governing class', and certain intellectuals and moral entrepreneurs based largely in London. Attention will be focused on the leading figures in both parties, and in other Metropolitan circles. Because we are adopting a somewhat biographical approach, we will, to some extent, be drawing ideal types. We are also well aware that in our attempts to distil out Tory, Whig and Radical positions,[1] some complexity and nuance will be lost. But we think that this approach will be useful in displaying the broad outlines of the thinking of intellectuals and men in the world of high politics regarding the policing of the countryside, and what the characteristic positions of various groups and important individuals tended to be.

As we have seen, the traditional form of policing in England, since at least the sixteenth century, had been the unpaid parish constable, acting under what, by the nineteenth century, was the rather loose supervision of the unpaid justice of the peace.[2] In theory at least, eighteenth-century landowners were supposed to keep order in their own localities by the exercise of their paternalist authority. If magistrates, they were to rely on the aid of the constables; if necessary on special constables or yeomanry. Only in extreme cases in which severe disorder threatened or was in progress were they to invoke the help of regular troops.

The eighteenth-century English state[3] was highly decentralized, had a relatively small central government and little in the way of a salaried central bureaucracy.[4] Apart from a few salaried Home Office clerks, the twelve judges (who sat in the courts in London and went out on Assize twice a year) and the legally trained men who acted as Clerks of the Peace and of Assize in each county, there were few other paid officials concerned with criminal justice. The government maintained a substantial standing army and navy; but the latter was never involved in the internal maintenance of

law and order.[5] The army did become involved when serious disorders threatened – but relatively infrequently, and under restrictions on their actions.[6] The army was meant to remain aloof from involvement in any form of normal or routine policing, but frightened, blundering or opportunistic magistrates occasionally commandeered regular troops to cope with low-level disturbances, or set the latter on tasks that verged on policing. When this occurred, there were usually repercussions.[7] For government of the counties and parishes outside London, the system relied heavily on the unpaid justices of the peace. The Poor Law – the main source of such social welfare as there was for the bulk of the population – was essentially a local responsibility, each parish being responsible for levying its own Poor Rate and relieving its own poor. Although both magistrates and constables technically acted in the King's name, the maintenance of law and order was primarily a local responsibility.

This system had not only been tolerated, it had been positively hailed by many English landowners as the cradle of English liberty, the necessary environment in which the 'freeborn Englishman' and his liberties could survive and flourish. The Bill of Rights of 1689 had declared that 'the raising or keeping of a standing army within the kingdom in time of peace, unless it be with the consent of parliament, is against law'.[8] Most eighteenth-century gentlemen chose to interpret this as a constitutional prohibition on any attempt to establish a state-run police. In 1785, William Paley defended the system in these words:

> The liberties of a free people, and still more the jealousy with which these liberties are watched, and by which they are maintained, permit not those precautions and restraints, that inspection, scrutiny, and control, which are exercised with success in arbitrary governments. For example, the spirit of the laws, and of the people, will not suffer the detention or confinement of suspected persons, without proofs of their guilt which is often impossible to obtain ... least of all will they tolerate the appearance of an armed force, or of military law; or suffer the streets and public roads to be guarded and patrolled by soldiers; or, lastly, entrust the police with such discretionary powers, as may make sure of the guilty, however they involve the innocent.[9]

Paley was sure that 'the liberties of a free people' would not survive the establishment of a government-run police, with special police powers, such as could be found in France.

In the same year in which Paley voiced these sentiments (1785), William Pitt's government introduced a bill to set up a regular paid police force for the London Metropolitan area. Discontent with the adequacy of the traditional parish constable system, and calls for its replacement with some form of paid police, had been voiced most strongly in London from the mid-eighteenth century. Henry Fielding, as salaried magistrate at Bow Street, had set up the small paid force of police popularly known as the 'Bow Street Runners'; his half-brother, Sir John Fielding, succeeded him as Bow Street magistrate and head of that small force. Both of them argued that the rapid growth of the metropolis, and the development of working-

class areas in which the upper class could not exercise their traditional paternalist authority, were causing serious crime and public-order problems, requiring urgent government action; they called on the government to legislate to provide a regular, paid police for London.[10] In the Gordon Riots in London in June 1780, the government lost control of the centre of London for nearly a week, and only regained control by deploying large numbers of troops, resulting in hundreds of people being killed. Following the riots, the philanthropist Jonas Hanway issued a passionate plea for a police for London, attacking the use of ideas of the constitution and liberty to justify their absence:

> It hath been a frequent complaint, that the nature of our constitution will not admit of a *police*; in other words, it will not admit of such salutary domestic regulations, as are calculated to preserve the lives and properties of the people, from that violence and rapine they are subject to, and which sometimes aim a dagger at the vitals of liberty ... The fact is, that in this land, so justly boasting of freedom, *liberty* is alloyed by *terror*, and the bright enjoyment of property by law, is darkened by rapine. Are the people of any civilized nation upon the earth, so subject to be disturbed on the highways, and even their beds, as the *English*; unless we except the outrages sometimes committed by daring violence in *Ireland*? ... We are become too profligate for the mild system of our government: liberty cannot stand without virtue. There is so gross an inconsistency in the harshness of our *penal* laws, that the tenderness with which they are executed is become a grievance. Let us make these *laws less severe*, but execute them with strict justice, and maintain their sanctity![11]

The government's 1785 bill – for a force of paid policemen, organized in nine divisions under three salaried magistrates – ran into strong political opposition, especially from representatives of the City of London, and they found it prudent to withdraw it. The bill's withdrawal was greeted with joy by the *Daily Universal Register* (soon to change its name to *The Times*), which stressed the dangers to English liberties posed by a French-style police force.[12]

> Although many inconveniences arise from an excess of liberty in this country, yet they are so greatly overbalanced by the advantages, that we cannot be too careful to preserve a blessing which distinguishes us from all the world. And there is no cause in which greater skill is required in the formation of a new law, than that of a police bill. Our constitution can admit nothing like a French police; and many foreigners have declared that they would rather lose their money to an English thief, than their liberty to a *Lieutenant de Police* ... This privilege [constitutional protection of liberty] is one of the peculiar rights which distinguish England from arbitrary states, and no friend to liberty will wish to see it contracted. ... Mr Reeves's bill intended to amend the *police*, if passed into a law would have tended to destroy the *liberty of the subject*.[13]

The major points made in this editorial – the threat which a police posed to the Englishman's traditional 'liberties'; the assertion that the very notion of a regular police force was a foreign, especially a French, one, which would result in a strong central government able to use such a force to rule despotically, as in France; and the view that, in return for enjoying the

advantages of English liberty, one must be prepared to pay a certain price, in terms of crime and disorder – were to be reiterated so frequently in the police debate of the ensuing 50 years as to become, by the 1830s, familiar clichés.

The history of the long campaign to establish the Metropolitan Police between 1785 and 1829, and Robert Peel's final success in passing his Metropolitan Police Act in 1829, has been fully explored, and it is not necessary to go over the ground again.[14] But we should note why the opposition succeeded for 44 years in defeating all the moves for a professional police for London. The Tories were in office almost continuously for nearly fifty years – from 1783 to 1830, with the break of only one year in 1806-7. Apart from the opposition of the City of London, it was the Tory country squires (as backbench MPs and JPs in their county Quarter Sessions) who were at the forefront of the struggle to block all legislation before 1829.[15] They viewed any plans for a government police force as a move towards a stronger, more centralized government, which might, in due course, undermine local self-government, and thus their own prestige and power. The backbench Tory view was rooted in traditional English 'Country Ideology,' which rested on suspicion of central government and paranoia about standing armies. The fear behind it, as Brewer observed, was always 'a loss of authority on the part of the landed classes, who, by virtue of their proprietorship, were deemed to be the natural rulers of the nation'.[16]

A police force for London alone appeared to many of the gentry as the thin end of the wedge; once granted, a police for the rest of the country, involving greater government powers and bureaucratic centralization, would surely follow. The spectre which they feared was of paid police and stipendiary (salaried) magistrates replacing the unpaid parish constables and JPs throughout the country. When the gentry talked of the threat to 'liberty' posed by a police, they meant, above all, the threat to *their* liberties, to their powers as justices in governing the counties and parishes.[17] This is why they saw the issue in terms of a necessary balance or trade-off – in order to preserve liberty as they defined it, they were prepared to tolerate a large measure of disorder and crime. The beliefs of the thin-end-of-the-wedge school of English gentleman were not entirely unreasonable; in fact, almost as soon as the Metropolitan Police Act had been passed, Peel *did* begin to speak about the desirability of provincial policing reform.

In the eighteenth century, the debate around a police centred largely on London and its peculiar circumstances, but the provinces occasionally came on to the agenda. Sir John Fielding, in addition to proposing a scheme to reform the police of London, also published a plan for dealing with robberies on the roads around London.[18] In 1772, he put up a more ambitious 'General Preventative Plan', designed to use his Bow Street office as a clearing-house for information about crimes committed throughout the country, and to co-ordinate nationally the local policing

responses of magistrates and constables.[19] Fielding's ambitious plan failed –
mainly owing to opposition from provincial magistrates to the notion of co-
ordination from London – but it had raised the possibility of some sort of
national scheme of English provincial policing.[20]

Radically reformed provincial policing was not a large preóccupation of
either eighteenth-century government or leading elements of the provincial
ruling class, and well-developed schemes were notable by their absence.
Apart from being extremely sparse, the few eighteenth-century plans of
provincial police that we have were sketchy, undeveloped (in comparison
to their prescriptions for the capital),[21] or cranky.[22] Before Bentham and
Colquhoun's 'Police Revenue Bill', the best thought out plan – clearly
inspired by the Reformation of Manners movement – was proposed by
George Barrett of Godalming.[23] He projected the division of the country
into sixty 'Decades' and smaller multi-parish district units. The chief objects
were the surveillance of the lower classes and, through a complex system of
residence registers and passports, the monitoring of their movements.

Jeremy Bentham's 'Police Revenue Bill', the fruit of his friendship and
collaboration with Patrick Colquhoun,[24] contained a sketch of a projected
national police structure. It would have created a central 'Board of Police'
in London. The country would be divided into police districts, each
supervised by a JP specially appointed by the Home Secretary and called a
'Police Magistrate' or 'Country Commissioner'. They would each control a
force of paid policemen called 'Surveyors'. Police Magistrates would
regularly report information about crime and criminals to the central
Board, from which it would put together a national picture of the crime
problem; the Board would transmit instructions to the Police Magistrates
on how to cope with these developments. Colquhoun said that there was a
need to create a class of men whose 'specialized duty' would be to 'watch
over the general delinquency' of the country as a whole, as well as of the
metropolis.[25] Prominent in the scheme was the quintessentially Benthamite
preoccupation with the need to regulate suspicious trades, efficiently collect
and diffuse criminal information and monitor the hordes of criminal
delinquents who left London every spring to prey on the country.[26]

During the period that the issue of a 'new police' for London was being
fought out, the British government was enacting successive measures for
professional police for Ireland.[27] The failed London Police Bill of 1785,
was adopted for Dublin the following year – though it was not a success
there. The Peace Preservation Act of 1814 created the paid and uniformed
Peace Preservation Police for those Irish counties proclaimed to be
'disturbed'. It was the work of Robert Peel, then the Chief Secretary for
Ireland. Well before London policemen were being called 'peelers', the
term was being applied to the Irish police. Henry Goulburn's Irish
Constabulary Act of 1822 created a regular county force for each Irish
county. In 1836 these were brought together into a single Irish
Constabulary (from 1867, 'Royal Irish Constabulary') for the whole
country, and a separate Dublin Metropolitan Police was also created. The

Irish Constabulary was created as a rural paramilitary force, and functioned as a *gendarmerie*. Dressed in military-style uniforms, armed with carbines and pistols[28] and stationed in barracks, from 1836 they were consolidated into one force controlled from Dublin Castle. For many English opponents of a 'new police', they exemplified the dangers to the liberties of the 'freeborn Englishman' that would follow from the creation of a similar force for England. With a very few exceptions (such as Edwin Chadwick, who was frank in extolling the Irish Constabulary as a useful model in some respects[29]) the Irish Constabulary hovered in the background largely as an example to be shunned. After passage of the 1839 County Police Act, it would be used as a rhetorical bludgeon by opponents to dissuade magistrates from voting in an English rural police that, in most respects, had little in common with it besides being organized, rural and a police.

Tory views: Peel and Wellington, backbenchers and JPs

Robert Peel got his Metropolitan Police Bill through both Houses of Parliament in 1829 by arguing from the criminal statistics that a new police was imperative. In the process, he invoked a new definition of 'liberty' and persuaded Members to accept it. 'Liberty' had been traditionally defined in the libertarian rhetoric of 'Country Ideology' as consisting of the absence of government control and interference in the lives of free-born subjects. Peel made the argument that there could be no liberty without security for person and property, and no security (in London at least) without a reorganized police structure under government direction. Peel wrote to Wellington, his Prime Minister: 'I want to teach people that Liberty does not consist in having your house robbed by organized gangs of thieves, and in leaving the principal streets of London in the nightly possession of drunken Whores and Vagabonds.' [30] Peel and Wellington articulated a new Tory view of order keeping that argued for the unique importance and special circumstances of the capital and made room for the intrusion of central state power (through the direct authority of the Home Secretary) into the policing arrangements of London. The Metropolitan Police were placed under the authority of two commissioners[31] appointed by the Home Secretary. By the time the drive for provincial police reform developed in the 1830s, the Metropolitan Police constituted yet another model for both government and reforming provincial gentlemen to ponder.

It must be remembered, however, that even before the foundation of the Metropolitan Police, the Home Secretary and the police of London had possessed a kind of national policing role. Provincial towns, parishes or groups, who could afford to pay the costs, could ask the Home Secretary for one of the Bow Street paid officers to be sent to their area to help solve particularly heinous crimes or outrages. Once the Metropolitan force was established, it quickly became fairly common practice to send individual Metropolitan policemen to serve as paid police for towns or parishes,[32]

while detachments of Metropolitan Police were occasionally sent into the provinces to deal with crises of public order.

It is not surprising that Peel should have taken a different approach from the bulk of the Tory squires and backbenchers.[33] He was far from a traditional landed Tory, being the son of a successful cotton manufacturer, and a man willing to contemplate the need for reform to the laws of Britain as the country experienced the full economic and social effects of the Industrial Revolution. He had shown himself, in the 1820s, willing to reform the criminal law substantially, making the first substantial changes to the capital statutes of the eighteenth-century 'Bloody Code'. As Chief Secretary for Ireland in 1814, he had introduced the Peace Preservation Act to reform Irish policing, and he followed that with his 1829 Metropolitan Police reform. Had it not been for his strong opposition to Catholic Emancipation, he would probably have thrown in his lot during the 1820s with the 'Liberal Tories' – Canning, Huskisson, Robinson – with whom he shared liberal economic, political and social views, rather than with Wellington and the 'Ultra' right wing.[34] Following the Reform Act of 1832, Peel showed himself perfectly able to work effectively within a reformed political system. When he returned to power as Prime Minister (1841–46), he presided over a number of major economic reforms, splitting his party over the repeal of the Corn Laws in 1846 and paving the way for his 'Peelite' followers to enter the mid-Victorian Liberal Party. Peel, writes Parry, 'changed the image of toryism single-handedly.'[35] Peel was a keen advocate of a strong executive, and embodied an administrative philosophy that was at variance with the mainstream of his party.

There are suggestions that Peel may have been contemplating, from the start, extending his Metropolitan Police reform to some wider national measure. Two days before he introduced his Metropolitan Police Bill into Parliament, he indicated, in the debate on the second reading of the Cheshire Constabulary Bill,[36] that:

> It had, indeed, been in his contemplation to apply a measure somewhat resembling that contained in the bill to all the counties of England ... Feeling, therefore, that the present bill would be an improvement, and recollecting the number of applications which were constantly made to the Home Office for the assistance of the Bow-street officers, he willingly gave his support to an attempt to organize an efficient local police.[37]

In the early 1830s, still wearing the mantle of the creator of the Metropolitan Police, he harassed the Whig government on their policing reform policies. In December 1831, the King's Speech promised government action on the matter of a provincial police. Over the next six months, Peel (in the Commons) and Lord Ellenborough (in the House of Lords) pressed the government, in questions, regarding the progress of legislation until Lord Melbourne (then the Home Secretary) admitted that his government had been forced, by the political difficulties of trying to legislate for a general police for the country, to shelve the idea.[38] In these

interchanges, both Peel and Ellenborough tried to capitalize on Peel's prestige and knowledge as the creator of the Metropolitan Police, and to highlight the Whigs' inexperience and lack of expertise in these matters.

In their comments and criticisms of the government, Peel and Ellenborough harped on one major theme: a new police structure should be kept clear of local interests. Peel refused to say under what specific authority it should be placed, but emphasized that in 'London the matter was easily settled. It was wisely placed under the authority of the executive power, who kept it free from all party and electioneering influence, which, if not effectually excluded, would make the police ... a curse.' Ellenborough brushed aside Lord Melbourne's worries that the government could not afford to pay for a new police, and his concern that 'the great difficulty ... would be to find persons willing to bear the additional expense ...' He reminded Melbourne that 'a former Administration, in proposing the Metropolitan police system' had not been afraid to lay down the law to the London parishes and compel them to pay. He, too, warned the government to be certain to keep their police clear of local interests: 'Police appointments should rest on the responsibility of his Majesty's government.'[39]

It is, of course, impossible to say how Peel might have crafted a reform of the provincial police, assuming his ideas went further than those he adopted in debate with the Grey administration. The Tories lost office in November 1830. From November 1830 till August 1841 – with a brief interlude from December 1834 to April 1835 – Whig coalitions or governments were in power. The important police legislation of that decade – the borough policing clauses of the Municipal Corporations Act (1835) and the County Police Acts of 1839 and 1840,[40] plus the more minor Special Constables Act (1831) and the Lighting and Watching Act (1833)[41] – were all the work of the Whigs. In attempting to conjecture what Peel might have done, what shape a rural police reform under his auspices might have taken, and whether he and Ellenborough believed enough in their own words to have attempted the big things they implied, one must remind oneself that all of Peel's pronouncements on this issue during the 1830s were made by a leader of the Opposition.

Wellington was a less likely candidate for support for police reform; his attitude towards it has rightly been described as ambivalent.[42] Coming from the Anglo-Irish aristocracy he may have supported the idea of a strong police to keep down the rebellious Irish populace. But the creation of an Irish national police system by 1836 had entailed the appointment of stipendiary magistrates, and the progressive stripping away of virtually all the traditional powers of the unpaid JPs. For Wellington and other landed Tories, this became a negative example of what police reform might produce in England as well. The link between police reform and threats to the position of the unpaid JPs (and thus to the status and power of the landed gentry in general) would become a major theme in the conflicts over county policing in the 1830s and 1840s. Wellington had been presented

with an estate in Hampshire, and he became Lord Lieutenant of that county from December 1820. He had no desire to see his fellow JPs of Hampshire, or of any other English county, experience a fate similar to the Irish justices of the peace, and was suspicious of any moves towards a stipendiary magistracy in the counties. He particularly feared, in the 1830s, that the Whigs and their Radical allies would use police reform to precipitate an unwelcome revolution in local government in the country-side. He feared that:

> The govt will not make use of the Magistrates and the existing Civil Authority of the country to regulate and direct the newly formed Police Force ... The Justices of the Peace and all their machinery connected with the land will be thrown aside altogether. They will at first be rendered useless and contemptible and then the institution will be abolished altogether.[43]

He had been parliamentary leader, in the 1820s, of the Tory right wing, who tended to be very suspicious of, and hostile towards, moves to establish regular police forces under government control. But Wellington had expressed himself in support of a police for London as early as 1820,[44] and, in 1829, as he alienated the Ultras over Catholic Emancipation, he also gave full support to Peel's Metropolitan Police Bill. Peel and Wellington would come to agree perfectly on policing requirements for the capital, but Wellington's attitudes towards rural police reform were much more cautious.

In the early 1830s, Wellington feared that a Whig reform of county policing might be effected on centralized Benthamite lines, but was reassured by the permissive 1839 County Police Act because it left the decision to use it to county Quarter Sessions and placed control of the county forces in the hands of the JPs in Quarter Sessions. He therefore would recommend to Hampshire Quarter Sessions that they adopt the Act, at least on a trial basis; according to Foster, this was 'the only occasion during his entire lord-lieutenancy when he made any attempt to influence the decision of quarter sessions'.[45] He had clearly expected something less congenial from the Melbourne administration, and at one point began to spread the word to Tory gentlemen that they ought themselves to reform the rural police lest the Whigs do it for them. A letter from the 1830s (probably written between 1836 and 1839 – before the passage of the County Police Act, but after the appointment of the Commission, whose report led to the Act), reporting the conversation of a Kent magistrate who had recently visited Walmer Castle (Wellington's residence as Lord Warden of the Cinque Ports) illuminates Wellington's thinking at the time. The Kent justices reported that Wellington spoke 'with great energy in favour of the adoption of a rural police throughout the Country', but warned:

> that the present [Whig] Govt. finding that the Country Gentlemen were opposed to them were desirous of putting them down and that if they resisted the adoption of a police force they [the Whig government] wd. in spite of their opposition take advantage of the smallest tumult as an excuse to form one and

create stipendiary magistrates and a contingent Constabulary force who wd. be conformable to their views making a civil power entirely at the appointment and controul [sic] of the Govt. – in other words a Gens d'armerie. The Duke therefore strongly recommended the Magistrates while *they were* such and had power in their hands to keep it – by adopting a Constabulary Force *themselves*. For if they now neglected to do so they by and by wd. not have the power to do so. He said it might be tried in small districts at first and that he was convinced the expense in the end wd. be less than that of the present system however the Farmers might cry out at the [?] first outlay and that in his county [Hants.] he had got people to be unanimous on the subject. Sir [?] has full permission and authority from the Duke to make his opinions on this subject as much known as possible ...[46]

Wellington's advocacy of a rural police was partly tactical – the JPs should adopt a force that they could shape now, to save them from having the Whig government force upon them stipendiary magistrates and a government-run gendarmeric. It also suggests the importance of Wellington's influence on the Hampshire gentry in shaping their attitudes regarding a rural police. When Charles Shaw Lefevre, Hampshire landowner and Whig MP for North Hampshire [and future Speaker of the House of Commons], was appointed to the Constabulary Force Commission in September 1836,[47] he told Edwin Chadwick, 'I dined yesterday in company with divers [Hampshire] Squires of strong Tory Politics – I led them to the discussion of the advantages of an improved rural Constabulary – in which they all agreed – & I suspect we shall have more Opposition from the out & out Radicals than from any other Quarter.'[48]

When the County Police Act was passed in 1839, Hampshire was one of the first counties to adopt it. In a debate in Hertfordshire Quarter Sessions, in April 1841, over whether or not to adopt the County Police Act, a pro-police magistrate claimed that a major reason that Hampshire Quarter Sessions had both established a county police and made it work well was the strong support given by Wellington.[49]

The national leadership of the Tory Party, Peel, Ellenborough, Wellington – one might also add the Duke of Richmond[50] – was clearly committed (enthusiastically or reluctantly) to the replacement of the traditional constables with paid, uniformed 'new police'. It was quite otherwise with many Tory backbenchers, not to mention the bulk of Tory gentlemen and JPs in the provinces.[51] In the waning days of Wellington's administration, two leading Ultra backbenchers, Sir Edward Knatchbull and Sir Richard Vyvyan, aired their suspicions that their own government intended to extend both the numbers and area of the new Metropolitan Police, under government control, at the expense of the JPs and traditional institutions of local government.[52] Vyvyan accused Peel of harbouring the intention

to supersede all the ancient institutions of the country ... He had never described the present police as a military body, but he objected to it that it was a large organized force, which might be increased to a great extent – the funds for paying which were not under the control of Parliament, and which was entirely

moved by the will of the Secretary of State. The Government was concentrating in its own hands the power of local magistrates, and superseding all constables and other officers elected by the people. He admitted that the present police had several advantages over the old system, but he did not like it because it was under the control of the Government.[53]

Outside Parliament, such attitudes were even more strongly represented among the rural justices of the peace. County JPs (and Lords Lieutenant, by whom JPs were recommended for appointment) were appointed by the Lord Chancellor, and by 1830 the Tories had been in power almost continuously for nearly fifty years. As a result, there was a heavy predominance of Tories over Whigs on most county benches. Among them were to be found some of the strongest supporters of the traditional ideas – a strong suspicion of anything to do with the national government or centralization, and the notion that JPs should govern their counties and keep order in the parishes with the aid of the old parish constables (supplemented by the yeomanry and the army in especially disturbed periods) and essentially paternalist policies. Closely connected with their opposition to government-appointed paid police was the suspicion that central government might want to remove entirely the power of the unpaid JPs, and replace them with stipendiary magistrates.

By the 1830s, the unpaid English JPs certainly had some cause to fear their replacement by stipendiaries.[54] From the late eighteenth century, there had been mounting criticisms of the adequacy of these amateur gentlemen for their task of local government and adjudication in a society undergoing rapid industrialization and urbanization. The first major breach in the principle of the unpaid lay justice came in 1792, with the appointment of 21 stipendiary magistrates for the summary courts of London; these men (generally called 'Police Magistrates'), appointed from barristers of some years' standing and paid a substantial salary, came to displace completely the old JPs in London.[55] Over the next fifty years, a few stipendiary magistrates were also appointed for large provincial cities or industrial areas; though they were not appointed in anything approaching sufficient numbers to displace the unpaid provincial English JPs. But the *idea* of replacing the unpaid JPs with stipendiary magistrates for their judicial duties was certainly raised in the 1830s and 1840s in a number of quarters.

In Ireland, the English JPs could ponder an example of what might happen to them. From 1787, the Irish government had begun to supplement the unpaid JPs in that country with salaried assistant barristers, because of concern about their ineffectiveness in coping with unrest. With each of the major Irish police reforms, of 1814, 1822 and 1836, the government appointed an increasing number of stipendiary magistrates, who, by the 1830s, had come to supplant the old unpaid JPs almost completely. The Anglo-Irish gentry disliked losing their powers as unpaid JPs just as much as their English counterparts did; but they were a smaller and more vulnerable élite; and their failure to keep order effectively in the

face of endemic agrarian violence undermined their claims to hold on to those powers.[56]

Within the national governing class, the argument for replacing English JPs with stipendiaries was reinforced by increasing uneasiness over the ability of the justices to cope with episodes of disorder. Whig governments of the 1830s were increasingly prepared to consider the use of stipendiaries. The inefficiency which many magistrates showed in dealing with the 'Captain Swing' risings of agricultural labourers in southern England in the winter of 1830–31[57] placed a big question mark against their future as far as the Whigs were concerned. One witness to the Poor Law enquiry of 1832–4, a deputy lieutenant of Berkshire, was very critical of the failure of the local magistrates to deal with 'Swing' and advocated the value of 'a resident, paid & responsible Magistrate' locally, commending 'what I have learned respecting the great service rendered by the appointment of Assistant Barristers in Ireland'.[58] In August–September 1842, when many county magistrates in industrial regions performed poorly in trying to cope with the 'Plug Plot' disturbances, the Tory Home Secretary, Sir James Graham, proposed adding salaried barristers to every Quarter Sessions alongside the unpaid justices.[59] And beyond these powerful ministerial circles, middle-class Radicals within and without Parliament beat the drum for getting rid of the county JPs altogether and replacing them with ratepayer-elected county boards and paid barrister-magistrates.

However, the unpaid English JPs were able successfully to resist the threat to replace them by stipendiaries, and county JPs continued to hold the bulk of their powers, judicial and administrative, until 1888.[60] 'Swing', though frightening to the English landed class, was fairly quickly crushed by repression, and did not lead on – as in Ireland – to continuous agrarian violence. English governments were always far more reluctant to tamper with the powers of the English gentry than with those of the Anglo-Irish ascendancy. As Peel (then Chief Secretary for Ireland) said, in introducing his Peace Preservation Bill in 1814, which created Irish stipendiary magistrates: 'In this country [England] the appointment of stipendiary magistrates was not necessary and therefore would be improper, but in Ireland the state of the country was so different, that the measure appeared [to him] indispensable for the public safety.' And Peel subsequently (as Prime Minister) opposed Graham's 1842 attempt to appoint salaried barristers to Quarter Sessions on the grounds that it would damage 'the useful influence of the best part of the local and provincial aristocracy of the country' and would lead to them being stripped of their power and influence like their Irish counterparts.[61]

English JPs kept sufficient political strength, not only to block any attempts, in the 1830s and 1840s, to replace them with stipendiaries or elected county boards, but also to ensure that any government (Whig or Tory) which tried to legislate for provincial policing, would have to take their views into account. As we shall observe, these ideas – suspicion of central government and centralization, and opposition to a government-run

police and the threat of replacement by stipendiary magistrates – were still strongly represented in the Quarter Sessions of many counties, and would be forcefully expressed in opposition to adoption of the 1839 County Police Act.[62] However, as we saw,[63] the opposition to regular paid police as 'unconstitutional' and a threat to liberty, which was still strongly maintained by many such JPs in 1830, was a view advanced by significantly fewer of them by 1839–40. The 1830s would be a key period for changing the ideas of a significant number of country gentlemen on key issues such as government reform of the Poor Law and policing. This decade would see a dampening of their enthusiasm for the older paternalist ideas and institutions.[64]

The largely Tory country gentlemen and justices would, by then, be in the midst of a reassessment of their own. The sentiments of Vyvyan and Knatchbull – the quintessential parliamentary spokesmen of the squires – would continue to be voiced into the 1850s, but a considerable number of the latter had persuaded themselves of the sense of Peel's argument that a police *per se* was a threat neither to liberty nor to their local prestige and authority. They were able to take heart from a string of successive Radical failures in Parliament to change the structure of local government and overcome their suspicions of rural police legislation proceeding from the Whigs. We will observe this clearly in our consideration of the important rural policing debates in county Quarter Sessions in 1839–40.[65] These had the effect of concentrating the minds of the squires. Almost everywhere, these debates revealed a significant split among Tory gentlemen which constituted a political opportunity for the government. By then Lord John Russell and the Melbourne administration had come to understand a simple proposition: no squires, no rural police. Russell sensed the reassessment of order-keeping that was proceeding among the country gentlemen and offered them something many could accept: a police; a police under their formal control; and a police presented with a minimum of Benthamite rhetoric.

Whig views on police reform

The Whigs had been out of power between 1783 and 1830. During this period of virtually permanent opposition, they tended to be suspicious, on civil libertarian grounds, of the growth of an over-mighty executive, and to oppose any moves towards stipendiary magistrates, paid by the government, or police forces, paid and run by the state.[66] This was essentially a legacy of the leadership, through the French Revolutionary period, of Charles James Fox. Fox had objected, in 1792, to the Middlesex Justices Act[67] on the grounds that replacing unpaid gentlemen JPs with stipendiary magistrates was:

> a dangerous innovation in principle. The police of this country was well administered in the ordinary mode by gentlemen who undertook to discharge the duty without deriving any emolument from it, and in the safest way to the freedom of the subject, because those gentlemen being under no particular

obligation to the executive power, could have no particular interest in perverting the law to oppression. To appoint a set of justices with salaries from government, and consequently to a certain degree, under influence, was to change the long-established practice, and to introduce a new principle, which might be indefinitely extended under various pretexts, and the effects of which no man could foresee ... This was a power pregnant with abuse; and as those who were likely to be the objects of it, the lower classes of the people, had seldom the means of applying for redress against abuse of power, they were entitled to the peculiar protection of the legislature in every law, by which they could be affected.[68]

Despite the opposition of Fox and some others, the bill passed easily, and the salaried 'Police Magistrates' which it created took over all the normal magisterial work of London. Between 1792 and 1829, a number of Whigs opposed government police measures on the grounds that they threatened the civil liberties of supposedly 'freeborn' Englishmen,[69] and the Foxite libertarian view of the need to protect the people – especially 'the lower classes of the people' who were not directly represented in Parliament – against an over-mighty state, continued within the party. But the Whigs, as a seemingly permanent opposition party, did not have much influence on the shape of any measures which were introduced or passed. Although they did not oppose Peel's Metropolitan Police Bill, before 1830 they had neither mounted a defence of traditional policing, nor put forward any plans of policing reforms themselves.

When Lord Grey's Whig-led coalition took over government in November 1830, they were immediately greeted by a public-order crisis – the 'Captain Swing' rural disturbances. Lord Melbourne, the new Home Secretary, was no Foxite or civil libertarian. He was politically opposed to reform unless it was absolutely necessary, and temperamentally disinclined to action if it could be avoided.[70] He has been quoted as summing up his view of government as: 'The whole duty of government is to prevent crime and to preserve contracts'.[71] One issue which *did* galvanize Melbourne into action – harsh action – was a serious threat to order and property. He co-ordinated the use of troops, special constables and other forces put together for the immediate purpose, in order to suppress 'Swing' disturbances, and did not hesitate to send in Special Commissions of judges to conduct trials and hand out sentences of death, transportation and imprisonment. Nineteen people were executed and 481 transported for 'Swing'.[72]

The discussions within the government – above all between Melbourne and his colleague the Duke of Richmond – in the wake of 'Swing' constitute the point of origin of all Whig thinking on provincial police. Peel and the Wellington administration had indeed broached the subject shortly before, but had not produced anything concrete in the way of a plan, much less draft legislation. The Swing phenomenon and the urban turmoil of the Reform Bill crisis that followed concentrated the minds of the new government. What had been merely pronouncements on what might be desirable in the hands of Peel, became quite concrete schemes and plans in

those of the Whigs. We shall see that the Grey administration, by 1832, had drafted what amounted to the first coherent, English national police legislation.

In 1831 Melbourne and Richmond began to ponder the question of the sufficiency of the old constabulary. The fifth Duke of Richmond was a colourful and somewhat eccentric character, described in 1829 by the diarist Charles Greville as 'well versed in rural affairs and the business of the quarter sessions, has a certain calibre of understanding, is prejudiced, narrow-minded, illiterate, and ignorant, good-looking, good-humoured, unaffected, tedious, prolix, unassuming, and a Duke'.[73] An Ultra-Tory who became a member of Grey's government from 1830 to 1834, Richmond had a particular interest in issues of policing and punishment. As an important landowner in West Sussex, he had helped to put down the 'Swing' disturbances in that county. He then drew on that experience to draft a bill to reform the appointment and regulation of special constables, which became law in October 1831.[74] Melbourne then asked him to 'turn your Mind a little now to the General Constables – the Parish Constables. Can We take no measures to render them more efficient as the law now stands, or can We get ready no provisions to enable us to do so?'[75] These words initiated a train of further thoughts, investigations and reconsiderations that would, by 1839, result in the issuance of a resounding 'No' to Melbourne's question of 1831. Indeed, as early as 1832, Melbourne was himself well on the way to giving the same answer.

Melbourne's discussions with Richmond arose out of the long and tortuous progress through Parliament of the government's Reform Bill. Its defeat in the House of Lords in October 1831 confronted the Grey government with serious disorders in cities, towns and industrial areas, and the threat of more to come. It was in this context that the government promised, in the King's speech of December 1831, to investigate 'the best means of improving the Municipal Police of the kingdom'.[76] In early 1832, Melbourne drafted his bill for a national police system.[77] In an accompanying memorandum for the Cabinet, dated 5 May 1832,[78] Melbourne set out four possible ways in which the government could try to implement the pledge in the King's speech. First, they might propose 'One new and general system of police ... for the whole of the country'. This Melbourne rejected, since 'it would be extremely difficult, if not impossible, to frame a general measure, which would suit the whole of England' and 'it would be indiscreet to attempt at once so large and comprehensive a measure which would probably meet with decided opposition ... from the larger proportion of the community'. Secondly, the ratepayers of each parish might be given the power to establish 'a new constabulary force within that parish' (as the Lighting and Watching Act of 1830 had already done, and the Lighting and Watching Act 1833[79] was to do more effectively). This was rejected because ratepayer opposition could make it too easy to block in most parishes: 'all the information, which I have received upon this subject, concurs in affirming, that a measure of

police, in order to be successful, *must be compulsory, that it must be imposed by legislative authority, and that it cannot be safely left to the decision of the inhabitants* ... even though it may be most evidently required'.[80] Thirdly, the magistrates of each county might be given 'a discretionary power of establishing a new constabulary force'. The objections to this option 'are evident ... such a power would be generally unpopular; would be viewed with great jealousy; would be subject to the imputation of jobbing ... and would be exercised upon no general plan, but according to the peculiar notions and opinions of each particular bench of justices'.[81] That left, for Melbourne, only the fourth option, giving the government a discretionary power 'to establish a constabulary, on the model of the Metropolitan Police, under such limitations and regulations as may appear to be convenient'.

The proposed bill would have allowed the government to appoint stipendiary magistrates for both sufficiently populous towns and large rural districts of counties, with powers to appoint forces of paid constables for those towns or districts. The bill, though seen and approved by Prime Minister Grey and some other members of the Cabinet, was never introduced into Parliament, being overtaken by the drama of the 'days of May' 1832, when the Whig government resigned over the Reform Bill, and were brought back in conditions of excitement suggesting possible revolution. Once the Reform Bill had been passed, and the disorder and excitement had died down, so too had the urgency for passing such a far-reaching bill. Melbourne was aware that such a bill was 'one of a very grave and serious character, against which much popular clamour may possibly be raised, and much popular feeling excited; and that it ought not, therefore, to be submitted to Parliament, except upon full and mature deliberation'.[82] In political terms, it would have involved a possibly losing struggle to overcome the fierce resistance of the (largely Tory) county magistrates, the squires generally, and considerable opposition from country gentlemen on the backbenches of both the Tory party and his own. One of Melbourne's famous aphorisms was: 'When in doubt what should be done, do nothing';[83] he accordingly, dropped the bill and avoided a political battle that he calculated was not winnable at that time.

The bill was never introduced into Parliament, and would perhaps not have got very far if it had been. But we should note that Grey, Melbourne and some other members of the Whig leadership had accepted its principle, and were prepared to commit themselves to a far-reaching measure. That bill would have tampered with the system of unpaid JPs and constables by giving the Home Secretary power to appoint stipendiary magistrates and paid police for those parts of the country where the government considered them necessary. Only three years after Peel had made the first significant inroads into traditional English policing, much of the national leadership of the Whig party seem to have been ready to join him and most of the national leadership of the Tories, in accepting the need for government-directed police reform.

After the shelving of Melbourne's 1832 national police bill, the Grey

government fell silent on the issue of police reform. The important Whig policing measures were passed under the auspices of Lord John Russell, who was Home Secretary for the period 1835-9 in Lord Melbourne's own government.[84] Russell was a Foxite Whig, more inclined to an activist policy, and more prepared to use the power of central government, than Melbourne had been. The Municipal Corporations Act of 1835[85] was the first Whig measure to replace the old constables with paid police; it required, *inter alia*, each corporate borough to appoint a watch committee to manage a paid borough police force. As Home Secretary, Russell introduced the bill into the Commons, but it was not really his initiative; and its policing section – a small part of a long and complex Act – had not generated any previous special consideration or discussion, and went through without any controversy.

Russell was personally far more closely and directly involved in all the measures which led up to the passage of the County Police Act of 1839. In October 1836, Russell, as Home Secretary, appointed a Royal Commission, comprising three commissioners, to report on 'the Best Means of establishing an efficient Constabulary Force in the Counties of England and Wales'. The immediate impetus towards setting up the Commission was a long letter from Edwin Chadwick[86] suggesting such a course of action; but well before he received Chadwick's letter Russell's attention had been drawn to national policing reform by the Duke of Richmond and some parliamentary pressure.

Richmond had left Grey's government in 1834, but he retained a strong interest in police reform, sending advice and plans on the subject to Melbourne and Russell. He was also an enthusiastic supporter of the New Poor Law, which he helped to implement in his county. An anti-Poor Law riot in Horsham, in December 1835 – which Richmond helped to suppress with the aid of a troop of dragoons, some Metropolitan policemen and a large number of special constables – set him thinking again on the need for a rural police. He wrote to both Melbourne and Russell on the subject, and put forward a brief plan for a rural police in December 1835. Both Melbourne and Russell approved the plan in general terms, Russell writing cautiously: 'A very good paper – & we may deal with it hereafter. But I fear till we have beat the cry of agricultural distress, we can hardly undertake such a plan. I hope in two years' more to see this country regularly organized [in terms of a police].'[87] Richmond's plan was a very simple one: it consisted essentially of appointing a small permanent paid police force (an inspector and five or six men) for his Poor Law Union, to be financed from local Poor Rates; presumably, this principle could then be extended nationally, to appoint such forces for all new Poor Law Unions.[88]

By this time, Russell seems to have been convinced of the need for thorough reform of provincial policing. He held no very high opinion of the (predominantly Tory) landed class from which the county JPs were drawn. He wrote to Melbourne that in Bedfordshire:

our Whig magistrates have reduced the expences 50 per cent by economy & honesty. The landed gentry are very respectable, & I have always found them kind & humane, but they are certainly the class in this country most ignorant, prejudiced, & narrow-minded of any. The uneducated labourers beat them hollow in intelligence.[89]

Russell was well aware, as Melbourne had been, of the difficulties and political dangers involved in legislating for some form of national police, but was unsure how to proceed, choosing in the end to create a Royal Commission of inquiry.[90] This set in motion the train of events which led to the first national provincial police legislation – the County Police Acts (1839–40)

We shall observe that, regarding the design of the practical machinery of a provincial police, Russell maintained an open mind. By the time the Royal Commission on Constabulary reported in 1839, Russell would have had before him a number of policy options – including a Poor-Law-based police along the lines recommended by Richmond and others; Melbourne's scheme of 1832; the recommendations of Chadwick's Royal Commission; and a further concept that emerged from leading elements of the gentry – the very class he labelled 'most ignorant ... and narrow-minded of any'. He would choose the latter.[91]

Middle-class Radical views on policing and local government: Joseph Hume and Edwin Chadwick

Policing cannot be said to have been an overwhelming preoccupation of Bentham's philosophic Radical disciples – with the exception of Edwin Chadwick, a case apart.[92] But they were a third important ideological source of ideas on policing reform[93] and, of all the groups we discuss in this chapter, the most determinedly London-based.[94] Bentham had seen the chief purposes of a rational system of criminal justice as being the prevention of crime and certainty of punishment, and, as part of his proposals for reform of Britain's system of criminal and penal law, he advocated a regular police force.[95] Joseph Hume, Charles Buller, Sir William Molesworth, Albany Fonblanque or Charles Grote simply took it as axiomatic that a well-organized, uniformed police was a natural appurtenance of a good, modern, efficient and cheap government.[96] Police reform was, thus, assigned its proper place in their campaigns against the unreformed system of local government operated (outside the boroughs) by the amateur, unpaid justices of the peace. These they despised as inept, jobbing, rate-wasting bumblers. In Parliament, the longest lived proponent of such views was Joseph Hume.

Hume was born into a lower-middle-class Scottish family in 1777.[97] He qualified as a doctor, and worked for the East India Company as both a doctor and an administrator, in which capacities he was able to make himself a fortune and return to England. He became a Member of Parliament, in 1812 for only a few months, and then from 1819 almost

continuously until his death in 1855. From 1819, Hume always identified himself as a Radical in Parliament; his main concerns were political reform and economic retrenchment – one of his supporters called him 'the indefatigable advocate of economy and good government'.[98] He harassed the Tory governments of the 1820s with an endless series of parliamentary questions, motions and speeches on these subjects; to the Whig governments of the 1830s – though he was disappointed by their failure to commit themselves to reform in all the areas which he favoured – he was more sympathetic, and he was prepared to compromise, for a time, some of his strong views.

Hume's major direct contribution to police reform was his introduction of the bill which became the Lighting and Watching Act of 1833.[99] If a parish vestry voted, by a two-thirds majority, to adopt the Act, they could appoint inspectors to levy a parish rate, and pay for a local force to patrol the parish by day and night. It replaced a Lighting and Watching Act of 1830[100] which had required a three-quarters majority for a parish to adopt it. This requirement had made it virtually unworkable. Getting even two-thirds of local ratepayers to agree to levy and spend a special police rate proved difficult enough, but many parishes and small towns did avail themselves of Hume's Act during the 1830s.[101] The essence of the measure was to provide a cheap and representative method whereby provincial parishes or groupings of parishes could improve their policing. If they were dissatisfied with their constables, they could appoint some paid police, but do so under the control of local ratepayers (rather than of central government, unelected county JPs, or unelected commissioners) who could control the expense. The bill was drafted by the Whig lawyer John Tidd Pratt to give parish ratepayers the possibility of paying for their lighting and watching without the great expense of obtaining a local Act;[102] and it fitted in well with Hume's ideas of ratepayer democracy as the best way to structure local government.

Hume's greatest influence over the debates on provincial policing of the 1830s stemmed from his attacks on the role and powers of the unpaid county magistracy, and his calls for their replacement with elected bodies for county government and stipendiary magistrates for administration of the laws. Hume attacked the unpaid justices of the peace as unelected, unrepresentative and irresponsible (mostly Tory) local despots. Hume saw them as 'irresponsible' in two senses, which both mattered deeply to him: 1) Their exercise of their powers of criminal justice (both summary and on indictment) was not subject to proper control, and often resulted in delays and injustices for those on the receiving end. 2) In governing the counties, they levied and spent a county rate without being held accountable to the ratepayers, or to any other body. This was 'taxation without representation'.[103]

As early as 1824, Hume tried to get returns of the numbers of people committed to London prisons by both the paid police magistrates and the county JPs for Middlesex and Surrey. Home Secretary Peel said that it was

reasonable to require this of the police magistrates, but not of the JPs; and Knatchbull and other country gentlemen objected vigorously to even the idea of making unpaid JPs answerable in this way to Parliament. The motion was easily defeated. Hume commented that: 'there was such an esprit de corps in the country gentlemen, that he never knew an instance of inquiry being called for into the conduct of magistrates, that they were not immediately up in arms to stifle all investigation'.[104]

In November 1834, the Whig government appointed a Royal Commission to investigate county rates – sparked by their rapid increase and a concern to find ways of controlling their rise.[105] Hume gave extensive testimony.[106] In his evidence, he advocated a rural police as being cheaper than parish constables in terms of 'the benefits to be derived, and the saving which would arise under other heads, from that precautionary and preventive system'. He recommended replacing the criminal jurisdiction of Quarter Sessions with local courts employing salaried barristers, as being both a quicker and cheaper form of justice. Most important of all, he advocated that the power to raise county finance should be taken away from Quarter Sessions altogether, and given to a county board to be elected by county ratepayers.

The commissioners strongly endorsed the call for a rural police and for local courts; but they were not prepared so thoroughly to despoil the justices of the peace. Instead they recommended a form of county council based on the Poor Law Unions, which would combine ratepayer-elected guardians with the unelected county JPs. The commission concluded: 'It is impossible not to admit that the persons who contribute to the County Rate have little control over its expenditure. The administration of this fund is the exercise of an irresponsible power, entrusted to a fluctuating body'.[107]

Hume followed up his proposals to the County Rates Commission by introducing a bill, in June 1836, for ratepayer-elected county councils on the model of the scheme outlined in his evidence.[108] Home Secretary Russell supported Hume's introduction of the bill; but it attracted – predictably – vociferous opposition from the country gentlemen in the House, and was defeated on second reading. In 1837, Hume reintroduced a slightly modified bill, but it was again defeated.

Hume had written to Thomas Spring Rice, 'I cannot but feel that there is such a thing as arousing a nest of hornets ...'[109] In 1837 gentlemen closed ranks, accusing Hume of wishing to destroy the link between rich and poor by depriving the latter of the magistrates, 'their natural friends and protectors'.[110] Montague Chapman MP was more blunt: 'Were not the magistrates selected from those who had the largest property in the county? – And would it now be said, that they should take from them the management of their own property ...?'[111] Russell and all other ministers who sat in the Commons were pointedly absent from the debate.[112] Hume tried and failed once more in 1838.[113] After that, the idea of trying to replace the county JPs with elected bodies was not again raised in Parliament for more than a decade.[114]

Hume's bill would have given each county council power to establish a county police under the control of 'a popular *representative*, and *responsible* body', rather than under the government or unrepresentative county JPs.[115] Three years later, when the County and Districts Police Bill of 1839 reached the Committee stage in the House of Commons, Hume returned to this point. Although he approved of the idea of establishing county police forces, he moved that the bill be deferred for three months, because it put control over those new county forces into the hands of the county JPs: it would

> transfer to an irresponsible power the right of taxing the whole community. Previously to carrying into operation such a measure as this, they ought to have constituted boards of rate payers, to be elected by, and to be responsible to the rate-payers, for the conduct of this business.[Russell, the sponsor of the bill] ought to consider well how he went about to violate that great principle that the people should only be taxed by their representative.[116]

Hume's attack on the powers of the JPs made him something of a bogeyman to those country gentlemen who were trying to resist both police and local government reform. He was portrayed, along with Edwin Chadwick, as one of those Metropolitan middle-class Radicals interesting in stripping provincial landowners of all their traditional powers, and rationalizing their functions under boards elected by middle-class rate-payers or appointed by central government. This was quite true. When Chadwick was setting up the Constabulary Force Commission, in September 1836, Hume wrote to him, supporting the initiative and saying that he thought 'you will do a great good by getting the Unpaid [Justices of the Peace] removed from their present power of doing mischief'.[117] Chadwick, a briefless Metropolitan barrister who needed steady salaried employment to support himself, had no more respect than Hume for the unpaid leisured gentlemen in the county commissions of the peace, and also favoured replacing them with salaried government employees. Unlike Hume, however, Chadwick was deeply interested in developing that portion of Bentham's work that had to do with police and prevention..

Edwin Chadwick was born in 1800, in Lancashire, into a middle-class Nonconformist family.[118] He went to London, read for the Bar in 1823, but did not practise as a barrister. Instead he became involved with the Philosophic Radicals in London, and began to develop ideas of reforming the criminal law, and other institutions, along Benthamite lines. In 1831, he met Bentham himself, and became his secretary for the last two years of Bentham's life. Chadwick had already absorbed most of Bentham's ideas from his writings; the period as his secretary set the seal on his apprenticeship as the archetypal Benthamite reformer.

In particular, Chadwick took from Bentham two crucial principles: the 'preventive' principle – that it was far better to design the system to prevent undesirable things ever happening, than to try to cure (or punish) them after they had occurred – and the 'tutelary' principle – that it might be

acceptable to use the powers of the state constructively in order to bring into harmony both social and anti-social interests. Although Chadwick basically believed in the doctrines of Political Economy, and favoured policies of *laissez-faire*, he was prepared to invoke the powers of the state – especially of the central state – in order to achieve measures of social reform aimed at prevention of what he defined as evils (pauperism, crime, insanitary conditions and poor public health). In a period of strong suspicion of central government power – both from adherents of Political Economy favouring *laissez-faire*, and from provincial local government (county, borough and parish) jealously guarding their local autonomy against encroachment from London – Chadwick soon became known (and distrusted by many) as an exponent of centralization in the service of plans of 'rational' Benthamite reform.

Chadwick's first significant publication on a reforming issue – which was to bring him to Bentham's notice as a promising disciple – was an article on 'Preventive Police'. He had written this as a submission to Peel's 1828 Select Committee on the Police of the metropolis, but it grew too long and it was sent in too late to be considered; he then published it as an article in the *London Review* in 1829.[119]

In the article, Chadwick argued that: 'Our present police consists of disjointed bodies of men governed separately, under heterogeneous regulations', who act only to catch and punish offenders after the event. By contrast:

> A good police would be one well-organized body of men acting upon a system of precautions, to prevent crimes and public calamities; to preserve public peace and order; and to perform whatever other useful functions might be comprehended in their duties without hindering the performance of those of the most important nature in the best manner.[120]

He argued that the statistics of committals to trial and conviction were unreliable as an indicator of the extent of crime and its increase or decrease. Instead of such sources, he preferred to use the published autobiography of James Hardy Vaux, a confessed thief transported for life to Van Diemen's Land (Tasmania), for what it was supposed to show about the true nature of criminals and their criminal careers. Using Vaux as evidence, Chadwick claimed:

> It is a fact, established from observation of the course of life and characters of those who appear as criminals in our penal courts, that in by far the greatest number of cases the motive to depredation is not necessity or poverty, in the common acceptation of the terms, but, as in the instance we have quoted, the 'easy-guinea', – an impatience of steady labour, an aversion to the pains of exertion, a proportionately strong appetite for the pleasures of ease ... A preventive police would act more immediately by placing difficulties in the way of obtaining the objects of temptation. If to obtain a given object of desire, as much mental or physical exertion be requisite as would suffice to obtain it honestly, the honest course will undoubtedly be preferred.[121]

He wanted to replace the present unsatisfactory constables and night watches etc. with forces of regular paid police. To counteract the argument that they might be paid just to patrol preventively, without actually encountering any offenders for weeks or months, he suggested that authorities could economize by employing the police on a number of ancillary duties as well: supervising street cleaning, arresting vagrants, keeping streets free from obstruction, and other duties done by parish officers.[122]

Chadwick ended 'Preventive Police' by stating that he hoped that 'we have dispelled all fears from the minds of many of our readers, that a good police can only be attained at the expense of the liberty of the subject', and by promising that 'the entire suppression of systematic depredation is perfectly attainable' by 'a combination of measures': 'giving complete and speedy information of all offences committed; creating in a better organized police an interest in the prevention of crime; and rendering penal procedure more simple, expeditious, cheap and certain'.[123] However, the alert reader concerned about the effect of such a police on civil liberties will have noticed how Chadwick (perhaps unconsciously) inverts Blackstone's maxim: 'the law holds, that it is better that ten guilty persons escape, than that one innocent suffer'.[124] In Chadwick's new utilitarian world of preventive police, this becomes: '... it should be borne in mind that the escape of one delinquent must do more mischief than the conviction of perhaps half a dozen guilty men can effect good, in the way of example'.[125] The change of emphasis is significant. Chadwick is much more concerned with creating an efficient deterrent police than with threats to civil liberties.

The article was ostensibly concerned with a police for London only; yet, when Chadwick wrote the Constabulary Force Commission Report nearly ten years later, advocating a national force for all the counties of England and Wales, his argument was essentially the same. The Report is much longer, and far more detailed, and incorporates large amounts of evidence specifically collected for the purpose by the Commission. But Chadwick's ideas about the causes of crime, the virtues of a regular preventive police, and the ancillary uses to which such a paid police could be put, had not altered at all; in many ways, he used the Commission Report simply to restate his 1829 views on a much larger canvas, and now with the addition of a great mass of highly coloured supporting evidence.[126]

Chadwick is a good example of a middle-class 'moral entrepreneur'.[127] In 1833, he served as a commissioner on the Royal Commission into child labour in factories, and made an important contribution to its report and the resultant Factory Act of 1833. From 1839 onwards, he was to make perhaps his most important contribution, in the area of public health, with his *Sanitary Report* of 1842 standing out as a classic exposé of conditions in the rapidly growing industrial towns which urgently required government action. He first came to public prominence as a member of the Royal Commission on the Poor Law (1832–4), and he wrote most of its report; the Poor Law Amendment Act of 1834 enacted most of the recommendations of that report, making Chadwick the major architect of the New Poor

Law of 1834. The essence of the New Poor Law was its preventive character: it was designed to deter pauperism by offering poor relief only in a properly regulated workhouse, and conditions in the workhouse were to be made 'less eligible' (i.e. less desirable) than those outside, thus creating a strong incentive for the able-bodied poor not to seek relief. Relief was no longer to be administered by individual parishes, but by parishes grouped together into larger Poor Law Unions, whose Boards of Guardians were to be elected by ratepayers. A national Poor Law Commission was set up to oversee the administration of the law by the new Unions.

Chadwick had expected that, as the main architect of the new law, he would be given one of the three salaried positions as Poor Law Commissioner – but he was disappointed; as a consolation prize he was appointed as Secretary to the Commission with the vague verbal promise that he would be a virtual 'fourth Commissioner' with equal power over supervision of the workings of the system. He soon, however, became dissatisfied with this role; feeling underemployed and insufficiently appreciated, he looked around for other ways to make his mark. He returned to his earlier interest in preventive policing, now thinking of it in a national, rather than Metropolitan, context. Towards the end of the Poor Law Report, Chadwick had raised his concern about the extent of vagrancy in the country, claiming that it had 'been converted into a trade', and referring to the substantial evidence collected on the subject by the Commission.[128] The author of the main report on vagrancy, H. G. Codd, Esq., stressed: 'Another point, the importance of which is much insisted on in the evidence, is the establishment of a rural police, for the purpose of coercing vagrants'.[129] Chadwick agreed that the New Poor Law could not effectively discipline the provincial poor if not complemented by a strong rural police; it was a point that he emphasized in urging Home Secretary Russell to create a Royal Commission on Constabulary in 1836.[130]

Vagrancy supplied one strong reason for Chadwick to press for a rural police; the experience of implementing the New Poor Law suggested another. The Poor Law Commission began work in the rural South, creating the new Poor Law Unions to administer the new measures from November 1834. Implementation of the new law in the South in the period 1834–6 was relatively peaceful and easy; there was nothing comparable to the massive demonstrations and riots which virtually paralysed implementation of the law in parts of the industrial North from 1837 onwards. Nonetheless, there were still some protests, attacks on officials and anti-Poor Law riots even in the South;[131] by the end of 1835, these had focused Chadwick's attention on the need for an organized police to suppress such disturbances. In January 1836, James Kay, Poor Law assistant commissioner in East Anglia, sent Chadwick two reports about anti-Poor Law disturbances in Suffolk in December 1835; Kay recommended an improved rural police, based on the Poor Law Unions, to deal with such episodes. Chadwick referred the reports to Home Secretary Russell for his consideration.[132]

His 1836 correspondence with Russell adverted more and more to the problem of the rural police. In July 1836, in the course of a letter to Russell about the bill for Registration of Births, Deaths and Marriages, Chadwick advocated the merits of the preventive principle in policing: 'It is the main defect of all the arrangements for the prevention of crime that it is not made the interest of public Agency to prevent crime to the uttermost extent, or rather that it is to the interest of the great body of subordinate agents that a certain amount of crime should be habitually committed.'[133]

This was followed at the end of August with another long letter strongly advocating the creation of a Royal Commission, with Chadwick as the leading commissioner, to design a national police system for provincial England. We observed that by this time Russell's mind had turned in this direction as well, and Chadwick successfully seized his chance.[134]

What Chadwick outlined in his article 'Preventive Police', and the national police structure he recommended in the Constabulary Force Commission Report, revealed a split on the police issue among Bentham's intellectual children. For most of them – Hume pre-eminently – a police, though necessary and desirable, had to be made responsible to the ratepayers, as had been the case since 1835 in the boroughs. The publication in the spring of 1839 of the Constabulary Force Commission Report led to a testy exchange with the Radical Charles Buller. He accused Chadwick of making some very strong statements 'on very insufficient evidence'. A centralized police 'would speedily be as corrupt and inefficient as all systems of Centralized Administration appear to me to become,' and would constitute 'an instrument in the hands of the executive for the destruction of liberty and good government'. 'I like', said Buller, 'the notion of a paid and trained police. I would consent to have large police districts, such as counties, under one ... authority, but that authority *ought, in my view, to be popular* . . .'[135]

Rural policing returns to the Home Office agenda (1835)

The Grey administration, as we observed, devised the first draft legislation on a provincial police, but was unable to pursue it in 1832. When Russell arrived at the Home Office in 1835, the more purely Whig Melbourne administration took up the issue again. But it did not completely disappear from view in the meanwhile. It was touched on by a number of Royal Commissions during that period, including the Royal Commissions on the Poor Law and County Rates. In the debate in the Lords on the Sale of Beer Bill at the end of the 1834 parliamentary session, it was brought up by the Opposition. Wellington argued that 'It would be very desirable ... that in the course of the recess his Majesty's Government should turn their attention to that subject [the rural police]; for I am ... convinced that the law cannot be administered if some measures be not taken to improve the condition of that force.' The Duke of Richmond seconded Wellington, reminding the government that a more efficient rural constabulary was

recommended by the Lords' Select Committee on County Rates. Melbourne replied that it might be a favourable time to act, the country being tranquil.[136]

No measure appeared in the next session, however. It was no easy matter to devise legislation that would command the support necessary to bring it forward safely as a government measure. Everyone might say (and, largely, did say) that something had to be done; but beyond that, the politics of policing were exceedingly delicate and fraught with difficulties, and always apt to become bogged down in a welter of competing schemes, interests, fears and scruples. Russell at the Home Office resolved to confront the task, but it would be at least three years between the resolution and the appearance of legislation. Barring the crisis atmosphere of the summer of 1839, which allowed his hastily thrown together County Police Bill to sail through Parliament, it might conceivably have taken still longer. We shall return to these developments in later chapters.

PROVINCIAL POLICING INITIATIVES: THE COUNTY, THE PARISH AND THE UNION

I feel confident that a very short period must elapse before the necessity for a rural police will be so evident that we shall only be astonished it has not been adopted before ... Like the London Police, The Reform Bill, The Poor Laws Amendment &c. &c., this measure must be brought forward again and again until it is adopted and then the blunderers will admire its efficiency. (Chadwick Papers 630, Thomas Dimsdale to Chadwick, 1 May 1837)

The justices and 'core justices' of Quarter Sessions

The unpaid justices of the peace were central to the running of the English state in the eighteenth and early nineteenth centuries. They were a self-confident group constituted out of the wider body of the landed class, elected by nobody, but possessing broad administrative powers and taxing authority in the counties in which they acted. The ambit of their activity and influence extended both downwards into the parishes and (after 1834) Poor Law Boards, and upwards into the arena of national political life, Parliament and government itself. The preservation of their stranglehold over county administration and their status as a 'self-constituting political élite' ultimately depended on the degree to which both the threats of a stronger central government and the introduction of an elective principle into local government could be held at bay.[1] Many justices took their role in county government very seriously. Justices were not obliged to be active,[2] nor were they compelled to attend Quarter and Petty Sessions regularly; but within every English Quarter Sessions there was a small group of magistrates who attended regularly and carried out their duties diligently. As the financial responsibilities of counties mushroomed in the early decades of the nineteenth century, most Quarter Sessions appointed finance committees from among the regular attenders to deal with county expenditure and the fixing of the county rate, and other committees to deal with issues such as police and prisons.[3] The Poor Law Amendment Act of 1834 took away from the JPs much of their responsibility in the area of poor relief; but they sat *ex officio* on the new Boards of Guardians, and

continued to exert some influence in that capacity.[4] Generally, it would not be putting it too strongly to talk of the emergence, by the 1830s, of a group of 'professional'[5] (though unpaid) JPs in the Quarter Sessions of each county, who dedicated a considerable amount of time to county government and administration, and developed a degree of financial and administrative expertise in the task. We refer to this group as the 'core justices'.

From the core justices came some significant provincial initiatives for reform of policing in the 1830s. They were also the people who had to face the practical problems of having to implement such schemes – whether devised by themselves or imposed on them from outside by government. Their loyalties tended to be, above all, to their own county and the landed class, but because they also had to attend to the question of the legitimacy of their rule, it was impossible to ignore entirely the views of the more substantial ratepayers. The latter objected strongly to measures which increased the county rates, showed occasional frustration over their inability to control or check the taxing power of the justices, and nurtured other resentments against the gentry over game-preserving, the administration of justice or as tenants or holders of parish office. This was the general local political milieu within which the justices had to operate and within which attempts to reform provincial policing took place.

'The first provincial attempt': the Cheshire Constabulary Act[6]

The earliest successful English police reform initiative – briefly preceding even Peel's introduction of the Metropolitan Police Act – was the Cheshire Constabulary Act. This was a private Act to appoint a paid constabulary force for the county, obtained at the instance of the Cheshire Quarter Sessions under the leadership of their chairman, Trafford Trafford. The magistrates' main motive for this action appears to have been concern at the large number of people coming up for trial at Quarter Sessions and Assizes, and the resultant growing expense to the county for the prosecutions. In the view of Trafford, this was

> partly attributable to the inefficiency of the police. It was well known that the persons appointed to the office of constable were from their habits, and the nature of their calling, totally unfit for the duties of such an office; and the natural result was, that a great deal of crime was committed with impunity, and the probability of escaping detection held out a strong inducement to the commission of more.[7]

The magistrates felt this concern particularly acutely about the northern manufacturing part of the county, around Stockport and Macclesfield, which was densely populated and adjacent to the similar manufacturing areas of Lancashire – seen as natural breeding grounds of crime and unrest.[8] In an attempt to exert some control over the unpaid rotating constables, Quarter Sessions appointed one constable from the Macclesfield hundred, George Burgess, as a paid 'special constable' to superintend

the others. However, as the law then stood, they found that, though they could pay him certain allowances, they were not able to pay him a regular salary. Trafford therefore induced his brother-magistrates to agree to petition Parliament for a private Act, which would enable the magistrates legally to appoint and pay salaried constables.[9]

Arguments drawn up by Trafford to support the second reading of the bill laid stress on 'the contiguity of part of Cheshire to the Manufacturing districts of Lancashire'. Efficient police establishments in Manchester, Liverpool and Warrington, it was claimed, drove offenders into areas where their own constables were entirely inadequate; this was particularly the case in the manufacturing and populous parts of North Cheshire, suffering from the dual problem of a dense and turbulent population and closeness to Lancashire's dangerous cities. This type of argument – that an efficient police in any town or part of a county would drive the villains into the contiguous area (sometimes referred to by historians as the 'migration thesis'[10]) – was (as we shall see) to become a common justification for a rural police. Trafford, in arguing for the value of appointing a few permanent paid police to take charge of the inefficient unpaid rotating constables, used an analogy from the Poor Law to invoke the advantages of the growing professionalism of local administration:

> A great improvement had been introduced in the administration of parochial affairs, by the appointment of permanent overseers; and the magistrates were of opinion that an application of the same principle to the office of constable would be attended with the most salutary effects, by the prevention of crime ... A great improvement might be made in the police of the county without interfering with the rights of lords of manors, and the present mode of appointing constables; and one which would effect a saving in the county expenditure infinitely greater than any expense which could attach to the measure.

Analogies between Poor Law reform and police reform (particularly after the Poor Law Amendment Act of 1834) were to become significant in the thinking of many provincial gentlemen during the 1830s. The local Tory newspaper, the *Chester Courant*, in expressing its support for the move, suggested another model, that of 'The Irish Constabulary Act [of 1822] (upon which we rather think the present Act has been modelled)'. The Liberal *Manchester Guardian*, on the other hand, feared that such an Act would 'place the whole police of the county under the immediate direction and control of the magistrates', who 'are not the proper parties for exercising the power which Mr. TRAFFORD's bill proposes to place in their hands'.[11] This too was to be a significant theme in the debate on provincial policing over the next decade.

The bill was duly introduced into the Commons, and passed with very little opposition; by 1 June 1829 it had become law as 10 Geo. IV, c. 97. On the second reading, two MPs asked for the bill to be postponed for six months: one on the grounds that it would lead to a stipendiary magistracy in Cheshire, and the other because he preferred to wait for a general measure

for the whole country rather than pass this Act for just one county. Home Secretary Peel, who introduced his Metropolitan Police Bill two days after the Cheshire bill reached its second reading, expressed cautious approval of the measure.

> As one of the Secretaries of State, he felt himself bound to take a part in the discussion, and to declare, that if the county of Chester was willing to bear the expense of this improvement, he saw no objection to the magistrates making the trial ... It had, indeed, been in his contemplation to apply a measure somewhat resembling that contained in the bill to all the counties of England; and he had even wished the hon. member for the county to postpone the bill for some time with that object; but it was found, from the nature of the subject, and the number of concurrent jurisdictions, that the previous enquiries must necessarily be very extended, and would occupy a very considerable period. Feeling, therefore, that the present bill would be an improvement, and recollecting the number of applications which were constantly made to the Home Office for the assistance of the Bow-street officers, he willingly gave his support to an attempt to organize an efficient local police.[12]

In terms of the Act, the justices in Quarter Sessions could appoint two kinds of paid constable: first, a special (or deputy) high constable could be appointed for any hundred or division of the county (to be paid a salary by the county, from the county rate; depending on the size of the population of the hundred or division, that varied between £60 and £150 per annum). Second, assistant petty constables could be appointed for a township or group of townships (to be paid a wage from the local Poor Rate of the township or townships; this ranged from £20 to £50 a year). Assistant petty constables were to be appointed by Quarter Sessions on the recommendation of three JPs from the local Petty Sessions. Both types of constable were to be full-time police officers, not practising any other trade, and not taking any fees or gratuities for their services. They were to have authority as constables throughout the county, but were required to reside in the hundred or townships for which they had been appointed. They could be discharged from their positions by the justices in Quarter Sessions, and temporarily suspended (until a hearing at the next Quarter Sessions) by the local JPs in Petty Sessions.[13]

In August 1829, Cheshire Quarter Sessions made its first cautious appointments under the Act – three special high constables, for two divisions of the Macclesfield hundred and for the Bucklow hundred, and a small number of assistant petty constables. The Cheshire Constabulary Act was never extended to cover the whole county, but was used only in those hundreds or divisions which the JPs felt required paid police. In all, no more than eight divisions of the county were placed under the Act in its first decade; by 1837, the paid police were being used in only seven divisions. Their numbers fluctuated, but normally amounted to fewer than 30 – typically, three special high constables and 20–24 assistant petty constables [see Table 5.1] Trafford testified that, since the assistant petty constables' wage came from the Poor Rates of the townships they policed, this new expense

Table 5.1 Strength of force appointed under Cheshire Constabulary Act (1829–37)[14]

Date	Hundred	Division	SHCs[a]	APCs	Total
1829	Macclesfield	Prestbury	1	2	3
	Macclesfield	Stockport	1	3	4
	Bucklow		1	4	5
	Eddisbury			5	5
	Nantwich			[5?]	[5?]
	Northwich			3	3
	(Altrincham and				
	Lymm townships)			2	2
	Total		3	24	27

[The *CFC Report* (p.111) states that the initial force 'appears to have consisted only of three special high constables and twenty-four petty constables'. Between 1829 and 1836, there were some changes. In 1831, there were 20 APCs for the Nantwich hundred; ratepayer complaints about the expense led to a reduction in their number in 1831, and their complete abolition in 1832. The Broxton hundred acquired 3 APCs, which were abolished before 1836.]

Date	Hundred	Division	SHCs[a]	APCs	Total
1836	Macclesfield	Prestbury	1	2	3
	Macclesfield	Stockport	1	3	4
	Bucklow		1	3	4
	Edisbury			5	5
	Northwich			5	5
	Wirral			2	2
	Total		3	20	23
1837	Macclesfield	Prestbury	1		1
	Macclesfield	Stockport	1	2	3
	Macclesfield	Hyde		2	2
	Bucklow		1	2	3
	Eddisbury			4	4
	Nantwich			6	6
	Northwich			5	5
	Wirral			3	3
	Total		3	24	27

[a]SHC = Special High Constable; APC = Assistant Petty Constable

was always initially very unpopular with the local ratepayers – which ensured that only a small number of paid police could ever be appointed. This constraint could have been removed if they had been paid from a general county rate, but Trafford and his fellow landowners would never approve such a rate, as that would mean that the rural areas were subsidizing the manufacturing areas where most of the police needs were generated[15] – a theme which was to recur in debates on the County Police

Acts of 1839 and 1840 in the Quarter Sessions of those counties with substantial manufacturing and rural areas. So, the Act was never used to try to establish a large regular police force in the modern sense. It was, rather, a system intermediate between the old parish constables and the new professional police forces like the Metropolitan Police. A number of the special high constables were recruited from the Metropolitan force. The intention behind the Act had never been that the paid police should entirely supplant the old parish constables; they were rather expected to supplement the constables by adding an element of permanent professional guidance. Throughout the period of the Act's operation (1829–56), parish constables continued to be appointed in Cheshire – two for each township – and to serve, as before.[16] In this respect – supplementing the old system by adding an element of police experience and permanent professional leadership – the Cheshire Constabulary Act system bears a considerable resemblance to the various local non-government police bodies set up during the 1830s, and the superintending constables schemes of the 1840s.[17]

The assistant petty constables were expected to carry out, efficiently and regularly, all the duties of the parish constables – arresting offenders and conveying them to gaol, attending Petty Sessions, serving warrants and summonses, curbing local public disorders. The special high constables, in addition to these duties, were expected to supervise both the paid and the unpaid constables, attend Quarter Sessions, collect and disseminate information about crimes committed, and assist the JPs in suppressing riots and breaches of the peace.

The record of the Cheshire paid police in carrying out these duties was a mixed one. As the only example of a paid county police then in existence, they were the subject of a detailed scrutiny by the Constabulary Force Commission in its deliberations between 1836 and 1839.[18] The Commission Report, written by Edwin Chadwick, severely criticized the Cheshire Constabulary Act and its implementation. This was, in part, strategically motivated – if Chadwick was to advance his own schemes for a national professional police force, then it was necessary to discredit rival models such as the Cheshire one.

But there was some substance to the criticisms. The Report produced witnesses and evidence to testify to the poor quality of some of the appointments, the inadequacy of the numbers, training, co-ordination and regulations of the police, and ratepayer dissatisfaction with the cost and usefulness of the system. But Chadwick was concerned that a total condemnation of the Cheshire experiment might be used as an argument against the appointment of *any* paid police, and even he acknowledged that the system had worked well in some areas. He ended this section of the Report by saying: 'When we speak of the Cheshire Constabulary Act as a failure, we would be understood that failure was relative; positively, the appointment of the paid officers has, we believe, amply justified the expense ... In particular districts where trained men have been in action,

they appear to have given satisfaction'.[19] Randle Wilbraham, Junior, JP for the Northwich hundred, said of the Act in 1836 that 'tho' much opposed at first, its utility appears to be generally understood, & it certainly works most beneficially'.[20] Others, who were more critical of some aspects of the Act, still argued that most special high constables (especially those who were former Metropolitan police officers), and some assistant petty constables, made a significant contribution to combating crime and disorder in their areas.[21]

The Act imposed the cost of these paid police on local ratepayers – on the county ratepayers of the hundred or division for the special high constables, and on the payers of the township Poor Rate for the assistant petty constables – and this stirred up considerable opposition. In 1831, ratepayers of townships in the Nantwich hundred petitioned Quarter Sessions to reduce the number of paid petty constables; since they lived in a rural area, they argued that the existing 20 paid constables were far more than they needed, when the much more populous manufacturing Macclesfield hundred had only 8 paid policemen.

They suggested that this was due to a cynical local gentry employing this large number of constables, at public expense, as gamekeepers, to catch poachers and safeguard their game preserves. Quarter Sessions agreed to a reduction in the numbers of police, but the ratepayers then went further; 54 of the 62 townships in the hundred petitioned for the complete abolition of the paid policemen, as a useless expense; despite the resistance of the local JPs, this move was ultimately successful. Lord Melbourne, in his cabinet memorandum about his draft national police bill in May 1832, referred to the Cheshire Constabulary Act and the example of the Nantwich hundred; he used it to raise, and dismiss as unsatisfactory, the option of giving a discretionary power to establish a constabulary force to the magistrates of each county.[22]

Ratepayers of townships in the hundred of Eddisbury likewise petitioned for abolition of their paid police, but without success. The general argument used in these petitions was that one paid policeman, serving six or eight townships, was not only more expensive than their local parish constables, but he was also of considerably less use, never being on the spot when they needed his services.[23] The larger question raised by these expressions of ratepayer feeling – how and by whom a professional police was to be paid for, and who would control the appointment and dismissal of police and the spending of the money – was to prove to be one of the most contentious issues in all provincial attempts to bring in paid policing.

In addition to its general indictment of the failings of the Cheshire police, Chadwick's report strongly criticized the fact that they were run by the county JPs. The report urged that the judicial role of the magistrates should be separated from the administrative role of running the police – as had been done with the commissioners of the Metropolitan Police.[24] Chadwick was condemning the Cheshire police for failing to measure up to his idea of what a proper preventive police force should be. But this view

was not universal. Despite this severe criticism, the magistrates of Cheshire persisted with their Act – not only through the 1830s, but also after 1839, choosing to stay with their own system rather than set up a new county force, as allowed by the County Police Act of that year.[25] What Chadwick and others condemned as faults in that system – that it placed the police totally under the control of the county magistracy (in Quarter Sessions and, to a degree, in their local Petty Sessions), and that it did not establish a uniform police force throughout the county but only provided a few paid men for certain designated areas – could be seen by Cheshire magistrates as positive advantages. As the JPs for the Wirral hundred put it, in their response to the questionnaire in 1836, 'The Constabulary Bill for Cheshire works exceedingly well and any measure carrying out its object and extending its benefits to the Country at large, we should consider beneficial, being understood to mean that the appointment of any police Force should rest with the local magistracy in all cases'.[26] Randle Wilbraham similarly felt strongly that 'the appointment of a Constabulary force vested in the Quarter Sessions or in some local authority would be considered more Constitutional than in a Commission appointed by the government'.[27] .

This was also the view taken by Trafford Trafford and the majority of Cheshire justices. When Quarter Sessions debated a motion to adopt the County Police Act in March 1840, it was decisively rejected by a two-to-one majority; the JPs opted to stay with their own local system. In that debate, Trafford objected to the idea of a uniform police throughout the county which would make the rural districts pay for the maintenance of order, which he saw as mainly a problem of the urban and industrial areas.[28] We should note here the inadequacy of any analysis of the police reform debate which conceives it as polarized starkly into only two viewpoints: pro-police reform (favouring professional 'new police' like the Metropolitan force), and anti-police reform (defending passionately the old amateur system of unpaid constable and JP). Trafford and his supporters were very clear critics of the inefficiencies and inadequacies of the old constables; and they were prepared to go to the lengths of a private Act to try to remedy those. But they were not prepared to abandon all elements of the old system, or to surrender the JPs' powers into the hands of salaried bureaucratic police commissioners and adopt entirely the model of the 'new police'. Between the extreme views at either end of the debate – of those who opposed *any* form of police reform, and those who favoured a uniform national, government-controlled, professional police force – there lay a wide spectrum of views; many people favoured a degree of reform and use of paid police without wholeheartedly supporting the 'new police' ideology. Even critics of the inadequacies of the Cheshire system might approve the idea of the JPs keeping some control of the police; Sir John Stanley, a longstanding Cheshire magistrate and Whig critic of its very Tory bench, wrote to his son in 1838:

> Those who had the framing of our Constabulary Act, (and I was of the Number) certainly made a Mistake in rendering a new Police the mere Creature and Servant of the Magistracy, by leaving to Justices the exclusive Power of appointing and dismissing and paying Police Officers as they pleased ... I am not quite satisfied however that Police Officers in Counties should be appointed so entirely independant [sic] of Justices as not to be punishable or removeable by them if they disobey'd their Orders or were found to be careless and remiss in the Execution of their Duties ... It is *theoretically true* that the *Conservation of the Peace* and the *functions* of the Justices of the Peace are *incompatible*, but the Publick [sic] will always trust (in rural Districts at least) to Justices acting in the double Capacity of Justices and Conservators of the Peace ...[29]

George Wilbraham, Cheshire JP and MP, who in 1832 had presented a petition to the House of Commons asking for the repeal of the Cheshire Constabulary Act, in 1836 defended it as a good Act on the whole, and said that the principle of the JPs appointing the special high constables and assistant petty constables was a fair one.[30] Few provincial JPs were prepared to give up their powers to central government bureaucrats or the equivalent of the commissioners of the Metropolitan Police; some felt that even having these powers exercised by the county magistracy collectively in Quarter Sessions, rather than by the local JPs in Petty Sessions, was already a degree of unacceptable centralization, threatening important liberties which the individual justices should defend. This issue pervades the debate on provincial police reform throughout the 1830s and beyond.

'Community' and private local police forces in the 1830s

> It is a sense of insecurity, as well as actual insecurity to person and property which has led in many districts to the establishment of police officers. The habits of the Country are changed; the population immensely increased, the facilities of moving from one place to another greatly augmented, and in like proportion the ease of removing stolen property is greater than formerly. (Diary of the Revd F. Witts, JP, 14 Nov. 1836 – founder, in 1834, and member of the committee of management, of the Stow-on-the-Wold (Glos.) Police Association, which employed two policemen by private subscription.)

We have already suggested, in looking at the Cheshire Constabulary Act, the inadequacy of a simple binary model of the debate on police reform, which would classify every participant as either an advocate of paid government-run police forces, or a defender of the unreformed, unpaid parish constables. In reality, the considerable spectrum of views which stretched between these two extreme positions allowed for a range of variations on the theme of paid police – small-scale practical experiments in policing, which were carried out by small communities or powerful local individuals, below the level of government (national, county or municipal), in which control was kept in the hands of small local élites.

During the 1830s, a number of provincial JPs, gentry and local property owners began to experiment with supplementing their parish constables with small numbers of paid policemen, appointed and controlled in a

number of different ways. The Revd F. Witts, a magistrate of Lower Slaughter in the Gloucestershire Cotswolds, whose extremely informative diary is quoted above, presided over one of these types of experiment. Clerical magistrates such as Witts were extremely prominent in organizing and running such schemes. Our best guide to these developments comes from the Constabulary Force Commission of 1836-9. At the end of 1836, the commissioners sent out questionnaires to all county JPs in their local Petty Sessions, and also to all Boards of Guardians of the newly formed Poor Law Unions; in those completed questionnaires, plus the section of the Commission Report entitled 'Trials of a Paid Constabulary Force', one can find listed and described many such experiments with paid police.[31] Apart from the special case of Cheshire, which we have already discussed, the other paid police all fall into one of the four following categories:

(a) Those appointed in terms of a local Act of Parliament to enable the parish or township to appoint and pay police officers.
(b) Those appointed in terms of the general Lighting and Watching Act (1833).
(c) Those appointed and paid for by voluntary subscription of local property owners.
(d) Those appointed by the local parish authorities and paid for from the parish Poor Rates.[32]

(a) Local Act forces

It was open to any town which did not enjoy borough status, and hence powers of municipal government, to apply for a private local Act to confer upon itself certain powers of local government. The commonest powers applied for were those of lighting, watching and cleansing the town; the Act would include the power of levying an Improvement Rate on the town to pay for these services; and the right of exercising these powers was normally vested in a group of local Improvement Commissioners. Many towns, before 1839, had applied for such local Acts,[33] and the Constabulary Commissioners' survey found a number of towns which employed paid policemen under such Acts.

Towns appointing paid policemen in this way, in the 1830s, had the advantage of being able to employ trained policemen, usually former members of the Metropolitan force, founded in 1829. Control of the local Act police was vested in the Improvement Commissioners, who were normally elected by ratepayers. Local Acts provided the police for towns as diverse – geographically, and in terms of size and employment – as Truro, Brighton, Croydon, Warrington, Sheffield and Birmingham. In the West Riding, local Acts often provided the basis for the night police or watch, with the day police coming under some other authority. Croydon procured its local Act in 1829, as a direct response to the formation of the Metropolitan Police (whose district did not extend as far as Croydon) in

that year, and the consequent withdrawal of the old Bow Street patrols. By 1838, the commissioners had adopted the rules and regulations, the uniform, and the paperwork, of the Metropolitan Police; in 1840, Croydon was incorporated into the Metropolitan Police district, and this little force of five men ceased to exist.[34]

The main drawback to this method of appointing a paid police for a town was the cost – particularly the initial cost involved in obtaining the Act of Parliament, and also the cost to the local ratepayers thereafter, of administering the powers granted. Consequently, its use was limited, almost entirely, to towns of some size, with a substantial rate base, which could bear such costs. It was, essentially, to remedy this problem, and make such local rate-supported paid police forces more widely possible, that Parliament passed the Lighting and Watching Act (1833).

(b) Lighting and Watching Act forces

The Lighting and Watching Act (1833),[35] a measure introduced by the indefatigable Joseph Hume,[36] was designed to provide a cheap method whereby small towns or country parishes could improve their policing. The Act specified that, if a parish vestry voted by a two-thirds majority to adopt the Act, they could then appoint inspectors to levy a parish rate, and pay for a local force to patrol the parish by day and night. This saved the parish the expense and trouble of having to secure a separate local Act of Parliament. The Constabulary Force Commission evidence shows that the Act had been quite widely adopted by small towns and parishes in all parts of the country by 1836.

As one might expect of any legislation associated with Hume, the principle behind the Lighting and Watching Act was ratepayer democracy, giving the ratepayers of the parish power over the appointment and control of the police. If two-thirds of the ratepayers voted to adopt the Act, they could put it into force and elect inspectors. The inspectors were empowered to levy a rate to pay the police, and to direct their actions; they were also given the power to use rate money for the expenses of prosecution of offenders.

Making use of the Lighting and Watching Act in this way was a popular option with many gentlemen. For example, the four JPs who signed the questionnaire return for the Warwickshire divison of Atherstone, recorded that they had run a night watch under the Lighting and Watching Act until that year, and indicated their clear preference for police appointed under that Act over the sort of new constabulary force which the commissioners were suggesting. They recommended that a measure similar to the Lighting and Watching Act for *country* parishes 'will effect the objects sought in a manner more constitutional more just and more efficient than the establishment of any new kind of constabulary force'.[37] One of those magistrates, C. H. Bracebridge, subsequently wrote a strong attack on the decision of the Warwickshire Quarter Sessions to establish a county force for one hundred of the county[38] – an indication that Bracebridge's

fundamental objection was not to the idea of paid police as such, under the control of local JPs, but to the county forces (controlled by Quarter Sessions, paid for by county ratepayers and under the ultimate authority of the Home Secretary) which were set up under the County Police Act 1839.

Some areas took to the Act with great enthusiasm. The Metropolitan policeman initally hired by the Poor Law Guardians at Blofield (Norfolk) proved so active that 30 of the 32 parishes in the local Poor Law Union combined under the Lighting and Watching Act, retained him as superintendent and hired three more policemen under his command. Local property owners were impressed by their assurance in giving evidence in court, and their effectiveness in removing vagrants in a district located on the main road between Norwich and Yarmouth.[39] The Norfolk parishes of Wymondham and Hingham also used the Act and hired Metropolitan policemen. After a number of years of operation, William Wodehouse reported total satisfaction to the Constabulary Force Commission. The police eliminated vagrancy ('vagrants now avoid us'); kept order in the workhouse and beerhouses; co-operated with the New Poor Law authorities; stopped disorderly behaviour and the insulting of respectable residents; and suppressed a 'plunder gang' based in Hingham. In addition: 'They are extremely useful attendants at the Petty Sessions which are held at both these parishes ... and their service of process, and their mode of bringing forward cases, form a striking contrast to the blunders of the parish constables.' Finally, (and without any self-consciousness) Wodehouse bragged that they 'assist the great landowners and game preservers in this hundred'.[40]

In the Kent division of Upper Scray, centred on Faversham, adoption of the Act spread widely to about one-third of all the parishes by the late 1830s – presumably as a result of the strange rising in that area inspired by the man calling himself 'Sir William Courtenay'. This was perhaps the most turbulent part of Kent, and the stronghold of the Ultra-Tory Knatchbulls.[41] In Kentish London, the parishes of Lewisham, Lee, Kidbrooke and Charlton came together under the Act to form a single district, and set up the 'Lewisham United District Watch'. The elected inspectors brought in a Metropolitan Police superintendent, who hired constables and instituted a beat system modelled on the Metropolitan Police. The Inspectors' Report for 1838 stated that the force had been instituted 'to note the conduct of idle and suspicious characters lurking about the neighbourhood; and, by anticipatory and preventive measures, to check the attempts of evil doers before their unlawful designs can be carried into execution'.[42]

The Lighting and Watching Act was adopted by a number of small unincorporated towns, such as Horncastle (Lincs.), Wigton (Cumberland), Ulverston (Lancs.), Walthamstow and Braintree (Essex), Hadleigh (Suffolk), Shoreham (Sussex), Ramsgate (Kent), Hemel Hempstead (Herts.)[43] and Luton (Beds.).[44] Others were set up in rural or semi-rural parishes. Many were established with the aid of the commissioners of the Metropolitan Police; many employed ex-Metropolitan policemen. Some

created proper little police forces, with Metropolitan-style uniforms, while others were little more than local watch forces.

However, there were problems with adopting the Lighting and Watching Act, which prevented it being more widely used. The whole scheme was objectionable to some police reformers, some of whom found it too democratic. If the inspectors were appointed from ordinary farmers or tradesmen, their direction of the policemen might lack professionalism. They feared that penny-pinching ratepayers would ensure that forces were kept chronically understaffed.[45] Moreover, the Act included a provision permitting a parish which had adopted it to abandon it, on a ratepayers' vote, and wind up the force; this was anathema to reformers who were aiming at a permanently policed society. But the greatest problem with the Act was the practical difficulty of availing oneself of it in the first place. A two-thirds majority of the vestry in favour of adoption was required. This proved to be a real stumbling block for parishes and small towns. It was easy to get the required signatures of three respectable local people – often gentlemen, justices or clergy – calling a ratepayers' meeting to consider adopting the Act; but it was very difficult to persuade a two-thirds majority of those who attended to vote for adoption. Local ratepayers – especially the small ratepayers who wanted to avoid the extra expense on their rates – could easily block such moves.[46]

The ratepayers, mainly farmers and tradesmen, resented paying extra rates for policing services, which they did not feel that they needed. This frequently led them into conflict with local gentlemen, JPs and clergy who were keen to raise money to set up a regular paid police. Thomas Marriott, a Worcestershire JP and chairman of the Pershore Board of Guardians, complained that, although the local Petty Sessions had repeatedly recommended adoption of the Act, the ratepayers objected to the expense which it would involve and refused to do so.[47] The Vicar of Tenbury (Worcs.) recorded that he 'and others, I think I may say the most intelligent and respectable parishioners' tried to get their parish to adopt the Act, but 'were outvoted at the meeting, and could not carry watching'. They then decided, together with two or three other adjoining parishes, to establish 'a voluntary subscription for the support of police constables'.[48] In 1838, R. Denison, a country gentleman from Pocklington in East Yorkshire, wrote to the Constabulary Force Commission to ask how they could form a local police. Redgrave, the Commission secretary, replied that:

> a Local Police is frequently formed under the provisions of the Act of the 3 & 4 Wm. 4 c. 90. This Act gives power to make a rate (Sec. 9) and to employ Constables (Sec. 39). But its machinery will be found too complicated to render its adoption advisable for the payment of a single officer. I am not aware of any other means of paying his weekly wages, except by a Voluntary subscription, which is the means most frequently resorted to in such cases.[49]

Provincial gentlemen, frustrated by the ease with which adoption of the Lighting and Watching Act could be blocked, often turned to the voluntary subscription force instead. By 1836, the voluntary subscription force, firmly

under the control of a small group of local gentlemen and clergy, was a widely used alternative.

(c) Voluntary subscription forces

The opportunity for local property owners to come together in some form of association in order to assist themselves with protection of their property, and catching and prosecuting offenders against themselves, was always available under English law; since the 1780s, many parts of the country had seen the formation of Associations for the Prosecution of Felons.[50] Some of these Associations had set up their own private police forces, paid for by the subscriptions of members; the most famous such Association police force was that of the Barnet General Association, in Hertfordshire (see below). But it was also open to people *not* grouped in formal Associations for Prosecution, to subscribe money to establish local paid police; and the Constabulary Force Commission evidence shows that this practice had been widely adopted by the end of the 1830s (see Appendix B).

These subscription forces had the disadvantage of placing the full financial burden of paying for a police on the subscribers' group, rather than all the ratepayers of the parish or county. But their wide popularity suggests that they offered certain advantages for the gentlemen and property owners who set them up. For one thing, as is suggested above by the Vicar of Tenbury, they offered a way of bypassing the local farmers and tradesmen who could block adoption of the Lighting and Watching Act. A subscription force could be easily set up if a few local gentlemen took the lead and were able to induce sufficient local property owners to join them. Control of such forces was vested in the hands of local JPs, clergymen and other notable local figures. Those who were suspicious of a professional police force in the hands of central government, of paid bureaucrats or even of the county Quarter Sessions – and who mounted strong rhetorical attacks against such a possibility – could happily accept the use of a few paid police under their own local control.[51] Like the parishes which adopted the Lighting and Watching Act, groups who set up subscription police in the 1830s were particularly keen to make use of the abilities of men trained in the Metropolitan force, and often appointed London officers to act as their paid policemen.

Charles Crawley, a Gloucestershire magistrate, attempted in 1834 to create a voluntary 'police association' in the Forest of Dean. His printed prospectus for the 'Westbury Association for the Protection of Life and Property and for the More Effectual Preventing of Misdemeanours'[52] provides excellent insight into the thinking and the intentions of the gentlemen who organized these schemes. It was aimed at the repression of petty crime, poaching and assaults, and would focus its attention on the problems of beershops, drunkenness and vagrancy. To avoid any confusion with an Association for the Prosecution of Felons, Crawley emphasized that the Westbury Association would offer no rewards, nor pay

for any prosecutions; instead it would be a 'police association'. He proposed to hire two Metropolitan policemen, who would be sworn in as special constables, armed with pistols and cutlasses, and used to supervise the parish constables. Members would pay an annual subscription, as with the Associations for the Prosecution of Felons.

Crawley's proposed 'police association' in the Forest division of Gloucestershire failed, but in the Cotswolds, the Stow-on-the-Wold Police Association became a great success, inspiring many imitators in Gloucestershire and adjoining parts of Oxfordshire, Warwickshire and Worcestershire.[53] The Association was established for Stow and its adjacent villages in May 1834, following 'an outrageous Murder and Robbery, committed in the outskirts of the Town of Stow'.[54] The local magistrates – the Revd F. E. Witts, the Revd C. Jeaffreson, and C. Pole – organized the local gentry, farmers and tradesmen into a voluntary Police Association, in which each paid an annual subscription calculated according to his assessment for the Poor Rate. Two Metropolitan Police constables were hired as local policemen – James Otway as senior officer at £80 a year,[55] and George Millington as subordinate officer at a guinea a week; Millington, in 1836, went to be senior officer for the neighbouring Moreton-in-Marsh Police Association, and was replaced by William Bennett. The Association was run by a committee of the three magistrates, who directly controlled the activities of the policemen.

The two paid policemen were equipped with pistols, cutlasses and lanterns, and were given responsibility for policing an area centred on Stow, with a radius of about 3 miles in each direction. They were told to concentrate on patrolling the area at night, exercising surveillance over suspicious characters, and inspecting regularly the public houses, beer-shops, and lodging houses used by vagrants. They also took responsibility for prosecuting the offenders – gathering evidence, organizing witnesses, presenting the case in court – they had arrested. The results, according to the magistrates, were quickly impressive, with a reduction in the number of normal rural offences – sheep and poultry stealing, barn breaking, house breaking, robberies – and a decline in drunkenness and disorderly behaviour.

The policemen used the new bureaucratic methods of the Metropolitan force rather than the practices of the old rural constables; the subordinate officer reported to the senior officer who, in turn, answered to the committee of magistrates. They kept records of all their cases and made an annual report of the outcome of all criminal prosecutions in which they had been involved. In prosecutions at Quarter Sessions and Assizes between June 1834 and October 1836, they claimed the credit for: one execution (of the man who committed the murder which had led to the Association being set up) and one recorded death sentence; sentences of transportation, for life (one), fourteen years (four) and seven years (three); and twelve sentences of imprisonment.[56] The success of the Stow Association in the period 1834–6 sparked the establishment of similar Police Associations

(subscriptions to pay trained policemen) based in the surrounding Cotswold towns of Bourton-on-the-Water, Moreton-in-Marsh, Chipping Norton, Northleach, Blockley and Andoversford.[57]

In 1836, the magistrates in charge of the police expressed to the Constabulary Force Commission their total lack of confidence in the old parish constables and their complete satisfaction, by contrast, with their paid police. But they were anxiously aware of the difficulty of sustaining, for any length of time, a police based on voluntary subscriptions; the initial murder had scared many people into joining the Association, but it was difficult to keep them paying their money once the murderer had been caught and the scare was over. The magistrates reported this weakness to the Constabulary Force Commission, and asked them for 'some legislative enactment by which our arrangements or others analogous to them may be rendered permanent, by being made to depend on funds derived from a rateable assessment on property chargeable to the poor-rates'.[58] They suggested that the new Poor Law Unions would make a good basis for rural police districts (each district to have six to seven paid and trained police under a chief constable), but that such forces should be supervised, not by the Poor Law Board of Guardians, but by 'the Acting magistrates of the District'.[59]

The magistrates' sense of the impermanence and vulnerability of a force based on voluntary subscriptions was accentuated by the fact that their Association did not enjoy unanimous support throughout its area. In 1835, a prominent local figure, Mr Ackerley, led a campaign against the Association; he gathered signatures on a petition arguing that a paid police was unnecessary and represented a threat to local civil liberties, and that the two policemen employed had been discharged from the Metropolitan Police for misconduct. Ackerley published his arguments in the local press, and got them taken up by Radical newspapers such as the *True Sun* and *Cobbett's Political Register;* he even brought them to the attention of the Home Office and Prime Minister. But his supporters were men of less wealth and local influence than the propertied subscribers to the Association – Witts described the signatories to his petitions as consisting 'of the very refuse of society in the place ... of idle, drunken, labourers; of the connections of women on the town; of the occupiers of beer shops and hush houses at the fairs ... of chimney sweepers, poachers, convicted pilferers, and their relations and friends'. Witts and his fellow magistrate Pole organized a 'respectable' approach to the government to counter Ackerley's charges, and rallied their subscribers to continue to support the Association.[60] In 1838, the Association had a more serious scare when disgruntled subscribers charged that the senior policeman Otway neglected his duties and was given to drunkenness. To get value for their money, they demanded his sacking and the employment of new policemen. Witts confided despondently to his diary that this showed the weakness of a voluntary subscription force:

> I am persuaded that the feeling against him [Otway] originates in personal
> motives, and is very much owing to his equal discharge of his duties, especially
> to his not having shrunk from his duty, when he was brought into collision with
> offending parties more or less connected with influential subscribers. There
> may also be a wish to render the control over the Officers more general among
> the subscribers; to supersede the private committee of management of which
> Mr. Pole, myself and Jeaffreson are now, as from the beginning, the only
> members ... It is obvious that from dissatisfied subscribers money cannot be
> got, and so the association will fall to pieces ...

Witts succeeded in carrying his point through a difficult meeting of the
Association, and retaining Otway's services; but it confirmed his view of the
inherent weakness of a voluntary subscription force:

> But it is manifest that a voluntary police force rests upon a weak basis, that many
> are tired of the subscriptions, few understand the system or see it in its right light,
> that there is a petty jealousy afloat, and that subscribers whose connections are in
> any way interfered with by the Police, when acting in the discharge of their duty,
> with impartiality, are sure to take umbrage & consider themselves ill-used.[61]

When the Gloucestershire Quarter Sessions, in 1839, discussed the
possibility of establishing a police force for the whole county, supported by
a county rate, Witts was a strong supporter and prime mover at Quarter
Sessions, seeing it as a logical development from the Stow Police
Association force.[62]

The best-known subscription police was that run by the Barnet General
Association for the Protection of Property in Barnet (Herts.) on the
northern edge of London.[63] They started, in the 1820s, with a force of two
paid policemen; by 1836, this had become six paid men – a superintendent
and five 'Patrols'. They regularly patrolled the roads and a large rural area
covering 90 square miles around Barnet, and kept a watchful eye on the
local beershops and 'bad characters'. In addition to patrolling preventively,
and catching offenders, the police assisted members of the Association to
prosecute offences against themselves; the superintendent, Isaac Pye,
organized witnesses and presented evidence for local prosecutions. The
Association published annual reports, which stressed their achievements in
preventing crime and catching thieves, and the good value for money which
they offered to their subscribers. Their secretary, Thomas Dimsdale,
trumpeted the success of the Association in the evidence which he gave to
the Select Committee on the Police of the Metropolis (1828), the
Commission on County Rates (1836) and the Constabulary Force
Commission (1836–9). Edwin Chadwick, in the Constabulary Force
Commission Report, used the Barnet Association to illustrate his more
general argument about the need for a regular, paid, trained, rural police
force. Dimsdale, in his evidence, expressed the modern police assumption
that a trained policeman, who 'knows' criminals and their ways, should be
allowed to bend the law to catch offenders and should not be constrained
by concerns about invasion of civil liberties. He became a correspondent
of Chadwick and a supporter of a national system of police; when

Hertfordshire adopted the County Police Act in 1841, Dimsdale acted as a consultant in its organization.[64]

By the mid-1830s, there were subscription schemes operating in a large number of English counties, with the areas of heaviest concentration being Gloucestershire, Hampshire, Hertfordshire, Norfolk[65] and Suffolk, and towns and parishes on the fringes of the Metropolitan Police district. It was easier to establish a voluntary subscription force than to satisfy the formalities of adopting the Lighting and Watching Act; but they had clear drawbacks as well. If local enthusiasm waned after the initial period, subscriptions became harder to collect, and the scheme could collapse financially. If the local farmers and tradesmen refused to subscribe – which was usually the case – the entire expense would fall on the local gentry and clergy. 'In a parish such as ours', wrote a clerical magistrate from Watford, 'a police will never be supported by a voluntary subscription. Many tradesmen dare not and many will not subscribe, and farmers never do anything to assist Tradesmen to protect their property – they say the land is sufficiently burdened with Rates and Taxes ...'[66] Many of the gentry sponsors intended their little police schemes to be demonstration models which would convince parsimonious tradesmen and farmers of the value of better policing and of creating something more permanent; the refusal of the latter to pay their share tended to undermine the schemes.

(d) Poor-Rate police forces

One expedient tried in many areas of the country by parishes and new Poor Law Unions was the use of local Poor Rates to pay for a local police.[67] It is not surprising that the grouping of parishes into larger Unions to offer a larger revenue base for poor relief should have suggested to some local élites that the Poor Law Union could be turned into a new, efficient, all-purpose unit of local government – and that they were ideally suited to the management and control of a rural police.[68] No less a figure than the Duke of Richmond came to this conclusion, and devised plans for police forces based on Poor Law Unions.[69] This was, by no means, the most popular view among gentlemen. Many would indeed see the new Poor Law Union as the proper, future, basic *geographical* unit of policing – as opposed to the parish, the petty sessional division, hundred, or county – but did not think that the *administration* of the police should be confided to the Poor Law authorities.

Forces based on Poor Law Unions became briefly a popular expedient in East Anglia, particularly after riots against the New Poor Law in Suffolk. The Blofield (Norfolk) force began in 1836 as a Poor Law police scheme. The guardians recruited a London policeman, who was paid by voluntary subscription, no doubt because of the illegality of payment from the rates by that time. As we observed above, this scheme was superseded in 1838 by adoption of the Lighting and Watching Act. J. P. Kay, Poor Law assistant commissioner, sent the Poor Law Commission a plan for a national police system, modelled and based on the Poor Law system.[70] Union police

schemes were set up for the Poor Law Unions of Swaffham (Norfolk), Barham and Hoxne (Suffolk), and Goddington (Beds.). We saw in Chapter 3 that in March 1836 the Poor Law Commission proclaimed illegal the use of Poor Rates for criminal justice purposes, and this permanently cut off the possibility that England might develop a system of rural police based on the Poor Law machinery.[71]

The returns made to the Constabulary Force Commission record the disbandment or conversion to other auspices of the forces for the Poor Law Unions of Swaffham, Barham and Hoxne, and Goddington. Similarly, the JPs of the Rugby (Warks.) division stated that they had paid an assistant to the constable in each parish, from the Poor Rate, but had had to desist after the Union auditor intervened; Huddersfield (West Riding) recorded that they had paid a deputy £100 per annum, from the Poor Rates, until a year or two before, 'but it was then declared illegal and discontinued'; they then converted to a Lighting and Watching Act force.[72]

But what is surprising is that local Poor Rates were *still*, at the end of 1836, being used for this purpose, despite the clear ruling. Huddersfield might have stopped paying their deputy from the Poor Rates, but two other West Riding towns, Wakefield and Bradford, both recorded that they were still paying police officers, using their local Poor Rates; the magistrates for the Wakefield district added to their return a strong recommendation of 'the propriety of providing for the *legal* payment of Police Officers' – suggesting that they were well aware that their current use of the Poor Rates for that purpose was illegal.[73] In the Whitby Strand division (North Riding) stipends were still being paid to constables from the Poor Rates. Similarly, two Lancashire districts, Chorley and Kirkdale, admitted paying for constables from their Poor Rates, Kirkdale adding that 'the appointment and payment require to be legalised'; while Tring (Herts.) continued to resort to the rates to support two policemen.[74] A number of Lancashire towns were listed as paying police officers, while being rather coy about the exact source of the funds; Ormskirk stated that their deputy constable was 'paid out of a peculiar Fund'; and the JPs for the township of Garston recorded that they did not know from what fund it paid its constable. Others listed police or watchmen paid 'by the public' (Blackburn, Lancs.), by a vestry-authorized rate (Over Darwen, Lancs.), 'from the Town' (Barnsley, West Riding), or from property owned by the town for public purposes (Melton Mowbray, Leics.),[75] which may conceal a use of the Poor Rates for this purpose.[76]

We have attempted to indicate the extent of the formation of local Act, Lighting and Watching Act and voluntary subscription police schemes for the period 1836–9 in Appendix B (Table B:1 on p. 237). This table does not pretend to be exhaustive; it is admittedly sketchy for Lancashire and the West Riding, where the situation was quite bewildering. The main purpose here is to display for the reader the general scope and variety of the schemes. There were certainly more[77] – possibly many more – of which we are unaware waiting to be uncovered by diligent local research.

The number of paid policing schemes that spread through provincial England in the 1830s – using local Acts, the Lighting and Watching Act, the Poor Rates or voluntary subscription – was astonishing. Most of them owed nothing to direct Benthamite inspiration or government fiat. By 1832, both Whig and Tory governments had concluded that a major overhaul of the rural police was necessary. During the 1830s, many landed gentlemen and county JPs came to accept the need to supplement or replace the parish constables with some form of paid police. Just as many country gentlemen accepted with little difficulty the New Poor Law of 1834,[78] which involved a rejection of the old paternalist ethos, a somewhat similar development took place on the issue of police reform. When Lord John Russell, in 1836, set up a Royal Commission to reform county policing, it was deluged by correspondence from country gentlemen and active rural clergymen, proffering accounts of what policing schemes they had set on foot in their localities and offering to the commissioners their own plans for general police reform.[79]

Other county initiatives: Durham, Shropshire and Lancashire

During the 1830s, Quarter Sessions in counties other than Cheshire also contemplated taking action to reform and improve their policing arrangements – particularly once it became clear that the Grey government's proposed national police bill of 1832 was not going to be introduced. But Cheshire was the only county to go so far as to obtain a private Act for a county-run police; the other counties' efforts remained at the level of plans or small local initiatives. There may be some other schemes, hidden in the records of the Quarter Sessions of some counties, of which we are not aware; but we discuss here some of the county initiatives, other than Cheshire's, which achieved a degree of national prominence and had some influence on the national legislation of 1839. These cases suggest that, in many counties, there were local men of influence – aristocrats, gentry, sometimes coal owners or manufacturers, active JPs – who were thinking seriously, during the 1830s, about the need to reform policing arrangements in their counties, and how to do this under their own powers and control.

All counties with substantial coalfields saw the colliers as constituting a particular public order problem by the 1830s. They shared with industrial workers a tendency to live in large, dense communities, and could make their large numbers felt when they went on strike, assembled in protest or rioted. Unlike industrial workers, however, miners were normally found, not in large towns or cities, but in groups of smaller mining towns or villages. So, whereas some of the threat from urban and industrial workers could be dealt with by towns with municipal government, borough magistrates and town police forces, the miners were the responsibility of the county JPs and Quarter Sessions. Staffordshire suffered particularly from this problem, with large mining and industrial populations to be

found in the towns and villages of the Potteries in the north of the county, and the Black Country in the south, each containing very few large corporate towns. In 1839, the county obtained private Acts of Parliament to appoint both a police force and a stipendiary magistrate for the Potteries; in 1842, their Quarter Sessions was jolted into adopting the County Police Act largely as a result of strikes and riots by the miners of the Potteries and Black Country.[80] This issue arose similarly, in the 1830s and 1840s, in other counties like Durham, Northumberland, Lancashire and the West Riding of Yorkshire, and contributed substantially to the debate over county policing in those counties. It could also arise in Midlands industrial counties like Leicestershire and Nottinghamshire, where much of the industrial activity was in manufacturing villages rather than towns; the deputy chairman of Leicestershire Quarter Sessions, in advocating adoption of the County Police Act in 1839, quoted what he had written in 1828: 'that manufacturing villages had acquired all the vices, without the means of prevention by police, &c. of large towns'.[81] Lord John Russell, in introducing the County Police Bill in July 1839, stressed that corporate towns with municipal governments could appoint their own regular police forces which could deal with serious disturbances. He then continued:

> But there are many districts, at present, which have grown so populous, which have become so thickly peopled with a manufacturing or mining population, that they do partake of the character or nature of a town population, while at the same time it is impossible to confer upon them municipal institutions. But, while this is the case – while you cannot confer upon them such institutions as these – still they do require the institution of a police force, and a more efficient administration of the power of the constabulary.[82]

In April 1832, the magistrates of Durham and Northumberland began to think seriously about the need for some sort of regular police to deal with their miners. In a long strike on the Durham-Northumberland coalfield in 1831, the colliers' trade union led by Tommy Hepburn had managed to extract significant concessions, on wages and conditions, from the cartel of major coal owners who controlled wages and prices in the coalfield.[83] Those owners were also the county magistrates for Durham and the coalfield area of Northumberland,[84] and their most notable members were Lord Durham (Whig cabinet minister and son-in-law of the Prime Minister Lord Grey) and the Marquess of Londonderry, a powerful Tory aristocrat. They organized a counter-attack on the union and its power in 1832. When the annual bonds of employment of the miners came up for renewal in April 1832, they refused to renew the bonds of union men. In May, the owners began a full lockout of the union men, declaring that they would only hire those who would swear an oath that they did not belong to a union. The owners asked for greater government protection for their struggle, and General Bouverie, in command of the Northern District, increased the detachments of cavalry and infantry in the Newcastle and Durham area. The owners then escalated the conflict, bringing in blackleg labour and evicting union pitmen and their families from company-owned

housing. Hepburn stressed the importance of the miners acting peacefully and legally, but the lockout ensured a level of violence, especially as pitmen resisted the evictions. Some union men attacked blacklegs, constables and policemen; in June 1832, two miners knocked an 80-year-old magistrate off his horse and beat him, from which he subsequently died, and a group of pitmen killed a colliery watchman. The lockout dragged on for several months, with Bouverie predicting that the union would only be beaten by 'the starvation of the Pitmen';[85] but by mid-August, it was clear that the owners were winning and the union had begun to fall apart. By October, the lockout was over, with the owners having won a decisive victory.

The owners had prepared carefully for the lockout, taking out a large bank loan to pay for the hire of blacklegs, and ensuring a large presence of military and special constables to back up their authority.[86] Before the lockout started, they asked the government about the possibility of a special police force to cover the northeastern coalfield. They were in a strong position to get their request heard. Apart from Durham's political influence, they could call directly on Grey himself – a Northumberland landowner and former MP for that county, whose son Lord Howick had succeeded to that seat – who had important political contacts with influential members of the coal trade in Newcastle. In March 1832, Grey asked Home Secretary Melbourne to consider a special measure to cover the northeastern coalfield. Melbourne responded cautiously, suggesting that it would be better to proceed with his plans for a general national police bill, but he approved sending men from the Metropolitan force to help organize a police for the colliery district. He also approved the issue of firearms and cutlasses to the local police and special constables in the area.[87]

In June 1832, as the violence increased, the magistrates of Durham and Northumberland resolved to establish 'an effectual Police for the Collieries'. Wearing their other hats as coal owners, they petitioned Parliament to ask the government to provide such a police. Melbourne had by this time dropped his plans for a national police; he said that the government would approve a force for the colliery district if the coal owners or ratepayers of Durham and Northumberland would pay for it, but there would be no government funding for it. In July, the coal owner-JPs resolved to pay for such a force by imposing a tax on coals exported from the Tyne and Wear; but Melbourne stated firmly that Parliament, having recently removed such duties, would not reimpose them just for the benefit of the Tyneside and Wearside collieries.[88] By the start of August, Melbourne was admitting that there was no chance of Parliament passing a general police measure that session, and was advising local authorities to use the Lighting and Watching Act of 1830 or the Special Constables Act of 1831, to provide themselves with police protection.[89] For the next few months, Melbourne and Grey continued to discuss seriously the possibility of setting up a police force for the northeastern coalfield; but without resolving the problem of how it was to be paid for. Grey tried to get the

Quarter Sessions of the two counties to take up the measure – but without any tangible result; by September, their public-order crisis was over, with the collapse of the pitmen's union, and the coal owner-magistrates had, for the moment, lost their interest in taxing themselves to provide a police. As Melbourne wrote to Howick in November: 'I suppose they [the coal owners] will not now require so large a force, as they might have done, if the measure had been [enacted?] in July last. The circumstances are not so urgent nor the [claim?] so great.'[90]

When the County Police Act was passed in 1839, the magistrates of Durham – a small county dominated by the coalfield – moved immediately, and with virtually no opposition, to adopt it.[91] On the other hand, in Northumberland – a large, predominantly rural county with its mining and industry concentrated in its southeastern corner – there was strong opposition to the whole county paying for a police which was seen as largely required for the Tyneside area only. An initial decision to set up a small force for two divisions of the county only, was quickly followed by the Quarter Sessions deciding to set up no county force at all – a decision to which they then adhered until 1856.[92]

Shropshire had the longest record of discussions about county policing in England, and, in a sense, its magistrates appear to be the true authors of the County Police Acts 1839-40. These discussions at Quarter Sessions dated to 1831-2, and were initially the product of magistrates' fears about public order – particularly to do with the colliers of Shropshire and its neighbouring counties. Over a period of two weeks between December 1830 and January 1831, large bands of striking coal miners from Denbighshire and Flintshire tried to enter Shropshire to bring out the collieries near Oswestry. The local JPs called in some regular troops, mobilized the county Yeomanry, and swore in special constables and Enrolled Pensioners. They confronted the colliers at Chirk Bridge, on the county's northwestern border, and prevented them entering the county. Eventually, the Riot Act was read; three of the miners were arrested and placed in Shrewsbury Gaol. This produced a panic two days later, with a rumour that the armed colliers were coming to rescue their imprisoned colleagues; once again, the Yeomanry, Militia, special constables and Pensioners were assembled, but no such attack eventuated. Shropshire Quarter Sessions had already expressed its concern, the previous year, about being invaded by unemployed 'large bodies of men begging' (a common way for miners to support themselves during strikes) from Denbighshire. This latest episode led Quarter Sessions, in January 1831, to resolve 'that the formation of a Constabulary Force throughout the County ... with a view to the preservation of the Peace and security of property should be adopted, and that this Court strongly recommends the Magistates ... to take immediate steps with a view to its organization.'[93]

Unlike Cheshire, Shropshire in early 1830s never sought a private Act of Parliament to authorize such a force, although by the end of the decade it would take the lead in formulating a plan of county policing, petitioning

Parliament on behalf of it, and seeking legislation that would enable all counties to avail themselves of it. Legislation was essential. Without it, it was questionable whether Quarter Sessions could legally resort to the County or Poor Rates for such a purpose.[94] Without a statute any county scheme might have been vulnerable to a successful legal challenge by the ratepayers.

Shropshire's 1831 initiative was allowed to lapse; but exactly a year later the justices faced a similar situation – this time on their eastern border with Staffordshire and Worcestershire. On this occasion, the Staffordshire colliers went on strike, to be followed by the colliers of Wellington in Shropshire. Once again, the Shropshire JPs mobilized their forces to confront the strikers and arrest some of them for riot and inducing others to leave their work. And, once again, it led Quarter Sessions, in January 1832, to resolve unanimously 'that it would be highly desirable to have a Police Force established in every parish throughout this County', and that the Lord Lieutenant should take the necessary steps to establish such a force and communicate with the Home Secretary (then Lord Melbourne) on the subject.[95] Melbourne, as we know, was then contemplating what became, in March 1832, a draft bill for a national police system; but he does not seem to have made any specific response to this Shropshire initiative. In his 'Observations' on that draft bill in May 1832, he refers specifically to the Cheshire experiment, but makes no mention of Shropshire's problems and requests.[96] In any event, this initiative also lapsed, and Shropshire Quarter Sessions took no further action on county police reform for the next five years.

Shropshire Quarter Sessions resumed its discussions of a paid county police in October 1837 when Sir Baldwin Leighton moved a committee to study the issue.[97] Leighton was a police reformer in his own district, experimenting with the appointment of a paid, professional policeman for his hundred of Ford; and he argued that this had been spectacularly successful in reducing crime.[98] Leighton had written to Edwin Chadwick at the Constabulary Force Commission, to ask his advice on the subject. He proposed a motion for a force not very different from the Cheshire one – one special [i.e. paid] constable to be appointed for each hundred of the county, reporting to one superior officer for the whole county, who could move them around as required; a committee of Quarter Sessions was to have the overall supervision of the force. Leighton's main arguments for his motion concerned themselves with the inefficiency of the existing constables and the problem of 'roving thieves' in the countryside. In this, he took a very similar line to the one Chadwick was to emphasize in his Constabulary Force Commission Report.[99] Chadwick, who optimistically thought that his report might be out by the end of that year (in fact, it took another sixteen months to appear), offered no specific advice about what Shropshire should do in the meantime.[100]

Why did the Shropshire élite come round so decisively in favour of a police force paid for from public funds, during the 1830s? There is no

doubt that public order issues played a part – a fear of turbulent miners at the start of the decade, and of riotous Chartists at the end. But there were other factors as well. JPs used versions of the argument about bands of migratory thieves plundering the unprotected countryside, and stressed the vulnerability of their position, as a Midlands county, with some industry and mining, bordering on similar English and Welsh counties on all sides, and containing some major roads. Leighton talked about 'roving thieves' in the Shropshire countryside being inadequately contained by the untrained, annually-rotating constables. R. A. Slaney favoured reform of both Poor Laws and police to protect property and general safety. In Quarter Sessions debate, he stressed that: 'The position also of Shropshire, almost on the direct line from Birmingham to Liverpool and Manchester (in which towns, with London, the most practised thieves were reared) exposed the inhabitants to greater injuries from these characters than in more remote districts ...'

He argued that, although a paid preventive county police would be expensive, it would be cheaper in the long run, and would benefit both ratepayers and, especially, the poor (who had no voice at all in these debates, except via self-proclaimed 'friends' of theirs such as Slaney). Another justice thought that a county police would 'put an end to the greatest of all possible nuisances, the Beer Shops'.[101] Chadwick approvingly told Leighton that, by a proper police force, 'crime may be prevented as extensively as I am informed by Lord Liverpool you have succeeded (by the firm application of sound principles) in suppressing pauperism to the great advantage of the labouring classes and the ratepayers'.[102]

Shropshire Quarter Sessions sent letters via the Clerk of the Peace to other counties inquiring about their arrangements for appointing salaried officers,[103] and opened a correspondence with the Home Secretary regarding the legality of a county creating its own force.[104] When Russell replied that legislation was imperative, Shropshire Quarter Sessions sent a petition to Parliament via R. H. Clive and the Lord Lieutenant (for the Lords). The 1838 petition is worth quoting, as it contains the precise scheme for the crucial legislation of 1839, which became the framework for English provincial policing (outside the boroughs) into the twentieth century. It was this that Russell and the government would take on board, shortcircuiting, as we shall later observe, the Royal Commission on Constabulary that he [Russell] had created.[105] The petition, dated 2 January 1838, stated:

> ... the Rural Police is at present totally inefficient for the prevention of crime, and ... the detection of it, as the former most important duty is not even attempted, and the latter is ... performed [in Shropshire] by ... office Constables attached to each Petty Sessions ... The passing of an Act to enable the Court of Quarter Sessions to appoint and pay out of the County Rate a body of Constables subject ... to the authority of the Magistrates but placed under the ... superintendence of a Chief Officer responsible to them for the arrangement and disposition of the Force ... within the Shire would confer a most important

benefit on Rural Districts inasmuch as such an Establishment would effectively provide for the prevention as well as detection of Offences; for the security of Person and property and for the ... preservation of the Public Peace.[106]

At the final meeting of the year in December 1838, Quarter Sessions voted the 'Salop Resolution' directed to the Home Secretary and the chairmen of all other Quarter Sessions. The 'Salop Resolution' restated the Shropshire plan and called for the formation of county police forces. Lancashire immediately responded favourably, with a unanimous endorsement,[107] and Russell, clearly attempting to orchestrate a nationwide show of interest on the part of the landed élite, then circulated the resolutions to the Quarter Sessions of every other county and asked for an official response. By April 1839, the chairman of Shropshire Quarter Sessions reported that he had received nineteen county responses, none unfavourable; and Russell also reported a largely favourable response.[108]

There were many reasons why both central government and county Quarter Sessions should be thinking seriously about the need for reform of provincial policing in early 1839. The most obvious and pressing one was concern about the threat of the Chartist movement, particularly in the industrial counties of the North and Midlands. This undoubtedly imparted a sense of crisis to the actions of national and county authorities, and helped the passage of a number of police Acts in 1839. But it would be wrong to attribute the police reforms of 1839 solely to Chartism and the threat of disorder it posed. English governments and elements of the landed class had been thinking about restructuring the provincial constabulary for nearly a decade by that time. The Constabulary Force Commission had been set up in October 1836 - well *before* Chartism assumed any serious dimensions as a movement. Cheshire, Shropshire, Durham and individual landed gentlemen in many other counties - through their discussions at Quarter Sessions and the numerous local experiments they presided over - were attending to this question at least since Wellington went out of office and the Whigs first came to power in 1830.

We should note that during the 1830s, the Shropshire gentry showed no sentimental attachment to the old policing agencies, any more than they did to those of the Old Poor Law. The government realized in 1839 that making such provincial policing initiatives their own was the route that it had been seeking. No rural police reform measure was going to be anything but controversial, but the chances of success would be maximized if a measure could be crafted largely to the specifications of the provincial ruling class.[109]

There was still, as we shall see, a substantial reservoir of provincial opinion opposed to national legislation for reform of the policing of the counties. In the debates which followed the passage of the County Police Act 1839, some JPs invoked the old rhetoric of constitutionalist and libertarian rejection of the very idea of a professional police; but the wide establishment of small local paid policing agencies during the 1830s suggests that many country gentlemen no longer objected to the *principle* of

a paid police – as long as the force, and the methods of payment for it, remained under some form of local control. Much of the debate would then shift to the questions: who should pay for the new police? how should they be paid for? and who should control them?

ANATOMY OF AN EARLY VICTORIAN ROYAL COMMISSION: THE CONSTABULARY FORCE COMMISSION, 1836–9

It has long been felt that the protection afforded by the rural constable was merely nominal; an unpaid officer, with private affairs of his own, changed annually, connected with the inhabitants, under no regulations, or regular superintendence, was not likely to be very efficient and was generally very ignorant of his duties. To those who like Pole and myself have had the direction of a rural police the proceedings of this Commission are very interesting, & from the selection of members of the Board it may be anticipated that something like our scheme will be adopted as a general institution. (Diary of the Revd F. Witts, JP, 14 November 1836, on receipt of the questionnaire sent to magistrates in Petty Sessions by the Constabulary Force Commission.)

You could not aim a more offensive blow to the factitious importance of our magisterial country gentlemen than by this reform of their police, unless you were to offer a provision by statute for the extermination of the game. You must expect to have all their aristocratic influence enlisted against you, and with effect, till popular conviction comes to your aid; and this can hardly be reckoned on till the Report has had time *to work*; when it has, I cannot doubt for an instant of the successful issue. (Sir George Stephen to Chadwick, 20 April 1839, Chadwick Papers, Item 1883, emphasis in original.)

Lord John Russell, Edwin Chadwick and the formation of the Constabulary Force Commission

At the end of August 1836, the Home Secretary, Lord John Russell, received a long letter from Edwin Chadwick stating that the Poor Law Commission had received 'repeated communications ... as to the inefficiency of the local Police for any of its purposes and the frequent expressions of expectation that something will be done to remedy the existing want of System'. This had produced pressure on the government to act quickly to remedy this situation. Chadwick warned that there would obviously be political dangers for the government in such a move:

The cry of Gendarmerie and of attacks upon the liberties of Englishmen will be raised in the village by every jobbing constable or Magistrates clerk; by every

Brewer for Beer Shops; by the Cobbettite Politicians and the press which has not yet ceased to assail the Metropolitan Police as being French and an instrument of despotism.

The safest way to avoid this, said Chadwick, was to appoint a Royal Commission, as had been done with the Poor Law, to be headed by himself.[1] Russell replied, strongly approving the idea of a Commission to investigate 'the rural police', and began to make arrangements to set up the Commission.[2]

The Royal Commission of 1836–9 did not come out of the blue; it must be viewed as another step in a series of actions taken by the Whigs since they came to power in 1830.[3] By the summer of 1836, the groundwork was being prepared for a policing measure. Russell had been receiving pressure from some MPs and country gentlemen. In May 1836, Sir Oswald Mosley demanded to know when a government bill would be forthcoming. In June, the County Rates Commission issued a strong recommendation for a preventive rural police along with a radical prescription for the reform of county government.[4] Home Office correspondence in July and August strongly suggests that Russell had decided to bring the issue forward on the agenda.[5] At the same time, meetings were taking place between Chadwick and the Metropolitan Police Commissioners regarding some 'plan which ... has been under discussion,' presumably between the commissioners and the Home Secretary. Chadwick reported to Russell that there was 'no material difference between myself and the Commissioners ... as to the principles of a measure'.[6]

The Royal Commission on a Constabulary Force was the third one in four years to address the matter of rural police reform. One of the instructions given to each assistant commissioner working on the large Royal Commission into the Poor Laws, between 1832 and 1834, was to 'inquire in each parish into the ordinary and extraordinary means which it possesses of enforcing public order ... And he will collect facts and opinions as to the propriety of any, and what, legislative measures on this subject [seem appropriate]'.[7] Appendix A of the Report of the Poor Law Commissioners contained reports on this subject, from a number of the assistant commissioners;[8] and Chadwick collected and filed more of them, which he intended to produce to the Constabulary Force Commission. The Royal Commission on County Rates, 1834–6, also devoted a part of its two reports to this topic.[9] All three Royal Commissions had been launched by the Whig government in the period following the Reform Act; and all three sounded a common theme – the need for substantial police reforms beyond London and the boroughs. Following the pattern of the Poor Law Commission, the issuing of a Royal Commission was now taken very seriously, for it had come to imply 'an intention on the part of *government* to legislate.'[10] Thus the very willingness of Russell to issue a Royal Commission on the constabulary was itself a proof of the determination of the Whigs to produce a bill.

Royal Commissions have been described as 'symbolic rituals aiding in establishing and reproducing the power of modern states'.[11] Chadwick and Russell were certainly well aware of the practical uses of a commission of inquiry: to attempt to 'distance a contentious issue from party politics; and as a device to shape the opinions of "interested parties", rather than the undifferentiated mass usually conceived of in notions of "public opinion" '.[12] Or, as Chadwick himself put it at the time, describing what he had done with the Poor Law Commission and now proposed to do with the Constabulary enquiry:

> By sending circulars asking for opinions as well as for information to the petty Sessions as well as to Parishes a good proportion of the public were brought as it were to a council and enlisted in support of measures which appeared to be and in some degree were the results of their deliberations.[13]

The main task of the Constabulary Force Commission was to shape the opinions of the landed classes, who dominated the Parliament which would have to pass any provincial police legislation. As we have seen, a significant portion of the magistracy and gentry had already become convinced of the need to make changes in the rural constabulary. With little Benthamite urging or inspiration, they had created a plethora of local police experiments in the countryside by 1836. The Constabulary Force Commission was deluged with correspondence from reforming gentlemen all over England. Many of them reported on schemes already in place in their localities, or offered the Commission their own plans for police reform.[14]

By the mid-1830s, there was broad consensus among the national political leadership on the issue of policing reform. Under Peel, the Tories had been responsible for the introduction of the Metropolitan Police and a suggestion that there would be more extensive police reforms to come; under Grey and Melbourne, the Whigs had taken up the policing issue from 1831, and were responsible for the passage of the subsequent important policing legislation – the Municipal Corporations Act (1835); Acts to provide a government police for Birmingham, Manchester and Bolton (1839); the County Police Acts (1839 and 1840); and the County and Borough Police Act (1856).

Edwin Chadwick was the last man to hide his light under a bushel, and he claimed most of the credit for himself for the establishment of this Royal Commission and for the subsequent legislation establishing county police forces; historians have generally agreed in awarding him this credit, though his most recent biographer takes a much more sceptical view of his claims.[15] As we have seen, though, the topic which Chadwick was raising was one not entirely new to the Whig Government nor to Home Secretary Russell. Russell had been in correspondence with the Duke of Richmond on this matter since the end of 1835, and, by mid-1836, was under some pressure to legislate for national police reform. By the time he received Chadwick's letter at the end of August 1836, he seems to have already

decided that government action to reform the county police was necessary, but he was uncertain how to proceed. Since Russell was aware that the subject was tremendously complex and fraught with great political danger – and, in any event, the government had no fixed plan of its own at this juncture – he responded positively to Chadwick's suggestion that a Royal Commission be issued.

Chadwick's initial letter proposing the Commission stated that he was prepared to head it, unpaid, while still discharging his duties as Secretary to the Poor Law Commission. He would do this by working during his vacation and two hours a night after the Poor Law Commission closed; he claimed (in late August) to be able to have it finished by October 1836. He reassured Russell that, though it would be necessary, for appearance's sake, to appoint a few other people to the Commission, he envisaged himself doing all the serious work: 'I would offer to take the whole commission myself if it were not expedient to obtain the sanction of other names: and if there were any useful object to be gained by placing my own name prominently.' This letter also makes it clear that Chadwick had already worked out the main lines of enquiry of the proposed Commission, modelling it on the Poor Law Commission; detailed questionnaires were to be sent out asking about numerous aspects of crime, public order and policing:

> I would submit that ... the interference with the regime of every village throughout the Country could only be properly made upon a more mature and complete exposition of the measure than could properly be given by any other means than a report. There is also a sort of propriety in consulting many individuals and some of the larger classes concerned in such a measure. Independently of the useful information gained we have derived great advantage from this course in the change of the poor Law.[16]

He had also already worked out the main answers he expected the Report to provide. The emphasis was to be on preventive policing, with a stress on Chadwick's own obsession with the evils of 'casual poor or mendicants and vagrants', for the suppression of which a rural police was the essential complement to his New Poor Law. About a week later, Chadwick expanded on his views about what the Commission should ask and what he expected it to find out. He also suggested ways to overcome popular opposition to the idea of a new paid police:

> To popularise the old police or to render a new one less obnoxious it has appeared to me to be necessary to divest it as much as possible of the aspect of a merely penal agency and make it an agency for many useful sanatory and immediately beneficent purposes, the prevention of calamities as well as of crimes.[17]

Therefore, according to Chadwick, the police should have an omnibus mandate going well beyond the repression of crime. They were to have control of fire engines and the means of rescue in case of drownings and other calamities, handle lost and found goods, trace runaway parents and

lost children, alert farmers to strayed cattle and broken fences, and so forth.

The Constabulary Force Commission – its composition and workings

Russell accepted Chadwick's suggestion of a Royal Commission, and informed him that the Duke of Richmond had given him 'the outline of a plan' for a reformed police. This news alarmed Chadwick, who regarded Richmond as unsound on the Poor Law, and did not want to find himself implementing Richmond's – or, indeed, anyone else's – plan; thus he fought hard to try to prevent Richmond being appointed one of the three commissioners. Fortunately for him, Richmond, though invited, declined to serve.[18] As a second commissioner, Russell appointed Colonel Charles Rowan, one of the two commissioners of the Metropolitan Police. Chadwick was on good terms with Rowan and approved of this.

For the third commissioner, Chadwick tried to get a congenial Benthamite lawyer, such as Henry Bickersteth, recently appointed as Master of the Rolls and created Lord Langdale, but Russell insisted that 'The Commnr. wanted is a Country Gentleman, & not a Lawyer or Londoner'.[19] Russell was well aware that no reform of the rural police would be politically feasible without some support from country gentlemen. He harboured no illusions about the likely response of the largely Tory gentry towards Whig police legislation if it reeked too much of Benthamism, or if it were developed without some consultation with the county JPs who would be directly affected. Russell pushed hard for the third commissioner to be the Hampshire gentleman Charles Shaw Lefevre, a Whig MP and brother of one of the Poor Law Commissioners. Shaw Lefevre was well regarded by the Tories and had some credentials in this area, having been on the Royal Commission on County Rates which had strongly recommended a reformed rural police just a few months before. Shaw Lefevre was initially reluctant to serve, claiming that he was too busy in the country and in Parliament, but eventually yielded to pressure from Russell and Chadwick (who greatly preferred Shaw Lefevre to Richmond). He accepted the appointment[20] on condition that he would not be required frequently to attend meetings of the Commission in London.

The Duke of Richmond had a particular interest in policing and punishment issues and was consulted closely by Melbourne when the latter was drawing up the abortive 1832 police bill. When Russell arrived at the Home Office, the correspondence continued. In 1835 Richmond sent Russell the Poor Law plan of police, described in Chapter 4. In the spring of 1836 Russell again asked him for 'the form of a Bill you would recommend' for a rural police. Richmond replied that he favoured a compulsory measure and forwarded what he called a 'rough sketch'.[21] This has erroneously been presumed lost.[22] The 'sketch' is similar in tenor and details to Richmond's brief Poor Law plan of 1835.[23]

Richmond was briefed on the progress of the CFC by Col Rowan who had been a fellow officer in the 52nd regiment during Wellington's Peninsular campaign, and was given early information on its outcome in 1839.[24] In May 1837, Richmond submitted another scheme to Russell. This too is presumed lost, but it may have been related to a manuscript version of a pamphlet by J. B. Freeland sent to Russell in early 1837.[25] Anthony Brundage has called Richmond a 'virtual fourth commissioner' and calls Shaw Lefevre 'a conduit for the ideas of the Duke of Richmond'.[26] However, our examination of the evidence does not bear this out. Chadwick, despite his position at the Poor Law Commission, never considered linking a police to the Poor Law machinery desirable; Shaw Lefevre, in the one plan that he submitted to his fellow commissioners,[27] positively warned against it. On the contrary, from the moment Richmond declined to serve on the Commission, his influence began to wane. His ideas, expressed largely through Freeland, were rejected by all three commissioners who signed a report calling strongly for a national police unconnected to the Poor Law machinery. For his part, as we shall see, Russell would pursue a course independent of both Richmond's ideas and those of his commissioners. Far from being a 'virtual fourth commissioner', Richmond's influence by 1839 had dropped to zero.

In the assistant Poor Law commissioners, Chadwick found himself in possession of a ready-made national network of informants well acquainted with local magnates and gentry who could take political soundings in the provinces and be used as his eyes and ears.[28] Other important figures in the working of the CFC were Samuel Redgrave, a Home Office civil servant, who was appointed as secretary to the Commission, and William Augustus Miles. Chadwick wrote to Russell:

> There is one gentleman whose services, I think it would be desirable to make use of. I mean Mr Augustus Miles the charity commissioner. He has paid much attention to the subject. He has written a pamphlet upon it which though possessing merit I do not think much of. But he has displayed much tact in the examination of vagrants and culprits and the investigation of the penetralia of crime. His continued researches I think would be extremely useful.[29]

William Augustus Miles – another 'moral entrepreneur' like Chadwick, but with less public impact and influence – had already published some views about vagrants, mendicants, crime and policing, which broadly echoed Chadwick's ideas, and had brought his opinions on these subjects to the attention of both Chadwick and Russell. Russell agreed to appoint him to collect evidence for the Commission. Miles was working for the Charity Commission, travelling around the provinces, and he continued to do so, but he was now also charged with collecting information and conducting examinations of witnesses for the enquiry into rural policing.[30]

The Constabulary Force Commission was formally set up in October 1836. Chadwick had suggested that it could report within a few months; in

fact, it took two-and-a-half years to complete its business, and did not report until March 1839. The Commission met twenty times in all over those 30 months. Chadwick attended all meetings, and Rowan all but one. Shaw Lefevre was at only a quarter of them; however, he kept in regular touch with the other two commissioners, and with Russell, by letter, and was able to exercise some influence on the final report. Two-thirds of the Commission's meetings were in the first two months, concerned with drawing up and wording questionnaires to send out to collect information. The questionnaires were sent: to all magistrates in Petty Sessions (comprising 48 questions, sent out on 8 November 1836); to all Boards of Guardians of the New Poor Law Unions where they existed (34 questions, sent out in November 1836) and to the Watch Committees in charge of the police forces of all boroughs with municipal government (34 questions, sent out on 26 December 1836).[31] After this, the Commission met only three times in early 1837, once in 1838 and twice in March 1839 when the final version of the Report was being decided.

Chadwick's hand is evident in the drawing up of the questionnaires, especially in the number of questions designed to elicit the answers he wanted. The 48 questions addressed to JPs[32] were accompanied by a letter from Redgrave drawing their attention particularly to Questions 3-14, which focused on the extent of crime in their area and the inadequacy of existing institutions for checking it. The letter reminded them, in relation to employing paid police, that paying them from the Poor Rates had been declared to be illegal, and asked the magistrates to suggest how far paid policemen could also be required, when they were not enforcing the law, to 'exercise other useful Public Functions'.[33] Questions asked included: whether most crime was the work of outsiders (Q. 10), about the 'lodging-houses for trampers, vagrants, or mendicants' and their role in local crime (Qs. 11, 12, 13), and about locals with no visible means of earning their living 'who are believed to live by habitual depredation' (Q. 14). Separate questions were included on the state of local beershops and public houses, riots, incendiarism and cattle maiming (Qs. 15-19). A large number of questions asked about the present policing arrangements, and invited complaints about their inadequacy (Qs. 21-43). Some of them are close to being leading questions, suggesting the answers which Chadwick hoped for. For example:

6. To what causes do you ascribe the failure to bring the offenders to justice; and have such failures been ascribable in any cases to the inefficiency of the constables? [This, as some angry magistrates pointed out in their answers, assumed, in advance of any evidence, that there *had* been such a failure.]

20. Is there reason to believe that offences of any description within your division are much more frequent than any official information would give reason to suppose? [The use of 'much' here suggests the expected answer.]

27. Are their [constables'] connexions or interests such as might tempt them to connive at illegal practices, or cause them to be less active than they ought to be in the performance of their duty?

42. Supposing it desirable to appoint paid constables to give their whole time to the performance of their duties, what other useful functions might be assigned to them? [This sought examples to assist Chadwick's plan (above) to lessen opposition to the expense of a paid police by having them perform ancillary public duties. Magistrates who had already said, in answer to earlier questions, that they *did not* think paid police necessary or desirable, sometimes gave terse replies to this query.]

46. What proportion of the expenses now incurred by the public in the apprehension and prosecution of offenders do you conceive might be saved by the establishment of a more efficient preventive force? [This query, as some irritated magistrates noted, begs the question by assuming that a paid preventive police automatically *would* save money.]

Apart from the considerable amount of information supplied in the answers to the questionnaires, the Commission also carried out an extensive programme of examination of witnesses. Between October 1836 and July 1837, Chadwick had W. A. Miles travel around the country, taking a great deal of evidence in Lancashire, Cheshire, the Midlands and Wales, about crime, vagrancy, policing (including the working of the Cheshire Constabulary Act) and punishment. He interviewed parish constables, local policemen, magistrates, prison governors and chaplains, and prisoners (who provided him with some juicy confessions for the final report). Miles also collected evidence about wrecking, and plundering of the wrecks, on the Cheshire coast, theft from canal boats and other means of transport, etc.[34]

Chadwick had had Miles appointed to the Commission because Miles' published views on vagrancy, crime and police coincided with his own. Miles saw crime as unconnected with issues of poverty or deprivation, but as the work, essentially, of professional criminals and vagrants from the slums of the cities and large towns, who preferred begging and crime to honest work. These people, he said, 'pour themselves forth periodically over the face of the country' in a continual migratory flow, begging and stealing from the vulnerable country dwellers who were unprotected by any police. There was only one solution: 'The formation of [a] General Police, centrally organized, would check this spreading gangrene by a constant communication that would carry regulation into every resort of crime, however remote'.[35] Miles' reports to the Constabulary Force Commission continued to stress the centrality of 'beggars and Trampers' to the problem of crime, and the need for a national police to make their lives as difficult as possible:

If punishments are made too severe against beggars & Trampers, the end will be defeated – because they will become objects of commiseration and the twaddling voice of a Pseudo philanthropy will be raised in their behalf to such an extent that the *Cadging System* will be materially benefitted.

Frequent inspection of these Lodging Houses will considerably annoy this vermin class of society – who dupe the public daily of an enormous amount – and if it were not that these fellows are generally Thieves, the Public only pay a daily tax for their credulity, and are scarcely worth protecting, as they encourage & foster these vagabonds.

> Every Lodging House is a link in the chain of crime – and I would have them all licensed – their doors should be open to the Police at all hours – and they should be compelled to make a daily return of the number of customers, their names – or nick-names (which latter when known would be the more desirable) together with a description of their persons.[36]

Chadwick made a central theme of his Report the constant migration of a stream of criminals and vagrants around the country, and the consequent need for a strong national police force to cope with them; and he drew heavily on Miles' evidence and his analysis for this purpose.

In addition to Miles' research, Chadwick himself (while continuing to work as Secretary to the Poor Law Commission) went to Lancashire, Cheshire and Birmingham in September–October 1837, and to Bristol and Bath in November 1837, to examine witnesses and gather information about crime and vagrancy, and about possible additional uses of police forces for fire-fighting, inspection of weights and measures, etc. He also conducted a substantial correspondence with people who might have useful information; and the Commission solicited and received a great deal of correspondence, from prison governors and inspectors, police authorities and officers, JPs, country gentlemen, Poor Law assistant commissioners and others, about issues of policing, crime, public order, vagrancy, poaching, drinking and the evils of rural beershops. Poor Law assistant commissioners – such as William Gilbert, Edward Gulson, Sir Edmund Head, James Kay and W. J. Voules – acted as Chadwick's eyes and ears in the provinces, and kept in regular correspondence with him.[37] They used their contacts with the provincial gentry and farmers to inform Chadwick about regional opinion on the policing issue. Some of them even ventured to submit their own plans of police.

By May 1838, Chadwick told Russell that they had examined 'nearly two hundred important witnesses'.[38] As with the questionnaires, the examinations of individual witnesses show many examples of blatant leading questions, designed to elicit answers about the benefits of an efficient paid police.[39] Not surprisingly, all this gathering and analysing of information – particularly analysing the bulky returned questionnaires from magistrates and Boards of Guardians – took far more time than Chadwick's optimistic forecast of a few months. Chadwick explained and excused the delay to Russell as the product of additional Poor Law Commission business and his own ill health.[40] Certainly, the huge anti-Poor Law demonstrations – sparked by the implementation of the New Poor Law in the industrial North in 1837 – which gathered force to develop into the Chartist movement in 1838–9, added substantially to Chadwick's burdens in this period; as Secretary to the Poor Law Commission and architect of the New Poor Law, he was heavily involved in defending the law and its enforcement.[41] Late in 1838, when the writing of the Report was well under way, and the final product was being impatiently awaited, Chadwick felt the need to gather more information on a particular obsession of his – 'the need of a police and of legislative provisions for the protection of

Capitalists and workmen against the interference of third parties namely the Trades Unions'. He wrote urgently to Colonel Shaw-Kennedy for information about his dealings with strikes when he was military commander at Manchester; to manufacturers R. H. Greg and Edmund Ashworth; to the factory inspectors; and to J. F. Foster, stipendiary magistrate at Manchester, for any information they could offer on the subject. They replied at some length. He also took evidence from manufacturer Thomas Ashton, whose nephew had been shot by striking trade unionists and who strongly urged the need for 'a police force of strangers that Government could send' to deal with strikers. Chadwick devoted a substantial section of the Commission Report to this topic.[42]

The drafting of the Report

> This Report, it is evident from the manner in which the questions are framed – leading questions to elicit the required answers – is concocted to establish a foregone conclusion. The three Commissioners had made up their minds as to the propriety of a rural, or rather a national, police; and then set to work to gather such information as might best substantiate their preconceived notions . . .[43]

The writer of the letter quoted above was a strong critic of the Constabulary Force Commission Report, but his criticisms have some basis in fact. Chadwick clearly saw the Commission as an opportunity to stamp his views on a major institution – as he had done with the Poor Law Commission report in 1834 – however, neither his colleagues nor Russell would give Chadwick an entirely free hand with the Report.[44] They were well aware, at the time the Commission was set up, that Chadwick was a man greatly disliked and distrusted – by large sections of the working class who were having to contend with the New Poor Law, but also by many of the landed class, who were deeply suspicious of this Metropolitan Benthamite with his ambitious plans for centralized institutions. In agreeing to join the Commission, Shaw Lefevre warned Russell of such suspicions: 'Col. Rowan will naturally be considered too much prejudiced in favour of a police similar to that under his Command. Mr. Chadwick will be suspected of being too well inclined to connect the new Constabulary with the Poor Law Guardians.' Russell himself cautioned Chadwick about what would be politically realistic:

> There is one thing always to be kept in mind. We are endeavouring to improve our institutions. I think they have been lax, careless, wasteful, injudicious to an extreme; but the country governed itself, & was blind to its own faults. We are busy in introducing system, method, science, economy, regularity, & discipline. But we must beware not to lose the co-operation of the country – they will not bear a Prussian Minister, to regulate their domestic affairs – so that some faults must be indulged for the sake of carrying improvement in the mass.[45]

Shaw Lefevre's own ideas on policing appear to have evolved during the course of the Royal Commission. In September 1837, he wrote to Rowan

that: 'We have seen in the Evidence already collected quite enough to convince us that a host of prejudices will be roused against any plan which possesses too centralizing a character', and that he suspected that nothing short of this would 'satisfy his [Chadwick's] appetite for centralization'.[46] His own plan of 1837, referred to in this letter, revolved around making a rural police responsible to the county councils proposed by the Royal Commission on County Rates, of which he had been a member. Beyond this, he favoured drafting policemen from the Metropolitan force; preventing the justices from using the constables for their own purposes; and keeping the police separate from the Poor Law machinery. By the beginning of 1839, when he put his signature to the Commission Report, he was prepared to accept a plan for a national police. His main concern by then was to reassure magistrates and country gentlemen that they should support legislation on the subject; to achieve this, he suggested that it should be left to the magistrates in Quarter Sessions to decide whether or not their county would accept a rural police linked to a central authority in London. Like Chadwick, he was disappointed with the County Police Act of 1839, which followed the Commission Report; he wrote to Chadwick in 1841: 'I wish they [the government] had taken the opportunity of establishing a General Police throughout the kingdom, paying a portion of the Expense out of the Consolidated Fund'.[47]

Rowan was also well aware of Chadwick's ambitious view of what he could achieve through the Commission. He told Richmond in January 1837:

> Chadwick appears very confident that with plenty of power entrusted to proper hands, crime as well as pauperism might be driven from the land, but I fear people in general are very unwilling to pay for any advantages whatever, each man hopes he is not the person who will be robbed or murdered, and he does not care much whether these chances happen to his neighbour. Then again Political feeling runs so high, that people seem more inclined to ask who it is they are to receive a measure from, than whether the measure be good or not.[48]

The evolution of Rowan's ideas on provincial policing, and his contribution to the Commission Report, are not easy to pin down.[49] In 1837, he would appear to have shared Shaw Lefevre's apprehensions about Chadwick's liking for centralization; yet, by 1839, he agreed with Chadwick's critique of the French police who had too 'many different, separate jurisdictions'.[50] Rowan was cautious, realistic and pragmatic about what could be achieved; he was inclined to favour a gradualist approach to the implantation of a professional police, and doubted whether his Metropolitan force could train and supply enough men for the provinces without straining its own resources. Like Shaw Lefevre, by 1839 he had come round to accepting Chadwick's essential conception of a police as the right one. In a letter to Richmond accompanying a copy of the Commission Report, he explained:

We carefully considered all the plans submitted to us with a view to remedy the evils set forth in the Report. I should almost fear the time has not yet arrived for our recommendations to be generally well received, but our object has been to propose something that would *permanently* meet the mischief that arises out of the present state of things under a State of Society in this Country so different from every thing in former times. We felt satisfied that nothing less comprehensive, or containing less of organization than what we have ventured to propose, would do so.[51]

Rowan was far from confident that the Whig government would legislate on their recommendations, but consoled himself that 'at least the Report contains some valuable information', while 'piece meal work' had failed to 'meet the exigencies of the times'.[52] Rowan used his position as Metropolitan Commissioner to provide Chadwick with technical assistance, such as computing the hypothetical costs of county police forces and calculating the necessary ratios of police to population. He was also an important political asset to the Commission, being well known as foundation commissioner of the Metropolitan Police; and he enjoyed social contact with important Tories and aristocrats such as Peel, Wellington, Richmond, and the Marquis of Tweeddale.

Rowan and Shaw Lefevre left Chadwick to run the Commission, and to write most of the Report; they intervened only on a few of the Report's important recommendations at the end of the Commission's term. However, as the Commission dragged on through 1837, without any sign of a draft report from Chadwick, his colleagues would seem to have grown impatient. In September 1837, Shaw Lefevre wrote to Rowan:

It is time we should be doing something with regard to the Rural Constab[ular]y. - and with a view to bring our deliberations *to a point* - I have sent you a rude sketch of the plan of which I hinted to you some of the leading features when I had the pleasure of seeing you in London. If you think it feasible pray forward it to Chadwick - altho' I do not expect it will satisfy his appetite for centralization ... I have ... endeavoured to contrive that a portion of the force shall emanate from the Government i.e. from yourself [i.e. the Metropolitan Police, of which Rowan was Commissioner] without exciting the Jealousy of the Inhabitants of Counties and remote provincial districts. I have also kept equally clear of magisterial patronage and poor-law machinery either of which would be fatal to the measure.[53]

This letter suggests that in 1837 Rowan was receptive to Shaw Lefevre's plans and his criticisms of Chadwick. Brundage presents it as showing 'collusion' between the two of them against Chadwick, with their ideas 'in sharp conflict with Chadwick's'.[54] This stretches a little evidence much too far: Rowan's letters to Chadwick, particularly in January-March 1839,[55] when Rowan was commenting very favourably on Chadwick's drafts of the Report, are very friendly and commendatory in tone; and this letter of alleged secret 'collusion' is found, not in the private papers of either man, but in the public papers of the Royal Commission - where it could, presumably, have been read by the secretary Redgrave or by Chadwick himself.

Rowan was growing a little impatient with Chadwick by late 1837 – as was Russell; it was well into 1838 when Chadwick finally began showing his two colleagues and Russell drafts of the Report.[56] From May 1838 until March 1839, Chadwick drafted the sections of the Report, showing the draft sections to the other two commissioners and the final Report to Russell; they forced a few significant modifications to the recommendations in the last section of the Report.[57]

Apart from these few amendments to the recommendations, however, they left the structure and writing of the Report to Chadwick; the resulting document, of 186 pages plus another 39 pages of appendices, was very much Chadwick's work. There are some interesting parallels here to his writing of the Poor Law Report in 1834. Mark Blaug has shown that Chadwick wrote that document without having carefully analysed the many volumes of evidence which had been collected by that Commission; essentially, he set out the views and recommendations which he had already formed, and used extracts from the evidence collected to lend support and credibility.[58] He did something similar with the Constabulary Force Commission Report. Chadwick had already formulated his views on the need for a preventive police, and the additional roles which they could perform, in his 1829 article;[59] nothing in the Report conflicts with those earlier views, though his experience of the New Poor Law and the protests against it had convinced him that his original proposal of a professional police force for London should now be extended to the whole country. As with the Poor Law Report, there is no evidence that the Commission fully analysed all of the vast amount of material contained in the returns to the questionnaires from JPs and Boards of Guardians; Chadwick skilfully selected and deployed some replies from those questionnaires to support his arguments.

We have suggested that the questionnaires contained leading questions designed to elicit the answers which Chadwick needed for his argument, and that Chadwick had chosen Miles as investigator because he shared his views about the role of migratory criminals, vagrants and trampers, and could be relied on to gather the right sort of material. A contemporary shrewdly noted these points about the way in which Chadwick and Miles used evidence about the poor and the criminal to suggest that the two groups were virtually synonymous. He quoted from the Constabulary Force Commission Report and from Miles' *Poverty, Mendicity and Crime* to support his point that the pictures of the lower orders given by Miles and Chadwick are:

... gross misrepresentations and very false pictures. ... all the lower orders are classed and confounded together as profligates and villains. ... The impression intended to be conveyed is, that every man living from hand to mouth (the necessary condition of the major part of the community) ... is little better than a thief, is one of the offal of society, and ought to be swept off into some common sewer of filth and corruption by a scavenger police.[60]

Similarly, when Chadwick wrote to the Revd Robert Wilson, a visiting magistrate in Norfolk, asking him to examine some of the prisoners in the local gaol, he made clear what answers he wanted: 'The class of cases which it would be most useful to select are those which show the migratory habits of criminals, those showing the origin of juvenile delinquency etc. The examinations already had on this subject are extremely instructive.'[61]

The published Report gains support for its arguments by frequent direct quotation from witnesses' evidence, from interviews or from written submissions. But the drafts of the Report suggest that Chadwick may have edited and rewritten their actual words, to make them say what he wanted them to say. For example, the Report quotes George Burgess, Governor of Knutsford Gaol and former deputy high constable under the Cheshire Constabulary Act, on the importance of removing the police from the direction of the magistrates. Chadwick amended, in draft, Burgess' words as originally recorded; comparing the draft with the final report shows that Chadwick removed some sections entirely or replaced them with words of his own, without indicating that the evidence had been edited in any way. In the passage quoted below the words in square brackets and in bold form part of Burgess' evidence in the draft, but have been removed entirely, or replaced by subsequent words, in the final Report:

If this were to be continued with a paid constabulary the magistrates would only have to [do the duty of the officers as well as their own, or rather they would have to pretend to do it.] make themselves not only magistrates but superintendents of a police. ... Gentlemen are appointed to the office of Magistrate from their high respectability [. The majority of them can only give a portion of their attention to the performance of public duties. They are far above the sphere of the persons to be known or acted upon and cannot know them or what is to be done in constabulary matters as well as the paid officer who gives his whole time to what he has to do.] to perform Magisterial acts, but they are of too high a station in life to be acquainted with the necessary technicalities connected with thief taking. ... The Magistrate can only act on the knowledge of his agents [. After all it is the Officer who instructs or directs the Magistrate], or the Magistrate acts in ignorance.[62]

The changes here are not major ones, and Burgess was a witness whose views very much coincided with Chadwick's own; but the changes constitute just one of a number of such instances which one can find by carefully comparing Chadwick's draft with the final Report; one would probably find more such instances if the entire draft Report had survived to be compared with the final version, instead of the few fragments which remain.

The first section of the Report set out a major theme – the danger to the provinces of England, and particularly to the rural areas, of a continual stream of migratory thieves and vagrants who move out into the country from London and the other large towns. Chadwick stated firmly, on the first page, that 'a large proportion of the more pernicious crimes against property in the rural districts is committed by bands of depredators who migrate from the large towns as from centres'.[63] He denied that the official

statistics of committals to trial were any sort of guide to the true incidence of crime (a point he had already argued in his 1829 article), illustrating this by comparing the large number of forged notes presented to the Bank of England with the small number of people prosecuted for forgery. A much truer measure of crime, said Chadwick, can be obtained by estimating the number of 'habitual depredators' at large in most urban centres, and calculating their chances of immunity in the towns and in the unpoliced rural areas – where their chances are at least twice as good. From this, he calculated that there were at least twice as many young able-bodied 'habitual depredators' at large as there were in prison, 'plundering' society to the extent of at least £700,000 a year (pp. 11–12).

Chadwick then devoted a major section (pp. 13–68) to describing in great detail these migratory thieves and their practices, supporting it with long extracts from confessions of offenders in prison (taken, for the Commission, by Miles). He similarly described the movement of hordes of vagrants and beggars, one of his targets under the New Poor Law, who were here labelled 'one great source of delinquency' and the agents of 'demoralization' throughout the country. He treated as one single issue 'the mischiefs of these migratory streams of depredators and vagrants', who took refuge from policed cities like London and Liverpool by moving into the unpoliced countryside where they constituted a serious menace to the inhabitants. Chadwick ended this section by 'proving' (to his own satisfaction at least) that property crimes were not caused by the pressures of poverty or need:

> We have investigated the origin of the great mass of crimes committed for the sake of property, and we find the whole ascribable to one common cause, namely the temptations of the profit of a career of depredation, as compared with the profits of honest and even well paid industry; and these temptations appear to us to arise from the absence of appropriate and practicable arrangements by means of a constabulary, such as forms the main subject of our inquiry. The notion that any considerable proportion of the crimes against property are caused by blameless poverty or destitution we find disproved at every step.[64]

The support for this sweeping assertion came in the form of statements by prison officials and confessions from thieves; if criminals have suffered any distress, it is generally their own fault. It is highly unlikely, however, that Chadwick's view was really based on the evidence gathered for the Commission. In his 1829 article, well before the Commission was set up, he had clearly outlined this notion in classical Benthamite terms:

> It is a fact, established from observation of the course of life and characters of those who appear as criminals in our penal courts, that in by far the greater number of cases the motive to depredation is not necessity or poverty, in the common acceptation of the term, but ... the 'easy-guinea,' – an impatience of steady labour, an aversion to the pains of exertion, a proportionately strong appetite for the pleasures of ease.[65]

Analysis of the detailed examinations of witnesses shows the questioner frequently asking leading questions of the witnesses, designed to push their answers into the form which Chadwick wanted. For example, Thomas Fellows, Task Master at the New Bailey Prison in Manchester, was asked what led the juveniles in his prison into committing their first crimes – idleness or necessity. He replied that, for some, it was the necessity of not being able to get employment. This was not good enough for Chadwick who tried to put words into his mouth by asking: 'Is it not through want of character or through want of foresight?' Fellows persisted that some could not get work, whereupon Chadwick eventually succeeded in getting the answer he wanted:

Q. Then with regard to the mass of juvenile delinquency you state that cause to be idleness
A. Yes – Idleness.[66]

It was on the basis of this sort of 'evidence' that Chadwick firmly claimed to have 'disproved' the notion that much of the crime against property was caused by poverty.

Having thus established the basic argument for a nationally controlled police to save the rural districts from these terrifying swarms of migratory depredators, Chadwick then moved on to the workforce of the industrial North, who were, at this time, making it so difficult to implement his New Poor Law in their areas. He devoted twenty pages (pp. 68–88) to the evils of trade unions and strikes in the industrial districts – a particular obsession of Chadwick's – and the need for a police force to break this power. Shaw Lefevre thought Chadwick's case for the insecurity of property in the manufacturing areas was irrefutable: 'Putting the Corn Laws aside, there is quite enough left to drive Capital abroad. The only wonder ... is how we retain our Manufacturing Supremacy under such ... conditions.'[67] In this section, Chadwick made a classic utilitarian defence of the use of a police force, rather than troops, as a riot-control force, not just because they would cause fewer fatalities and injuries, but also because they would do it more efficiently:

Of the military force it may be observed that the private soldier has both hands occupied with the musket, with which his efficient action is by the infliction of death by firing or stabbing. The constable or the policeman, whose weapon is the truncheon, or, on desperate occasions, the cutlass, has one hand at liberty to seize and hold his prisoner, whilst with the other he represses force by force.[68]

The second section of the Report offered a paid preventive police force as the remedy to the situation described in the first part. Chadwick used a brief survey of the history of the constable in England to argue that the institution had declined into serious inefficiency and inadequacy, and that 'this inefficient state of the civil force, a state of inefficiency which a large class of persons maintain from objection to the supposed expense of a paid

agency to carry out a better system, is in reality the most expensive'.[69] He then discussed existing examples of paid police forces in England outside London – the Cheshire Constabulary Act, the Barnet Association, and various forces set up under local Acts, the Lighting and Watching Act, or by private subscription.[70] Chadwick had to tread a careful path with these local paid forces; he was concerned to emphasize the superiority of paid, regular police over unpaid casual constables, but he could not make these locally controlled forces seem too successful without undermining his argument for the need for a *national* government-run police. So he stressed the theme of the migratory nature of the criminals and the inadequacy of separate local forces to deal adequately with them. The people of Stow-on-the-Wold, for instance, were praised (pp. 131–3) for setting up their private subscription force of two Metropolitan policemen; but their good effects, in turning the local population honest, 'are confined chiefly to the resident or settled delinquents: the effects of any partial operations (and such only have as yet been tried) on the migratory classes of habitual depredators being simply to shift the evil by driving them into other districts'.[71]

He argued, from these sorts of examples, the need for a police measure to be national, centrally controlled and uniform; a voluntary or local measure would simply leave unpoliced gaps within which the criminals could shelter. Being well aware of the degree to which resistance to police forces was based on their cost to local ratepayers, Chadwick then included a section (pp. 149–59) in which he drew on replies to the questionnaires to set out all the useful ancillary tasks which a paid police could be used to perform – acting as firemen, life-savers, inspectors of nuisances or of weights and measures, process servers, surveyors of roads, collectors of rates; taking care of lost children and lost property; preventing road accidents, and supervising the cleansing and lighting of the roads. As we have seen, he had already recommended this course as the best means of reducing the unpopularity of a permanent paid police force.

When it came to the recommendations of the Report, Chadwick was not given a free hand by his fellow commissioners and Russell. Chadwick's own conception was of a full-time, paid, national preventive police. It had to be *national*, because the migratory nature of the depredators and vagrants required a force with national links and communications to deal with them. A *preventive* police would not only catch offenders after the event, but would also prevent crimes being committed, by regular patrolling.

Anthony Brundage[72] has claimed that Chadwick's drafts of the Report reflected his predilection for a police structure based on the Poor Law machinery, and that it was only the last-minute intervention of Shaw Lefevre which compelled him to change it. Some contemporaries made similar assumptions about Chadwick's preferences,[73] but this was far from the case. His drafts of the Report[74] show if that Chadwick had a favoured model for the organization of a rural police it was the Irish Constabulary – suitably modified for England. An English version should not be militarized or armed. The virtue of the Irish Constabulary was that it was

directed by a central executive, and, although it was responsive to the magistrates, neither they nor any other local body possessed any 'patronage' in it.[75] For the police of England, Chadwick's chief requirements were: (1) that the Metropolitan Police Commissioners (or a future Central Board) play the main role in the general management of the force, and serve as the sole source of trained manpower for the provincial police; and (2) that the creation of a provincial police be *gradual* – implanted with the positive assent of important local bodies. To succeed, the police must be both popular and mobile – but placed under *national* auspices to minimize jobbing and corruption, and enable the authorities to concentrate police resources for the purposes of dealing with disturbances and repressing the 'migratory classes of depredators' who Chadwick thought were at the heart of the crime problem.

Therefore neither the Boards of Guardians nor the JPs – *nor any other local* authority – should have the power to immobilize a police within its own district. The force in a county 'might be made to act on the same principle in respect to intercommunity of information, combined action, and subserviency to general rule, in relation to other counties and the kingdom at large, that one division of the Metropolitan Police acts in respect to another and to the whole force.' All 'separate and disconnected operations ... without combined management' would not be satisfactory.[76] And, in order to preserve the independence, impartiality and popularity of the police, appointments must not be made by the justices.[77] Since policemen needed certain specific qualifications and training, patronage appointments must be strictly avoided.[78]

Chadwick's analysis of the deficiencies of the Cheshire Constabulary Act confirmed his opposition to magisterial appointments and a police under local JPs. There 'must be deep seated and real causes of distrust of a direct appointment and administration of such a force by the magistrates', and therefore, no 'discretionary power of making district arrangements should be conferred on the [petty sessional] divisions.[79] Ideally, as in Ireland or London, the police and judicial functions of the magistrates should be separated, and no longer be both held by the same man. Appointments to the police should be made by a central authority, and the local magistrates should exercise only a judicial and supervisory role.'

Despite these arguments, however, Chadwick's drafts[80] – as well as the final Report – allotted the most important local powers to the magistrates and not the Poor Law authorities. The police must be responsive to the local justices and obey their orders. The police would be required to submit to the magistrates all charge and occurrence sheets, and make reports to Quarter Sessions. The justices were to 'frame rules and regulations for the service of process and attendance at Petty or Quarter Sessions'; they, in turn, would communicate with the highest police officer in the county (whom Chadwick, at this point, called a 'superintendent'), who would be responsible for taking action. Most importantly, in the drafts as well as the final Report, the power to initiate dismissal proceedings

against policemen was reserved to the justices alone.[81] Chadwick wished to 'combine with a general system under ... the supreme executive a local control'.[82]

What then of the role of the Poor Law authorities in Chadwick's rural police scheme? Chadwick had always stressed that connecting a new police with the Boards of Guardians was crucial to the success of the New Poor Law:

> Indeed the complete operation of the principles of the poor Law Amendment Act is largely dependant [sic] on the aid of a rural Police whose chief functions would necessarily be clearly connected with the poor law business of a Board of Guardians - in respect of casual poor or mendicants and vagrants, the pursuit and apprehension of runaway parents, the punishment of refractory paupers, the suppression of tumult connected with the administration of relief.[83]

Boards of Guardians were indeed assigned a role, but a subsidiary one. Being 'representatives of the ratepayers of every parish', they would constitute the chief point of contact between the police and the 'middle ranks of life'. Policemen would attend board meetings, receive criminal intelligence from them, and respond to complaints. Since magistrates were *ex officio* members of the Boards of Guardians, complaints against police would be taken in the presence of men with the power to initiate disciplinary proceedings against policemen.[84] In general, the new police were to make themselves useful to, and popular with, the farmers and other members of the provincial middle class. Police might make use of workhouse buildings for police stations and holding Petty Sessions, and use their strong rooms as lockups. And, since Poor Law Unions employed trained professional officers of their own, these could play a role in reanimating the special constabulary.[85] But Chadwick, even in his initial drafts, assigned to the Poor Law Guardians no specific authority over the police, nor any role in their administration; unlike a number of the police plans sent to the Commission, Chadwick never proposed a police based on the organization of the Poor Law Unions and Boards. He added to the final Report this comment:

> We have no doubt that the management by such Boards would be deemed good amidst districts where nothing could easily be worse; but our chief objections to such an arrangement consist of the stated objections to the management of a police by committees, or by numerous bodies; to local appointments, to untried and practicably unchangeable constables, to uncombined and conflicting management, and the absence of securities for efficiency or of unity in general action.[86]

These are quintessentially Chadwickian notions, completely consonant with everything he wrote on police since 1829. A Poor Law police would have run counter to his chief *sine qua non* - a national police under a central board of London Commissioners.

Russell was concerned that any recommendations should be politically feasible. The county gentry, sitting in Quarter Sessions and in Parliament,

would not look with favour on moves to remove their control over the local police, nor on a centrally controlled police in government hands. Shaw Lefevre had been placed on the Commission largely to ensure the acceptability of the findings to rural gentlemen. As we have seen, gentry opinion (predominantly Tory) was neither monolithic nor totally unchanging; indeed, there is evidence that it was starting to change significantly during the 1830s, with one indicator being attitudes towards the New Poor Law, and another the establishment of various types of local paid police.[87] Both Shaw Lefevre and the Duke of Wellington had helped to incline their fellow landowners in Hampshire towards the merits of a regular county police.[88] Now, at the start of 1838, urging Chadwick to push on with drafting the Report, Shaw Lefevre suggested that the climate of opinion appeared favourable to legislation on the subject, stating that he had noticed at his Hampshire Quarter Sessions the previous week,

> that the Village Dogberries are gradually declining in the Estimation even of the great unpaid. Crime is making very rapid Strides in the rural districts - & gentlemen begin to feel their pockets & possessions exceedingly insecure. *Pray work at the Report* - because I verily believe something might be done during the present Session if it could be brought out in time.[89]

Chadwick had had a similar report about the opinions of Tory rural gentry and peers from Edward Gulson, a Poor Law assistant commissioner, at the time the Commission was set up. Gulson wrote that he had been urging the need 'for the establishment of a good Rural Police', in Berkshire, Oxfordshire, and now Lincolnshire, on which subject:

> I have much opportunity of hearing the opinions of Tory Lords ... The opinions of most of the Tories are *in favour* of the measure - I mean of the principle and its adoption. *All* concur in the necessity ... but of course you will have to work out the *details* of the machinery in such manner as to meet *party views*. Of course the Tories would be very averse to the existing [Whig] Government having in *their* hands so formidable an engine as a general police. The Duke of Rutland - Earl Winchilsea - The Duke of Newcastle - and all the Tories object to *any* Government having the control of such a force - and I think very justly - these will be points for you to work out - & upon which to steer as clear as possible of *party* power.[90]

The county magistrates were not going to approve any police measure which largely excluded them from its operation or compelled them to share power with some other body. From late 1838, Russell, as Home Secretary, had to deal with growing Chartist activity in the industrial North - a development which suddenly placed a premium on having efficient provincial police in place to deal with the expected threat to public order. Three years before, Russell, characteristically, canvassed many people on the subject, while never disclosing what his preferences were. By 1839, he had a firmer concept of a police plan in mind, and it did not, emphatically, call for a national police along the lines suggested by the Royal Commission.

While Chadwick was still delaying in producing the Commission's final Report, the Shropshire Quarter Sessions, at the end of December 1838,

again proposed the creation of county police forces under Quarter Sessions' control. When Russell responded positively to this suggestion,[91] Shaw Lefevre became alarmed, writing to Chadwick:

> He [Russell] must have totally forgotten the Existence of our Commission – or he could not have thrown us over in such a barefaced manner. However, it makes it doubly important that our Report should be before the Public *as soon as possible* – or the Magistrates in Lancashire will resort to some clumsy Expedient such as the Cheshire Constabulary – and enter into expensive and troublesome arrangements for no good purpose.[92]

This led to a frantic rush to complete the Commission Report, during which some changes were made in the final recommendations. Brundage argues that these involved altering the powers of the Boards of Guardians and modifying a call for a national police, but actually, the bulk of the Report remained unchanged. What was amended was only the *mechanism* for implanting a police in the provinces.

Chadwick had believed for some time that it was so important to get the co-operation of both the upper and middle strata of rural society that he proposed to make the introduction of the police:

> extensively dependent on their votes. We ... believe that the voluntary demand for a trained force would keep pace with the means of supplying them. A further advantage of bringing them in by vote would be that it would be in the interest of the police to propitiate the people of the district [and] lay the foundation of the habit of responding to the wishes of the public.[93]

He proposed originally that local applications to the Metropolitan Commissioners for trained policemen be accepted upon positive votes of:

> a majority of the justices assembled at any Quarter Sessions ... or upon application from a majority of the magistrates of any Petty Sessions, or from a majority of the Guardians of any union or from a majority of the rated inhabitants of any parish ... setting forth the insecurity of persons or property and the want of paid constables ...[94]

Chadwick submitted his final draft of the Report to Rowan and Shaw Lefevre. He received Rowan's approval, but failed to wait for Shaw Lefevre's response before sending it to Russell at the beginning of March 1839. This led to a minor contretemps. Shaw Lefevre refused to agree to it being sent to Russell 'until I have seen it put together', and demanded a meeting of the three commissioners to finalize the Report. Chadwick had hastily to write to Russell to ask him 'to consider the draught as not sent in'.[95] The meeting was held on 4 March 1839; the minutes record precisely what took place: 'Several alterations were suggested by Mr Lefevre, and it was resolved that the *application* for a police should not be for a less district than a whole County – and that the permission to Boards of Guardians and parishes to apply be omitted.'[96] The text of the Report was altered so that only Quarter Sessions could apply for a police.[97]

Reserving applications to Quarter Sessions was, for Chadwick, a separate issue from his notion of an ideal administrative unit of provincial police.

He had advocated the county as the smallest acceptable unit for a police well before Shaw Lefevre's intervention. His draft fragment of November 1838 states: 'Any less scale of preventive ... administration than for a whole county does not comprehend a sufficiently wide basis for adequate efficiency and economy.'[98] This was an issue quite distinct from that of which bodies, under Chadwick's scheme of progressive, popular implant-ation of new police might *apply* for a police.[99] The effect of Shaw Lefevre's intervention was merely to block Chadwick's plans to allow bodies other than Quarter Sessions to call on the national authority for a draft of trained policemen.

Three weeks later, just before the three commissioners signed the final version of the Report, Shaw Lefevre got Chadwick to make another change which, though small, was again designed to strengthen the power of Quarter Sessions:

> We recommend 'That the Constables shall be liable to be dismissed upon the representation of the Magistrates in *Petty* Sessions'. We ought to have added 'and the Superintendents upon the representation of the Magistrates in *Quarter* Sessions' or it will appear as if we wished to place the Superintendent without the *judicial supervision* alias *control* of Her Majesty's Justices.

The published Report reflects this change, and recommends that the superintendents be dismissable by Quarter Sessions and the sergeants and constables by JPs in Petty Sessions.[100]

Russell forced a more significant change to the recommendations. Chadwick was well aware that a major objection to the establishment of a paid provincial police was the cost, which would have to be borne by the local ratepayers. He therefore included a section in which he purported to prove that it would actually cost very little (no more than $1\frac{1}{2}$ d. in the pound) and would make great savings to the local community by its activities. He concluded this section by stating that, since it would also save the government money, 'we shall recommend that at least one third of the expense be defrayed by the general Government'. However, Russell, painfully aware of the poor state of government finances, demanded that this be changed: 'In London it is one fourth, & going beyond this proportion may get me into much difficulty.' The final version reads: 'that at least *one-fourth* of the expense be defrayed by the general Government.'[101]

The major recommendations made in the published Report were:

(1) A paid, trained national police force shall be established by the government on the lines of the Metropolitan force, under Police Commissioners.

(2) On an application by the majority of JPs in any Quarter Sessions that their county needs police, the Police Commissioners, with the approval of the Home Secretary, shall send as many police as are needed to that county.

(3) The costs will be paid, one-quarter from government revenue and three-quarters from the county rates.

(4) The constables so appointed will report to the JPs in Quarter and Petty Sessions of that county.

(5) The superintendents will be subject to dismissal by the JPs in Quarter Sessions, and the sergeants and constables by the JPs in Petty Sessions.

(6) The JPs in Quarter Sessions will frame regulations for their county force, which must be approved by the Home Secretary, and will then be binding for that county.

(7) The Police Commissioners will make rules and regulations for the general management of the national police, which, once approved by the Home Secretary, will be binding.[102]

The reception of the Report

Russell was now exerting great pressure on the commissioners for the production of the final document.[103] During the last week in March, he told Shaw Lefevre that 'he must have the Constabulary Report to lay before the House before the adjournment for the holidays'. The Report was finally issued at the very end of the month, and tabled in the House of Commons in early April. The rush to publish created more confusion. Copies of it were printed in which the fifth recommendation was repeated as the sixth with slightly different phrasing. This problem had to be sorted out and accurate copies printed and distributed.[104]

Chadwick's overall strategy called for the Royal Commission to be carried on 'unostentatiously', but for its end product to receive a great blast of publicity.[105] Chadwick and his two colleagues did their best to ensure maximum distribution for the Report. In addition to about five thousand copies sold, more than three thousand were distributed to influential individuals and newspapers. Chadwick arranged for copies to be sent to all Lords Lieutenant of counties, Petty Sessions and watch committees, and to every county newspaper. Rowan ensured that copies reached influential Tories such as Wellington, Peel, Richmond and the Marquis of Tweeddale. Shaw Lefevre similarly handled the Hampshire gentry and the Whigs (though it was Chadwick who sent a copy to Lord Brougham, stating that 'I believe you will find it to be next to the poor law report of enquiry one of the most influential reports that has been published and that it is likely to be much neglected').[106]

Chadwick's friends loved it. Sir George Stephen, adverting no doubt to the highly coloured interviews with criminals and other details of English low-life, enthused: 'It is a second life of Turpin!' and assured him that when the national police was created, 'You will of course be Inquisitor General'.[107] But the Report made less public impact than one might expect; it was briefly noted in *The Times* and leading provincial papers, without much comment.[108] Both Finer and Brundage give the impression that the Report was violently attacked in the press; Finer talking of 'ferocious opposition to the whole measure' from 'the Ultra-Radical and

Chartist Press'. However, all of Finer's supporting press quotations come from just one Chartist newspaper, *The Charter*. The *Northern Star*, the main Chartist newspaper, paid little attention to the Report. Brundage is content to cite Finer as his authority for the statement that much of the press comment – especially that of *The Times* and the Chartist papers – was unfavourable; but neither he nor Finer gives a specific reference to *The Times*, and we can find no such comment in that paper at this period.[109] *The Times* did, however, take a position of strong opposition to the County Police Act which followed the Report, and to those county magistrates who favoured adopting the Act.[110] Perhaps this is the source of Finer's confusion.

The Report received some spotty attention in the periodical press. The verdicts were mixed. The legal publication *The Justice of the Peace* published a detailed and hostile article. Shortly before the Report came out, an editorial had considered the pressures for government reform of the rural police, and expressed strong opposition to:

> organization and centralization, words adapted from foreign usages ... We are decidedly hostile to the introduction of such an organized system, as that of the metropolitan police throughout the kingdom, for the mere purpose of repressing crime and apprehending offenders. If it were necessary in this country that a system of political espionage should be established, that might be a reason for its introduction ...

When the Report appeared, the editors fiercely criticized its evidence – presenting 'an exaggerated and overdrawn picture' of the dangers of rural crime, which was 'rather too much, even from the overwrought fervour of mind of the ingenious secretary to the poor law commission' – and its recommendations, as advocating a system of 'complete centralization' which would be 'distasteful' and 'foreign and irreconcilable ... to our habits and usages'.[111] More favourable notices appeared elsewhere.[112]

Chadwick was disappointed with the reaction to the Report. More serious was the fact that it had been anticipated and upstaged in the political arena by Russell's clear embrace of the Salop Resolution as the government's preferred plan of police.[113] By April, the Salop Resolution had been circulated to all Quarter Sessions by Russell, and had attracted favourable responses from a number of them, including a unanimous endorsement by Lancashire. It looked as if the Constabulary Commission, with its two-and-a-half years of work and detailed Report, might be pre-empted, in terms of legislative effect, by a one-sentence Quarter Sessions resolution. However, the Whig government, initially, took no legislative action on either the Commission Report or the Shropshire resolution.

Politically enfeebled, preoccupied with their own financial problems and the growing Chartist threat, they were in a weak position to legislate on police in early 1839. In May 1839, they even lost office very briefly, and were restored to government in a weakened and even less effective state. They were in no mood to take on the added political troubles and financial

burdens which would inevitably accompany any moves to implement the Commission's recommendations. When they finally acted very hurriedly a few months later, it was not as a considered response to the Commission Report. Russell's 1839 bill was partly a genuine response to Chartist disturbances in sensitive parts of the country and partly the result of his realization that an opportune political moment had arrived in which to achieve something without having to face the prolonged political logjam that would have inevitably accompanied a rural police bill in less edgy times.

Chadwick remained proud of the Constabulary Force Commission Report to the end of his days, and was still distributing copies of it to various people decades later.[114] But he was furious with the legislation which resulted – the County Police Act of 1839 – which was far less than what he had recommended. He produced a draft memorandum – which he seems not to have sent to anyone – strongly criticizing it. In it he returned to the example of Ireland, and lamented the failure of the Whig government to follow that model in their legislation:

> The beginning of civil order in Ireland is acknowledged to be in the complete organization of [the] constabulary force, and the completion of the organization was in making it one uniform force, [and] in taking away the power or appointment and control from the magistrates. ... The government measure [the County Police Act], in the face of the experience of all Ireland, of the Metropolis and of Cheshire proposes to begin by forming institutions in the rural districts which it boasts of having elsewhere removed as inefficient or mischievous.[115]

THE COUNTY POLICE ACTS (1839-40) AND THEIR RECEPTION: ISSUES AND OUTCOMES

If I were called upon to say what I considered to be the best and most effective system of police for a country, perhaps I should propose a general uniform system, independent of local feeling, and governed by one central head. But when we are endeavouring to combine a system of police with the existing institutions of a country like this - which are, for the most part, local - of a country in which the administration of justice, and all the transactions with reference to the management and government of prisons, are carried on without reference to the Government in the capital, - I think it would not be expedient to have a police dependent, only, on the commissioners at Whitehall. For this reason, I deem it better to leave the control and management of the force in the hands of the magistrates of the county in which it may be established - though such a system may not be so effective as if it were conducted on the principle of one central head. (Lord John Russell, First Reading of the County Police Bill, 24 July 1839, *Mirror of Parliament* (1839), V, p. 4262)

The unpaid and independent magistracy directing the civil force is an institution, by which station, property, character and intelligence, under the control of equal laws, are engaged in the defence of people of whom they form a part, against violence and injustice from whatever quarter it may be offered. It is proposed to establish a body of men, who shall be among the people but not of them, to replace the old influences by that which I will venture to call a new species of aristocracy - of commissioners, agents, and police, creatures of the government, in whom all knowledge of law and all force in its execution are to be vested. (Anon. [Sir Henry Halford, Leicestershire MP and county magistrate] *Some Remarks on The Report of the Constabulary Force Commissioners and upon the Acts Founded On That Report. Respectfully Addressed to The Magistrates of the County of Leicester. By A County Magistrate* (Leicester, 1840), p. 66)

The County Police Acts, 1839-40

At the beginning of 1839, while Chadwick was still labouring over the Royal Commission Report, Lord John Russell turned to a new strategy: to capitalize on demands for rural police reform emanating from county Quarter Sessions. We observed that Shropshire had shown a keen interest in county police reform dating to the early 1830s. Its Quarter Sessions

communicated with other counties,[1] formed a police committee in 1837 and petitioned Parliament at the beginning of 1838 for legislation to enable them to form a county police.[2] In December 1838 Shropshire Quarter Sessions passed a new resolution, the 'Salop Resolution', which read:

> That in consequence of the present inefficiency of the Constabulary Force, arising from the great increase of population and the extension of the trade and commerce of the country, it is the opinion of this Court, that a body of constables appointed by the magistrates, paid out of the County Rate, and disposable at any point of the Shire where their services might be required, would be highly desirable, as providing in the most efficient manner for the prevention as well as detection of offences, for the security of person and property, and for the constant preservation of the Public Peace.

Since 1835 Russell had sought and taken advice on the subject from numerous people and bodies,[3] but without ever committing himself fully to any particular plan. The Home Office's endorsement of the 'Salop Resolution' signalled that Russell had made a decision to work with the established grain of county government – to employ a *bona fide* provincial initiative to attempt to foster a national consensus among the gentry via the justices of the peace. Russell made it the basis of a Home Office circular and sent it to all Quarter Sessions chairmen in the country with a demand that it be discussed by their courts.[4] This had a number of advantages: 1) It brought the landed class to a council on the matter; 2) It presented English justices with an initiative emanating, not from the government, but from their brother magistrates; 3) The proposal made no mention of any involvement of the Metropolitan Commissioners or a dominant role for the government in appointments or finance. The Shropshire concept could thus be presented as less threatening and divisive than the recommendations of Chadwick and the Royal Commission – or any proposal that came from London. In the spring of 1839, the 'Salop Resolution' was discussed in a number of counties; the results were generally gratifying.[5]

The 'Salop Resolution' was followed by a similar display of enthusiasm in industrial Lancashire. Russell communicated with the Lord Lieutenant of Lancashire, the Earl of Derby, enclosing letters from Sir Richard Jackson, the military commander of the Northern District, complaining of the insufficiency of the constabulary throughout the North for the preservation of order and 'of the employment of the military in police duties'.[6] Russell presented the Lancashire justices with the 'Salop Resolution', and proposed that Lancashire create a county police force to be formed and controlled by the magistrates.[7] Derby then called a special meeting of the county JPs in Preston at the end of January to consider the desirability of 'an efficient constabulary force, placed under the direction of the magistrates, and kept in a constant state of discipline'.

The Lancashire justices were in a receptive mood. At that meeting,[8] the discussion was dominated by Sir Peter Fleetwood (Tory MP for Preston), the Revd J. T. Horton (JP for both Lancashire and the West Riding), T. B. Addison (chairman of Preston Quarter Sessions) and J. F. Foster (chairman

of Salford Quarter Sessions), all of whom emphasized the need for an
improved police. Two resolutions were passed:

> 1) That it is the opinion of the magistrates of this county here assembled, that a
> more efficient and well-regulated constabulary system would add to the
> uninterrupted enjoyment of the liberty of the subject, as well as to the security
> and protection of person and property.
>
> 2) That this meeting invite the attention of the public to the advantages derived
> by all classes of persons, both in London and the rural districts round it, from
> the improved system of police there established, in confirmation of their
> opinion [above expressed].[9]

There was no dissent on the issue of the need for a more efficient police
under magisterial control; the only disagreement was over whether they
should demand that the government contribute half the cost. The main
arguments in favour of the motion were: the threat to public order from the
populous manufacturing centres; the need for better protection for
property; and the total inefficiency of the existing constables for these
tasks, especially the maintenance of public order. The main stumbling
block was seen as the expense of a properly organized paid police; but the
meeting accepted the arguments of Horton and others that even that great
expense might be justified over the long term; the cost of a new police, they
argued, would be more than made up by the reduction in the property
losses from crime and the diminished expenses of prosecution and
imprisonment. Like Shropshire, the Lancashire JPs translated these views
into concrete action; they were one of the first Quarter Sessions to adopt
the County Police Act after its passage, and they established the largest of
the county forces.[10]

Two other counties in a hurry were Gloucestershire and Essex.
Gloucestershire sent its own memorial to Parliament in April 1839 praying
for a rural police, and another to the Home Secretary to the same effect. At
Easter Quarter Sessions (1839), Essex considered together the text of the
Constabulary Force Commission Report, and the resolutions of Shropshire
and Lancashire. The 'Salop Resolution' was approved unanimously and,
four months before any national legislation, Essex began discussing the
structure of a county police force.[11]

Russell's focus at this time was the orchestration of the opinion of the
landed class. He circulated to all the other English Quarter Sessions both
the Salop and Lancashire resolutions. Easter Quarter Sessions meetings all
over the country thus had before them these two public expressions of their
brother magistrates in favour of establishing county forces. In addition, like
Essex, many of them had just received the recently published text of the
Constabulary Force Commission Report.

There is no evidence that Russell had originally intended to introduce
legislation at any time in 1839;[12] but the Chartist disturbances of the
summer of 1839 presented a window of opportunity for Russell and the
Whigs to fulfil a longstanding objective of government, stretching back to

Melbourne's abortive bill of 1832, or even perhaps to Peel's last days as Home Secretary.[13] In late July 1839, at the very end of the parliamentary session, Lord John Russell introduced, and rushed through Parliament, a hastily and poorly drafted bill, which became the County and District Constabulary Act 1839,[14] the foundation of provincial policing legislation in England until, arguably, the consolidations of the 1960s and 1970s. It was accompanied by three other emergency bills, triggered by the Chartist disturbances, providing government-run police forces for the towns of Birmingham (which had just experienced the Chartist 'Bull Ring riots' in early July[15]), Manchester and Bolton. Because of Chartist strength in these towns and the multiplicity of local government authorities, they were considered vulnerable to disturbances.[16]

Russell's rhetoric in presenting the County Police Bill is interesting. He stressed its compatibility and continuity with previous public-order legislation, and thus its innocuousness. His speech introducing the bill (and the preamble to the printed bill itself) recited the provisions of the Special Constables Act, with which it had nothing to do. The point was to emphasize that just as the Special Constables Act reserved to the *justices* the responsibility of organizing bodies of special constables in times of tumult when 'the ordinary officers ... are not sufficient,' it was now to be left to them to certify the insufficiency of the old constabulary for the day-to-day protection of persons and property and organize a permanent, paid, new constabulary.[17] The measure could thus be presented merely as an *augmentation* of the magistrates' powers. Secondly, he stressed the dangers of over-reliance on the military in disturbed periods, and the recent complaints of field commanders regarding threats to the morale and discipline of the troops. Only then did he advert to the Constabulary Force Commission, but as a prelude to assurances that he had rejected its police plan.[18]

> There were general reasons, affecting the state of the country as respected its police, that induced the Government to take the subject into consideration some time ago, and to give great attention to the report made by the commissioners relative to the constabulary. But when the report was taken into consideration, the remedy proposed by the commissioners, though it might be the best that could be devised with a view to the establishment of a general system of police over the whole country, appeared to the Government to be too large and extensive to be applied at once to the country, and likewise to go beyond the necessity of the present case.

But there were now reasons requiring urgent legislation:

> The meetings which had lately taken place, and the riots and alarm consequent upon them, had increased the demands for the military force ... These were the reasons which made him think it desirable to introduce a bill on the subject, not as a general measure, because if he brought in a general measure, he thought he should be proposing the establishment of a paid and regular police in many districts where at present it was not wanted ... but there was a necessity that magistrates in certain districts should be enabled to appoint a constabulary regularly organized, and permanently maintained by them.[19]

In Quarter Sessions debates during the year which followed, on whether or not to adopt the County Police Act, some county JPs revealed that they thought that it had been intended to be simply a *temporary* measure, to deal with the immediate emergency, rather than a permanent Act for county police forces.[20] However, the government intended it, from the start, as a *permanent* measure; although, because of its hasty drafting, they had to pass an amending Act a year later, in August 1840.[21] As Henry Halford MP, an opponent of the bill, later pointed out: 'It met with but little opposition, nor was much discussed; a sense of danger on account of the prevalence of Chartism, and the disturbed condition of certain districts at the time, combining with a thin attendance to facilitate its progress through Parliament.'[22] In this atmosphere of urgency, there was very little serious scrutiny of the bill's provisions. In the Commons, the bill was attacked by a number of Radical MPs and by some right-wing Tories, including Disraeli; in the Lords, only Earl Stanhope dissented from general support for the bill.[23] Miller's analysis of the voting pattern on the 1839 legislation shows that it drew support from the broad centre of contemporary politics and across party lines. Some opposition came mainly from right-wing or paternalist Tories, but primarily from the Radicals who, on this issue, largely deserted the government.[24] By the end of August, it had received the Royal Assent and become law.

A Norfolk magistrate who opposed the Act later (and inaccurately) stated that the Act was:

> framed from the Constabulary Report, which put the ... police under the orders of Government ... The money was to be raised without the controul [sic] of the magistrates, for the support of the police, and in no respect was the Secretary of State to be limited, he was to do what he pleased ... If they let Government do all this then it would follow that the men would consider themselves officers of the Government, and not care ... about the instructions of the magistrates.[25]

Edwin Chadwick, disappointed by the government's failure to follow the recommendations of the Constabulary Force Commission Report, wrote more accurately of the measure:

> In settling the provisions of the county & district constabulary bill the Government was guided mainly by what it considered the popular opinion, or what would be acceptable to parliament. In settling the measures which they should recommend, the constabulary force commissioners were guided mainly by the consideration of what by such experience as could be obtained was found to be the most efficient for the attainment of the objects of a constabulary force, not merely for any present emergencies but for all times, so far as could be foreseen.[26]

The County Police Act differed in two significant ways from the recommendations of the Constabulary Force Commission. First, it did not set up a single, national force under Police Commissioners; nor did it *compel* the establishment of any police forces at all. It was, instead, a *permissive* measure, which permitted the counties to establish their own separate forces if they wished. Five JPs in any Quarter Sessions could give

notice of a motion to adopt the Act. If Quarter Sessions passed the motion, they would activate the machinery for setting up a police force for their county by reporting to the Home Secretary 'that the ordinary Officers appointed for preserving the Peace are not sufficient for the Preservation of the Peace, and for the Protection of the Inhabitants, and for the Security of Property within the County'.[27] On the other hand, if Quarter Sessions were content with their existing policing arrangements, there was no obligation on them even to debate the Act, let alone to adopt it. (In this respect, the Act resembled the circulated Shropshire Quarter Sessions motion more closely than it did the recommendations of the Commission.) The Act made no provision for any form of central or government control over the county forces which would be established, other than the very mild one of requiring that the Home Secretary approve the Quarter Sessions' choice of chief constable and issue uniform regulations for the various county forces (s. 2). Once the chief constable was appointed and approved, the appointment of policemen, and running of the force, were to be matters for him alone, under the authority of his Quarter Sessions (ss. 4-7). The Act limited the number of police who could be appointed for each force, to a maximum of one for every thousand inhabitants of the county (s. 1), but it did not specify a minimum size for each force.

The second difference lay in an issue central to all discussions of police reform from 1829 onwards – how would a permanent force be financed? Peel's Metropolitan Police were paid for by national taxpayers, out of general revenue, and by local ratepayers; Melbourne's 1832 police scheme would have been funded by a local police rate; the borough forces, set up from 1835 onwards, were paid for by borough ratepayers, who – unlike county ratepayers – at least elected the councils which spent their money. The County Police Act made the expense of establishing and running a police force exclusively a county charge. There were two reasons for settling on this course, one of them political, the other dictated by practical necessity.

One reason for specifying local financing was to facilitate the measure's acceptance by sceptical justices who feared (or said they feared) a gendarmerie controlled from Whitehall. Considering the fraught nature of the issue of rural policing, the object was to make the County Police Act as small a political target as possible. If the police were paid by the county, the government could claim little in the way of control over appointments, deployment or other operations. This was consonant with Russell's strategy of making any measure as palatable to the landed class as possible. The County Police Act was thus deliberately crafted to appear as constitutionally safe as possible, but, in the process two major difficulties were created: 1) it led to genuine concern on the part of many justices about the degree to which the costs would fall upon the land, and 2) it exposed magistrates to the full fury of the ratepayers. Between them, these factors probably accounted for the failure of adoption of the Act in a number of counties.

A second reason was the extreme financial embarrassment of the Whig government in the late 1830s. It could take no steps that would further

strain a budget unbalanced by increased spending on the colonies, defence and a £1-million loss to the treasury consequent upon the introduction of the penny post.[28] Chadwick had initially recommended that the government pay one-third of the total cost, the rest to be left on the county rate; this was whittled down by Russell to one-quarter; but when the County Police Bill was introduced, it contained no government subvention at all.

The 29 sections of the 1839 Act set out very little of the financial arrangements for running a new county police force, simply stating that the salaries, allowance and other expenses of the new forces would be paid out of the County Rate (ss. 20-21). The amending Act of 1840 was introduced to meet many complaints from Quarter Sessions about the workings of the 1839 Act.[29] This Act spelled out more fully the financial details, including making provision for: a specific Police Rate, separate from the County Rate (ss. 3-5); a Superannuation Fund for the policemen (ss. 10-11); the power to provide station houses and strong rooms for the force (ss. 12-13); the power for borough forces within the county to consolidate with the county force if they wished to do so (ss. 14-15); and the power of the chief constable of the new county force to take over local forces established under the Lighting and Watching Act or a local Act (ss. 20-22). The Act also allowed for a county which had established a force to discontinue it (s. 24); however, this could only be done after six months' notice had been given and with a three-quarters majority of the Quarter Sessions and the consent of the Home Secretary – conditions which made it virtually impossible for any county which had once established a force to abolish it thereafter.[30] The most important provision, for a number of counties, was the one allowing Quarter Sessions to divide their counties into a number of police districts, to be rated at different amounts (ss. 27-8).[31] This was designed for counties which contained substantial urban or industrial areas, where the rural JPs tended to claim that crime and disorder were largely an urban and industrial phenomenon, and that it was therefore unfair to make the farmers pay high police rates to deal with them. Differentially rated police districts would enable such counties to make the areas of supposed high crime generation bear a higher share of the police costs.

Chadwick had already been warned about the potential danger to the success of a Police Act, of the issues of both cost and centralization. Edward Gulson, the Poor Law assistant commissioner who had told him in October 1836 that provincial 'Tory Lords' were moving towards support for a rural police, had also emphasized the importance of the cost of a police force to ratepayers in influencing county opinion:

> It appears to me that the great point by which to ensure a general conviction in favour of the measure is *thro' the pocket*. You may work upon a large portion of *the intelligence* of the country by enforcing upon them a sound principle and adapting it to a good & useful purpose – but I have seen quite enough to convince me that *the great majority of the mass* are much more easily convinced *through their pockets* – than their *heads* ...[32]

Another assistant commissioner, Sir Edmund Head, wrote to Chadwick after he had seen proofs of the Commission Report, expressing strong support for a police force under central government control. If districts objected to the principle of central control, he told Chadwick, they should be coerced into accepting it, by the threat of making them financially liable for all injuries to property committed in districts which refused to accept such a police. 'I cannot help thinking that something of this kind might frighten rural districts into anything – work on the *farmer* through his breeches pocket'.[33] Another of Chadwick's correspondents, the Hertfordshire magistrate William Blake, who was struggling to get his Quarter Sessions to adopt the County Police Act, wrote in 1840: 'Expence [sic] & Centralization are the great Bugbears that we have to meet & they would be too powerful even with some of our own Supporters'.[34] All three of these men draw attention to the importance, in the county opposition to a new rural police, of 'the pocket' or 'Expence', together with opposition to centralization. In the event, a good number of Gulson's 'Tory Lords' came round, but many Tory squires and Head's 'farmer' were to be heard from when the counties began to debate the measure.

The issues, 1839–41

The County Police Act left it entirely to the justices in county Quarter Sessions meetings to decide whether or not a county police would be implanted. From October 1839 through 1841, animated, often heated, debates took place all over the country.[35] Magistrates flocked in unprecedentedly large numbers to their Quarter Sessions. Substantial debates (above all in counties whose JPs were evenly divided on the issue) ensued, offering useful insights into contemporary views about order, police and crime, and the proper scope of and limits upon both county and central government. Much of the rhetoric deployed in the debates revolved around the following major issues. Each justice finally cast his vote on the basis of some permutation of them in his mind.

Crime and the 'migration thesis'

The discussions at Quarter Sessions saw a debate over the meaning and significance of criminal statistics and the concept of prevention. Armed with national figures, Chadwick's arguments in the Constabulary Force Commission Report and information drawn from local gaol calendars, proponents pointed to inexorable rises over previous decades in criminal committals, and maintained that crime was increasing faster than population. This demonstrated, in the words of the chairman of Worcestershire Quarter Sessions, 'an imperious necessity' to create 'an adequate and efficient body of police to check this frightful increase ...'[36] The rise in crime was accompanied – again because of the inadequacy of the old constabulary – by an intolerable level of impunity. Proponents

believed that what we would now call the 'dark figure' of crime was large and rising, and that an unacceptable number of known crimes were not being prosecuted. When 'there were depredations committed in which the offenders were not brought to justice and convicted,' this proved 'that another description of Constabulary Force was required'.[37] John Balguy Esq., chairman of Derbyshire Quarter Sessions asked:

> Was it likely that constables who had their own business to attend to – who were connected with the parish – aye and with the beer shops ... Was it probable, then, that constables – idle, indolent, and indisposed to the work – would be as efficient as a well-trained and well-organised force, whose whole time would be devoted to this work?[38]

The Quarter Sessions debates ventilated some important questions regarding rural crime. What would be the benefits and costs of a major assault on the mass of hitherto unprosecuted petty crime which, all sides presumed, a new police would mount? Would such an expensive effort really produce positive effects, and, if so, how positive? And would the costs incurred be worth the effort? Those who had absorbed Chadwickian criminal arithmetic argued that to arrive at the true number of criminals and the true costs of criminality, one had to go beyond the official statistics. To arrive at the number of criminals, the number of commitments had to be multiplied by a factor of five. To compensate for the 'take' of receivers, one then multiplied an estimate of the 'earnings' of each thief by another factor. This gave the cost. When this methodology was applied, the 'true' value of losses could be made to appear astronomical, and the cost of a police by contrast very reasonable.

Opponents maintained that in addition to the costs of a police one had to factor in the costs of considerably more prosecutions, prisons and prisoner maintenance. Would it then be worth it to spend such huge sums on the repression of the more minor sorts of crimes? This was the conclusion of the Gloucestershire justice and penal reformer T. B. L. Baker, who had also been involved in reforming policing experiments in his district: 'It is true that this [projected] force would prevent much crime, but it is also true that very many delinquents would be brought to justice who now escape, and therefore it is possible that our prisons would be as full, and consequently our expences as great as they now are.'[39] And, he added, is it worth the expense 'if we consider the small value of nine tenths of the property stolen ...'?

A great deal ultimately rested on the persuasiveness of the claim that a police could prevent crime. Even assuming the validity of the prevention effect (as Baker did), opponents among the justices had doubts whether an affordable force would be large enough to produce that effect. If, as one Suffolk justice said, there was to be one constable for three thousand in the population, each man would have to cover five parishes. Since 'efficiency was one of the great arguments of recommendation', he continued, 'how could such a force be efficient?' And if it proved inadequate, would there

not be future demands to double or treble the force? What would that cost? And would that expense be equal to the evil to be repressed?[40]

Other justices questioned whether the preventive principle was applicable to agricultural districts at all. The chairman of Dorset Sessions conceded that the police might be effective in London, but 'the prevention of ... poultry stealing, and many other offences could not be effected by any ... amount of constabulary force'.[41] In these discussions, the governors of the English countryside were attempting to imagine what the effects of an experiment would be in advance of the fact. Over one hundred and fifty years later the question of the impact of the police on crime is still being argued.

In October 1837, the Revd Dr Acworth, of Rothley in Leicestershire, demanded of Lord John Russell that the government legislate on a rural constabulary, observing that:

> in every provincial town a police is now established who are as alert as the metropolitan, and the consequence has been that the bold and lawless who were accustomed to commit their depredations in the town, have been driven into the country where they pursue their projects of spoliation without fear of discovery or apprehension. In many of the rural parishes of which my own is one, situated half way between the two large manufacturing towns of Leicester and Loughboro', there is not spirit enough to create a force which would [arrest?] these thieves, or check their depredations.[42]

Chadwick, as we have seen, used this argument as a major theme of the Constabulary Force Commission Report;[43] so did other advocates of a rural police. Its essence was the claim that once a new police force had been established anywhere – in London, Liverpool, Manchester, any town, or all or part of an adjacent county – it would drive the criminals into the neighbouring unpoliced, rural areas. This was advanced as a sort of 'domino theory' of necessary police growth: the establishment of any one force in the country would make new forces necessary for all adjacent areas, and, eventually, for the whole country. This argument was widely employed. It was used by Sir Baldwin Leighton and other magistrates in Shropshire to argue successfully the need for a police for that county. Trafford Trafford and the JPs of Cheshire had also deployed it as a major reason for demanding the Cheshire Constabulary Act from Parliament in 1829. On the borders of the Metropolitan Police District, it was believed that the London police caused 'increased depredations ... within a circle from five to ten miles beyond their precincts'.[44] John Pakington MP, Chairman of Worcestershire Quarter Sessions, in moving the resolution to adopt the County Police Act, said:

> It was a lamentable result that the great and unquestioned increase of crime should be caused by the vicious characters who were driven from the towns to the rural districts, by the operation of the detective power in cities, and comparative impunity afforded to plunderers in the rural districts by the incompetency of the old parochial constables.[45]

How real this phenomenon was is immaterial.[46] Nearly everyone, proponents and opponents of the County Police Acts alike, believed it. A pro-police Buckinghamshire Tory justice argued:

> In no well regulated community should there be two systems of police – one astringent and the other lax – but that would be the case here, if this county refused to establish this force, for, it being in operation in the adjoining counties, the tide of crime would flow out of them into those where it was not established.[47]

Thomas Law Hodges, one of the leaders of the anti party on the Kent bench, conceded that if adjoining counties adopted the rural police, Kent would become a 'cul de sac' for the reception of villains from Surrey and Sussex and would then have no choice but to adopt a police for themselves.[48] George Bankes of Dorset, another opponent, expected that if nearby counties formed police forces 'many idle and disorderly persons driven from those counties, would take refuge in this,' and Dorset might have to reconsider.[49]

Socializing the costs of crime and disorder

Proponents of the Acts spoke of the desirability of socializing the risks and costs of crime and disorder – the idea that, whether one lived in a rural or industrial area, small town or village, everyone should bear the responsibility and cost of effective law enforcement within the county boundaries. A Suffolk justice, Henry Wilson, asked why the whole [county] community – in other words, all ratepayers – should not contribute to the security of all. He conceded that some districts were more crime-prone than others, but 'do parishes not producing any lunatics object to contributing to the county lunatic asylum?'[50] The Bromley magistrate J. Behrens put the argument this way: The justices

> should not do their duty to the poorer inhabitants ... if they did not give them the protection which they now sought for in the establishment of a paid police. ... It was not for themselves that this ... was so much required, as they had men and horses at their command, and could send out in all directions to give information whenever a robbery was committed upon them. It was for the poor man more particularly this protection was necessary. ... Crime against the poorer classes was increasing ... there were gangs of delinquents prowling about the country, and took the opportunity, whilst the labourer was absent, to break open his home ... or rob him ...[51]

There were other variants on this theme. Some argued that the poor were often unable to prosecute because of the extra expenses involved in paying constables; a police would help them to obtain justice presently denied. Others – including many clerical justices – thought that the poor would benefit immensely from the control a new police would exercise over the beerhouses and other low resorts.[52]

Many justices might have accepted the notion of shifting more of the costs of criminal justice from the individual – especially the poor individual

– to society. But socializing the costs of criminality and disorder could also imply something more ominous: forcing agricultural districts (through the mechanism of the county rates) to share the costs of urban criminality with the towns. Many justices pointed to the different proportions of committals from different parts of the county and stated that it was 'unfair to make one part of the county pay for the disorders in another part'.[53] Some powerful justices maintained that, even in uniformly agricultural counties, no district should subsidize any other: '[T]hose who wanted paid constables should pay for them, and not call on other parts of the county ...'.[54] The author of this remark was the Duke of Richmond, whose views essentially settled the issue in West Sussex, *against* adoption, until 1856. In West Suffolk, Lord William Poulett expressed it thus: 'The part of the county in which he resided was thinly populated, and if he should be obliged to pay any equal proportion with those who lived in populous districts, and not derive so much benefit from it as they would, he should consider it an unfair proposition.'[55] S. C. Whitbread's riposte in Bedfordshire was 'that they should recollect that they were *magistrates for the whole county* and not for any particular division'.[56]

Lord Wharncliffe pointed out, in the West Riding of Yorkshire, that 'the rural districts paid a great deal more towards the county rate in proportion to the population than the manufacturing districts'.[57] These were difficult arguments to combat: justices were not only debating principle, but were also carefully counting the cost, worrying whether they might return home to a swarm of angry tenants, or trying to calculate finely *cui bono* – who might end up subsidizing whom under the proposed scheme. This argument was especially difficult to counter in debates which took place before the amending Act of 1840 permitted Quarter Sessions to divide counties into differentially rated police districts. But even then, in counties such as the West Riding, where lines between urban, populous out-township and rural areas were hard to draw, the concern then became how to draw them so as to create purely rural rating districts – a problem that never could be resolved.[58] County policing foundered in the West Riding on this rock.

In addition to its implications for the parish-based system of local government and the principle of amateurism in the enforcement and administration of the law, the County Police Act also marked a break with the English tradition of individual responsibility in criminal justice matters. Not only had the individual been ultimately responsible for setting the criminal justice system in motion, but he/she also had to play the major role in finding suspects, gathering evidence, marshalling witnesses, laying charges and manipulating the prosecution. This had long been considered both right and natural,[59] and accounted for the popularity of Associations for the Prosecution of Felons. Proponents of the County Police Act now argued that relieving *all* individuals – not just those who could afford to join an Association – was one of the chief virtues of adopting the Act. George Warry, a Somerset gentleman, stated: 'My

contribution to the county police would be far less than the expense of a private watchman.' He complained of damage to his woods by vagrants and felt the want of a police to whom he might address his complaint. His outlook was similar to the Suffolk justice who thought that every parish and district within the county should contribute to the watching of all others.[60] The County Police Act divided justices between the old, comfortable notion that individuals (and, by extension, localities) should ultimately depend upon themselves, and the new idea of the desirability of socializing the costs of crime and disorder.

The 'constitutional' issue and civil liberties

The argument from the constitution was, in part, an emotional state, an expression of fear of the unknown or of partisan mistrust, but it proceeded from a country party ideology with a long pedigree and still had resonance in some quarters in the 1830s and 1840s. A few politicians such as Disraeli, and a number of magistrates, argued that a rural police in itself threatened civil liberties. Disraeli warned that it presaged not only the marginalization of the magistracy, and an attack on the rural middling ranks, but an assault on the poor cottager as well. His point was that if the justices delivered the poor to the tender mercies of the police, they would lose the moral right to exercise legitimate authority. When England came to that pass, said Disraeli, 'he would be prepared to support with rapture the motion for stipendiary magistrates and elected [county] boards'.[61]

The *Durham Advertiser* greeted the adoption of the County Police Acts with the following:

> We have no doubt that our readers would be astonished at the unanimity which prevailed at the meeting of the county magistrates, convened for the purpose of adopting the French system of police. ... the measure is objectionable on constitutional grounds, inasmuch as the police, whatever they may be at the outset, will inevitably degenerate into government spies. ... There can be no doubt that their numbers will be augmented, and that ere long we shall have two hundred policemen prowling about the county, whose principal duty it will be to act as spies upon the actions of their neighbours, ... From this it will be but a step to the passport system, when no one will have the liberty of travelling a few miles from his own door, either upon business or pleasure, without first being at the trouble and expense of obtaining a licence to travel from a government-paid magistrate, or commissary.[62]

This line drew on the somewhat different argument that the County Police Act was unconstitutional because it created a police force *in the hands of government*. Hearkening back to older political struggles, it was argued that a police answerable to the central state was a form of standing army, and therefore prohibited. This was an argument that had been deployed against proposals for a police from the moment they were propounded.[63] In 1839–40, it appeared most frequently in the provincial press.[64] The Duke of Newcastle told the magistrates of Nottinghamshire:

If you adopt the new police measure, you will be proceeding to overthrow our ancient scheme of local jurisdiction, as established by the wise Alfred, and transmitted to us by our Saxon forefathers, under which we have long flourished prosperously, and enjoyed greater freedom and security than any nation upon the earth. Now, what are you to substitute in the place of this tried and admirable system? Surely you will not adopt the Frenchified system ... If you do, you sacrifice your free institutions, and you establish a rule of force and intrigue, instead of a popular control exercising a great and salutary moral influence.[65]

A Leicestershire justice wrote:

The existing system provides, in theory at least, for the due and temperate administration of the law, under the influence of the enlarged views, the strict integrity, the just application of general principles resulting from liberal education, and which are or ought to be the attributes of station and character; while it trusts for its adequate execution to the common ties, pursuits and sympathies, by which Magistrates and Constables alike are bound in the same interest with the mass of society. The proposed alteration on the other hand assumes that law and society have arrived at a point at which a technical dexterity to be acquired only by special training and education, and a constant vigilance which is incompatible with any other pursuit, are absolutely necessary for protection of property and preservation of the public peace. The old influences to which we have been accustomed to trust, are to be superseded by the pledges of stipendiary duty, regulations from the Home Office, and the enforcement from thence of military discipline.[66]

Although this sort of rhetoric was still heard at Quarter Sessions in 1839–40, it was spelt out most plainly by pamphleteers, leader writers at *The Times,* maverick Tories such as Disraeli, traditionalist agitators such as Richard Oastler[67] and the partisan provincial press. Most of the magistrates had already moved beyond it. The bulk of Tory justices seemed unresponsive to mere appeals to the constitution, and many Liberal magistrates seemingly no longer even understood them. J. Hammond, a Liberal (Kent) justice was 'at a loss to believe how an act of parliament could be unconstitutional'.[68] J. B. Sharpe, another Liberal (Buckinghamshire) magistrate, was utterly bemused, asking 'what could be more constitutional than an act of parliament that had received the sanction of the three branches of the legislature?' Col Rowan, probably a Conservative himself, wrote a heavily ironic letter to Chadwick mocking these concerns:

It occurred to me and I stated to [Russell] that one means of getting over the humbug of danger to the liberties of the Country would be to give the power *absolutely*, of dismissal [of policemen] to the Magistrates. Thus if the Secretary of State should take it into his head to endeavour to enslave a whole County (which is not at all unlikely after paying 20 millions to enfranchise the *Niggers*) by sending six or seven additional Police Constables 'armed with a bare bodkin' into that County, the Magistrates might, seeing the immensity of the danger, immediately dismiss the said six dangerous individuals and thus frustrate the base attempt. It is impossible to maintain gravity on the subject. ... What a pity it is that all men who are not Rogues, should be fools. Present company excepted.[69]

Proponents could rather easily counter the less sophisticated varieties of constitutionalist rhetoric by referring to the text of the Act to show that the powers of the county magistrates were large and those of the Home Secretary severely limited. Whatever force the arguments of the Duke of Newcastle, Sir Henry Halford or Richard Oastler possessed was really derived from something else. Opponents saw the County Police Acts as part of a wider assault on the existing system of county government, and argued that it heralded the future despoliation of the magistracy.[70] Numbers of uncommitted justices who were left cold by a mere rhetorical appeal to Alfred, cared not a whit for perpetuating the control of parish élites over policing and were indifferent to the civil liberties of cottagers, were nonetheless very interested to know whether the Acts might, in some way, lead to the future diminution of the magistracy. This gave them pause.

The relationship of the magistracy to the centre: the bugbear of centralization

The issue of centralization was closely associated with the constitutional argument, and overlapped with the concerns over the future of the magistracy and the established pattern of county government. Much the same traditional rhetoric (including the anti-French prejudice) was employed, and issued from the same people. The Revd D. R. Currer, opposing a police for the West Riding, stated that:

> he objected to it on the ground ... that it was quite of a military character, and would have a tendency to put the people of this country under a surveillance similar to that which he had witnessed on the continent, where every man must have a passport to show where he came from and where he was going to. The establishment of such a system here would be a great infraction of the liberty of the subject, and on that ground he should oppose it. The system of centralization on which it was based was highly objectionable ...[71]

Gulson had warned Chadwick in 1836 that 'the Tories would be very averse to the existing government having in *their* hands so formidable an engine as a general police'.[72] This argument was particularly used by some Tories who were not necessarily opposed to the idea of a police force as such, but who feared that a Whig central government might somehow use it for nefarious purposes.[73]

We observed that in drafting the County Police Act, the government soundly rejected Chadwick's centralist model in favour of a much weaker, less coercive, and decentralized scheme. Some important Tories such as Wellington were reassured by this, but this did not allay the fears of the some of the backwoods gentry. Opponents of the Act could represent even Quarter Sessions' control of a police force as too great a degree of centralization at the expense of Petty Sessions, since much of the power in Quarter Sessions lay with the chairman and the core justices who dominated the key committees. Such critics might accept police forces which they could control directly through Petty Sessions, but reject one

under the control of Quarter Sessions. Some argued that the 'centraliza-
tion' contained in the Act stemmed from the Home Secretary's power to
draft regulations and veto a county's selection of chief constable; these were
the mechanisms whereby the government would actually control the police
whatever the legislation said on its face about the powers of county justices.
A few magistrates had also clearly not read the legislation and had it in their
heads that the Act embodied the recommendations of Chadwick and the
CFC. For some justices, the new figure of the chief constable seemed
mysterious and ominous. W. Webster won 'loud applause' when he
informed the Derbyshire Quarter Sessions that the Act which it was
proposed should be adopted was unconstitutional. It took the power out of
the hands of the magistrates, and lodged it in those of 'the great chief
constable, and through him directly in the hands of the Home Secretary of
State'.[74]

Like the constitutional argument, with which it substantially overlapped,
this argument also seems to have been of declining importance and
credibility by 1839. There was still strong suspicion in the provinces of the
centralizing schemes of an over-mighty government, but not many JPs made
this the main ground of their opposition to adopting the County Police Act.

Implications for local government

The County Police Acts appeared to imply a major wrench in established
patterns of local government. It contemplated stripping the village notables
and the parish system of their roles in appointing constables. This raised in
the minds of some justices a more general concern about the future of the
general principle of amateurism in *county* government. If the justices voted
to strip the parish notables, could not the same be done to them by the
government? The analogy was disturbing and suggested an unsafe
precedent. A Kent gentleman said:

> He believed that if the provisions of those acts were generally adopted, before
> many years a most decided alteration would thus be made in the administration of
> local justice. . . . He believed that if they now for the sake of expediency, admitted
> the principle of those acts, a salaried magistracy would be sure to follow.[75]

What adoption of county policing might augur for the future of the
unpaid magistracy was an important and serious concern. It touched the
interests of the whole of the landed class, not merely of its most
traditionalist spokesmen.[76] Judging from their votes, the cry of danger to
the magistracy did not persuade most Whig/Liberal provincial gentlemen,
but it was an important source of division within Tory ranks. Wellington
had been much exercised over the issue, but interpreted Russell's police
bill as a slap in the face to Chadwick and the centralizers. Lord Wharncliffe
in Yorkshire advised his fellow justices to adopt the Acts because they were
the surest way of *preserving* the future viability of an unpaid magistracy:

> It was said that [the measure was] the commencement of a system to do away

with magistrates ... Supposing they refused to establish this force, and a disturbance should arise in any particular district. Would not the government have a plea to say that the magistrates were not doing their duty [and then appoint] another description of magistrates who would be both able and willing to cooperate with them in upholding the law?[77]

Lord Wodehouse undertook the same task of reassurance of Tories in Norfolk:

This act seemed so framed as expressly to empower the Magistrates ... the government had extended considerable power to the Magistracy, and consequently it was not fair to entertain suspicions of them. ... A more important Act had never been passed by any set of Ministers in this country, and opposed as he generally was to their measures ... he should state [that] it was an Act which should have been passed many years ago.[78]

Meeting the argument that adoption of county policing presaged a sea change in the mode of county administration was both easy and impossible at once. Ran-and-file justices could be satisfied on this point after listening to a Wodehouse or Wharncliffe. And yet nagging questions remained. Would the new figure of the chief constable, hired by Quarter Sessions but approved by the Secretary of State, become the stooge or puppet of the latter? And if so, where did this leave the authority of the magistrates, so large on the surface? And if there was to be no patronage for the justices – either at the level of Petty or Quarter Sessions – but all further constabulary appointments were to be left in the hands of the chief constable, what did *this* augur for the authority of the justices?

On the other side were the Disraelis, the Newcastles and the Knatchbulls of the party, who could not be disabused of their suspicions that the Act was a nefarious Whig plot however the text might read on its face.[79] Behind these apprehensions was a sense that the County Police Act expressed a *tendency* towards a greater assumption of control over criminal justice by the central state.[80] One must say that in the deepest sense they were correct about this, and it is no surprise that the antennae of the ultra-conservatives would sense it best. Hence their seemingly absurd arguments that the text of the Act implied its opposite, their immediate strategy of defending traditional local government at all levels, and the support they gave to the interests and protests of the ratepayers.

The relationship of the magistracy with the rural middle classes

[The County Police Act] increases the irresponsibility and authority and powers of Justices. ... it so completely takes out of the hands of the parishes and inhabitants all voice in their own local government and protection that no time is to be lost in adopting it ... We beg to be understood as ... friendly to a better system of county police ... but we ... object in toto to the authority and control being taken out of the rate-payers. Adopt this act, and the only local taxation in which they will have a voice is the highways.[81]

This was the voice of the ratepayer. The farmers, shopkeepers and

country tradesmen hated the County Police Act;[82] they resented being taxed for it and they perceived it as a subtraction from the parish system.[83] As the above quotation makes clear, the blame would fall not only on the government but the magistrates as well. Ratepayers deluged Quarter Sessions with petitions. There were even occasionally mass meetings in East Anglia. Since the ideal of this stratum was ratepayer democracy,[84] they perceived the mode of creation and operation of the proposed rural police as a trespass upon them. A speaker at a Stowmarket public meeting said: 'the authorities demanded that the people should pay ... yet would not allow them to exercise a choice. He ... understood it to be a sound ... maxim, that taxation should be equal with representation ...'[85] Just as a section of the magistracy entertained a certain paranoia *vis-à-vis* the government, many farmers, shopkeepers and others in the middle ranks of rural society had their own paranoia about the gentry. The police issue became a vehicle for expressing their resentment of preserving, and their suspicions that a covert gentleman's scheme was afoot to fasten the costs of gamekeeping on to the public:[86] '... if those magistrates ... do not increase the number of their gamekeepers in a greater proportion than they intend to increase the Constabulary ... the whole of their argument in regard to the moral principles of the measure, must be known by them to be mere trashy cant to deceive us'.[87]

The consideration of the County Police Acts thus brought landed gentlemen face to face with the question of their relationship to the ratepayers, often their tenants in agricultural counties. Forced by a recent statute to transact county business in open court,[88] they could no longer retire to the privacy of the Grand Jury room and conduct business in private. Quarter Sessions, which imposed rates for prisons, county buildings, lunatic asylums and other purposes was elected by nobody. It embodied in the most unambiguous way the principle of taxation *without* representation. Insofar as the decisions of Quarter Sessions (being made by appointees of the Crown) were intended to be for the public good, everyone could agree that in some sense it was virtually representative.[89] But beyond this there were two schools of thought on the issue.

First, there was the notion that it was the exclusive responsibility of justices to discover and enact what was in the larger society's interest. But this could only be done by insulating the magistracy from public opinion. The chairman of East Suffolk Sessions stated: 'Magistrates before whom, and for whose decision this application solely came, had a ... higher duty to perform, both to themselves, the country and mankind at large, than to decide on [the measure's] popularity or unpopularity'. Because in his opinion the County Police Act would act 'for the good and welfare of society', justices should adopt it whatever the ratepayers said.[90]

The other position held that precisely *because* the magistracy was unelected it had a duty to listen to and take into account the interests and representations of those upon whom they levied the rates. The Suffolk clerical magistrate J. H. Groom professed himself 'perfectly aware that the

Magistrates had the power of decision in their own hands ... [but] the opinions of ... petitioners should not ... be left out of sight'.[91] E. B. Denison argued that because justices could not be removed by the people they 'ought to be doubly cautious, what they did in the matter, that they might not irritate the minds of the ratepayers ...'[92] For many of the lesser gentry on the bench, those who would have to go back to their parishes and live intimately with the disgruntlement of their tenants and neighbours, this made perfect sense. The clash between these two views occasionally played itself out in open court, as in Cheshire:

> *Mr Davenport*: it was their ... duty to consult the wishes of the inhabitants, and not impose additional taxes without absolute necessity existed. How had that necessity been shown?
> *Mr Clarke*: there were forty nine magistrates present, and surely they were the judges of the necessity?
> *Mr Davenport*: Not more so than the inhabitants.
> *Mr Ashton, Jun.*: magistrates ought to adopt the act without consulting the townships, for they would never consent. ... If they asked consent, the ill-disposed would never grant it. That was the reason they ought not to consult the people.[93]

Opponents, of course, invariably took Davenport's position. Justices such as E. B. Denison in the West Riding said that whatever boon rural policing might confer on the poor or others, justices were bound to defer to the ratepayers on this particular issue because their lives and property were always more exposed than those of gentlemen. If they were willing to take their chances of being robbed rather than pay the tax, justices should not impose it on them.[94] For ultra-conservatives, solicitude for the ratepayers often amounted to a ploy to torpedo county policing; but many who voted for it also made a show of concern. The great increase in rates justices would have to impose was extremely sobering for all involved. Failure to be seen to listen to the farmers, shopkeepers and other ratepayers was generally thought to be high-handed, tending to a diminution of trust and co-operation between the gentry and the middling ranks – a bad thing.

Efficiency, economy and the county rates

The cost projections for creating and operating a county police were high, but some justices considered the measure cheap because: 1) they believed that the state of crime and disorder contained immense hidden costs dispersed among numerous individuals and public entities; 2) they thought that the remedy was socialization of those costs and the risks of criminal injury; 3) they credited the 'prevention' effect of a new police. According to this view, a decrease in crime, disorder and vagrancy over the long term would result in a lowering of costs generally. These effects would inevitably follow the implantation of the police, and thus the latter would constitute 'a plan of economy to the ratepayers ...'[95] The Shropshire gentleman R. A. Slaney MP used the Constabulary Force Commission Report to argue that

'an efficient Preventive Police would [save money] for it would protect more property from plunder than would pay all the outlay, (hear, hear) besides lessening materially the collateral expenses attending the capture, and safe keeping, and punishment, of thieves and strolling vagabonds'.[96]

Sir John Pakington, the Worcestershire chairman, justified the expense to the county by arguing that it would reduce the number of prosecutions, the fees paid to constables and the plunder of property; the Revd J. T. Horton, a magistrate for Lancashire and the West Riding, claimed similarly that a paid police force would save the county money in the long run, through preventing crimes and diminishing the number of costly prosecutions and imprisonments.[97] Other magistrates were less sanguine. A swingeing increase in the rates *now* was not a minor consideration. Nor was the possibility of a worsening of class relations in rural society that might be caused by imposing the police and the rate. How could one be *sure* that crime could be prevented to the extent enthusiasts for rural policing claimed?

During the 1820s and 1830s county rates had risen greatly, largely owing to increased criminal justice costs. The Act placed the entire cost of a rural police on the county rate, and hence on the occupiers of property.[98] Attempts to rate moveable property, notably stock in trade, collapsed with its exemption by statute in 1840.[99] It was argued that since thefts were committed on chattel property while prosecutions (and the projected police) fell on real property, the burden on the land would be great while the 'prevention effect' remained to be seen. In addition, the method of financing the new police was bound to lead, especially in counties with significant manufacturing, to suspicions that the countryside would be unduly taxed to repress urban criminality.

Mountains of ratepayer petitions, containing many thousands of signatures, were presented in many counties against the establishment of a new police force, and in adopting counties, petition drives demanding the disbandment of the police sometimes continued for years. Although the JPs were not elected officials, many of them were sensitive to such expressions, and keen to avoid antagonizing the ratepayers.[100] Generally speaking, in any county, if the pro-police advocates gave ratepayers time to mobilize their opposition before they pushed adoption through Quarter Sessions, then that opposition would suffice to block a police force. If, on the other hand, they pushed adoption through quickly, before the end of 1839, then any number of ratepayer petitions against would prove too late to reverse the decision. In Derbyshire, for example, the opposition had mobilized by December 1839, in time to contribute to the negativing of adoption. Gloucestershire, on the other hand, was one of the first counties to adopt the Act, in October 1839; by early 1842, the ratepayers, angry at the huge increase in rates which had resulted, had organized well over a hundred large petitions in support of a motion to abolish the force – but it was too late. It was relatively easy to block initial adoption of the Act, but almost impossible to abolish a county force once established.[101]

This objection to the cost of the new forces was more than just a political debating point. Establishment of a county force *did* normally involve a great increase in the county rate in order to pay for it. Gloucestershire established their force at the maximum strength of one policeman to every thousand inhabitants; this gave them a very large county force of 250 men, to pay for which they had to more than double their normal county rate.[102] The issue of expense could unite a number of diverse groups in opposition: crusty old conservative gentlemen, middle-class Radicals and spokesmen for the farmers could all act together on the issue of the local rates.[103]

The ratepayers even developed their own version of the argument from the constitution. What was 'unconstitutional' for them was taxation without representation coupled with the stripping of the parish authorities of responsibility for the constabulary:

> His opinion was that the introduction of a Rural Police was not only unnecessary, inexpedient but unconstitutional. The petty constables ... had been chosen by the people and paid by them, but now the authorities demanded that the people should pay ... yet would not allow them to exercise a choice. He had always understood it to be a sound political maxim that taxation should be equal with representation – that was, the choice of those who paid, should be allowed in the adoption of that for which they were to be a fiscal burden.[104]

Pro-police advocates could find themselves caught in an embarrassing position on the issue of the expense to the county.[105] In most counties, an attempt to cover the entire county (including large, sparsely populated rural areas) with the maximum permitted number of police, would be ruinously expensive (as in Gloucestershire). To appease ratepayer opposition, some of them kept their initial forces quite small, the chief object being to establish the principle, and a force which could be expanded in the future. But this could lead to a county establishing a force ludicrously small in relation to the tasks required of it; Leicestershire, for instance, when deciding to adopt the Act, initially appointed only a tiny 25-man force to police the entire county.[106] Such small forces, distributed over a whole county, would obviously be inadequate to stop riots or other disturbances, or even to provide a normal police presence. This was a strong argument used by the opponents of a police in the West Riding: a new county police would have to be either ruinously expensive or ludicrously inadequate. If the size of the force was limited to keep down expense, then townships would experience an actual reduction in police presence under the county force. Under the old arrangements, each township had the regular presence of two parish constables; under a limited county force, they might be lucky to see a patrolling policeman once a week.[107]

The fact that the County Police Act placed the entire cost of a force on the county's ratepayers was its Achilles' heel. More than any other factor it accounts for the fact that many English counties initially refused to adopt it voluntarily. Even where counties did vote, narrowly, to adopt the Act, many subsequent fights in Quarter Sessions would centre upon the need to control the expansion of the force, and thus the rates. If the government

had initially been able to offer a subvention, the rural police would almost certainly have been carried in a number of counties where the issue was narrowly lost, and possibly even in other counties where it was defeated roundly;[108] but, as we observed, this was hardly possible under the circumstances prevailing at that time.

Outcomes: the pattern of adoption and resistance

Between October 1839 and April 1841, the English counties divided almost evenly on the Act: 21 adopted it for all or part of their territory; another 24 declined to adopt it at all.[109] The debates of this eighteen-month period determined the shape of county policing for a long time. Other counties came under the Acts after the first burst of adoptions in a slow but not steady stream. In the fifteen years between 1841 and the compulsory

Table 7.1 Earliest adoptions of County Police Acts (1839–42)

Counties adopting (for all or part)	Counties not adopting [later adoption]
Bedfordshire (Jan. 1840)	Berkshire [1855]
Cumberland (1 Division only – Oct. 1839)	Buckinghamshire
Durham (Nov. 1839)	Cambridgeshire (County) [1851]
Cambridgeshire [I. of Ely] (April 1841)	Cheshire
Essex (Nov. 1839)	Cornwall
Gloucestershire (Oct. 1839)	Derbyshire
Hampshire (Oct./Nov. 1839)	Devon [in process 1856]
Herefordshire (1 district only – Jan. 1841; abolished 1850)	Dorset [1849]
Hertfordshire (Jan. 1841)	Huntingdonshire
Lancashire (Nov. 1839)	Kent
Leicestershire (Oct. 1839)	Lincolnshire (Parts of Kesteven)
Norfolk (Jan. 1840)	Lincolnshire (Parts of Lindsey)
Northamptonshire (Jan. 1840)	Lincolnshire (Parts of Holland)
Nottinghamshire (Nov. 1839)	Northumberland
Shropshire	Oxfordshire
Staffordshire (for 1 Hundred – Nov. 1839; for whole county – Nov. 1842)	Rutland [1849]
	Somerset [1856]
Suffolk (East) (Jan. 1840)	Suffolk (West) [1844]
Sussex (East) (Apr. 1840)	Surrey [1851]
Warwickshire (1 Hundred only Jan. 1840)	Sussex (West)
Wiltshire (Oct. 1839)	Westmorland
Worcestershire (Oct. 1839)	Yorkshire (East Riding) [1849]
	Yorkshire (North Riding)
	Yorkshire (West Riding)

Sources: Provincial newspapers; County Quarter Sessions records; D. Foster, *The Rural Constabulary Act 1839* (1982), chap. 3; C. Emsley, *Policing and Its Context 1750–1870* (1983), p. 72; T. A.Critchley, *A History of Police in England and Wales* (1967), p. 89; S. Palmer, *Police and Protest in England and Ireland 1780–1850* (Cambridge, 1988), p. 442; R. D. Storch, 'Policing Rural Southern England before the Police: Opinion and Practice 1830-1856', in D. Hay and F. Snyder (eds), *Policing and Prosecution in Britain 1750–1850* (Oxford, 1989), pp. 211-66.

legislation of 1856, the JPs of nine more legal English counties (West Suffolk, Westmorland, Dorset, Rutland, Cambridgeshire [County], Surrey, Somerset, Yorkshire [East Riding] and Berkshire) chose to establish forces.

The first opportunity for counties to debate adoption of the County Police Act came at their Michaelmas Quarter Sessions, in October (or, by adjournment, November) 1839. Nine counties – Gloucestershire, Wiltshire, Hampshire, Essex, Shropshire, Worcestershire, Leicestershire, Lancashire and Durham – immediately adopted the Act for their entire counties at these Sessions, with little or no serious dissent.[110] Four more counties – Bedfordshire, Norfolk, East Suffolk and Northamptonshire – did the same at their January 1840 Sessions.[111] Nottinghamshire voted in November 1839, against stronger dissent, to adopt the Act, but did not finally dispose of the opposition to a county force until April 1840.[112] Three counties voted, in this period, for only partial adoption of the Act: Cumberland resolved, in October, to set up a minuscule force for the Derwent division of the county only;[113] Staffordshire decided, in November, to establish a small force for just the southern division of the hundred of Offlow South (in the south-east corner of the county, adjacent to Birmingham);[114] Warwickshire, in January 1840, did similarly for the Knightlow hundred only.[115]

In twelve counties (Somerset, Berkshire, Kent, East and West Sussex, Buckinghamshire, Hertfordshire, West Suffolk, Lincolnshire [parts of Lindsey], Cheshire, Derbyshire, and Northumberland) adoption of the Act was debated between October 1839 and January 1840, but was either postponed to a later meeting or defeated outright; only two of these counties subsequently set up forces under the Act, in 1840 and 1841. Fourteen counties (Cornwall, Devon, Dorset, Surrey, Oxfordshire, Herefordshire, Huntingdonshire, Cambridgeshire [County], Cambridgeshire [Isle of Ely], Lincolnshire [parts of Kesteven], Westmorland, and the East, North and West Ridings of Yorkshire) did not debate the County Police Act in their Sessions of October 1839 or January 1840. The issue was subsequently debated, but defeated, in six of these – Herefordshire, Oxfordshire, Surrey, and the East, North and West Ridings.[116] In 1841, Cambridgeshire [Isle of Ely] adopted the Act, and Herefordshire (having failed to pass it for the whole county) adopted it for just the one district of Kington.[117] Westmorland, in 1844, adopted the Act, but appointed only one man (increased to two in 1846) for the Kendal and Lonsdale wards of the county; though an official adoption of the County Police Act, this resembled far more the superintending constables appointed by a number of counties.[118] Surrey and Cambridgeshire [County], having rejected the idea of county forces in the 1839-41 period, belatedly established forces under the Act in 1851. The major initiatives on the County Police Act came between October 1839 and January 1840; after this, and following the passage of the amending Act, only four more counties (East Sussex, Cambs. [I. of Ely], Herefordshire, Hertfordshire) opted for forces, wholly or partially, in 1840-41.

If we examine those counties which did and did not adopt the Act, no obvious pattern emerges; there is no single factor – geographical, economic, social or political – which clearly distinguishes the adopting from the non-adopting counties.[119] Of the seventeen counties which adopted the Act for the whole or part of the county within the first few months, six were from the South or East Anglia, eight from the Midlands, and three from the North. Eight of those Northern and Midland counties were industrial, or had a substantial industrial or mining sector. It was a view commonly expressed in the Quarter Sessions debates, by proponents and opponents of county forces alike, that dense manufacturing and mining populations were more prone to crime and disorder than rural areas. And, during 1839, Lancashire and the other industrial and mining counties were certainly concerned about the spread and influence of Chartism. But rural southern Wiltshire, East Anglia, Sussex, Hampshire, and Gloucestershire (a south-western county with an industrial past, but whose industry was now in decline) also adopted a police immediately. It would be hard to ascribe these adoptions to fear or panic about Chartism. It also fails to explain why Lancashire's industrial neighbours – the West Riding, Cheshire and Derbyshire – did not similarly opt for the new Acts; or why some industrial and mining Midlands counties – Leicestershire, Nottinghamshire, Shropshire, Worcestershire – adopted the Act for their whole counties, while others – Staffordshire, Warwickshire – introduced it only on a very small scale for a limited area.

The most we can say is that there seems to be a reasonably good correlation of early adoption with the *attitudes* of a county's magistrates towards a permanent paid police, expressed three to five years earlier in response to the Constabulary Force Commission questionnaire.[120] In regard to favouring the idea of a permanent paid police, of the bottom quartile (those counties whose justices were least favourable in 1836), 22 per cent adopted the County Police Acts in 1839-41. Of the top quartile (counties whose justices were most favourable), 89 per cent adopted. The middle 50 per cent split fairly evenly (47 per cent adopting; 53 per cent rejecting). This is interesting, but not very enlightening. It merely throws us back on a further question: why did the justices of counties similar or even adjoining to those in the top quartile in 1836 have quite different attitudes towards reformed rural policing at that particular time? We cannot answer this question, but these results strongly suggest the existence of particular 'political cultures' or 'climates of opinion' within the county bench. They even appear to give substance to the existence and persistence into the nineteenth century of the 'county community',[121] an intricate web of social and political relations and contacts within a county's borders that, no doubt, shaped and produced such 'climates of opinion' and differentiated them from those of other counties, sometimes even from those next door.

We can understand the ease with which the motions for a county police passed the Quarter Sessions of Shropshire, Durham and Lancashire when we recall their earlier initiatives in requesting of the government, before the

passage of the County Police Act, powers to establish regular paid county police.[122] But then we have to explain why Cheshire (the pioneer of county policing) did not. Proximity to London, and the problems of criminals from the metropolis, might suggest why Essex, Bedfordshire and Hertfordshire adopted relatively early; but it does not explain why Surrey did not adopt until 1851, nor why Buckinghamshire and Kent never did. Not surprisingly, considering the existence of such varied internal political climates within the élites of the English counties, attempts at simple explanations break down beyond a certain point.

The question being decided by each Quarter Sessions involved a more complex mix of issues than a simple binary opposition of police versus no-police. For one thing, counties which rejected the Act sometimes had *some* type of paid policing – in the form of the Cheshire Constabulary Act, local forces set up under local Acts or the Lighting and Watching Act or by voluntary subscription, or (after 1842) superintending constables; and towns within those counties with municipal government had usually established their own paid regular borough police forces, which could be substantial in some cases.

We must also remember that the partisan political affiliations of magistrates, though not always dominant, were sometimes important in deciding the outcome – above all the local climate of opinion (and divisions) among the Tories – and that the role of powerful local figures could crucially influence the outcome of the debates in their counties. This last point applies particularly when these men were chairmen of their Quarter Sessions, who could shape (or even control) the terms of the debates through their sheer prestige, the important speeches they made at the beginning of Quarter Sessions administrative sessions, or the privilege of charging the Grand Jury. Attendance by JPs at Quarter Sessions was voluntary and, for many of them, quite irregular. In the rural policing debates, unusually large numbers of justices turned up and voted. This was an important factor in those counties where the crucial debate was decided by just a few votes.

Let us return to the pattern of counties which adopted or refused to adopt the County Police Act in 1839–41. During that time, seventeen Quarter Sessions adopted the Act for the entire county, and another four for part of the county. Those seventeen included Lancashire, the foremost industrial county, and five others (Durham, Nottinghamshire, Leicestershire, Shropshire, Worcestershire) with an important industrial or mining sector. Two, Essex and Hertfordshire, were affected by their proximity to London. The nine other counties which fully adopted the Act were largely rural counties from the South, South-West or East Anglia. The four which partially adopted the Act divided evenly between two industrial and two rural counties. Among the twenty-two counties which refused to adopt the Act during 1839-41 were: four Northern or Midland counties with an important industrial or mining sector, including the West Riding of Yorkshire; two (Kent and Surrey) contiguous to London; and sixteen rural

counties, from the South, Midlands and North. This may suggest that industrial or mining counties were slightly more likely to adopt the Act, and rural counties less likely to do so, but the tendency is a bit too weak to be greatly significant. Adoption by Bedfordshire, Wiltshire, Hertfordshire, East Sussex, Hampshire, two of the three legal counties of East Anglia, and Cambridgeshire (I. of Ely), demonstrates that the County Police Act was not without its attractions in predominantly rural counties as well.

We must also consider the timing of the police initiative. Of the twenty-one counties which adopted the Act, wholly or partially, seventeen had succeeded in getting the crucial vote through by January 1840. This was important, since delay offered time for ratepayer resistance to mobilize, and that resistance, combined with political divisions and hesitations among the justices, was able to defeat the police initiative, as in Derbyshire and the West Riding; on the other hand, significant ratepayer resistance to the expense of the force in Gloucestershire came too late to defeat adoption, and they found that abolition of a force, once established, was virtually impossible. After January 1840, only four more Quarter Sessions passed motions to adopt the Act in 1840 or 1841. Pro-police magistrates who were sufficiently well organized to bring their resolutions to a vote between October 1839 and January 1840, generally succeeded; those who found themselves delayed into 1840 and 1841 generally failed.

A number of counties adopted the County Police Act quickly, with minimal dissent, such as Shropshire, Bedfordshire,[123] Durham, Lancashire, Worcestershire, Gloucestershire and Wiltshire. It is noticeable that their debates tended to be dominated by a few prominent pro-police magistrates; and some of them had a history of previous county concern with police reform. In Shropshire, we have seen that the Quarter Sessions had been pushing for some form of county police reform since 1831, with a leading role being taken in this by their chairman, Thomas Kenyon, Sir Baldwin Leighton and R. A. Slaney. In January 1839, they took the lead in mobilizing opinion, in their own and other Quarter Sessions, in favour of the power to appoint county police forces.[124] It is not surprising that, in October 1839, their Quarter Sessions, chaired by Kenyon, and dominated in debate by Leighton, Slaney and a few other prominent JPs, resolved unanimously to adopt the County Police Act.[125] Similarly, the Durham magistrates had been looking for some means of setting up a paid police, to deal with their coalfields, since 1832;[126] in November 1839, they resolved, with only one dissenting vote, to adopt the County Police Act.[127] We observed that the Lancashire justices began to prepare for a revamped police seven months before the national legislation. In November 1839, the Lancashire Quarter Sessions unanimously agreed to adopt the County Police Act, and set up what became the largest of the county forces.[128] Worcestershire debated adoption of the Act in October 1839; their chairman, John Pakington MP, proposed the motion to adopt, spoke strongly for it, and totally dominated the debate; it was passed unanimously.[129] Gloucestershire adopted the Act by a large majority in

October 1839, following a debate dominated by the pro-police views of its Tory leaders, Charles Bathurst, the chairman, Lord Ellenborough, and the Lord Lieutenant, Lord Segrave. They proceeded to create the largest force permissible under the Act. Ellenborough and Segrave stressed that the force must be as large as possible in order to be efficient; in the long run both crime and the county rates would be reduced. Bathurst held out the hope that, ultimately, the government would pay 'a considerable part of the expense', as the Constabulary Force Commission had originally recommended.[130] In Wiltshire, which similarly adopted the Act by a large majority in October 1839, the leading role was played by the Whig magnate Lord Radnor.[131]

But this was hardly a rule. Radnor was less successful in Berkshire, the other county in which he had large estates. Berkshire looked, at first sight, like ground favourable to adoption, its Quarter Sessions having affirmed the 'Salop Resolution' some months earlier. But the proposal was delayed, permitting the mobilization of ratepayer opposition; and the issue was then defeated – by Tory JPs raising constitutional objections; magistrates responding to ratepayer concern about the expense; and, perhaps most significant, the failure of the Whig-Liberals to act with the solidarity that they usually displayed elsewhere.[132] In Derbyshire, the strong support of the chairman, John Balguy, and a powerful core of justices was not enough;[133] the strong support of the chairman of Devon Quarter Sessions, the Earl of Devon (expressed publicly in an open charge to the Grand Jury) could not bring along a majority of justices facing aroused ratepayers.[134] In still other counties, the chairmen and core justices prevailed, but they had to bargain by 'bidding down' the size of the force in order to carry adoption. In East Sussex they felt compelled to promise formally never to exceed a certain maximum rate.[135] In such counties, forces were established, but they remained small, and attempts to expand them often had to wait until the 1850s. The support then of prominent, powerful and influential justices was absolutely necessary, but not always sufficient.

In other counties, dominant figures in Quarter Sessions threw their weight against adoption of the Act, and helped to ensure its defeat or created significant delays. This was the case in Cheshire, where their chairman, Trafford Trafford, had ensured their support for the Cheshire Constabulary Act in 1829, but then also ensured the defeat of a motion to adopt the County Police Act in March 1840. It was also the case in the West Riding, where the chairman, Lord Wharncliffe, failing to carry a compromise resolution of a force limited to the industrial parts of the Riding, then helped to sweep the whole issue off the agenda. In Hertfordshire, the influence of the Marquess of Salisbury helped to delay the adoption of the Act there until 1841. In counties which were evenly divided, the issue sometimes turned on just a few votes – Hertfordshire got a bare majority of one and went ahead with a county force; Derbyshire had a tied vote, which led to them dropping the idea entirely.[136] There was thus

often an element of serendipity in the pattern of adoptions of the County Police Act. Its rejection was not an infallible indicator of the sentiment of justices, or the gentry in general, towards police reform *per se*. Some of the districts most active in creating local 'new' police forces did not greet it with unalloyed enthusiasm. Many Norfolk forces, for example, used full-time, trained, Metropolitan personnel, kept records, had formal reporting procedures – they were in every respect reformed, 'modern' police. Yet both Wymondham and Blofield would participate in petition drives against the Norfolk Constabulary. They argued against losing the efficient and locally responsible police that they had created, or getting fewer police at higher cost under the Act.[137] Sentiment (or even justices' votes) against the County Police Act after 1839 did not *necessarily* imply opposition to reformed, professional, paid and uniformed police.

It would be risky, for example, to overinterpret Derbyshire's failure to adopt as a major rejection of the idea of reformed policing. Even in counties where the issue was lost on less close votes, the same caution applies. One can imagine alternative scenarios involving snowstorms, dirty parliamentary manoeuvres[138] or other factors that might have produced a somewhat different pattern of adoption and rejection. And because we believe that a lot of opposition on 'constitutional' grounds was soft (or even a pretext masking objections on pecuniary grounds), the inclusion of a government subvention[139] would certainly have dampened ratepayer protest, given the justices more political room to manoeuvre, and produced much better compliance with the legislation.

In the final analysis, the best explanation of the pattern of adoption of the permissive County Police Act seems to be a combination of factors: the county's geographic location and socio-economic make-up and the political disposition of forces within Quarter Sessions – whether they were dominated by a few individual JPs, the position taken by them on the issue, the extent to which the Tory justices were divided, a failure of Whig-Liberal solidarity – the timing of the crucial vote on the Act; and the strength and effectiveness of ratepayer resistance. None of these factors by itself can explain why the English counties divided evenly on the adoption of the Act; but, examined on a county by county basis,[140] they can explain the overall outcome – an untidy national patchwork of counties with and without formal county police forces which endured until the compulsory legislation of 1856.

A damp squib?

Previous interpretations of the County Police Acts of 1839 have fallen into two categories. The most interesting is associated with William Watts Miller. Miller's interpretation has the virtue of recognizing the importance of the County Police Act as an important landmark in English criminal justice history. With this we can agree. Miller takes seriously the objections of both Radicals and right-wing Tories, which were based upon concern for

the preservation of local government and/or the desire to hold on to a paternalist social order. He thinks that opponents had the better arguments on the issues of cost, efficiency and the threat of crime. Serious crime, he believes, was not very prevalent (probably true) and petty crime was really too petty for the landed class to have taken the notice they did. But they *did* take notice and considered it a symptom of disequilibrium in rural society – something to which they could not remain indifferent. It was precisely the high level of common disorder and the constant petty thieving and pilfering (combined with periodic movements of rioting, mass mobilization and arson) which accounts for so many of the anti-Arcadian descriptions of the early nineteenth-century countryside that issued from gentlemen and justices. It also accounts for why so many of the latter concluded that the security of person and property was touched as much (if not more) than would have been the case if high rates of murder, rape or highway robbery prevailed. We do not believe that the response of the provincial ruling class to the state of rural society in the 1820s and 1830s was irrational. Miller is somewhat selective in taking seriously what contemporaries took seriously. His point seems to be that, although Chadwick's scheme was outrageous, even the County Police Act was a blunderbuss – and quite unnecessary.

Most other views treat the County Police Acts as a damp squib. They tend to measure the forces these acts created against police systems which twentieth-century criminologists or social scientists would consider adequate or ideal. For Radzinowicz, for example, the defeat of rationalizers such as Chadwick was regrettable.[141] This somewhat anachronistic view has coloured the interpretation of the fact that only about half of the English counties adopted the Acts immediately. They are portrayed as a kind of false start; only after the County and Borough Police Act of 1856, with its compulsion, greater uniformity, government subventions and inspections, was the proper start made, with a better state of things gradually prevailing.

Our view is that the County Police Acts of 1839–40 constitute the foundation of English provincial policing. Their passage and adoption were major consequences of the landed class' rethinking of provincial order keeping.[142] This re-evaluation was not irrational, but was founded upon factors that went beyond merely a heightened sensitivity to petty crime. There *was* such a heightened sensitivity, but why? The early nineteenth-century English countryside was rife with disorder, poaching, epidemic petty crime and periodic outbreaks of riot and fire; it was this that suggested the need for a 'new police'. The incidence of serious crime was not very high; for this the old system of parish constables, 'Bloody Code' and selective enforcement of the death penalty had been perfectly sufficient. But the problem was insubordination (a perceived derangement at base of rural society) not crime *per se*. Poaching, petty pilfering, overt insults, the culture of the beerhouse, riot and arson were symbolic indications of this disturbance. The 'migration thesis' was largely unfounded (but deeply and widely believed), but in addition to garden-variety pilfering and poaching,

there *was* an extensive rural criminal culture and rural criminal gangs, some with links to criminals in the towns, or even the metropolis.[143]

We do not subscribe to the 'damp squib' interpretation. Despite bemusement or resistance by some sections of the landed class and the bulk of the rural middle ranks, the Acts of 1839–40 constitute a watershed. They decisively settled an issue. The essential features of nineteenth- and early-twentieth-century county policing were laid down in this legislation. Although later legislation in the 1840s and early 1850s created new policing alternatives, the County Police Acts became a touchstone, constricting the space for further *ad hoc* experimentation, and, ensuring that even in those counties which did nothing immediately, that situation would be temporary. Russell, despite his stated preference for its approach,[144] saw that a police plan founded entirely on the Report of the Constabulary Force Commission would not have been a practical proposition. England, with its highly developed sense of national identity, but strong and decentralized local government – based upon an administratively and judicially active landed class – was not fertile ground for a centrally directed rural police.

The 'damp squib' school views the number and pace of adoptions of the County Police Acts as unimpressive.[145] But we would join the late D. J. V. Jones in stressing the extent of the achievement.[146] It should be remembered that *all* plans of police propounded in the first half of the nineteenth century contemplated gradual growth and extension. Even the initial conception of the Metropolitan Police contained a permissive feature and provision for implementation over a considerable period. Certain London parishes were to be initially included and others were to be left out. The latter would be allowed to join by application; but the Metropolitan scheme as a whole was to be implemented by degrees.[147] Even Chadwick believed that his centralized scheme would have to be gradually implemented, with the matter left dependent on a vote of local bodies.[148] The *normal* expectation in this period was that no extensive police scheme could be implanted quickly. The County Police Acts were permissive, but even compulsory legislation at this time would have called for a quite extended period of implementation.

Russell professed delight at the reception of the 1839 Act. In March 1840, he stated:

> That Bill [the Act of 1839] was only passed in August last, and it might reasonably have been expected that the magistrates of counties would be disposed, for the greater part, to wait ... and to see how their neighbours fared, who might, in the first instance, have adopted it. If, out of the forty counties of England, thirteen have adopted it, which is more than one fourth, I think that more favour for it has been realised than could have been expected.[149]

Was he simply putting a good face on a disappointing situation? We think not. He understood quite well that passage of the County Police Act was a major watershed. He had every reason to think that the system the Whigs created would be bound to expand in the future.[150] To speed up the

process, the government merely needed to resist attempts to introduce bills to improve the performance of the old parish constables, and to block determinedly legislation that would make available any alternative scheme of professional policing. The Whigs lost office in 1841, and this strategy did not quite work out. We shall see how matters developed after 1841 in Parliament and in the counties, and what the ultimate outcome was of the encounter of the county justices with the permissive County Police Acts between 1839 and 1856.

THE RHETORIC OF POLICE REFORM: THE QUARTER SESSIONS DEBATES OF 1839-41

[S]ystematic communication in cases of Felony ... might be obtained by the appointment of paid Constables, and on a Scale so moderate as to obviate all objection; but to attempt the establishing a paid Force to an extent which would admit of a sufficient number being brought together in a reasonable time for the suppression of Riot or Tumult, whilst it would seriously attract public attention from the prodigious expense it would occasion, would, probably, also excite much Constitutional Jealousy ...
(J. B. Freeland 'Observations on, and Plan for, Rural Police', in PRO HO 73/71, 15 Jan. 1837)

All Politics is Local.
(Thomas 'Tip' O'Neill, Late Speaker of the United States House of Representatives)

The magistracy and 'public opinion'

The rural policing debates took place almost entirely within the restricted group of the county magistracy, but 'public opinion' was far from absent. The provincial and national press participated (sometimes ferociously), and the ratepayers were present both as an ominous presence in the courtrooms, and offstage – in the pubs and inns where farmers gathered on market days to discuss important matters among themselves. An 1834 Act (4 & 5 Wm. IV, c. 48) had laid down that all county business should be transacted in open court.[1] This enabled the provincial press to report debates fully and record the crucial votes. In some counties full division lists appeared in the newspapers.[2] The rural policing issue had to be discussed under the direct gaze of local farmers and other ratepayers. Occasionally, they took the liberty of interjecting comments or posing questions from the floor or galleries – and were promptly shut up or ejected.[3]

The optional nature of the legislation gave justices little political cover. They could not use the excuse that Parliament had mandated a law with which one had to comply. Unless a decision was made to ignore the

measure entirely, its merits had to be debated openly; each justice present had to cast a vote that might well appear alongside his name in the newspapers. The redefinition of the basic unit of English policing from the parish to the county (and the responsibility for it from the vestry, leet and township to the justices) clearly implied a subtraction from the old system of parish government and a blow to the *amour propre* of the village notables. The latter were also important ratepayers, who would surely not be thrilled at a projected doubling of the county rate. As a Norfolk justice aptly put it: 'if these measures were adopted, it would involve them [the magistrates] in a struggle between the Government and the ratepayers ...'[4] Many magistrates quailed not only at being accused of a power-grab, but of forcing those deprived of power to pay for it. Justices who wished to adopt the act had to take a thick-skinned approach: ignore furious ratepayer protest; stand on the principle that imposing the new rates was consonant with their duty to ensure the peace and protect property; cast a public vote for adoption; ignore even more furious ratepayer protests; and then swallow hard and hope that the performance of the police would match their promises and wear away the opposition of the rural middle ranks within a reasonable time.

All the county justices – indeed the landed class at large – regarded the policing issue as an extremely important one. All of the specific issues and considerations we outlined in Chapter 7 – which intimately touched social relations and the distribution of power in the countryside – were about to come into play. The chairman of Kent General Sessions remarked 'that this was certainly the most important question that had ever come before the court since he had been connected with the magistracy ...' The chairman of Shropshire Quarter Sessions stated: 'The question, viewed in any light, was one of the most important that had been brought before the Bench for many years.' The chairman of Gloucestershire Sessions similarly called it 'a subject of such exceeding importance that all others sank into insignificance before it'.[5]

Quarter Sessions were unusually packed with magistrates. Some arrived with *idées fixes*, others with open minds, and still others in a state of some doubt or confusion about the precise details of the measure before the court. Attendance by magistrates at Quarter Sessions was voluntary, and, in many counties, only a handful – those who sat on the powerful committees – could be relied on to turn up regularly to the court. But on this occasion the backwoods justices bestirred themselves and descended on Quarter Sessions. This meant that the issue of rural policing would not be discussed and voted upon by the usual cosy gathering of the active, core-magistrates of the county. In all parts of the country, the press noted that the debates attracted 'very numerous' bodies of JPs; many newspapers wrote of 'unusually' or 'unprecedentedly' large attendances.[6]

The atmosphere of the debates was tense and excited: 'The chamber was densely crowded the whole of the time, and presented anything rather than an appearance of that order and decorum which ought to be expected from

a bench of worshipful magistrates.' The mood of these meetings indicated the extent to which the issue of substantial county police reform served as a focus for the current fears and insecurities of conservative members of the landed classes. Though the County Police Act fell far short of the national police scheme envisaged by Chadwick, it still represented a radical break with traditional modes of provincial law enforcement. This raised sensitive issues regarding local government, the distribution of power and status in rural society and – in the minds of the most conservative gentlemen – even the future ability of rural society to cohere. The County Police Act redefined the proper 'policing community' as the county, and challenged the longstanding principle of amateurism in the enforcement and administration of the law. Some justices saw in its attack upon the traditional system of parish self-government the seeds of a future attack upon themselves.

A significant element of the landed class had shown, by the late 1830s, that they were able to accept these redefinitions; but many traditionalist rural Tories – and not just Tories – saw the County Police Act as going too far. Their remarks and speeches show that they were far from self-confident about the cohesiveness of rural society and the effect on it of changes in the Poor Law, policing and other facets of local government. They were worried about their own prestige and power within that society. They thought that their own interests were intimately bound up with resisting further efforts to diminish parish self-government.[7] In the fights over county policing, they often allied themselves with movements of ratepayer protest, sometimes participating in farmer meetings, agitating beyond the doors of the Quarter Sessions court, or helping to orchestrate the protest. This was the group most apt to make bitter speeches, overflowing with hyperbole about the 'unconstitutionality' of the proposal and the serious consequences for rural society.

Shrill and prominent as they sometimes were, their proportions varied from county to county, and they were never a clear majority in any Quarter Sessions. In those counties which rejected the County Police Act, those opposing it included a wider constituency than diehard traditionalists – including those who objected to the considerable expense it would involve. Those counties in which the debate was fiercest were those where the JPs split down the middle on the issue. Roughly speaking, the magistrates who supported adopting the Act were those who accepted the desirability of change or saw it at least as inevitable; their irreconcilable opponents were those who saw the 1830s as a destabilizing and threatening litany of events in large part attributable to Whig mismanagement, arrogance, or even malevolence. In the middle were the uncertain, the waverers, and those who could be swayed by a simple cost-benefit analysis; both sides devoted much of their efforts in the debates to trying to win over these men.

The rest of this chapter examines the debates largely in some of the counties in which the magistrates divided evenly and the outcome hung in the balance. We have prefaced them with an account of what transpired in

Wiltshire, where there was great unanimity and easy adoption. Those counties in which little serious dissent was expressed generated less public debate and, therefore, less information about the issues raised by the legislation. This is true as well for those counties which easily *rejected* – or simply ignored – the Act. In the closely contested counties one finds the most thorough airing of the issues thought to be at stake. We have grouped the counties into three areas: the South (including the Home Counties and East Anglia), the Midlands and the North, and chosen some particular counties for treatment in depth.

The South

Wiltshire

In Wiltshire, the County Police Act was adopted quickly and easily, and the discussions on the issue were marked by almost complete unanimity of opinion among both Liberal and Tory justices. This easy success was due to: strong support of the measure by the Tory chairman of Quarter Sessions and by a powerful group of Whig aristocrats led by the Earl of Radnor, the Marquis of Lansdowne, the Earl of Shelburne and Lord Andover; the strong support of both the Liberal and Tory press; and strong resistance by the magistrates to ratepayer petitions of opposition and protest. The Wiltshire debate also demonstrated the degree to which the language of 'prevention' in policing had been thoroughly absorbed by the gentry of the county. The Wiltshire justices showed a solid consensus on the issue of police reform. In their responses to Chadwick's questionnaire in late 1836, they had professed considerable dissatisfaction with existing constabulary arrangements, and shown interest in the idea of a preventive professional police. This reflected, in part, the profound impact that the 'Captain Swing' disturbances made on the Wiltshire justices.[8]

The Salisbury bench was dominated by the Earl of Radnor, an outspoken Whig aristocrat and a fierce proponent of both the New Poor Law and a government-run rural police to complement it. Edwin Chadwick and his ideas had fewer more fervent admirers among the peerage than Radnor. Most gentlemen, of course, were far from sympathetic to Radnor's Benthamite approach, and a clash between him and the largely Tory justices of Wiltshire might well have produced a political squabble fatal to agreement on this issue. Fortunately for pro-police proponents, the point of departure for deliberations in Wiltshire was not Chadwick's Constabulary Force Commission Report, but Russell's circularized 'Salop Resolution'. Wiltshire took the latter up in April 1839. At this early date (months before the passage of the County Police Act), Quarter Sessions adopted a motion almost identical to that of Shropshire and debated the issues of control, structure and appointment of a rural police. This laid the political groundwork for a consensus that would herald the rapid adoption of the

legislation. In the further debates that ensued, the fears and suspicions expressed elsewhere by Tory justices that the Act was designed to curb their power were totally absent; the constitutionality of the measure was hardly questioned and there seemed to be no fear of the reaction of the ratepayers.

In October 1839, Quarter Sessions set up a committee of justices, representing most of Wiltshire's petty sessional divisions and chaired by Radnor, to work out the details of the proposed establishment. Radnor was keen to adopt the Act, but would have preferred a national police, paid for by the government. A police, he said, 'in the agricultural districts is so necessary that where I live we have been obliged to appoint a police paid by ourselves. I think it hard that we should be compelled to do so. The government ought to do it.' A succession of largely Tory gentlemen then offered speeches of support. Joseph Neeld, connected by marriage with the Tory aristocracy and one of the most influential landowners in Wiltshire, was the lone dissenter. Neeld argued that adoption would degrade the magistracy. The large calendar of committals for criminal trial at Quarter Sessions and Assizes, pointed to by Radnor as evidence of the need for a regular police, Neeld cited as proof of the perfect adequacy of the parish constables. But Neeld got no support from his fellow JPs.

In November, Radnor's committee presented a report proposing a force of 201 men at a cost to the county of nearly £11,000. Radnor stressed that the committee had included justices from nearly every district in the county, and they were nearly unanimous in their recommendation. The report was approved by Quarter Sessions, by a vote of 35–3, the three dissentients including Neeld. Walter Long, another prominent Tory, agreed 'with Lord Radnor in wishing the establishment of the force' but thought that justices 'ought to be careful how they put their hands into other peoples' pockets'. He proposed an amendment supporting a force of 124 men which would cost only £5–6,000, but this was overwhelmingly rejected and Radnor's proposed force overwhelmingly approved.

In the West Riding, as we shall see, many JPs demanded that a police be created for – and funded by – only the industrial parts of the Riding. Wiltshire, though a predominantly rural county, had a woollen district in its western part around Trowbridge and Bradford, the scene of some Chartist ferment in 1839.[9] One might have expected some magistrates to argue that that district should receive, and pay for, most of the police. But only the dissentient Joseph Neeld made this argument. None of the other gentlemen, though representing essentially rural divisions of the county, argued that a police was primarily needed to discipline urban and industrial areas. The main problems they listed as requiring a police were: the demoralization of the agricultural labouring population, the existence of rural criminal gangs, the allegedly high incidence of highway robbery on Salisbury plain and in the countryside around Devizes, and the usual complex of petty rural crime found anywhere in the country – the theft of sheep, fowls, wood and produce.[10]

Radnor spoke at length about the frightening extent of rural depredation. A clerical justice from the Salisbury division described the:

awful demoralization of the poor ... arising from the beershops, those pests which were altogether uncontrolled ... The correcting of that evil alone would induce him to support such a measure. ... The farmer would be ... reimbursed by the protection [a police] would afford to his flocks, his barns, his fences, and all his other property.

Another justice characterized the increase of crime as 'most fearful. Formerly the fowlstealers were contented with taking a fowl or two, now they stripped the roost altogether; formerly the sheep stealer would take one sheep, now he took them by the 5 or 6 at a time.' A Marlborough justice stated that he possessed information that would lead to the detection of a gang of rural depredators, 'but with the present constabulary he could not attempt it'. Magistrates portrayed the Wiltshire countryside as a troubled place where the farmer went to bed full of anxiety, 'thinking of the devastation that might be being committed on his property'. The chairman added that, of 60 felonies charged at the last sessions, only one-third stemmed from the towns – not 'manufacturing towns merely, but every place in the county that was called a town' – with the rest committed in the rural districts.[11]

The Wiltshire justices coupled this portrait of their county as an anti-Arcadia with a fervent belief in the concept of crime prevention and a preventive police. Radnor thought that a voluntary subscription police in his district had greatly prevented crime; now that it had collapsed, crime was rising again.[12] The Tory Quarter Sessions chairman Ludlow Bruges declared that their great object was to prevent crime, which could only be done by appointing 'persons ... who would be constantly on the look out'.[13] Editorials in both the Liberal and Tory press looked forward to the prospect of emptier prisons, fewer turnkeys and a dramatic drop in losses from theft. The Tory *Devizes and Wiltshire Gazette* rhapsodized that the modern preventive police was constitutional, no tool of arbitrary power, 'formidable only to the thief, the robber and the rioter', and, moreover [thanks to Peel] a good Tory invention which had, in the past, been a 'favourite topic of Whig and radical hostility'.[14]

Only the Grand Jury ventured to suggest that the police be restricted to the woollen district.[15] Bruges used his charge to the Grand Jury to convey his message to the ratepayers of Wiltshire. He first assured them that the County Police Act was entirely constitutional and legal, vesting control of a police entirely in the hands of the magistracy. It was decidedly not a measure such as was contemplated by the Constabulary Force Commission, which would have indeed placed an unconstitutional engine of power in the hands of the executive authority. He then laid out the deficiencies of the parish constables. What was wanted was not amateur constables but policemen who would 'be constantly on the watch for suspicious characters, and to try thereby to *prevent* crime, or, from the

knowledge of such persons, to apprehend those by whom offences were committed'. The current situation – in which victims had to act as their own detectives, resorting to the constable only when they had a suspect in mind and a search warrant procured – was intolerable; in 99 out of every 100 cases, 'the guilty party escaped; and therefore, in point of fact *the prosecutor was . . . his own constable*'. He held out to the farmers the prospect of future prevention of crime, greater efficiency in its prosecution and the certainty of suppression of labourers' disturbances. In 1830 the agricultural districts of Wiltshire had suffered so cruelly from the visitation of 'Captain Swing' chiefly because of the 'wretched inefficiency of the police'. These benefits would not come cheaply, and he did not disguise the fact that, if the court voted for adoption, 'they and their brother farmers would have to bear the principal burden of the expense'. The Grand Jury then presented a resolution that the existing constables were inadequate for the prevention of crime and the creation of a county police force was necessary.[16]

Wiltshire voted to adopt the Act in October 1839. During the period of the debate and the subsequent establishment of the county force, with the exception of one petition from Malmesbury presented by Joseph Neeld, 'not a single memorial from the farmers was presented against the measure'.[17] In many other counties, as we shall see, Quarter Sessions were deluged with petitions from ratepayers objecting to the cost of a proposed police; the absence of such petitions was a measure of the degree to which the Wiltshire justices were united in their policy and were able to keep matters under their own strict management.

Berkshire

In Berkshire, as in Wiltshire, the lead in pushing for adoption of the County Police Act was taken by Lord Radnor, a member of the Berkshire county bench by virtue of his Berkshire seat, Coleshill Park. But no such consensus emerged as in Wiltshire. The Berkshire debates became highly acrimonious and, at one point, tinged with a measure of party political animosity. In Berkshire, Radnor signed the necessary requisition by five or more JPs to adopt the Act, and he was joined by the Tory Viscount Barrington. The Berkshire debate was largely dominated by the county gentry.[18] Berkshire had few large landowners, relatively large numbers of freeholders farming 40 to 80 acres and few old gentry families.[19] In such a county the voice of the farmer, and of the ratepayer in general, was difficult for the magistrates to ignore.

The imposition of the New Poor Law had left a particular legacy of bitterness among some Berkshire magistrates. Many of them viewed the County Police Act as an unwelcome corollary of the Poor Law, making further inroads into the old paternalist order. To them were added other justices who were primarily concerned about the effect on the rates; dubious whether the benefits would justify the cost; or worried that a stipendiary police would be followed in the near future by a stipendiary

magistracy. Berkshire had no permanent chairman of Quarter Sessions. The chairmanship rotated among three men according to when the Sessions were held at Newbury, Abingdon or Reading. Two of the rotating chairmen, Thomas Goodlake and Robert Palmer MP, were unfriendly to the County Police Act; the third, Viscount Barrington, was a supporter, but hardly intruded himself into the debates. Some justices saw Radnor as an outsider from Wiltshire, and his strenuous efforts to influence and cajole fellow magistrates as haughty and shrill bullying.

On the face of it, Berkshire did not look like unfavourable territory for adoption of the County Police Act. In response to the 1836 questionnaires, the Newbury, Windsor and Reading divisions had all favoured some variant of a 'well appointed and efficient police'. The Farringdon division (whose return does not survive) was the stronghold of Radnor, of Robert Throckmorton, a pro-police MP, and of the Revd J. F. Cleave, a Tory cleric who signed the 1839 requisition to adopt the Act. Wantage, whose return was made solely by Thomas Goodlake, was strongly opposed; Maidenhead was non-committal; Abingdon, although it did not support any particular reform, had told the Constabulary Force Commissioners that for the 'prevention of crime ... the present constabulary force is perfectly useless'.[20] As in Wiltshire and many other counties, Berkshire Quarter Sessions, in the spring of 1839, approved the 'Salop Resolution'.[21] But between April and October 1839, when Berkshire debated adoption of the new County Police Act, opinion shifted decisively, and Radnor found himself outmanoeuvred by the opponents of a county police.[22]

Radnor reiterated the standard arguments in favour of adoption: that a permanent police to deal with normal crime and disorder was greatly needed. This was, he stressed (correctly), no mere temporary measure designed to deal with Chartism or applicable primarily to those districts threatened by Chartism, but intended to prevent 'continual depredations', most of them of a trifling nature which together added up to huge losses to individuals, many of them poor and with limited recourse to the law because of their poverty. A police would be effective, preventive, and just towards the poor; because it would be preventive, it would also be cheaper in the long run and would save the costs of the present constables, reduce county charges for the conveyance of prisoners, and diminish the costs to the county of reimbursement of prosecutors' and witnesses' expenses. Ratepayers would have to pay £5,000 or £6,000 per annum – but since the New Poor Law had saved the ratepayers £50,000 in 1838 alone, this would be a long-term benefit to the ratepayers! As he had done in Wiltshire, Radnor concluded by proposing a resolution to set up a magistrates' committee to make a definitive inquiry into the constabulary of the county and the expediency of adopting the Act.

But the outcome in Berkshire was very different. Thomas Duffield, a Tory MP, opposed the motion, stating that there was no need for a police force whose adoption would be the first step 'towards the appointment of stipendiary magistrates', and attacked Radnor personally for not being

resident in Berkshire. He was supported by Charles Eyston, one of the county's most influential Liberal country gentlemen, who said that he could not vote for the resolution because the opinion of the ratepayers had not been ascertained; until that time he would oppose adoption. Radnor's motion for a committee to study the question and recommend a course of action was voted down by 21–6.

Radnor and his allies let it be known that they would reintroduce the subject at the next Quarter Sessions. The January 1840 Sessions were, accordingly, highly charged and acrimonious; each side mobilized as many supporters as possible, producing 'an unusually numerous attendance of magistrates',[23] including most of the county's MPs. Radnor led a bipartisan group of fourteen signatories on a new requisition to adopt the Act.[24] The anti-adoption forces were also bipartisan, including John Walter, the proprietor of *The Times*, Thomas Goodlake[25] and Charles Eyston, all technically Liberals.[26] But Tory MP Thomas Duffield was ready to introduce a party political note. He suggested that:

> if a Tory measure of a similar character had been brought forward 10 years ago, the noble Earl would have denounced it as an unconstitutional measure ... What had been the doctrines of the noble Earl, and those with whom he politically acted? Why, they had dinned into the ears of the public that there ought to be no taxation with[out] representation, and yet they now called on the magistrates ... to impose on the ratepayers the enormous tax ... adoption ... would require ...

Eyston, who voted with Duffield, chided him for introducing 'into the discussion party expressions which ought not to have been introduced into a court'. Goodlake, who had argued that a constabulary force might be used by the government 'for bad purposes', stressed that of course the *present* [Whig] government would never do so, but a future 'vicious ministry' [doubtless a Tory one] might well do so. Walter argued that the Constabulary Act was of a piece with the New Poor Law, on whose cruelties he expounded. He concluded by saying that the only sure prevention of crime lay, not in a police force, but in ensuring that labourers were paid enough to support their families in decency and comfort. Duffield and another Tory JP presented two farmers' petitions against adoption, which they had helped to organize since October. Radnor's motion was decisively defeated, 37 to 21. Six of the fourteen signatories to the requisition were not even present at the sessions,[27] and another of them voted with the opposition, but even if all had turned up and voted in favour, the motion would still have failed. The margin against adoption was provided by the confused and cautious JPs, who spoke of their worries about the cost of a police force, or whether a police was really appropriate for rural areas.

In Berkshire (as elsewhere), barring a big law-and-order catastrophe that allowed a new opening for proponents and political cover for ex-opponents, defeat of a county police in early debates usually guaranteed that this highly charged issue would not be revisited until the 1850s, if ever.

Berkshire would not vote again on adoption of the County Police Act until 1855, when a panic about a crime wave and ticket-of-leave men in the eastern part of the county, provoked a change of heart. In January 1855 Hopkins, who had voted with Duffield and his allies in 1840, wrote to the Home Office from Maidenhead complaining of a rash of sheep-stealing and a robbery within ten yards of the parish constable's door. He suspected ticket-of-leave men and demanded help from the Metropolitan Police. Palmerston, then at the Home Office, told him bluntly that the Metropolitan force was too busy to be county constables as well – in effect, that Berkshire, having made its bed in 1840, must now lie in it.[28] Berkshire did not wait for the compulsory legislation of 1856 and placed itself under the provisions of the County Police Acts at the Michaelmas sessions of 1855.[29]

Hertfordshire

Essex, a county adjacent to London, adopted the Act very quickly and with little dissent.[30] The outcome might have been expected to be the same in Hertfordshire, a county similarly situated, and through which passed some of the main roads to the North. Hertfordshire property owners had long complained about being vulnerable to criminals from London; the county was the home of the Barnet General Association, which ran its own model police force under Thomas Dimsdale; and, of all Southern counties, its principal ratepayers seemed most hospitable to the idea of an improved rural police when surveyed by the Constabulary Force Commission in 1836.[31] In 1836, the Lord Lieutenant and nineteen magistrates of the county had petitioned Home Secretary Russell about 'the defective state of the Constabulary Force, and want of local Police', the inadequacy of the Lighting and Watching Act for remedying this, and 'the necessity of establishing a more efficient Constabulary or Police Force in large Towns and Parishes not already provided with the same'.[32] Yet the passage of the County Police Act turned out to be extremely close and contentious.

A special meeting of Quarter Sessions was called in November 1839 to debate a motion to adopt the Act. Like many other such meetings, it drew the usual 'very full attendance of magistrates'. The chairman, Lord Dacre, began by warning the meeting that, if they established a full force for the county, it would cost more than £5,000 a year, which would nearly double the county rate. The proposer of the motion, Mr William Blake, made a strong speech in favour of adoption. Blake was an enthusiastic admirer of the Metropolitan Police and of Chadwick's Constabulary Force Commission Report; he argued that Hertfordshire suffered more than £40,000-worth of property crime every year, which must be repressed, and that they could 'raise a really efficient police, and he thought that the expense ought not for one moment to be considered'. Brushing aside the issue of cost in this way was a tactical error.

Mr Heathcote saw the Act 'as a step to the establishment of a Stipendiary Magistracy throughout the country'; he considered that 'it would be quite unjustifiable in the Magistrates to quarter a despotic force upon the county, and wring the money from the pockets of those who found it already quite difficult enough to provide for the demands made upon them'. And the Marquis of Salisbury threw his influence against adoption, arguing that since the Metropolitan Police had failed to prevent crime in London, there was no justification for Hertfordshire adopting 'a new and costly system of police'. The resolution was defeated.[33]

Blake and other pro-police magistrates then organized for a long fight. Blake wrote to Chadwick asking for, and receiving, information about the results of adoption in other counties to enable him to counter Salisbury's arguments.[34] In October 1840, the pro-police forces tried again; this time, they won the vote 40 to 19, and the Sessions set up a committee to investigate the number and pay of the required police.[35] But at the next meeting, in January 1841, with ratepayer petitions pouring in and Lord Salisbury personally presenting many of them, the motion to send the required certification to the Home Secretary was eventually carried only by 38 to 34.[36]

At the April 1841 Sessions, the anti-police forces made their last stand on the motion to appoint a chief constable for the new force. Both sides exerted themselves to turn out their supporters. Blake and his allies even induced the Chancellor of the Duchy of Lancaster, the Earl of Clarendon, and Lord Melbourne, the Prime Minister himself, to journey to Hertford to case their votes! Salisbury proposed his motion that the court should not proceed with the election of the chief constable. There followed a confused and acrimonious debate, at the end of which Salisbury and his allies were defeated by a single vote, 63–62.[37] On such a slender basis could the establishment of a county force hang. Hertfordshire, on the basis of a bare majority of one – only obtained by packing the meeting with magistrates who did not usually attend, including two government ministers – went ahead with its county force.[38]

Buckinghamshire

Buckinghamshire was situated somewhat similarly to Essex, Berkshire and Hertfordshire. Though its northern reaches (the Newport petty sessional division) lie to the north of parts of Northamptonshire, its southern extremities (the Stoke division near the Thames) include Eton and border directly on Staines and Uxbridge, that is to say within the ambit of greater London. The justices' returns to the Constabulary Force Commission in 1836[39] present a profile of a county in which the County Police Act might have been expected to be fairly well received.

In Buckinghamshire in 1836, the Stoke division bordering on Middlesex had been enthusiastic for an active, paid police; so too were the Newport Pagnell and Buckingham divisions, in the extreme north and northwest of

the county, respectively. Stoke and Buckingham were also active in generating pre-1839 local policing schemes. The Stoke hundred was the location of the Salt Hill Society for the Protection of Person and Property from Thieves, a prosecution association very active since the 1790s,[40] and of the Salt Hill Watch, an organized body of patrolling special constables, a voluntary subscription scheme organized in the wake of Captain Swing and still in operation in 1836.[41] Around Brackley, a former Metropolitan inspector was hired as a mounted superintendent at £90 per annum, under a voluntary subscription scheme comprising the thirty parishes of a Poor Law Union. Perhaps as a result of the Brackley model, the Buckingham bench stated their desire for a mounted force of six for the division 'under the county magistrates'.[42] The Burnham division at Beaconsfield and Chalfont St Giles advocated 'permanent paid constables ... coextensive with the magistrates' authority'.

The responses of the other reporting divisions in 1836 were lukewarm towards police reform. The Great Missenden division, stronghold of George Carrington who later led the fight against adoption of the County Police Act in 1839 and 1840,[43] warned about the expense and advised a reform of the parish constables. The bench at Ashendon was dominated by the Marquis of Chandos, and the adjoining Quainton division by four members of the Pigott family;[44] these divisions were also disinclined towards police reform. Sir Harry Verney, who sat on these benches, appended his individual dissent, arguing the inefficiency of the parish constables and the need for 'a more efficient and organised rural Police'.[45] By 1839, the Pigotts and the Duke of Buckingham[46] had veered around strongly on the police issue, but they still refused to support any proposal for the adoption of the County Police Act generally. They supported rather the notion of petty session divisional choice – any division wishing a force under the Act should be allowed to have it, but those benches opposed should be allowed to stick with the old parish constables. This weakened the case made by Sir Harry Verney, Sir William Young and others for *general* adoption of the Act by the whole county. In 1841 the Duke parted company with the Pigotts, and made a speech retracting his support for a divisional police, thus helping to kill the proposal in Buckinghamshire.

In the end, adoption of the County Police Act was crushed in Buckinghamshire by the substantial margin of 37–14, despite the fact that its supporters represented a cross-section of the leading liberal and conservative families and county figures. Supporting adoption of the Act were: three MPs – Verney (Whig), C. G. Dupre and Sir William Young (both Tory) – as well as Lord Nugent (Whig), Grenville Pigott (Tory), and, for a time though not wholeheartedly, the Duke of Buckingham himself. The fight against adoption was led by the Tory squire George Carrington. In the debates, no one of great consequence (except Disraeli) was reported to have voiced the same sentiments. Most of those who took the same line were parsons and the humbler squires.

No list of votes was ever published in the press, but, as in many other

counties, the biggest split was on the conservative side. The Liberals, as usual, showed considerable solidarity in favour of the measure. Only one identifiable Liberal, Dr John Lee, spoke against it – on the ground of excessive expense.[47] A substantial section of the county élite, particularly the Tory one, was willing to treat the issue seriously and consider, in Grenville Pigott's words, 'that the subject involved no question of political or personal interest'. In addition, there was an unusual absence of vituperation and hysteria in the Tory press.[48] In its support of George Carrington it adopted a respectful tone towards the measure's advocates, observing that a proper constabulary force would not only mean an immediate increase in the county rates to pay for the force, but would also, by being more efficient in catching offenders, drive up the costs of prosecution. At the same time it bowed dutifully in the direction of the Duke of Buckingham, arguing that there surely were hundreds in the county 'where the lawlessness of the lower classes is nightly developing itself', and where 'some other force is required than is now in operation'.[49]

The squires and parsons of Buckinghamshire were as sensitive to the ratepayers as they were in other counties; but, in contrast to Berkshire or Suffolk, gentlemen did not try to agitate the farmers, and there were no ratepayers' meetings and, apparently, no monster protest/petition drives organized by either gentlemen or the farmers themselves. The only ratepayer petitions mentioned in Buckinghamshire were two presented by Maurice Swabey, the leading magistrate of the Stoke division; somewhat unusually, these were in favour of the County Police Act.

There is no question that, among the 'core justices' of the Quarter Sessions at least, dissatisfaction with the old constabulary was widespread. Buckinghamshire had replied to Russell's circular letter accompanying the 'Salop Resolution' in the spring of 1839 by declaring the constabulary force inefficient and advocating 'that a body of constables, acting under the orders of a police authority, and under the supervision of the magistrates, would be highly desirable in providing ... for the prevention as well as detection of offences, for the security of persons and property, and for the preservation of the public peace'.[50] But the Quarter Sessions meeting which debated adoption of the Act contained unusual numbers of 'non-core' JPs who rarely attended Sessions. The active justices in the commission of the peace in Buckinghamshire numbered about 80; at least 60 attended the first debate in October 1839, of whom between 35 and 40 per cent were parsons.

Since the Duke of Buckingham and his allies were anxious to preserve the ability of any Petty Sessions bench to opt out of the scheme, pro-adoption forces avoided an initial motion to adopt the Act for the whole county. Instead, Verney's motion called merely for the formation of a committee of Quarter Sessions to inquire into the state of the police, the cost of a force under the Act, and the number required for the county. The committee was to report back to Quarter Sessions at an early adjourned Sessions. Verney urged speed, 'as it was important that the arrangement

should be completed before the coming winter'. He went directly to the cost issue, arguing that it was the present system that was exorbitantly expensive, but its true costs were concealed: the 'real expense of the present system ought to be considered to consist in the value of the depredations committed, [and] in the injuries sustained'; since these tended to be borne primarily by individuals, they were almost invisible. The lack of a proper police was itself a source of great expense as it occasioned 'the general demoralization of the lower classes of society'. The County Police Act was a means of socializing the costs of crime repression, and through the preventive effect of a new police, lessening, over the long run, the expense to both society and the individual. He then read, *verbatim* from the Constabulary Force Commission Report, the section on the organization and functioning of the voluntary subscription police association at Stow-on-the-Wold[51] – to illustrate the virtues of the new system, and that it could be enthusiastically supported by good Tory country gentlemen and parsons.

The seconder, G. J. Penn, declared the beershops to be 'standing arguments in favour of a new system', symbolizing the demoralization of the lower orders. Penn placed particular stress on an argument made elsewhere – the rural police Act was, above all, a poor man's measure, benefiting men of small property:

> He had an example in his own part of the county ... A poor and industrious man had acquired a little property by his care and prudence, and had invested that property in ... a small flock of sheep. Two ... of the poor man's sheep were stolen, and thus had he lost all the advantages he ought to have derived from his excellent moral conduct and prudent management. While the sheep pens of the rich farmers had been left unmolested, the poor man was robbed. And this for want of that protection which is the object of the motion now before us. If the poor man was not protected in his accumulations of property, where was the inducement to honest labour and prudent forethought?

Penn presented adoption of the Act as a measure which would broadcast society's approval of those individual qualities that demarcated the respectable from the less respectable poor.

George Carrington feared that if the committee were set up, it would naturally tend to favour a new police; so he opposed even the constitution of a committee. Verney had not told anyone how much it would cost, but, at one policeman per thousand inhabitants, it would double the county rate. If it really was a poor man's measure, how was it that the ratepayers 'had expressed no wish in favour of the change'? How could they venture so lightly upon an untried experiment 'which would take from the magistrates all the patronage of the appointments' and be irrevocable besides? Carrington then wheeled out the standard opposition argument used in most counties: a new centralized system under the Home Secretary would be established; the police would be removed from the control of the magistrates; and soon the unpaid magistrates themselves would be marginalized by the appointment of stipendiaries. Pro-police magistrates tried to counter Carrington with a barrage of facts and arguments; but the

Sessions defeated Verney's motion for a committee, by 21-17. This was a mistake, as it allowed sections of the press to hold the justices up to ridicule. One observed: 'The committee ... was not appointed, as the magistrates had determined not to be informed on the subject'.[52]

At this point, Grenville Pigott detailed the 'many cases of sheep-stealing, cattle maiming and other acts of depredation which had been committed in the ... Ashendon district, none of the perpetrators of which had been brought to justice', and called on the Duke of Buckingham to corroborate his account. The latter reported that, in the previous year in and near Brill alone, ninety sheep had been killed, and in Oakley parish there was a 'gang of desperate fellows' that needed to be put down; he had hired and paid for two policemen to patrol his property and that of his neighbours.[53] They called on the county to establish a force of twelve police for the Ashendon hundreds; but, as Verney pointed out, since Quarter Sessions had voted down a committee, there was now no mechanism by which Ashendon's wants could be satisfied.[54]

In January 1840, the justices of the Newport division filed a formal requisition for a constabulary force under the Act. C. G. Dupré, a Tory MP, again proposed a committee to inquire into the issue. The ensuing debate rehashed many of the arguments, on both sides, of the previous meeting. Disraeli appeared, and made a long, brilliant and heavily ironic speech on the unconstitutionality of a county police; Sir William Young, Sir Harry Verney and Lord Nugent devoted most of their efforts to trying to counter this argument. Nugent pointed out that the same objections had been raised against Peel's Metropolitan Police Act:

> Sir Robert Peel's measure, the appointment of a new constabulary Force for the Metropolis, had encountered an opposition similar to the one now given to the Constabulary Force Bill. It was said that London was to be divided into sections – in each of which was to be a body of gens d'armerie, ready at all times to thrust their bayonets down the throats of the peaceful citizens. And yet these men had been found a most excellent body ... very expensive, certainly – but an expense which was doubly and trebly repaid by the great additional security which was ... conferred both on life and property. And so would it be with regard to the ... Constabulary Force Act.

George Carrington concentrated, not on issues of constitutionality or the threat to the unpaid magistracy, but on the concerns of those ordinary squires and parsons whose political and social world was primarily the county, or even their hundreds or parishes. He asked if such a major step were really warranted by present conditions? Were life and property seriously threatened at the moment? And even if they were, was such a novel and expensive expedient the remedy? And he pointed out – correctly – that once the justices voted for a county police, the 1839 Act made it virtually impossible to get rid of it. For many county gentlemen, the expedient of raising an extraordinary force, to repress crime or to enforce or restore public order, had traditionally been considered a temporary one; when the danger was over, the yeomanry were disembodied or the special

constables disbanded. Creating a *permanent* force was a very large and novel step. For the moment, Carrington's opponents triumphed, and got their committee appointed;[55] but ultimately, he would win the day in Buckinghamshire.

The committee, chaired by James Dupré, immediately started work. It collected data on the cost of the old system – showing the expenses allowed to parish constables by committing magistrates and Quarter Sessions, and the amounts spent on conveyance of prisoners. A circular letter was sent to every Poor Law Board in the county, asking their opinion on the Act and furnishing them with some estimates of potential cost.[56] Sir William Young spoke directly to the question of the justices' responsibility to the ratepayers in this instance, arguing that in managing the county rate the justices acted 'ministerially'. They were *required* to look after lunatics, the gaol and certain other matters, and were obliged to raise what was needed, but 'in regard to this act, there was a *discretionary power* given to them, and on this ground it was that the committee applied to the Boards of Guardians to ascertain the feelings of the farmers and the public'.[57] The Union authorities apparently passed the survey on to the parishes – with entirely predictable results: of 158 parishes only 17 were in favour of the measure.

The final round of Buckinghamshire debates took place in October 1840.[58] Grenville Pigott and Sir William Young made a final appeal, referring to the description of the migratory habits of thieves in the Constabulary Force Commission Report. These 'propagated the most dangerous publications, as well as diseases in their travels; the Police Act, if in operation in neighbouring counties, would surely cause the tide of crime to flow out of them into Buckinghamshire.' To recruit more votes, they decided to bid down the size of the proposed force to 50. It did not work.

Shortly before the division, the Duke of Buckingham did a *volte face*, breaking with Pigott. He now professed that the justices should investigate means of improving the present constables by paying them; he had become convinced that 'if the police was established by them, their hundred would be entailed with the expense forever'.[59] As Marquis of Chandos, Buckingham had cultivated a political reputation as the 'Farmer's Friend';[60] he now took the line which, the parish survey had indicated, was that which most farmers shared. The Duke's sudden change of heart ensured the defeat of the motion – forever, as it turned out – with Quarter Sessions decisively rejecting adoption of the County Police Act by 37–14.[61]

Though Quarter Sessions decisively rejected adoption of the County Police Act, and never again discussed its adoption, Buckinghamshire remained a county with a keen interest in police reform. It responded eagerly to the Parish Constables Act of 1842, created a lock up committee, and began to appoint some superintending constables under that Act. An indicator of its continuing interest in the policing of the county was the appointment of numerous committees all through the 1840s and 1850s to study the issue. In the 1850s, Buckinghamshire would develop a full-scale

superintending constable system with a set of printed rules, regulations and bureaucratic procedures that was studied as a model by other counties.[62]

Kent

It was entirely characteristic of Kent, with its powerful tradition of divisional bench solidarity and autonomy,[63] that the struggle over county policing began at the end of 1839 with a request on behalf of the Sevenoaks bench by Col Austen, a Tory justice, *not* for a county force but for five policemen for that division alone under the County Police Act.[64] J. Berens, a Bromley magistrate and chairman of the West Kent Quarter Sessions, then moved to apply the Act to the whole county. Berens, a legally trained man, voiced his exasperation with the extent to which justice was failing in the county: 'I have seen over and over again cases fail from the inefficiency of the constables which probably never would have failed if we had a regular force which ... would also have the advantage of constant communication with the Metropolitan police.' A threepenny rate would provide excellent protection for property and persons throughout the whole county. He then made the standard 'argument from prevention' – a county-wide police founded on the best principles would produce great savings to the county rate on prosecution and other expenses. Although the County Police Act had, for a time, wide support among Kent justices from all parts of the county, the initial arguments for applying it either on a divisional basis or for the whole county were made by magistrates from Sevenoaks and Bromley in West Kent – areas close to the Metropolitan Police district.

Sir Edward Knatchbull MP, chairman of General Sessions, rose immediately to contest the motion. Knatchbull, a well-known Ultra-Tory MP and the very model of the classic Tory country member,[65] led a somewhat uneasy coalition of forces which ultimately defeated county policing in Kent. This comprised a diverse collection of Ultras, Tory peers and squires, a very few Liberals, and a key group of justices worried primarily about the costs. As chairman, Knatchbull was able to wield immense influence on this matter. Kent had separate Quarter Sessions, for judicial business only, for East and West Kent; but since 1814, a 'general sessions', composed of a relatively stable and small group of magistrates from both parts of the county, dealt exclusively with administrative business and the county rate.[66]

Knatchbull did not think that no reform of the constabulary was wanted.[67] With the Earl of Winchelsea, he had personally answered the questionnaire for his division (Ashford) in 1836.[68] He had called the parish constables 'illiterate and inefficient men', and favoured 'an improved arrangement of the Constabulary Power under the control of the Justices'. The County Police Act, however, went too far for him, and he used every argument and parliamentary tactic available to get Kent to ensure its defeat. Knatchbull's position in 1839-40, shared by a small but powerful group of Kent justices including William Deedes MP (chairman of East Kent

Sessions),[69] proceeded from a suspicion that the hidden agenda of the government was to undermine and replace the unpaid magistracy.[70] He would set himself against the establishment of a police *either* for the county or for any division within it. Knatchbull and Deedes claimed that the key to the meaning of the County Police Act lay in the Constabulary Force Commission Report:

> When he [Knatchbull] read that report ... he could not but feel a most strong conviction that it was the ultimate intention to relieve the present magistracy of the important duties which they had hitherto ... discharged, and he would most earnestly caution them against adopting any steps which might be construed into a partial sanction of such a course. Why had he formed this conviction? Because if any one would take the trouble to wade through that report, he would find ... page after page [of] sly and insidious attacks on the magistracy. Why had these attacks been made? They were altogether unconnected with the police.

If the Act was adopted, Knatchbull asked, how could chief constables be properly supervised, considering that Quarter Sessions chairmen were already overburdened? Their reports would 'ultimately be made to ... either the Secretary of State or the commissioners of police sitting in London'. Finally, Knatchbull claimed that a new county police would launch an all-out onslaught on rural petty offences, which would swamp the courts, crowd the gaols, and involve the county in expenses over and above the exorbitant cost of the police themselves.

E. R. Rice, Liberal MP, J. C. Herries, a Tory MP close to Peel,[71] and J. T. Bridges, a Tory JP, tried to counter Knatchbull and Deedes. Rice argued that the County Police Act gave the magistracy more power over the constabulary than it ever had before, taking their appointment away from 'the court leets with all their mummery'. Bridges said that he understood the chairman to say that 'in the event of this act being adopted they should have so many prosecutions and so many thieves detected that they should not know what to do with them. He ... thought that the strongest possible argument in favour of its adoption.' There would have to be a threepenny rate, but, considering the state of crime and 'particularly that of the beershops', it would be money well spent.

The adjourned Sessions of December 1839 resulted in adoption of the County Police Act by a vote of 28–24. Confusion then ensued. After the vote, some magistrates bolted for the door and left for home. With 30 per cent of the justices gone, Norton Knatchbull then proposed adjournment *sine die* 'with the avowed intention of vitiating the effect of the resolution'.[72] A disorderly discussion ensued, one justice declaring that he had never known an instance in which the magistracy of the county had been summoned to discuss a question, carried it and seen it overturned by the minority. The chief Liberal opponent, Thomas Law Hodges MP, then proposed a compromise: that the motion to adjourn *sine die* be withdrawn; and a committee of inquiry into the state of the constabulary in Kent be appointed, to report to an adjourned sessions – but also that it 'be

understood that the final decision on ... adoption ... be taken on the presentation of that report'. The vote on Hodges' proposal ended in an 18–18 tie, broken by Knatchbull's casting vote as chairman. Knatchbull's dirty parliamentary tricks and Law Hodges' voice of sweet reason combined to sink a county police in Kent until it was compelled to create one in 1856.

A committee of 22 justices, roughly evenly split between proponents and opponents of the Act, was appointed; in the following months, they sent out a county questionnaire to the Petty Sessions. Local magistrates were asked about reported crime, the number and remuneration of parish constables, and the extent of local, paid constabulary schemes; but the divisions were never asked directly their views on the County Police Act. Instead they were to report whether they would want a paid police force for the division under the government legislation *if* the Act were not adopted for the county as a whole.

The results of the county questionnaire[73] are difficult to interpret. Some Petty Sessions – including Bromley, whose justices had spoken louder at Quarter Sessions than any others in favour of adopting the Act – made no returns. Five of twelve benches ordered vestry or ratepayer meetings to be held, polled the parishes and simply summarized the parish results. Passing on questions to the vestries or ratepayers, where an increase in rates was involved, was usually a sure way of producing a strong negative response, but this did not happen in all the relevant divisions in Kent. In the Shepway division, all parishes except one wanted nothing to do with a police for the division; the one parish in favour specified that their approval was conditional on the imposition of no more than a threepenny rate. In the Upper division of the Lathe of Scray (Faversham), there was uniform disapproval, but 16 of the division's 47 parishes already had policing schemes under the Lighting and Watching Act of 1833. In the Home division of St Augustine (Canterbury), 28 per cent of the parishes favoured a police, as did a remarkable 43 per cent of parishes in the Rochester division.[74] In the divisions where the justices filled in the forms themselves, a few thought that, to be efficient, the County Police Act had to be adopted for the whole county. Sevenoaks came out very strongly for a divisional police, whatever the county as a whole did. Unsurprisingly, Hodges' division of Cranbrook and Knatchbull's of Ashford produced strong rejections of a county police.

The Quarter Sessions committee declared that, based on the returns, 'it was imperatively necessary that some great improvements should be made in the county police'. Many divisions had certified that the parish constables were inactive; when they did act, they were often unable to recoup their expenses because they were unrecoverable from the Poor Rate. The committee recommended that the County Police Act not be adopted until it could be ascertained what was to be contained in the government's amending bill of 1840.[75] But the main reason for delay was the introduction into Parliament of a constabulary reform bill by Thomas

Law Hodges, MP for West Kent. Law Hodges' bill both retained the old constabulary and provided for a significant component of professionals.[76] The Law Hodges scheme gave the justices of each division the ability to tailor a force to their own local needs. It offered the opportunity to procure modern, professional police services, but without a county chief constable, police committee, or resort to the county rate. By the spring of 1840, every Kent magistrate knew the details of his bill. To many concerned largely with the cost, it seemed a reasonable and cheaper alternative to the County Police Act; to those worried about the imperialism of Maidstone there was reassurance; to those Tories with profound suspicions of the current government, it appeared politically safer. Even Kent Radicals were attracted to the principle of local autonomy in the bill, as it would prevent the setting up of a 'centralising, liberty-crushing gendarmerie,' although they lamented that it denied the ratepayers a more direct voice.[77]

By the spring of 1840, support for the County Police Act in Kent was waning as an enthusiastic consensus developed around the Law Hodges plan. At an adjourned sessions in August 1840, general adoption of the County Police Act was debated for the last time.[78] By this stage it was clear that the government would not accept Law Hodges' bill. At the August 1840 Sessions, proponents, their position weaker, bid down the size of the proposed county police – with a view to picking up as many of the votes of the cost-conscious as possible – ultimately to a force of just 40, more than a third smaller than earlier suggestions. It was defeated 26–22 – a close defeat, but enough to end any prospect of Kent adopting the County Police Act.

With Kent now unlikely to adopt a force for the whole county, and Law Hodges' bill withdrawn in Parliament, those magistrates who still hoped at least to get county police for their own divisions, had to try to get Quarter Sessions to adopt the County Police Acts, at least partially. So the last round in the Kent debates – at a General Sessions in November 1840[79] – was a rerun of the first, with a demand by the Petty Sessions bench at Wingham, led by J. P. Plumptre, a Tory justice and MP, for a divisional police under the County Police Acts. All the usual arguments were again deployed on both sides. Thomas Bentley, after listening to a Knatchbullite argue that the Acts would transform England into as ill-governed a country as Ireland, exploded:

All the argument . . . against it had been comprised in the repetition of the words *gendarmerie, espionage, unconstitutional, and centralization.* He believed this lack of argument against the measure and the good sense of the county were a strong justification of the course Mr. Plumptre had taken. He cordially supported . . . the experiment in the Wingham division [because it] would prove so successful as to lead to the general adoption of the police in the whole county.[80]

As E. R. Rice pointed out, 'if they granted it to the Wingham division, they would not be able to refuse it for the Sevenoaks division'. For the supporters of Knatchbull and Hodges, this is precisely what they feared,

and why they wished to thwart Wingham;[81] they succeeded by 22–17. Wingham would not be permitted to have a divisional police, and the entire police issue would go into abeyance in this county until the advent in 1842 of the superintending constables, an expedient avidly adopted by Kent. The final words came from two Tory MPs. It was objected, said J. C. Herries, that no testimony was adduced of the necessity of the force in Wingham,

> but could any testimony which could be produced have more influence than the testimony of a majority of the Wingham magistrates – the testimony of a majority of magistrates in session was sufficient for the Secretary of State, and why was this testimony not sufficient for the General Sessions? Did they believe that in rejecting testimony like this they were upholding the character of the magistrates?

J. P. Plumptre, on behalf of Wingham, regretted that the magistracy of Kent were to 'sit still and do nothing, after passing in that court a strong opinion that the county constabulary were totally inefficient'.

The liberal *Maidstone Gazette* was scathing about the failure of the county to adopt a police force, for which they blamed the Ultra Tories. Those Tories aligned with Peel had behaved moderately, but those who had fought the County Police Act tooth and nail were the same reactionaries who had previously opposed repeal of the Test Acts, Catholic Emancipation, Parliamentary Reform and Municipal Corporation reform. The Tory 'glory of our land', it continued, is identified with 'the glory of unrestricted sheep stealing and petty larceny'. The question 'is no longer whether or not we ought to have a skilled police, but whether or not we ought to have a better magistracy'.[82] There was a certain irony about the eventual result in Kent. Like Hertfordshire (above), the West Riding and Derbyshire (below), the Quarter Sessions had been fairly evenly divided on the issue. In Kent, Derbyshire and the West Riding, the JPs had actually voted initially in favour of adopting the Act – but had ended up, after a series of complex manoeuvres by the anti-police forces and a series of further votes, rejecting a police force. In Hertfordshire, by contrast, they had initially voted against adoption, but had ended up establishing a police force – with the crucial final division being won by one vote. Clearly when the divisions were as close as this, the element of serendipity played a role in deciding the final outcome.

Suffolk

Suffolk was a centre of resistance to the implementation of the New Poor Law and a classic site of poverty-driven rural crime, labourer emigration, resentment against the clergy, poaching and waves of overt and covert protest – which took the form of 'Captain Swing' (in 1830–1), animal maiming and arson.[83] The introduction of the New Poor Law in 1835–6, and the subsequent disturbances, marked a rupture in the ties between the

magistracy and the labourers and their refounding on a new basis. Like much of the rest of East Anglia, Suffolk was, in the 1830s, a county with what might be termed a broken paternalism.[84]

In the 1830s, Suffolk produced fewer professionalized voluntary subscription forces than Norfolk, but still employed a number of Metropolitan or Metropolitan-trained policemen. Metropolitan men were hired to deal with the anti-Poor Law riots, and some of them were kept on thereafter in the Blything, Cosford and Hoxne Unions. Metropolitans were also hired on a permanent basis to police Hadleigh and Stoke, and for an ill-fated Lighting and Watching Act scheme at Haverhill in the Risbridge division of West Suffolk. There were voluntary subscription schemes in alliances of parishes at Hengrave and around Wickham Market. J. P. Barclay, secretary of an Association for the Prosecution of Felons, intended the Wickham Market scheme, which employed a former Metropolitan policeman, as a demonstration model and a prelude to the adoption of the Lighting and Watching Act over a larger district of sixteen parishes. But it apparently collapsed in 1837 after a falling out between gentry and farmers; the farmers suspecting that it was a landowners' scheme to shift the costs of gamekeeping on to the public. Barclay noted that, since the late 1820s, there had been a growing outcry among the propertied over inefficient policing. He thought that a rural police would be welcomed under certain conditions, 'that is to say the Farmers would like it if at others' cost, and the proprietors if they could secure the patronage'.[85] Suffolk also produced the author of a classic scheme of police based on the Poor Law Unions. Stephen Clissold was a staunch Tory parson, and a justice of the peace. Directly involved in managing the two policemen hired in Blything Union, he emerged as a proponent of the adoption of the County Police Act at East Suffolk Sessions in 1840.[86]

Suffolk comprised two legal counties, each with its own Quarter Sessions: East Suffolk, holding rotating Sessions at Beccles, Woodbridge and Ipswich; and West Suffolk, at Bury St Edmunds. The replies of these two counties to the queries of the Constabulary Force Commission at the end of 1836 foreshadow the outcome of 1840: adoption in East Suffolk and initial rejection in the West.[87] The question of adoption of the County Police Act was considered separately by each part of the county, and there were separate debates and votes in the three subdivisions of East Suffolk.[88] West Suffolk rejected the act in 1840, but created a police in 1844, after a frightening wave of arson.[89]

East Suffolk

In Suffolk there were few undecided or wavering justices. By early 1840, opinions on the issue were firmly held, minds were made up early on and were not changed. In East Suffolk, some of the minority who opposed a county force – above all Lord Henniker, Colonel H. B. Bence and Sir Thomas Gooch – felt so outraged by the decision to form one that they

carried on their resistance beyond Quarter Sessions. Some magistrates were even prepared to make inflammatory speeches at farmers' protest meetings and to organize ratepayer petitions against the move.

The outpouring of negative reaction by East Suffolk farmers and ratepayers was amongst the most extensive and best organized anywhere in England. Suffolk farmers were already suspicious about the New Poor Law. Now they perceived the adoption of a county police by the unrepresentative and unelected Quarter Sessions – which had not consulted ratepayers before saddling them with this new rate burden – as a further example of the arrogance of the big landowners and a final straw. A ratepayers' meeting at Stradbrooke, attended by Lord Henniker, his relative the Revd J. Bedingfield and a few other prominent Tories, strongly condemned the measure 'about to be thrust by force down the throats of the ... agricultural population', as the *Suffolk Chronicle* put it.

At another public meeting at Stowmarket at the end of January 1840, one speaker complained:

> Mr Tyrell had stated that the owners and occupiers should have got up a Memorial ... previously to the meeting of those magistrates. Now that could not have been, for he ... knew very well that a large proportion of the farmers were not aware of the provisions of the Act until a meeting of the magistrates made them known. He might say ... that not more than one-third of the rate-payers knew what the Act contained. ... The calculations of the magistrates had been made, and their data fixed; and ... he was not aware that the presentation of a Memorial would lead them to alter their judgement.[90]

Another speaker raised explicitly the issue of loss of local control over policing:

> The petty constables ... had been chosen by the people and paid by them, but now, the authorities demanded that the people should pay for the establishment of a Rural Police, yet would not allow them to exercise a choice. He had always understood it to be a sound ... maxim that taxation should be equal with representation – that was, the choice of those who paid, should be allowed in the adoption of that for which they were to bear a fiscal burden. It was not so, however, as respected a Rural Police.[91]

Reform of the Poor Law – which much of the Suffolk magistracy had opposed[92] – had resulted in greater empowerment of this stratum of rural society; but now the adoption of the Police Act by Quarter Sessions was understandably perceived as a measure of disempowerment, of removal of control of policing from the level of the parish and vestry. The considerable margin of victory for the proponents of a county police on the bench (34–19 overall for the three subdivisions of East Suffolk) indicated that the justices had made their decision and would not easily relent.

The number of East Suffolk justices was relatively small for a county of its size, and the participation rate, on an issue as charged as this, was high – helped by the adjourned Sessions being held in three different towns, which made it easy for all JPs to attend and take part.[93] The lines initially drawn in East Suffolk's discussions of the 'Salop Resolution' of January

1839,[94] remained unchanged until final adoption of the County Police Act in January 1840.

Discussion of adoption of the County Police Act began at the end of December 1839, with the Sessions rotating from Beccles to Woodbridge to Ipswich. The first round, at Beccles, was the most explosive. Here the bench finally voted to adopt, by only 10-8, in the teeth of the opposition of the chairman, Sir Thomas Gooch, and of Colonel Bence, a local Tory firebrand, and a deluge of ratepayers' petitions from 41 places in the division. Gooch argued that the present constabulary was indeed defective, but that this could be remedied if the parishes took better care in their appointments, the magistrates more diligently scrutinized their choices and if some way could be found to remunerate the constables. He pursued the legalistic line that, in order to adopt the Act, the magistrates had to show that *both* property and persons were insecure; he doubted that the latter could be shown. He thought the Act unconstitutional, giving the Home Secretary too much power. Other opponents argued that the Lighting and Watching Act was more constitutional, and that, to be efficient, a new force would have to be so numerous as to be unduly costly.

Proponents rested their case upon the insecurity of property and the widespread plague of poaching. They stigmatized their opponents' arguments as contradictory. John Garden stated:

> the whole argument of its being of an unconstitutional nature fell to the ground - for if the new constabulary were not sufficiently numerous to suppress crime, how in the world could a Secretary of State be able ... to put down the liberties of this country - how could that force be sufficient to suppress all honest men and yet not be adequate to the control of the rogues?

He had had enough of 'the Dogberrys at present in some of the parishes'; what was wanted was *system* and a body of 'active, vigilant and otherwise effective men'. The Revd Henry Owen thought it was a question of the moral condition of the rural population. He had read the Constabulary Force Commission Report, and was convinced that the feebleness of the constabulary encouraged crime and was destructive of the morals of the people. The crucial vote for adoption was carried, and a motion passed to recommend the salary of a chief constable and the size of the force.

Colonel Bence then exploded: 'I think this measure so unconstitutional, so uncalled for - so un-English - that I shall not record my vote upon this motion. I shall not have anything to do with it.' Bence launched a public vendetta against the Act, attacking, in a letter to the press, a prominent Liberal proponent from the Woodbridge division, R. N. Shawe, and speaking at (and probably helping to organize) mass meetings of farmers and ratepayers. Bence was particularly outraged that the margin of victory at Beccles was provided by two justices who acted mainly for the Lodding and Clavering division of Norfolk - so the votes of outsiders lumbered Suffolk with the Act.[95]

The question then passed on to Woodbridge, where, again, adoption

was carried against the views of the Tory chairman John Moseley. Here, too, the meeting of the court was greeted by a bundle of petitions from nearly every parish in the division which, one magistrate jokingly observed, would take a couple of days to read. Opinion here was led by R. N. Shawe, later to become a Liberal Suffolk MP. He presented the issue as one of proper social subordination. The extent of rural crime was high, there were extensive robberies; some men lived by a system of plunder and a great number of young men were 'brought up to the committal of crime by the force of bad example', and by observing that plunderers lived better than other labourers and were rarely prosecuted. They observed in the beershops that idleness was rewarded. Three things were necessary to remedy the degraded moral condition of the labouring population: 'useful and religious education', employment, and a police that would reduce the impunity of criminals and convey a new message to impressionable youth.

Shawe was fully conversant with the arguments of the Constabulary Force Commission Report and was anxious to shock his colleagues by some estimate of the true extent of crime in the division. Between July 1839 and January 1840, he had conducted an enquiry into the extent of undetected theft in 30 parishes of the division and found that 150 had occurred. Since this comprised only about a third of all the parishes, the total for the whole division was likely to be around 450. This appeared to be powerful empirical evidence and was difficult to counter. Another Liberal gentleman, Major Moor, put the rest of the case, raising the spectre of the county becoming an Alsatia for thieves, rogues and vagabonds now that both Norfolk and Essex, the adjoining counties, had voted for a rural police.

Throughout the Woodbridge debate, opponents of adoption were on the defensive, relying too exclusively on the argument that the Act was unconstitutional and gave the Home Secretary too much power. One justice attempted to refute Shawe's data on undetected crime by pointing to sixteen individuals recently transported from Woodbridge, showing some successes for the parish constables; but Major Moor retorted that twelve of the sixteen had been arrested by just *one* active constable.[96] Moseley, the chairman, did not contest this analysis. He argued that the prevention of crime was an important objective for which it was worth paying a high price, but he could not help but feel that the measure was unconstitutional, and 'would destroy that feeling which connected all grades of the people ... reciprocally with each other'. The Woodbridge justices voted by a margin of two to one (8–4) in favour of adoption.[97]

The outcome at Ipswich was similar, the vote again being strongly in favour of adoption (16–7). The debate here was dominated by the chairman, Edward Godfrey. Four magistrates from other subdivisions (three proponents and one opponent) sat on the bench but, out of courtesy, did not vote. The chief local opponents were all Tories: Lord Henniker, Sir Edward Kerrison, and parsons James Bedingfield (a relation of Henniker) and Augustus Cooper.[98] Godfrey used the Grand Jury charge at

Ipswich to make his case to the farmers. He told them that in ancient times there had been a requirement to keep watch and ward in the villages; the new police would re-establish an institution that had fallen into decay. Essex and Norfolk were establishing new constabularies, and criminals inevitably would migrate into Suffolk if they did not do the same. On the thorny issue of cost, he did not think that the charge would be more than 2d. per acre; even if it were larger, 'it would not fall upon the occupier, but the landholder in the long run . . . as short terms were the fashion, why the occupier, knowing the burdens on the land, could make his terms with the landlord accordingly'.[99]

Godfrey, who had signed the requisition, then relinquished his chair and piloted the pro-police side of the issue against Henniker and his allies, who presented the usual pile of ratepayer petitions to the court and rested their case on the need to respond to ratepayer opinion and pause to see how the policing scheme worked in other counties. Godfrey proved an acute student of the approach to criminal statistics taken by Chadwick in the Constabulary Force Commission Report. He took the average committals for felony over the previous five years and multiplied them by a factor of five (the estimated dark figure) to give 695 criminals. Assuming that thieves got 10s. a week from their plunder (one-third of the actual value), the real cost to the individuals robbed was no less than £54,000 per annum. Why balk at spending a few thousand to prevent annual losses of tens of thousands?

He then challenged the constitutional argument, asking whether the 'Government of so large and important a country as this [would] find it worth its while, or its time . . . to attend to the wretchedly trifling affair of the appointment of a county constable? The supposition was idle and absurd.' He finally addressed the clergy and argued that the police would 'strengthen their hands for the doing of good, it would reduce the number of temptations that now surrounded the labouring classes.' Of the 23 justices voting at Ipswich, 12 were clerical magistrates, 8 of whom voted for adoption, providing half of the votes for the 16–7 victory.[100]

The magistracy of all three divisions met at Woodbridge in February 1840 to elect a chief constable. There the anti-police forces rallied for a last-ditch effort, proclaiming the irregularities of the Beccles vote. Henniker, Bence and others had been agitating at ratepayers' meetings; now they argued that, since adoption had been carried in Beccles in 'a most indecent manner', any ratepayer could question the legality of the rate, and no magistrate could order a distraint upon him. Every argument pro and con hitherto heard was rehashed at length; the meeting culminated in a raucous shouting match after Godfrey presented a statistical table on felonies, assaults and poaching offences which showed the Hoxne and Hartismere hundreds (areas covered by the Beccles division) in an unfavourable light. 'The greatest excitement appeared to prevail at this stage of the proceedings, and cries of "Question!" drowned the voices of several magistrates who rose to address the bench.' But the justices voted, by 30 to 11, to proceed to the election; one month later,

they appointed John Hatton, of the Meath Constabulary in Ireland, as their first chief constable.

Colonel Bence would not relent. He made attempts at Beccles, over the next eighteen months, to pull the division out of the county police arrangements, arguing that Beccles, possessing its own house of correction, treasurer and surveyor, was a legal county in itself! He also pursued a personal vendetta against the prominent Liberal R. N. Shawe, attacking him in the press for his role in the struggle over the police, and on party political grounds as being soft on Roman Catholicism.[101] A good portion of the April 1841 adjourned Sessions was taken up with a reading of Bence's letter to the press and Shawe's defence.[102] On at least one occasion, large numbers of Ipswich and Woodbridge justices showed up at Beccles Sessions to make sure of swamping the votes of Bence and his friends.[103] By the summer of 1841 Bence's campaign had lost impetus, and most of his anti-police colleagues lost interest. The East Suffolk county police force was firmly established.

West Suffolk

West Suffolk initially rejected the County Police Acts in 1840, but put them into effect in the spring of 1844 after a frightening wave of arson had convinced enough magistrates that creating a police force was inescapable. Chairman of West Suffolk Sessions was the Revd Nicholas Colville, DD of the Babergh division in southwest Suffolk. This district was periodically disturbed and deeply pauperized; it has been described as 'one of the sorriest corners of rural England'. Here small farms, chronic oversupply of labour, truck payments and dying industries sent average wages as low as 6s. a week during times of depression. Colville, and his colleague on the Long Melford bench, Robert Mapletoft, remained diehard opponents of a county police. Their return to the Constabulary Force Commissioners in 1836 claimed no failures of justice, perfect efficiency among the parish constables, and no need for any changes whatsoever. Mapletoft continued to make these claims in 1840. Cosford, the division just to the east centred on Hadleigh, had a different orientation in both 1836 and 1840. Hadleigh, like Wymondham in Norfolk, had a reputation as a criminal town. Professor Henslow, who was a rector in the area, inferred from what he observed around him that the country villages were thoroughly pervaded by petty crime, 'openly and unblushingly practised, and ... commonly tolerated'.[104] The Cosford division had experienced considerable disturbances in 1835 at the time of the formation of the Cosford Union. Hadleigh had adopted the 1833 Lighting and Watching Act and hired an ex-Metropolitan policeman; in 1836 its bench was, of all the divisions in West Suffolk, most unequivocal in favouring paid police.[105] At the West Suffolk debates in January 1840, the Revd Frederick Calvert of this division emerged as a chief proponent of the County Police Act.

Considerable support for a police was offered from the Bury bench, representing the joint hundreds of Thingoe and Thedwastry on either side of Bury St Edmunds, although a sizeable minority opposed it. Majorities against adoption came from the Blackburn division at Ixworth and Risbridge in the extreme southwest corner. The strongest opposition, however, emanated from the Mildenhall bench, dominated by the Tories Lord William Poulett and H. S. Waddington MP. This division, covering the northwest border with Cambridgeshire and Norfolk, was by far the most sparsely populated district of the county, and part of its rates might heavily subsidize other parts of the county in a police rate. When the West Suffolk force was created four years later, there were loud complaints from the light land and fen portions that they were getting less service in return for the rates they paid compared to the more densely populated districts of the county.[106]

Support for the motion to adopt the Act[107] came from J. H. Powell of Hengrave, northwest of Bury St Edmunds. He reported on the beneficial effects there of a voluntary subscription scheme covering twelve parishes and a population of 2,700 to which the farmers subscribed; all the large occupiers were now calling for a county police. His sentiments were seconded by Robert Bevan (director of an insurance company), who recounted the effects of a similar scheme – the diminution of petty crime, better order in the beershops and the lessening of the fear of launching a prosecution. He praised the parish constables, but argued that what was now needed – preventive patrolling – was clearly something the constables could not do.

The opponents of adoption resorted to the argument from local needs: even if conditions in Mr Powell's district seemed to warrant its police scheme, that does not apply to *my* district, which is peaceful and quiet; each locality should look after its own needs. '[T]hat a gentlemen should ... move the adoption of the police bill as a *general* measure appeared a most unjust proposition, particularly when the expenses were expected to be borne by the whole [county]'. The solution, said Lord William Poulett, was for districts wishing a police to adopt the Lighting and Watching Act. Mapletoft had come prepared to counter the argument from criminal migration, and was surprised that the proponents had not tried to use it ('he seemed at present to be fighting against air'). The case made by the advocates of adoption was made weakly, almost half-heartedly when compared to the fact-and-statistics-laden presentations made in East Suffolk, and aligned against them were an influential aristocrat, local-minded squires and two Tory parliamentarians. The issue was killed in West Suffolk with a vote against the motion of 25–19.

It was then revisited twice in 1844. In March it was again rejected; but in October 1844, Quarter Sessions adopted the Acts by a comfortable margin. This belated decision to adopt was clearly a reaction to the terrifying outbreak of arson in the county.[108] A tremendous amount of pressure was put on magistrates, not least by the insurance companies who met with them and issued proclamations favouring a rural constabulary; they even

paid the costs of a London policeman in one village.[109] In order to change sentiment on the bench, testimonials from colleagues in East Suffolk and Norfolk, some of them justices who had originally opposed the formation of a police, were introduced. Lord Euston, who had played no part in the debates of 1840, now signed the requisition and made a speech extolling the utility of a police in repressing crime. He reassured the magistrates and readers of the newspapers which reported the debate, that the cost would be quite moderate. Robert Bevan, defeated n 1840, had now become more aggressive, remarking that anyone who had witnessed the fires:

> would have welcomed and prized the presence of two or three of these blue-coated gentlemen ... The other day, when the calamitous fire occurred at Tuddenham [some] of the Mildenhall people did all they could to promote the fire by throwing on fuel. A magistrate who was present said ... that he could not prevent it. Now a few policemen stationed here would be a great advantage.[110]

Opponents urged once again that those who wanted a police should use the Lighting and Watching Act or the Parish Constables Act of 1842. The issue was again lost - but by a margin of only two votes.

At the October sessions, the attempt was renewed, with a number of magistrates reporting that they had actually tried to get local vestries to adopt the Lighting and Watching Act, and in most cases it had proved impossible. The argument was put strongly that there now was no alternative but a county police; as Professor Henslow said, since the people were paralysed 'now the magistrates must act for us'. The magistrates did act, and voted 29-16 for a county police.[111] A separate police force for the western division was created. In 1846 East Suffolk proposed that both forces be united under their chief constable, Hatton, but West Suffolk refused the offer, and appointed a Colonel Eyres.[112] The two forces, like the two divisions of the county, continued separate existences through the rest of the nineteenth century.

The Midlands

Derbyshire

Derbyshire was a Midlands county, with a mixed economy - a substantial industrial sector, in the form of cotton textile factories, but also large agricultural areas - and a county bench which reflected that mixture. The chairman of Derbyshire Quarter Sessions, John Balguy, strongly favoured adoption of the County Police Act. At the first Sessions after the passage of the Act, he used his address to the Grand Jury to urge adoption of the Act, stressing 'the present very inefficient state of the constabulary in some of the rural districts' and their inadequate protection of property.[113] A special adjourned sessions was held, at the beginning of November 1839, to debate adoption. The majority of magistrates at this meeting seemed generally favourable to adopting the Act, but some strong opposition was expressed,

especially to the expense of such a measure, and on the need to consult the ratepayers of the county first. They finally agreed to a compromise motion, proposed by Thomas Gisborne MP, to adopt it subject to an enquiry by a committee into the size and cost of the force required.[114]

That committee presented its report to the next meeting, on 31 December 1839. But that meeting attracted 'the largest Bench of Magistrates we ever remember to have seen assembled'.[115] Many of the backwoods justices came out to defeat the measure. The anti-police forces had taken advantage of the delay to mobilize effectively. Justices arrived at the meeting bearing vast quantities of protest petitions from ratepayers. The committee also admitted that they had sent questionnaires to all Petty Sessions, and most of them had responded *against* the need for a county police force. Nevertheless, the committee recommended adoption of a force of 67 men for the whole county, and the chairman proposed that they endorse the committee's report.

The debate which followed was very full and closely contested. The chairman, Balguy, used all his authority to stress the inefficiency of the constables – 'the present vile, inefficient, and useless constabulary force'; he had strong support on this from Edward Strutt MP and other members of the influential Strutt family of industrialists. But there was also strong opposition, which mostly stressed the expense of establishing a county force, and the burden which this would impose upon the county ratepayers. W. Webster drew 'loud applause' when he called the Act 'unconstitutional' because, 'It took the power out of the hands of the magistrates, and lodged it in those of the great Chief Constable, and through him directly in the hands of the Home Secretary of State' – though he was alone in expressing such extreme views. But the opposition forces succeeded, by 29-26 (a narrow, but crucial, anti-police majority), in replacing the motion with an amendment to postpone further consideration of the issue until the October Sessions.[116]

At that time, the magistrates duly met again, in fractious and legalistic mood. Eventually, William Evans MP proposed a motion that the Act be adopted for the whole county; it was countered by an amendment, proposed by Philip Gell, that the Act should not be introduced into any part of the county.[117] After another long debate, in which the arguments used on both sides closely followed those used previously, the magistrates voted on the amendment, producing a *tied vote*, 26-26. This caused confusion and uncertainty as to where this left the issue, and what to do next. The proposer Evans, with Thomas Gisborne MP, now tried to introduce a motion to adopt the Act for just a *part* of the county; this was strongly opposed as out of order and improper, since the necessary notice had not been given for that particular motion. After a few minutes of loud disorder, Gisborne agreed to withdraw their motion, conceding that:

> as they had failed in negativing Mr Gell's amendment, it was improbable that they could succeed in carrying a motion for the partial introduction of the force;

for some gentlemen who had voted against rejecting the measure altogether, would not support its being adopted in parts of the county. It was evident, therefore, that they were not in sufficient numbers to carry out the measure harmoniously and efficiently; and under these circumstances, he thought it would be better to allow Mr Evans's original motion to go to the votes and be lost.[118]

And with those words, the pro-police forces in Derbyshire effectively gave up the fight to adopt the County Police Act. The *Derby Mercury*, a Tory newspaper, expressed its delight at the defeat of what they called 'a centralised police', 'a rural *gendarmerie*', and an unconstitutional 'legal system of *espionage*', belonging in France, rather than in England;[119] the *Derbyshire Courier*, also Tory, was far more circumspect about expressing any view, for or against. Extraordinarily, even though they had come so close to success (including winning the initial vote), the pro-police group accepted this defeat as final. Over the next sixteen years, they made no further attempt to pass a motion to adopt the County Police Act, and Derbyshire established no county force until it became compulsory in 1856. Like Kent, the West Riding and a number of other counties which did not adopt the Act, they relied on the appointment of superintending constables, from the time that that became a legal option in 1842, until 1856.[120]

The issue of cost was paramount in Derbyshire. The creation of a county police was strongly supported by a group of influential JPs, including the chairman John Balguy, Lord Waterpark, Edward Strutt MP and other members of the powerful Strutt family, and Thomas Gisborne MP. But a number of magistrates objected, from the outset, to the expense of a police; when the large numbers of ratepayer petitions poured in opposing adoption of the Act, more JPs decided not to risk incurring the wrath of the farmers and shopkeepers in their petty sessional districts. Justices sitting for rural divisions of the county argued that most of the need for the police would be in the urban and industrial parts of the county, so that it would be unfair to make the rural parts pay an equal share of the cost. This opposition was sufficient to block adoption of the Act in 1840, and, ultimately, to defeat that proposal completely for Derbyshire.

Some Midlands counties (Shropshire, Worcestershire) adopted county policing with virtually no resistance at all, and others adopted it, wholly or partially, against less opposition than appeared in Derbyshire. It is worth looking at a few of these.

Nottinghamshire

The Quarter Sessions debates on the County Police Act in Nottinghamshire cannot be followed in the same depth as in most other counties, since it was one of the very few counties not to allow the local press complete freedom to report proceedings at Quarter Sessions. The three crucial initial meetings of Quarter Sessions were held on 12 and 21 November 1839 and

2 January 1840; only the meeting of 21 November was held in open court, allowing the press to report details of the debates, the arguments used and the voting on the motions.[121]

However, the broad outline of events is clear. A meeting of a committee of magistrates was held on 12 November to consider adoption of the County Police Act. It recommended in favour of adoption. At the special adjourned Sessions on 21 November 1839, the Nottinghamshire magistrates, after a long discussion, approved this recommendation and voted to recommend to the next Quarter Sessions that they establish a county force. They decided on a force of only 42 men – not a large force for a county with the population of Nottinghamshire, a ratio of one policeman per 4,000 of population, whereas the Act allowed the ratio to be as large as 1 to 1,000 of population.[122] The January 1840 Sessions duly voted to adopt the Act – but we have no details of the debate or the vote itself, since the magistrates retired from the open court to the closed Grand Jury Room (to which the press was not admitted) for the crucial debate and vote.[123] At the end of the meeting, the chairman announced that they had agreed to adopt the Act and to set up a force of 42 men.

As in Hertfordshire, the anti-police forces – led in Nottinghamshire by the Duke of Newcastle and Col Wildman – continued the fight by trying to block the appointment of the new chief constable. The Duke of Newcastle addressed an open letter to his fellow magistrates, in which he attacked the new police as unconstitutional and a threat to the unpaid magistracy and the civil liberties of the country, and called on the JPs to 'reject this wily project of our unwearied enemy'.[124] However, Newcastle in Nottinghamshire was not able to force the same sort of close vote as the Marquis of Salisbury had achieved in Hertfordshire. When the Nottinghamshire JPs met at their April 1840 Sessions, to choose a new chief constable, the pro-police forces triumphed by the decisive vote of 33-9.[125]

Leicestershire

At the beginning of 1839, when Russell circulated the 'Salop Resolution' in favour of giving the county justices the power to appoint a paid police force, the Leicestershire JPs unanimously endorsed it at their Easter 1839 Sessions. On 14 October 1839, they met, in an 'unusually numerous' attendance, to discuss adoption of the new Act. Their chairman, C. W. Packe, did most of the talking at this meeting, and ensured a unanimous vote in favour of a county force. The *Leicester Chronicle*, a Whig paper, approved their decision and the cautious way in which they were proposing to implement it.[126]

This apparent unanimity of Quarter Sessions, however, disguised divisions among the magistrates, and an unwillingness on the part of most of them to pay more than the bare minimum for their new police. The initial proposal of the chairman was that their force start with no more than a chief constable and fifteen men (for a county with a population of about

150,000 – a ratio of one policemen for every ten thousand inhabitants!) This was defeated by the narrowest of margins by a motion which increased the force to just 24 men. Leicestershire had thus voted itself a force for the whole county – but the desire to keep the cost down had resulted in it being the smallest of all the county forces. Its ratio of one policeman to six thousand or more inhabitants made it a ludicrously small force to police the area of the whole county, even against ordinary crimes, let alone to try to deal with any serious disorders.[127] Subsequent attempts to increase the size of the force, to 43 or 40, brought out strong anti-police opposition from Leicstershire magistrates, and they were defeated.[128] Henry Halford, MP and Leicestershire county JP, warned, in these debates, of the inherent tendency of the new rural police to become dangerous to traditional constitutional principles and liberties; he published a pamphlet setting out these views more fully.[129] Leicestershire kept its small county force, but it became something of a target of ridicule for anti-police forces, who used this small force to demonstrate their argument that a county force large enough to be really effective would be ruinously expensive to the ratepayers, while one small enough to be affordable would be so tiny as to be useless for the task of patrolling effectively the large rural expanses of the county.

Staffordshire

Staffordshire, unusually, arrived at a force for the whole county in two stages. Initially, a small force was appointed for only one division; three years later, it was extended to the entire county. When Russell circulated the 'Salop Resolution', Staffordshire replied cautiously. They agreed that the existing constables were insufficient (and, some added, inefficient), but they were not prepared to accept the idea of taxing themselves to pay for a professional police.[130]

When they first considered the County Police Act, at a special adjourned Sessions in November 1839, Quarter Sessions did not even have before it a motion for a force for the whole county; instead, the Earl of Dartmouth, Vice-Lieutenant of the county, with the unanimous support of the magistrates of the division involved, proposed that it should be adopted for just the southern division of the hundred of Offlow South. This was in the extreme south-east of the county, the part of South Staffordshire's 'Black Country' which was immediately contiguous to Birmingham and which, as a result (claimed Dartmouth), 'was infested by gangs of depredators' from that city. Dartmouth and some other JPs argued a version of the 'migration thesis' to support the need for a paid police – bad characters from Birmingham were spreading easily into the poorly policed area of Staffordshire. This situation would be bound to be aggravated by the new police being established for Birmingham. Dartmouth's resolution for a small force for Offlow South was carried with little opposition, and a force was set up, for this one division, consisting of one superintendent and

twenty constables. However, Major Chetwynd MP expressed his opposition to the basic principle of the County Police Act, and argued that establishing even a small force could prove to be the thin end of the wedge. Drawing also on the 'migration thesis', Chetwynd warned that establishing a force in one part of the county would mean that 'the disorderly characters would be driven from that particular part of the county to those parts where such a force did not exist – (hear) – and thus they would be led by compulsion to adopt the act for the whole county (Hear)'.[131]

Staffordshire made no further moves in relation to the County Police Act until 1842, when the ratepayers of the parish of Darlaston petitioned the July Quarter Sessions for relief from paying their share of the cost of the Offlow force, since their policemen constituted 'a vexatious and useless burthen on the rates'. It was agreed that the next Quarter Sessions, in October, should consider a motion to exclude them from the police district. Ratepayers from other parishes in Offlow South then began to petition for exemption from both the force and the police rate.[132] However, in August–September 1842, Staffordshire erupted in a series of Chartist-related strikes and riots commonly referred to as the 'Plug Plot'. The strikes were widespread in the coal mines and iron manufactories of the 'Black Country' of South Staffordshire, and in the coal mines and potteries of North Staffordshire. In the Potteries, there were attacks by angry crowds upon the houses of magistrates and manufacturers. In response, in October 1842, the government sent a Special Commission of Assize to Staffordshire where 276 people were tried for their part in the events, severe sentences being meted out to most of them.[133]

The extent and severity of the riots shocked a number of magistrates who had previously opposed a county force on the grounds of cost; these now argued that the Potteries and Black Country could no longer afford *not* to have a paid police. At the October Quarter Sessions, the motion to remove the Offlow South police was withdrawn and replaced by a motion to establish a force for the whole county. That motion was extensively debated at that Sessions, and at an adjourned Sessions two weeks later, and was finally carried *nem. con.* though considerable opposition had been expressed in the course of the debates.

The overriding theme of the renewed debates was that the magistrates faced an inescapable choice of evils: the undoubted increased expense to the ratepayers involved in introducing a county force, versus the serious dangers of trying to control large and populous mining and manufacturing districts (the Black Country and the Potteries) without a strong police. In the event, the magistrates' fear of danger and disorder overcame their dislike of paying for a police. As Lord Sandon said, in proposing the motion to establish a force for the whole county: 'in regard to the populous districts there could not be a doubt that a more efficient system of police was required, whether for cases of disturbance or the common prevention of crime'. When John Barker, a magistrate who was also a major Wolverhampton coal and iron master, objected to the increased rates he

would have to pay, he was answered by the Revd Isaac Clarkson, a clerical magistrate for an adjacent Black Country district:

> [T]he rioters in the south of the county, during the late disturbances, were apprehended, with very few exceptions, by the police of Offlow South. These policemen were up guarding property for three nights and days together, and were never allowed during that period to leave the property of the coal and iron masters, who now made so much complaint about the payment of the rates.

The implication was clear – the employers of Staffordshire would have to accept the need to pay for protection of their persons, property and businesses – and most of the JPs accepted the logic of this argument. The fact that neighbouring counties Shropshire and Worcestershire had established county forces in 1839 strengthened the fears of the Staffordshire magistrates – particularly those who believed in the 'migration thesis' – that they could no longer afford to be without their own efficient professional force.[134]

Staffordshire, being a county with substantial and populous mining and industrial districts, but also with large rural areas, faced the same problem as bedevilled the West Riding and Derbyshire in trying to establish a force – the argument that it would be unfair to expect the rural districts to pay for a force which was needed mainly to police the densely populated industrial and mining districts. This argument defeated moves for a police in the West Riding, and played a part in their defeat in Derbyshire as well. In Staffordshire, it was handled by dividing the county into three districts, differentially rated, for police purposes:[135] the Potteries District in the north; the Mining District (the Black Country) in the south; and the Rural District in between. The Rural District was to be policed very lightly and cheaply, initially with only 12 superintending constables in charge of parish constables; the bulk of the police, 158 men at ratio of about 1 per 1,500 inhabitants, were to be stationed in the two industrial districts.[136]

Staffordshire offers us the clearest case of all the counties in which fear of serious disorder played a major part in their decision to establish a county force. A Quarter Sessions which strongly opposed adoption of the County Police Act for the whole county, mainly owing to fear of the probable expense, was forced to change its mind by the greater fear of the disorder and danger which could come from not having an efficient police to control the county's turbulent industrial and mining populations.[137] In Staffordshire, unlike most other counties in which the issue was divisive, the chairman of Quarter Sessions, Francis Twemlow, played no significant part in the debates in 1839 and 1842, restricting himself to presiding over them in an essentially neutral role. The pro-police arguments were put by landed and clerical magistrates (with the Vice-Lieutenant, the Earl of Dartmouth, playing an important role). The opposition comprised some traditional landed gentry, objecting on constitutional grounds, together with coal and iron masters (recently promoted to the bench) who objected to the police rates which would be imposed to pay for the new police.[138]

The North

Lancashire and the West Riding of Yorkshire

The magistrates of Lancashire, the largest and most important county in terms of industry and population, adopted the Act very easily, with no dissent and without a political struggle. This should not be taken as meaning that there was no opposition to the new police in Lancashire from the press or from the wider community. The radical *Preston Chronicle* condemned the magistrates for agreeing to 'this most expensive, rigorous and obnoxious *espionage* arrangement'. Chartists criticized the new Lancashire force as being an agency of oppression of the working class and its legitimate claims, and there were some episodes, in their early years, of concerted working-class attacks on members of the force.[139] But in Lancashire, unlike many other counties, this opposition was not reflected within the Quarter Sessions.

As we have already seen, the Lancashire JPs had shown strong support for a county police at the beginning of 1839.[140] As soon as the County Police Act had been passed, they agreed to hold a special adjourned Sessions, in early November, to discuss its adoption. That meeting was attended by 62 JPs; some of the men who had dominated the January meeting were again prominent. The motion to adopt the Act for the county was passed unanimously, with virtually no discussion. Unlike the West Riding (below), there was no opposition in the Sessions; either to the principle of a county police, or to treating all parts of the county alike. The only discussion and disagreement came over the issue of how large the force should be, and how much it should cost. The Act specified the maximum size permitted for a county force as a ratio of one policeman per thousand inhabitants; after some discussion, the Lancashire Sessions agreed on a force of one chief constable and five hundred men – a ratio of one policeman to about 1,500 inhabitants, and, in absolute terms, the largest of all the county forces established.[141]

The West Riding, like Lancashire, was a major industrial county – the centre of the woollen and worsted industry, and a substantial iron and steel production – yet the outcome of its police debates was quite different. As was the case elsewhere, huge numbers of magistrates were drawn to Quarter Sessions for discussions that were particularly divisive and acrimonious. At a number of meetings between April 1840 and April 1841, justices debated the Act without being able to resolve their disagreements. Powerful forces were involved on both sides of the debate.

Most of the important county Tories tried to steer the Sessions to a compromise: the establishment of a paid county police in the more industrial and populous parts of the Riding and the exclusion of the purely rural areas. Members of this group were Lord Wharncliffe,[142] (its leader); the Hon. Edwin Lascelles, Wharncliffe's successor as chairman; Wharncliffe's son John Stuart Wortley; and Edmund Denison, a close political

associate of Wharncliffe's. Among the fiercest opponents of a police force in any form was the paternalist Tory William Busfield Ferrand, opponent of the New Poor Law and supporter of factory legislation, who was strongly supported by the violently partisan *Leeds Intelligencer*.[143] Ferrand, however, acted rather apart from the bulk of West Riding Tories, most of whom were quite pro-county police (although with important reservations), and whose rhetoric was devoid of constitutionalist blather or Oastlerism. Leading Whig proponents of a police were Whig MPs Charles Wood, Sir Francis Wood, William Busfield, W. R. C. Stansfield and J. W. Childers.[144] The Revd J. T. Horton served as a JP for both Lancashire and the West Riding, had been a leading proponent of the county police in Lancashire, and now pushed strongly for a police for the Riding. The proceedings in the West Riding were highly politicized, and were clearly linked to disputes and conflicts between Liberals and Tories on a range of other issues having nothing to do with policing. The great party-political division in this county manifested itself in the controversy over the extent of a police, not a police itself. In the West Riding, very few justices argued that a police was not needed at all.[145]

A motion to adopt the Act for the whole county was first proposed by the Liberal Bradford justice Matthew Thompson in April 1840 in a packed courtroom of about a hundred JPs. After a long debate, it was clear that there was considerable division on the issue, the main sticking point being the unwillingness of the magistrates for the rural areas of the Riding to pay not only for their own protection but to – in their view – subsidize the manufacturing areas. The chairman, Lord Wharncliffe, largely shared this view: he wanted a police for the Riding, especially for the industrial areas 'in these times of agitation', but he did not want to saddle the rural ratepayers with the cost. Since the amending Act, which would enable Quarter Sessions to divide the county into differentially rated districts, was due to be passed later that year, Wharncliffe supported a proposal to defer consideration of the motion until a special Quarter Sessions meeting in September 1840; this was unanimously agreed to.[146]

By the time of the September meeting, the amending Act had been passed; but it had also given ratepayers time to mobilize and organize large petition drives. Many of these greeted the justices in September; not one supported the creation of a county police. Wharncliffe delivered a long speech ridiculing the notion, expressed in the ratepayer petitions, that the Acts were unconstitutional. It also served notice that this line of argument among the justices would be a waste of time. The issue should be debated and decided on more pragmatic, businesslike grounds.

> Now, when we are told that the appointment of ... this Rural Police is unconstitutional, I confess I do not understand the argument. ... Why, gentlemen ... this Act of Parliament ... has been sanctioned by those whom you have chosen to represent you ... and therefore I cannot think that its introduction is in any degree unconstitutional. With respect to the argument that because constables ... have been appointed by court-leet ... that they are

sufficient, and that to depart from the practice would be unconstitutional, I should beg to ask this question – are we living in the same state of society, and more especially in the West Riding, as that under which our Saxon ancestors existed ...? I only beg of any body to examine the population of the Riding. Let him look at Huddersfield, Halifax, and the neighbourhood of Bradford ... where villages have sprung up which were but hamlets some fifty years ago and then say whether additional means are not required to enable the Magistrates to discharge their public duties ...[147]

[H]e came to another charge, namely that the measure was unconstitutional because it would destroy the independence of the magistrates ... It appeared to him that of all the charges made against the measure this was the most absurd. ... If there were two acts of parliament ... which retained in the hands of the magistrates the power they actually possessed, these were the two.[148]

A Saddleworth petition claiming that adoption of the police would 'uproot our ancient and domestic institutions ... lead to a confiscation of our vested rights ... and ... be a final death-blow to the rights and liberties of the people', was greeted by the magistrates with laughter. These lines of argument had little resonance within the West Riding magistracy by 1840; they were nothing if not businesslike in their approach to the issue.

Although county politics at work in the West Riding were complicated, even Byzantine, the decision on county policing revolved around an irreconcilable dispute that is easy to understand and can be readily set out in the words of the participants themselves.

1. Mr Childers (L):

He had taken the trouble to make out a list of the different wapentakes ... and he found that only three of them were purely agricultural ... These only contained a population of 80,000, out of the whole 800,000, and he thought to exempt them from the operation of the Acts, would ... be inflicting an injury upon them, for the active exertions of the force in the manufacturing parts would drive the thieves into those districts which were the least efficiently protected.[149]

2. Mr Wood (L):

Lord Lincoln, had ... succeeded in carrying a [proposition] for applying the Act in the whole Northern division of Nottinghamshire, because ... property was not secure, whereas the public peace and the lives of the inhabitants might be. (Hear, hear.) He contended that the Act was as much required in the agricultural as in the manufacturing districts ... He had conversed with a great number of farmers and other persons in the agricultural districts, and he had not met with a single individual who considered his property secure under the existing police system.[150]

3. Lord Wharncliffe (T):

... the rural districts paid a great deal more towards the county rate in proportion to the population ... In the table which had been drawn up ... it appeared that within the district proposed to be included, there were 577,250 acres; population ... 645,308; annual assessment value, L 1,141,069. In the part proposed to be excluded, there were 207,649 inhabitants ... and the number of acres 1,031,190, which were assessed at the annual value of L 883,836; so that

the population of 207,649 had to pay to the county rate more than two-thirds as much as the population of 645,308. (Hear, hear.) The greater part of the subject matter of valuation in the populous districts was not land, but buildings, which were increasing in value every year, and if a rate of one penny in the pound was enforced ... it would not amount to any thing like one half penny in the pound on the real value. ... The inhabitants of the northern parts of Lancashire complained ... that they were taxed to support a force for the protection of Rochdale, Bolton and other places ...[151]

Although Quarter Sessions took under consideration the possibilities of differential rating under the 1840 amendment Act, the business of drawing maps ensuring that very few peoples' oxes got gored turned out to be impossible.[152] In the West Riding, there were largely rural districts that contained within them industrial villages, and others which were truly mixed. Where, after all, should the lines be drawn? Any maps would place some districts on one side or the other of a particular line, with some paying more and some less. In any event, the political atmosphere became so irremediably poisoned by the parliamentary tactics of the Liberals that the whole enterprise collapsed.

At the September 1840 Sessions, a motion, pushed largely by prominent Liberals, to adopt the two County Police Acts for the entire county was defeated, with only 32 of the 86 magistrates present voting for it. Wharncliffe then tried to find some form of compromise. He proposed a motion for the partial adoption of the Act – for the industrial parts of the Riding only; after another hard-fought debate, this was carried 39–30.[153]

Wharncliffe's compromise seemed set to resolve the issue acceptably. A committee was set up to consider the number and extent of police districts, and the number and cost of police required.[154] But then the Liberal group arguing for a complete county police overreached themselves. Quarter Sessions met again at Wakefield, in February 1841, in the middle of a harsh winter, which kept many of the magistrates away. The proponents of an all-county police took advantage of this situation to ram through a motion (passed 27–21) for a police for the *whole Riding*.[155] The latter were jubilant, as they seemed to have succeeded in out-manoeuvring their opponents, and fastening a police force on the entire Riding.

At the next Quarter Sessions in April,[156] the anti all-county police group mobilized their supporters in force. The backwoodsmen poured into Wakefield; no fewer than 108 magistrates – an unprecedented number – turned up for this Sessions. The tables were then turned. A proposal to adopt the committee report setting out the numbers and pay of the proposed West Riding force was defeated (51–38); the majority then voted to defer any further consideration of the issue. Wharncliffe took some satisfaction in informing his opponents that they had only themselves to blame for ensuring that the Riding would get no county force at all[157] and that he had washed his hands of the whole matter.

The April 1841 Sessions proved to be the decisive one for the West Riding; the issue was not again seriously raised during the balance of 1841 or

1842. Wharncliffe became a member of Peel's new Tory government in September 1841; he sent a letter to the adjourned Sessions of the West Riding in October 1841, stating, on the 'question of the Rural Police', that 'it would be in the highest degree unwise to revive [it] at this moment'; they should instead wait and see how Lancashire's experiment with a new county police worked out.[158] His colleagues seem to have taken him at his word, and made no further effort to adopt a county force that year, or at any time during the 1840s. Attempts in 1851 and 1855 to get the Riding to adopt the Act were again unsuccessful; and the West Riding did not establish a county force until it became compulsory in 1856.[159] During this period, the West Riding relied, for police purposes, on various schemes in place in the large, unincorporated towns such as Sheffield and Huddersfield and the borough police of Leeds, and on superintending constables (under the Parish Constables Acts of 1842 and 1850) for the out-townships and populous villages.

Partisan politics played its part in defeating the adoption of the Whig government's Act. Wharncliffe, national Tory politician as well as chairman of Quarter Sessions, played a key role in pushing for a force limited to the industrial parts of the Riding; the Hon. Edwin Lascelles, who succeeded Wharncliffe as chairman in 1842, continued this role. Edmund Denison, Wharncliffe's close political associate, also contributed to the Acts' defeat in 1840-41. When attempts were made again, in 1851 and 1855, to adopt the Act, Denison, by then a Tory MP, led the resistance, again emphasizing the unnecessary expense of such a police.

It would be wrong to attribute the defeat of the police motions solely to a Whig–Tory division among the JPs. At least as important was the division between magistrates from urban and industrial areas of the Riding who tended to favour a police, and those representing rural parts, whose ratepayers fiercely opposed having to pay for a police, and who voted accordingly; these points were sometimes stated explicitly in the debates.[160] By rejecting Wharncliffe's compromise proposal, the Liberal group that pushed for universal application of the Acts ended up with no police at all – a surprising (and ironic) result for such a large, populous and important industrial area; but, of course, from their point of view, placing the rate burden exclusively on the manufacturing parts of the county was precisely what was politically unacceptable to them. And so, the complex political chemistry at work in the West Riding produced a final decision which did not even loosely reflect or represent the wishes of the majority of the magistrates of all parties![161] The outcome was a permanent impasse, and an understandable reluctance to revisit the matter. Renewed debates in the future came to grief over the same old issue. Conservatives who continued to dominate the chairmanship of West Riding Quarter Sessions would ultimately call upon the *government* to impose a police districting map upon them – as they were unable to do it themselves – or, even better,[162] shift all the costs of county policing from the ratepayer to the taxpayer.

Cheshire

Cheshire had taken an early lead in the campaign for county police forces. As we observed, its Quarter Sessions, under the leadership of their chairman Trafford Trafford, had sponsored its own Cheshire Constabulary Act in 1829.[163] By the time the County Police Act was passed, Cheshire had had a decade of experience of operating its own Act. In 1829, the Cheshire magistrates had been sufficiently anxious about crime and the inefficiency of their parish constables (especially in the manufacturing district contiguous to Lancashire) to go to the trouble and expense of securing a private Act to appoint their own paid police. In 1839, one might have expected the Cheshire Quarter Sessions (still under the chairmanship of Trafford) to take up eagerly the opportunity which the 1839 Act offered to appoint a full county force under their authority.

Six Cheshire magistrates duly gave the required notice of a motion to adopt the County Police Act, which was considered by Quarter Sessions in October 1839. At that meeting, Chairman Trafford did not commit himself on the issue, and the JPs voted to postpone the motion.[164] The latter was taken up at the Sessions in March 1840 before a small gathering of JPs. Trafford employed his formidable authority as chairman *against* adoption of the Act, arguing that it would be unfair to make the agricultural districts of the county pay for what was essentially a problem of 'the densely populated district of Hyde' (in the north-east of the county, adjacent to Manchester) where 'this force was chiefly required to protect property of a particular description – chiefly that of factories'. The motion to adopt the Act was defeated 14–7, on the grounds that 'it does not seem expedient to adopt the provisions of such Act in this county'.[165] At the Sessions of July 1840, there was a brief discussion of the advisability of putting the Cheshire Constabulary Act officers into uniform (a characteristic of all the 'new police' forces – the Metropolitan force, the borough forces, and the new county forces), but they decided against this, agreeing 'that the uniform was a great obstruction to the success of the officers, in making captures'.[166] The last attempt of those magistrates favouring adoption of the County Police Acts came at the Sessions of January 1841; a motion to adopt the Acts for the southern division of the county only was defeated 18–6; a second motion, to adopt them for the hundreds of Eddisbury and Nantwich alone, went down by 14–7.[167] Thereafter, the issue of adoption of the County Police Acts was never again raised.

As late as 1851, Trafford (who was still chairman) defended the Cheshire Constabulary Act, and attacked the County Police Act as a form of 'centralization' which would impose a huge burden of expense on the county; the resolution passed contrasted Cheshire's 'present Constabulary Act', which they wanted to keep, with 'the more expensive machinery of the General Rural Police Act', which they professed not to want.[168] Cheshire JPs agreed with Trafford that their own system was cheaper than a county police. The Cheshire system had no county chief constable. Although

technically under the auspices of Quarter Sessions, the power centre of the Cheshire system was the local Petty Sessions. Adoption of the County Police Acts would have necessarily involved an attack upon and a diminution of their power. This probably would have involved a political struggle of some complexity. Standing behind the Cheshire Police Act was a way of proclaiming that the county was already well policed at a moderate cost and avoiding a very bitter conflict among the county justices for which nobody, at this time, had the stomach. It was always one thing for magistrates to contemplate stripping the parish system and its village notables; quite another to think about doing the same to brother magistrates who had been in charge of an institution for a decade. The justices of Cheshire stayed with their own local model of policing until county police forces were made compulsory in 1856. In politics (barring unusual circumstances), the 'default' is frequently the status quo.

Under the Cheshire Constabulary Act,[169] special high constables and assistant constables continued to be appointed to those parts of the county which were considered in need of them.[170] The Cheshire system, a pioneer in its day, ultimately converged in many respects with the system of paid, professional superintending constables (under the 1842 Parish Constables Act and its 1850 amendment) adopted in the 1840s and early 1850s by many counties that had eschewed the County Police Acts.[171]

Cheshire is a good case study with which to end this chapter. Historians who have written about the debates on the adoption of the County Police Acts have often couched their discussion in the form of a binary model of pro-police magistrates versus anti-police magistrates. As we have seen, even before 1839, the debate was more nuanced than this, with some magistrates being prepared to set up paid local forces under their local control – under the auspices of a local Act, the Lighting and Watching Act, or a voluntary subscription – without necessarily favouring a more extensive system of paid regular police forces.[172] The example of Cheshire and its response to the County Police Acts adds some further complexity to the picture. Cheshire Quarter Sessions, led by Trafford Trafford, were the pioneers of county police reform. It would be absurd to label them 'anti-police', or to think of them as opposed to paid police, or to a police under the authority of Quarter Sessions. Yet they clearly rejected the County Police Acts model of a county police force, in favour of their own, which (they professed) had the proper locus of control and at moderate cost. Control and expense – rather than the more dramatic fears about unconstitutional behaviour or threats to traditional English 'liberties' – were ultimately the issues which had most influence over the outcome of the county policing debates.[173]

EPILOGUE, 1840–56: 'ONE SYSTEM ALONE OF RURAL POLICE'

[T]he government with a most reprehensible blindness, is determined ... to overrun all the towns and rural districts with an enormous standing police force, to be maintained at a cost which will be found intolerably oppressive ... We have said that trained and organized bands of police, at the disposal of government, are to be established throughout the country. We mean this; for the magistrates may be assured that the bill [the 1839 County Police Bill] is but a preparatory, not to say a most insidious measure, for placing these also under the future control of the executive. ... Therefore, it is our earnest hope that the bill may not pass. (*The Justice of the Peace*, III, 33, 17 August 1839)

[T]here can be little doubt that the majority of persons believe that the adoption of the rural police acts has proved beneficial ... and would be equally advantageous to those wherein it has not yet been adopted ... [The advantage] results from a feeling of increased security which cannot be measured by money ... Another part consists in the belief that undetected crime is of less frequent occurrence in [non-adopting counties] and that offences against property and person are likely to be prevented ... These have no money value. ... the bill [the 1856 Police Bill] steers perfectly clear of ... centralization, and displays an anxiety to do justice to all parties affected by it ... (*The Justice of the Peace*, XX, 6, 9 February 1856).

The struggle at Westminster, 1841–2

The County Police Acts of 1839–40 became the permanent basis of English rural policing. Obvious to us, it was less so to contemporaries. The passage of the two Acts was immediately followed by a struggle to repeal them or create other policing alternatives, ushering in a period of even greater variety in rural policing institutions than had prevailed before.

This chapter examines new initiatives and conflicts over rural policing, both at Westminster and in the counties, between 1840–56, seeking to ascertain why it was that Russell's concept of 1839 should have finally prevailed by the early 1850s. The County and Borough Police Act of 1856,[1] which finally settled the question for the whole of England and Wales, was firmly supported in Parliament by county members, but it has always been something of a puzzle why the resistance to the Whig Acts of 1839–40 among a portion of the gentry should have collapsed so

thoroughly by 1856. Previous treatments of this question have tended to focus too much on national developments, and too little on provincial ones – particularly the further local experiments which were attempted, largely by the magistrates, the results of those experiments, and the conclusions which they drew from them.

In the early 1840s, the landed class – and, above all, the Tory section – was still greatly split on the question of constabulary reform. At one end of the spectrum were gentlemen unwilling to go beyond what we might term the old reform plan of the gentry. This centred upon curtailing the prerogatives of courts leet and vestries, a magisterial takeover of constabulary appointments and a reformed manner of paying parish constables. Generally Tory country gentlemen, they worried that anything smacking of professionalism would further erode what remained of rural solidarity, reinforce pressures for undesirable reforms of local government and lead to the marginalization and/or demotion of the magistracy.[2] In the manoeuvrings at Westminster that followed the County Police Acts, this strand of landed opinion found its parliamentary champion in Sir Edward Knatchbull.[3]

At the other end of the spectrum were the bulk of Whig/Liberal country gentlemen and a contingent of largely moderate, proto-Peelite conservatives – essentially, the political coalition which had carried the County Police Acts in those counties in which it was adopted. This group was convinced of the necessity of professional rural police establishments on some scale, supported the marginalization or abolition of the parish constabulary, and saw little threat in the legislation of 1839-40 to the prestige, standing or authority of the magistracy. This category included a number of Conservatives who had supported (or even led) the fight for the County Police Acts in their own counties. Unlike most Whigs, however, these men were also often willing to support other measures to reform the parish constables, or alternative schemes of professional policing which fell short of the county police forces established by the Acts of 1839-40.[4]

In the middle was a diverse group composed of those who wished a professional police, but on a smaller scale than county forces, placed under the control of Petty Sessions with little Quarter Sessions oversight and no county chief constable. They also supported leaving the parish constables in place while reforming their appointment and control. Plans of this type would draw the support of many moderate Conservatives and a few Liberals. A Liberal member for West Kent, Thomas Law Hodges, led the first fight at Westminster to legalize such a scheme.

Finally, overlapping with the second group, there were those who wanted to make the County Police Acts compulsory, but combined with a central government subvention towards their cost, or even payment of their full cost, from general revenue. They were likely to be MPs from adopting counties discomfited by the costs to county ratepayers of operating county forces, and men who had ended up on the losing side in non-adopting counties.[5] They hoped that a subvention and/or compulsion would relieve

justices of the moral obligation to be responsive to the ratepayers, and would produce faster and greater compliance by the counties. A group of prominent Conservative supporters of the 1839 measure fell into this category.[6]

These gentlemen were to be disappointed. The finances of the Whigs were too precarious and put this course out of the question.[7] There was also a large political stumbling block. When Lord Ellenborough proposed that England adopt the Irish model 'where the public pays one half of the cost', Normanby, the new Home Secretary, riposted: 'If the Government [in Ireland] pay half the expense, they have the whole of the appointments'.[8] Ellenborough was invited to contemplate the howls of 'tyranny', 'centralisation' and '*gendarmerie*' which would arise in such a case.

Apart from resisting appeals to throw the cost of county policing on to the Consolidated Fund, government strategy in 1840–1 was to: block all moves to repeal the County Police Acts; resist the introduction of alternative cheaper and less ambitious schemes of reformed rural policing, apt to seduce non-adopting counties; and stop even a reform of the terms of appointment, service and payment of parish constables. The Whigs declared the provincial policing issue to be settled. Counties refusing to avail themselves of the County Police Acts would be permitted neither a different professional policing scheme,[9] nor even the possibility of making the parish constables more efficient. Non-adopting counties were to be made aware of the vulnerability of their situation. Without a new police, and with no hope of an alternative, the pressure of events would inevitably produce further adoptions and a cascade effect sometime in the future. The Whigs made no secret of their view that it was the County Police Acts or nothing.

Three parliamentary challenges were raised in 1840 and 1841, all launched by Kent MPs.[10] The first was an attempt by Sir Edward Knatchbull to repeal the County Police Acts, by referring the whole question to a select committee. This was roundly defeated.[11] Knatchbull then returned with a modest measure designed to reform the parish constabulary, containing all of the features of what we have termed the 'old reform programme' of the gentry – appointment of constables by the justices, a uniform table of fees and allowances determined by Quarter Sessions and re-legalization of payment from the Poor Rate to constables for criminal justice duties.[12] The government would not allow even this.[13]

Because it provided for another system of professional rural policing, the most serious threat to the government's policy of 'one system, alone, of rural police' was Thomas Law Hodges' plan, first broached in the Kent Quarter Sessions debates. Hodges, a Liberal, but otherwise a typical game-preserving, protectionist country gentleman, presented his scheme as moderate, cost-effective, and solicitous of the magistracy, while conceding the need for professional policing in the countryside.[14] It operated at two levels. First, it proposed a reform of the parish constabulary, endorsed by the majority of Tory gentlemen. Leets were to be left only with the nomination of constables. Petty sessional justices would henceforth appoint

them, enforce minimum standards of age, character and literacy, and keep a registry of qualified constables. Petty Sessions would also be empowered to make rules for the constables, create formal tables of fees and allowances, assess the parishes for rates, and pay all expenses from the poor rates. Secondly, the accompanying plan of professional rural police empowered Petty Sessions to create a small police force of up to four men for each division. The head of the divisional police, to be styled 'Special High Constable', would be chosen by the Home Office,[15] and up to three full-time, salaried 'Special Petty Constables' would be appointed by the justices. Salaries would be determined by Petty Sessions, which had full authority to levy a rate on the parishes.[16] Law Hodges' chief objects were: retention of the institution of the old constabulary (because it was deemed to have the 'moral effect of enlisting ... the people in the execution of the law'); the creation of small, divisional police establishments under firm local control; and cheapness. The scheme was twice considered by the Commons. It had to be withdrawn in 1840, but was debated again in 1841.[17] The House divided on going into committee and soundly defeated the bill.[18]

But the bill evoked a disturbing popularity among Tory country gentlemen, both in Parliament and in some southern counties.[19] Law Hodges frankly stated that if it 'became the law of the land, the public will have the choice of two measures ...'[20] This is precisely what made it dangerous. For the Whigs (and many Liberal-conservatives) local self-government in relation to rural police meant *county* government; for most Tory country gentlemen, and those who spoke for them at Westminster, it meant something closer to the parish or petty sessional division. The defects of the Law Hodges plan from the government's viewpoint were that it: proposed too much local autonomy; envisaged the creation of little police fiefdoms under Petty Sessions justices; and allowed no uniformity of rules between the small forces, nor any central superintendence by a chief officer and/or Quarter Sessions. But above all, as E. R. Rice put it, it would 'delay ... the adoption of a more efficient and better measure' by creating a competing rural police system. What the Whigs were after was neatly summed up by Fox Maule: '... it will be but just to all parties in the country that they shall see that one system, alone, of rural police, is to be persevered in; and that they shall know what that system is'.[21]

However, the Whigs could not immediately succeed in ensuring just 'one system, alone, of rural police'. The election of 1841 brought in Peel and the Tories with a large majority. Not surprisingly, a Tory government proved more open to a range of other alternatives. Liberal Tories, such as the new Home Secretary Sir James Graham, were, generally, strong proponents of the County Policing Acts,[22] but they were a minority within the Conservative party.[23] Melbourne and Russell, in government, had been able to count on solid Whig backing for their policy, both in Parliament and among country JPs;[24] Peel and Graham were in a different situation.

Graham was famously tough. He resisted calls for despatching Metropolitan policemen into disturbed parts of the country[25] and 'tried to blackmail county magistrates in the more disturbed areas into adopting the ... 1839 ... act by withholding troops unless they agreed to do so'. He even favoured, in some circumstances, the introduction of stipendiary magistrates. This was anathema to most Tory country gentlemen.[26] But Peel's behaviour in 1840 signalled what was to come. During the debates on the Law Hodges bill, he made vague statements regarding the desirability of installing other more modest types of police establishments in non-adopting counties.[27] The only Tory legislation on the policing of the countryside was the Parish Constables Act of 1842, a reflection to some extent of the constraints placed on Peel and Graham by the diversity of opinion within their party.[28]

Tory initiatives: the Parish Constables Act (1842)

One of the most significant (and least noticed) features of the Parish Constables Act was the augmented power assigned to both local benches and county Quarter Sessions *vis-à-vis* the parish and its authorities. It confided exclusively to Petty Sessions the appointment of constables and the determination of the numbers required in any parish.[29] It terminated the role of courts leet in appointing constables for keeping the peace; vestries were left with only the duty to compile lists of men eligible to serve as constables.[30] Parishes were allowed to resolve to have paid constables, agree to a rate, and unite with other parishes in sharing the costs (though the choice of the men to appoint remained with the justices). But, in practice, parishes rarely availed themselves of the opportunity.[31] County justices could establish lockup houses paid for from the county rate in places of their choosing and remove parish facilities from local jurisdiction. Most important, wherever a lockup was established, a professional 'Superintending Constable', paid by the county and responsible to Quarter Sessions, could be appointed to take charge of both the lockups and of all paid and unpaid parochial constables.[32]

It is impossible to know precisely how widely the counties availed themselves, during the 1840s, of the provisions of the Parish Constables Act for lockups and superintendents. No complete returns were ever published. Since any widespread programme of building of lockups and appointing superintending constables was bound to cost considerable amounts of money, and the ratepayers in the 1840s were still on the alert against such expenditure, many counties seem to have done little.[33] County initiatives in the 1840s were patchy.[34] Even Kent did not, apparently, avail itself of this part of the 1842 Act.[35] By 1855, Devon had, besides paid parish constables in 44 parishes (of the usual variety of quality and activity), seven lockup constables.[36] Warwickshire appointed six lockup superintendents in its eleven divisions. Berkshire, in 1853, had only one lockup superintendent at Faringdon.[37]

Buckinghamshire tried seriously to make these provisions work. Despite the defeat of the County Police Acts in that county,[38] Buckinghamshire justices aimed at 'a uniform and efficient system of discipline and management ... throughout the county'.[39] Committees of Quarter Sessions studied the efficiency of the high constables, the state of the lockups and alternative means of improving the constabulary. By 1843 a Lockup Committee, which evolved into a Constabulary Committee, had become a permanent feature of Quarter Sessions. In 1843 two lockups, one to serve the south and the other the north of the county, were approved, and a third for Beaconsfield was debated.[40] By 1848, the county had five lockups in operation; Quarter Sessions had procured and studied police rules from other counties, they had issued a book of rules and regulations for the guidance of the superintendents, and they were considering a plan to divide the county into fifteen districts with a superintendent for each.[41]

There were other problems about the 1842 Act which limited its use. Superintendents could be stationed only in districts where lockups were built. Adopting the scheme meant, not only creating new, salaried county officials, but also spending upwards of £400 per facility on bricks and mortar – and all of this would fall on the county rate.[42] Moreover, the new districts created by the system did not coincide with existing petty sessional divisions – a matter of which many justices would complain. The superintendents appointed under the Act were largely tied to their duties at the lockup. Rarely did they (or could they) actively take control of the parochial constables or engage in strenuous attempts to impose new standards of public order or decorum. So, the 1842 Act, though containing the seeds of an alternative rural police system, did little to create one in practice.[43] In sum, the major change wrought by the Parish Constables Act was an overhaul of the method of appointing and remunerating parochial constables – a milestone of sorts. It was designed to reinforce the power of local justices, but at the same time constituted a blow to the parish system. It was thus simultaneously an affirmation of and attack upon a principle which the Tories supposedly held dear – local self-government.[44] The power of justices *vis-à-vis* the government was reinforced, but the autonomy of the parish *vis-à-vis* the magistrates was diminished.

Between 1842 – when immense popular disturbances and pressure by the Home Office led to the application of the County Police Acts to the whole county of Staffordshire[45] – and 1849, only the legal county of West Suffolk and Westmorland (for a tiny portion of the county) adopted the County Police Acts. The great stumbling block was cost – both pecuniary and political. Although many justices had scruples of their own about the rates – above all about their tendency to fall disproportionately on agricultural property – the smaller ratepayers acted as a constant check on the magistrates. In adopting counties, various forms of pressure slowed the expansion of forces; in non-adopting counties, a ratepayer alliance with magistrates opposed to the County Police Acts immobilized Quarter Sessions. In a few counties (the West Riding, Somerset and Kent, for

example), further attempts were periodically made to adopt county policing, but in most of them the great Quarter Sessions discussions of 1839–41 were not repeated, if at all, until the 1850s. But the parliamentary debates of 1840–2 demonstrated that a large portion of the landed class was searching for a way to bring some measure of professional policing into counties which had rejected the County Police Acts. Between 1842 and 1854 (when Palmerston introduced an ill-fated measure), all initiatives finding their way to Parliament were of provincial provenance, the products of discussion and debate among local gentlemen.[46]

A second system of rural police: the superintending constables of the 1850s

In the early 1850s, a second rural police system took shape in the English counties. The Parish Constables Act of 1850,[47] amending the 1842 Act in order to remedy some of its perceived deficiencies, created an alternative system which proved attractive to many English counties and was widely implemented. Police districts now were to be strictly coterminous with petty sessional divisions, and the appointment of superintendents was decoupled from the building of lockups. The provisions of the 1842 Act for lockups and lockup superintendents remained in place, but the latter (and the parish constables) were now to be subordinated to divisional super-intendents. These new figures were to be employed by the county and paid from the county rates. Quarter Sessions choosing to use these provisions of the 1850 Act were not required to appoint superintendents for all divisions; but most tended to do so. The superintending constable system originated in a resolution of Kent Quarter Sessions to seek a means of appointing divisional, professional superintendents unconnected with lockups.[48] Many counties chose to employ its provisions,[49] and for a time it looked like developing into the second legal system of rural police dreaded by Russell and the Whigs of 1839.

The 1850 Act broke the log-jam in many counties. It was implemented fully in Buckinghamshire, Herefordshire, Kent, Lincolnshire (all parts), Northumberland, Oxfordshire, Derbyshire, West Sussex[50] and all three Ridings[51] of Yorkshire.[52] The West Riding decided in April 1852 to adopt the system, appoint a superintending constable in every division of the Riding in which a regular Petty Sessions was held, and set aside at least £4,000 for the building of lockups.[53] There remained considerable suspicion among West Riding JPs of the idea of a regular county police force under the 1839–40 Acts.[54]

Kent and Buckinghamshire offer good examples of the workings of the system; they also show why it came to be regarded as flawed, even in the eyes of some of its original enthusiasts. Kent implemented fully the Act of 1850 and placed a superintendent in each petty sessional division outside the Metropolitan district. A county police committee, created in July 1850, supervised the system.[55] The superintendents' duties were extensive.[56]

They were responsible for extensive record keeping – journals, charges, accounts, reports to justices – plus: monthly visits to each parish; superintending lockups and parish constables; noting and reporting to Petty Sessions nuisances and highway obstructions; visiting pubs and beerhouses; communication with other superintendents; and execution of arrest and search warrants in criminal cases.[57] They were to investigate and 'prevent' all crimes. Superintendents were mounted and issued with pistols and short swords.[58] The men were drawn from a new, upwardly mobile,[59] professional police élite. In Kent, they were veterans of the Metropolitan Police, or of the Gloucestershire, Staffordshire and East Suffolk constabularies; they possessed good testimonials and had held the rank of sergeant or above.[60]

However, John Dunne, a Kent superintendent, who subsequently became chief constable of Norwich, subjected the Kent system to devastating criticism. The rationale of the scheme was that superintendents would rejuvenate a parish constabulary that was now meant to be of better quality than those men complained of so frequently in the 1830s. But Dunne found the parish constables still disinclined to serve, refractory, hopeless (and expensive)[61] when called out to watch, occasionally obstructive, and inclined to sabotage inspections of public houses by tipping off landlords about impending visits.[62] Furthermore, the system was disjointed. There was no chief constable to supervise and co-ordinate the men, and act as a counterweight to the whims of Petty Sessions magistrates, who sometimes refused to allow their men to act within other divisions. But, above all, the major deficiency was the lack of an embodied force of professional subordinates who would do what they were ordered to do, when ordered to do it.[63] Finally, unlike the County Police Acts, the Parish Constables Act did not order the disbandment of Lighting and Watching Act forces within the area where it was adopted; and superintendents complained of lack of co-operation and assistance from those forces.[64] Superintendents were overburdened by their numerous duties and demands on their time. Dunne considered that, overall, efficient use could not really be made of them under these conditions:

> I was very frequently obliged to go out with three horses a day, in the performance of my duties; when I returned ... I would find waiting ... some communication from another part [of the division] to the effect that I was required; that there had been a serious robbery, or something requiring my attention, and the magistrates had sent me an order to go immediately.[65]

This was the general tenor of the testimony of all the superintendents who testified before the Select Committee of 1853.[66]

The Kent Quarter Sessions Constabulary Committee developed its own set of complaints. The high value placed in Kent on Petty Sessions autonomy produced ongoing tension between the latter and Quarter Sessions, in whom the statutes vested supreme authority over the superintendents. Initially, Petty Sessions was allowed great weight in the

hiring of superintendents[67] and great latitude in general; but ultimately the questions of hiring and the emergence of divisional fiefdoms had to be confronted.[68] The result was a progressive drawing of power over the system into the hands of the Constabulary Committee of Quarter Sessions – in other words, the dreaded 'centralization'. The Constabulary Committee ordered Petty Sessions to detach their men when needed in adjacent divisions, emphasized that *it* would determine where super-intendents were to be stationed,[69] and took over the recruitment and hiring of officers.[70]

Buckinghamshire, which had been assiduous in attempting to make the Act of 1842 work, responded as well to the amending Act. Its system differed from that of Kent in a few respects. Under a plan of economy, superintendents were to convey prisoners to and from gaol, and take over the duties of the inspectors of weights and measures. A full complement of superintendents was hired from the London police, and from the Essex, Cambridgeshire, Lancashire, Denbighshire, Northamptonshire and Surrey constabularies. From the outset, the County Constabulary Committee exercised more authority over local Petty Sessions than in Kent. Hiring was the exclusive province of Quarter Sessions, and superintendents were sometimes given direct orders by its Constabulary Committee.[71] Over a number of years of working the system, the Buckinghamshire justices came to a similar verdict about the effectiveness of the system as did those of Kent. If anything, they went further, verging on the conclusion that it was misconceived. They expressed dismay at low clear-up rates, the over-burdening of the superintendents and above all the failure of the parish constables to play their proper part in the scheme.[72] In May 1853, the Buckinghamshire justice Maurice Swabey offered to the Select Committee on Police such a critique, and the opinion that so much money and ego had been invested in the system that Quarter Sessions would not be likely to admit its failure.[73]

He was wrong. In 1854, the Constabulary Committee conducted a searching review of the whole scheme, and issued, in early January 1855, a special report. While praising the men, and recounting stories of some of their successes as detectives, the report was a confession of loss of faith in the system. Attempts to repress sheep-stealing had failed. Only a 'complete system of Nightly Patrol such as it is impossible for a single Officer ... who has varied engagements during the day, to undertake', could make any difference. The implication was that only an embodied force could have a good effect. The key problem was that the whole system had been predicated on the idea that an alternative to the rural police could rest on the transformation of parish constables into reliable auxiliaries. The Buckinghamshire Constabulary Committee now admitted that this could not be done:

> ... the Force is composed of intelligent, courageous, trustworthy Officers, well qualified for the performance of their ... duties. But it is clear that this number of Officers, however ... zealous, cannot perform the Constabulary duties of a

whole County without considerable assistance from subordinates; and the question then arises, to what extent do the Parochial constables really represent the subordinate Constables in an organised Police Force, and what amount of assistance do they practically render to their superior Officers?[74]

No formal recommendation was made regarding adoption of the County Police Acts, but between the lines one can read that, after its experiment with superintendents, Buckinghamshire was beginning to see no alternative. The Revd Phillimore, a member of the Constabulary Committee, demanded a large extension of the force and a chief constable to control it – even though this would be expensive: 'We must put our hands in our pockets.'[75]

It is difficult to say how many other counties were reaching the same conclusions by 1854, but since so many were trying to use the superintending constable system, it is safe to assume that similar, cautiously negative conclusions were being drawn elsewhere regarding its fundamental premise: that efficient professional policing could be had without a *police force*. An active Northern justice reported that on the Lancashire-Yorkshire border, West Riding superintendents complained that parochial constables 'dare not do their duty' and,

> so far from yielding obedience to the superintendent some of them have denied his authority and set him at defiance. All along the border many of their duties are, in fact, performed by the Lancashire police. Summonses granted on the Lancashire side are served [in Yorkshire] by them, and they often execute warrants also. Yorkshire prisoners committed from the border petty sessions are invariably conveyed to the Wakefield House of Correction by the Lancashire police. ... Prizefights, dogfights, etc., organised in Lancashire, are constantly brought over the border. When it is known ... that 'such an event is to come off', they [Lancashire policemen] follow the parties and dog them over the border if they cross it.[76]

The experience of Buckinghamshire with the superintending constable scheme shows that practical, trial-and-error experiments on the ground led gentlemen to begin to doubt that any system predicated on the continued use of parish constables as second-tier auxiliaries could be satisfactory.[77] This was true even of Kent.

The final result of Kent's experience with the new system was yet another scheme for revision, the Deedes Plan – the last in a series of parliamentary initiatives brought in by Kent members, stretching back to the Law Hodges bill of 1840. It was a final attempt to improve the superintending constable system; but its implications pointed away from the whole scheme and towards the County Police Acts system. William Deedes was chairman of Kent General Sessions and a Tory MP. His bill became almost a permanent fixture in Parliament in the early 1850s.[78] Its main features were: *compulsory* appointment of superintendents in all non-adopting counties; the stripping of any residual authority from Petty Sessions; a permissive power to Quarter Sessions to introduce more than one superintendent into divisions; and power to appoint a chief constable

to control the county establishment.[79] The characteristic preoccupation of Kent justices in the 1840s with reinforcing the authority of Petty Sessions was gone; all lines of authority now ran to Quarter Sessions. The addition of a chief constable to control the superintendents meant that even the Kent Quarter Sessions had finally accepted that day-to-day operations and policies of the police ought not to be conducted by the justices themselves. The Deedes bill was debated in Parliament in three sessions, and was defeated by a coalition made up of: supporters of the County Police Acts, the government,[80] and county members from some non-adopting counties who dreaded the idea of compulsion.[81] The debates on the Deedes Plan foreshadowed the ultimate success of the County and Borough Constabulary Act in 1856. Many speakers, significantly, did not speak directly to the bill, but used the floor to urge the government to provide subventions to county forces – an indicator of the decline in residual opposition to county policing by the early 1850s. Deedes himself, revealingly, told members for other non-adopting counties (and, seemingly, not as a warning) that 'if they adopted this Bill of his, it would be a stepping stone to the introduction of the Rural Police Act into such counties'.[82] In the 1850s, even the Kent brains trust of maverick police reformers was, reluctantly, converging towards the principles of 1839.

The 'policed' counties

By the early 1850s, there were few English rural and small-town areas that were without *some* type of professional policemen; but those counties with forces under the County Police Acts assimilated a police into the fabric of rural society to a degree impossible under the superintending constables scheme, the old Lighting and Watching Act or voluntary subscription forces.

It should be said that much less is known (and can be known) about the pre-1857 county forces than one would like. Apart from plentiful registers of personnel, useful in studying the origins and vagaries of the early lower ranks, a lot of other documents have been lost or destroyed.[83]

The rank and file of early county forces was primarily composed of men with no previous police experience, who were shaped (like army recruits) by strict discipline exercised by a militarized chain of command and a set of rules and penalties for infringing them.[84] Supervisory personnel, although sometimes natives of the region, usually had either some police or some military experience. Some new county superintendents had served in older borough, voluntary subscription, Lighting and Watching Act or similar forces – but even they might have had previous Metropolitan[85] or large borough service.

The bulk of the lower ranks of the new forces consisted of an unstable mass of former labourers, shopkeepers and tradesmen,[86] with a high turnover, so that their average length of service in the early years was a few years at most. This would suggest the new rural forces were disorganized

and, therefore, ineffective. There is some truth in this, but, overall, it was not the case. Early teething problems, consequent on the organization from scratch of a large bureaucratic organization, were frequent, as were inexperience and high resignation rates; and these were gleefully highlighted by unfriendly newspapers. But the arrest statistics of the first years of operations were impressive nonetheless. Above all, the unprecedented presence of the police on the roads, at feasts and fairs, public sporting events, in small town streets and around the pubs had a great impact.

On Newton Abbot fair day (1857), Constable Webster of the new Devon police stopped a man whose cart lacked the required owner's name. There were words, the man was ordered to 'move on', and a crowd collected. Two others were arrested and the crowd threatened to storm the station. A magistrate calmed things by granting bail and chastizing the police authorities for officiousness. Webster was transferred.[87] But the inhabitants of Newton Abbot learned something that day – the police would act, even in cases seemingly as minor as failure to display a name on a cart. Webster had probably been ordered by his superintendent to look out for carts out of compliance, and other infractions likely to be encountered on a fair day. The simple presence of a body of men paid to enforce order, their continual movement and activity, the pressure of surveillance, their aptness to pop up when least expected – all this must have had an impact on peoples' expectations and public behaviour.

Certainly, the early forces were characterized by lack of uniformity. The Home Office had very little power over them, and such rules as they issued were very limited; so Quarter Sessions and the new chief constables had virtual *carte blanche* to put their own stamp upon their own forces. Absence of uniformity began with uniforms themselves; though all the county forces were marked by putting their men into uniform – which already distinguished them from the parish constables and the various local forces – the type of uniform used varied greatly in its essentials, and even in its colour; blue was *not* the universal police colour – Lancashire put its men in rifle green, as did Shropshire, where they were called 'Paddy Mayne's Grasshoppers'.[88]

The great variations in *size* of the initial forces established,[89] persisted; where forces had been established with a small initial complement, each attempt to augment them could produce a new struggle within Quarter Sessions, a minor version of the initial struggle to adopt the County Police Acts. At the outset, Gloucestershire and Wiltshire were at one end of the spectrum with the largest ratios of police to inhabitants of 1 to 1,000 and 1,110, respectively; at the other end were East Sussex,[90] with 1 to 4,125, and Leicestershire with 1 to 6,708; in the middle were Isle of Ely with 1 to 1,405 and Essex at 1 to 1,450.[91] By the early 1850s, there had been a few new county adoptions; and, in counties which had adopted in 1839–41, there had been considerable augmentations of thinly staffed forces and reinforcement of already large ones.[92] The objectives of all forces were

broadly similar – the prevention and detection of crime and the imposition of new standards of order and decorum in public – but some forces were too small to be able to mount the 24-hour-a-day watch which was the ideal at which all commanders aimed. East Sussex, with 41 men in 1846, had no choice but to operate rather differently from Hampshire with a force of 171 men, or Wiltshire with 196 men.

In Wiltshire, the force was organized into divisions, subdivisions and districts. The men were scattered in the parishes, but always remained in contact with, and under the eye of, superior officers. The constables patrolled day and night, joining up at certain conference points. Meetings were sometimes personally verified by sergeants, but were always logged and checked by superior officers. On their beats, constables would receive complaints from the villages and farms which they passed; these were to be immediately reported to superiors. Patrol routes and times were varied, to make the appearances of the men as unpredictable as possible.[93] Since the beats were linked, meetings were also used to exchange information, to pass the information up to officers and to pass on sudden changes in orders.[94] Forces such as those of Wiltshire, Gloucestershire, Hampshire, Lancashire or Essex could therefore patrol regularly, keep an eye on suspects, and concentrate in case of disturbances, strikes or similar problems of public order. Their blunders and fiascos were well publicized in the press, which might make them sometimes seem comical or ridiculous, but the new county forces were developing into powerful order-imposing machines. They possessed a great will to act, which stemmed from local political and bureaucratic imperatives: the insistence of chief constables on them making and recording arrests, and producing the arrested people to be charged; the desire of the county magistrates to be vindicated in the eyes of the ratepayers and each other for the expenditure of county rates; and the powerful need to impress a sceptical rural middle class (by success in campaigns to control vagrants, beerhouses and fairs, and to suppress the theft of livestock and produce) that they were getting value for their money.

Small county forces such as East Sussex were less flexible. They could suspect local 'bad characters' and occasionally concentrate for particular operations (such as moving on gypsies or confronting gangs of burglars), but could not mount the kind of night patrols routine in counties with greater manpower resources.[95] Here, too, the men were scattered over the villages, but each constable was responsible for twenty square miles, double the English average.[96] The police in East Sussex had to be much less proactive and more dependent on direct citizen approaches to them, and had to assign a role to parish constables – who, predictably, gave no satisfaction.[97] So the East Sussex county police remained subject to ratepayer protests long after they died away in most other places.[98] The magistrates would never consent to abolish the police, but at the same time were extremely reluctant to augment the force, a situation which prevailed up until 1856.[99]

The organization and deployment patterns of early forces varied as well. In most counties, police divisions coincided with petty sessional divisions;

but in Durham, Norfolk and East Sussex, there was no such correspond-ence.[100] Most chief constables, when manpower levels were sufficient, used some variant of the plan of organization and deployment found in Wiltshire. But one large force, Gloucestershire, was based squarely on the model of the Irish Constabulary.[101] Here the men were grouped together about four to a station – in effect, little barracks – instead of being scattered in the parishes. Because each station had a resident sergeant or superintendent, supervision by superior officers was even closer than in Essex or Wiltshire. But, as in Wiltshire or Essex, patrols covered the countryside, extending out three to four miles in a radius from the station, which served as a fixed and perpetually open point – no place in the county being more than about three miles or so from one – for the reception of information and complaints when constables were not nearby.[102]

A common characteristic (because embodied in statute) was governance through a chief constable, an exceedingly powerful figure from the start. Most were recruited from military and coastguard officers and were gentlemen,[103] able to mix on easy terms with landowners and magistrates. In matters of operations, organization, deployment, standards, and training and discipline, the freedom of action of early chief constables was practically unlimited. Quarter Sessions and their Police Committees generally left them free to run their forces.[104] Apart from demanding reports and statistics on crime and police matters, Quarter Sessions tended to preoccupy themselves with finances (including setting force levels) and the construction and acquisition of buildings.[105] Except for severe institutional crises or spectacular events touching on the efficiency or gross misbehaviour of the police, chief constables were generally left alone to get on with it.[106] The following responses to questioning by the chairman of Essex Quarter Sessions were typical:

> You think any interference on the part of the magistrates with the movements of the men would be prejudicial to the efficiency of the force? – I think it cramps a chief constable in the same way as control would cramp the colonel of a regiment.

> You think unlimited confidence should be placed in the chief constable? – Yes; let the county choose a ... good chief constable; if you do not you cannot place confidence in him.[107]

That chairman, Burnardiston, went on to emphasize that magistrates should never act as arbiters between policemen and the chief constable, nor respond to pressure from petty sessional justices to retain or rotate particular superintendents either favoured or disliked by them.[108]

A related question is: what was, and should have been, the relationship between divisional commanders and the local justices? It was clearly a crucial relationship, as it was here that important lines of power and authority within a county converged. County force superintendents were in a delicate situation. They had to carry out the orders of their superiors in the bureaucratic chain of command; they also had to deal with, and

respond to, powerful gentlemen used to the exercise of authority and to the compliance of those they regarded as subordinates, who might object to certain operations or official policies.[109] Unfortunately, little is known or documented about this for the period of the early county forces.[110]

Since the ordinary constables were a constantly fluctuating body,[111] how effective could these forces be? They could still be effective, because the efficacy of the system depended primarily on the men acting under the orders of a bureaucratic hierarchy, possessing little discretion and under close supervision.[112] The beat arrangements, or the mode of operation of the Irish-model Gloucestershire force, ensured that constables would be strictly monitored and supervised. What made the rural police effective is what makes good armies effective: the discipline of the lower ranks, but above all the skill and professionalism of the non-commissioned and commissioned officers. What a constable needed to know could be, largely, acquired on the job or with minimal training.[113] For the rest, strict discipline and close supervision compensated for his individual deficiencies. Lancashire's first chief constable saw the effectiveness of his new force as a function of the 'strictest discipline, the most proper and effectual mode of securing which is by establishing an exact gradation of responsibility from the highest to the lowest'.[114]

The key to the effectiveness of the new police lay in their officers, above all the superintendents. A parade of highly experienced men of this type testified before the House of Commons Select Committee on Police in 1853. Their observations, and obvious mastery of their craft, were impressive. Like all other policemen, they were subordinates in a chain of command. Their autonomy was not complete, but it could be large. Some showed a remarkable physical and mental vitality. Early provincial superintendents were highly active outside the police stations, visiting the men on their beats, and leading their men personally in confrontations with strikers, navvies or other perceived disturbers of the peace. Famous in his time and place, Superintendent English of West Suffolk worked for a time undercover, dressing and working as a labourer to identify and arrest arsonists.[115] Superintendent Baxter of Shropshire, the 'Brummagem Button Stick,' had a long policing career, dating back to his employment before 1839 as a paid policeman in a voluntary subscription scheme in the Ford hundred of Shropshire. Baxter became one of Chadwick's informants for the Royal Commission, and went to work for the new Shropshire force, where he became famous for his activity and physical prowess. He gained an excellent record for crime control, was prominent in various successful actions against striking miners, and showed no hesitation in wading into the midst of threatening crowds of Irish navvies, sustaining frequent injuries in his activities.[116] Where the officers organized their subordinates into reliable sources of information and disciplined foot-soldiers who would carry out the orders transmitted to them, the result was the creation of a powerful machine for the repression of crime and maintenance of order.[117]

The earliest county forces sought experienced men for these crucial positions: men who had served in the Metropolitan Police, the Irish Constabulary or borough forces considered efficient, or men who had proved themselves in subscription police or as long-serving paid officers under a variety of other schemes.[118] But, in the early 1840s, such men were not easy to find. Of the initial group of Shropshire superintendents, only half were familiar with police work.[119] Of the original seven superintendents in the Essex force, one was a solicitor, and the remainder appear to have had military backgrounds.[120] It is not clear how successful such ex-servicemen were in ingratiating themselves with those whose good opinion of the new police it was important to cultivate; but their employment may have been very useful in creating a functioning, disciplined, bureaucratic institution from nothing. In its initial recruiting in 1850, Surrey chose men with police backgrounds. The original seven men appointed as superintendents and inspectors comprised: two former inspectors from the Essex Constabulary and Bath Police; a former superintendent from Godalming; two men with Staffordshire Constabulary experience; one from the Carmarthen Constabulary; and one from a Mounted Police Association in Northumberland.[121]

A crucial task of divisional officers was to compile information on individuals apt to cause problems or commit criminal acts. As Superintendent Redin told the Select Committee: 'A policeman would not properly discharge his duty if he were not acquainted with the residences of suspicious characters.'[122] The aim was to acquire an intimate local knowledge of petty thieves, poachers, sheep-stealers, criminal families and problem people. Constables were to note such individuals in their diaries, and 'Bad Character' books were maintained. Creating the reliable flow and recording of such information was an early preoccupation of chief constables. The information filtered up from the men in bits and pieces to the officers, who were, thus, able to gain some overall picture of the deviance of their districts. This information collection and analysis was a key to the effectiveness of the new police. The skill of the ordinary constable played only a subordinate role. The length of time constables spent in a posting was considerably shorter than that of inspectors and superintendents.[123] Superior officers were not often moved;[124] and the knowledge which they built up compensated for the rapid turnover among the men. New constables or officers could be briefed by sergeants, inspectors and superintendents on the basis of that detailed local knowledge.

When particular types of crime were committed, the officers of a division knew who 'the usual suspects' were, and, therefore, whom to round up. T. B. L. Baker, a West Country magistrate, who had initially been strongly opposed to the establishment of the rural police, later wrote:

> I know that in my county ... there can hardly exist one habitual thief in 100 whose habits, as well as habitat, are not pretty well known to the police. Indeed, of all the men ... I have known who usually earned one quarter of their

subsistence by theft, I have rarely found their liberty between imprisonments average above six months, a proof that they are ... well known.[125]

The local knowledge of the new police was not superior to that of the villagers, nor of the old parish constables, who had usually known the 'bad characters' in their parishes. But, unlike the old constables, the new police had the will and incentive to act, and the stamina and numbers to keep up a steady pressure of surveillance. Older entrepreneurial constables (where they existed) were often quite persistent, and might have followed up leads and tracked suspects assiduously; but new policing was more pervasive and relentless. This was one important thing that made it new.

Whatever the stated reason or precipitating factor for creating a particular county force, the chief area of activity of all of them was daily, routine maintenance of order and repression of petty crime. In predominantly agricultural counties, the police concentrated on theft of livestock and crops. In all counties, they placed heavy emphasis on vagrancy, the clearance of gypsies,[126] and a large number of small public-order problems and regulatory offences. This was characteristic of all new policing – even of the subscription and Lighting and Watching Act forces, and the superintending constable schemes described above – but under the new county forces this occurred even more rigorously and consistently.[127] The new forces subjected pubs and beerhouses to closer surveillance, and regulated the minor violence which was endemic in such places.[128] The police now monitored feasts, fairs[129] and other local celebrations. The Yorkshire hiring fairs were closely watched, with special attention given to bad language and offensive behaviour by young men towards young women.[130] When they learned of them, the new county police interfered with illegal prizefights, and monitored large, legal sporting events, sometimes with massive shows of force. They cracked down on gambling in the fields, cockfighting and other brutal sports.[131] Breaches of the peace, being drunk and disorderly, vagrancy, highway offences and petty larceny were the standard offences for which the police made most of their arrests.[132] The first Wiltshire chief constable spoke of his policy of concentrating on wood-stealing, garden and field thefts, and other similar night offences – which had rarely been pursued by the old constables.[133] This all amounted to an early form of what has recently been called 'Broken Windows' policing,[134] in which low tolerance was shown for petty infractions and regulatory offences, with a view to raising the general level of public order and – it was thought and hoped – thereby preventing more serious crime.

Rates of arrests and committals to trial generally soared upon the introduction of the county forces.[135] Chief constables demanded that their men make arrests, on pain of dismissal; superintendents, in particular, were placed under threat of the sack if sheep-stealing prevailed in their divisions.[136] Gatrell argues that it was relatively easy for the new police forces, in their early decades, to make substantial inroads into the numbers

of local criminals who had existed comfortably alongside the old parish constables for many years: 'The effect of even this kind of casual surveillance was startling. Quite credibly in the 1850s, small and untrained forces could claim dramatic decreases ... not long after their establishment.'[137] An Essex farmer, asked in 1853 about sheep-stealing in the county, replied:

> We used frequently to lose sheep; I have lost several myself; to give some idea of the extent to which that went on: I was a member of a society for the prevention of crime and for the apprehension of offenders; I frequently have received money from that society, before the police was established towards my expense for prosecution; since the police has been established I have not had a single prosecution, nor an application from the society for any rate, which shows that crime has decreased.[138]

One should approach the evidence given to this Select Committee with a degree of scepticism, since many of the questions asked, and much of the evidence given by police officers and landed gentlemen, were aimed at achieving particular political results in the area of policing reform. But there is little reason to doubt the truth of such stories as the above one about sheep-stealing. Before the coming of the 'new police', farmers had treated theft of their animals, produce and wood as part of the cost of doing business; even where the likely offenders were known to them, the cost and trouble of finding and prosecuting them was high. Now the new county forces could find and arrest such people, and prosecute them without any fear of reprisals. This substantially raised the risk for rural criminals of continuing such depredations, and offered, in the early decades, a greater degree of protection to the farmer's property.

'One system alone of rural police': towards 1856

After 1842, the government had done little to shape the emerging county forces, leaving it essentially to the individual county Quarter Sessions and chief constables to decide things for themselves. But in the early 1850s, the government entered the arena again, intervening, between 1853 and 1856, to create a more uniform system of county policing. Two Home Secretaries – Lord Palmerston (in 1853–4) and, above all, Sir George Grey (in 1856) – took the principles of 1839 and made them mandatory. It is perhaps fitting that this occurred under the ministries of Aberdeen (1852–5) and Palmerston (1855–8), which brought together moderate Whigs with Peelite Liberal-Conservatives – the two political groupings who had always been most favourable to the County Police Acts.[139] There was no shortage of sound and fury even at this stage, but this time, the protests came less from country gentlemen and county members than from town councils and borough MPs.

During both the Tory and Whig administrations of the 1840s and early 1850s, government would have found it pointless to return to this matter. A large portion of the Tory Party was committed to alternative schemes of

rural policing, and were in no mood to respond until they had been able to see the results. Most importantly, nothing could be done under any circumstances unless and until the government made a major financial commitment. Counties would have to agree to compulsion and to the achievement of some minimum standard of uniformity, in return for a government subvention towards the cost of the police. In 1856, the Palmerston administration came up with the necessary money, and the deal was done which led to the County and Borough Police Act of that year. The story of the passage of the Act has been fully told many times recently,[140] so we shall be brief on the details.

Palmerston, as Home Secretary,[141] began his official involvement with policing questions with the appointment of the House of Commons Select Committee on Police of 1853. Palmerston appears to have had a personal interest in these questions, having been involved in a local attempt in Hampshire to pressure the Watch Committee of the borough of Romsey to consolidate its force with that of the county.[142] He responded favourably to letters from fellow aristocrats in non-adopting counties, complaining of the state of their police. Lord Fortescue wrote from Devon complaining of the 'petty depredations', the sheep-stealing, and the swarms of 'sturdy beggars' who had to be repelled from his own house by a servant employed for that purpose. A proper police would be cost-effective 'even were the whole to be charged to the Consolidated Fund' by the 'saving of private property now plundered and destroyed'.[143] Remarkably, even Edwin Chadwick found Palmerston sympathetic to his views on police.[144] Chadwick advised him to create an unashamedly Benthamite 'General Police', governed by a separate department within the Home Office responsible for both London and the provinces.[145] Fortescue, Chadwick and Palmerston all had a private fondness for the model of the Irish Constabulary; in his speech explaining his national police bill in June 1854, Palmerston praised it – which proved to be the first of his many errors in that episode.

The Select Committee of 1853 was well stacked with a bipartisan group of supporters of rationalization of the provincial police. The chairman, E. R. Rice of Kent, who had proposed the motion for the committee, was a long-standing supporter of the County Police Acts going back to 1839.[146] The committee produced a set of persuasive arguments for a universal national police system which proved very hard to rebut. Its witnesses and evidence were chosen to extol the virtues of county policing and to highlight the deficiencies of the superintending constable systems, and of the small borough forces. Unlike the mid-1830s, proponents of reform could now come armed with statistics and other data purporting to show the good effects produced by functioning forces. The Select Committee's chief target was the superintending constable system.[147] If the effectiveness of the only alternative was successfully impugned, what was left except an updated County Police Acts scheme, or a Chadwickian national police system? The witnesses questioned by the committee included: Chadwick; a series of sober and articulate county chief constables,[148] who came laden with papers

containing statistics of crimes, criminal committals and costs, and further suggestions for police rationalization; MPs and other country gentlemen; farmers living on the borders of counties, who stressed the contrast between a policed and an unpoliced countryside;[149] Quarter Sessions chairmen,[150] who spoke of the difference the county police had made in producing better order, control of vagrants and suppression of crimes against agricultural property; and a group of present and past superintending constables who made strong and well-informed attacks on the entire alternative policing system.

The Select Committee delivered a very short report, which praised the efficiency of the existing county forces, but condemned the permissive principle of the County Police Acts, which had created irrational gaps in coverage. It lamented the lack of co-operation and co-ordination between borough and county police, and recommended that, at the least, the small boroughs be amalgamated with the counties. It also recommended immediate legislation 'rendering the adoption of an efficient Police Force on a uniform principle imperative throughout Great Britain', and a central government subvention to assist with the cost of county forces. It praised the superintending constables, but severely criticized the system as too 'dependent on the aid of Parochial Constables', who were essentially useless 'for the protection of property ... the prompt detection and pursuit of offenders, [and] the maintenance of order ...'[151]

One portion of the evidence was quite startling. Two chief constables provided detailed comparative cost estimates showing expenditures for a county police, as compared to parish constables alone, and to a superintending constable scheme (with its attendant costs for the parochial constabulary). Capt. McHardy of Essex – by including sums formerly paid to parish constables, and claiming a large sum to represent money saved on the decrease of vagrancy, fines, conveyance of prisoners and an estimate of the value of property recovered and protected by the county force – came up with a balance sheet purporting to show that the Essex Constabulary was a 'self supporting force'! William Oakley, Chief of Police of Bath, estimated that for Somerset to use superintendents plus parish constables would cost much *more* than a police force.[152] These balance sheets were noticed and reproduced elsewhere.[153]

In June 1854, following on from the Select Committee, Palmerston introduced his national police bill. It was poorly conceived and badly handled, and failed to get through. For one thing, it had a somewhat Chadwickian ring about it: counties would be compelled to form police forces; the five smallest counties would be amalgamated with surrounding counties; there would be government inspection; county forces would be governed by new Police Boards elected by the magistrates from the magistrates. For the boroughs, those with fewer than 20,000 inhabitants would have their forces taken over by the county (which meant the unelected county magistrates replacing the elected borough council as the authority in charge); and, even in those that retained their police, the power

of chief constables would be increased in relation to their Watch Committees. And, above all, the bill offered the counties and boroughs no financial aid from central government towards the cost of the force.

County members disliked the bill, but it provoked the greatest hostility from the boroughs, which sent representatives to London to protest *en masse*. Palmerston had to bow to the strength of the objections and withdraw the bill.[154] Instead of waiting until the next session for things to cool down, Palmerston came back with another bill, this time referring to the counties only. But county members found that it embodied the 'same objectionable compulsory principle', still without any government subsidy; it, too, had to be withdrawn.[155] It was only when, in 1856, the 'objectionable compulsory principle' was offered together with a central government subvention, that the entire matter proved to be negotiable after all.

Palmerston became Prime Minister in February 1855. Sir George Grey, who now returned to the Home Office,[156] was craftier and less impulsive than Palmerston. He understood that, as long as government did not propose to remove the oversight of a county police from the justices, 'principle' was no longer the issue; the key was government willingness to provide money. Grey had a sincere 'faith in the ability of local government to provide law and order without the intrusion of central government'.[157] The County and Borough Police Bill, which he introduced in February 1856, was designed to provide the counties with overall guidance, firmer rules, minimum standards and central government inspection. Above all, it was concerned with making the principles of 1839 mandatory, and ensuring that county forces were not undermanned. To sweeten the pill, counties and boroughs with 'efficient' forces were now offered grants of one-quarter of the cost of paying and clothing their police forces.[158] The structures of supervision and command of the county police were left essentially unchanged.[159]

The Commons debates on the bill dragged on from February to the end of May, filling over 80 pages of *Hansard*.[160] Most of the opposition came from the borough members, who raised the old cry of 'centralization' and violation of the rights of self-government; it now carried far less weight politically than it had done twenty years, or even ten years, before.[161] Grey put the boroughs on warning in March 1855 by telling them that the government would no longer station small detachments of troops in their vicinity to keep public order; they must now look to their own police. In the course of a brilliant two-hour speech, he also lectured them on the responsibilities of Parliament under the Municipal Corporations Act. In an unusually rare and explicit manner, Grey delivered a government homily on the British constitution, reminding boroughs (and perhaps not only boroughs) that local self-government was not absolute, and that they 'were [not] sacred ground upon which Parliament could not venture'.[162]

After a period which had seen a proliferation of many different schemes on a local level, the state finally found itself, in 1856, able to insist upon a more 'uniform'[163] police system. From 1839, the government had

propounded a redefinition of the basic policing unit of rural society. In 1856, the county MPs, JPs and gentry had finally accepted it. With compulsion, local government for policing purposes (other than for the borough forces) was firmly defined as *county* government. There was no more room for little police schemes based on parishes, petty sessional divisions or Poor Law Unions, nor for superintending constables, or small forces appointed under the Lighting and Watching Act or voluntary subscription. Those alternative models, widely tried in the 1830s and 1840s, were now no longer available. The 1856 police system – firmly grounded on the principles of 1839, derived from the Constabulary Force Commission Report, the Shropshire Quarter Sessions Resolution and Russell's County Police Act – remained in place for the rest of the nineteenth century and well into the twentieth.

Counterfactual scenarios and conclusions

This book has been concerned to highlight the complex interplay between the 'national governing class' – the men who held national government office in this period – and the 'provincial ruling class'[164] – landed gentlemen, above all the justices of the peace, whose primary field of activity was the county or even the division – on the question of a police for the English countryside. And it has also examined the struggles *within* the provincial ruling class itself over this issue. At the beginning of our period, governments made their first public pronouncements, and, in 1832, the Whigs concocted the first (abortive) draft bill for a provincial police. During the 1830s and 1840s, the national governing class became less and less tolerant of the way in which the provincial magistracy performed their task of maintaining public order and repressing crime. Many of the provincial ruling class feared that they would be progressively stripped of their considerable local political authority, or even by-passed altogether. Some of the sound and fury emanating from provincial gentlemen in the debates over the County Police Acts of 1839–40 stemmed from the fact that the rural police issue became caught up in the sensitive wider debate of that period over the shape of local government and the future role of the magistracy.

John Styles has argued that more rigorous standards expected of the magistracy in the early nineteenth century produced demands for reform and expectations which they could not fulfil. A police would be crucial in such a reform programme in buttressing the authority of a new stipendiary magistracy.[165] It is true that national leaders such as Peel and Russell *did* become impatient with the magistracy, and might privately have supported its radical reform; but neither could ever hope to win a majority for this in Parliament. The most fervent advocates of reform of *both* police and magistracy (and local government) were the parliamentary Radicals; but their Whig allies would never support them to this length. Because the magistracy was indeed feeling beleaguered and vulnerable, this engendered

a degree of paranoia among a portion of them. They, and many country gentlemen in general, were, therefore, initially unable to see that the County Police Acts would not be harmful to their interests. By the 1850s, these fears had almost entirely receded.[166] The justices hung on to the bulk of their administrative authority, and their judicial authority was actually reinforced by new legislation for summary justice from the mid-century. Significant reform of county government did not come until 1888. This was one reason for what has been called 'the quiet reform of the English police, 1854–6'.[167]

Throughout this book we have emphasized the role which the provincial ruling class itself played in the process of rural police reform. Linked to the national governing class through its Lords Lieutenants, Quarter Sessions chairmen, MPs (who were sometimes also active justices), family ties and friendship, it was also starting to reassess the foundations of order and crime control in the counties by the late 1820s.[168] As we have shown, many provincial gentlemen were involved, in the late 1820s and 1830s, in launching and maintaining numerous local policing experiments. The Cheshire Constabulary Act of 1829, the host of suggestions and plans submitted to the Royal Commission of 1836–9, and the Shropshire plan of 1839 – these were all examples of initiatives or models that bubbled up from the provincial gentry. The response of the magistrates in 1836 to the Royal Commission questionnaires suggests that a substantial portion of the provincial ruling class was prepared to entertain thoughts of police reform. The problem for government was that the plans and opinions of provincial gentlemen friendly to police reform were diverse, often at odds with each other and did not always conform to what ministers, or utilitarian reformers, favoured.

By the end of the 1830s, landed gentlemen had reached a broad consensus that parish constables were no longer sufficient, and should be either relegated to auxiliaries or taken in hand by the justices; but there was profound disagreement among them regarding the professional component of a rural police. There was enough acceptance of Russell's principles of 1839 to create county forces of varying size in half the English counties by 1841, 60 per cent by the end of the 1840s and 67 per cent just before the compulsory legislation of the mid 1850s. And we must re-emphasize that in some of the non-adopting counties the issue had been lost on very close votes. But others favoured alternative schemes which they thought would be constitutionally safer, cheaper or more acceptable to the ratepayers. Tory gentlemen, in particular, continued to search for other alternatives in the 1840s and early 1850s: the Law Hodges Plan, the Pakington Plan, the Parish Constables Acts of 1842 and 1850, and the Deedes Plan – all of which had *bona fide* provincial origins.

The early 1850s clearly saw a narrowing of these options. The widespread experiment with superintending constables, which commenced with great enthusiasm, was giving diminishing satisfaction by the mid-1850s. Between 1850 and 1856, there was a general lurch towards more

thoroughgoing rural police reform in a number of counties, largely in the Southwest, but also in Yorkshire and in Surrey adjoining the Metropolitan Police District. Berkshire, Devon, Dorset and Somerset ignored the superintendent constable option entirely, and had put themselves under the County Police Acts (or were in the process of doing so) when the 1856 County and Borough Police Act took effect.[169] In addition, in the early 1850s, county forces whose operations were limited to certain divisions of the county were extended to take in more divisions, and there were moves to extend what had been just divisional forces to cover the entire county. Finally, it would seem that, where Quarter Sessions returned unsuccessfully to the question of adoption of the County Police Acts, the margins of defeat were narrowing.[170] These developments accompanied (and in some cases preceded) the renewed government push of Palmerston and Grey to secure national legislation; and they reveal something of the trend in county opinion.

In October 1850, after an atrocious murder, Surrey hurriedly appointed a Quarter Sessions committee to suggest a course of action. In December, it recommended that the County Police Acts be adopted and the county divided into three police divisions.[171] Notable in these deliberations was the detailed attention given to costing a new police, foreshadowing the powerful arguments made by the 1853 Select Committee, purporting to demonstrate the cost-effectiveness of a rural police.[172] Cambridgeshire [county], reacting to an outbreak of incendiarism, adopted at the same time.[173] A few years later, Berkshire, Somerset and the East Riding adopted the Acts for the whole county, and Devon was in the process of doing so when the 1856 Act intervened.[174] Two other counties, Dorset and Warwickshire, were also moving towards county-wide police establishments in the early 1850s. Dorset had established a divisional force for the Sturminister division in 1849; in 1850 the Shaftesbury division joined it; in 1855 the Wimborne division requested a force. By 1856 there were similar requests from the Wareham, Cerne, Bridport and Dorchester divisions. By the time the Act of 1856 came into effect, the outlines of a county police were largely in existence in Dorset. The Acts of 1839–40 had been used similarly in Warwickshire, where a divisional police had existed for the Knightlow hundred since 1840. A movement to extend it to the Barlichway hundred began in 1854. In early 1855, this was approved by Quarter Sessions, and the two hundreds were placed under one chief officer.[175]

Let us look now at the final outcome of the county magistrates' encounter with the County Police Acts – that is to say, the situation as it stood on the eve of compulsion in 1856. Rates of 'compliance' by that time were quite substantial. Russell's optimism in 1840 regarding the inevitable tendency of the system to spread appeared to have been justified.

Barbara Weinberger noted of Warwickshire in the mid-1850s: 'It is as though the major battles of principle ... had all been fought out earlier, while the motivation for a new battle against the "centralising tendency" of the [1856] Act was apparently not as substantial as the opposition's

Table 9.1 Rates of 'compliance' with County Police Acts before County and Borough Police Act (1856) in 43 English legal counties (excluding Middlesex and Cheshire), for England and by region.[176]

I England (43)
 By 1845: 51%
 By 1856: 67%
II By region
 A South[177] (23)
 By 1845: 52%
 By 1856: 74%
 B Midlands (12)
 By 1845: 54%
 By 1856: 54%
 C North (8)
 By 1845: 38%
 By 1856: 63%

Sources: S. Palmer, *Police and Protest;* provincial newspapers and county records.

rhetoric had implied.'[178] What is not explained is *why* the residual opposition of the landed class (expressed ultimately through the votes of the county members in 1856) had become so brittle. The standard explanations have centred around three factors: the ending of most transportation to Australia in 1853,[179] requiring those convicts henceforth to be dealt with in Britain; the stripping of troops from the North of England for the Crimean War, and the decision to concentrate them in military camps thereafter; and the growth of the railways.[180] These are valid points – but we should remember that the landed class had encountered other even more threatening issues in the past but had never before voted overwhelmingly for a 'policeman state'. The year 1856 should be seen, in this respect, as the end of a long and complex process of both ideological change and practical experiment in the countryside – which long predated these specific developments of the 1850s.

During the 1856 debate on Grey's bill, Sir Francis Baring complained that 'it was wrong to use the Consolidated Fund for the purpose of tempting the Members for counties to adopt a measure which, but for that temptation, he did not believe they would ever agree to'.[181] It is true that there was a somewhat unseemly scramble for government money in 1856, which ensured defeat for borough members like Baring. But by then, for many *county* members (since principle no longer entered into it), the outcome really came down to the simple question of whether or not a subvention was offered.[182] Other details, such as government inspection, might seem objectionable, but could be swallowed.

Three years earlier, E. B. Denison, a prominent Tory and county MP, repeated to the Select Committee on Police the reasons which had led him to help defeat adoption of the County Police Acts in the West Riding in 1840–1:[183]

... the county rate is based upon a wrong principle. It is a property tax, but the county rate is raised for purposes which depend upon the density of population. Prisoners ... come from the most densely populated parts of the county ... the lunatic asylums are built for parties who come from the most populated parts. ... Sheffield has ... cost ... above £3,000 per annum for the prosecution and maintenance of its criminals, more than it contributed to the county rate purse; but the money was raised in the agricultural parts of the Riding, according to the value of the property, as if they had produced an equal number of criminals.

Denison was not at all preoccupied with issues of local autonomy, and, by this time, did not oppose compulsion *per se*. On the contrary:

[Denison] I think the Government ... ought to appoint a rural police over the whole kingdom. In my opinion, everything connected with crime ought to be under the control of Government officers ... Having taken upon itself to relieve the West Riding from the payment of £20,000 for the prosecution of crime, it does not seem ... logical that the Riding should be called upon to pay for the police, which is merely to prevent the crime which the Government has undertaken to prosecute.
[Question:] Then you would make the expense of the police a national charge ...?
[Denison:] Decidedly. ... objections to a rural police have increased since the Government has repaid a part of the expenses of the prosecution of felons; and I think the Government ought to apply that system still further.[184]

Denison stated that adoption of the County Police Acts had recently been reconsidered twice, and emphasized that but for the insoluble conflict over the application of the rate, Quarter Sessions would have adopted them readily in the West Riding.

Let us close with some 'counterfactual'[185] scenarios of our period of police history. More can be imagined, but we shall limit ourselves to two. What if the Peel or Russell ministries of the 1840s had brought in an amendment to the Acts of 1839-40 offering a substantial subvention? We would guess that of the non-adopting counties, many would have promptly adopted the Acts. We think that the major battles of principle were largely over even then.[186]

Second scenario: Let us imagine that the views of the (largely) Tory police reformers had prevailed. Rural England would then have been covered by small police forces somewhat analogous to American county sheriff's departments. As imagined by Law Hodges and others, the ideal was a police district under the control of local petty sessional justices. It might have amounted to the County Police Acts writ small. The police would have been placed under the justices, the chief officer would have been responsible to the local bench, and the latter would have had, in theory, unlimited power to tap the Poor Rate (as opposed to the county rate) to support the establishment. Although local, such a system would have been far from a ratepayer democracy, and thus the ratepayers might have cried as loudly against the impositions of their local justices as they did against the county rate in the early years of County Police Acts forces. Such pressure would have acted as a constraint upon justices to keep police

establishments as barely staffed as possible, precisely as was the case for county establishments (and county rates) in many adopting counties.

Had Law Hodges and the rest triumphed, one can imagine the tenor of future parliamentary inquiries into the rural police. The justices would have been accused of cheese-paring, pandering to the ratepayers and maintaining undermanned, inefficient establishments, as some of the boroughs were (in non-counterfactual history) accused of doing during the 1840s and 1850s. Would such a system have survived parliamentary scrutiny without further reforms? Finally, since Quarter Sessions had come to wield extraordinary power as the chief executive agency of counties, how long would it have remained aloof? Would not the same temptations have arisen to shift the costs from the Poor Rate to the county rate, as those which arose, in fact, to shift them from the county rates to the Consolidated Fund? In which case, how long would Quarter Sessions have permitted the persistence of these petty sessional police fiefdoms?[187] The Tory reform scenario did not, we think, promise much in the long term.

In reality, by the early 1850s, certain notions had become largely accepted: a police force should take its place as a regular county responsibility under an appropriate Quarter Sessions committee (and a chief constable) alongside bridges, prisons and lunatics; a new standard of order and public decorum should be enforced and 'taught' to the disorderly poor by blue-coated 'domestic missionaries';[188] and the repression of petty crime, or of even more serious offences, should no longer be left to the efforts of villagers or the discretion of parish notables. We started this book at 1820, in a society relying on parish constables to deal with crime and disorder; by 1856 – after a long period of political struggle – we see the 'new police' forces firmly established in what was becoming a recognizably modern 'policed' society. In the course of those three-and-a-half decades, provincial England had undergone a change in its machinery of law enforcement as profound in the long term, and as far-reaching in its effects, as the transition over that same period from a horse-drawn society to the railway age. Arguably, until the reorganizations of recent decades, the English provincial police system remained largely a product of the period with which we have been concerned and the political struggles of those days.

APPENDIX A

Table A.1 Percentage of petty sessional benches in each county favouring a permanent paid police (1836)[1]

County	Percentage in favour	County	Percentage in favour
Beds.	100	Kent	50
Staffs.	86	Essex	47
Worcs.	83	Lancs.	45
Herts.	82	Bucks.	43
Herefordshire	80	Notts.	40
Hants.	77	Somerset	38
Sussex	71	Suffolk	33
Glos.	68	Warks.	29
Derbys.	67	Cornwall	25
Cumberland	66	Oxon.	25
Devon	65	Yorks. (E.R.)	22
Wilts.	63	Leics.	20
Yorks. (N.R.)	62	Northumberland	17
Yorks. (W.R.)	60	Salop	11
Berks.	57	Lincs.	6
Northants.	57	Dorset	0
Durham	55	Rutland	0
Cambs.	50	Westmorland	0
Hunts.	50		

Source: Magistrates' Returns to CFC, PRO HO/73/5

[1] Data for Norfolk are missing. Cheshire and Middlesex are omitted. Cheshire had a police under the Cheshire Police Act. Much of Middlesex was in the Metropolitan Police District.

APPENDIX B

Table B.1 Known policing schemes under local acts, Lighting and Watching Act, voluntary subscription and other auspices (1836–9)[1]

County	Location	Auspices	Personnel	Other details
Bedfordshire	Ampthill	LW	1 Night Constable	
	Goddington	Poor Rate	U	Abolished after Poor Law Commission Ruling (see Chap. 3)
	Luton	LW	1 day police; 2 Night Watch	Day officer paid 14s. p.w.
	Woburn	VS	Watch	Converted to VS from Poor Rate
Berkshire	Bascot District	VS	2 policemen	5-parish district
	Newbury Parish	LA	4 night; 1 day constable	
	Speen	LA	1 Night Watch	
	Windsor	U	MET Officer	
Buckinghamshire	Brackley District	VS	Mounted Supt. Ex-MET inspector	Paid £90 p.a. 30-parish district
	Eton	LW	2 watchmen	
	Salt Hill Watch	Prosecution of Felons Assn	Patrol	Local men
	Brill District	VS	2 MET officers	
	Buckingham	U	1 paid man	
Cambridgeshire	Linton District	LW	1 officer; 2 assistants	5-parish district
Cheshire	Under Cheshire Police Act			See Chapter 5 for force distribution
Cornwall	Truro	LA	Night police	
Cumberland	Keswick District	VS	1 policeman	6 townships
	Whitehaven	LA	3 policemen & 2 dock policemen	Uniformed like MET. Paid 35 guineas plus fees
	Wigton	LW	4 paid constables	

[1] **LA** = Local Act; **LW** = Lighting & Watching Act; **VS** = Voluntary Subscription; **U** = Unknown; **MET** = Ex-Metropolitan Police; **PLU** = Poor Law Union

County	Location	Auspices	Personnel	Other details
Derbyshire	Bakewell	VS	1 paid officer	
	Buxton	VS	1 paid officer	
	Hartshorn	VS	1 policeman	
	Repton District	U	1 officer	Repton and adjoining villages
Devon	Ashburton	U	2 'permanent officers'	
	Axminster	VS	1 officer	
	Clifton	U	U	
	Islington	U	U	
	Paignton	LA	1 officer	Paid £35 p.a.
	S. Molton	U	U	
	Teignmouth	LA	5 policemen	Uniformed and equipped like MET
Durham	Darlington	LA	2 officers	
	S. Shields	LA	2 officers	
	Sunderland	LA	3 officers	Paid £1 p.w.
	Wearmouth	U	2 officers	
Essex	Bishop's Stortford District	VS	U	Bishop's Stortford and adjoining villages
	Braintree	LW	2 Watchmen	
	Colchester	Justices	Detective	Also Insp. of Wts. and Measures. Fee basis
	Hinckford Hundred	VS	MET officer	Several parishes in district
	Upminster	VS	Night constable	Protects subscribers only
	Walthamstow (town)	LW	1 sgt., 6 officers	
	Epping, Leyton, Little Ilford, West Ham, Woodford, and Walthamstow parishes	Government	Metropolitan Police Mounted Patrol	
Gloucestershire	Andoversford Police Association	VS	2 MET officers	
	Bibury, Kempsford, Fairford District	VS	1 (MET?) officer	5-village district near Wilts. & Berks. borders
	Blockley Police Association	VS	U	Operate in parts of Worcs.
	Bristol Area	VS	U	Organized by T.B.L. Baker and other gentlemen. 6-parish district
	Bourton-on-the-Water Police Association	VS	1 MET officer & 1 assistant	5-parish district
	Cheltenham	LA	25 officers	Later under Municipal Corp. Act. Dressed as MET police

County	Location	Auspices	Personnel	Other details
	Cirencester	LA	1 officer	Paid 25s. p.w.
	Moreton-in-Marsh Police Association	U	2 MET officers	7-parish district. Operate in parts of Worcs. & Warks.
	Minchinhampton Police Association	VS	3 MET officers	Act within the Longtree Hundred
	Northleach Police Association	VS	2 officers	
	Siddington and Down Amprey	VS	1 or 2 officers	Adjoining Cirencester
	Stow-on-the-Wold Police Association	VS	2 MET officers	Stow and 15 parishes
	Stowell	VS	1 officer	3 parish district
	Stroud	VS	2 (MET?) officers	Operate in 20% of parishes in Stroud Union.
	Winchcomb	VS	2 officers	
Hampshire	Abbots Langley	VS	1 MET officer	Abbots Langley and King's Langley. Discontinued 1838
	Alresford	LA	U	
	Alton	LW	1 full-time local man	
	Cheriton	VS	1 policeman	Paid 12s. p.w.
	Overton	VS	paid men	
	Ryde	LA	paid police	Number U
	Stratton	U	1 policeman	Stratton and 3 adjoining parishes. Paid £20–30 p.a.
	W. Cowes	LA	paid police	Number U
	Whitchurch	VS	paid men	
	Winchester District	VS	U	4-parish district in Winchester
Hertfordshire	Barnet General Association	VS	6 officers	Uniformed. Outgrowth of Prosecution of Felons Association
	Bayford	VS	1 MET officer	
	Berkhamsted	VS	1 MET officer	
	Bishop's Stortford Union	VS	U	Near Essex border
	Cheshunt Div.	LW/VS	1 sgt; 4 constables	Uniformed like MET. Paid half by rate; half by VS
	Codicote	VS	1 MET officer	
	Hemel Hempstead	VS/LW	1 sgt; 2 constables	Uniformed like MET. Went under LW in 1837. Sgt. paid 40s. p.w.
	Royston	U	3 policemen	Royston & adjoining parishes
	Stevenage	U	(MET?)	Established with MET Assistance

County	Location	Auspices	Personnel	Other Details
	Totteridge	VS	1 MET officer	
	Tring	U	2 MET officers	
	Ware	LA	U	
	Watford	VS	2 MET officers	
Kent	Ashford	LA	3 men. Watch	
	Beckenham Association	VS	2 MET officers	
	Blackheath Watch	LW	1 MET supt. and constables	
	Chatham Hill	LW	5 Royal Marine Pensioners	8-parish district in Milton Union
	Margate	U	U	
	Ramsgate	LW	MET Officers	
	Tonbridge	LW	6 men. Night Watch	
	Tunbridge Wells	U	1 supt; 6 policemen	Supt. paid 25s. p.w.
	Upper Scray Div.	LW	U	Faversham District. 16 of 46 parishes.
Lancashire	Ashton	LA	U	Salaried constables under LA from 1827. Other (Leet) constables as well.
	Blackburn	Vestry/Rates	Police officer and full-time assistants	By vestry under typical Northern arrangements. Policeman paid £100 p.a.
	Bolton	Leet	U	Government commissioners took over establishment (1839)
	Burnley	U	1 officer	
	Chorley	Vestry/Rate	1 officer	
	Clitheroe	Township	U	Officer doubles as overseer
	Habergham Eaves	VS	Night Watch	
	Kirkdale	LW	Night patrol	3-township district
	Lancaster	LA	U	
	Manchester	Leet/LA	Day force; night force	Incorporated 1838. Police under 3 authorities until 1839. Govt. commissioners took over establishment (1839)
	Oldham	LA	10 men	Full-time paid. Other conflicting bodies (see Chap. 2)
	Ormskirk	Leet	1 paid deputy	Northern paid deputy system

County	Location	Auspices	Personnel	Other Details
	Over Darwen	U	1 paid officer	Paid £60 p.a.
	Preston	LA	1 supt.; 1 insp.; 5 men	
	Rochdale	LA	Capt. & Night Watch	Under Improvement Act
	Ulverston	LW	2 policemen	Paid £52 and £36 p.a.
	Warrington	LA	Deputy & assistant	
Leicestershire	Ashby de la Zouch	U	1 man	
	Hartshorn	VS	1 paid man	
	Hinckley	U	Night constables	
Lincolnshire	Gainsborough	LW	Night Watch	
	Horncastle	LW	2 policemen	
Middlesex	Edmonton Parish	LW	10 men	
	Hayes	VS	U	Similar to Beckenham (Kent) Association
Norfolk	Ashwellthorpe	VS/C/LW	1 MET officer; 1 other officer	Converted from VS (1839). 18-parish district
	Blofield District	PLU-VS/LW	1 MET officer, & 3 locals	30-parish district. Initially under PLU & funded VS; then LW
	Burnham Union	PLU	2 MET officers	Ephemeral
	Fetwell	U	1 MET officer	
	Docking Union	PLU	3 MET officers	Ephemeral
	Downham	VS	2 officers	
	Grimshoe Hundred	VS	2 officers	
	Hingham	LW	1 MET officer	Serve population of 1500
	Long Stratton	VS	1 MET officer	
	Starston & Harleston	VS	1 officer	Starston, Harleston & surrounding parishes
	Stratton St Michael District	VS	U	
	Swaffham Union	VS	2 MET officers	Converted from force paid by PLU?
	Tasburgh Police Association	LW	3 MET officers; 2 local men	16-parish district
	Wymondham	LW	3 MET officers	23-parish district
Northamptonshire	Peterborough	LA	U	
Northumberland	Alnwick	LA	1 man	Part-time
	N. Shields	LA	14 Night constables	
Nottinghamshire	Edwinstown	VS	1 policeman	
Oxfordshire	Bicester	VS	3 MET officers	
	Chipping Norton Police Association	VS	MET personnel. Number U	Part of Cotswold chain of police associations. See Glos.
	Henley	LA	1 MET officer	Operates in rural parishes

County	Location	Auspices	Personnel	Other Details
Salop	Ellesmere	LW	2 police officers	Paid £20 + £12 p.a.
	Whitchurch	VS	1 MET officer	Paid 30s. p.w.
Staffordshire	Smethwick	LW	6 officers	
	Wolverhampton	LA	13-man watch	
Suffolk	Barham Union	PLU	2 MET officers	Ephemeral
	Beccles	U	Supt. & 3 constables	
	Blything Union	PLU	2 MET officers	Ephemeral
	Cosford Union	U	3 MET officers	Ephemeral
	Hadleigh	LW	1 MET officer	
	Haverhill	LW	1 MET officer	
	Hengrave	VS	U	12-parish district
	Hoxne Union	PLU	1 MET officer	
	Wickham Market I	VS	1 MET officer, 1 local man	Demonstration model as prelude to LW adoption (1836?). Gentry only
	Wickham Market II	VS	1 officer hired from Westminster House of Correction	Refounded on new VS basis with farmer participation (1837)
Surrey	Croydon	LA	1 supt & 5 men	Constables paid 35s. p.w.
	Mortlake	VS	U	
	Richmond	LA	Day police; Night patrol	
	Upper E. Sheen	VS	U	
Sussex	Arundel	LW	2 paid men	
	Ashington + Winstonhove	LW	U	
	Battle Div.	LW	U	Union of several parishes
	Brighton	LA	Chief officer; 2 supt.; 3 inspectors; 19 men	
	Brunswick	LA	3 officers	
	Burwash Div.	LW	U	Multiple parish district. Seems to be a watch
	Lewes Union	LW	U	4-parish district
	Petworth	LW	1 policeman	Paid £44 p.a. plus clothing
	Petworth District	LW	U	2-parish district adjoining Petworth
	Shoreham	LW	1 policeman	
	Steyning	LW	U	3-parish district
	Ticehurst	LW	U	
	Worthing	U	3 men	
Warwickshire	Atherstone	LW	4 night constables	LW collapsed. Became VS (1836?)

County	Location	Auspices	Personnel	Other Details
	Birmingham	LA	Large force of day & night constables, plus street keepers	Some watchmen were paid by subscription. Government commissioners took over establishment (1839)
	Coleshill	VS	1 officer	
	Deritend & Bordesley	LA	1 policeman & assistant; 1 night constable	Some of the night watchmen paid by subscription. Policeman paid 1 gn. p.w.
	Duddeston & Nechells	VS	13 Night-watchmen	
	Kenilworth	VS	1 policeman	Several parishes
	Leamington Priors	LA	6 policemen	
	Nuneaton	LW	1 paid local man & 6 Night-watchmen	Officer accused of partiality and corruption
	Polesworth	VS	1 paid officer	
	Rugby & Dunchurch Parishes	Poor Rate	1 MET officer	Disallowed by Poor Law Commission. Collapsed
	Sutton Coldfield	LA	1 officer	
	Cubbington & Other Parishes	VS	1 MET officer	5-parish district. Police association?
Wiltshire	Chippenham	LA	1 Night Watchman	
	Corsham	VS	U	
	Lacock	VS	1 police officer	Paid 21s. p.w.
	Warminster	VS	2 officers	Formerly paid from Poor Rate. Converted to VS after ruling of illegality
Worcestershire	Bromsgrove	Vestry/VS	1 man	Entrepreneurial constable
	Pershore	U	U	Appears to be VS Police Association
	Stourbridge	Vestry/VS	1 man	Entrepreneurial constable
	Tenbury	VS	U	Tenbury & adjoining parishes in Salop
Yorkshire (E.R.)	Howden	U (LA?)	3 assistant constables	Paid by town and fees
Yorkshire (N.R.)	Middlesborough	U	1 officer	Gets salary plus fees
	Stokesley	LW	1 MET officer	Paid £65 p.a.
	Thirsk	VS	1 MET officer	
Yorkshire (W.R.)	Barnsley	LA	1 policeman	
	Boroughbridge	U	1 man	Salaried deputy
	Doncaster	U	1 man	Riding constable (see Chap. 2) paid by Prosecution Society
	Halifax	Vestry/VS	2 officers	Northern paid deputy system (day); Night Watch under town trustees

County	Location	Auspices	Personnel	Other Details
	Huddersfield	LW	20 day police & Night Watch	
	Knaresborough	U	1 officer	Salaried deputy
	Knottingley	U	1 man	Paid £30 p.a. + fees. Northern deputy system?
	Otley	U	1 person	Paid £30 p.a. + fees. Northern deputy system?
	Sheffield	LA	20 police	
	Wakefield	LA	2 salaried deputies	
	Wetherby	U	2 officers	Paid deputies
	Upper Strafforth & Tickhill	VS	4 sgts; 16 man day patrol	Sgts. paid £1 p.w.

Sources: PRO HO 73/5 (Returns of JPs' Questionnaires to CFC); PRO HO 73/6-9 (Returns of Boards of Guardians' Questionnaires to CFC); PRO HO 73/2-4 (Correspondence of CFC); PRO HO 61/19; CFC Report, pp. 129-39; UCL Chadwick Papers 1573; B. J. Davey, *Lawless and Immoral. Policing a Country Town* (Leicester, 1983); D. Hobbs, 'The Croydon Police ...', *Journal of Police History Society 2*, (1987), pp. 66-79; P. Marsh 'Policing Ulverston ...' *Police Review* (June 1966); E. C. Midwinter, *Law and Order in Early Victorian Lancashire*, (York, Borthwick Papers, 34, 1968); provincial newspapers.

[1] We have excluded entrepreneurial constables dependent only on fees and payments from individuals and all office constables. For those see Chapter 2.

BIBLIOGRAPHICAL NOTES

Chapter 1

Earlier general histories of policing in England are: W. Melville Lee, *A History of Police in England* (1901); Charles Reith, *The Police Idea* (1938) and *A New Study of Police History* (1956); and Sir Leon Radzinowicz, *A History of English Criminal Law and Its Administration from 1750* (1948–1968), especially vols. 3 and 4.

Some recent general histories are: Clive Emsley, *Policing and Its Context 1750–1870* (1983) and *The English Police. A Political and Social History* (2nd edn 1996); T. A. Critchley, *A History of Police in England and Wales* (1st edn 1967; revised edn 1978); and the comprehensive S. H. Palmer, *Police and Protest in England and Ireland 1780–1850* (Cambridge, 1988). For London, see D. Ascoli, *The Queen's Peace: The Origins and Development of the Metropolitan Police, 1829–1979* (1979) and the still invaluable W. Miller, *Cops and Bobbies. Police Authority in New York and London, 1830–1870* (Chicago, 1977). Useful and provocative is R. Reiner, *The Politics of the Police* (Brighton, 1985), chapter 1. A recent short synthesis is D. Taylor, *The New Police in Nineteenth-Century England. Crime, Conflict and Control* (Manchester, 1997).

Useful works on aspects of nineteenth-century police reform include: F. C. Mather, *Public Order in the Age of the Chartists* (Manchester, 1959); E. C. Midwinter, *Social Administration in Lancashire 1830–1860* (Manchester, 1969); Carolyn Steedman, *Policing the Victorian Community. The Formation of English Provincial Police Forces, 1856–1880* (1984); V. A. C. Gatrell 'Crime, authority and the policeman-state', in F. M. L. Thompson (ed.), *The Cambridge Social History of Britain 1750–1950* , vol. 3 (Cambridge, 1990), pp. 243-310; David J. V. Jones, 'The New Police, Crime and People in England and Wales 1829-1888', *Transactions of the Royal Historical Society*, 5th Series, vol. 33 (1983), pp. 151-68, and essays in his *Crime, Protest, Community and Police in Nineteenth-Century Britain* (1982); V. Bailey (ed.), *Policing and Punishment in 19th Century Britain* (1981). Also some of the authors' contributions to this literature: R. D. Storch, 'The Plague of the Blue Locusts: Police Reform and Popular Resistance in Northern England, 1840-1857', *International Review of Social History*, 20

(1975), pp. 61-90; 'The Policeman as Domestic Missionary: Urban Discipline and Popular Culture in Northern England 1850-1880'; and 'Policing Rural Southern England Before the Police: Opinion and Practice 1830-1856', in D. Hay and F. Snyder (eds), *Policing and Prosecution in Britain 1750–1850* (1989), pp. 211-66; D. Philips, *Crime and Authority in Victorian England. The Black Country, 1835–1860* (1977), chapter 3; '"A New Engine of Power and Authority": The Institutionalisation of Law-Enforcement in England 1780-1830', in V. A. C. Gatrell, G. Parker and B. Lenman (eds), *Crime and the Law. The Social History of Crime in Western Europe since 1500* (1980), pp. 155-89. A still valuable essay on the nature of the change from an 'unpoliced' to a 'policed' society is Allan Silver, 'The Demand for Order in Civil Society: A Review of Some Themes in the History of Urban Crime, Police, and Riot', in D. Bordua (ed.), *The Police: Six Sociological Essays* (1967), pp. 1-24.

A few works essential to understanding the political context of the struggles over policing and local government reform are: N. Gash, *Politics in the Age of Peel. A Study in the Technique of Parliamentary Representation 1830–1850* (Atlantic Highlands, NJ, 1977) and *Reaction and Reconstruction in English Politics, 1832–1852* (Oxford,1965); D. Eastwood, *Governing Rural England. Tradition and Transformation in Local Government* (Oxford, 1994) and *Government and Community in the English Provinces, 1700–1870* (Basingstoke, 1997); T. A. Jenkins, *The Liberal Ascendancy, 1830–1886* (New York, 1994); P. Mandler, *Aristocratic Government in the Age of Reform: Whigs and Liberals, 1832–1850* (Oxford, 1990); J. Prest, *Liberty and Locality. Parliament, Permissive Legislation, and Ratepayers' Democracies in the Nineteenth Century* (Oxford, 1990); B. Keith-Lucas, *The Unreformed Local Government System* (1980); J. Parry, *The Rise and Fall of Liberal Government in Victorian Britain* (New Haven, 1993); K. B. Smellie, *A History of Local Government* (1963).

Information about the Essex parish constables in 1820 was culled from the depositions and recognizances to prosecute at Quarter Sessions for that year in the Essex Record Office; the Essex Return of Peace Officers (1832) is also in the Quarter Sessions material in the Essex Record Office. Evidence regarding the Essex constabulary in 1853 comes from the *First and Second Reports from the Select Committee on Police; with the Minutes of Evidence*, PP 1852-3, XXXVI, 1–159, 161–343. A recent history is M. Scollan, *Sworn to Serve. Police in Essex 1840–1990* (1993).

Chapter 2

The main source of material on the parish constables in the 1830s is the wealth of information to be found in the returns by JPs and Poor Law Guardians to the questionnaires sent out by the Constabulary Force Commission at the end of 1836 - to be found in Public Record Office (PRO) HO 73/5 to 73/9. There is some similar material to be found in William Augustus Miles' reports to the Commission, in HO 73/16. The

Chadwick Papers, in University College, London (UCL) (items 3, 13), also contain some relevant material.

These have been supplemented by: information from Quarter Sessions and parish vestries, to be found in County Record Offices; local newspapers; local histories; and by some evidence cited in other parliamentary reports: *Report from His Majesty's Commissioners for Inquiring into the Poor Laws*, PP, 1834, XXVIII; *Second Report of the Commissioners on County Rates*, PP (1836), pp. 1–383; *First and Second Reports from the Select Committee on Police; with the Minutes of Evidence*, PP 1852–3, XXXVI, pp. 1–159, 161–343.

On the parish constable in the sixteenth and seventeenth centuries, see Joan Kent, *The English Village Constable, 1580–1642* (Oxford, 1986) and J. Sharpe, 'Enforcing the Law in the Seventeenth-Century English Parish', in V. A. C. Gatrell, B. Lenman and G. Parker (eds), *Crime and the Law. The Social History of Crime in Western Europe Since 1500* (1980), chapter 4, and *Crime in Early Modern England, 1550–1750* (1984), chapter 4. A defence of the adequacy of policing arrangements in the capital before the Metropolitan Police is R. Paley, '"An Imperfect, Inadequate and Wretched System"? Policing London Before Peel', *Criminal Justice History*, 10 (1989), pp. 95–130. To our knowledge, no recent literature on the provincial parish constabulary in the eighteenth and nineteenth centuries exists apart from the forthcoming work of Peter King on the eighteenth century and Chapter 2 of this volume.

Chapter 3

The major source for our contention that a key element of the landed gentry came to accept the desirability of rural policing by the 1830s is the correspondence of the Constabulary Force Commission between 1836 and 1839, to be found in PRO HO 73/2-3, and replies by JPs and Guardians to questionnaires (PRO HO 73/5-9). This was supplemented by the Chadwick Papers (UCL), item 13, and some of the correspondence of Home Secretary Lord John Russell (PRO 30/22). Statements indicative of changing opinions were also found in reports in the local press, contemporary local pamphlets, and some recent local studies of the crisis in rural communities in the 1830s. The nature and variety of gentry-inspired police reform schemes is explored in R. D. Storch, 'Policing Rural Southern England Before the Police: Opinion and Practice, 1830–1856', in D. Hay and F. Snyder (eds), *Policing and Prosecution in Britain 1750–1850* (Oxford, 1989), pp. 211–66. On the parallel case of the reconsideration of the Old Poor Law among the gentry see P. Mandler, 'The Making of the New Poor Law *Redivivus*', *Past and Present*, 117 (1987), pp. 131–57, critiques by A. Brundage and D. Eastwood, and Mandler's rejoinder in *Past and Present*, 127 (1990).

Chapter 4

The main source for this chapter is the reports of parliamentary debates, in *Hansard* and *Mirror of Parliament*, plus the report of the *County Rates Commission* 1836. It also draws on biographies, and some of the correspondence of the politicians – Peel, Wellington, Knatchbull, Vyvyan, Melbourne, Richmond, Russell, Hume – involved.

Useful material on Lord Melbourne's abortive 1832 police bill is in West Sussex Record Office, Papers of the 5th Duke of Richmond, Goodwood MSS, 694 and Royal Archives, Melbourne Papers, MP 89/5. This episode is examined in D. Philips and R. D. Storch, 'Whigs and Coppers: The Grey Ministry's National Police Scheme, 1832', *Historical Research*, vol. 67, no. 162 (1994), pp. 75–90.

For the views of Edwin Chadwick, we have relied on his papers in University College London; Chadwick's 'Preventive Police', *London Review*, no. 1 (Feb. 1829), pp. 252–308; S. E. Finer, *The Life and Times of Sir Edwin Chadwick* (1952); R. A. Lewis, *Edwin Chadwick and the Sanitary Movement* (1952); A. Brundage, *England's 'Prussian Minister'. Edwin Chadwick and the Politics of Government Growth, 1832–1854* (University Park, PA, 1988) and 'Ministers, Magistrates and Reformers: The Genesis of the Rural Constabulary Act of 1839', *Parliamentary History*, 5 (1986), pp. 55–64.

Chapter 5

Our account of the Cheshire Constabulary Act is based on material found in: the Cheshire County Record Office; Cheshire newspapers; the Chadwick Papers (UCL), item 8; the CFC Report, pp. 110–29; and CFC returns relating to Cheshire in PRO HO 73/5 and 73/16. The Shropshire material comes from the Shropshire County Record Office and local newspapers; the Durham material mainly from PRO HO 40/30 and 41/11, the Grey Papers in the University of Durham Archives, and local newspapers.

The account of local forces appointed under local Acts or the Lighting and Watching Act, or as voluntary subscription or Poor Law-based forces, is based on returns of questionnaires to the CFC in PRO HO 73/5-9, PRO HO 61/19 and gleanings from local pamphlets and newspapers. A local study of the operation of the Lighting and Watching Act is B. J. Davey, *Lawless and Immoral. Policing a Country Town 1838–1857* (Leicester, 1983). A number of local schemes under various auspices are discussed in R. D. Storch, 'Policing Rural Southern England Before the Police: Opinion and Practice, 1830–1856', in D. Hay and F. Snyder (eds), *Policing and Prosecution in Britain 1750-1850* (Oxford, 1989), pp. 211–66.

Chapter 6

The anatomy of the Constabulary Force Commission (1836–9) is based primarily on the Report of the Commission itself and the correspondence on this subject of Lord John Russell, Charles Rowan, Charles Shaw Lefevre and others, largely in the Chadwick Papers (UCL), items 1–14. Other letters (including Chadwick's correspondence with his contacts in the field) and the papers of the CFC (including Chadwick's drafts of the Report) are in PRO HO 73/2-9 and 73/16. Commission minutes and other miscellaneous items are in PRO P[rivy] C[ouncil] 1/2547 and 2552.

Chapters 7 and 8

Analysis of the County Police Acts and their passage are based on the Acts themselves, and the reports of parliamentary debates in *Hansard* and *Mirror of Parliament*. Previous useful treatments are in L. Radzinowicz, *A History of English Criminal Law and Its Administration from 1750* (1948–1968), vol. 4, and C. Emsley, *The English Police. A Political and Social History* (2nd edn, 1996).

Our analysis of the debates in Quarter Sessions over adoption of the County Police Acts is based on the ample reports in the local newspapers (plus *The Times*), and (for counties such as Buckinghamshire, Cheshire, Derbyshire, Essex, Gloucestershire, Kent, Shropshire, Surrey, Sussex, the West Riding) on Quarter Sessions material in the County Record Offices.

Some published accounts, mostly brief, are I. P. Collis, 'The Struggle for Constabulary Reform in Somerset', *Proc. Somersetshire Arch. and Nat. Hist. Soc.*, 99 (1956), pp. 75–104 (Somerset); D. Eastwood, *Governing Rural England. Tradition and Transformation in Local Government 1780–1840* (Oxford, 1994), chapter 9 (Oxon.); D. Foster, 'Police Reform and Public Opinion in Rural Yorkshire', *Journal of Local Studies*, 2, 1 (1982), pp. 1–8 (East and North Ridings of Yorkshire); R. D. Storch, 'Policing Rural Southern England Before the Police. Opinion and Practice, 1830–56', in D. Hay and F. Snyder (eds), *Policing and Prosecution in Britain 1750–1850* (Oxford, 1989), pp. 211–66 (a number of Southern counties); R. Wells, 'Implementation and Non-Implementation of the 1839-40 Policing Acts in East and West Sussex', *Policing and Society*, 1, 4 (1991), pp. 299–317 (Sussex).

Chapter 9

The account of parliamentary developments 1841-2 is based on the reports of parliamentary debates in *Hansard* and *Mirror of Parliament*, and local newspapers.

Analysis of the Parish Constables Acts of 1842 and 1850 and their implementation is drawn from: the Acts themselves, and material in local record offices on counties – such as Buckinghamshire and Kent – which

tried to implement them. There is useful material on the superintending constables in the evidence given to the *First and Second Reports from the Select Committee on Police; with the Minutes of Evidence* PP 1852-3, XXXVI, (603, 715).

We have similarly made use of the evidence in those two reports, along with local newspapers and some local histories, in dealing with the county forces between 1841 and 1856. Useful here, too, are: Carolyn Steedman *Policing the Victorian Community. The Formation of English Provincial Police Forces, 1856–1880* (1984); S. H. Palmer, *Police and Protest in England and Ireland 1780–1850* (Cambridge, 1988); D. Philips, *Crime and Authority in Victorian England. The Black Country, 1835–1860* (1977); W. J. Lowe, 'The Lancashire Constabulary, 1845-1870: The Social Composition and Occupational Function of a Victorian Police Force', *Criminal Justice History*, 4 (1983), pp. 41–62; and R. D. Storch, 'The Plague of the Blue Locusts. Police Reform and Popular Resistance in Northern England, 1840-57', *International Review of Social History*, 20, 1 (1975), pp. 61–90, and 'The Policeman as Domestic Missionary: Urban Discipline and Popular Culture in Northern England 1850-1880', *Journal of Social History*, vol. 9, no. 4 (1976), pp. 481–509.

Finally, for our account of developments leading up to the passage of the 1856 County and Borough Police Act we relied, along with the above sources, largely on: T. A. Critchley, *A History of Police in England and Wales* (2nd edn 1978); C. Emsley, *The English Police. A Political and Social History* (2nd edn 1996); J. Hart, 'The County and Borough Police Act, 1856', *Public Administration*, 24, (1956), pp. 405–16; and L. Radzinowicz, *A History of English Criminal Law and Administration from 1750* (1948–1968), vol. 4.

NOTES AND REFERENCES

Chapter 1

1. W. Melville Lee, *A History of Police in England* (1901).
2. The two most substantial are *The Police Idea* (1938) and *A New Study of Police History* (1956). The others, which use much of the same material, are *Police Principles and the Problem of War* (1940), *British Police and the Democratic Ideal* (1943), and *The Blind Eye of History* (1952).
3. Four volumes - vol. 1, *The Movement for Reform* (1948), vol. 2, *The Clash Between Private Initiative and Public Interest in the Enforcement of the Law*, vol. 3, *Cross-Currents in the Movement for the Reform of the Police* (1956) and vol. 4, *Grappling for Control* (1968). A fifth volume, *The Emergence of Penal Policy*, written with Roger Hood, which covers the second half of the nineteenth century, was published in 1986.
4. F. C. Mather, *Public Order in the Age of the Chartists* (Manchester, 1959), chapters 3, 4; see also E. C. Midwinter, *Social Administration in Lancashire 1830-1860* (Manchester, 1969), chapter 4.
5. T. A. Critchley, *A History of Police in England and Wales* (revised edn 1978); C. Emsley, *Policing and Its Context 1750–1870* (1983); *The English Police. A Political and Social History* (2nd edn 1996). He also devotes a chapter of his *Crime and Society in England 1750–1900* (2nd edn 1996) to 'the old police and the new'; R. Reiner, *The Politics of the Police* (Brighton, 1985), pp. 10-47.
6. S. H. Palmer, *Police and Protest in England and Ireland 1780–1850* (Cambridge, 1988).
7. V. A. C. Gatrell, 'The Decline of Theft and Violence in Victorian and Edwardian England', in V. A. C. Gatrell, B. Lenman and G. Parker (eds), *Crime and the Law. The Social History of Crime in Western Europe since 1500* (1980), pp. 238-370, at 261-79; and 'Crime, Authority and the Policeman-state', in F. M. L. Thompson (ed.), *The Cambridge Social History of Britain 1750–1950* , vol. 3 (Cambridge, 1990), pp. 243-310, at 287-92.
8. These would include: Allan Silver's inspirational early essay 'The Demand for Order in Civil Society: A Review of Some Themes in the History of Urban Crime, Police, and Riot', in D. Bordua (ed.), *The Police: Six Sociological Essays* (New York, 1967); David J. V. Jones, 'The New Police, Crime and People in England and Wales 1829-1888', *Transactions of the Royal Historical Society*, 5th Series, vol. 33 (1983), pp. 151-68, and essays in his *Crime, Protest, Community and Police in Nineteenth-Century Britain* (1982); and chapters in important collections of essays - V. A. C. Gatrell, B. Lenman and G. Parker (eds), *Crime and the Law: The Social History of Crime*

in Western Europe since 1500 (1980), V. Bailey (ed.), *Policing and Punishment in Nineteenth-Century Britain* (1981) and D. Hay and F. Snyder (eds), *Policing and Prosecution in Britain 1750–1850* (1989). See also the debate on police origins between Michael Brogden and John Styles, in *British Journal of Criminology*, 27, 1 (1987): M. Brogden, 'The Emergence of the Police: the Colonial Dimension'; J. Styles, 'The Emergence of the Police – Explaining Police Reform in Eighteenth and Nineteenth-Century England'. Brogden emphasizes the influence of British colonial models, Styles the development of the British state and new models of local government. Finally, some contributions by the authors: R. D. Storch, 'The Plague of the Blue Locusts: Police Reform and Popular Resistance in Northern England, 1840–1857', *International Review of Social History*, 20 (1975), pp. 61–90; 'The Policeman as Domestic Missionary: Urban Discipline and Popular Culture in Northern England 1850–1880'; and 'Policing Rural Southern England Before the Police: Opinion and Practice 1830–1856', in Hay and Snyder (eds), *Policing and Prosecution*, pp. 211–66. D. Philips, *Crime and Authority in Victorian England: The Black Country, 1835–1860* (1977), chapter 3; ' "A New Engine of Power and Authority": The Institutionalisation of Law-Enforcement in England 1780–1830', in Gatrell, Lenman and Parker (eds), *Crime and the Law*, pp. 155–89.

9. D. Taylor, *The New Police in Nineteenth-Century England: Crime, Conflict and Control* (Manchester, 1997).
10. In addition to the works already cited, these would include D. Ascoli, *The Queen's Peace: The Origins and Development of the Metropolitan Police, 1829–1979* (1979).
11. As well as some of the works already cited, these would include: J. Field, 'Police, Power and Community in a Provincial English Town: Portsmouth, 1815–1875', in Bailey (ed.), *Policing and Punishment*, pp. 42–64; R. Swift, 'Police Reform in Early Victorian York, 1835–1856', *Borthwick Paper No. 73* (York, 1988); M. Weaver, 'The New Science of Policing: Crime and the Birmingham Police Force, 1839–1842', *Albion*, 26, 2 (1994), pp. 289–308.
12. *Policing the Victorian Community: The Formation of English Provincial Police Forces, 1856–1880* (1984).
13. See n. 6, above.
14. For policing reform in the Welsh counties, see David J. V. Jones, *Crime in Nineteenth-Century Wales* (1992), chapter 7.
15. Essex Record Office Q/SMr 5 Recognisances to Prosecute, Q/S Bb. 459 Depositions, Easter Quarter Sessions.
16. Essex Record Office Q/SPb. 19 Process Book, Q/SMr 5 Recognisances to Prosecute, Q/S Bb. 459 Depositions, Epiphany, Easter & Midsummer Quarter Sessions.
17. Although we shall note (Chapter 2) that there were entrepreneurial constables who did so before rural police reform.
18. Essex Record Office Q/SMr 5 Recognisances to Prosecute, Q/S Bb. 459 Depositions, Epiphany, Easter, Midsummer & Michaelmas Quarter Sessions.
19. Essex Record Office Q/CR 7/1.
20. Evidence about the Essex force is taken from the *First and Second Reports from the Select Committee on Police; with the Minutes of Evidence* PP 1852-3, XXXVI, 1–159, 161–343. The evidence of Captain McHardy, chief

constable of the Essex county constabulary, about his force, is in *First Report*, pp. 46–57, and *Second Report*, pp. 59–61, 95. Other witnesses to this committee who gave evidence about the Essex force were: James Parker, Robert Baker, William Hamilton and Thomas Redin (*First Report*, pp. 60–71, 85–93); James Beadel, John Clayden, William Oakley and N. C. Burnardiston Esq. (*Second Report*, pp.15–16, 35–8, 44–59, 77–81, 93–5).

21. For a recent history of the Essex force, see M. Scollan, *Sworn to Serve: Police in Essex 1840–1990* (1993); chapters 1-6 deal with the force from its foundation in 1840 to the 1860s; Appendix VI lists the 204 men (with their ages, former jobs and birthplaces) who joined the force in 1840 - 40 of those were dismissed and 26 resigned, during 1840. All of the constables appointed had to be under the age of 40.

22. *First Report SC on Police,* p. 55. Other witnesses testified to the merits of the Essex county force: William Hamilton, a former member of the Essex force and now a superintending constable in Buckinghamshire, called it 'a very efficient force' and said 'I consider there is not a more efficient police in England at the present day.' (*First Report*, pp. 67, 70); Thomas Redin, a former member of the Essex force and second-in-command of the Liverpool borough force and now Governor of the County Gaol at Carlisle, said, 'The Essex system worked extremely well; at the commencement there was vast opposition to the force, but it gradually subsided.' (*First Report*, pp.85–6); William Oakley, a former member of the Essex force and now Governor of the Somerset County Gaol, stated that the Essex force was 'the most efficient in England' (*Second Report*, p. 58).

23. *First Report SC on Police,* q. 765, pp. 51–2.

24. A. Silver, 'The Demand for Order', *passim.*

25. An ungainly term, for which we apologize. We mean those government ministers and other politicians of both parties whose field of activity was, principally, London, or who took a broad national view of this and other problems.

26. D. Eastwood, *Government and Community in the English Provinces, 1700–1870* (Basingstoke, 1997), p. 141.

27. See, for example, the brilliant, two-hour, blunderbuss speech of Sir George Grey supporting the compulsory rural police bill of 1856, *HPD*, 3rd Series, 140, 10 March 1856, cols. 2113-45.

28. So, for example, J. J. Tobias, in his *Crime and Industrial Society in the Nineteenth Century* (1967), accepted uncritically everything that Chadwick said, in the Report of the Royal Commission into a Constabulary Force for England and Wales, about the existence and nature of a 'criminal class', and what police authorities themselves had to say about crime and the 'criminal class' without much critical examination of the context, politics, pressure, motives, etc.

29. Cyril D. Robinson, 'Ideology as History: A Look at the Way Some English Police Historians Look at the Police', *Police Studies*, vol. 2, no. 2 (Summer 1979), pp. 35–49. E. P. Thompson, preface to *The Making of the English Working Class* (1963; Pelican 1968), p. 13.

30. E.g. the otherwise useful books of Charles Reith (see n. 2 above), which all took this teleological and rather simplistic approach.

31. Another ungainly term for which we apologize. We mean the landed gentry and the magistrates and Quarter Sessions courts drawn from it.

32. See Chapter 3 for policing initiatives undertaken by provincial gentlemen.
33. PRO HO 73/2/1, 73/3 - letters 1836-9.
34. See Chapter 9.
35. For exemplary discussions of the parish system, the vestry and parish aristocracies see D. Eastwood, *Governing Rural England. Tradition and Transformation in Local Government 1780–1840* (Oxford, 1994), chapter 2 and *Government and Community*, pp. 28-49.
36. Storch, 'The Plague of the Blue Locusts'.
37. A matter interestingly explored in the case of the reform of the Poor Law by P. Mandler, 'The Making of the New Poor Law *Redivivus*', *Past and Present*, 117 (November 1987), pp. 131-57.
38. P. Dunkley, *The Crisis of the Old Poor Law in England, 1795–1834: An Interpretive Essay* (New York, 1982), p. 104; D. Eastwood, *Government and Community*, pp. 109-10; P. Mandler, *Aristocratic Government in the Age of Reform: Whigs and Liberals, 1832-1850* (Oxford, 1990), p. 173.
39. UCL Chadwick MSS, 1733, Russell to Chadwick, 9 October 1836.

Chapter 2

1. J. Kent, *The English Village Constable, 1580–1642* (Oxford, 1986). J. Sharpe, *Crime in Early Modern England, 1550–1750* (1984), chapter 4; *idem.*, 'Policing the Parish in Early Modern England', unpublished paper (1983); *idem.*, 'Enforcing the Law in the Seventeenth-Century English Village', in V. A. C. Gatrell, B. Lenman and G. Parker (eds), *Crime and the Law: The Social History of Crime in Western Europe Since 1500* (1980), chapter 4; *idem.*, 'Crime and Delinquency in an Essex Parish, 1600-1640', in J. Cockburn (ed.), *Crime in England, 1550–1800* (1977), chapter 4; K. Wrightson, 'Two Concepts of Order: Justices, Constables and Jurymen in Seventeenth-Century England', in J. Brewer and J. Styles (eds), *An Ungovernable People. The English and Their Law in the Seventeenth and Eighteenth Centuries* (New Brunswick, NJ, 1980), chapter 1.
2. In the 1840s and 1850s, parish constables became increasingly less important; they were abolished in 1872.
3. Shakespeare's constable in *Much Ado about Nothing* – a byword for inefficiency and shirking.
4. *First Report from the Select Committee on Police*, PP 1852-3, XXXVI, Q.1295, evidence of A. Hughes. The source of this story is somewhat suspect; as a professional policeman, Hughes had a vested interest in discrediting the old constables.
5. PRO HO 73/7/1 Guardians' returns to CFC, Stratton St Michael (Norfolk).
6. PRO HO 73/9/2 Guardians' returns to CFC, Wolborough (Devon).
7. Guardians' returns to CFC, Winkleigh (Devon), PRO HO 73/9/2. From Hadbury (Bucks) it was the same story: 'our two constables keep beershops,' Guardians' returns to CFC, PRO HO 73/7/1. The Parish Constables Act (1842) finally disqualified publicans and beershop keepers from serving.
8. PRO HO/73/9/1 Return of Sheppey Union (Kent) to CFC.
9. We refer here to the genre of nostalgic local histories that began to appear around the 1870s. The authors often portrayed aspects of early nineteenth-century social life in a comical light. They would offer tales of 'parish constable days'. The literature is enormous, but see e.g. R. E. Leader,

Reminiscences of Old Sheffield: Its Streets and Its People (Sheffield, 1876); H. Speight, *Chronicles of Old Bingley* (1876); W. Smith, *Morley, Ancient and Modern* (1886); Anon.[Charles Shaw], *When I Was a Child, by an Old Potter* (1903); J. Freeman, *Black Country Stories and Sketches* (1930).

10. In 1836 the CFC sent queries regarding crime, disorder and police to every petty sessional bench in the country. The returns are in PRO HO 73/5/1 & 2. We count 51.2 per cent. This is based on an analysis of q.6 of the questionnaire which posed a (leading) question regarding inefficiency of local constables. It is probably an underestimate, since in 1836 the over-whelmingly Tory magistracy was inclined to be somewhat cautious in its responses to a Whig-created Royal Commission; one doubts that they offered full candour.

11. PRO HO 73/3 T. Baring to CFC, 28 December 1836, *GC*, 19 October 1839.

12. PRO HO 73/5/2 Returns of Justices of Bromley Division to the CFC. Edwin Chadwick, who drafted the Report of the Royal Commission on a Constabulary Force, used this as a 'Dogberry' story – CFC Report, p. 102.

13. PRO HO 73/5/2 Return of Justices of Bingham Division (Notts.) to CFC.

14. R. W. Jeffery (ed.), *Dyott's Diary, 1781–1845* (1907), p. 199.

15. PRO HO 73/5/2 Return of Justices of Thanet Division (Kent) to CFC.

16. PRO HO 73/9/2 Guardians' returns of St Nicholas and East Budleigh (Devon) parishes to CFC.

17. PRO HO 73/16 Correspondence of W. A. Miles with CFC.

18. On eighteenth-century attempts to energize and mobilize the constables, see J. Innes, 'Politics and Morals. The Reformation of Manners Movement in Later Eighteenth-Century England', in E. Hellmuth (ed.), *The Transformation of Political Culture in England and Germany in the Late Eighteenth Century* (Oxford, 1990), chap. 3, and D. Eastwood, *Governing Rural England. Tradition and Transformation in Local Government, 1780–1840* (Oxford, 1994), pp. 226–7.

19. J. S. Henslow, *Suggestions Towards an Enquiry into the Present Condition of the Labouring Population of Suffolk* (Hadleigh, n.d. [1844]), p. 21. His evidence for this was provided by his own experience as a student and proctor at Cambridge!

20. See discussion of this point in Chapter 7. The Constabulary Force Commission received a bewildering variety of different plans from all over the country. Many were completely at odds with each other regarding the locus of control and command, the proper geographical district for a police, the proper role of the government, and so forth. The Constabulary Force Commission correspondence (PRO HO 73/2-4) is full of querulous exchanges over the details of future professionalization of law enforcement; these often had little in common except a shared desire to replace the old constabulary with something different.

21. Magistrates could only appoint when a serving constable died or moved, or if some other body neglected its responsibilities. They could also 'refuse deputies and, apparently, appoint additional constables' if, in their judgement, an increase in the population warranted it, R. Burn, *The Justice of the Peace and Parish Officer* (1810 edn), I, p. 542.

22. Although not based on a parish-by-parish account, it represents the best, indeed the only, data obtainable for the country as a whole.

23. Data drawn from PRO HO 73/5/1 & 2. In parts of Hampshire and Sussex, leet juries operated what amounted to a rota. See also *Report from His Majesty's Commissioners for Inquiring into the ... Poor Laws* PP, 1834, XXVIII, Reports of Assistant Commissioners, Report of Capt. Chapman, Appendix A, Pt. I, p. 466. Unofficial rotas surely prevailed in more locations than those of which we are aware.

24. *Poor Law Report*, p. 28, and Report of Capt. Pringle, Appendix A, Pt. I, p. 313; Burn, *Justice of the Peace*, p. 539, reported that most authorities allowed that it was good 'since a woman in such case may procure another to serve for her'.

25. PRO HO 73/5/ 1 & 2 Returns of Justices of East and North Ridings of Yorkshire and the Justices of the East Division of Penwith to CFC.

26. PRO HO 73/5/1 Returns of the Justices of the Lewes Division (Sussex), Odiham Division (Hampshire), and Farnham Division (Surrey) to CFC; HO 73/8/1 Return of Guardians, Byfleet parish (Surrey) to CFC. The magistrates of the Ermington and Plympton Division (Devon) reported to the CFC that they were refusing to acknowledge leet constables; this may have been part of a campaign to shift appointments to the vestries (HO 73/5/1). Quotation from Farnham magistrates' clerk in *Second Report of the Commissioners on County Rates* PP (1836), pp. 1–383, Appendix B, pp. 89–90.

27. The Farnham bench, much exercised over leet appointments of unfit and illiterate constables, went on to praise other courts leet in the division for appointing long-serving, 'efficient officers', (PRO HO 73/5/1 Return of Justices of Farnham Division (Surrey) to CFC).

28. *Second Report of the Commissioners on County Rates.*, Appendix, p. 102, communication of Thomas Dyer (emphasis added). For parts of Somerset and Devon, see *Poor Law Report*, Reports of Assistant Commissioners, Report of Capt. Chapman, Appendix A, Pt. I, p. 466.

29. S. A. Peyton (ed.), 'Kettering Vestry Minutes, A.D. 1797–1851' in *Publications of Northamptonshire Record Society*, 6 (1933), pp. x, xxiv–v, 133–4.

30. *WG*, 19 October 1839.

31. Questionnaire filled in by Thomas Ward in PRO Privy Council (henceforth PC) 1/2548. Similar complaints about the quality of leet appointments or the indifference of stewards are in Returns of Justices of Keynsham and Wincanton Divisions (Somerset) and Hinckley Division (Leicestershire) to CFC (PRO HO 73/5/2) and Return of Guardians of Byfleet parish (Surrey) to CFC (PRO HO 73/8/1).

32. PRO PC 1/2547 Lord Radnor to CFC. Col. F. Page reported that in Newbury and Speen (Berkshire) the office was often imposed on people maliciously, or as a lark, UCL Chadwick Papers, item 3/3, Draft of Report on Rural Police as Part of the Poor Law Inquiry.

33. See remarks of two Quarter Sessions chairmen, Lord Wharncliffe (West Riding) and the Earl of Devon (Devon) in *LM*, 12 December 1840 and *WFP*, 24 October 1839. Wharncliffe deplored both vestry and leet appointments, dismissing the latter as 'a remnant of feudalism'.

34. See e.g. PRO HO 73/5/2 Return of Justices of St Albans Division (Hertfordshire) to CFC.

35. See: N. Landau, *The Justices of the Peace, 1679–1760* (Berkeley, 1984); D. Eastwood, *Governing Rural England*, chapters 3, 4. For recent attempts to

push back the date of origin of these developments to the seventeenth century, see M. Braddick, 'State Formation and Social Change in England: A Problem Stated and Approaches Suggested', *Social History*, 16, 1 (January 1991) pp. 1–17 and J. Kent, 'The Centre and the Localities: State Formation and Parish Government in England, Circa 1640–1740', *Historical Journal*, 38, 2 (1995), p. 3.

36. See e.g. C. D. Brereton, *The Subordinate Magistracy and the Parish System Considered* (Norwich, n.d. [1827]), a violent denunciation of the encroachment of the magistrates on the parish and its officers.

37. These conservative reform ideas were embodied in the Parish Constables Acts of 1842 and 1850, which effectively ended the role of courts leet and vestries in counties without rural police forces – see Chapter 9.

38. The constables of Tiddenham and St Arvans, just inside Monmouthshire, were given 12s. a year at Tiddenham; one guinea at St Arvans 'for serving the office'. The constable and borsholder of Lydden (Kent) received £3 and 30s. respectively (I. Waters, *Chepstow Parish Records* (Chepstow, 1955), p. 87; C. Buckingham, *Lydden. A Parish History* (Dover, 1967), p. 68). In 1833 Kettering compounded for most of the fees the men would have earned, paying each of its two constables £12-10s. per annum plus fees for collecting the county rate and, presumably, private payments (*Kettering Vestry Minutes*, p. 130).

39. In towns with proactive constables, informing constables could rely on portions of fines levied in misdemeanour cases. William Smith, a Cheshire entrepreneurial constable, who boasted of looking 'for things to pull people up upon', got a moiety of the fines for furious driving, riding on cart shafts, etc. (PRO HO 73/16 Correspondence of W. A. Miles with CFC 1837, interviews with Joseph Barlow, Jonathan Greenwood and William Smith).

40. UCL Chadwick Papers, item 13, Evidence Taken by the Constabulary Force Commissioners, printed but unpublished, p. 29, testimony of E. Price. The Buckinghamshire justice, William Swabey, spoke of constables' dread of drawn-out preliminary examinations in the absence of guarantees (PRO HO 73/5/2. Return of Justices of Newport Pagnell (Bucks.) Division).

41. Kent Record Office, Q/GPa1 Returns of Peace Officers (1832); Essex Record Office, Q/CR 7/1.

42. Kent Record Office, Q/GPa1 Return of Peace Officers (1832), Nonington parish; PRO HO 73/6/1 Return of Guardians of Morchard Bishop (Devon) to CFC.

43. S. Rayner, *The History and Antiquities of Pudsey* (1887), p. 145.

44. On the complexity of the laws governing recovery of compensation from the county, see D. Philips, *Crime and Authority in Victorian England. The Black Country, 1835–1860* (1977), pp. 111–16.

45. See D. Philips, 'Good Men to Associate and Bad Men to Conspire: Associations for the Prosecution of Felons in England, 1760–1860', in D. Hay and F. Snyder (eds), *Policing and Prosecution in Britain, 1750–1850* (Oxford, 1989), pp. 113–70, at p. 147.

46. For a discussion of this crisis, see Chapter 3.

47. Kent, *English Village Constable*, pp. 82, 88, 221.

48. *Ibid.*, p. 22.

49. See, e.g., a Suffolk vicar's admiring assessment of his parish constable, a farmer, assessor, 'a man of power and authority', in R. Fletcher (ed.),

Biography of a Victorian Village. Richard Cobbold's Account of Wortham, Suffolk, 1860 (1977), p. 100.

50. J. Gyford, 'Men of Bad Character. Property Crime in Essex in the 1820s', unpublished MA thesis, Essex University (1982), fig. 19, no pagination.

51. P. King, 'Resources Available to Victims', unpublished manuscript, pp. 41-2. We are grateful to Peter King for permission to cite this work.

52. See more complete data for Staffordshire, 1843-8, in Philips, *Crime and Authority*, p. 63. The picture broadly resembles that in Surrey. The period beginning in 1842 might have seen a rise in the status of constables in counties without police forces, as the leets and vestries no longer had the exclusive power to appoint them.

53. Eastwood, *Governing Rural England*, p. 192.

54. PRO HO 73/5/2 Return of Justices of Bassetlaw (Nottinghamshire) to CFC.

55. See e.g. PRO HO 73/5/1 & 2 Returns of Justices of Wraggoe Division (Lincolnshire) and Churbury Division (Shropshire) to CFC.

56. In 1829, 13 to 17 per cent of constables in the Witham Division (Essex) were labourers (Gyford, 'Men of Bad Character', fig. 19, no pagination). W. H. S. Stanley claimed that before Hampshire adopted the rural police in 1840, 'a great number of them [constables] were labourers' (*First Report from the Select Committee on Police*, PP 1852-3, XXXVI, pp. 1-159, p. 22, Q. 281. The Hampshire justices' reports of 1836 confirm this. In Hampshire, labourers were appointed as both principals and substitutes.

57. PRO HO 73/6/2 Return of Guardian of Potsgrove (Bedfordshire) parish to CFC. See also HO 73/7/1 Returns to CFC of Guardians of Bledlow (Buckinghamshire); HO 73/6/1 Cooling (Kent); , HO 73/9/1 Worth (Kent); HO 73/6/1 Coleshill and Fernham (Berkshire); HO 73/6/2 Suttonwick (Berkshire); HO 73/9/1 Sayer Brereton (Essex), and HO 73/9/2 Chulmleigh (Devon).

58. Based on justices' returns to CFC for these counties, in PRO HO 73/5/1 & 2.

59. See e.g. PRO HO 73/7/2 Return of Stroud (Gloucestershire) Poor Law Union to CFC.

60. *CC*, 29 November 1839, William Shaen JP. Similar sentiments were expressed in the Return of Justices of Strafforth and Tickhill Division (West Riding) to CFC (PRO HO 73/5/1). The justices of the Thanet Division (Kent) suggested that there was a trade-off between activity and respectability; their entrepreneurial constables might drink and connive, but did not keep out of the way when there was work to be done (PRO HO 73/5/2).

61. PRO HO 73/7/1 Return of Guardians of Tivetshall St Margaret parish (Norfolk) to CFC.

62. Essex Record Office, Q/CR7/2 Return of Peace Officers (1832).

63. PRO HO 73/8/1 Return of Dorking (Surrey) Poor Law Union to CFC; HO 73/5/1 Return of Justices of Everly and Pewsey Division (Wiltshire) to CFC.

64. As was the case in Cliffe Pipard, where marginal tradesmen were appointed to keep them from falling into pauperism (Return of Guardian of Cliffe Pipard parish (Wiltshire) to CFC, PRO HO 73/8/1).

65. PRO HO 73/5/1 & 2 Returns of Justices of Copthorne and Effingham Division (Surrey) and Pershore Division (Worcestershire) to CFC.

66. See Philips, *Crime and Authority*, chapters 3 and 4.

67. Taking the example of one county, Hertfordshire, by the end of the 1830s, had police under a variety of such schemes at King's Langley, Cheshunt,

Barnet, Royston, Hemel Hempstead and a group of parishes northwest of Bishop's Stortford. The Hemel Hempstead force, of a sergeant and two constables in Metropolitan-style uniforms, was set up under the Lighting and Watching Act in 1837 (Hertfordshire County Record Office QSCB 32, Quarter Sessions Survey of Parishes on Crime and Police, 1839).

68. Gyford, 'Men of Bad Character', p. 21.

69. *WGS*, 8 October 1839.

70. UCL Chadwick Papers, item 13, Evidence Taken by the Constabulary Force Commissioners, printed but unpublished, p.1, testimony of T. Spencer; cf. the remarks of the justices of the Prescot Division (Lancashire) to CFC: constables 'absent themselves' to avoid loss of time and trouble, so that 'apprehension falls generally on the victim', (PRO HO 73/5/2).

71. By this time some magistrates were protesting against having to sally forth *in person* to confront, pursue and secure rural rioters. This had been one of the oldest duties of the magistracy, taken for granted and constituting a badge of honour. On their obligation to do so see R. Vogler, *Reading the Riot Act. The Magistracy, the Police and the Army in Civil Disorder* (Milton Keynes, 1991), pp. 1-12. Military men held in high esteem justices who had the physical courage to face down mobs (W. Napier, *The Life and Opinions of General Sir Charles James Napier*, II (1857), p. 64). Nonetheless, during the 'Captain Swing' outbreak in Norfolk in 1830, Lord Wodehouse had been outraged that he had to 'take these men from the houses and hedges where they were secreted ... He would ask was it right that ... the Lord Lieutenant of the county should be obliged to act as a policeman ...?', *NC*, 30 November 1839.

72. See D. Philips, ' "A New Engine of Power and Authority": The Institutionalization of Law-Enforcement in England, 1780-1830', in V. A. C. Gatrell *et al.* (eds), *Crime and the Law*, chapter 6.

73. Compounding a felony is the settlement of a crime in return for a monetary payment or return of stolen property, and was itself a crime. On the limited circumstances in which compromise could be tolerated see *Russell on Crimes* (1843), I, p. 132. For recent discussions, see Philips, *Crime and Authority*, pp. 62 and 91 n. 42; and D. Hay and F. Snyder, 'Using the Criminal Law, 1750-1850. Policing, Private Prosecution and the State', in Hay and Snyder (eds), *Policing and Prosecution*, p. 38.

74. Described by the Justices of the Prescot Division (Lancashire) to CFC (PRO HO 73/5/2). See the Dorset example given in R. Storch, 'Policing Rural Southern England Before the Police: Opinion and Practice, 1830-1856', in Hay and Snyder (eds), *Policing and Prosecution*, pp. 225-6.

75. PRO HO 73/16 Correspondence of W. A. Miles with CFC (1837), Interviews with J. Barlow, J. Greenwood and W. Smith. His principals, two tradesmen, believed that Smith 'was always ready to screen or inform according to the amount he could obtain' and 'would compound a case for a glass of gin'. A similar character was Haddon, the assistant constable of Nuneaton. He too acted as an intermediary between 'bad characters' and victims to 'make matters up'. He was accused of being employed by 'the friends of predators', and like Smith, of being a drunkard, PRO HO 73/8/1, Return of Guardian of Nuneaton to CFC.

76. PRO HO 73/7/2 Return of Guardian of Watlington (Norfolk) to CFC; HO 73/3 E. Aitchison to Chadwick, 3 December 1836. The officious constable

was a perennially unpopular figure (Kent, *English Village Constable*, p. 256).

77. PRO HO 73/5/2 Return of Justices of Longtree Hundred (Glos.) to CFC.
78. This was not new. Seventeenth-century constables interfering at pubs, with maypoles, Sunday observance and so forth were often reviled and/or assaulted (Kent, *English Village Constable*, pp. 255-9).
79. PRO HO 73/5/1 Return of Justices of Cosford Division (Suffolk) to CFC.
80. PRO HO 73/5/2 Return of Justices of Repton Division (Derbyshire) to CFC.
81. *MG*, 3 November 1840 (E. R. Rice JP). The guardian of a Buckinghamshire parish complained: 'the constable of Wendover ... has had a warrant to apprehend Stephen Brandon about twelve months ... and has not apprehended him ... although he sees him often' (PRO HO 73/7/1 Return of guardian of Halton parish (Bucks.) to CFC). The reason for his reluctance in this case was intimidation, not friendship.
82. PRO HO 73/5/2 Return of Justices of Bassetlaw Division (Nottinghamshire) to CFC.
83. PRO HO 73/5/1 Return of Justices of Teignbridge Division (Devon) to CFC; cf. HO 73/5/2 Returns of Justices of Warwick Division and Eskdale Division (Cumberland) to CFC.
84. A Surrey magistrate believed that there was no book within the means of constables - Chitty at £5 being the cheapest, 'and of course totally out of their reach ... it is hard to punish a man for neglect of duty without giving him any means to learn it' (*Second Report of the Commissioners on County Rates* (1836), communication of Thomas Dyer, Appendix, p. 102). In one Nottinghamshire division, a handbook had once been provided, but retrenchment had stopped the practice some years back (1836) (PRO HO 73/5/2 Return of Justices of Newark Division (Nottinghamshire) to CFC). See also UCL Chadwick Papers, item 13, Evidence Taken by the Constabulary Force Commissioners, printed but unpublished, p. 28, testimony of E. Price. One handbook was Joseph Ritson, *The Office of Constable* ... (2nd edn, 1815). What circulation it had among constables is hard to say; it was far from clear and simple.
85. J. Chitty, *A Practical Treatise on the Criminal Law* (1816), I, p. 23.
86. Clearly the constable did not wish to risk his life over a mere poaching dispute. See PRO HO 73/5/2 Return of Justices of Ampthill (Bedfordshire) to CFC.
87. PRO HO 73/5/1 Return of Justices of Copthorne and Effingham Division (Surrey) to CFC. On threats against constables and actual bodily harm see C. Emsley, *Crime and Society in England, 1750–1900*, (2nd edn, 1996), pp. 217-18, and R. A. E. Wells, 'Sheep Rustling in Yorkshire in the Age of the Industrial and Agricultural Revolutions', *Northern History*, 20 (1984), pp. 139-40. Constables on the south and east coasts could leave confrontations with smugglers, who - like large-scale livestock thieves - could be quite violent, to the Excise and Coast Guard.
88. *MG*, 3 April 1840 (W. O. Hammond JP).
89. Russell thought it settled that constables had no power to arrest without a warrant for affray out of their sight (*Russell on Crimes*, I, p. 295).
90. PRO HO 73/5/2 Return of Justices of Prescot Division (Lancashire) to CFC. See also the two Staffordshire scandals involving parish constables chaining up prisoners in their own homes (Philips, *Crime and Authority*, pp. 61, 91, n. 40).

91. Chitty, *Practical Treatise*, p. 23.
92. Philips, *Crime and Authority*, p. 113.
93. *Second Report of Commissioners on County Rates*, p. 12. The parish then refused to pay. When the magistrates showed great zeal (as in a murder case) and presided over a search, they sometimes paid considerable sums if there was no arrest and commitment. Conscientious justices would occasionally pay a constable out of their own pockets if 'he scrupled to execute the warrant' and 'had no one to look to for reimbursement' (*ibid.*, p. 13).
94. A 1782 case, *Blatcher* v. *Kemp*, established that a constable was guilty of trespass for entering a suspect's home. Although he had a warrant, and was the closest constable to the residence of the suspect, he acted in a parish and hundred other than his own. Although the warrant was directed to the constable of Shipborne, it was also directed to 'all other officers of the peace in the county of Kent'. The constable argued that he therefore came within the warrant, but a judge ruled against him. See Burn, *Justice of the Peace*, pp. 546-7. In the 1830s, justices were still complaining that constables were unwilling to act outside their parishes, although presumably legislation of 1824 (5 Geo. IV c. 18) had removed the difficulties. There were other reasons, relating to constables' fears of losing money and time on long journeys, as well. On a day-to-day basis, all sorts of irregularities were probably unwittingly engaged in and probably winked at by justices (when they came to their knowledge) if not too serious.
95. Burn, *Justice of the Peace*, p. 548; L. Radzinowicz, *A History of English Criminal Law*, vol. 3 (1956), p. 83.
96. Chitty, *Practical Treatise*, p. 50.
97. Chapter 3.
98. See Philips, *Crime and Authority*, pp. 59-63.
99. PRO HO 73/5/1 Return of Justices of Chippenham Division (Wiltshire) to CFC; the justices of the Rydur Division (Cornwall) made a similar estimate (HO 73/5/2).
100. E.g. at Calne (Wiltshire), where the constable got £6 per annum. The rest was piecework, and depended on how enterprising he was willing to be.
101. PRO HO 73/5/2 Return of Justices of South Division of Yarborough (Lincolnshire) to CFC. Occasionally the salary represented a compounding between the constable and appointing authority for the former's bills (*Kettering Vestry Minutes*, pp. xxiv, 130).
102. PRO HO 73/5/1 Return of Justices of Wallingford Division (Surrey) to CFC.
103. But not uniquely. The most efficient constable, stated the Crediton (Devon) justices, 'was also the Assistant Overseer of the Poor'. The practice was also reported in Derbyshire and Cornwall. PRO HO 73/5/1 & 2 Returns of Justices of Crediton Division, Smalley Division (Derbyshire), West Kirrier Division (Cornwall) to CFC.
104. *WG*, 19 October 1839. Craig's plight was pointed to by the chairman of Quarter Sessions as a reason for the county to adopt the County Police Act and establish a regular system of police.
105. *WG*, 19 October 1839. Craig and King were well regarded by the justices, and were later made superintendents in the new county police force - see Emsley, *Crime and Society*, p. 229.
106. PRO HO 73/5/1 Return of Justices of Strafforth and Tickhill Division (West Riding) to CFC; likewise, HO 73/5/2 Atherstone Division (Warwickshire).

The West Ham (Essex) prosecution society paid John Wright, the long-serving constable of Stratford, two guineas a year for ten years until he died (Philips, 'Good Men to Associate', p. 147).

107. PRO HO 73/5/1 & 2 Returns of Justices to CFC of North Division of Yarborough, Horncastle and Kirton and Skirbeck Divisions (Lincolnshire), Drayton Division (Shropshire), Braunton Division (Devon), Castleford Division – referring to Knottingley constable – (West Riding).

108. PRO HO 73/5/2 Return of Justices of Allerdale Above Derwent Division (Cumberland) to CFC.

109. PRO HO 73/5/1 Return of Justices of Wallington Division (Surrey) to CFC. The men were armed at night.

110. B. J. Davey, *Lawless and Immoral: Policing in a Country Town* (Leicester, 1983). For a fuller exploration of this topic, see Chapter 5.

111. The hired deputy constable of Halifax in the 1760s was involved – seemingly along with everyone else – in the coining trade – see J. Styles, 'Our Traitorous Money Makers: The Yorkshire Coiners and the Law, 1760–83', in Brewer and Styles (eds), *An Ungovernable People*, p. 200.

112. PRO HO 73/5/2 Return of Justices of Kirkdale Division (Lancashire) to CFC. They reported 18 township constables and 48 paid assistants in the division. They commended this system and recommended that townships combine for police purposes, presumably to create little district forces.

113. PRO HO 73/5/2 Return of Justices of Leyland Division (Lancashire) to CFC. The constable was of the standing or perpetual type, as was his predecessor, who served for fourteen years.

114. PRO HO 73/5/2 Return of Justices of Part of Higher Division of Blackburn to CFC. Compare Halifax, where two 'honorary constables' were appointed by the leet of the Duke of Leeds. The duty was performed by deputies (J. Crabtree, *A Concise History of the Parish and Vicarage of Halifax in the County of York* (Halifax, 1836), p. 18, and PRO HO 73/51 Return of Justices of West Morley Division (West Riding) to CFC). The magistrates referred to them as 'chief constables'.

115. PRO HO 73/5/1 Return of Justices of Agbrigg Division (West Riding) to CFC. At Barnsley, the chief deputy received a salary and the three assistants got all the income from serving process, etc. (PRO HO 73/5/1 Return of Justices of Staincross Division (West Riding) to CFC).

116. PRO HO 73/5/1 Return of Justices of Agbrigg Division (West Riding) to CFC; J. W. Walker, *Wakefield. Its History and People* (1934), pp. 407–9, 471–2.

117. PRO HO 73/5/1 Return of Justices of Agbrigg Division (West Riding) to CFC; D. F. E. Sykes, *The History of Huddersfield and Its Vicinity* (Huddersfield, 1898), pp. 384–94; R. Brook, *The Story of Huddersfield* (1968), pp. 113–14.

118. PRO HO 73/5/1 Return of Justices of Upper Strafforth and Tickhill Division to CFC; Leader, *Reminiscences of Old Sheffield*, p. 113.

119. PRO HO 73/5/1 Return of Justices of Skyrack Division (West Riding) to CFC.

120. These debates are reported in detail in the *LM* and *LI* for April and September 1840 and January and April 1841. See Chapter 8.

121. A classic (but not typical) example of the politicization of policing was Oldham (Lancs.), where the Radical capture of the vestry led to: the revival

of the authority of the Salford Court Leet; the rejection of the leet constables' accounts by the vestry; the creation of an unelected Police Commission, and its eventual takeover by the Radicals. This struggle lasted for decades. The Radicals' objects were to secure constables who would refrain from interfering with political meetings, and deny control of the police to the Tory county magistrates. After the *County Police Acts* (1839–40), Oldham was incorporated. See J. Foster, *Class Struggle and the Industrial Revolution* (1974), pp. 56–61, and J. Vernon, *Politics and the People. A Study in English Political Culture, c. 1815–1867* (Cambridge, 1993), pp. 27–9, 194–7.

122. PRO HO 73/3 Letter of Constables of Halifax to Captain Williams, n.d. [1830s]; P. Taylor, *Popular Politics in Early Industrial Britain: Bolton 1825–1850* (Keele, 1995), pp. 29–30. In general, see E. Midwinter, *Social Administration in Lancashire, 1830–1860* (Manchester, 1969), pp. 136–8.

123. John Beattie has concluded provisionally that this was the case for the constables of the City of London. We are grateful to him for showing us some work in progress. Kent, *English Village Constable*, found little trace of substitution in the seventeenth century, although it occasionally occurred. Emsley, *Crime and Society*, p. 218, reminds us that Elbow in *Measure for Measure* was a substitute.

124. For example, in the West Manley hundred of Lincolnshire respectable small farmers served, but used other small farmers and 'the better sort of labourers' as assistants. The latter did most of the work, but the appointed constable acted with them 'in cases of need'. (PRO HO 73/5/2 Return of Justices of West Manley to CFC.)

125. Burn, *Justice of the Peace*, gives a resumé of cases on this question, pp. 541–2.

126. Or so Sir Thomas Baring complained about the Winchester Division of Hampshire (PRO HO 73/3, Baring to CFC, 28 December 1836). When Kettering decided to appoint a 'standing constable', the vestry actually took tenders (*Kettering Vestry Minutes*, p. 134).

127. PRO HO 73/5/2 Return of Justices of Shepton Mallet (Somerset) to CFC.

128. See the complimentary remarks of the Justices of Lower Division of Bramber Rape (Sussex) to CFC, PRO HO 73/5/1.

129. E.g. the remarkable Cheshire deputy William Smith referred to above. Smith was not only constable, but also crier, beadle and market toll collector.

130. P. Colquhoun, *A Treatise on the Functions and Duties of a Constable …* (1803), p. 78 (emphasis in original).

131. *Ibid.*, pp. xiv–xv.

132. Kent County Record Office, Q/GPa1 Return of Peace Officers (1832).

133. Essex County Record Office, Q/CR7/2 Return of Peace Officers (1832). For a sampling of other locations, see PRO HO 73/5/1: Returns to CFC of Justices of Keynsham, Ilminster and Bedminister Divisions (Somerset), Roborough Division (Devon); and PRO HO 73/5/2: Bisley and Longtree Divisions (Gloucestershire), Tonbridge, South Aylsford, Lower Scray and Thanet Divisions (Kent), and Smalley Division (Derbyshire).

134. On these men see C. Emsley, *The English Police: A Political and Social History* (2nd edn, 1996), p. 34; Waters, *Chepstow Parish Records*, p. 87; Leader, *Reminiscences of Old Sheffield*, p. 113; Speight, *Chronicles of Old Bingley*, p. 259; returns of Justices of Dudley Division (Worcestershire) to CFC, PRO HO 73/5/2.

135. Gyford, 'Men of Bad Character', p. 81; PRO HO 73/8/1 Return of Patrington Poor Law Union (East Riding) to CFC.
136. See the published plan of Warden of Bedford – J. H. Warden, *These Few Observations on the Necessity of a Permanent County Police* ... (1822).
137. Smith, *Morley*, p. 55.
138. Shaw, *When I Was a Child*, pp. 31-2. There are similar descriptions of the constables of the Staffordshire Black Country towns of Darlaston (W. Derrincourt, *Old Convict Days* (1899)) and Bilston (J. Freeman, *Black Country Stories and Sketches* (1930)). William Bland of Sheffield was of the same type (Leader, *Reminiscences* p. 113).
139. Smith, *Morley*, p. 55. In 1839, parish constables near Lancaster were sent to stop the navvies, who were building the Lancaster-Preston railway, from stealing food and sexually assaulting the servant girl at a local inn. But 'they could do nothing against so many but remonstrate', and the navvies ignored them (*MGu*, 27 March 1839). Staffordshire magistrates, faced with a similar situation in 1838, swore in special constables (Staffordshire County Record Office, Q/S Bm 24 Leicestershire Clerk of the Peace to Staffordshire Clerk of the Peace, 15 March 1838). Charles Shaw recalled that when the Tunstall constable tried to stop colliers smashing colliery machinery during the 'Plug Plot' strike of 1842, they half-drowned him in a pit of water (*When I Was a Child*, pp. 32-3).
140. PRO HO 73/8/1 Return of Patrington Poor Law Union to CFC.
141. PRO HO 73/5/1 Return of Justice of Alton Division (Hampshire) to CFC.
142. UCL Chadwick Papers, item 3/3, notes by W. A. Miles.
143. PRO HO 73/5/1 Return of Justices of Castleford Division (West Riding) to CFC. Corruption can lie in the eye of the beholder. The constable, no doubt, regarded what he took as his legitimate fee for breaking up a disturbance. The job was often on 'piecework', after all.
144. The justices of the Strafford and Tickhill Division (West Riding) remarked that the township deputies were dissolute, but showed great activity (PRO HO 73/5/1 Return to CFC); cf. Return of Justices of Thanet Division (Kent) to CFC, PRO HO 73/5/2. The superintendent of Blofield, a salaried man and former Metropolitan policeman, was refused transfer to the new Norfolk Constabulary on the grounds that, although a brave man, he was 'a perfect bully'. The local bench backed him to the utmost of their exertions (Storch, 'Policing Rural Southern England Before the Police', p. 232).
145. East Sussex County Record Office, Q AC/1/E1 Unsigned memo by a justice to East Sussex Quarter Sessions (1839); cf. Returns of Justices of Cuttleston Division (Staffordshire), PRO HO 73/5/1 and Rydur Division (Cornwall) PRO HO 73/5/2.
146. *Royal Commission on the Poor Laws*, Report of C. H. Maclean, Appendix A, p. 579.
147. They were also sometimes called 'riding' or 'special' constables depending on the region. They should not be confused with the special constables who were sworn in temporarily in times of disorder.
148. See, e.g., PRO HO 73/5 1 & 2 Returns of Justices to CFC of Winstree and Lexden Half of Colchester Division (Essex), Broxash Division, (Herefordshire), Skyrack and Strafforth and Tickhill Divisions, (West Riding), Chichester Division (Sussex), Retford, Newark and Bingham Divisions (Nottinghamshire), Whitchurch Division (Shropshire), Howdenshire Div-

ision (East Riding), Rydur Division (Cornwall), Stourbridge Division (Worcestershire), Kingsclere Division (Hampshire), Woodbridge Division (Suffolk), Newport Pagnell Division (Buckinghamshire).

149. PRO HO 73/5/1 Return of Justices of Whitchurch Division of Bradford (Shropshire) to CFC.

150. See *Shropshire Abstracts of Quarter Sessions Orders* (1837), p. 314; *SC*, 20 October 1837. For a discussion of Shropshire's policing reform initiatives in the 1830s, see Chapter 5.

151. See discussion at Dorset Quarter Sessions on these defects. Appointment of special constables was recommended to remedy this '*casus omissus*', *WFP*, 15 April 1839.

152. The magistrates of the Skyrack Division (West Riding) stated that after the appointment of a 'riding constable' the ordinary constables were appointed as before but 'relieved of duty' (PRO HO 73/5/1).

153. Innes, 'Politics and Morals', pp. 69, 78, 114. See also Eastwood, *Governing Rural England*, p. 227.

154. P. Colquhoun, *Treatise on the Functions of a Constable* (1803), p. 77. For the Police Revenue Bill, see Chapter 4.

155. R. Paley, ' "An Imperfect, Inadequate and Wretched System?" Policing London Before Peel', *Criminal Justice History* (1989), pp. 95–130; J. Beattie, *Crime and the Courts in England, 1660–1800* (Princeton, 1986), pp. 71–2; Philips, *Crime and Authority*, pp. 59–63.

156. Peter King has noted the active entrepreneurial constables in southwest Essex, near London ('Resources Available to Victims', pp. 50–1). William Robertson (*Old and New Rochdale and Its People* (Rochdale, 1881), pp. 96–9) spoke of the appointment of a 'superior class of men' in the 1830s; Leader (*Reminiscences of Old Sheffield*, pp. 112–14) spoke of the constables and assistants of the 1830s with respect. Both contrasted them with their turn-of-the-century predecessors, portrayed as drunken buffoons and the butts of practical jokes.

157. Storch, 'Policing Rural Southern England', *passim*.

Chapter 3

1. R. W. Jeffery (ed.), *Dyott's Diary 1781-1845*, II (1907), p. 242.
2. *CC*, 29 November 1839.
3. The Revd T. Spencer, *The Successful Application of the New Poor Law to the Parish of Hinton Charterhouse* (1836), pp. 6-7.
4. See Chapter 5 for the Cheshire and Shropshire initiatives.
5. The Tory clerical magistrate, the Revd F. E. Witts, recorded discussions on ways and means of creating rural police forces with his Quarter Sessions chairman and other Gloucestershire gentlemen, MS Diary of the Revd F. E. Witts, entries for 5 December 1834, 14 November 1836. Witts was in touch with Cheshire gentlemen regarding details of the Cheshire Constabulary, entry 9 September 1835. A similar type, the Revd Stephen Clissold, was consulting with individuals in other Suffolk hundreds about a rural police at the same time (PRO HO 73/2/1 J. Day to E. Chadwick, 5 January 1835). The Vicar of Watford in Hertfordshire kept in touch with gentlemen in Somerset and Norfolk on this subject, and with the Home Office (UCL Chadwick Papers, item 1573 W. Capel to S. M. Phillips, 14 March 1838;

PRO HO 73/2/1 W. Capel to Lord John Russell, 25 February 1839). Such men were instrumental in shaping gentry opinion in their counties. In Hampshire, potent individuals such as Charles Shaw Lefevre and the Duke of Wellington played key roles in this regard (R. Foster 'Wellington and Local Government', in N. Gash (ed.), *Wellington. Studies in the Military and Political Career of the First Duke of Wellington* (Manchester, 1990), pp. 215–37).

6. Most accounts concentrate, however, on the initiatives of government and well-known police reformers. An exception is A. Brundage 'Ministers, Magistrates and Reformers: The Genesis of the Rural Constabulary Act of 1839', *Parliamentary History,* 5 (1986), pp. 55–64.

7. R. Foster, *The Politics of County Power. Wellington and the Hampshire Gentlemen, 1820–52* (1990) considers that their dominance of the institutions of state were grounded in their control of local affairs, p. 105.

8. How could the County Police Acts (1839-40) have passed through Parliament unless the principles embodied in them had been made palatable to a considerable bloc of the justices and squires who were connected by interest, friendship or blood to MPs?

9. This important point was first made by the late D. J. V. Jones, 'The New Police, Crime and People in England and Wales, 1829-1888', *Transactions of the Royal Historical Society,* 5th Series, 33 (1983). pp. 151-68, p. 158. The right circumstances, as we shall see, were: assurances that there would be no government police and no stipendiary magistrates.

10. See R. Storch, 'Policing Rural Southern England Before the Police: Opinion and Practice, 1830-1856', in D. Hay and F. Snyder (eds), *Policing and Prosecution in Britain 1750–1850* (Oxford, 1989), pp. 211-66; and Chapter 5.

11. Even where the County Police Acts (1839-40) were voted down by Quarter Sessions, margins of defeat were sometimes small. In Berkshire, 37 per cent of the justices voted for it; in Derbyshire nearly 50 per cent; in Kent 44 per cent; in West Suffolk 43 per cent; in the West Riding 43 per cent. These were healthy minorities, bespeaking the progress reform ideas had made among the gentry in the recent past.

12. E.g. the Earl of Derby (Lancs.), the Duke of Wellington (Hants.), the Duke of Richmond (West Sussex) and Lord Wodehouse (Norfolk).

13. In the parallel context of the rethinking of the Poor Laws by the gentry, Mandler calls this group an 'elite within the landed elite', and 'the political cream of the landed elite', P. Mandler's contribution to 'Debate: The Making of the New Poor Law *Redivivus*', *Past and Present,* 127 (May 1990), p. 198.

14. The phrase is Peter Mandler's, 'The Making of the New Poor Law *Redivivus*', *Past and Present,* 117 (November 1987), p. 140.

15. See Chapters 7 and 8.

16. Even members of this group conceded the inefficiency of the constabulary, but said it could be rendered efficient by better pay and greater subordination to magisterial control.

17. See discussion of the Parish Constables Act (1842) in Chapter 9.

18. R. Wells remarks that in parts of the South the crisis not only affected farmers and labourers. The ranks of rural tradesmen with a 'plebeian clientele' were hard hit. The crisis was truly general, 'Social Protest, Class,

Conflict and Consciousness in the English Countryside 1700–1880', in M. Reed and R. Wells (eds), *Class, Conflict and Protest in the English Countryside, 1700–1880* (1990), p. 130.

19. Relations between the gentry and farmers deteriorated. In East Anglia an independent farmer political movement emerged, W. H. Apfel, 'Crisis in a Rural Society, 1790-1830: Social change and Class Relations in Norfolk, England', Unpublished Ph.D. thesis, Brown University (1984), chapter 9. On the struggle between these elements over allotments see J. Archer, 'The Nineteenth-Century Allotment: Half an Acre and a Row', *Economic History Review*, L, 1 (1997), pp. 21-36.

20. P. Dunkley characterizes this period as experiencing 'the breakdown of social cohesion in the English countryside', *The Crisis of the Old Poor Law in England, 1795–1834* (New York, 1982), p. iv, and a 'spectacular social crisis', 'Whigs and Paupers: The Reform of the English Poor Laws, 1830-1834', *Journal of British Studies*, XX, 2 (Spring 1981), p. 145. These works explore the fraying of paternalism, the ambivalence of the gentry and the disorientation of the labourers. Archer, 'Half an Acre . . .' *passim*, discusses an attempt to re-found paternalistic relations between the gentry and labourers.

21. See P. Harling, 'The Power of Persuasion: Central Authority, Local Bureaucracy and the New Poor Law', *English Historical Review*, 422 (January, 1992), pp. 30-53.

22. The literature is immense, but see P. Dunkley, 'Paternalism, the Magistracy and Poor Relief in England, 1795-1834', *International Review of Social History*, XXIV, 3 (1979), pp. 371-97, and W. Apfel and P. Dunkley, 'English Rural Society and the New Poor Law: Bedfordshire, 1834-47', *Social History*, X, 1 (January 1985), pp. 37-68. Mandler, 'Making of the New Poor Law *Redivivus*' . . .' claims that they were happy to be relieved of these responsibilities and turned more narrowly to discharging their duties regarding law and order, pp. 156-7. D. Eastwood views them as reluctantly acquiescing after 'Captain Swing' demonstrated the 'bankruptcy of the gentry's own brand of reformism', in 'Debate: The Making of the New Poor Law *Redivivus*', *Past and Present*, 127 (May 1990), p. 193.

23. See D. Philips and R. D. Storch, 'Whigs and Coppers: The Grey Ministry's National Police Scheme, 1832', *Historical Research*, vol. 67, no. 162 (1994), pp. 75-90.

24. And had done so for quite a long time. Mid-eighteenth-century magistrates observed that they were usually paralysed with fear in such situations. Or, alternatively, they 'were the very persons who appeared at the head of the mob', A. J. P. (1757) quoted in T. Hayter, *The Army and the Crowd in Mid-Georgian England* (Totowa, NJ, 1978) p. 19; also p. 101 for other instances of constables leading eighteenth-century riots.

25. Maj. General Sir R. Jackson detailed precisely where in northern England he considered the army the first line and where the last: letters to Under-Secretary of State, S. March Phillips, 5, 9, 12 December 1838, *The Times*, 4 February 1839. On the role of the military in the maintenance of order in this period, see F. C. Mather, *Public Order in the Age of the Chartists*, (Manchester, 1959), chapter V.

26. Russell to Earl of Derby, 11 January, 1839, *The Times*, 29 January 1839. The army never forgot the lesson of the 1831 Bristol Riots. The field commander

committed suicide while awaiting court martial for failing to use deadly force soon enough. See C. Townshend, *Making the Peace. Public Order and Public Security in Modern Britain* (Oxford, 1993), pp. 17–18.

27. See, e.g., W. Napier, *The Life and Opinions of General Sir Charles James Napier, G.C.B.*, 2 (1857). Napier, a Radical, thought a police would do no good in the long run, but 'it is good for me ... by placing a strong body between the soldiers and the crowd', p. 54. Like all field commanders he hated to see troops used for police duty, quelling rows among railway labourers and similar duties, p. 44. George Stephen saw a national police as a desirable substitute for the portion of the army devoted to internal order keeping. He thought it would be more effective and 'less offensive to popular feelings', G. Stephen, *A Letter to ... Lord John Russell on the Probable Increase of Rural Crime in Consequence of the Introduction of the New Poor Law and Railroad Systems* (1836), p. 15.

28. P. Dunkley, 'Whigs and Paupers: The Reform of the English Poor Law, 1830–1834', p. 143.

29. E. Hobsbawm and G. Rudé, *Captain Swing* (New York, 1968), pp. 126–7; Dunkley 'Whigs and Paupers ...', p. 129. R. Foster considers that Captain Swing marked the beginning of a re-evaluation of rural policing among the Hampshire gentry, *The Politics of County Power*, p. 93.

30. *WGS*, 8 October 1840. When ricks were being burned at Northwood (Salop), a justice wrote, 'I should have been most glad to have had a well organized force', (PRO HO 73/5/1 Return of Justices of Churbury Division, Salop, to CFC).

31. *NC*, 30 November 1839. This observation is itself a reflection of a changed conception of law enforcement. In the case of disturbances, it had always been a magistrate's duty to confront mobs directly and personally. Wodehouse thought it was someone else's job.

32. Apfel, 'Crisis in a Rural Society', p. 263.

33. *Ibid.*, p. 267, n. 77.

34. J. Lowerson, 'The Aftermath of Swing: Anti-Poor Law Movements and Rural Trades Unions in the South East of England', in A. Charlesworth (ed.), *Rural Social Change and Conflicts Since 1500* (Hull, 1982), p. 59, and J. Archer, 'Rural Protest in Norfolk and Suffolk 1830-70', in *ibid.*, pp. 83–95.

35. N. Edsall, *The Anti-Poor Law Movement* (Manchester, 1971), chapter 2.

36. J. Archer, *By a Flash and a Scare. Incendiarism, Animal Maiming and Poaching in East Anglia* (Oxford, 1990), pp. 18–19; J. Lowerson, 'The Aftermath of Swing', pp. 55–83. See also K. D. Snell, *Annals of the Labouring Poor. Social Change and Agrarian England, 1660–1900* (Cambridge, 1985), pp. 135–6.

37. R. Storch, 'Policing Rural Southern England', pp. 234–5.

38. On the change in attitude in East Suffolk, see PRO MH 32/38 J. P. Kay to Poor Law Commission, 26, 27 December 1835 and 28 January 1836.

39. *CC*, 29 November 1839; cf. PRO HO 73/5/1 Return of Walden Division (Essex) to CFC, on the preference of young men for stealing to applying for relief. R. Wells documents how Wealden farmers gave first preference in hiring to married men, the abandonment of farm labour and the adoption of a criminal life by some young men around the age of eighteen, 'Popular Protest and Social Crime: the Evidence of Criminal Gangs in Rural Southern England', in B. Stapleton (ed.), *Conflict and Community in Southern England* (Stroud, 1992), pp. 170–1. On the inducements the New Poor Law held out

to young men to poach or steal see, Archer, *By a Flash and a Scare*, p. 54. Contemporary testimony to the disadvantages of young men in the labour market is J. S. Henslow, *Suggestions Toward an Enquiry into the Present Condition of the Labouring Population of Suffolk* (Hadleigh, 1844), pp. 11–12.

40. G. Crewe, *A Word for the Poor, and Against the Present Poor Law* (Derby, 1843), pp. 6–7, quoted in Snell, *Annals of the Labouring Poor*, p. 9.

41. PRO 30/22/2A, Russell Papers, G. Crewe to Lord John Russell, 28 March 1836. He begged Russell to act on the police question 'for our relief'.

42. G. Stephen to E. Chadwick, 25 April 1838, PRO HO 73/2/1.

43. *Royal Commission on County Rates* PP 1836, (58) XXVIII, statement of Thomas Dyer, Appendix B, p. 101.

44. *Ibid.*, evidence of T. Dyer, p. 15. Dyer was one of those who predicted an upsurge in criminality.

45. PRO HO 73/2/1 T. Dyer to Lord J. Russell, 7 February 1838. Wells, 'Popular Protest and Social Crime . . .' makes the important point that the old Poor Law aided men who, unable to find farm work, took up rural crafts or petty trading. He believes that after parish assistance was withdrawn, criminal activity 'could make the difference between success and failure' (p. 171).

46. PRO HO 73/2/1 T. Dyer to Lord J. Russell, 7 February 1838. For examples of calls by magistrates to replace the old constabulary on these grounds see PRO HO 73/5/1 Returns of Justices of Holsworthy Division, Devon and Walden Division, Essex to CFC. Also the Revd T. Spencer, *The Successful Application of the New Poor Law* (pp. 6, 9). He argued that the New Poor Law could not do its good work without police reform.

47. G. Stephen, *A letter to . . . Lord John Russell on the Probable Increase of Rural Crime in Consequence of the Introduction of the New Poor Law and Railroad Systems* (1836), p. 6. The Governor of Wilton House of Correction attributed increases in crime to the stringency of the New Poor Law which refused relief to impostors, forcing them to choose between working and stealing, PRO HO 73/3 J. Gane (?) to S. Redgrave, 16 December 1837. The justices of the Linton Division, Cambs. stated that young men preferred to live by robbery and poaching rather than go into the workhouse, PRO HO 73/5/2 Return of Linton Division to CFC. See also PRO HO 73/5/1 Return of Walden Division, Essex, and PRO MH 32/48 Mr Calvert, chairman of the Cosford Union (Suffolk) to J. P. Kay, 14 June 1836.

48. Chadwick's friends feared that the Constabulary Force Commission evidence would provide ammunition to their enemies. The latter argued that an increase in robbery and food theft would accompany a decline in the Poor Rates. One correspondent advised Chadwick to suppress his data, PRO HO 73/3 B. Muggeridge to S. Redgrave, 14 January 1839; cf. similar warnings from Assistant Poor Law Commissioner Charles Mott to Chadwick, cited in J. Knott, *Popular Opposition to the 1834 Poor Law* (New York, 1986), p. 79, and PRO HO/73/2/1, George Stephen to E. Chadwick, 25 April 1838.

49. *Report of House of Commons Select Committee on Criminal Commitments and Convictions*, PP 1826-7 (534), VI, pp. 3–4. Henslow, *Suggestions*, considered that the old Poor Law tended 'to the utter subversion of all law and order among us . . .', p. 12.

50. Snell, *Annals of the Labouring Poor*, p. 124, acutely observes that the contemporary meaning of this term was 'impudence, assertive social action, and free moral behaviour . . .'

51. Wellington to Mrs Arbuthnot, 1 May 1831, in Seventh Duke of Wellington, *Wellington and His Friends* (1965), p. 95. Wellington believed 'we shall have a revolution'. Cooler heads in the 1830s such as Melbourne, Peel and Russell never anticipated revolution, but they believed that the disordered condition of rural England warranted thoroughgoing criminal law and police reform.
52. *Report of the Visiting Magistrates of the Gaol and Bridewell of Winchester*, PP 1831-2 (375) XXXIII, p. 3.
53. Henslow, *Suggestions*, p. 18.
54. M. Wiener, *Reconstructing the Criminal. Culture, Law and Policy in England, 1830–1914* (Cambridge, 1990), p. 16.
55. Wiener's phrase, *ibid.*, p. 49.
56. See exchange between Sir Edward Knatchbull and J. T. Bridges, *KG*, 10 December 1839. Bridges saw the problem as impunity and the remedy to increase the prosecution rate. Only a police could accomplish this.
57. PRO HO 73/5/1 Return of Justices of Howdenshire (E. Riding) to CFC; *LM*, 13 February 1841. See also Anon. [William Blake?], *Rural Police. An Address to the Rate-Payers of the County of Hertford* (1841). Lord Salisbury was claiming that offences were rare. The author retorted that sheep theft had occurred in Hatfield parish within the fortnight, and handbills were about offering £100 rewards. A Hatfield butcher reported his losses at 5-6 sheep per winter, p. 5.
58. *SCh*, 4 January 1840. Shawe, a Liberal, favoured both the New Poor Law and a new police. Mitford was the author of a number of contemporary rural idylls; the best known is *Our Village* (1824). The Suffolk antiquary John Glyde published a little article making the same argument regarding the criminality of rural areas versus towns. See J. Glyde, 'Localities of Crime in Suffolk', *Journal of Statistical Society of London*, XIX, 2 (June 1856), pp. 102-6; also remarks of Ludlow Bruges, chairman of Wiltshire sessions, to the effect that only 35 per cent of the felonies dealt with at the Quarter Sessions emanated from the towns, *DWG*, 21 April 1840. Things could appear differently to rural gentlemen in a county such as Warwickshire, where the impact of Birmingham was enormous.
59. A. J. Peacock, 'Village Radicalism', p. 39.
60. See D. Philips, 'Crime, Law and Punishment in the Industrial Revolution', in P. O'Brien and R. Quinault (eds), *The Industrial Revolution and British Society* (Cambridge, 1993), pp. 156-82. V. A. C. Gatrell favours the notion of a 'prosecution wave' - 'Crime, Authority and the Policeman-State', in F. M. L. Thompson (ed.), *Cambridge Social History of Britain, 1750–1950*, III, (Cambridge, 1990), p. 250 ff.; *idem. The Hanging Tree. Execution and the English People, 1770–1868* (Oxford, 1994), pp. 18-19; also discussion in D. Jones, *Crime, Protest, Community and Police in Nineteenth-Century Britain* (1982), pp. 3-5 and C. Emsley, *Crime and Society in England 1750–1900* (2nd edn, 1986), p. 36.
61. See Gatrell, 'Crime, Authority and the Policeman-State', on 'projected anxieties about social changes which had nothing directly to do with crime itself', a discussion of 'change' as an explanation of crime and its link to an early nineteenth-century deteriorationist perspective, pp. 248-53. Apfel's local study of Norfolk concludes that 'it was only during the 1820's that crime became a matter of extensive public discussion ...' By the late 1820s 'the issue was truly one of pressing interest', 'Crisis in a Rural Society', pp. 254-5.

62. See the discussion in J. Archer, *By a Flash and a Scare*, chapter 1.
63. Even they might be suspected of setting 'out at night with a load of produce, taking along with them trusses of hay and clover ... which they dispose of ... to the Ostlers at the night houses', PRO HO 73/5/2 Return of Justices of Enfield Division (Middx.) to CFC. Archer, 'The Nineteenth Century Allotment', p. 32, concludes: 'even respectable labourers were involved in petty crime as a matter of course'.
64. R. Wells, 'Popular Protest and Social Crime', *passim*. Wells uncovered a vast criminal culture in the rural South, and explored the phenomenon of the criminal gang and the role of itinerants, vagrants and hawkers as cogs in a criminality that linked the village, the towns and the Metropolis.
65. PRO HO 73/2/2 Examination of Thomas Parsall. See also Storch, 'Policing Rural Southern England', pp. 258-9.
66. Henslow, *Suggestions*, pp. 17-20. A determined (and cogent) opponent of the Rural Police Acts (1839-40), the Revd C. D. Brereton also viewed a police as a 'new system of moral discipline', *A Refutation of the First Report of the Constabulary Force Commissioners*, Pt. II (1840), p. 1.
67. PRO HO 73/5/2 Return of Justices of Speethorn Division (Middx.) to CFC.
68. See *Royal Commission on County Rates*, letter from Sir G. H. Rose to County Rates Commission (n.d.), Appendix B, p. 91.
69. MS Diary of the Revd F. E. Witts, 14 November 1836. G. Stephen, *A Letter to ... Lord John Russell*, *passim*, makes the same argument.
70. D. Jones, *Crime, Protest, Community and Police*, pp. 4-5. Also see C. Emsley, *Crime and Society*, p. 34. Looking back over the previous decades, Thomas Plint contrasted the agricultural counties rather unfavourably with the manufacturing ones, *Crime in England* (1851), pp. 80-131.
71. Examples could be multiplied, but see Anon. [the Revd Stephen Clissold], *Police Regulations for Establishing a System of Morality and Good Order in Rural Districts Under the New Poor Law Act* (1836), who worried that crime and public expenditures on criminal justice in Suffolk were rising faster than population, pp. 3-6, and remarks of J. Pakington, chairman of Worcestershire Quarter Sessions, *WG*, 9 November 1839. Large rises in county rates after 1815, mostly attributable to criminal justice costs, were obvious to all.
72. See the revisionist account of R. Paley, '"An Imperfect, Inadequate and Wretched System?" Policing London Before Peel', *Criminal Justice History* (1989).
73. On the admiration of the Hampshire gentry for the Metropolitan Police and the use of their services see R. Foster, *Politics of County Power*, p. 93. The Metropolitan Police sent officers to help set up permanent police forces in 88 places between 1830 and 1837 In addition, 2140 men were sent to different provincial locations to preserve order or apprehend criminals (PRO HO 61/19).
74. The term was actually used. Reporting on a typical rural police experiment of the 1830s, William Gough claimed the change in the state of the Tasburgh district since a police was put on was 'perfectly magical' (PRO HO 73/2/1 Gough to CFC, 1 December 1836).
75. H. Morton to Lord Durham, 22 May 1832 (Lambton MSS, Lambton Estate Office); reference supplied courtesy of James Jaffe. For an account of this episode, see Chapter 5.
76. PRO HO 52/38 F. North to Russell, 24 November 1838.

77. UCL Chadwick Papers, item 13 'Evidence Taken by the Constabulary Force Commissioners', printed but unpublished, evidence of R. Hall, p. 87. The Revd Witts ticked off the number of executions and sentences of transportation and imprisonment he attributed to the activity of Otway and Millington, the two ex-Metropolitan police working for the Stow Police Association (Diary of the Revd F. E. Witts, 28 May 1835).

78. On Suffolk see Storch, 'Policing Rural Southern England', p. 235.

79. Governments and the Metropolitan Commissioners worried that rural gentlemen might begin regarding the Metropolitan Police as a resource on which they could draw only when needed, thus saving ongoing costs to the ratepayer and constituting an incentive to do nothing about the local police. This issue became more acute after the County Police Acts (1839–40).

80. Historians now regard many of them as understaffed, overstretched and even disorganized: C. Emsley, *The English Police*, pp. 43–4; D. Taylor, *The New Police in Nineteenth-Century England: Crime, Conflict and Control* (Manchester, 1997), pp. 77–9; J. Hart, 'Reform of the Borough Police, 1835–1856', *English Historical Review*, LXX (1955), pp. 411–27.

81. Radnor's suggestion is in PRO HO 73/5/1 Return of Salisbury Division to CFC.

82. Henry Smith. Note attached to return of Lyncombe, Somerset to CFC, PRO HO 73/8/2.

83. See Chapter 2.

84. East Sussex Record Office, QAC/1/E1 Return of Cuckfield Bench to survey on crime/police conducted by East Sussex Quarter Sessions (1839).

85. See Chapter 2 – negligence and tardiness in serving warrants; fear for physical safety; fear of injury to their trades; lack of co-ordination with other parishes; lack of education and respectability; too old; under no proper supervision, etc. A typical example is PRO HO 73/3 Sir Thomas Baring to CFC, 28 December 1836. He went on to detail the positive changes in his Hampshire parish after a uniformed professional was hired.

86. PRO HO 73/4/1. G. Stephen to E. Chadwick, 12 January 1837.

87. An important point made by Mandler in relation to reform of the Poor Law.

88. In the rural policing debates of the 1830s, one encounters many well-known national figures arguing the issues in their roles as landed gentlemen and/or county magistrates – e.g. Disraeli debating the policing issue as a Buckinghamshire justice at Aylesbury Quarter Sessions.

89. Apfel, 'Crisis in a Rural Society', p. 259.

90. For a selection of magisterial expressions of support for 'prevention' and a 'preventive police' in 1836, see PRO HO 73/5/1 & 2 – returns to Constabulary Force Commission from: Whorwellsdown, Salisbury and Chippenham Divisions, Wilts.; Basingstoke Division, Hants.; Drayton Division, Salop; Christchurch Division, Monmouthshire; Abingdon Division, Berks.; Bishop's Stortford Division, Herts.; Petworth Division, Sussex; Blackheath Division, Kent.

91. The Revd S. Clissold told Chadwick that the costs of a proper rural police might fall upon the ratepayer, but that they were 'as a particle of dust when compared to the real though not the apparent burthen of the old Parochial Constabulary ...' (PRO HO 73/2/1, 18 January 1839).

92. This argument was not strictly true. County rates rose tremendously in the early nineteenth century largely due to costs associated with criminal justice.

93. In response to the queries of the Constabulary Force Commission in 1836, some gentlemen attempted to research the total costs of the parish constable system. They could not be ascertained, since local accounts were not kept of what constables received from individual prosecutors and the county rate. See e.g. the enquiry of The Revd D. Price, the Vicar of Steeple Claydon, Bucks. in PRO HO 73/9/2 and Thomas Dyer's estimates in PRO HO 73/4/1.

94. *AN*, 26 October 1839 (Sir Harry Verney).

95. *First Report from the Select Committee on Police*, PP 1852-2, XXXVI, evidence of W. Heathcote, Q.248.

96. PRO HO 73/9/1 Return of the Guardians of Newchurch parish, Kent to CFC. Even the London upper classes could find a prosecution maddening. See Bentham's nephew's account of his frustrating adventures in prosecuting a pickpocket, George Bentham, *Autobiography, 1800–1834* (Toronto, 1997), p. 387.

97. PRO HO 73/2/1 B. Leighton to E. Chadwick, 27 February 1839. From Hampshire, PRO HO 73/4/1 W. Bourne to CFC, 1 January 1837, stressing that, although committals were at a recent low in his division, theft had not diminished. He detailed his own and his tenants' livestock losses; a preventive police was needed. From Wiltshire, PRO HO 73/2/1 J. Garrett to S. Redgrave, 3 December 1836, suggesting better ways to ascertain the real amount of crime.

98. We have his data for October 1835 to October 1836 and October 1837 to February 1838 (PRO HO 73/4/1 and HO 73/2/1 Dyer to Russell, 7 February 1838). After the publication of the CFC Report, some gentlemen were influenced by Edwin Chadwick's method of estimating the full extent of criminality and the true cost of crime. See CFC Report, p. 7. For the employment of Chadwick's 'multiplier' by reforming gentlemen in East Anglia, see reports in *NC*, 30 November 1839, and *SCh*, 4 January 1840.

99. PRO HO 73/2/1 T. Dyer to Lord John Russell, 7 February 1838. Dyer was vague about whether London was discharging its criminality on Chobham or actually exporting its criminals. In Beckenham, the projectors of a police association believed that the Metropolitan Police 'drove suspicious characters into Beckenham' (*Report of the Beckenham Association for Raising a Fund to Provide and Pay a Police* (1836)). Exurban villages often formed private forces, e.g. Beckenham, Hayes, Blackheath and Plaistow; and/or demanded an extension of the Metropolitan district e.g. Plaistow, Finchley. PRO HO 61/19 T. Reynolds to C. Rowan, 15 August 1837, and J. Waite to C. Rowan, 5 September 1837.

100. *CC*, 29 November 1839.

101. *KG*, 10 December 1839.

102. *HPD*, N.S. XVIII, cols. 786–8, 790–97 (1828); N.S. XXI, cols. 868–71 (1829).

103. E. Chadwick, 'Preventive Police', *London Review*, I (1829), p. 273.

104. *SCh*, 11 January 1840. Robert Bevan was, significantly, a director of an insurance company.

105. *First Report from the Select Committee on Police*, PP 1852-2, XXXVI, evidence of G. Warry, qq. 1366–8, emphasis added. Warry, a leader of the unsuccessful struggle to adopt a county police for Somerset, had held such opinions since the 1830s, I. P. Collis, 'The Struggle for Constabulary Reform

in Somerset', *Proceedings of Somerset Archaeological and Natural History Society*, 99 (1956), pp. 95-104. It was also argued that present members of private prosecution associations would get better and cheaper services from a police: UCL Chadwick Papers, item 3/5, T. Marriott, 'To The Guardians of the Pershore Union'.

106. See e.g. remarks of the clerical justice, the Revd Robert Wilson, *NC*, 26 October 1839.

107. *NC*, 30 November 1839.

108. J. Beattie, *Crime and the Courts in England, 1660-1800* (Princeton, 1986), p. 636. An extended discussion of these issues is D. Philips, ' "A New Engine of Power and Authority": The Institutionalization of Law-Enforcement in England 1780-1830' in V. A. C. Gatrell et al. (eds), *Crime and the Law. The Social History of Crime in Western Europe since 1500* (1980), pp. 155-89.

109. Beattie, *Crime and the Courts*, p. 636.

110. A. de Tocqueville, *Journeys to England and Ireland* (1958), p. 63. As a Frenchman (and famously keen observer) he may have ultimately developed this view unaided. However, one of his chief English informants was Lord Radnor, a Benthamite aristocrat.

111. J. Styles, examining loss of faith in the efficacity of the printed crime advertisement, concluded (as we did for the old constabulary) that they were often effective, but 'the piecemeal, unsystematic way in which the public used and responded to them' came to be viewed as a fatal defect. This 'lack of system' impeded the kind of 'intensified surveillance' reformers sought, 'Print and Policing: Crime Advertising in Eighteenth Century Provincial England', in D. Hay and F. Snyder (eds), *Policing and Prosecution*, p. 93.

112. J. Peel JP to Edward Baines, Chancellor of the Duchy of Lancashire, read by Sir George Grey to Parliament, *HPD*, 3rd Ser., 140, 10 March 1856, cols. 2121-2.

113. J. S. Henslow, *Suggestions*, p. 18. See Lord Radnor's argument that the purpose of a police had nothing to do with repressing political movements and everything to do with rural petty crime and village disorder, *RM*, 19 October 1839 and Mr Stansfield JP, *LM*, 13 February 1841.

114. Another East Anglian clergyman, C. D. Brereton, an arch-opponent of police reform, referred to the rural police as 'a new system of moral discipline', *A Refutation of the First Report of the Constabulary Force Commissioners*, Pt. II (1840), p. 1.

115. Henslow, *Suggestions*, p. 20.

116. For their activities in this area see N. Lutt (ed.), 'Bedfordshire Muster Lists, 1539-1831', *Pubs. Bedfordshire Historical Record Society*, 71 (1992). By 1830 constables had been stripped of their duty to compile jury lists under the Jury Act of 1825. This function was transferred to the overseers of the poor, who were judged more competent: J. Gyford, 'Men of Bad Character. Property Crime in the 1820s', unpublished MA thesis, Essex University (1982), p. 80.

117. *NC*, 30 November 1839.

118. See C. Herrup, *The Common Peace: Participation and the Criminal Law in Seventeenth Century England* (Cambridge, 1987), p. 61.

119. See Chapter 2.

120. After the release of the CFC Report, some of its more sophisticated arguments entered directly into the discourse of reforming magistrates and gentlemen. See above, n. 98.

121. It was Peel, in the 1829 debate on the Metropolitan Police Bill, who emphasized the close link between an increase in crime and the absence of an efficient police. Cf. Wellington's remarkable statement in the Lords that it 'is perfectly clear ... that this rapid and extraordinary increase in crime arises *wholly* from the deficiency of the police', *MOP*, vol. 3, p. 2050 (5 June 1829) [our emphasis].

122. The sample consisted of 142 petty sessional divisions (about 35 per cent of the total in England) in 15 counties: Bedfordshire, Buckinghamshire, Derbyshire, Durham, Essex, Hereford, Kent, Lancashire, Leicestershire, Nottinghamshire, Oxfordshire, Surrey, Sussex, Worcestershire and Yorkshire (West Riding).

123. Cheshire and Norfolk are excluded, the former because it already possessed a small county establishment; the latter because the data have not survived.

124. All counties below the traditional Wash–Severn line. A county-by-county breakdown is provided in Appendix A.

125. See Chapters 7 and 8.

126. We reckon that this figure represents close to 80 per cent of petty sessional divisions existing at the time. See V. Lipman's list for England in 1831, *Local Government Areas 1834–1945* (Oxford, 1949), table pp. 22–3.

127. A small number of queries were returned by chairmen or secretaries of Poor Law boards on behalf of entire Unions; these were excluded unless a countable parish-by-parish breakdown for the Union was given. The reader should note that the incidence of No Responses was much higher among parish guardians than Petty Sessions – overwhelmingly so in some counties. We interpreted the numerous blank responses among these farmer-tradesmen respondents as either an expression of (silent) disapproval or the result of bemusement at the idea of a paid permanent police; it is, naturally, impossible to distinguish the one from the other.

128. See e.g. the Guardians' Returns (PRO HO 73/6/2, 7/1 and 9/1) for Iver, Newport Pagnell, Aylesbury, Aston Clinton, Denham, Buckingham, Bledlow, Marsh Gibbon, Steeple Claydon in Bucks.

129. See Chapters 7 and 8.

130. PRO MH 10/7 Poor Law Commission circular to union officials regarding illegal uses of Poor Rates, 1 March 1836. In November, magistrates were reminded of this again, in a notice accompanying the queries sent by the Constabulary Force Commission, PRO HO 73/2/2. The functioning of coroners was also adversely affected: D. Eastwood, *Governing Rural England. Tradition and Transformation in Local Government 1780–1840* (Oxford, 1994), pp. 69–70.

131. See Storch, 'Policing Rural Southern England', pp. 234–5.

132. PRO HO 73/5/2 Return of Justices of Abingdon Division, Berkshire and Ampthill Division, Bedfordshire to CFC.

133. PRO HO 73/6/2 Return of Guardian, Little Oakley, Essex to CFC.

134. PRO HO 73/5/2 Return of Justices of Newmarket Division, Cambridgeshire to CFC. Large areas of the North, in which no Poor Law Unions yet existed, continued payments from the Poor Rates as before, although the justices knew it was illegal (PRO HO 73/5/2 Return of Justices of Kirkdale Division, Lancashire to CFC).

135. PRO HO 73/5/1 & 2 Return of Justices of Buckingham Division, Buckinghamshire and Epping Division, Essex to CFC.

136. PRO HO 73/5/2 Return of Justices of St Albans Division, Hertfordshire to CFC; PRO HO 73/5/1 Return of Justices of Farnham Division, Surrey to CFC.
137. PRO HO 73/5/2 Return of Justices of St Albans, Hertfordshire to CFC; PRO HO 73/5/2 Return of Justices of Rugby Division, Warwickshire to CFC.
138. PRO HO 73/5/1 Return of Justices of Wallington Division to CFC, Surrey to CFC; *WG*, 19 October 1839. For Craig and King, see Chapter 2. The Belper justices did not know how they could continue to maintain the lockup. The parish supported it out of the rates, but these payments were now stopped (PRO HO 73/5/2 Justices of Belper Division, Derbyshire to CFC).
139. See e.g. PRO HO 73/5/3 Return of Justices of Northwest Division of Darlington (Bishop Auckland), Durham, to CFC; PRO HO 73/5/2 Return of Justices of Oundle, Northamptonshire to CFC.
140. PRO HO 73/5/2 Return of Justices of Newport Division, Buckinghamshire to CFC.
141. See e.g. PRO HO 73/7/2 Return of Guardian of Fyfield parish, Essex to CFC.
142. The Guardian of Cliffe Pipard parish, Wiltshire reported that, because of the new policies, many who had served the office for years and knew the duties had resigned (PRO HO 73/8/1 Return to CFC).
143. PRO HO 73/5/1 Return of Justices of Brighton Division, Sussex to CFC.
144. PRO HO 73/5/1 Return of Justices of Frant Division, Sussex to CFC; the Justices of the Brighton Division, Sussex also reported a rising price, *ibid.*
145. UCL, Chadwick Papers, item 13 'Evidence taken by the Constabulary Force Commissioners', printed but unpublished, evidence of N. Blake, p. 46. There were numerous reports of disgruntlement among constables – see e.g. PRO HO 73/7/2 Return of Guardians of Little Horksley parish, Essex to CFC; PRO HO 73/5/1 Return of Justices of Witham and Winstree and Lexden Half of Colchester Divisions, Essex to CFC.

Chapter 4

1. Party labels are somewhat slippery in the late eighteenth and early nineteenth centuries. Certainly the younger Pitt would have not accepted the Tory label had it been applied to him during his lifetime.
2. 'Justice of the peace' ('JP' or 'justice' for short) is synonymous with 'magistrate'.
3. We use here the term 'English state' because in the areas with which we are here concerned, England and Wales formed a separate and distinct unit; both Scotland and Ireland were governed separately in these areas.
4. Though John Brewer, in *The Sinews of Power. War, Money and the English State, 1688-1783* (1989), shows that the English central state built up a formidable fiscal and economic machine – particularly in the form of efficient Excise and Customs services, controlled from central government and staffed by paid officers – the day-to-day governing and administration of England was carried on at lower levels.
5. However, a significant role was played by the 'Preventive Service' or Coast Guard in the repression of riots and tumults in coastal areas. They were

occasionally sworn in as special constables, PRO HO 73/9/2, Return of E. Budleigh parish (Devon) to CFC, Return of Justices of Worthing Division, (Sussex) to CFC, HO 73/5/1. Many parishes and benches in Essex, Kent, Norfolk, Devon and Sussex reported resorting to the Coast Guard in times of disturbances. In 1867, they were still being called upon, but acted with extreme reluctance. See R. D. Storch, 'Popular Festivity and Consumer Protest: Food Price Disturbances in the Southwest and Oxfordshire in 1867', *Albion*, 14 (Winter 1982), pp. 209–34, at p. 220; also D. Richter, *Riotous Victorians* (Athens, OH, 1981), p. 13. In the 1830s, the Bradwell (Essex) parish guardian reported that the Coast Guard was always co-operative, but drew the line at activities that the local commander considered routine policing, PRO HO 73/6/1 (cf. n. 6). The role of the 'Preventive Service' in order keeping might be worth further investigation.

6. This was governed essentially by the Riot Act of 1715. See L. Radzinowicz, *A History of English Criminal Law and its Administration from 1750*, (4 vols. 1948–68), vols. 2–4; T. Hayter, *The Army and the Crowd in Mid-Georgian England* (Totawa, NJ, 1978); B. Turner, 'Luddism and the Law' (unpub. PhD thesis, University of Queensland, 1993).

7. In 1838, in the context of anti-Poor Law disturbances and trade union activity among agricultural labourers in Sussex, Battle justices ordered a detachment of dragoons to patrol villages, search public houses, and so forth. The officer in charge was disgusted, considering it improper duty. The Home Secretary became involved and the Lord Lieutenant, the Duke of Richmond, intervened to remind the magistrates never to call out the military under such circumstances, HO 52/38, Stileman to Richmond, 3 February 1838, Richmond to Stileman, 6 February 1838, Richmond to Russell, 13 February 1838. Magistrates were told that the resort ought to be to special constables and Metropolitan Police to lead them. London police were never 'afraid to do their duty'. See also HO 52/28, Humphrey to Russell, 27 July 1836, for a Cheshire case in which a justice ordered two companies of the 83rd Regiment to break up a prizefight on a moor. In this case, too, the Home Secretary was quite annoyed. While commanding troops in the North, Sir Charles Napier's dealings with justices who tried to use troops in cases of disorderly conduct or merely to stop rows among railway navvies led to his growing contempt for the magistrates, W. Napier, *The Life and Opinions of General Sir Charles Napier* (1857), vol. 2, p. 44. On the role of the army, generally, in serious disturbances and the attitudes of ministers, see Chapter 3.

8. 1 Will. & Mary, c. 2, s. I.

9. William Paley, *The Principles of Moral and Political Philosophy* (1785), Book VI, chapter IX, 'Of Crimes and Punishments', pp. 541–2.

10. Henry Fielding, *An Enquiry into the Causes of the Late Increase of Robbers* (2nd edn, 1751); John Fielding, *An Account of the Origins and Effects of a Police Set on foot by His Grace the Duke of Newcastle in the Year 1753, upon a Plan presented to his Grace by the late Henry Fielding Esq.* (1758).

11. Jonas Hanway, *The Citizen's Monitor: Showing the Necessity of a Salutary police, executed by resolute and Judicious Magistrates* (1780), pp. iii–v (emphasis in original).

12. Sir William Mildmay's explication of the French police for an English readership was by then a well-known and horrifying negative example, *The*

Police of France; or an Account of the Laws and Regulations . . . for the Preservation of Peace and the Preventing of Robberies (1763). Mildmay discussed a police structure emphasizing surveillance of citizens, intrusive inspection and controls on certain trades and businesses.

13. *Daily Universal Register*, 1 July 1785 (emphasis in original).
14. See D. Philips, '"A New Engine of Power and Authority": The Institutionalization of Law-Enforcement in England 1780-1830', in V. A. C. Gatrell, G. Parker and B. Lenman (eds), *Crime and the Law: The Social History of Crime in Western Europe since 1500* (1980), pp. 155-89; T. A. Critchley, *A History of Police in England and Wales* (revised edn 1978), chapter 2; C. Emsley, *Policing and Its Context 1750-1870* (1983), chapters 2-4; S. H. Palmer, *Police and Protest in England and Ireland 1780-1850* (Cambridge, 1988), chapters 3, 5, 8. It is dealt with in great detail in Radzinowicz, *History of English Criminal Law*, vol. 3, *Cross-Currents in the Movement for the Reform of the Police* (1956), and vol. 4, *Grappling for Control* (1968).
15. Philips, 'A New Engine'.
16. Brewer, *Sinews of Power*, p. 156.
17. See e.g. the views of the Ultra-Tory county MPs Knatchbull and Vyvyan in 1830 discussed below.
18. John Fielding, *A Plan For Preventing Robberies Within Twenty Miles of London* (1755).
19. J. Styles, 'Sir John Fielding and the Problem of Criminal Investigation in Eighteenth-Century England', *Transactions of the Royal Historical Society*, 5th Series, vol. 33 (1983), pp. 127-49.
20. P. Rawlings argues that Fielding's ideas 'represented an important turning point', in that they attempted to shift the focus from punishment to law enforcement, and redefined the roles of individuals, victims and the community as mere providers of information to full-time, expert public officials (such as themselves) charged with operating the machinery of criminal justice, 'The Idea of Policing: A History', *Policing and Society*, 5 (1995), pp. 129-49, esp. pp. 139-41.
21. E.g. 'A Magistrate', *Cursory Remarks on the Police* (1797).
22. E.g. Anon., *Regulations of Parochial Police . . .* (4th edn, 1803) reflective of wartime paranoia about the depletion of the country of its honest and industrious labourers. The residue, an idle, profligate and desperate urban population, and a rural army of sturdy (but disloyal and Jacobin-inclined) domestic servants, wanted the strictest surveillance, pp. 24-6, 32-7.
23. G. Barrett, *An Essay Towards Establishing a System of Police on Constitutional Principles* (1786).
24. On Colquhoun as a reformer of the police of London, see Philips, 'A New Engine', pp. 175-78.
25. Bentham's drafts are in UCL Bentham Papers, 150a, pp. 125-70, 178-289. See also: P. Colquhoun, *A General View of the National Police System Recommended by the Select Committee of Finance to the House of Commons* (1799); L. J. Hume, *Bentham and Bureaucracy* (Cambridge,1981), pp. 123, 127, 133-4, 154, 279.
26. Themes that would resurface in Edwin Chadwick's private notes and the CFC Report of 1839. See Chapter 6.
27. See Palmer, *Police and Protest*, chapters 3, 4, 6, 7, 9.
28. Peel took care to ensure that his Metropolitan Police were put into

deliberately non-military uniforms and armed only with truncheons (and cutlasses, but no firearms, for dangerous occasions). We will note that some of the earliest English, voluntary-subscription rural police schemes had no hesitation in providing their men with pistols.

29. One of the new post-1839 English county forces, the Gloucestershire Constabulary, was not only directly modelled on the Irish Constabulary, but was also formed and commanded by a chief constable brought over from Ireland.

30. British Library, Peel Papers Add. MSS 40308, p. 267 Peel to Wellington, 5 November 1829 (reproduced, with slight errors - including 'women' for 'Whores' - in C. S. Parker (ed.), *Sir Robert Peel from his Private Papers* (3 vols, London, 1899), vol. 2, p. 115).

31. Colonel Charles Rowan, a retired army officer, and Richard Mayne, an Irish barrister.

32. See e.g. Peel's suggestion as Home Secretary in 1826 (refusing a Lichfield justice's demand that government pay the costs of prosecution of arsonists), that he would be glad to send down 'an active Police Officer' from Bow St., PRO HO 45/7, p. 245, Peel to Littleton, 8 June 1826. On the service of former Metropolitan policemen in the provinces in the 1830s, see Chapter 5.

33. On Peel's views and political career, see: N. Gash, *Mr Secretary Peel. The Life of Sir Robert Peel to 1830* (1961) and *Sir Robert Peel. The Life of Sir Robert Peel after 1830* (1972); D. Read, *Peel and the Victorians* (Oxford, 1987).

34. See J. Parry, *The Rise and Fall of Liberal Government in Victorian Britain* (New Haven, 1993), chapter 1.

35. *Ibid.*, p. 159.

36. For the Cheshire Constabulary Act, see Chapter 5.

37. *HPD*, 3rd Series, vol. 21, cols. 740-2 (13 April 1829). Lord Melbourne stated, in 1832, that Peel had viewed the Cheshire Act as 'an experimental Bill, and as a step to the introduction of an improved general police throughout the kingdom'; and a Cheshire MP, George Wilbraham, told the Constabulary Force Commission in 1836 that Peel had supported the Act as 'an experiment for the whole Country' (D. Philips and R. D. Storch, 'Whigs and Coppers: The Grey Ministry's National Police Scheme, 1832', *Historical Research*, vol. 67, no. 162 (1994), pp. 75-90, at p. 77). Many years later, in November 1836, the *Law Magazine* (pp. 490-1) stated confidently that Peel and Wellington planned the establishment of a rural police. Peel possibly. But *Wellington?* No trace of an elaborated national police scheme survives in Peel's papers.

38. The King's speech had mentioned only legislation on a municipal police. In fact, the government's draft bill contemplated something much wider. For a full account of the abortive Whig Police Bill of 1832, see Philips and Storch, 'Whigs and Coppers', and below.

39. See *HPD*, 3rd Series, IX, 6 December 1831, col. 78; X, 7 March 1832, col. 1234; XIII, 29 June 1832, cols. 1157-8.

40. 5 and 6 Will. IV, c. 76; 2 & 3 Vic., c. 93; 3 & 4 Vic., c. 88.

41. 1 and 2 Will. IV, c. 41; 3 & 4 Will. IV, c. 90.

42. R. Foster, 'Wellington and Local Government', in N. Gash (ed.), *Wellington: Studies in the Military and Political Career of the First Duke of Wellington* (Manchester, 1990), pp. 214-37, at p. 226. On Wellington's views on policing and the magistracy, see this essay and Foster's *The Politics of County Power: Wellington and the Hampshire Gentlemen, 1820–1852* (1990). On his

political career and views, see Elizabeth Longford, *Wellington: Pillar of State* (1972).

43. Wellington Papers 4/2/8 Wellington to Sturges Bourne, 16 November 1837, quoted in Foster, 'Wellington and Local Government', p. 230.
44. Philips, 'A New Engine', p. 183.
45. Foster, *Politics of County Power*, p. 94.
46. West Sussex Record Office (WSRO), Petworth House Archives 5392, the Revd ? to Col. George Wyndham (n.d., clearly 1830s), emphasis in original.
47. See Chapter 5.
48. University College London (UCL), Chadwick Papers item 1798, Shaw Lefevre to Chadwick [n.d., 23 September 1836].
49. *The Reformer* (Hertford), 17 April 1841, report of Adjourned Easter Quarter Sessions. Mr Blake (refuting an opponent alleging that the county policing had failed in Hants.): 'Now, he could inform the Court, on the very best authority, that there was no greater friend to the Rural Police than the Duke of Wellington, and that it was owing to his active and powerful support in the county of Hants. that it had succeeded so well.'
50. At this point, Richmond, a Tory Ultra on Catholic emancipation, was estranged from his party and was, briefly, associated with Grey and the Whigs.
51. It may be significant that the parliamentary leader of a subsequent anti-Peel revolt was Benjamin Disraeli, the only prominent Tory MP to speak against the County Police Bill in 1839.
52. *HPD*, N.S., vol. 24, cols. 1199–1201 (28 May 1830), vol. 25, cols. 355–64 (15 June 1830).
53. *HPD*, N.S., vol. 25, cols. 359–60 (15 June 1830).
54. See J. Styles, 'The Emergence of the Police – Explaining Police Reform in Eighteenth and Nineteenth Century England', *British Journal of Criminology*, 27, 1 (1987).
55. See Philips, 'A New Engine', pp. 155–89; J. Davis, 'A Poor Man's System of Justice: The London Police Courts in the Second Half of the 19th Century', *The Historical Journal*, 27, 2 (1984), pp. 309–35.
56. Palmer, *Police and Protest*, chapters 3, 4, 6, 7, 9; R. S. Tompson, 'The Justices of the Peace and the United Kingdom in the Age of Reform', *The Journal of Legal History*, 7 (1986), pp. 273–92.
57. On the 'Captain Swing' risings, see E. Hobsbawm and G. Rudé, *Captain Swing* (Penguin edn, 1973).
58. UCL Chadwick Papers item 3/3, evidence of Col. Frederick Page (n.d.), pp. 24–5.
59. Palmer, *Police and Protest*, p. 462.
60. See the reflections of John Stuart Mill, *Considerations on Representative Government* (Indianapolis, 1958), pp. 216–17; E. Moir, *The Justice of the Peace* (Harmondsworth, Penguin, 1969); Philips, 'A New Engine' and 'The Black Country Magistracy 1835-60. A Changing Elite and the Exercise of its Power', *Midland History*, III (1976), pp. 161–96; C. Emsley, 'The English Magistracy, 1700-1850, *Bulletin of the International Association for the History of Crime and Criminal Justice*, 15 (1992), pp. 28–38; , J. V. Beckett, *The Aristocracy in England 1660–1914* (Oxford, 1986), pp. 392.
61. Quoted in Palmer, *Police and Protest*, pp. 202, 462.
62. The only significant Tory provincial police legislation was Sir James Graham's Parish Constables Act of 1842 (5 and 6 Vic. C.109), amended

in 1850 during Russell's Administration. To some extent it was a sop to these attitudes. See Chapter 9.

63. See Chapter 3.

64. See P. Mandler, 'The Making of the New Poor Law *Redivivus*', *Past & Present*, 117 (1987), pp. 131–57; D. Eastwood, '"Amplifying the Province of the Legislature": The Flow of Information and the English State in the Early Nineteenth Century', *Historical Research*, vol. 62, no. 149 (1989), pp. 276–94, and *Governing Rural England. Tradition and Transformation in Local Government 1780–1840* (Oxford, 1994), chapters 5–9; Foster, *Politics of County Power*, chapters 4, 5.

65. See Chapters 7 and 8.

66. N. Gash, *Mr. Secretary Peel*, p. 310. In 1840, the Whig magnate Lord Radnor was taunted with the accusation that if a Tory government had proposed a measure like Russell's County Police Act (1839) a decade earlier, he [Radnor] would have been the first to cry 'unconstitutional', *BC*, 4 January 1840.

67. 32 Geo. III, c. 53. It created seven London police offices, each with three stipendiary magistrates and employing up to six paid police officers.

68. *Parliamentary History*, vol. 29, cols. 1464-5 (18 May 1792); also in *Parliamentary Register*, vol. 33, pp. 53-4 (18 May 1792). It would be hard to distinguish these sentiments from the later fulminations of Disraeli against the County Police Acts (1839-40). See his speech at Bucks. Quarter Sessions, *AN*, 4 January 1840 in which he appeals on behalf of the liberties of the lower classes.

69. See Philips, 'A New Engine', pp. 169–74.

70. On the political career and views of Lord Melbourne, see Lord David Cecil, *Melbourne* (Indianapolis, 1955) and P. Ziegler, *Melbourne. A Biography of William Lamb, Second Viscount Melbourne* (1976). The best recent analysis of the Whigs in power (1830-41) is P. Mandler, *Aristocratic Government in the Age of Reform: Whigs and Liberals, 1830–1852* (Oxford, 1990). There is a good account of their reforms of local government and social policy in the 1830s in J. Parry, *The Rise and Fall of Liberal Government*, chapter 5.

71. Quoted in Cecil, *Melbourne*, p. 214, who quotes it (without giving a reference to the source) while discussing Melbourne as Home Secretary 1830-34; Mandler, *Aristocratic Government*, twice quotes it (pp. 128, 172) as referring to Melbourne as Home Secretary. However, Ziegler, *Melbourne*, p. 288, quotes it with a slight difference of wording, as recorded by the young Queen Victoria as an utterance of Melbourne as Prime Minister in 1839.

72. Hobsbawm and Rudé, *Captain Swing*, pp. 266-7.

73. *The Greville Memoirs 1814–1860* (ed. L. Strachey and R. Fulford, 1938, 8 vols), vol. 1, p. 284, 5 April 1829. See also *Dictionary of National Biography*, 'Lennox, Charles Gordon, fifth Duke of Richmond'.

74. Special Constables Act, 12 Wm. IV, c. 41.

75. West Sussex Record Office (WSRO) Goodwood MS 636, p. 92, Melbourne to Richmond, 24 October 1831.

76. *HPD*, 3rd Series, vol. 9, col. 4 (6 December 1831); see also cols. 11, 38, 45, 66, 72, 78-9. The public mention of police reform in the King's speech produced a few pamphlets. See e.g. M. Gore, *A Letter to Viscount Melbourne on Police* (1832), demanding a parliamentary Police Act. Gore favoured an extension of the Metropolitan Police system and salaried police magistrates

to the big towns, from whence they could operate in all parts of a county (pp. 11, 13).

77. Printed copies of the draft bill are in PRO P[rivy] C[ouncil] 1/4934 and WSRO Goodwood MSS, 694.

78. There are two handwritten copies of the memorandum in the Melbourne Papers, Royal Archives, Windsor, R.A. MP 88/15 & 16. A printed copy headed 'Observations upon the Draft of a Bill for the Establishment of an efficient Police in such towns and Districts in England and Wales as may require the same' is to be found in the papers of the Duke of Richmond, WSRO Goodwood MSS 694. It is reprinted in Philips and Storch, 'Whigs and Coppers', pp. 87-90.

79. For the Lighting and Watching Act 1833, see Joseph Hume, below, and Chapter 5.

80. Our emphasis.

81. Melbourne seems to mean here local forces, under local petty sessional benches. He seems not to have considered the path later taken by the Whigs in 1839: county forces under Quarter Sessions. This idea, we shall see, appears not to have proceeded from government at all, but had a provincial provenance. See Chapter 6.

82. 'Observations upon the Draft of a Bill ...'

83. Cecil, *Melbourne*, p. 182.

84. On Russell as Home Secretary, see Mandler, *Aristocratic Government*, pp. 170-93; J. Prest, *Lord John Russell* (1972), chapters VIII, IX; J. Parry, *The Rise and Fall of Liberal Government in Victorian Britain* (1993), chapter 5.

85. 5 and 6 Wm IV, c. 76.

86. See Chapter 6.

87. For the report of the riot, and the correspondence among Richmond, Melbourne and Russell, see: PRO 30/22 [the Russell Papers], 1E Richmond to Russell, 17, 19 (2 letters), 24, 30 December 1835, Richmond to Melbourne, 23 December 1835, plus memo of same date (containing Richmond's plans of police reform – both passed on to Russell for comment); WSRO Goodwood MSS 1580 Russell to Richmond, 18, 19, 20, 26 (from which quotation comes) December 1835, Melbourne to Richmond, 26 December 1835.

88. For Richmond's subsequent interventions see Chapter 6.

89. See the series of letters between Melbourne and Russell: PRO HO 30/22 1E, pp. 196-8, Melbourne to Russell, 6 October 1835, pp. 202-3, Melbourne to Russell, 13 October 1835; Southampton University Library, Melbourne (Broadlands) Correspondence, MEL/RU/11, Russell to Melbourne, 9 October 1835 (from which the quotation comes).

90. For the workings and progress of this Royal Commission, see Chapter 6.

91. See Chapter 7.

92. Radicals came in many shades. We focus on the London-centred group of philosophic Radicals, some of whom entered politics or remained prominent in Metropolitan intellectual circles and/or journalism. We are not here concerned with those provincial Radicals (e.g. Cobbett *père et fils*, Fielden) who saw themselves as tribunes of the working classes, or with those urban, provincial middle-class Radicals who, on the policing issue, worked exclusively (and defensively) to prevent the county justices or the government from getting their hands on the police of the boroughs or the unincorporated urban areas.

93. On Bentham and his ideas, see E. Halévy, *The Growth of Philosophic Radicalism* (1928); W. Thomas, *The Philosophic Radicals: Nine Studies in Theory and Practice 1817–1841* (Oxford, 1979), chapter 1; J. R. Dinwiddy, *Bentham* (Oxford, 1989); L. J. Hume, *Bentham and Bureaucracy* (Cambridge, 1981). For the way in which some of his ideas formed the basis for specific reforms of policing, Poor Laws and public health, see S. E. Finer, *The Life and Times of Sir Edwin Chadwick* (1952), Book I, chapter 2, and 'The Transmission of Benthamite Ideas, 1820–1850', in G. Sutherland (ed.), *Studies in the Growth of Nineteenth-Century Government* (1972), pp. 11–32.

94. T. A. Jenkins, *The Liberal Ascendancy, 1830–1886* (New York, 1994), p. 13.

95. See Radzinowicz, *History of English Criminal Law*, vol. 1, pp. 369, 394–5; vol. 3, pp. 431–47.

96. For characteristic expressions of biting Radical views on the amateur magistracy and new police see Albany Fonblanque's 'The Magistracy' (pp. 82–90), 'Magisterial Incapacity' (pp. 293–5), 'The Thieving Trade Before the Improvement of the Metropolitan Police' (pp. 115–21), and 'The Ancient Watch and New Police' (pp. 265–72) (full of praise for the Metropolitan Police), in *England under Seven Administrations*, I (1837).

97. The only modern biography of Hume is R. K. Huch and P. R. Ziegler, *Joseph Hume: The People's M.P.* (Philadelphia, 1985), which is not very useful; see also the entry in *DNB*. Every account of politics or of radicalism, from the 1820s to the 1840s, mentions Hume and some of his activities; but there is no good account of his ideas or achievements. Thomas, *Philosophic Radicals*, is good on other leading members of the Philosophic Radical group, but has little on Hume.

98. E. Mullins, *A Treatise on the Magistracy of England, and the Origin and Expenditure of County Rates* (1836), p. 18.

99. 3 & 4 Wm. IV, c. 90. For Hume's introduction of the bill in the Commons, see *MOP*, vol. 2, p. 1663; vol. 3, pp. 2637 (13 June 1833), 2986 (12 July 1833), 3011 (15 July 1833); vol. 4, p. 3405 (29 July 1833). On the general context of this permissive Act, see J. Prest, *Liberty and Locality: Parliament, Permissive Legislation, and Ratepayers' Democracies in the 19th Century* (Oxford, 1990), chapter I.

100. 11 Geo. IV, c. 27.

101. On the adoption and implementation of the Act, see Chapter 5.

102. On Tidd Pratt, see Prest, *Liberty and Locality*, p. 12; *DNB*, 'John Tidd Pratt'.

103. A concise statement of his views on local government and police is Anon., *The Principle of the Corporation Reform Bill Applied to Counties . . .* (1835), almost certainly written by Hume.

104. *HPD*, N.S., vol. 10, 2 March 1824, cols. 646–50, vol. 11, 27 May 1824, cols. 902–10 (quotation at col. 909).

105. *Report of the Commissioners for Inquiring into the County Rates*, Preliminary Report, PP 1835, XXXVI (508), 17–26; Report, PP 1836, XXVII, 1-383. The Commission followed on from Select Committees on county rates appointed by the House of Lords (*HPD*, 3rd Series, vol. 21, 25 February 1834, cols. 754-6) and the House of Commons (*HPD*, 3rd Series, vol. 21, 7 March 1834, cols. 1349-52), both of which reported in the summer of 1834. On the background to the Commission, see B. Keith-Lucas, *The English Local Government Franchise: A Short History* (Oxford, 1952), chapter 4.

106. Hume's evidence is in *County Rates Commission, Second Report*, Appendix A; it is referred to in *Second Report* at pp. 11-12, 19, 50.
107. *County Rates Commission, Second Report*, p. 50.
108. See E. Mullins, *A Treatise on the Magistracy of England, and the Origin and Expenditure of County Rates* (London, 1836). Mullins apparently drafted Hume's bill. He argued that the account he offered in his book of the origins of the JPs (and 'their Irresponsibility') and of the county rate, and the evidence of the huge increase of the county rate in the previous 30 to 40 years, showed how necessary and important was Hume's bill.
109. Anon., *The Principle . . .*, p. 14.
110. *HPD*, 36, 10 February 1837, col. 422.
111. *Ibid.*, col. 428. Thornhill believes that the underlying motive was 'the protection of their [the landowner's] pockets as the main ratepayers in the counties', introduction to W. Thornhill (ed.), *The Growth and Reform of English Local Government* (1971), p. 15.
112. As J. P. D. Dunbabin put it, 'the Government studiously stood aside', 'British Local Government Reform: The Nineteenth Century and After', *English Historical Review*, 365 (1977), pp. 777-805, at p. 779.
113. *HPD*, 3rd Series, vol 43, 6 June 1838, cols. 548-50.
114. *HPD*, 3rd Series, vol. 33, 19 May 1836, col. 1117, vol. 34, 21 June 1836, cols. 680-95. Keith-Lucas, *English Local Government Franchise*, pp. 94-100; Parry, *Rise and Fall*, p. 123.
115. Mullins, *Treatise*, chapter VI, quotation at p. 70 (emphasis in original).
116. *HPD*, 3rd Series, vol. 50, 7 August 1839, col. 6.
117. UCL Chadwick Papers 1066, Hume to Chadwick, 21 September 1836.
118. On Chadwick's career and ideas, see S. E. Finer, *The Life and Times of Sir Edwin Chadwick* (1952); R. A. Lewis, *Edwin Chadwick and the Sanitary Movement* (1952); A. Brundage, *England's 'Prussian Minister': Edwin Chadwick and the Politics of Government Growth, 1832–1854* (University Park, 1988) and 'Ministers, Magistrates and Reformers: The Genesis of the Rural Constabulary Act of 1839', *Parliamentary History*, 5 (1986), pp. 55-64.
119. E. Chadwick, 'Preventive Police', *London Review*, no. 1 (February 1829), pp. 252-308.
120. *Ibid.*, p. 252.
121. *Ibid.*, p. 265. The influence of Bentham's utilitarian ideas - that 'Nature has placed mankind under the governance of two sovereign masters, *pain* and *pleasure*', and that people will naturally tend to do those things which produce pleasure and avoid doing those which cause pain - is most obvious in this passage.
122. *Ibid.*, p. 290.
123. *Ibid.*, p. 307.
124. W. Blackstone, *Commentaries on the Laws of England* (8th edn, 1778), Book IV, chapter 27, p. 358.
125. Chadwick, 'Preventive Police', p. 302.
126. See Chapter 6.
127. For the term 'moral entrepreneur'- defined as someone who makes a career out of arousing public alarm on some issue(s), advocating certain necessary measures and reforms to deal with the problem, and then putting him/herself forward as the right person to carry out those measures and reforms - see Howard Becker, *Outsiders: Studies in the Sociology of Deviance* (1963),

chapter 8. Chadwick, in his activities in the areas of reform of factory legislation, Poor Laws, police and public health, fits the category well.

128. *The Poor Law Report of 1834* (eds S. G. and E. O. A. Checkland, Pelican 1974), pp. 467-9, quotation at p. 467. The evidence is in Appendix E, 'Vagrancy', PP 1834 (44), XXXVIII, pp. 1-93.

129. Appendix E, 'Vagrancy', p. 37.

130. UCL Chadwick Papers 1733/I Chadwick to Russell, August 1836.

131. See J. Knott, *Popular Opposition to the 1834 New Poor Law* (1986), chapter 3.

132. PRO HO 73/2/1 Kay to Chadwick, 5 January 1836 (with 2 appended letters), HO 73/4/1 Kay to Poor Law Commissioners, 5, 9 January 1836, T. Frankland Lewis to Chadwick, 14 January 1836; for a fuller account of the Ipswich workhouse riots which Kay reports, see Knott, *Popular Opposition*, pp. 72-74.

133. UCL Chadwick Papers 1733/I Chadwick to Russell, 3 July 1836.

134. See Chapters 6 and 7.

135. UCL Chadwick Papers, 398, Buller to Chadwick, 24 April 1839 (our emphasis) and Chadwick's reply that a centralized system of depredation required a centralized mechanism of repression, Chadwick to Buller, 16 May 1839. Chadwick had been furious with Buller for putting it about that Chadwick was angling to become the head of the police machinery, Chadwick to Buller, 13 April 1839. Considering Chadwick's discontents at the Poor Law Commission, this may have struck home.

136. *MOP*, vol. 4, p. 3370 (12 August 1834).

Chapter 5

1. See the exemplary discussion in D. Eastwood, *Government and Community in the English Provinces 1700–1870* (Basingstoke, 1997), pp. 94-111.

2. There were many men in the Commission of the Peace who failed to swear the requisite oath and take out their *dedimus*, without which a justice could not legally act.

3. These developments can be followed in the records of Minutes and Resolutions kept by Quarter Sessions, and also in the full reports of Quarter Sessions in the local newspapers.

4. A. Brundage, *The Making of the New Poor Law* (1978), p. 184.

5. In the sense of 'committed' or 'dedicated', as opposed to the amateur or dilettante approach.

6. The phrase quoted comes from the CFC Report, p. 128. At the end of a section critical of the adequacy of the police set up under that Act, the report concedes some credit to the Cheshire magistrates for having made 'the first provincial attempt' at police reform.

7. *CCo*, 20 January 1829, report of chairman's charge to Quarter Sessions Grand Jury. Similarly, after the Act had been passed, Trafford told the Grand Jury that the existing parish constables 'were *annual* officers only, and so soon as they had obtained some knowledge of the duties of their office, they were obliged to vacate their situations, and were succeeded by others ignorant as themselves had been'; and their paid jobs distracted them from their police work. The appointment of paid permanent constables would remedy that. (*CCo*, 21 July 1829, report of Quarter Sessions; emphasis in original.)

8. John Barrett, appointed as a paid Special High Constable for the Stockport and Hyde Divisions under the Cheshire Constabulary Act, claimed that it

had been a murder in the Stockport area which the parish constables could not solve which had led the Cheshire magistrates to apply for the private police Act for the county. (UCL Chadwick Papers 8/1, examination of John Stavely Barrett, 25 September 1837). In practice, the Act was heavily applied for a time in some *rural* districts (p. 90).

9. CFC Report, Trafford's evidence, p. 111 (the full account of Trafford's examination about the Cheshire Constabulary Act, on 30 September 1837, is in UCL Chadwick Papers 8/1); *CCo,* 20 October 1829; PRO HO 73/3, copy of motion of Cheshire Quarter Sessions, 14 January 1829.

10. See J. J. Tobias, *Crime and Industrial Society in the Nineteenth Century* (1967); J. Hart, 'Reform of the Borough Police 1835-56', *English Historical Review,* 70 (1955), pp. 411-27; C. Emsley, 'The Bedfordshire Police 1840-56: A Case Study in the Working of the Rural Constabulary Act', *Midland History* (1982), pp. 73-92, at pp. 75-6.

11. Cheshire County Record Office QCX 5/1 'Statement for second reading of the Constabulary Bill - Chester'; *CCo,* 20 January 1829; *MGu,* 17 January 1829. For the Irish Constabulary Act of 1822 see Chapter 4.

12. *HPD,* New Series, vol. 3, cols. 740-42 (13 April 1829).

13. Since 10 Geo. IV, c.97 is a private Act, only its title is listed in the volumes of statutes. There are printed copies of the Act in Chapter CRO QCX 5/1; the *CCo,* 30 June 1829, published a useful abstract of the Act; see also *CCo,* 21 July 1829, report of chairman's charge to Quarter Sessions Grand Jury.

14. The sources for determining the strength of the force under the Cheshire Constabulary Act are scanty and, at times, inconsistent with each other. This table represents the best estimates based on the following sources: CFC Report, pp. 110-29; PRO HO 73/5/2, Cheshire Questionnaire answers and 73/2 Abstract of Returns for Cheshire Divisions; HO 73/16 Schedule of Paid Constables in the County of Cheshire (1837); HO 73/2/1 R. Wilbraham Jun. to CFC, 2 December 1836; UCL Chadwick Papers 8/1; *HPD,* vol. 14, cols. 215-19 (July 1832); *CCo,* 18 August 1829.

15. UCL Chadwick Papers 8/1 Examination of Trafford Trafford, 30 September 1837.

16. *CCo,* 20 January 1829; PRO HO 73/2 and 73/5/2 Cheshire questionnaires 1836; HO 73/16, examinations conducted by W. A. Miles concerning the working of the Cheshire Constabulary Act; UCL Chadwick Papers 8/1, examinations conducted by Chadwick, 25 September 1837, concerning the working of the Cheshire Constabulary Act; CFC Report, pp. 111-21, 125-8.

17. For the superintending constables, see Chapter 9.

18. The section of the CFC Report dealing with the workings of the Cheshire Constabulary Act is pp. 110-29.

19. CFC Report, p. 129. In replying to enquiries by the Shropshire JP Sir Baldwin Leighton about the possibilities of appointing paid county police officers, Chadwick expressed a similar view about the Cheshire Constabulary Act: 'It has been only partially carried into operation and though it has succeeded well or rather well appointed officers have done much in particular places yet you will I think see when the evidence is published that the Act is a failure' (UCL, Chadwick Papers, 6 Chadwick to Leighton, 1 November 1837). Leighton's letter to Chadwick, of 11 October 1837, is in PRO HO 73/3.

20. PRO HO 73/2/1 R. Wilbraham, Jun. to Secretary of Constabulary Force Commission, 2 December 1836.

21. Witnesses to CFC, quoted in Report, pp. 111, 115-6, 118-21; *Morning Chronicle*, 3 December 1836, letter from 'Mercator' [George Burgess] *re* the workings of the Cheshire Act; PRO HO 73/3 G. Wilbraham MP to Constabulary Force Commission, 10 December 1836; HO 73/2/1 R. H. Gratton JP to Trafford Trafford, 4 October 1837; UCL Chadwick Papers, 1872 Sir John Stanley to E. J. Stanley, 26 November 1838.

22. For this bill and memorandum, see Chapter 4. The latter is reproduced in full in D. Philips and R. D. Storch, 'Whigs and Coppers: The Grey Ministry's National Police Scheme, 1832', *Historical Research*, vol. 67, no. 162 (1994), pp. 75-90.

23. PRO HO 73/9/2, petitions to Cheshire Quarter Sessions for and against the abolition of paid constables in the hundreds of Nantwich and Eddisbury 1831-2; *HPD*, 3rd Series, vol. 14, cols. 215-19 (10 July 1832), presentation by G. Wilbraham of petition from Cheshire ratepayers against the Cheshire Constabulary Act, asking for its repeal; CFC Report, pp. 111, 118. Melbourne's discussion of Nantwich Hundred and his contrast of it with Macclesfield Hundred closely resembles George Wilbraham's remarks in introducing the petition against the Cheshire Act in the Commons two months later; this suggests that Wilbraham had briefed Melbourne on the workings of the Cheshire Act.

24. CFC Report, pp. 121-5.

25. See Chapter 8.

26. PRO HO 73/2 'Abstract of the Returns from seven Divisions of the County of Chester'; also in HO 73/5/2.

27. PRO HO 73/2/1 R. Wilbraham, Jun. to Secretary of Constabulary Force Commission, 2 December 1836.

28. *CCo*, 24 March 1840, report of Quarter Sessions.

29. UCL Chadwick Papers, 1872, Sir John Stanley to E. J. Stanley, 26 November 1838 (emphasis in original). See also PRO HO 73/2/1 R. H. Gratton JP to Trafford Trafford, 4 October 1837.

30. PRO HO 73/3 G.Wilbraham MP to CFC, 10 December 1836.

31. CFC Report, pp. 110-49. The completed questionnaires are in PRO HO 73/5 (JPs) and HO 73/6-9 (Poor Law Guardians).

32. These forces have been examined, for southern England, by Robert Storch in 'Policing Rural Southern England before the Police', in D. Hay and F. Snyder (eds), *Policing and Prosecution in Britain 1750–1850* (Oxford, 1989), pp. 211-66.

33. For a detailed examination of the working and importance of such Acts, see J. Prest *Liberty and Locality: Parliament, Permissive Legislation, and Ratepayers' Democracies in the Nineteenth Century* (1990).

34. D. Hobbs, 'The Croydon Police, 1829-1840', *Journal of the Police History Society*, 2 (1987), pp. 66-76.

35. 3 & 4 Wm. IV, c.90. On the Act in general, see Prest, *Liberty and Locality*, chapter I.

36. For background on Hume, his ideas and his activities, see Chapter 4.

37. PRO HO 73/5/2, Return of Justices of Atherstone to CFC.

38. C. H. Bracebridge, *A Letter addressed to the Ratepayers of the Hundreds of Hemlingford, Barlichway, and Kineton, in the county of Warwick* (1840) - long extracts published in *The Justice of the Peace*, vol. 4, no. 28 (18 July 1840), pp. 420-1.

39. PRO HO 73/2/1 J. D. Borton to Constabulary Force Commission, 14 January 1839; CFC Report, p. 137.

40. PRO HO 73/2/1 William Wodehouse to Chadwick, 19 January 1839. Certainly Chadwick did not receive the news about the police involving themselves in poaching affairs with joy. He understood that the rural middle classes would not be won over as long as they believed that policing schemes were a landowners' plot to shift the costs of gamekeeping on to the rates. See also CFC Report, pp. 136-7.

41. Kent County Record Office Q/Gpa 2, County Survey on Crime and Police conducted by Kent Quarter Sessions. On the 'Sir William Courtenay' rising, in May 1838, see P. G. Rogers *Battle in Bossenden Wood* (Oxford, 1962) and B. Reay, *The Last Rising of the Agricultural Labourers: Rural Life and Protest in Nineteenth-Century England* (Oxford, 1990).

42. PRO HO 73/9/2 'Report of the Inspectors Appointed under the Statute 3rd and 4th Wm. IV, c. 90 to the General Annual Meeting of the Ratepayers', 24 January 1838.

43. Here a force of a sergeant and two constables was hired in 1837 for a population of 6,500. They wore Metropolitan-style uniforms, and concentrated on vagrancy, beerhouse supervision and the systematic visitation of farmhouses. See Herts. Record Office QSCB/32 (1838).

44. PRO HO 73/5/1 & 2 Returns of JPs of Cumberland, Lancashire, Essex, Suffolk, Sussex, Kent, Hertfordshire, Bedfordshire; HO 73/3 C. F. Sandham to CFC, 3 December 1836 (*re* Shoreham); B. J. Davey, *Lawless and Immoral: Policing a Country Town 1838–1857* (Leicester, 1983) (*re* Horncastle); P. Marsh, 'Policing Ulverston in the 1830s', *Police Review* (June 1966).

45. A problem with some of the borough forces, which were responsible to the ratepayers through the watch committees.

46. See PRO HO 73/2/1 Memorial of 19 Herts. magistrates to Lord John Russell complaining that small ratepayers block the 'respectable inhabitants' (n.d., late 1830s); HO 45/OS 2671 Memorial of Clerk of Peace of Division of South Hunsley Beacon (East Riding) to Sir George Grey, 20 October 1849.

47. UCL Chadwick Papers 3/5, open letter from Thomas Marriott, 'To the Guardians of the Pershore Union', 10 March 1843.

48. CFC Report, p. 140.

49. UCL Chadwick Papers, 6, Letters & Accounts of CFC, Redgrave to Denison, 20 June 1838.

50. See D. Philips, 'Good Men to Associate and Bad Men to Conspire. Associations for the Prosecution of Felons in England 1760-1860', in Hay and Snyder (eds), *Policing and Prosecution*, pp. 113-70.

51. See the discussion in Philips, 'Good Men to Associate', pp. 145-9. The managers of the Bourton-on-the-Water Police Association wrote to the Constabulary Force Commission to voice their suspicions of government schemes of police reform, and to state that the voluntary police association worked well (PRO HO 73/4/1).

52. In PRO HO 73/5/2. Some printed materials of other, more successful, schemes are: *Report of the Beckenham Association for Raising a Fund to Provide and Pay a Police . . .* in PRO HO 73/9/1; *Rules and Regulations Agreed to by the Inspectors of the Stratton Police . . .* (Norfolk), in PRO HO 73/4/1; *Report of the Police Association of Bourton-on-the-Water* (Glos.) in

PRO HO 73/4/1. All of these schemes used former Metropolitan policemen.

53. Information on the Stow Association is drawn from: PRO HO 73/2/1 Magistrates, Stow-on-the-Wold – CFC 8 December 1836; HO 73/5/2 Glos. JPs' Questionnaires; HO 73/7/2 Glos. Poor Law Guardians' Questionnaires; HO 73/9/2 Poster of Stow Association, May 1834, and List of Prisoners Tried 1834-6; CFC Report, pp. 131–3; Storch, 'Policing Rural Southern England', pp. 230-1. The richest source of information on the association has been the diary of the Revd F. E. Witts JP.

54. PRO HO 73/2/1 Magistrates of Stow to CFC, 8 December 1836 (most of this report is reproduced in CFC Report, pp. 131–2).

55. Otway was a good example of the new law-enforcement professional of the 1830s. Starting in the Metropolitan Police, he supervised the Stow Police Association and then did private security work for the Duke of Marlborough at Blenheim; in the early 1840s, he became a superintendent in the Essex county police (Witts Diary, 26 March 1841).

56. HO 73/9/2; Witts Diary, 28 May 1835, 9 August 1838. The Revd F. E. Witts, driving force of the association, was a great believer in the value of figures and statistics; he was a member of the Gloucestershire Quarter Sessions accounts committee and audited their accounts. His contribution to the Quarter Sessions debates on a county police in the years 1839-42 was largely quantitative and statistical; he was very scornful of Sir John Guise's attempt, in April 1842, to reduce the size of the county force with a speech 'making no reference to returns or statistics'. Witts was a clear convert to the 'new police' methods and ideas of the Metropolitan Police and people like Edwin Chadwick (Witts Diaries 1835-1842; *Gloucester Journal*, 8 January, 16 April 1842).

57. Witts Diary, July 1834, 14 November 1836; PRO HO 73/4/1, Bourton-on-the-Water Association to CFC, 9 December 1836; HO 73/5/2 Questionnaire for division of Slaughter; CFC Report, p. 133.

58. PRO HO 73/2/1 Magistrates of Stow to CFC, 8 December 1836; CFC Report, pp. 131–3.

59. PRO HO 73/2/1 Magistrates of Stow to CFC, 8 December 1836.

60. Witts Diary, April-May 1835, quote from 7 May 1835.

61. Witts Diary, July-August 1838, quotes from 27 July and 9 August 1838.

62. Witts Diary, April, August, 1839, October 1840, January, April 1842.

63. For a discussion of the Barnet Association, and the sources available on it, see Philips, 'Good Men to Associate', pp. 145-6, 148-9, and Storch, 'Policing Rural Southern England', pp. 229-30. There is an extensive contemporary account in UCL Chadwick Papers, 13, 'Printed Evidence Taken by the Constabulary Force Commissioners', pp. 52-79.

64. Anon. [William Blake?] *Rural Police. An Address to the Rate-Payers of the County of Hertford* (1841), p. 7.

65. Norfolk probably had more locally initiated police schemes, under all the different categories of 'community' police, than any other county. The Tasburgh Police Association, which covered sixteen parishes, was a voluntary subscription scheme which later converted to the Lighting and Watching Act; the scheme in the Depwade Union around Ashwellthorpe, which included eighteen parishes, did the same. (PRO HO 73/2/1; HO 73/7/1; HO 61/19. Others, such as the schemes covering parishes around Harleston, and

another at Long Stratton, remained under voluntary subscription (PRO HO 73/7/1).

66. PRO HO 73/2/1 Hon. & Revd W. Capel to Russell, 25 February 1839. See also his letter to Samuel March Phillipps at the Home Office, transmitted to Chadwick, in which he says that they had twice tried and failed with a voluntary subscription police at Watford, and would never try one again; the police should be 'a Government measure' (UCL Chadwick Papers, Capel to Phillipps, 14 March 1838).

67. See the discussion in Storch, 'Policing Rural Southern England', pp. 233–5.

68. See, e.g., Extract of a Letter from John Paynter Esq., Boskenna (Cornwall) in *Second Report of County Rate Commission*, Appendix B, p. 93, in which he suggests using the Poor Law Unions as the basis of all local government, including an improved, paid rural police; (Anon.), *Police Regulations for Establishing a System of Morality and Good Order in Rural Districts Under the New Poor Law Act* (1836); PRO HO 73/2 S. Clissold, Rector of Wrentham (and probably author of the above pamphlet), to Chadwick, 18 January 1839; PRO HO 73/4/1 W. Voules to Constabulary Force Commission (n.d.). See the very fully elaborated Poor Law plan of police submitted to the CFC by the Guardian of Swaffham (Suffolk), Henry Day, PRO HO 73/7/2 (Guardians' Returns). He was keen to avoid 'the intervention of a Central Board of Commissioners'.

69. For Richmond's police plans, see Chapters 4 and 6. The clearest and most elaborated rationale for a police under the actual auspices of unions is the Chichester magistrate J. B. Freeland's, *State of the Police in the Rural Districts* (Chichester, 1839). Freeland was close to the Duke of Richmond, and may have been the source of his ideas.

70. See PRO HO 73/2/1 J. P. Kay to Chadwick, 5 January 1836; HO 73/4/1 Frankland Lewis to CFC, 14 January 1836, enclosing report by J. P. Kay of 9 January 1836.

71. See Chapter 3 and Storch, 'Policing Rural Southern England', p. 235. On the Swaffham Poor Law police, see PRO HO 73/2 J. W. Keppel (chairman of Swaffham Union) to Constabulary Force Commission, 10 January 1839.

72. PRO HO 73/5/1 and 73/5/2.

73. PRO HO 73/5/1, emphasis in original.

74. PRO HO 73/5/1 and 73/5/2.

75. *Ibid.*

76. Northern localities were in something of a dilemma. The paid deputy system was largely dependent on the rates. Many localities surely wondered what course to take in view of the legal situation and delayed as long as they could. Parts of the North were not yet fully organized under the New Poor Law at this time. There were, therefore, no Union auditors to stop the practice, whereas in the South auditors were intervening wherever the rates were used for criminal justice purposes.

77. There was, for example, the unique force of fourteen pistol-packing Metropolitans employed for three years on Otmoor by Oxfordshire Quarter Sessions. After Cheshire, this was the earliest force under county auspices, although it was never meant to be permanent. See D. Eastwood, 'Communities, Protest and Police in Early Nineteenth-Century Oxfordshire: The Enclosure of Otmoor Reconsidered,' *Agricultural History Review*, 44 (1996), pp. 35–46. Oxfordshire's experience taught magistrates something

about the great cost of professional forces; they refused to adopt the County Police Acts.

78. See P. Mandler, 'The Making of the New Poor Law *Redivivus*', *Past and Present*, 117 (November 1987), pp. 131-57.

79. This correspondence can be found in PRO HO 73/2, 73/3 and 73/4. We shall note (Chapter 7) that active gentry police reformers did not always support the creation of county police forces.

80. See Chapter 7.

81. Report of Quarter Sessions, *LC*, 19 October 1839.

82. *MOP* (1839), vol. 5, p. 4253, 24 July 1839.

83. There is a useful recent account of the 1831 strike and 1832 lockout in J. Jaffe, *The Struggle for Market Power, Industrial Relations in the British Coal Industry* (Oxford, 1991), chapters 7, 8.

84. 'I understand that a Resolution has been passed by the Magistrates (who are all Coal Owners) at the Coal Trade Office in Newcastle that an application be made to the Secretary of State for an additional force of Infantry to be stationed at Newcastle & Tynem|ou|th in order to control the combination of the workmen'. (PRO HO 40/30 Gen. Bouverie to Phillips, Home Office, 12 April 1832).

85. PRO HO 40/30 Bouverie to Fitzroy Somerset, 17 June 1832.

86. The correspondence between General Bouverie (commander of the Northern District), the Home Office, and the local justices/coal owners, concerning military and police protection for the owners' property and persons, and the maintenance of public order in the colliery district, can be followed in PRO HO 40/30, pp. 93-254, April-October 1832, HO 41/11, April-October 1832, HO 43/42 and 43, March-October 1832.

87. University of Durham Archives (UDA), Grey Papers Melbourne to Grey, 17 March 1832; PRO HO 41/11 Lamb to Williamson, 13 April 1832, Phillipps to Bouverie, 29 May 1832; HO 40/30 Bouverie, to Phillipps, 20 April, 2, 27 May 1832. For Grey's links with men like James Losh of Newcastle, a small colliery owner, see: UDA, Grey Papers Grey to Melbourne, 17 September 1832; E. A. Smith, *Lord Grey 1764–1845* (1990), pp. 41, 150, 213, 227; Jaffe, *Struggle*, p. 93.

88. PRO HO 40/30 Bouverie to Phillipps, 12, 22 June, 16 July 1832 (quote from 12 June); HO 41/11 Phillipps to Bouverie and to C.W. Bigge Esq., 10 July 1832; UDA, Grey Papers Melbourne to Howick, 20 July 1832; *HPD*, 3, 13, cols. 1152-1158. The petition was presented to the House of Lords by Lord Wharncliffe, a prominent Tory politician, who, as chairman of Quarter Sessions of the West Riding, was to play a key role in 1840-41 in his county's debates about whether or not to adopt the County Police Act.

89. PRO HO 41/11 Lamb to Clerk to Magistrates South Shields, 30 July 1832, Melbourne to Bigge, 2 August 1832. On the fate of Melbourne's police bill, see D. Philips and R. D. Storch, 'Whigs and Coppers: The Grey Ministry's National Police Scheme', *Historical Research*, 67, 162 (1994), pp. 75-90 and Chapter 4.

90. UDA, Grey Papers Melbourne to Grey, 12 September, Grey to Melbourne, 17 September, Grey to Melbourne 25 September, Melbourne to Howick, 10 November 1832; quotation from last letter cited.

91. *Durham Advertiser*, 18 October, 22 November, 29 November, 13 December 1839; and see the discussion in Chapter 7.

92. *Newcastle Journal*, 26 October, 30 November 1839; *Newcastle Chronicle*, 23, 30 November 1839; *Newcastle Courant*, 22 November 1839; *Northern Liberator*, 23 November 1839; *Tyne Mercury*, 3 December 1839.
93. Shropshire County Record Office [Sal. CRO] QSF/20/441 Shropshire Clerk of the Peace to Denbighshire Clerk of the Peace, 22 July 1830; *Sal.C.*, 24 December 1830, 7 January 1831; Sal. CRO Abstracts of Quarter Sessions Orders [AQSO], January 1831.
94. On the legal uncertainties, see the letter by Shropshire JP Sir Baldwin Leighton to Chadwick (PRO HO 73/3, 11 October 1837), and Home Secretary Russell's letter to Salop. Quarter Sessions, 24 November 1837, reproduced in *SC*, 5 January 1838.
95. *SHc* 9, 16 December 1831; Sal. CRO AQSO, January 1832.
96. The Cheshire Constabulary Act is briefly discussed by Melbourne in his 'Observations' (see Philips and Storch, 'Whigs and Coppers') when he considers, and dismisses, the option of giving a discretionary power to the magistrates of each county to establish a constabulary force. This would probably have made him unsympathetic to Shropshire's proposal.
97. *SC*, 20 October 1837.
98. *SHc* and *SC*, 4 January 1839.
99. PRO HO 73/3 Leighton to Chadwick, 11 October 1837; Sal. CRO Quarter Sessions [QS] Order Book October 1837; *SC*, 20 October 1837.
100. UCL Chadwick papers, Chadwick to Leighton, 1 November 1837.
101. *SC*, 5 January 1838, *SHc*, 18 October 1839; Royal Archives, Windsor Castle, Melbourne Papers 42/100 Slaney to Melbourne, 11 September 1833.
102. UCL Chadwick papers, Chadwick to Leighton, 1 November 1837.
103. Salop Record Office, QSF/26/407.
104. *SC*, 5 January 1838.
105. See Chapter 6.
106. Salop Record Office, QSF/27/24.
107. On the 'Salop Resolution', its importance and other counties' reactions and initiatives, see Chapter 7.
108. 'Leaves from the Records of the Court of Quarter Sessions for the County of Salop', in *Transactions of the Shropshire Archaeological Society*, Ser. 2, vol. 3, p. 231, January 1839; *SHc*, 4 January, 12 April 1839; *SC*, 4 January 1839; *Mgu*, 9, 30 January, 2 February 1839; *Chester Chronicle*, 4 January, 8, 29 March 1839; *LM*, 19 January 1839; *Copy of a Circular Letter addressed by direction of Lord John Russell to the Chairmen of the Quarter Sessions of all Counties (except Lancaster and Salop) in England and Wales*, PP 1839, XLVII, p. 517.
109. Shropshire was one of the first counties to adopt the County Police Act. The only debate was over the size of the force and its projected cost, see reports of the Quarter Sessions discussions in *SHc* 18 October 1839, 3, 31 January 1840.

Chapter 6

1. UCL, Chadwick Papers, item 1733/I Chadwick to Russell, August 1836.
2. UCL Chadwick Papers, item 1733/I Russell to Chadwick, 1 September 1836. Its official title was 'A Commission to Inquire as to the Best Means of Establishing an Efficient Constabulary Force in the Counties of England and Wales'.
3. See Chapter 4.
4. *HPD*, 3rd Series, 33, 13 May 1836, cols. 905–6; PRO HO 73/2/1 the Revd

F. J. Hilliard to Russell, 8 July 1836; *Report from the Commissioners for inquiring into the COUNTY RATES, and other matters connected therewith.* PP 1836, XXVII; the recommendations for a rural police are at pp. 8–15.

5. PRO HO 43/49 Fox Maule to the Revd J. W. Cunningham, 29 July 1836 and HO 43/51 Fox Maule to W. Gwynn, 24 August 1836.

6. UCL Chadwick Papers, item 1733/I Chadwick to Russell, August 1836. No details of the plan have been discovered.

7. *Report of His Majesty's Commissioners for Inquiring into the . . . Poor Laws*, PP 1834 (44), XXVII, Instructions to Assistant Commissioners, Supplement 3, p. 255.

8. See, e.g. reports of C. H. Maclean, A. Majendie and J. D. Tweedy, in *ibid*, Appendix A, *passim*.

9. See Chapter 4.

10. D. Eastwood, 'Men, Morals and the Machinery of Social Legislation, 1790–1840', *Parliamentary History*, 13, 2 (1994), pp. 190-205, at pp. 200-1. But note that governments were not always able to legislate *strictly* on the recommendations of the Royal Commissions they issued. The Whigs could embody in bills neither the local government reforms suggested by the County Rates Commission nor the police reforms emanating from the CFC. Since in both cases the power and status of the gentry would have been thought to have been gravely touched, backbench resistance would have been very stiff. We shall see that Chadwick, the principal author of the CFC Report, would disavow the rural police legislation actually introduced by the government in 1839.

11. A. Ashforth, 'Reckoning Schemes of Legitimation: On Commissions of Inquiry as Power/Knowledge Forms', *Journal of Historical Sociology*, III, 1 (1990), pp. 1-22, at p. 11.

12. *Ibid.*, p. 2.

13. UCL, Chadwick Papers, item1733/I Chadwick to Russell, August 1836.

14. PRO HO 73/2-4 is a mine of such plans. The Commission kept a log of the more significant and useful plans sent to them (PRO PC 1/2547).

15. Chadwick's claims are generally repeated by S. E. Finer, *The Life and Times of Sir Edwin Chadwick* (1952) and R. A. Lewis, *Edwin Chadwick and the Public Health Movement 1832–1854* (1952), and by L. Radzinowicz, A *History of English Criminal Law and its Administration*, vol. 3 (1956), chapter 15 and vol. 4 (1968), chapters 6, 7. Anthony Brundage is more sceptical of Chadwick's claims in his *England's 'Prussian Minister'. Edwin Chadwick and the Politics of Government Growth, 1832–1854* (University Park, 1988) and 'Ministers, Magistrates and Reformers: The Genesis of the Rural Constabulary Act of 1839', *Parliamentary History*, 5 (1986), pp. 55-64.

16. UCL Chadwick papers 1733/I, Chadwick to Russell, August 1836;

17. PRO 30/22, 2C Chadwick to Russell, 6 September 1836 (copy also in Chadwick Papers 1733/I). Chadwick had set out the utility of employing the police to perform such ancillary public services in his 1829 article 'Preventive Police', pp. 290-1; he expounded on this at greater length in an unpublished draft from 1831-2 (UCL Chadwick Papers item 2/2, [n.d. – internal references show that it was written during the cholera epidemic of 1831-2]). Apart from producing greater efficiency in responding to such problems, he believed that charging the police with these functions would make them popular.

18. UCL Chadwick Papers, item 1733/I Russell to Chadwick, 16, 19, 30 September, 9 October, Chadwick to Russell, 17, 29 September 1836; 1798 Chadwick to Shaw Lefevre, 22 September, Shaw Lefevre to Chadwick, 23 September 1836; WSRO Goodwood MSS, 1876, Russell to Richmond, 22 September 1836; PRO HO 30/22, 2C Richmond to Russell, 2 October 1836.

19. UCL Chadwick Papers, item 1733/I Chadwick to Russell, 15 September 1836, Russell to Chadwick, 16 September 1836 (from which the quotation comes). Russell seems to have been sceptical of the value of Bickersteth's Benthamite views; in 1835, he had written to Melbourne, thanking him for the copy of a paper by Rolfe, and stating: 'it is certainly more practical than Bickersteth's, qui donne dans le Benthamisme'. (Southampton University Library [SUL] Melbourne (Broadlands) Correspondence, MEL/RU/8 Russell to Melbourne, 3 October [1835]).

20. UCL Chadwick Papers, item 1733/I Russell to Chadwick, 1, 16 September 1836, Chadwick to Russell, 3, 15, 17, 19 September 1836, item 1798 Shaw Lefevre to Chadwick, 18 September 1836, Chadwick to Shaw Lefevre, 22 September 1836; PRO 30/22, 2C Shaw Lefevre to Russell, 11, 22 September 1836.

21. WSRO Goodwood MSS, 1876, fol. 1019, Russell to Richmond, 28 April 1836; Richmond to Russell, ibid., 1881 p. 39, Richmond to Russell, 4 May 1836.

22. By T. A. Critchley, A History of Police in England and Wales (1978 edn), p. 69 and following Critchley, Brundage, 'Ministers, Magistrates . . .', p. 56.

23. The 'sketch' is in the hand of J. B. Freeland, a Chichester lawyer and close associate of Richmond, with an insertion in Richmond's hand. It called for a permanent, uniformed, salaried police appointed by the Unions and local guardians. On the model of the Highway Act, magistrates would be able to appoint if the proper authorities failed, WSRO Goodwood MSS, 1881, p. 3, Richmond to Russell, undated but with other 1836 correspondence. Russell's comments to Chadwick about Richmond's 'sketch' refer directly to details in this document (UCL Chadwick Papers 1733, Russell to Chadwick, 1 September 1836). Brundage is probably right to think that Richmond's sketch was Russell's earliest point of departure. In this sense, it was briefly the 'government plan.' But other schemes were under discussion at the time, such as the plan that the Metropolitan Police Commissioners were broaching with Chadwick and Russell. And soon there would be others that would rapidly eclipse Richmond's scheme and, ultimately, the CFC's as well. Russell was famously open-minded and receptive to ideas emanating from many quarters.

24. UCL Chadwick Papers, 1722, Rowan to Chadwick, 5 March 1839.

25. The State of the Police in the Rural Districts (Chichester, 1839). Richmond sent it with a cover letter praising Freeland's ideas (PRO HO 73/71, Richmond to Russell, 15 January 1837. Even if Richmond's lost scheme of May 1837 had no specific reference to Freeland's manuscript, it is inconceivable that he had developed radically different ideas so soon after endorsing it. In fact, Richmond remained faithful to a Poor Law plan of police into the 1850s, rejecting every piece of legislation on the issue from the County Police Act of 1839 to the Superintending Constables Act of 1850.

26. Brundage, 'Ministers, Magistrates and Reformers', p. 62.

27. PRO HO 73/3 Shaw Lefevre to Rowan, 18 September 1837. For details of the former's conception see below.

28. PRO Russell Papers, 30/22/E, Chadwick to Russell, 19 January 1837. The papers of the CFC contain many such reports from Assistant Commissioners such as William Voules, W. J. Gilbert , James Kay and Edward Gulson. See, e.g., Gulson's report on the disposition of Tory aristocrats towards a police measure below, p. 130.

29. PRO HO 30/22, 2C, Chadwick to Russell, 6 September 1836. Miles authored *Suggestions for the Formation of a General Police: In a Letter to the Right Hon. Lord John Russell* (1836). The following year he published *A Letter to Lord John Russell, Concerning Juvenile Delinquency, Together with Suggestions Concerning A Reformatory Establishment,* (1837).

30. UCL Chadwick Papers, item 1733/I Russell to Chadwick, 7 September, 11 October 1836, Chadwick to Russell, 17 September 1836. For Miles (who ended up in charge of the police in Sydney, New South Wales) and his views, see D. Philips, 'An Uneasy Moral Entrepreneur in England and Australia: William Augustus Miles on Police, Pauperism and Crime in the 1830s and 1840s' (Paper delivered at the Fifth Australasian Modern British History Association conference, University of Melbourne, November 1987); and D. Philips, 'The Royal Bastard as Policeman? William Augustus Miles and the Sydney police, 1841-1848', in D. Philips and S. Davies (eds), *A Nation of Rogues? Crime, Law and Punishment in Colonial Australia* (Carlton, Victoria, 1994).

31. The minutes of the Commission are in PRO PC 1/2552. The papers of the Commission (including the completed questionnaires) are in PRO HO 73/2 to 9 and HO 73/16 - 16 large boxes of material. The three questionnaires are reproduced in Appendices 1-3 of the *Constabulary Force Commission Report.*

32. The questionnaires to the Boards of Guardians omitted fifteen of the questions asked of the JPs, but the remaining questions (with one exception) were identical. The completed questionnaires from the magistrates in Petty Sessions are to be found in PRO HO 73/5, and from the Boards of Guardians in HO 73/6-9. No replies from borough watch committees can be found in the papers of the Commission in the PRO.

33. UCL Chadwick Papers, item 3/5, Redgrave to Magistrates in Petty Sessions (printed circular), 8 November 1836.

34. Philips, 'Uneasy Moral Entrepreneur'. Miles' reports for the Constabulary Commission can be found in UCL Chadwick Papers items 4, 13, 1398, and in PRO HO 73/16; and are reprinted in W. A. Miles, *Poverty, Mendicity and Crime; Or, The Facts, Examinations, &c. upon which the Report was Founded, Presented to the House of Lords by W. A. Miles, Esq.* (ed. H. Brandon, 1839), pp. 57-85; his schedule of expenses and movements is in UCL Chadwick Papers, item 7.

35. For Miles' views on crime, vagrancy and policing, see his reports for the Constabulary Commission, in UCL Chadwick Papers, items 4, 13, 1398, in PRO HO 73/16, and reprinted in Miles, *Poverty, Mendicity and Crime*, pp. 57-85; see also his *Suggestions for the Formation of a General Police* (1836), and his *A Letter to Lord John Russell, Concerning Juvenile Delinquency* (1837); and Philips, 'Uneasy Moral Entrepreneur'. Quotations from WSRO Goodwood MSS. 1577 Miles to Richmond, 30 September 1835; *Suggestions*, pp. 8-9.

36. UCL Chadwick Papers, item 1398, report, 9 October 1836 (emphasis in original).
37. Their letters are to be found in UCL Chadwick Papers, items 808, 907, 971, 1130, 2029.
38. UCL Chadwick Papers, item 1733/III Chadwick to Russell, 3 May 1838.
39. Chadwick's personal correspondence is in UCL Chadwick Papers, item 7 of which contains his schedule of movements and expenses on commission business; correspondence with the Commission (addressed to the Secretary, or to one or more of the commissioners) is in PRO HO 73/2, 3 & 4. Transcripts of, or extracts from, the examinations of many of the witnesses (by Miles or Chadwick or others) can be found in UCL Chadwick Papers, items 8, 9, 10; PRO HO 73/16.
40. UCL Chadwick Papers, item 1733/III Chadwick to Russell, 3 May 1838.
41. See Chadwick's long complaint to Russell about the anti-Poor Law and Chartist agitators and their attacks on both himself and the Poor Law assistant commissioners (UCL Chadwick Papers, item 1733/III Chadwick to Russell, 1 February 1837).
42. UCL Chadwick Papers, item 6, Chadwick to Shaw-Kennedy, 22 October 1838, to R. H. Greg, 20 November 1838 (from which the first quotation comes), to Henry Ashworth, 21 November 1838, to each of the three factory inspectors, 21 November 1838, Redgrave to J. F. Foster, 9 January 1839. The replies are in PRO HO 73/2/1 - J. Shaw-Kennedy, 22 November 1838; R. H. Greg, 2 December 1838; Leonard Horner, 5 December 1838, J. F. Foster 23 January 1839 - and HO 73/3 T. Jones Howell, 28 November 1838. Ashton's examination (from which the second quotation comes) is in Chadwick Papers, item 9, and is also quoted in CFC Report, pp. 82-3. Chadwick set out his hostility to trade unions, and his belief in the need for a reformed police to suppress them, in a very long letter to Russell, 29 January 1838 (UCL Chadwick papers item 1733/III). See also UCL Chadwick Papers for Chadwick's earlier correspondence with Henry Ashworth, 8 October, 24 December 1836 (item 203) and with R. H. Greg, 17 September 1834 (item 878); and the letter to the Commission from R. M. Muggeridge, 14 January 1839 (HO 73/3).
43. Letter to the Editor of the *Sun*, 'Rural Police', printed in *Northern Star*, 7 December 1839. Henry Halford MP similarly described the commissioners as 'biased in favour of particular opinions', and the report as 'A body of evidence collected by men appointed for the sake of a particular theory, from witnesses chosen by themselves in support of that theory, not given on oath, and presented to the public in such portions, and with such comments as shall suit their views' (Anon. [Sir Henry Halford] *Some Remarks on The Report of the Constabulary Force Commissioners and upon the Acts Founded On That Report. Respectfully Addressed to The Magistrates of the County of Leicester. By A County Magistrate.* (Leicester, 1840), p. 13.
44. At the outset, Chadwick had demanded of Russell that the other commissioners would not 'hinder the labour' of writing the Report and that he (Chadwick) be allowed to select the other commissioners, UCL Chadwick Papers 1733/I, Chadwick to Russell, August 1836.
45. PRO 30/22, 2C Shaw Lefevre to Russell, 22 September 1836; UCL Chadwick Papers 1733/I, Russell to Chadwick, 9 October 1836.
46. PRO HO 73/3 Shaw Lefevre to Rowan, 18 September 1837.

47. UCL Chadwick Papers 1798, Shaw Lefevre to Chadwick, 30 January 1841.
48. WSRO Goodwood MSS 1589 Rowan to Richmond, January 1837.
49. C. Reith, *A New Study of Police History* (1956) is a sort of biography of Rowan – though Reith greatly exaggerates Rowan's role in the development of the recommendations of the Constabulary Force Commission.
50. UCL Chadwick Papers, item 1722 Rowan to Chadwick, January 1839.
51. WSRO Goodwood MSS 1605 Rowan to Richmond, 2 April 1839 (emphasis in original).
52. *Ibid.*
53. PRO HO 73/3 Shaw Lefevre to Rowan, 18 September 1837. The full plan itself is not to be found with the letter, but Shaw Lefevre states that it is to be based on the establishment of county councils – made up of representatives of the ratepayer-elected Poor Law Boards of Guardians plus some or all of the county JPs sitting *ex officio* – which he and his colleagues had recommended in their *Report of the Commission into County Rates*, p. 50.
54. Brundage, *England's 'Prussian Minister'*, pp. 62–3.
55. UCL Chadwick Papers, item 1722.
56. UCL Chadwick Papers, item 1733/III Chadwick to Russell, 3 May, Russell to Chadwick, 4 May 1838.
57. In something of a jumble in the PRO are fragments of the draft Report in Chadwick's handwriting (HO PRO 73/4) which can be (painfully) compared with the published Report.
58. M. Blaug, 'The Myth of the Old Poor Law and the Making of the New', *Journal of Economic History*, XXIII (1963), pp. 151–84, and 'The Poor Law Report Re-examined', *Journal of Economic History*, XXIV (1964), pp. 229–45.
59. See Anon. [E. Chadwick], 'Preventive Police', *London* Review, I (1829), pp. 252-308. See esp. pp. 252, 272–4, 280–2, 289–90.
60. 'State of the Poorer Classes', in the *British Critic*, (reprinted in *The Times*, 9, 22, 27 July 1840; quotation from 9 July 1840).
61. UCL Chadwick Papers, item 6 Letters and Accounts book of Constabulary Force Commission, Chadwick to the Revd Robert Wilson, 25 November 1837. This series contains similar suggestions made, in November–December 1837, to prison governors about their choice of prisoners for examination, and to authorities in major towns, in August 1837, stressing the Commission's interest in 'the *migratory* habits of thieves and Vagrants' (quotation from Redgrave to Mr Thomas, Manchester, 22 August 1837).
62. PRO HO 73/4/1 draft report in Chadwick's hand; CFC Report, p. 124.
63. CFC Report, p. 1.
64. *Ibid.*, p. 67. Quotes in previous two sentences at pp. 30, 36, 37.
65. 'Preventive Police', p. 271.
66. UCL Chadwick Papers 10, examination of Thomas Fellows.
67. UCL Chadwick Papers 1798, Shaw Lefevre to Chadwick, 14 January 1839.
68. CFC Report, p. 83.
69. *Ibid.*, p. 107.
70. See Chapter 5.
71. CFC Report, p. 141. On the Stow-on-the-Wold Police Association and their voluntary subscription force, see Chapter 5.
72. Brundage, 'Ministers, Magistrates and Reformers', and *England's 'Prussian Minister'*, chapter 4.
73. 'We apprehend,' wrote the *Law Magazine*, 'that any new force must ... be

connected with the new [Poor Law] unions, and perhaps Mr. Chadwick's appointment had reference to their interests.' (*Law Magazine*, XVI (November 1836), p. 491.)

74. PRO HO 73/4/1 & 2.
75. PRO HO 73/4/1 draft. Brundage thinks that the references to Ireland in the drafts were expunged from the final Report owing to the opposition of the other two commissioners. There is no evidence of this. The final report states: 'we are firmly convinced that no system of a constabulary in England that is not based upon that principle which has been established in the case of the constabulary force of Ireland, can be efficient, or remain pure from much corruption, or obtain permanency' (p. 166). (For other references to the Irish model, see pp. 167, 181.) On the Irish Constabulary in this period, see S. Palmer, *Police and Protest in England and Ireland, 1780–1850,* (Cambridge, 1988), chapters. 7, 9.
76. CFC Report, p. 168; cf. draft fragment HO 73/4/1 (somewhat differently phrased).
77. Only a 'distant Central Board', a 'stranger power', unconnected with the local landed or manufacturing classes, would be above local interests (draft fragment HO 73/4/1); *a fortiori* this meant that Boards of Guardians should not make the appointments.
78. Shaw Lefevre was also concerned about local patronage – '[In my plan] I have also kept equally clear of magisterial patronage and poor-law machinery, either of which would be fatal to the measure.' (PRO HO 73/3 Shaw Lefevre to Rowan, 18 September 1837.) When he handed over the Home Office to Lord Normanby, Russell warned him, regarding the County Police Act, that the 'magistrates, when they cease to be frightened will try to job ...' (Normanby Papers V/477 Russell to Normanby, 4 September 1839).
79. PRO HO 73/4/2 fragment of draft CFC Report.
80. PRO HO 73/4/1 fragment of draft CFC Report.
81. *Ibid.*; CFC Report, p. 184.
82. PRO HO 73/4/1 fragment of draft CFC Report. In the final Report, he uses the phrases 'local supervision' and 'control of the appointments' (CFC Report, pp. 166, 177).
83. UCL Chadwick Papers 1733/I Chadwick to Russell, August 1836.
84. PRO HO 73/4/1 fragment of draft CFC Report.
85. Draft passages relating to the ancillary uses of workhouses, and the uses of Union professional staff for organizing Special Constables, were removed from the final Report.
86. CFC Report, pp. 175-6.
87. See Chapter 5. P. Mandler, 'The Making of the New Poor Law *Redivivus*', *Past & Present*, 117 (November 1987), pp. 131-57; see also his contribution to 'Debate: The Making of the New Poor Law *Redivivus*', *ibid.*, 127 (May 1990), pp. 194-201.
88. See Chapter 4.
89. UCL Chadwick Papers, item 1798 Shaw Lefevre to Chadwick, 28 January 1838 (emphasis in original).
90. UCL Chadwick Papers, item 907 Gulson to Chadwick, October 1836 (emphasis in original).
91. On the Shropshire QS motion, Lancashire's favourable response, and Russell's enthusiastic circulation of it to all county QS, see Chapter 5. Russell himself

wrote to the Earl of Derby on 11 January 1839, proposing county police forces under the authority of the county magistrates (*The Times*, 29 January 1839).

92. PRO HO 73/3 Shaw Lefevre to Chadwick [n.d., but internal evidence shows it must be February 1839] (emphasis in original).

93. PRO HO 73/4/1 fragment of draft CFC Report.

94. PRO HO 73/4/1 draft sent to Russell in 1838. The text of the final report (CFC Report, p. 179) was less explicit, but still noted that 'generally we have recommended the permissive course as being, under existing circumstances, the most expedient with the view to the conciliation of voluntary exertions in aid of the operations of the new force'. Implantation could not be abrupt. Nothing would be worse than staffing new forces with ill-trained men. Chadwick imagined London as the great training base for police personnel, from whence they would be hired into new provincial forces. It was important that demand not outrun supply. Hence there was time for the local votes he envisaged.

95. UCL Chadwick Papers 1798, Shaw Lefevre to Chadwick, 2 March 1839; 1733/IV Chadwick to Russell, 4 March 1839.

96. PRO PC 1/2552 Minutes of Constabulary Force Commission (emphasis added).

97. CFC Report, p. 184. Nothing else was changed. In the haste to complete and publish the Report, traces of Chadwick's original conception providing for votes by bodies other than the magistrates were inadvertently left embodied in the text (pp. 177, 179). Rowan and Chadwick sent a follow-up letter to Russell the next day, reiterating that Petty Sessions, Poor Law Unions and parishes would be barred from applying for a police; only Quarter Sessions might apply (UCL Chadwick Papers, 6 Rowan and Chadwick to Russell, 5 March 1839).

98. PRO HO 73/4/2 draft, dated 15 November 1838.

99. Anthony Brundage seems to have conflated these two distinct issues, and credits Shaw Lefevre with forcing Chadwick to take a position at which – as we have shown – Chadwick had already arrived of his own accord.

100. UCL Chadwick Papers 1798, Shaw Lefevre to Chadwick, 27 March 1839 (emphasis in original); CFC Report, p. 184, #297, proposal V.

101. UCL Chadwick Papers, item 1733/IV Russell to Chadwick, 6 March 1839; PRO HO 73/4/1 draft report in Chadwick's hand; the final version is in CFC Report, p. 164 (emphasis added).

102. CFC Report, pp. 164–86; the specific recommendations are set out on p. 184.

103. UCL Chadwick Papers, S. Redgrave to Chadwick, 1657, 28 March 1839.

104. This erroneous version was sent to the *Law Magazine*, which printed it (*Law Magazine*, XXI, February–May 1839). One of the authors possesses yet another version containing only six of the seven recommendations. These errors are further evidence of the haste with which the CFC concluded its labours.

105. UCL Chadwick Papers 1722/I, Chadwick to Russell, August 1836. On Benthamite techniques of utilizing Royal Commissions and Select Committees see S. E. Finer, 'The Transmission of Benthamite Ideas, 1820–50,' in G. Sutherland (ed.), *Studies in the Growth of Nineteenth-Century Government* (1972), pp. 24–6. The idea was to combine 'a manipulated inquiry with a manipulated publicity' p. 26.

106. UCL Chadwick Papers 7, Papers *re* CFC running expenses, shows 3,280

copies of the report distributed to such sources; item 1722 Rowan to Chadwick 22, 27 March, 1, 5, 26 April 1839; item 1798 Shaw Lefevre to Chadwick, 31 March 1839; item 1657 Redgrave to Chadwick, 13 April 1839; UCL Brougham Papers 10, 798 Chadwick to Brougham, 22 April 1839. WSRO Goodwood MSS 1605 Rowan to Richmond, 2 April 1839.

107. UCL Chadwick Papers 1883, G. Stephen to Chadwick, 18 April, 20 April 1839.

108. *The Times* 19 March 1839; *Chester Chronicle*, 29 March, 19 April 1839; *LM*, 13 April 1839; *SHc*, 19 April 1839; *MGu*, 20 April 1839.

109. Finer, *Life*, pp. 173–8; Brundage, *Prussian Minister*, p. 73. The *Northern Star* reprinted, on 25 March 1839 an editorial from the *Morning Herald*, headed 'Rural Police', which criticizes the French centralized preventive police and attacks Melbourne and Russell for 'endeavouring to transplant [this system] into this country'; this presumably refers obliquely to the CFC Report. It also reported a resolution of a Chartist meeting, condemning 'the tyrannical attempts of our oppressive Government to force a Rural Police and Spy System, which is intended to take away the last vestige of our liberties' (6 April 1839). But the *Star* ventured no editorial opinion of its own about the CFC Report. Rowan reported to Chadwick a favourable article in *John Bull* (UCL Chadwick Papers, item 1722 Rowan to Chadwick, 30 April 1839).

110. See Chapter 7.

111. *The Justice of the Peace*, vol. 3, nos. 6, 15, 16 (9 February, 13, 20 April 1839).

112. E.g. *Law Magazine*, 21 (February–May 1839), pp. 258–305; *Monthly Chronicle*, 3 (June 1839), pp. 537–51; *British and Foreign Review*, 9 (June 1839), pp. 64–125. *Taits Edinburgh Magazine* was hostile. Curiously, it was ignored by the *Westminster Review*. Many of these periodicals published excerpts from the Report *in extenso*.

113. See Chapter 5. Chadwick later observed that 'the time was very unfortunate for us: there were violent contests going on, and it [the CFC Report] was little read by Members [of Parliament] ...' UCL Chadwick Papers, item 741, Chadwick to H. Fitzroy at Home Office, 27 January 1854.

114. Brundage, *Prussian Minister*, p. 73. He also continued to be obsessed with the idea that the work of the CFC remained incomplete. He continued to bore successive Home Secretaries into the 1860s with letters requesting authorization to write and issue a second report on further measures for the prevention of crime. (UCL Chadwick Papers, items 6, 7, 15, 16).

115. UCL Chadwick Papers, item 5 'Draft of Thoughts on Adoption of the Constabulary Bill'.

Chapter 7

1. Shropshire County Record Office, QSF/26/407, Clerk of Peace (Salop) to Clerks of Peace (Staffs. and Glos.), 9 November 1837.

2. See Chapter 5.

3. During the existence of the Constabulary Force Commission, the police plans of all the principals became evident – with the exception of Russell, whose preferences remained enigmatic. According to A. P. Donajgrodzki ('Sir James Graham at the Home Office', *Historical Journal*, 20, 1 (1977), pp. 97–120, at p. 101), this was typical of his style of operation. In 1840, Russell claimed to prefer a 'general force', under the control of commissioners and

paid by the government', but did not wish to press his personal opinion (*MOP*, 3, 24 March 1840, p. 1921). He defended the County Police Acts as the best that could be obtained.

4. *A COPY of a CIRCULAR LETTER addressed by direction of Lord John Russell to the Chairmen of the Quarter Sessions of all Counties*, PP (1839) (259) XLVII, dated 29 April 1839. The letter itself was dated 2 February 1839. The 'Salop Resolution' reached other Quarter Sessions in two forms: Russell's circular and another copy sent directly to every other bench in the country by Shropshire itself, see *CC*, 12 April 1839.

5. A number of counties which would ultimately reject the County Police Act of 1839 went on record as supporters of the 'Salop Resolution': eg. Berkshire, Buckinghamshire, Cornwall, Lincolnshire (Kesteven), Oxford, and Yorkshire (North Riding). Even at this stage, counties displayed nervousness about the cost, e.g. Devon, which demanded that the Consolidated Fund pay half, (Devon County Record Office, Quarter Sessions Order Book 1/28, Devon Midsummer Sessions).

6. This highlighted again government's long-standing alarm whenever the army was required to engage in activities construed as policing, and its general concern about the role of the army in keeping order, its high costs and the effects on military morale, UCL Chadwick Papers, 1657, S. Redgrave to Chadwick, 30 January 1839. Redgrave, a Home Office official (and at the time Secretary to the CFC), was intimately involved in the correspondence with General Jackson. The latter was made public and appeared in *The Times*, 29 January 1839. See also L. Radzinowicz, 'New Departures in Maintaining Public Order in the Face of Chartist Disturbances', *Cambridge Law Journal*, (April 1960), pp. 51–80, at p. 72.

7. See Chapter 5.

8. *MGu*, 2 February 1839, report of meeting of Lancs. magistrates and editorial; *Chester Chronicle*, 8 February 1839.

9. *MGu*, 2 February 1839.

10. See Chapter 8.

11. MS Diary of the Revd F. E. Witts, 9 April 1839; Essex County Record Office, Quarter Sessions Order Book Q/SO36, Sessions of 9 April 1839, *CC*, 12 April 1839. Essex was moving towards some kind of professional, paid police, but sentiment was still strongly in favour of putting constabulary appointments in the hands of the Petty Sessions. The alarm of the Constabulary Force Commissioners regarding what pro-police counties might choose to do on their own (see Chapter 6) was justified.

12. Russell was prepared to be patient on this issue. Had it not been for the extraordinary disturbances of the summer of 1839, Russell might have been willing merely to continue his publicizing and encouraging initiatives for some time. See F. C. Mather, *Public Order in the Age of the Chartists* (Manchester, 1959), pp. 4–5, n. 4. *The Times* (23 April 1839) took Russell's initiatives vis-à-vis the justices as a signal that a reform was in preparation, but unlike 1832, the government appears to have had no bill prepared in the spring of 1839.

13. Radzinowicz ('New Departures ... p. 80) views Russell as a reluctant reformer who 'regarded the police establishment as a mere dispensable innovation' and, but for the Chartist scare of 1839, might have postponed legislation. We agree with the last point, but Russell was no recent convert to

reformed policing; it had been on his agenda for at least three years. Radzinowicz supports his argument with Russell's public rhetoric during the parliamentary debates on the 1839 bill, taking it at face value. Russell's objective was to sway a House dominated by landowners to vote for a completely new departure in law-and-order policy. See our observations below on Russell's crafty presentation of the measure.

14. 2 & 3 Vic., c. 93. It will be referred to as 'the County Police Act'.
15. On the functioning of the Birmingham Police for its first three years, under a government commissioner, see M. Weaver, 'The New Science of Policing: Crime and the Birmingham Police Force, 1839-1842', *Albion*, 26, 2 (1994), pp. 289-308; T. A Critchley, *A History of Police in England and Wales* (2nd edn 1978), pp. 80-88. An interesting contemporary perspective by an admittedly disgruntled ex-member of the force is G. Bakewell, *Observations on the Construction of the New Police Force* (1842).
16. See *The Times* and *MGu*, 17 July-28 August 1839; *Aris's Birmingham Gazette*, 29 July, 5, 12, 19, 26 August 1839; Mather *Public Order*, chapter IV; Palmer, *Police and Protest*, pp. 411-29; Emsley, *The English Police*, pp. 41-2; W. Watts Miller, 'Party Politics, Class Interest and Reform of the Police, 1829-56' in R. Reiner (ed.), *Policing*, vol. 1 of *International Library of Criminology, Criminal Justice and Penology* (Aldershot, 1996), pp. 99-117, at pp. 108-9.
17. Critics noticed Russell's rhetorical sleight of hand. C. H. Bracebridge pointed out that under the Special Constables Act justices had to certify on oath that a riotous (or potentially riotous) situation prevailed and that invocation of the Act was only 'for a *local object*, and for a *short definite period of time*'. The County Police Act required no oath, was not designed to cope only with emergencies, and was to be permanent, *A Letter addressed to the Ratepayers of the Hundreds of Hemlingford, Barlichway and Kineton, in the county of Warwick* (1840), (extracts reproduced in *The Justice of the Peace*, IV, 28, 11 July 1840, p. 421), emphasis in original.
18. *MOP*, vol. 5, 24 July 1839, pp. 4251-2.
19. HPD, 3rd Series, vol. 49, 24 July 1839, cols. 729-30. Peel believed (incorrectly) that the government were 'seriously alarmed'. Russell had no hesitation about leaving the Home Office to Normanby and moving to the Colonial Office at precisely this moment, remarking to Melbourne: 'Holland ... dislikes my leaving the Home Office ... still ... *the real danger is in the Colonies,* Broadlands Papers, Southampton University, MEL/RU/97, Melbourne to Russell, 22 August 1839. Our emphasis.
20. See, e.g. J. Pye Esq., in debate in Derbys. Quarter Sessions [hereafter QS] (*DC*, 4 January 1840).
21. 3 & 4 Vic., c. 88. The two Acts together will be referred to as 'the County Police Acts'.
22. Anon. [Sir Henry Halford, Leicestershire MP and county magistrate], *Some Remarks on The Report of the Constabulary Force Commissioners and upon the Acts Founded On That Report. Respectfully Addressed to The Magistrates of the County of Leicester. By A County Magistrate.* (Leicester 1840), p. 3.
23. HPD, 3rd Series, vol. 50, 8 and 15 August 1839, cols. 116-7, 356-8. (Commons); 20 August 1839, cols. 453-6 (Lords).
24. W. Watts Miller, 'Party Politics', table, p. 110. This pattern was reproduced in the Quarter Sessions votes on adoption with one obvious exception: there were few radicals on county benches. Generally speaking, in most counties

the Whigs were usually solidly in favour of the measure, although there were exceptions. The Tories were split. Often outcomes were determined by the *degree* to which the Tories were divided, the latter invariably constituting a majority of the justices.

25. *NC*, 26 October 1839, report of QS (Weyland).
26. UCL Chadwick Papers, item 5, draft MS, in Chadwick's hand, on the 1839 County Police Bill.
27. County Police Act 1839, s.1.
28. On the critical state of Whig finances in the late 1830s, see discussions within the government in Broadlands Papers, Southampton University, Russell to Melbourne, 28 August 1837, MEL/RU/42/3, Melbourne to Russell, 30 August 1837, MEL/RU/393, Russell to Melbourne, 16 August 1838, MEL/RU/52; also see N. Gash, *Reaction and Reconstruction in English Politics 1832–1852* (Oxford, 1965), p. 177.
29. 3 & 4 Vic., c. 88. See *HPD*, 3rd Series, vol. 50, cols. 387-90 for its introduction and justification.
30. The only abolition was the disestablishment of the divisional force for Kington, Herefordshire in 1850 - see PRO HO 45/OS3302, Magistrates of Kington Division to Home Office. Home Secretary Sir George Grey minuted 'approved'.
31. These clauses were added at Peel's suggestion. See Fox Maule's remarks in *HPD*, 3rd Series, 56, 3 March 1841, col. 1298.
32. UCL Chadwick Papers 907, Gulson to Chadwick October 1836 (emphasis in original). For the paragraph preceding this one, about Tory gentry and aristocratic views, see Chapters 4 and 6.
33. PRO HO 73/3 Head to Chadwick, 9 February 1839 (emphasis in original); see also his letters to Chadwick of 13 & 20, January 1839.
34. UCL Chadwick Papers 322, Blake to Chadwick, 27 October 1840.
35. An index of the seriousness with which Quarter Sessions treated the issue was the commissioning of county surveys on crime and policing by Quarter Sessions. Questionnaires were sent to Petty Sessions and/or the parishes to sound out opinion on the ground. For Sussex see *SAd*, 11 November 1839. After the formation of the East Sussex force, Petty Sessions and parishes were surveyed on satisfaction levels (East Sussex Record Office, QAC/1/2); for Herts. (1839), Hertfordshire Record Office, QSCB/32; Kent (1840), Kent Record Office Q/GPa2; Surrey also surveyed the parishes and Petty Sessions (report in *CC*, 29 November 1839). There were, perhaps, others of which we are unaware.
36. *WG*, 9 November 1839.
37. *SCH*, 8 February 1840 (Kerrick).
38. *DC*, 8 January 1840, report of Derbys. QS Epiphany 1840. See also P. E. Towneley, Lancs. QS (*PC*, November 1839); Bennett Martin, W. Riding QS (*LI*, 17 April 1841).
39. UCL Chadwick Papers, 229, Baker to Chadwick, 5 June 1839. By the 1860s, Baker had become an enthusiast for the Gloucestershire Constabulary.
40. *SCh*, 4 January 1840 (the Revd C. Clarke).
41. *WFP*, 15 April 1839.
42. PRO HO 73/2/1 Acworth to Russell, 23 October 1837. See Chapter 3 for the spread of these notions among provincial gentlemen in the 1830s.
43. See Chapter 6. The 'Migration Thesis' seemingly originated in the debates

over the policing of London in the 1820s. Peel's speech on the Metropolis Police Bill, *MOP*, vol. 2, 15 April 1829, p. 1327, demanded a more uniform police in London because varying degrees of impunity existed between the parishes, forcing thieves into the less well-policed ones. Sir Richard Birnie employed it as early as 1822 (Watts Miller, 'Party Politics', p. 100).

44. *Second Report Royal Commission on County Rates*, PP 1836, XXVII, Appendix B, test. B. C. Cator, p. 121.

45. WC, 16 October 1839, report of QS. See, similarly, C. Bathurst, Glos. QS (*GC*, 19 October 1839); Lord Dartmouth, Staffs. QS (*WCh*, 27 November 1839); W. B. Higgins, Beds. QS (*Bedford Mercury*, 4 January 1840); E. Strutt MP & P. Heacock, Derbys. QS (*DC*, 4 January 1840); the Revd H. B. Cooke, W. Riding QS (*LI*, 26 September 1840); Edward Dawson, Leics. QS (*LC*, 19 October 1839); editorial comment in *SHc*, 27 December 1839.

46. There has been a contemporary debate about this. J. Hart, apparently, is now at one with J. Tobias (*Crime and Industrial Society in the Nineteenth Century* (1967), pp. 233–6) in crediting this phenomenon, 'Police', in W. R. Cornish *et al.* (eds), *Crime and the Law in Nineteenth-Century Britain* (London, 1978), p. 195.

47. *BG*, 24 October 1840 (G. Pigott).

48. See our discussion of Kent in Chapter 8.

49. *WFP*, 6 January 1840.

50. *IJ*, 23 March 1844.

51. *MG*, 25 August 1840.

52. See e.g. the speech of Mr Godfrey JP in Suffolk, *SCh*, 4 January 1840.

53. *BH*, 26 October 1839, reporting R. L. Orlebar in Beds. QS. The issue was not new. In the 1829 debate on the Metropolis Police Bill, it was the Whigs who argued that a uniform rate would be unfair to the less densely populated outer parishes. See speech of Lord Holland, *MOP*, vol. 3, 5 June 1829, p. 2051.

54. *SAd*, 9 July 1844.

55. *SCh*, 11 January 1840.

56. *BH*, 26 October 1839, emphasis added.

57. *LM*, 12 December 1840. The identical point was raised in the Quarter Sessions of Derbyshire, another county divided between substantial industrial and agricultural areas – *DC*, 24 October 1840.

58. See discussion of the West Riding in Chapter 8.

59. Although the state had progressively taken steps, since the middle of the eighteenth century, to lighten the burden of expense – see D. Philips, *Crime and Authority in Victorian England* (1977), pp. 112–13, and 'Crime, Law and Punishment' in P. O'Brien and R. Quinault (eds), *The Industrial Revolution and British Society* (1993), pp. 165–6.

60. *SCh*, 11 January 1840.

61. *AN*, 4 January 1840.

62. *Durham Advertiser* editorial 'The Rural Police', 29 November 1839. Cf. editorial in *Chester Chronicle*, 18 October 1839, complained that the 'magisterial estimate of the people … is, that they are in a constant state of insurrection – and that the only preventive is by … studding the country … with a drilled, armed and military accoutered police force … Now we at once protest against the county … being treated as if it was in a state of insurrection … We deny the necessity for any setting aside the constitution of the land …'

63. See Radzinowicz, *History*, vol. 3; Critchley, *History*, chapters 1, 2; Emsley, *Policing*, chapters 1-3; Philips, 'A New Engine'; Palmer, *Police and Protest*, chapters 3, 5, 8; R. Reiner, *The Politics of the Police* (Brighton, 1985), chapter 1.

64. In addition, *The Times* carried on an editorial war against the Constabulary Force Commission and the later legislation (19, 21, 31 October 1840). They linked it to the New Poor Law, which the paper had also long opposed. *The Times* reprinted all examples they could find of provincial opposition to establishing county forces.

65. Letter 'To The Magistrates of the County of Nottingham', *NJ*, 19 March 1840, approvingly reprinted by *The Times* 1 April 1840. The appeal to Alfred could cut both ways. Lord Nugent asked: 'Did [his opponent] refer to Saxon times . . .? If so [they] would find that the magistrates were then elected . . .', *BG*, 24 October 1840.

66. Anon. [Halford] *Some Remarks*, p. 37. See also C. H. Bracebridge, *A Letter addressed to the Ratepayers of the Hundreds of Hemlingford, Barlichway, and Kineton, in the county of Warwick* (London 1840) - extracts published in *The Justice of the Peace*, vol. 4, no. 28 (18 July 1840), pp. 420-21. Disraeli, of course, took this line. See also, the Revd C. D. Brereton, *A Letter to the Lord Lieutenant and Magistrates of the County of Norfolk on the Proposed Innovation in the Rural Police* (Swaffham, n.d.[December 1839]) and *A Refutation of the First Report of the Constabulary Force Commissioners* (3 parts, 1840). Brereton, the rector of Little Massingham, was *not* a justice.

67. See his letter in *LI*, 18 April 1840, arguing that the choice was between a 'French system of *centralisation*' and the '*old* English system of *local* government'.

68. *MG*, 3 November 1840, *BG*, 24 October 1840.

69. UCL Chadwick Papers, item 1722 Rowan to Chadwick, 26 April 1839 (emphasis in original). Finer, *Life and Times*, p. 171, quotes most of this passage, but misreads 'humbug' as 'cry', and surprisingly misattributes it as a letter of Rowan and Chadwick to Russell, 5 March 1839. The British Parliament in 1833 had emancipated all slaves in the British Empire and voted £20 million to compensate the slave-owners.

70. The hyperbolic rhetoric of the *Chester Chronicle* (n. 38) was merely a preface to a serious point: that the Act would have the effect of 'depriving the ratepayers of the present control of local government, as respects means to preserve the public peace . . .', which was indeed a concrete implication of the measure.

71. *LI*, 17 April 1841, report of Adjourned QS.

72. UCL Chadwick Papers, 907, Gulson to Chadwick, October 1836 (emphasis in original); see Chapter 6.

73. This emerged clearly in *The Times* and in the Tory provincial press: e.g. the *Northampton Herald*, 28 December 1839, stated that 'we have within us as Englishmen an unconquerable hatred of gens d'armerie, and to every thing savouring of that centralising principle, which *might* be nowhere so triumphantly or so tyrannically exercised, as in the appointment of a Police in direct communication and connexion with the Government of the day' (emphasis in original).

74. *DC*, 4 January 1840, report of Derbys. QS. For other examples, see Storch, 'Policing Rural Southern England', pp. 238-47. The *LI* warned that adopting the County Police Act meant 'The French system of Centralization' (18 April 1840) and that 'the control of the police is taken away from the local

magistracy and vested in the Home Secretary, who governs through the Chief Constable' (26 September 1840).

75. *MG*, 25 August 1840 (W. Deedes). Also the similar statements of Hughes in *Hampshire Independent*, 13 April 1839; Duffield in *BI*, 19 October 1839; Carrington in *AN*, 26 October 1839; Heathcote, *JOJ*, 23 November 1839.

76. Absolutely unique were the remarks of the Norfolk Whig Sir Jacob Astley, who said that he, personally, would prefer to be tried by a barrister than two justices, *NC*, 30 November 1839.

77. *LM*, 12 December 1840.

78. *NC*, 30 November 1839.

79. See, for example, the remarks of George Palmer MP (*CC*, 29 November 1839), who reminded Essex Quarter Sessions that the New Poor Law Act had transferred power from the magistrates to the Poor Law Commissioners, and that Hume's bills on County Councils appeared to have had the initial backing of the government. This was proof of the perfidy of the Whigs, who really did harbour the intention of wrecking the magistracy.

80. See R. Lévy and X. Rousseaux, 'États, Justice Pénale et Histoire: Bilan et Perpectives', *Droit et Société*, 20/21 (1992), pp. 249-78; Philips, 'New Engine . . .' *passim*.

81. *Chester Chronicle*, 25 October 1839.

82. A glance at the various crime and police surveys of the parishes commissioned by Quarter Sessions in this period bears this out. See e.g. the Hertfordshire survey in Herts. Record Office, QSCB/32, the results of the Bucks survey in *BG*, 24 October 1840 and the E. Sussex survey in East Sussex Record Office, QAC/1/E2. The results of the Guardians' questionnaires returned to the CFC in 1836 were predictive of the ratepayer response.

83. We have borrowed this useful term from D. Eastwood, *Governing Rural England*.

84. In general see J. Prest, *Liberty and Locality. Parliament, Permissive Legislation and Ratepayers' Democracies in the Nineteenth Century* (Oxford, 1990).

85. *SCh*, 1 February 1840.

86. A letter from 'A Farmer', *NC*, 30 November 1839, is typical.

87. *Ibid*.

88. See Chapter 8.

89. *BC*, 4 January 1840 (Eyston); *SCh*, 4 January 1840 (Clarke). Prof. Henslow, having declared himself a representative of the ratepayers, then cast a vote in W. Suffolk Sessions of which they would not have approved, *SCh*, 26 October 1844. D. Eastwood, *Governing Rural England*, pp. 74-5, links these notions to a 'quasi-Burkean view'. Justices 'represented nobody, but they virtually represented the . . . dominant interests within English rural society'. True, but in the policing debates they put forward claims to represent interests beyond those.

90. *SCh*, 4 January 1840. Some justices even opposed receiving ratepayer petitions. Glos. Quarter Sessions actually resolved not to do so by a large majority, *GC*, 9 November 1839.

91. *SCh*, 4 January 1840.

92. *LM*, 17 April 1841.

93. *Chester Chronicle*, 18 October 1839. This was the standard complaint about the Lighting and Watching Act: the ratepayers could not be persuaded to do the proper thing.

94. *LM*, 17 April 1841. He was rebuked for this statement by his political ally, Lord Wharncliffe, who reaffirmed the responsibility of justices to the *crown*. The matter was not solely 'one of payment of the rates, and ... hardship to individuals'.

95. Anon. [the Revd S. Clissold], *Police Regulations for Establishing a System of Morality and Good Order in Rural Districts* . . . (London, 1836), p. 5.

96. *SHc*, 18 October 1839.

97. *WC*, 16 October 1839 (Pakington); *MGu*, 2 February 1839 (Horton, in Lancs. debate on Russell's letter *re* rural police); *LI*, 13 February 1841 (Horton, W. Riding). The *LC* (26 October 1840) hailed their Quarter Sessions' adoption of the Act and predicted that 'Eventually, the economy of an organized police force will be generally and freely acknowledged by the ratepayers'. See also Lord Ellenborough, Glos., who called for 'as large a force as would crush crime' if they wanted to 'reduce the county rate' (*GC*, 19 October 1839); CFC Report, pp. 160–4.

98. Some justices on both sides of the issue believed that wherever short leases prevailed, the costs would ultimately fall on the landowners, or be shared between farmers and landowners, (*SCh*, 4 January 1840 [Godfrey], *MG*, 2 August 1840 [Behrens], *NC*, 15 January 1842 [Earl of Orford]). Malthus thought that when new leases were made, taxes were 'generally thrown off upon the landlord', *Observations on the Effects of the Corn Laws* (2nd edn, 1814), p. 53. To whatever extent this *was* true, it would have entered the calculations of justices as landowners. Farmers were not persuaded by such assurances.

99. E. Cannan, *The History of Local Rates in England* (London, 1912), chapter 4, esp. pp. 88–101. Amazingly, still the standard work on the subject.

100. See e.g. in Derbys. QS, W. J. Bagshawe and Sir George Crewe MP (*DM*, 6 November 1839), Lord Waterpark (*DC*, 4 January 1840). Edmund Denison, a West Riding JP, argued that, precisely *because* magistrates were appointed for life and never faced an electorate like MPs, they 'ought to be doubly cautious' in imposing a large 'annually recurring tax' like a police rate (*LI*, 17 April 1841, report of QS).

101. For Derbyshire, see Chapter 8; for Gloucestershire, see Gloucestershire Record Office Q/SO 17 Quarter Sessions Order Book 1836–1845; Q/AP 5–9 Petitions & Correspondence *re* the Formation of the Glos. Police Force 1839–42; Q/AP 1–4 Correspondence & Papers *re* Establishment of Glos. Police Force 1839–43; Q/SM 3/5 Quarter Sessions Minute Books 1839–43; *Gloucester Journal*, 19 October 1839, 8 January, 16 April 1842; *GC*, 19 October 1839.

102. In 1841 and 1842, their normal county rate never rose above $^{3}\!/_{4}$d. in the £, while the special Constabulary rate alone was as high as 1d. in the £ (Gloucestershire County Record Office Q/SM 3/5 Quarter Sessions Minute Book 1839–43).

103. E.g. The *Chester Chronicle* strongly opposed adoption of the Act as 'one of absolute coercion ... so Tory in its principle', by which 'the county will be saddled with a twopenny rate to maintain an unnecessary force' (18 October 1839). It was joined in opposition to the Act by its fierce antagonist, the strongly Tory *CCo*, which derided the Whig government 'for their attempt to thrust down the throats of the Ratepayers the new Rural Police Act, which is quite certain ... to entail an enormous increase upon the County Rates' (7

January 1840). The West Riding Tory magistrate and MP, Edmund Denison, maintained a consistent opposition over fifteen years to a county force on the grounds of expense. He was supported by the *LM,* a newspaper strongly opposed to him politically (editorials 8 November 1851, 17 November 1855). See also Anon. [Halford], *Some Remarks,* pp. 8–10.

104. *SCh,* 1 February 1840, report of ratepayers' meeting at Stowmarket.

105. Eastwood provides the example of J. Lechmere JP, an Oxfordshire supporter of rural police reform. Shocked at the projected cost estimates, he voted against the County Police Acts, saying 'even gold may be purchased too dear,' *Governing Rural England ...,* p. 237, n. 72. There were Lechmeres everywhere.

106. For Leicestershire's initial appointment of this tiny force for the whole county, see Chapter 8.

107. See reports of W. Riding QS in *LI,* 11 April, 12 December 1840, 17 April 1841, *LM,* 8 November 1851.

108. In the former category would have been the West Riding; Devon and Somerset in the latter. See the ludicrous speech of Somerset Quarter Sessions chairman Sir James Bathurst in *WFP,* 6 January 1840. In one breath he denounced the County Police Acts as unconstitutional; in the next he declared himself favourable to a 'uniform system of police for the whole country, and that it should be paid ... by general taxation'.

109. The County Police Act 1839 (s.28) construed the word 'county' 'to mean County, Riding, or Division having a separate Court of Quarter Sessions of the Peace'. We have followed this definition in counting as counties those divisions of counties with separate Quarter Sessions jurisdiction (East, West and North Ridings of Yorkshire; parts of Holland, Lindsey and Kesteven in Lincolnshire; East and West Suffolk and Sussex; Isle of Ely). This list is of English counties only, and does not include the Welsh counties, which were also affected by the County Police Act. For these two reasons, there is a slight variation in the number of counties listed in different accounts: see D. Foster, *The Rural Constabulary Act 1839* (London 1982), chapter 3; C. Emsley, *Policing,* p. 72; Critchley, *History,* p. 89; Palmer, *Police and Protest,* p. 442. We excluded Middlesex.

110. *Gloucester Journal,* 19 October 1839; *GC,* 19 October 1839; *WGS,* 19 October 1839; *CC,* 29 November 1839; *SHc,* 18 October 1839; *WC,* 16 October 1839; *WG,* 19 October 1839; *LC,* 19 October 1839; *MGu,* 23 October 1839; *PC,* 9 November 1839; *Durham Advertiser,* 22 November 1839; R. Foster, *The Politics of County Power: Wellington and the Hampshire Gentlemen, 1820–1852* (1990), chapter 5; Storch, 'Policing Rural Southern England', pp. 236–52.

111. *Bedford Mercury,* 4 January 1840; *Northampton Herald,* 4 January 1840; Storch, 'Policing Rural England', pp. 245–52; C. Emsley 'The Bedfordshire Police 1840-1856: A Case Study in the Working of the Rural Constabulary Act', *Midland History* (1982), pp. 73–92.

112. *NJ,* 15 November, 22 November 1839, 3 January 1840; *MGu,* 29 April 1840. The Duke of Newcastle, an outspoken opponent of the 'new police', led the opposition here. Of the three crucial meetings of Quarter Sessions in November 1839 and January 1840, two were not held in open court, so the newspapers were unable to report details of the debates and the voting. At the April 1840 meeting, the vote in favour of a police force was a decisive 33–9.

113. Reports of Cumberland Michaelmas Quarter Sessions, in *Carlisle Journal*, 19 October 1839 and *Cumberland Pacquet*, 22 October 1839. The force was established with one superintendent and three policemen; as late as 1853, it had grown no bigger (*First Report from the Select Committee on Police; with the Minutes of Evidence*, PP 1852-3, XXXVI, 1-159, at p. 87 (evidence of T. H. Redin)).

114. Reports of Staffordshire Michaelmas and Adjourned Quarter Sessions, in *SA*, 23 November 1839 and *WC*, 23 October, 6 and 27 November 1839 In November 1842, following serious Chartist strikes and riots, Staffordshire opted to set up a force for the whole county, making use of the amending Act to divide the county into three differently rated districts - see D. Philips, *Crime and Authority in Victorian England: The Black Country 1835–1860* (1977), chapter 3.

115. *Aris's Birmingham Gazette*, 6 January 1840, report of Warwickshire Epiphany Quarter Sessions.

116. *HT*, 22 August 1840; *JOJ*, 11 April 1840; *The Times*, 26 October 1840; *Yorkshire Gazette*, 11 April 1840; *Westmorland Gazette*, 19 October 1839; D. Eastwood *Governing Rural England. Tradition and Transformation in Local Government 1780-1840* (Oxford, 1994), chapter 9; D. Foster 'Police Reform and Public Opinion in Rural Yorkshire', *Journal of Local Studies*, vol. 2, no. 1 (Spring 1982), pp. 1-8, and 'The East Riding Constabulary in the Nineteenth Century', *Northern History*, vol. 21 (1985), pp. 193-211. On the complicated situation in the West Riding, see Chapter 8.

117. *Cambridge Independent Press*, 10 April 1841; *HT*, 9 January 1841.

118. *Westmorland Gazette*, 20 April, 11, 18 May, 20 July, 10 August 1844, 14 April, 16 May, 6 June 1846; *Kendal Mercury*, 16 May 1846. For superintending constables, see Chapter 9.

119. For example, Storch, 'Policing Rural Southern England ...', p. 250, failed to find a strong relationship between adoption of the County Police Act and the intensity of 'Captain Swing' disturbances in the southern counties.

120. See the 1836 results by county in Appendix A, **Table A:1.**

121. See the interesting discussion on this point in D. Eastwood, *Government and Community in the English Provinces, 1700–1870* (Basingstoke, 1997), pp. 100-2.

122. See Chapter 5.

123. C. Emsley, 'The Bedfordshire Police 1840-56: A Case Study in the Working of the Rural Constabulary Act', *Midland History*, 7 (1982), pp. 73-92.

124. See Chapter 5.

125. *SHc*, 18 October 1839, report of QS. It should be noted that even in Shropshire, the force ultimately created was quite small.

126. See Chapter 5.

127. *Durham Advertiser*, 22 November 1839, report of QS.

128. *PC*, 9 November 1839, report of QS; *Chester Chronicle* 15 November 1839. The force established was one chief constable and 500 men; a parliamentary return in March 1840 listed Lancashire as the largest new county force with 500 men, and Leicestershire as the smallest with only 26 (*MGu*, 21 March, 1 April 1840).

129. *WC*, 16 October 1839 and *WG*, 19 October 1839 - reports of QS.

130. *GC*, 19 October 1839 and *Gloucester Journal*, 19 October 1839 - reports of QS; Gloucestershire Record Office Q/SO 17 Quarter Sessions Order Book,

15 October 1839, Q/SM 3/4 Quarter Sessions Minute Book, 15 October 1839.

131. See Chapter 8.
132. See the full account of the Berkshire debates in Chapter 8. There is also an account in Storch, 'Policing Rural Southern England', pp. 243–5, which missed the latter factor.
133. See Chapter 8.
134. See his charge to the Grand Jury in *WFP*, 24 October 1839. The cost factor was paramount here. Devon responded positively to the 'Salop Resolution,' and created a 'Constabulary Force Committee' in the summer of 1839 to study the issue. By the time the committee reported in the spring of 1840, there had been a considerable ratepayer mobilization (*Exeter Flying Post*, 16 April 1840). No vote was ever taken in Devon. The order for the consideration of the Constabulary Force Committee report was discharged; silence then prevailed.
135. See R. D. Storch, 'Policing Rural Southern England Before the Police', pp. 247–9, and R. Wells, 'Implementation and Non-Implementation of the 1839–40 Policing Acts in East and West Sussex', *Policing and Society*, 1, 4 (1991), pp. 299–317.
136. For a detailed discussion of the debates in these counties, see Chapter 8.
137. Norfolk Record Office, P/3033, Petition from ratepayers of the Blofield and Walsham Hundreds (1840), *Norwich Mercury*, 31 October 1840; C. D. Brereton, *A Refutation of the First Report of the Constabulary Force Commissioners* (n.d. [1840]), Pt. III, pp. 52–4. On the conflict between Blofield and the Norfolk Constabulary, see Storch 'Policing Rural Southern England', p. 232. Blofield had operated under the Lighting and Watching Act, but the leading spirit, the Revd J. D. Borton, continued to prefer a Poor Law police, with appointments and control vested in the Boards of Guardians, PRO HO 73/2/1, J. D. Borton to CFC, 14 January 1839. In 1836, the Atherstone (Warks) justices told the Constabulary Force Commissioners that they wished to remain as they were, as did the committee of the Bourton-on-the-Water Police Association, PRO HO 73/5/2, Return of Atherstone Division to CFC; 'Report of the Police Association of Bourton-on-the-Water,' in PRO HO 73/4/1. Other projectors and managers of the local forces of the 1830s such as the Revd F. Witts (Stow Police Association) and Thomas Dimsdale (Barnet General Association) were great enthusiasts for a county police.
138. See accounts of debates in the West Riding and Kent (Chapter 8), where such factors played a role.
139. This would have been the case in Devon, Somerset and, probably, many other counties. Devon magistrates agreed that the principles of the County Police Act were unobjectionable, but unless the government paid 50 per cent of the cost it could not be carried (*WFP*, 7 July 1839).
140. We attempt at least a portion of this in Chapter 8.
141. L. Radzinowicz, *A History of English Criminal Law and its Administration from 1750* , vol. 4 (1968), chapter 7, epitomizes this line.
142. See Chapter 3.
143. R. Wells, 'Popular Protest and Social Crime: The Evidence of Criminal Gangs in Rural Southern England', in B. Stapleton (ed.), *Conflict and Community in Southern England* (Stroud, 1992); and discussion in Chapter 3.
144. See Russell's speech, *MOP*, 3, 24 March 1840, p. 1921.

145. S. Palmer, *Police and Protest in England and Ireland 1780–1850* (Cambridge, 1988), pp. 444–5. Palmer overstresses Chartism as an impetus.
146. D. J. V. Jones appreciated the change in the attitudes of the landed élite, the key role played by the leaders of county society and county MPs, and the full significance of the fact that half the counties decided to tax themselves for police purposes ('The New Police, Crime and People in England and Wales, 1829–1888', *Transactions of the Royal Historical Society* 33 (1983), pp. 151–68, at p. 158.
147. See Wellington's speech on the Metropolis Police Bill, *MOP*, 3, 5 June 1829, p. 2052.
148. See Chapter 6.
149. *MOP*, 3, 24 March 1840, p. 1921.
150. As indeed it did. By the time of the enactment of compulsory legislation in 1856, 67 per cent of the 43 legal counties of England (excluding Middlesex and Cheshire) had adopted the County Police Acts. See Chapter 9, p. 233, **Table 9.1.**

Chapter 8

1. In a few counties (e.g. Notts. and Northumberland) the press were (illegally) barred. The *CCo*, in an editorial (7 January 1840) headed 'The Value of Open Courts', commented on the usefulness to the ratepayers of the requirement that all administrative business be conducted in public. Quarter Sessions Minute and Order Books recorded motions debated and decisions taken, but tell us nothing about the substance of debates.
2. Proponents of the Act sometimes resisted proposals to publish division lists as attempts to expose individual JPs to ratepayer pressure and intimidate them into not voting for adoption – see the ill-tempered exchange over this issue in Derbyshire (*DC*, 8 January 1840).
3. See the account of the East Suffolk Quarter Sessions, where there were repeated interjections (*SCh*, 4 January 1840).
4. *NC*, 30 November 1839.
5. *KG*, 10 December 1839 (Chairman Knatchbull); *SHc*, 18 October 1839 (Chairman Kenyon – see also editorial in same issue *re* the importance of the issue); *Gloucester Journal*, 19 October 1839 (Chairman Bathurst). See reports of similar statements by chairmen of QS in: *DM*, 6 November 1839 (*re* Derbys. QS); *JOJ*, 23 November 1839 (*re* Herts. QS); *WC*, 16 October 1839 (*re* Worcs. QS).
6. Phrases frequently used by the press to describe the attendance at these QS debates included: 'an unusually/extraordinarily/unprecedentedly numerous/ large/full attendance' (*WC*, 16 October 1839 on Worcs. QS; *SHc*, 18 October 1839 on Salop QS; *LC*, 19 October 1839 on Leics. QS; *The Times*, 3 January 1840, on Berks. QS; *Northampton Mercury*, 4 January 1840 on Northants. QS; *JOJ*, 11 April 1840 on Oxon. QS; *HT*, 22 August 1840 on Herefordshire QS; *The Reformer*, 17 April 1841 on Herts. QS; *SA*, 12 November 1842 on Staffs. QS. Also *CC*, 29 November 1839 on Essex QS; *Newcastle Journal*, 30 November 1839 on Northumberland QS; *LI*, 26 September 1840 on West Riding QS).
7. We shall observe in Chapter 9 that, in the long-run, commitment of this group to supporting the claims of village notables was weak.

8. PRO HO 73/5/1, Wilts. Returns to CFC.
9. See R. B. Pugh, 'Chartism in Somerset and Wiltshire', in A. Briggs (ed.), *Chartist Studies* (1962), pp. 174–219.
10. *WGS*, 16 November 1839; *DWG*, 17 September 1840.
11. *WI*, 17 October 1839; *WGS*, 16 November 1839; *DWG*, 21 April 1840.
12. *WI*, 17 October 1839.
13. *WI*, 24 October 1839.
14. *DWG*, 8 October 1840.
15. *WGS*, 16 November 1839.
16. *DWG*, 8 October 1840 (emphasis added). The charge to the Grand Jury had long been used as a means of moulding public opinion or signalling a matter of importance; see J. Innes, 'Politics and Morals. The Reformation of Manners Movement in Later Eighteenth-Century England', in E. Hellmuth (ed.), *The Transformation of Political Culture. England and Germany in the Late Eighteenth Century* (1990), p. 71. The charge was also used, by other QS chairmen, to announce their *opposition* to the County Police Acts – see the charge of J. Barneby to the Herefordshire Grand Jury, *Hereford Journal*, 1 January 1840.
17. *DWG*, 8 October 1840.
18. F. M. L. Thompson, *English Landed Society in the Nineteenth Century* (1963), p. 31 and table p. 32, shows that Berkshire ranked fairly low in the proportion of its area occupied by great estates.
19. N. Gash, *Politics in the Age of Peel* (1971), pp. 270–1.
20. PRO HO 73/5/2 Berks. Returns to CFC. In 1836 Reading thought that the 'sole management of a rural police [should] be committed to the Board of Guardians', and proposed the stationing of six policemen in every Union; in 1839, six of the fourteen requisitioners for adoption of the County Police Act (a mix of Liberal and Tory gentlemen) were from this division.
21. *RM*, 13 April 1839.
22. For the Berkshire debates, see *RM*, 19 October 1839 and *BC*, 19 October 1839 and 4 January 1840.
23. *The Times*, 3 January 1840, 'Berkshire Epiphany Sessions'.
24. Eight party affiliations of the fourteen have been traced. Of the eight, four were Whigs and four Tories; six are unknown. Professor Norman Gash kindly helped with political party affiliations.
25. Storch incorrectly labelled him a Tory in 'Policing Rural Southern England ...' His Liberal politics only reinforce the point made in that essay: adoption or rejection of the County Police Act was rarely a straight party political question. In Berkshire and some other counties, a few Liberal-inclined men like Goodlake or Eyston argued against a police on various grounds. Most Liberals, however, were usually found on the pro-County Police Act side.
26. By 1840, Walter was deeply estranged from the government, blaming the Whigs for the New Poor Law which he passionately detested.
27. Among the missing were Viscount Barrington, Throckmorton, the Revd J. F. Cleave, Liberal squire George Mitford, and the Revd C. Bouverie, a relative of Lord Radnor. J. Blagrave, a Tory with a military background, who had signed the requisition, voted with the opposition.
28. HO 45/OS6236, Palmerston to Hopkins, 2 January 1855.
29. On the alleged 'crime wave' and adoption of the Act, see *RM*, 21 October

1854 and 24 November 1855. Also Berkshire County Record Office, D/EPG/30W, Edmonds to Radnor, 17 November 1855. See Chapter 9.

30. See *CC*, 18 October, 29 November 1839, 3 January, 14 February 1840; *Essex Herald*, 22 October, 3 December 1839, 18 February 1840. In Chapter 7 we noted that Essex had begun preparations for a county police months before Russell's legislation.

31. See also the contribution to the debate on the First Reading of the County Police Bill of Mr Ward, MP for a Herts. borough, who stressed that Herts. suffered from 'the great number of bad characters driven out of London by the excellence of the metropolitan police', and their need to rely on voluntary associations for any sort of effective police (*MOP*, vol. 5, 24 July 1839, p. 4259). On the Barnet Association, see Chapter 6.

32. Printed in *Hertfordshire Reformer*, 12 April 1836; the paper supported this petition in an editorial (26 April 1836) stressing that 'in parishes near London having large towns, and not already provided with a police, a more efficient one than the Leet constable is become absolutely necessary'. Cuttings of these two articles were sent to the CFC (see PRO HO 73/2/1).

33. *JOJ*, 23 November 1839, report of Herts. QS.

34. UCL Chadwick Papers 322, Blake to Chadwick, 21, 27 October 1840; Chadwick to Blake, 24 October 1840.

35. *The Reformer* (Hertford), 31 October 1840, report of QS. Blake immediately wrote to Chadwick to tell him the news and ask his advice on numbers and salaries for the force; Chadwick replied with ideas based on the CFC Report evidence (UCL Chadwick Papers, 322, Blake to Chadwick, 27 October 1840, Chadwick to Blake, 29 October 1840).

36. *The Reformer*, 16 January 1841, report of QS. The County Police Act required a Quarter Sessions statement of the inefficiency of the constabulary before the Home Secretary could act.

37. *The Reformer*, 17 April 1841, report of QS.

38. Cf. the case of Derbyshire (below) where a tie vote sank a county police force for sixteen years.

39. These returns are in PRO HO 73/5/1 & 2.

40. See Philips, 'Good Men to Associate and Bad Men to Conspire: Associations for the Prosecution of Felons in England, 1760-1860' in D. Hay and F. Snyder (eds) *Policing and Prosecution in England, 1750–1850* (Oxford, 1989).

41. Its organizer, J. Trumper, reported that he took action after the Marquis of Chandos introduced him to Peel, with whom he consulted – PRO HO 73/2/1 Trumper to CFC [n.d.].

42. PRO HO 73/2/1 Sir Harry Verney to CFC, 3 December 1836; HO 73/5/2 Buckingham Division Return.

43. George Carrington of Great Missenden was a Tory, not related to the mostly Whig family of Lord Carrington.

44. R. W. Davis, *Political Change and Continuity, 1760–1885: A Buckinghamshire Study* (1972), p. 62.

45. PRO HO 73/5/2 Returns of three hundreds of Aylesbury (Great Missenden), Burnham and three hundreds of Ashendon (Quainton) to CFC.

46. Formerly Marquis of Chandos – he succeeded as Duke in 1839.

47. He never wavered. When Bucks. was experimenting with superintending constables in the late 1840s, Lee denounced a proposal by Verney to build a

lockup and station a superintendent at Steeple Claydon in Verney's own division. Lee said that, if Verney would get rid of the Game Laws and form a temperance society, there would be no need for a police. (*Buckinghamshire Advertiser*, 10 April 1847).

48. It was the Liberal press which indulged in extravagant *ad hominem* attacks. The *AN*, 26 October 1839, called one of Carrington's speeches 'one of the most confirmed Tory obstructiveness we ever listened to. We were perfectly astonished to hear ... Mr Carrington avow such sentiments - sentiments only to be expected from old women of 70 years of age.'

49. *BH*, 26 October 1839, leader.

50. The text of Buckinghamshire's response was printed in *Copy of a Circular Letter addressed by direction of Lord John Russell to the Chairmen of the Quarter Sessions of all Counties ... in England and Wales*, PP 1839 XLVII (259), p. 517.

51. See Chapter 5.

52. *AN*, 26 October 1839, report of QS.

53. *AN*, 26 October 1839.

54. This account of the Bucks. October Sessions is based on *AN*, 26 October 1839 and *BH*, 26 October 1839.

55. *BG*, 4 January 1840.

56. The boards were told that a rate of 1½ d. in the £ would be sufficient, so that a ratepayer paying £100 rent could expect to pay 12s.6d. per annum (Bucks County Record Office Q/Unclass/ V/A/.5, manuscript minutes of committee meeting 10 January 1840).

57. *BG*, 24 October 1840 (emphasis added).

58. Our account of this meeting is taken from the report in *BG*, 24 October 1840.

59. He was not wrong about this.

60. On Chandos' political activities and influence, see Davis, *Political Change and Continuity*; on the 'Farmer's Friend', see D. Spring, 'Lord Chandos and the Farmers, 1818–1846', *Huntington Library Quarterly*, XXXIII, 3 (1970), pp. 257–81.

61. Some justices who favoured adoption apparently joined the majority on the grounds that the 50 constables proposed was not enough to give the new system a fair trial. Maurice Swabey, looking back on the debates of 1839-40 in 1853, recalled: 'Expense was the principal ground of opposition; there might have been a little admixture of politics, but I think I may say generally it was on the ground of expense it [the County Police Act] was rejected'. (*First Report from the Select Committee on Police; with the Minutes of Evidence*, PP 1852-3, XXXVI, 1–159, Q. 841 at p. 58).

62. On Buckinghamshire's later experience with police reform, see Chapter 9.

63. On this see C. Steedman, *Policing the Victorian Community* (1984), pp. 19–20. Steedman perhaps overemphasizes this, viewing nearly all Kent denunciations of centralization as fear of control by Quarter Sessions in Maidstone, not from London. Opponents in Kent feared strongly that a police under Russell's Acts would somehow become a stepping stone to a major revolution in local government that would supercede the unpaid magistrates. The Knatchbulls, although ridiculed for it by many of their colleagues, seemed truly to believe it.

64. The following account of the Kent General Sessions meeting of December 1839 is based on the report in *KG*, 10 December 1839.

65. For his views in Parliament on police reform, see Chapter 4.
66. B. Keith-Lucas, *The Unreformed Local Government System* (1980), pp. 52–3.
67. See Chapter 9 for the bill he later introduced into Parliament.
68. PRO HO 73/5/2 returns to CFC.
69. On Deedes' role in the legislative history of police reform, see Chapter 9.
70. See the discussion of this issue in Chapter 4.
71. Herries was closely associated with Peel and Lord Ellenborough in organizing the opposition to the Whigs after 1830. One of his main tasks was attracting Ultras like Knatchbull back into the fold. See R. Stewart, *The Foundation of the Conservative Party, 1830–1867* (1978) pp. 58, 68–9, 102–3.
72. They seemed to be under the impression that what was legally necessary for the official letter to the Home Secretary was not only an affirmative vote, but a statement on the size of the proposed force and other details. If not all settled at the same meeting, the vote would not be binding.
73. The 1840 Kent survey is in the Kent County Record Office, Q/GPa/2.
74. Here, too, there was a considerable amount of policing activity under local Acts and the Lighting and Watching Act. See *KH*, 5 and 19 March 1840, for a description of one such scheme at Rainham and adjoining parishes.
75. *MG*, 10 March 1840; *KH*, 19 March 1840.
76. A Liberal, Law Hodges was a proponent of triennial Parliaments and the ballot, but, like the Berkshire Liberals Eyston, Goodlake and Walter, an opponent of the New Poor Law – see R. Wells, 'Resistance to the New Poor Law in the Rural South', in A. Digby (ed.), *The New Poor Law* (1985), p. 17. In other respects, he was a classic country gentleman, a spokesman for the agricultural interest and a keen protectionist. He described himself as being 'one of those who go to considerable expense in preserving game' (*MOP*, vol. 3 [1840], p. 1920). On Law Hodges and his police scheme, see Chapter 9.
77. *KH*, 9 April 1840. Law Hodges' scheme would have kept control of the police and the ability to levy a local rate firmly in the hands of petty sessional justices, see Chapter 9.
78. Reported in *MG*, 25 August 1840.
79. Reported in *MG*, 3 November 1840.
80. *MG*, 3 November 1840. In the late 1840s and early 1850s this is precisely what happened in Dorset. For Dorset, see: Storch, 'Policing Rural Southern England', p. 255; PRO HO 45/OS2668 Clerk of Peace, Sherborne to Home Office, March 27, 1849, and HO 4/OS3305 Clerk of Peace, Shaftesbury Division to Home Office, April 23, 1850. Something similar happened in a few other counties, see Chapter 9.
81. The Wingham bench, besides containing two Tory MPs and a future Tory MP (Sir B. W. Bridges), was a bastion of clerical justices. Nearly one-third were parsons. This was most unusual in Kent.
82. Editorial comment in *MG*, 1 September 1840.
83. See J. E. Archer, 'Rural Protest in Norfolk and Suffolk', in A. Charlesworth (ed.), *Rural Social Change and Conflicts Since 1500* (Hull, 1982), p. 87; David Jones, 'Arson and the Rural Community: East Anglia in the Mid-nineteenth Century', in his *Crime, Protest, Community and Police in Nineteenth-Century Britain* (Oxford, 1982), chapter 2.
84. See A. Brundage, *The Making of the New Poor Law, 1832–39* (1978), pp. 116–20; N. Edsall, *The Anti-Poor Law Movement, 1834–44* (1971),

pp. 34-7; J. Archer, *By a Flash and a Scare. Incendiarism, Animal Maiming, and Poaching in East Anglia, 1815–1870* (1990).

85. See Storch, 'Policing Rural Southern England', pp. 229, 250. For the various policing experiments of the 1830s, see PRO MH 32/38, MH 12/11730, HO 61/19; for Haverhill and Hengrave see *SC*, 11 January 1840; for Wickham Market, see HO 73/2/1 J. P. Barclay to Constabulary Force Commissioners, 15 January 1839.

86. On Clissold, see his pamphlet, published anonymously: *Police Regulations for Establishing a System of Morality and Good Order in Rural Districts under the New Poor Law Act* (1836), in PRO P[rivy] C[ouncil] 1/2547; also his letter to Chadwick at the Constabulary Force Commission, 18 Jan 1839, in PRO HO 73/2.

87. PRO HO 73/5/1 Suffolk magistrates' returns to CFC.

88. The vote at Beccles was 10-8; at Woodbridge 8-4; at Ipswich 16-7. Combining all three, East Suffolk voted for adoption 34-19.

89. See J. D. Wheeler, 'The Constabularies of West Suffolk from 1836' (1959), MS in West Suffolk Record Office, Bury St Edmunds. On the West Suffolk arson wave see Archer, *By a Flash and a Scare*, pp. 107-25 and *passim*. For the magistrates' reactions in 1844 see *Bury Herald*, 31 January 1844 and *IJ*, 23 March 1844, and 26 October 1844. On the influence of Robert Bevan (Thingoe and Thedwastry Division), a director of the Suffolk Fire Office, see *IJ*, 23 March 1844 and Archer, *By a Flash and a Scare*, pp. 153-4.

90. *SC*, 1 February 1840. The Revd R. Daniels of Combs, a parson friendly to adoption, retorted at the meeting: 'it was the fault of the ratepayers – clearly not of the magistrates … they should read the newspapers'. See also the letter of 'A Yeoman' in *SC*, 4 January 1840, complaining that persons such as he were to be totally ignored by the magistrates and referring to the petition from the Blything Hundred containing 945 signatures.

91. *SC*, 1 February 1840.

92. See J. P. Kay's comments about the opposition among the Suffolk magistracy to the New Poor Law in PRO MH 32/33.

93. The turnout was remarkable. More votes were recorded in 1840 than the number of justices acting for East Suffolk in the mid-1830s (see list in *Royal Commission on County Rates*, PP 1837, XXXIII, Appendix, Part II). A number of justices who normally acted for Norfolk participated and voted at Beccles.

94. In a heated discussion at Beccles in July 1839 – see *SC*, 6 July 1839.

95. *SC*, 4 January 1840. One of the Norfolk justices was J. Kerrick; the other cannot be identified. Bence did not mention that, among those voting with him was J. J. Bedingfield, who also acted for Lodding and Clavering in Norfolk. If the bench was packed, apparently both sides did it.

96. Probably Robert Barnes, a semi-professional detective and thief catcher who worked for 5s. a day plus 10d. a mile. He was employed by private individuals and occasionally by the magistrates (PRO HO 73/5/1 Woodbridge magistrates' return to CFC). As happened at Woodbridge, proponents of a new police could point to the prospect of efficient services of this type being made available to all.

97. *SC*, 4 January 1840.

98. Cooper had signed the 1836 return for the Hoxne Division, claiming that no changes in the constabulary were necessary; he had not changed his

mind by 1840. His colleague, the Revd Henry Owen, in 1836 asked for a police 'upon the system of prevention', and voted the same way at Ipswich in 1840. But some changed their minds. Richard Etough, DD, had written the response of the Bosmere and Claydon Division of Ipswich in 1836, expressing fears of placing a police under a 'central board in London under the patronage of the Secretary of State' which would be a 'system of espionage' and not in accord with the spirit of a free constitution'. In 1840 he voted for the County Police Act (PRO HO 73/5/1 Hoxne and Bosmere and Claydon returns to CFC).

99. This was a rare response to the issue from a magistrate; in view of its intended capacity to mollify farmers and ratepayers, one wonders why it was not more used. See the discussion of the county rate in Chapter 7.

100. *SC*, 4 January and 1 February 1840. The clerical vote at Beccles and Woodbridge was less significant and more evenly divided.

101. Shawe was defended by the pro-police Tory parson Stephen Clissold, who gently admonished Bence to keep party politics out of the affair.

102. *SC*, 10 April 1841.

103. *SC*, 1 July 1841.

104. J. S. Henslow, *Suggestions Towards and Enquiry into the Present Condition of the Labouring Population of Suffolk* (Hadleigh, n.d. [1844]) pp. 16–19; cf. D. Jones, 'Thomas Campbell Foster and the Rural Labourer; Incendiarism in East Anglia in the 1840s', *Social History*, 1 (January 1976) pp. 11–12. Henslow, by 1844 a magistrate, was calling loudly for a police, although he considered himself a representative of the ratepayers of Hitchin who still opposed it – a classical illustration of the dilemma in which the rural policing issue landed them (*IJ*, 26 October 1844). See also Chapter 7 on the magistrates and the ratepayers.

105. PRO HO 73/5/1 returns to CFC.

106. *IJ*, 21 March 1846.

107. This account of the West Suffolk debate is based on *SC*, 11 January 1840.

108. Archer, *By a Flash and a Scare*, pp. 107–16.

109. *Ibid*, pp. 153–4; Storch, 'Policing Rural Southern England', p. 250.

110. *IJ*, 23 March 1844.

111. Account of the 1844 debates based on *IJ*, 23 March and 26 October 1844.

112. *IJ*, 20 June 1846.

113. *DM*, 23 October 1839; see also *DC*, 19 October 1839.

114. *DM*, 6 November 1839; *DC*, 9 November 1839.

115. *DM*, 1 January 1840.

116. *DC*, 4 January 1840; *DM*, 1 January 1840. Derbyshire County Record Office: Quarter Sessions Order Books 1839–57; Box V/2-3 Documents relating to the adoption of Police Act 2 & 3 Vic., c. 93; Box V/11 Petitions presented to Quarter Sessions against the adoption of 2 & 3 Vic., c. 93 (there are more than 100 such petitions; the lowest number of signatures per petition is 10 to 20, the highest well over 100 signatures).

117. Report of the meeting and its context in *DC*, 24 October 1840; *DM*, 14, 21, 28 October 1840.

118. *DC*, 24 October 1840.

119. *DM*, 21 October 1840, editorial.

120. *DC*, 9 January, 10 April, 3 July, 23 October 1841, 26 July, 18 October 1856; *DM*, 7 January, 25 February, 8 April, 1 July 1857. Derbyshire County Record Office Quarter Sessions Box V/4 Lists of superintending constables

appointed under 5 & 6 Vic., c. 109, 1842–1856. On the superintending constable system, see Chapter 9.

121. See Chapter 7.
122. *NJ*, 15 November, 22 November 1839.
123. *NJ*, 3 January 1840.
124. Newcastle's open letter, published in the *NJ*, in March 1840, is reprinted in *The Times*, 1 April 1840, under the heading 'Rural Police'. For a sense of the extravagant language and ideas of this open letter, see the quotations from it in Chapter 7.
125. *MGu*, 29 April 1840.
126. *LC*, 19, 26 October 1839.
127. *LC*, 19, 26 October 1839.
128. *The Times*, 6 January 1840 (report of Leics. Jan 1840 QS – motion to increase force to 43 defeated 13-9); UCL Chadwick Papers 112, Press Cuttings Booklet 1840 (report of Leics. October 1840 QS – motion to increase force to 40 defeated 22-14).
129. *Ibid.*; Anon., *Some Remarks on The Report of the Constabulary Force Commissioners and upon the Acts Founded on That Report. Respectfully Addressed to The Magistrates of the County of Leicester. By A County Magistrate* (1840). Halford proudly acknowledged authorship of the pamphlet in the October 1840 QS debate.
130. *SA*, 13 April 1839.
131. *SA*, 23 November 1839, 4 January 1840; *WC*, 23 October, 27 November 1839.
132. *SA*, 2 July 1842; *WC*, 6 July 1842.
133. See D. Philips, *Crime and Authority in Victorian England: The Black Country 1835–1860* (1977), chapters 3, 8, and 'Riots and Public Order in the Black Country 1835-60', in J. Stevenson and R. Quinault (eds), *Popular Protest and Public Order* (1974), pp. 141-80; F. C. Mather, 'The General Strike of 1842', in *ibid.*, pp. 115-40.
134. *SA*, 22 October, 12 November 1842; *WC*, 26 October, 16 November 1842; Philips, *Crime and Authority*, chapter 3.
135. This was specifically allowed by the amending County Police Act of 1840 (3 & 4 Vic., c. 88).
136. *SA*, 12 November 1842; *WC*, 16 November 1842; Philips, *Crime and Authority*, chapter 3.
137. The Tory *WC* (16 November 1842) condemned the decision to establish a county force as 'an unwise and inconsiderate, and scarcely less malefic course' and blamed it on a disproportionate panic reaction to the 'Plug Plot' troubles: 'The danger which the magistrates in sessions apprehend is manifestly another outbreak – another destroying of life and property like to that which lately disgraced the Potteries. It is clear enough to any one that if these crimes had not happened we should have heard nothing of a county police; it is not even pretended that the ordinary police of the county is insufficient for its ordinary duties ... We deeply regret the over acute susceptibility of the magistrates – we think they have been hurried away by undue fears, and instead of putting a small blister plaster in the right place, have blistered the patient all over.'
138. For a discussion of the social composition of the Staffordshire magistracy in this period, see D. Philips, 'The Black Country Magistracy 1835-60. A

Changing Elite and the Exercise of its Power', *Midland History*, III (1976), pp. 161–96.

139. *PC*, 9 November 1839; on working-class attacks, see R. D. Storch, 'The Plague of the Blue Locusts: Police Reform and Popular Resistance in Northern England, 1840–1857', *International Review of Social History*, XX (1975), pp. 61–90.

140. See Chapter 5.

141. *PC*, 9 November 1839, report of QS; *Chester Chronicle*, 15 November 1839. A parliamentary return in March 1840 listed Lancashire as the largest new county force with 500 men, and Leicestershire as the smallest with only 26 (*MGu*, 21 March, 1 April 1840).

142. A Tory frontbencher in the Lords and chairman of the Riding Quarter Sessions. On Wharncliffe, see *Dictionary of National Biography*, vol. 19, 'Stuart-Wortley-Mackenzie, James Archibald, first Baron Wharncliffe (1776–1845)'.

143. See *LI*, 17 April 1841, (1) report of QS, for Ferrand's speech against a police, stating that 'Gentlemen had forgotten that property had its duties as well as rights'; (2) editorial rejoicing at the defeat of the motion, and claiming that 'there was a full attendance of Whig members of parliament who were there to do the work of the Ministry'.

144. For some correspondence about West Riding Whig politics in this period, between Charles Wood, Sir Francis Wood and his brother-in-law William Busfield, see The Borthwick Institute of Historical Research, University of York, Halifax Papers A2/21, 36, 37, 73, 74, A4/50a.

145. Correspondence between Wharncliffe and Denison makes clear that, whatever the theory may have been of gentlemen leaving their politics at the door when they entered Quarter Sessions, party political issues were frequently considered by those who ran the West Riding Quarter Sessions in the early 1840s. For correspondence between Wharncliffe and Denison, discussing the politics of the West Riding QS from a Tory perspective 1841-2, see Sheffield Record Office Wharncliffe Muniments Wh.M 449a./109, 112–115.

146. *LM* and *LI*, 11 April 1840, reports of QS meeting; 18 April 1840 for editorials and letter on the subject; *Northern Star* editorial, 2 May 1840.

147. *LM*, 26 September 1840.

148. *LM*, 12 December 1840.

149. *Ibid*.

150. *LM*, 13 February 1841.

151. *LM*, 12 December 1840.

152. See the plaintive speech of Mr Fawkes, a Liberal in *ibid.*, who contested the districting map and begged to have a particular portion of the division of Skyrack excluded. There were also concerns that some of the more urbanized areas would have to give up the police that they had built up. Wharncliffe's concern was to make sure that the large, unincorporated industrial villages and out-townships of the Riding were well policed. This is what was lost in 1840-1.

153. *LM*, *LI*, 26 September 1840, reports of QS and editorials.

154. *LM* and *LI*, 12 December 1840, reports of QS; *The Times*, 16 December 1840.

155. *LI*, 9, 16 January 1841; *Yorkshire Gazette*, 16 January 1841; *LM* and *LI*, 13 February 1841, reports of QS.

156. The *LI*, a committed enemy of a county police told its readers: 'The Resolution of the last meeting, as our readers are aware, is not final, We therefore exhort *all* the magisterial opponents of the measure, in its present unnecessarily stringent form, to be at Wakefield on Tuesday ... let all the magistrates who wish to save the public money, and to act in unison with the feelings of the mass of the people, be present on Tuesday'. And, to prevent a similar mishap as at the February meeting, 'we would recommend the opponents of the measure to confer together and lay down a plan of operations before going into court. Nothing should be left to chance in such cases' (10 April 1841).

157. *LM* and *LI*, 17 April 1841, report of QS.

158. *LI*, 16 October 1841.

159. In July 1856, Parliament passed the County & Borough Police Act (19 & 20 Vic., c. 69), making it compulsory for every county to establish a force from 1 January 1857; only then did the West Riding agree, in August 1856, to establish a force under the old Act. See: *LI*, 12 June, 4 September, 16 October, 18 December 1841, 22 October 1842; *LM*, 1 October 1842, 13 April, 6 July 1844, 12 April, 18 October, 8 November 1851, 10 April, 16, 23 October 1852, 17 November 1855, 2 August, 15 November 1856; West Yorks. Archives (Wakefield) QS 10/53-58 Quarter Sessions Order Books 1838-1857; QC 7/1 Minute Book Police Committee, 1 August 1856.

160. Wharncliffe angrily stated, at the February 1841 QS: 'He could not help remarking that it was much more easy to get together Magistrates in a manufacturing than those acting in an agricultural district, and he could not help noticing also, that with the exception of Mr. Scott and Mr. H. Thompson, who were country gentlemen, the other Magistrates who had signed this notice [for a police for the whole Riding] were from the manufacturing districts. (Loud cries of 'Hear'.)' Examples of pro-police speeches by JPs from manufacturing areas: M. Thompson Esq. (April 1840), John Rand (September 1840); of anti-police speeches by JPs representing rural areas: Hon. E. Lascelles and Col. Markham (February 1841), the Revd J. A. Rhodes and Mr O. Farrer (April 1841).

161. A point that was not lost on the participants. See E. B. Denison's remarks, *Second Report HC Select Committee on Police*, PP 1852-3, XXXVI (715), q. 2983.

162. *Ibid.*, qq. 2962-4, 2984.

163. See Chapter 5.

164. *Chester Chronicle* 18, 25 October, 8 November 1839.

165. *CCo*, 7 January, 24, 31 March 1840 (quotation from 24 March 1840, report of QS); Cheshire County Record Office QJB 6/1 Quarter Sessions – Printed Minutes 1838-1847 (quotation from minutes of QS 23 & 25 March 1840).

166. *CCo*, 7 July 1840.

167. Cheshire County Record Office QJB 6/1 Quarter Sessions – Printed Minutes 1838-47, minutes of QS January 1841.

168. *Stockport Advertiser*, 3 July 1851, report of QS; Cheshire County Record Office QJB 6/2 Quarter Sessions Minutes 1848-61, minutes of QS 30 June 1851.

169. Amended in 1852 to pay the assistant petty constables from the county rate instead of from the Poor Rates as previously.

170. *CCo*, 10 January, 17 April, 3 July, 23 October 1852; *Stockport Advertiser*, 3

July, 16 October 1851; Cheshire County Record Office QJB 6/1-2 Quarter Sessions Minutes 1838–61; CJP 1/1 Quarter Sessions Police Committee Minutes 1857–84.

171. Under both systems, professionals wore plain clothes, were paid from the county rate, were controlled largely by petty sessional justices, and played a role in the supervision of parish constables. The major difference lay in the absence in other counties of the Cheshire style assistant petty constables. On the superintending constable system see Chapter 9.

172. We note that even some keen projectors and operators of policing schemes did not necessarily favour the County Police Act – e.g. Borton of Blofield (Norfolk) and the JPs of Bourton-on-the-Water (Glos.). Others such as Dimsdale of Barnet (Herts.) and Witts of Stow (Glos.) were enthusiasts for it.

173. Accounts of Quarter Sessions debates in other counties are contained in I. P. Collis, 'The Struggle for Constabulary Reform in Somerset', *Proc. Somersetshire Arch. & Nat. Hist. Soc.*, 99 (1956), pp. 75–104 (Somerset); D. Eastwood, *Governing Rural England. Tradition and Transformation in Local Government* (Oxford, 1994), chapter 9 (Oxon.); D. Foster, 'Police Reform and Public Opinion in Rural Yorkshire', *Journal of Local Studies*, 2, 1, (1982), pp. 1–8 (East and North Ridings of Yorkshire); R. D. Storch, 'Policing Rural Southern England Before the Police. Opinion and Practice', in D. Hay and F. Snyder (eds), *Policing and Prosecution in Britain, 1750–1850* (Oxford, 1989), pp. 211–66 (six Southern counties); R. Wells, 'Implementation and Non-Implementation of the 1839–40 Policing Acts in East and West Sussex', *Policing and Society*, 1, 4 (1991), pp. 299–317 (Sussex).

Chapter 9

1. 19 & 20 Vic., c. 69.
2. This group allied itself with the ratepayers in 1839–40. The alliance was fragile. The substantial ratepayers, when they favoured police reform at all, often wanted some scheme accountable to themselves. No Tory alternative to the County Police Acts would offer this.
3. On Knatchbull, see Chapters 4, 7 and 8.
4. E.g. the chairman of Wilts. Quarter Sessions, W. H. Ludlow Bruges, MP, who opposed the government's attempt to kill the policing scheme of Thomas Law Hodges (discussed below). See his speech in favour of passage of the scheme in 1841 (*HPD*, 3rd Series, 56, 3 March 1841, col. 1300, and division list, *ibid*, Appendix 2, referring to 3 March 1841, cols. 1415–16).
5. E.g. the Earl of Devon, speech in the Lords on the 1840 amendments to the County Police Act (*MOP*, vol. 5, 20 July 1840, p. 4690), and Sir Harry Verney of Buckinghamshire, speech in the Commons (*MOP*, vol. 3, 24 March 1840, p. 1922).
6. E.g. Lord Ellenborough, H. Gally Knight, Tory MP for Notts. North, and Sir John Pakington – all from adopting counties. See Knight's remarks in *MOP*, vol. 5, 18 June 1840 p. 3852.
7. See Russell's reponse to these demands, *MOP*, vol. 5, 18 June 1840, p. 3852. Apart from the assumption of upwards of 25 per cent of costs by the Consolidated Fund, the government possibly contemplated a sudden flood of adoptions by Quarter Sessions no longer immobilized by the ratepayers

and their erstwhile supporters among the justices – and, therefore, quite crushing expenses.

8. *MOP*, vol. 2, 23 March 1840, p. 1867.
9. See Fox Maule's remarks on this score, *HPD*, 3rd Ser., 56, 3 March 1841, col. 1298.
10. In a sense, this represented a spillover into the parliamentary arena from Kent Quarter Sessions, where the County Police Act debates (see Chapter 8) were still going on. In Parliament, prominent roles were taken by Kent MPs who played major roles in the Quarter Sessions debates: E. R. Rice, Sir Edward Knatchbull, T. Law Hodges and J. Plumptre. The issues they raised were of universal interest.
11. *MOP*, vol. 3, 30 March 1840, pp. 2094-8; 18 June 1840, pp. 3846-51. Knatchbull's motion failed by a majority of 66; hardly a single Liberal or Radical supported him.
12. 'A Bill for the Appointment and Payment of Parish Constables in England and Wales', PP 1841 (59) 271 and PP 1841 (369) 275 [bill as amended by committee].
13. After getting a second reading and committee consideration, in June 1840 it was put off for three months and thus killed.
14. *KH*, 19 March 1840.
15. Although this was not specified in his bills, Law Hodges had made it clear that Special High Constables would come from the Metropolitan Police (*MG*, 10 March 1840).
16. The plan gave no satisfaction to those who complained that the County Police Acts gave unelected justices the power to tax without representation. The ratepayers were assigned no responsible role. Prominent Radical MPs, such as Wakley and Hume, refused to vote to go into committee on Law Hodges' bill, no doubt seeing in it a tyranny of petty sessions as bad as that of the county justices.
17. In 1841, Law Hodges announced that he wished to modify the original passivity of Quarter Sessions, and assigned to them the powers to install professional superintendents anywhere, at their discretion, and to decide the parish constables' scales and allowances (*HPD*, 3rd Series, 56, 3 March 1841, cols. 1296-7). The printed text did not contain these changes, 'Bill to Amend the Laws Relating to the Constabulary Force in England and Wales', PP. 1841 (5) 255.
18. The vote was 60-38 against (*HPD*, 3rd Series, 56 appendix, cols. 1415-16). Most Liberals present, a number of important Radicals, and ten Tories, voted against the bill. Those supporting Law Hodges were mostly Tory country gentlemen.
19. C. F. Goring, JP and MP, proposed that West Sussex petition in favour of it. The Duke of Richmond gave it guarded support (*Sussex Agricultural Express*, 18 April 1840). The petition ultimately submitted stopped short of a full endorsement, but Law Hodges took it as such (*MOP*, vol. 5, 18 June 1840, p. 3845). In East Sussex, there were expressions of support for the replacement of their recently created county police with the Law Hodges plan (East Sussex Record Office, QAC/1/E2, Survey of the Petty Sessions on Functioning of the East Sussex Constabulary (1841), response of the Rye bench and letter from C. Frewin to Quarter Sessions, 29 September 1841). In Hertfordshire, some justices used the introduction of the Law Hodges bill

to try to delay or stop adoption of the County Police Acts (Hertfordshire County Record Office, Quarter Sessions Order Book, QSB/23, Epiphany Adjourned Sessions, 1841). After criticizing the scheme in 1840, *The Justice of the Peace* came out for it in 1841 (IV, 15, April 11, 1840, V, 20, 15 May 1841).

20. *MOP*, vol. 5, 15 July 1840, p. 4597.

21. *MOP*, vol. 3, 24 March 1840, p. 1921. Normanby, the new Home Secretary, sat in the Lords. Fox Maule, the Undersecretary, managed the debates for the government in the Commons.

22. They were its strongest and most consistent supporters – see W. Watts Miller, 'Party Politics, Class Interest and Reform of the Police, 1829–56', in R. Reiner (ed.), *Policing* vol. 1 in *International Library of Criminology, Criminal Justice and Penology* (Aldershot, 1996), pp. 99–117, at p. 111; S. Palmer, *Police and Protest in England and Ireland 1780-1850* (Cambridge, 1988), p. 425. Peel had helped the Whigs with the County Police Act of 1840, especially the provisions regarding differential rating.

23. N. Gash, *Reaction and Reconstruction in English Politics 1832–1852* (Oxford, 1965), p. 148. Gash estimates their strength at between one-quarter and one-third of the parliamentary party.

24. That they lost the Radicals on this issue was not a great handicap.

25. F. C. Mather, *Public Order in the Age of the Chartists* (Manchester, 1959), pp. 132–3.

26. A. P. Donajgrodzki, 'Sir James Graham at the Home Office', *Historical Journal*, 20, 1 (1977), pp. 97–120, at p. 111; J. T. Ward, *Sir James Graham* (1967), pp. 14, 191–2; Palmer, *Police and Protest*, p. 461. On the pressure which Graham exerted on the magistrates of Staffordshire (successfully) and the West Riding (unsuccessfully) to adopt the County Police Acts, and on Durham to increase the size of the force, see L. Radzinowicz, *A History of English Criminal Law and its Administration from 1750*, vol. 4 (1968), pp. 281–3 and Mather, *Public Order*, pp. 132–3.

27. He even stated that in such counties the ratepayers might be enabled to appoint 'a policeman or two', but seemed to qualify it later (*MOP*, vol. 5, 18 June 1840, pp. 3852, 3854).

28. Graham referred to 'strong prejudices' and 'violent suspicions' in the party regarding the County Police Acts (quoted in Donajgrodzki, 'Sir James Graham', p. 111).

29. 5 & 6 Vic., c. 109. Referred to as the Parish Constables Act.

30. Technically, Leets could still appoint constables for civil matters (*The Justice of the Peace*, 6, 42, 22 October 1842, p. 691). In those counties which adopted the County Police Acts after 1840, parish constables (now styled 'local constables') were still to be chosen by the local Petty Sessions, but from a list compiled by the county chief constable, and they were now placed under the latter's authority; the vestries in these counties lost their power over the constables. In addition, all local Act forces and, in 1840, Lighting and Watching Act forces, were dissolved. (County Police Act Amending Act 1840, s. 16).

31. The use made of this provision can be traced in 'Abstract of Return of ... Parishes or Districts that have adopted the System of Paid Constables ...' PP 1846 (715) XXXIV 785. Palmer, *Police and Protest*, p. 449, counted 420 paid constables in the 21 non-adopting counties in the mid-1840s. Most

parishes using this provision paid a small retainer to some local man. Lists of Surrey parish constables 1842–49 show little use being made of paid constables, whether substantially salaried or under retainer (Surrey Record Office, QS 5/3/A; see also R. D. Storch, 'Policing Rural Southern England Before the Police: Opinion and Practice, 1830-1856,' in D. Hay and F. Snyder, *Policing and Prosecution in Britain 1750–1850* (Oxford, 1989), p. 256, n. 97.

32. 5 & 6 Vic. c. 109, ss. 22-3.

33. Apparently, under the 1842 Parish Constable Act it was impossible to borrow for this purpose. Building costs had to be passed on immediately to the ratepayers. Under the County Police Acts, money for building lockups and stations could be borrowed; policemen helped to discharge much of the debt through their rent payments.

34. Based on our scrutiny of records in the Kent, Berkshire, Surrey, and West Sussex Record Offices.

35. Kent considered a general lockup and superintendent programme in 1842. One lockup was built for the northern division of the Lathe of Aylesford, but action on others was deferred (*KH*, 22 September 1842). There appears to have been no further activity during the 1840s.

36. Storch, 'Policing Rural Southern England', pp. 255-6. A list of paid parish and lockup constables for 1855 appears in the *Western Times*, 7 July 1855.

37. *A Return Showing the Several Counties ... in which Superintending Constables have been Appointed ...* PP 1852-3 (675) LXXXVIII.

38. See Chapter 8.

39. Herefordshire also implemented fully the lockup and superintendent provisions of the 1842 Act. The development of its network can be traced in *HT,* 22 October 1842, 4 January 1845, 12 April 1845; *Hereford Journal*, 18 October 1843, 6 January 1844.

40. Buckinghamshire County Record Office, Miscellaneous Committee Minute Book, 1827-48, Q/Unclass/V/A/5, Minutes of Lock-Up Committee, n.d. (between Easter and June 1843).

41. Buckinghamshire County Record Office, Miscellaneous Committee Minute Book, 1827-48, Q/Unclass/V/A/5, Report of Constabulary Committee to Quarter Sessions, 14 January 1848.

42. As one magistrate pointed out, since all districts watched intently to see that 'as much public money was spent on them as another', a Quarter Sessions commitment to build a lockup in one area would call up demands from others to do the same. 'The case is seldom met upon its merits' (*First Report from the Select Committee on Police*, PP 1852-3 (603) xxxvi, pp. 1-159, test. M. Swabey, q. 853 at p. 59. This was another reason why some Quarter Sessions thought it prudent to do little or nothing.

43. In the Select Committee on the bill, Sir John Pakington unsuccessfully proposed a substitute that would have come closer to this objective. He suggested that all non-adopting counties appoint a mandatory county chief constable and a professional superintendent and lockup *for each division* – all of these to be under Quarter Sessions. The vote (7-6) was extremely close, however (*Select Committee on the Parish Constables Bill*, PP 1842 (470) XIV, 107). Parts of the Pakington Plan re-emerged in the important 1850 Amending Act to the legislation of 1842.

44. See Palmer, *Police and Protest*, p. 448, who correctly sees the Parish

Constables Act as a major transfer of power on the local level. Palmer thinks that its chief significance lay in bypassing vestries which were centres of working-class radicalism. This was true in parts of the North – by no means everywhere even that region – but the main impact was felt in the *countryside*, and, therefore, had little to do with working- class radicalism.

45. See Chapter 8 for Staffordshire's adoption of the County Police Acts in 1842, in response to serious Chartist-influenced strikes and riots.

46. These schemes were brought in or co-sponsored by MPs from Kent, Worcestershire, Somerset and Herefordshire.

47. 13 & 14 Vic. c. 20.

48. This seems to have been a result of an *impasse* produced by the failure of a further attempt, in 1849, to adopt the County Police Acts (C. Steedman, *Policing the Victorian Community. The Formation of English Provincial Police Forces, 1856–80* (1984), p. 19). Emsley views it as being the result of Kent Quarter Sessions' satisfaction with the workings of the Act of 1842 (C. Emsley, *The English Police. A Political and Social History* (2nd edn, 1996), p. 48. On the resolution, see letter of Earl of Romney to all Kent justices, 8 February 1850 (Kent County Record Office, Q/GPa5). Quarter Sessions wished to spend a large amount of money on these new superintending constables; to sweeten the pill of the expense, magistrates were told to inform ratepayers that it would save the county from the 'necessity of adopting the "Rural Police Act"'. The legislation was drafted and brought in by three Kent MPs: Law Hodges, William Deedes, and J. Plumptre, an erstwhile Tory supporter of the County Police Acts. Its sponsorship reflected the emergence of a cross-party consensus in Kent.

49. There is a paucity of treatments in local studies. For brief general accounts of the Act and its implementation: T. A. Critchley, *A History of Police in England and Wales* (1967), p. 93; Emsley, *The English Police*, pp. 48–9; Mather, *Public Order*, pp. 78–9; Steedman, *Policing the Victorian Community*, pp. 19–21; Storch, 'Policing Rural Southern England', pp. 252–4; and R. Olney, *Rural Society and County Government in Nineteenth-Century Lincolnshire* (Lincoln, 1979), pp. 122–3.

50. As a result of a (rare) rebellion of West Sussex Quarter Sessions against the Duke of Richmond. He argued that it 'would be only taking the first step' towards a detestable system of county policing. Interestingly, a number of justices, at this juncture, argued that the scheme was not extensive enough (*SAd*, 15 April 1851).

51. In the East Riding, a force of nine operated in one division under the County Police Acts; elsewhere there were superintendents.

52. 'A Return Showing the Several Counties … in which Superintendent Constables have been Appointed …' PP 1852-3 (675) LXXXVIII. A number of non-CPA counties adopted the superintending constable system incompletely, e.g. Derbyshire, Berkshire and Warwickshire. In Berkshire there was but one who served as lockup superintendent at Faringdon; in Warwickshire there were six, all lockup superintendents. Kent, on the other hand, seems to have created two corps: proper divisional superintendents and sixteen lockup keepers.

53. West Yorkshire Archives (Wakefield) QS 10/57 Quarter Sessions Order Books 1850-1853, 31 October 1851, 5 April 1852, 14 October 1852; *LM*, 10 April 1852, 16 October 1852.

54. Edmund Denison, a staunch opponent of the County Police Acts, was still suspicious that appointing superintending constables constituted 'the thin edge [*sic*] of the wedge of the rural police'. The chairman emphasized to the Grand Jury that implementing the superintending constable system would prevent the necessity of 'adopting a stronger and more expensive system (that of the rural police) for the riding' (*LM*, 16, 23 October 1852).

55. In 1851, one justice from each division was added to the committee. These were almost certainly magistrates normally active at Quarter Sessions.

56. First Report of Kent Constabulary Committee, 12 September 1850 (Kent County Record Office, Q/GC1). The Kent document on qualifications and duties of superintendents was copied almost point for point by West Sussex when it implemented the scheme (West Sussex Record Office, Report of Committee on Weights and Measures, Midsummer 1852, QAC/5/W7). Kent, in turn, later studied Buckinghamshire's model book of 'Rules and Regulations for Guidance of the Superintendent Constables'.

57. Other warrants and summons, e.g. for non-payment of rates were left to parish constables, along with the responsibility of conveyance to gaol. With only one professional per division, the superintendents clearly could not discharge this duty without leaving their districts uncovered. Elsewhere, assigning conveyance to superintendents was part of a plan of economy; reimbursements were directed to their salaries and expenses.

58. It is unclear under what circumstances these were to be carried.

59. In one case spectacularly so. The Kent superintendent John Dunne (see below) later became chief constable of Norwich and Newcastle, the senior chief constable in the United Kingdom, and a knight, B. D. Butcher, *A Movable Rambling Police. An Official History of Policing in Norfolk* (Norwich, 1989), pp. 24–5. These posts were stepping stones to borough chief constableships. See *MG*, 2 December 1851 on attempts to retain Supt Dunne, then being courted by Norwich.

60. Justices raided the county forces to get good superintendents. See complaints by Cambs. (Isle of Ely) Quarter Sessions: 'they [Lincolnshire] take away our best men as superintendents ... Huntingdonshire is the same.' (*Second Report from the Select Committee on Police*, PP 1852–3 (715) XXXVI, test. W. Townley, q. 2732, p. 14.

61. They then became a charge on the Poor Rates on the scale of fees mandated by Quarter Sessions.

62. There were also suggestions that they frustrated superintendents by tipping off suspected felons (*Second Report from the Select Committee on Police*, test. W. Oakley Esq., q. 3284, p. 47).

63. An index of success of professional officers in rural areas was arrests of sheep-stealers. Superintendents complained of the torpor or lack of co-operation of parish constables and/or victims. Delays of 5 to 15 days in initial complaints were reported (Kent County Record Office, Q/GPa6 Memorial from Supt J. McGregor to Kent Constabulary Committee, n.d.).

64. *First Report from the Select Committee on Police*, PP 1852–3 (603) XXXVI, pp. 1–159, test. J. Dunne, qq. 1951–86, pp. 116–19.

65. *Ibid.*, q. 1983, p. 119.

66. Cf. testimony of W. Hamilton on Buckinghamshire in *ibid.*, qq. 1004–1113, pp. 67–71.

67. They interviewed candidates and made shortlists from which Quarter

Sessions picked the man, Kent County Record Office, Q/GC1, Minutes of Constabulary Committee, 4 April 1853.

68. See a case in which the Ashford justices refused to allow their man to assist the Tonbridge superintendent in a complicated investigation. Tonbridge brought in a Metropolitan officer and Quarter Sessions received an unwelcome bill for his services (*South Eastern Gazette*, 28 June 1853). Kent, it must be said, had made it a rule at the outset that no superintendent could leave his district without the justices' permission (*MG*, 24 September 1850).

69. The Elham justices were rebuked for stationing their man in the Cinque Ports, outside the jurisdiction of Kent Quarter Sessions (*South Eastern Gazette*, 27 June 1854).

70. Kent County Record Office, Minutes of Constabulary Committee, Q/GC1, 23 December 1853.

71. Buckinghamshire County Record Office, Minute Book of Constabulary Committee, Q/Unclass/VA/1, 20 November 1851, 19 November 1853.

72. Despite the Constabulary Committee's willingness to take out summonses against parish constables for neglect of duty (Buckinghamshire County Record Office, Minute Book of Constabulary Committee, Q/Unclass/VA/1, 28 June 1852).

73. *First Report from the Select Committee on Police*, test. M. Swabey, qq. 820–67, pp. 57–9.

74. Buckinghamshire County Record Office, Q/AP/85/1 *Special Report of the Constabulary Committee*, 1 January 1855.

75. *Buckinghamshire Advertiser*, 1 July 1854. The special report included estimates of the costs of a proper rural police. The constabulary committee clearly wanted to put this option back on the agenda.

76. *HPD*, 3rd Series, 140, 10 March 1856, col. 2122.

77. On the early enchantment of magistrates with superintending constables and the reasons for it, see Storch, 'Policing Rural Southern England', pp. 254–5. Favourable testimony by justices before the Select Committee of 1853 was taken in the first flush of enthusiasm. If the examples of Buckinghamshire and Kent are indicative, the same witnesses may have been more qualified in their responses a few years on. See descriptions of Bucks., Herefordshire, Kent, Oxon., Lincs. and the West Riding in *First* and *Second Reports of SC on Police, passim*. Compare the testimonies of Bucks. superintendent W. Hamilton (*First Report*, qq. 1004–1113) and the magistrate G. Carrington (*Second Report*, qq. 3135–3248). Carrington was the principal author of the Bucks. Constabulary Committee's critical report two years later. These conclusions were also, clearly, the product of changed (and rising) expectations about what a good constabulary should be able to achieve.

78. It was introduced in 1852, 1853 and 1855.

79. 'Bill to Amend the Laws Regarding Appointment and Payment of Superintending and Parish Constables', PP 1852–3 (77) V, p. 261. All the Deedes' bills were essentially the same.

80. Although, at one point, Home Secretary Palmerston, reacting to the humiliating rejection of his National Police Bill of 1854, petulantly advised the House to pass the Deedes' plan (*HPD*, 3rd Series, 128, 17 May 1855, col. 710).

81. Remarks of Capt. Scobell (Somerset) (*HPD*, 3rd Series, 120, 21 April 1852, col. 963) and Denison (West Riding), (*HPD*, 122, 16 June 1852, col. 817).

82. Deedes meant this in a positive sense; five years earlier, it could have been

designed to inspire fright (*HPD*, 3rd Series, 124, 16 February 1853, col. 160). His bill did contain most of the essential features of the 1839 Act – Quarter Sessions' supremacy, a county chief constable and inferior officers in the field. Only a body of professional constables was missing.

83. This is shown clearly by the excellent *A Guide to the Archives of the Police Forces of England and Wales*, compiled by I. Bridgeman and C. Emsley (Police History Society, 1989). County Record Offices contain some of this type of material, but not much.

84. By the 1850s this had changed. Rank-and-file constables in the Buckinghamshire force (formed in 1857) were considerably more likely to have had previous police experience (Steedman, *Policing the Victorian Community*, table p. 74).

85. See Chapter 5 for the Norfolk and Cotswolds experiments. Ex-Metropolitan policemen played a key role in many of these.

86. See W. J. Lowe, 'The Lancashire Constabulary, 1845–1870: The Social and Occupational Function of a Victorian Police Force', *Criminal Justice History*, 4 (1983), pp. 41–61, table p. 47; Palmer, *Police and Protest*, table p. 565; Steedman, *Policing the Victorian Community*, Buckinghamshire and Staffordshire data, tables pp. 73, 76; D. Philips, *Crime and Authority in Victorian England. The Black Country, 1835–1860* (1977), pp. 64–74.

87. *Torquay Chronicle*, 27 June 1857, excerpted in W. J. Hutchings, *Out of the Blue. History of the Devon Constabulary* (Torquay, 1957), pp. 45–7.

88. Named after their first chief constable, Capt. Dawson Mayne RN (D. J. Elliott, *Policing Shropshire, 1836–1967* (Studley, 1984), p. 22).

89. See Chapters 7 and 8.

90. East Sussex was initially constrained by a public bargain with ratepayers to limit the police rate to no more than 3d. in the £. Quarter Sessions slowly raised the size of the force, especially after a new valuation of the county. Elsewhere, the deal with the ratepayers was probably implicit, with JPs fearing to stir ratepayers to angry action on the police issue. In some counties (e.g. Hertfordshire, Northamptonshire and Shropshire) forces were no bigger in 1856 than at founding (Palmer, *Police and Protest*, Table 11.3, p. 442.

91. *Abstract of Returns Showing the Number of the Constabulary Force in Each County*, PP 1844 (222) XLII, p. 95. There were also some differences in the manner of levying the rate. In most agricultural counties, making use of the differential rating option of the 1840 Act was not an important issue. Lancashire and Staffordshire, two industrial/manufacturing counties used it: for some reason, Durham did not.

92. Between 1844 and 1852, the Leicestershire force was more than doubled. Other initially small forces, such as Durham and Worcestershire, were increased by 65 per cent and 75 per cent, respectively. The initially larger Hampshire force increased by 62 per cent (*Return Showing the Number of the Police Constables in Each County* ... , PP 1852 (321) XLI, p. 49).

93. On the Wiltshire force, see testimony of the chief constable, Capt. Meredith, in *First Report of SC on Police*, pp. 143–51, especially his explanation of their arrangements (qq. 2385–8, p. 146). T. H. Redin (a member of the new, upwardly mobile police officer élite, a former Essex officer, deputy chief constable of Liverpool, risen to be governor of the Cumberland county gaol) argued that 'the uncertainty of the movements of the rural policeman is the

terror to thieves' (*ibid.*, pp. 85–93, quote at p. 92). Gatrell argues that much of the efficacy of nineteenth-century policing consisted of the fact that possible surveillance or interference by the police became an important factor in the daily lives and calculations of criminals (V. A. C. Gatrell, 'Crime, Authority and the Policeman-state', in F. M. L. Thompson (ed.), *The Cambridge Social History of Britain 1750–1950*, vol. 3 (Cambridge, 1990), pp. 243–310, at 287–92.

94. Meredith claimed that, using the system, he had, in the case of a recent strike put fifty men into the district in two hours, and could do so again at any time (*First Report of SC on Police*, q. 2391, p. 146).

95. The chief constable reported, as late as 1853, that the force was 'physically unable to accomplish ... this important duty', *SAd,* 28 October 1853.

96. *SAd,* 21 October 1845. The East Sussex Quarter Sessions struck a bargain with the ratepayers never to exceed a certain rate; the justices stuck to it religiously; the ratepayers agitated ceaselessly for abolition, on the grounds that policemen were not seen often enough in the villages. The chief constable was forced to remove constables from some villages to satisfy cries for protection from others; the deprived villages then protested (*SAd, 5* July 1845).

97. See *SAd,* 19 April 1841 (by the chief constable) and 13 September 1841 (by the Quarter Sessions chairman) for laments about the failure of parishes to do their part. In Essex, Chief Constable McHardy experimented with local constables. The results were considered dismal (*Second Report of SC on Police*, test. N. Burnardiston, Esq. JP, q. 3587, pp. 77–8).

98. *SAd,* 2 July 1850. The chief constable frequently begged for more manpower. Although there were occasional increases – by 1855 there were 51 men in the force – the justices kept to the bargain of 1840. On the failure of East Sussex's 'two tier' concept of policing, see *SAd,* 19 April 1841 and R. Wells, 'Implementation and Non-Implementation of the 1839–40 Policing Acts in East and West Sussex', *Policing and Society,* 1 (1991), pp. 299–317, at p. 309. On the ambivalence of the ratepayers in the early days of the Hampshire force, see R. E. Foster, 'A Cure for Crime? The Hampshire Constabulary 1839–1856', *Southern History,* 12 (1990) pp. 48–67, at p. 57. Here opposition dropped away rapidly owing to the feeling that the police was costly, but *cost-effective.* The cheese-paring of the East Sussex justices simply prolonged their agony and created a perpetually distressed chief constable.

99. See Capt. Mackay's complaint in *SAd,* 28 October 1853, attaching statistics showing East Sussex's low ranking on all indices of effectiveness: square miles per constable, police to population and parishes per officer.

100. *Return Showing the Number of Police Constables in Each County. ... in England and Wales*, PP 1851 (327) XLVI, p. 361. East Sussex's organizational scheme is in *SAd,* 11 January 1841.

101. See B. C. Jerrard, 'The Gloucestershire Police in the Nineteenth Century', (M. Litt thesis, University of Bristol, 1977). The Chief Constable was recruited from Ireland. He brought with him eighteen RIC constables, all of whom were sent away within a year as being too brutal for England. The first Staffordshire Chief Constable, J. H. Hatton, also came from the Irish Constabulary, and brought with him both some Irish Constabulary personnel and a paramilitary model, which emphasized military drill and semi-military

deployment for the constables (Philips, *Crime and Authority*, pp. 65, 76–7).

102. *First Report of SC on Police*, evidence of. G. Blathwayt Esq., qq. 2098–2117, p. 128; Palmer, *Police and Protest*, p. 451.

103. There were two exceptions: Henry Goddard, first Chief Constable of Northamptonshire, a former fishmonger and Bow Street Patrol member; and Frederick Goodyer, first Chief Constable of Leicestershire, an ex-Metropolitan inspector and head of the Leicester Borough Police (C. Emsley, *Policing and Its Context 1750–1870* (1983), p. 72; B. Elliott, 'Leicestershire's First Chief Constable – Frederick Goodyer (1839-1876)', *Journal of the Police History Society*, 3 (1988), pp. 95-8, at p. 95).

104. Meeting normally only four times a year (though monthly in Essex), Quarter Sessions police committees could not directly manage such a complicated bureaucratic organization.

105. A scan of a decade of Quarter Sessions records after the foundation of the Essex and Hertfordshire forces respectively, reinforces this point. Essex Quarter Sessions concerned itself almost exclusively with financial matters and county buildings; Hertfordshire audited police accounts *pro forma* only; on one occasion it gave a decision on the circumstances in which the police should carry on a prosecution (Hertfordshire County Record Office ASB/ 23, Epiphany Sessions 1843).

106. These patterns of authority, traceable to the County Police Acts of 1839-40, go to the question 'who controls the police in Britain', and remain a matter of modern debate – see B. Keith-Lucas, 'The Independence of Chief Constables', *Public Administration*, 38 (Spring 1960), pp. 1-11 and D. N. Chester, 'Some Questions', *ibid.*, pp. 11-15; and discussion in C. Townshend, *Making the Peace. Public Order and Public Security in Modern Britain* (1993), pp. 15-16.

107. *Second Report of SC on Police*, evidence of N. Burnardiston Esq., qq. 3633-4, p. 81.

108. *Ibid.*, qq. 3632, 3637, p. 81.

109. The Game Laws were a source of friction. Local gentlemen (and even some justices) might have expected help on this front. Many chief constables made it a firm item of policy to stay clear of enforcing the Game Laws, and it would have been the superintendent's duty to refuse to act. In Norfolk, for example, Standing Orders read: 'constables are positively forbidden to assist in watching game preserves or to lie in wait for poachers', quoted in J. Archer, *By a Flash and a Scare: Incendiarism, Animal Maiming and Poaching in East Anglia, 1815–1870* (1990), p. 241. This situation was only changed by the Poaching Prevention Act of 1862.

110. C. Steedman, *Policing the Victorian Community* (p. 2), seems to stress an enhanced role of Petty Sessions and argues, for a later period, that the Act of 1856 'put the individual magistrate at the apex of the local police division'. This seems dubious. At the apex was surely the superintendent backed by the authority of the county chief constable, who had the confidence of Quarter Sessions, the supreme political authority by that statute. This is not to say that desires and representations of local magistrates were routinely ignored. Even Sir George Stephen, a severe critic of the magistracy, complained that, in the divisions, police were *too* disconnected from the local magistrates (*Magisterial Reform Suggested in a Letter to Viscount Palmerston . . .* (1854), p. 11).

111. There was a high turnover among the men in the Staffordshire force in its early years (D. Philips, *Crime and Authority in Victorian England. The Black Country, 1835–1860* (1977), pp. 64–8. Average length of service in the Lancashire force 1845–55 was 4.5 years, W. J. Lowe, 'The Lancashire Constabulary, 1845–1870: The Social Composition and Occupational Function of a Victorian Police Force', *Criminal Justice History*, 4 (1983), pp. 41–62, at p. 55.

112. On the ordinary constable's lack of autonomy, and important observations on this point, see Steedman, *Policing the Victorian Community*, pp. 6, 146–7.

113. Essex seemed to provide more than a bare minimum of training, M. Scollan, *Sworn to Serve. Police in Essex 1840-1990* (Chichester, 1993), p. 8. On the foundation of the Shropshire force, its chief constable (a military man with no police experience) hired an experienced professional officer as a trainer; the first intake received a course of several weeks, D. J. Elliott, *Policing Shropshire*, p. 20. The early Staffordshire force was trained mainly in military drill, and in means for dealing with riots and public disorders, Philips, *Crime and Authority*, pp. 78–82.

114. Quoted in Lowe, 'Lancashire Constabulary', p. 44. See also M. Weaver, 'The New Science of Policing: Crime and the Birmingham Police Force, 1839-1842', *Albion*, 26, 2 (1994), pp. 289–308. Constables' personal lives were highly regulated. Their superiors enquired into the debts which they incurred; they were often forbidden to marry without permission, were compelled to attend Sunday church services, and to possess plain clothes of a certain quality, etc.

115. Archer, *By a Flash and a Scare*, p. 156.

116. On Baxter's exploits see Elliott, *Policing Shropshire*, pp. 21, 35, 48. In 1850, however, he was dismissed for embezzling county funds.

117. This point is emphasized by Gatrell, who stresses how easy (but wrong) it is to underestimate the effectiveness of the early forces in law enforcement just because one can point to their failures or shortcomings ('Policeman-state', pp. 287–92).

118. Such as the Worcestershire constables Craig and King mentioned in Chapter 2.

119. Elliott, *Policing Shropshire*, pp. 20–1.

120. Scollan, *Sworn to Serve*, p. 7. They were former commissioned officers (below the rank of major) and non-commissioned officers. The chief constable, Capt. McHardy, who later displayed a predilection for using the police as a militarized auxiliary force, may have positively preferred superior officers with military backgrounds, see *Second Report of SC on Police*, Appendix 7, pp. 153–4.

121. Surrey Record Office, CC 98/4/1 Surrey Constabulary Appointment Book. Some of these experienced police officers may also have had military service further back in their backgrounds.

122. *First Report of SC on Police*, evidence of T. H. Redin q. 1504, p. 92.

123. They were rotated through the divisions, and made frequent exits from the force, through resignation or dismissal, in the early years.

124. *First Report of SC on Police*, test. W. Harris, q. 93, p. 9.

125. T. B. L. Baker, 'Abstracts and Inferences Founded upon the Official Criminal Returns of England and Wales for the Years 1854-9', *Journal of the Statistical Society of London*, 23, 4 (December 1860), p. 437.

126. Even the small East Sussex force did not hesitate to use its resources for this

purpose, and with some success (*SAd*, 2 January 1855). In Eastern Hampshire, they pushed vagrants into western Sussex (*First Report of SC on Police*, evidence of F. King, qq. 368-9, p. 26). See also N. Osborn, *The Story of Hertfordshire Police* (Letchworth, n.d.), p. 27; D. Foster, 'The East Riding Constabulary in the Nineteenth Century', *Northern History*, 21 (1985), p. 208; and C. Emsley, *The English Police*, p. 76 (Cambridgeshire).

127. See Buckinghamshire Record Office, AR21/89 Great Missenden Petty Session Book, 1852-63. In this period, spanning both the superintending constables and the Buckinghamshire Constabulary, one can read of the informations laid against publicans for illegal hours, permitting drunkenness and disorderly conduct, furious driving, etc. The new Essex Constabulary attempted to repress furious driving straight off, Scollan, *Sworn to Serve*, p. 15.

128. Wells, 'Adoption and Non-Adoption', p. 307. Severe injuries could be incurred in encounters outside pubs, Elliott, *Policing Shropshire*, p. 48.

129. Accounts of police activity at Halstead and Braintree fairs formed some of the earliest police reports in Essex (Scollan, *Sworn to Serve*, p. 15). The intelligent new chief constable of Huntingdonshire ordered a light surveillance of village feasts in the first year, to demonstrate that in future 'improved order will be expected'. An excellent example of how the police exercised their tutelary function in demarcating parameters of tolerated behaviour in public spaces (Emsley, *The English Police*, p. 76).

130. Foster, 'The East Riding Constabulary', p. 208.

131. Philips, *Crime and Authority*, pp. 84-6; R. D. Storch, 'The Plague of the Blue Locusts. Police Reform and Popular Resistance in Northern England, 1840-57', *International Review of Social History*, 20, 1 (1975), pp. 61-90, at pp. 78-9 (the large confrontation between the brand-new Lancashire Constabulary and the crowd at Lancaster Races in 1840) and 85-6.

132. Such offences accounted for 75 per cent of all police arrests in Hampshire 1840-50 (R. E. Foster, 'A Cure for Crime? The Hampshire Constabulary 1839-1856', *Southern History*, 12 (1990), pp. 48-67, at p. 62) and for most arrests by the Staffordshire force in its early years (Philips, *Crime and Authority*, p. 86).

133. *DWG*, 22 October 1840.

134. J. Q. Wilson and G. Kelling, 'Broken Windows', *Atlantic Monthly* (March 1982), p. 30. The gospel of prevention is currently back in vogue, complete with references to Peel and statements of principles that proponents impute to the early Metropolitan Police, G. Kelling and C. Coles, *Fixing Broken Windows. Restoring Order and Reducing Crime in our Communities* (New York, 1996), pp. 71, 105-6, 235.

135. Storch, 'Policing Rural Southern England', pp. 257-8; Philips, *Crime and Authority*, pp. 86-7. Chief constables were careful to attribute this to increased police activity, rather than to increasing crime - see Surrey Record Office, CC 98/1/2-5, Report of Chief Constable of Surrey to Quarter Sessions (1855). See Foster's interesting tabulation of arrests by the Hants. police, 1840-50, ('A Cure for Crime?', p. 6).

136. J. D. Wheeler, 'The Constabularies of West Suffolk from 1836' (1959), (MS in West Suffolk Record Office, Bury St Edmunds), p. 57; B. C. Jerrard, 'The Gloucestershire Police in the Nineteenth Century', M. Litt thesis, University of Bristol, 1977, p. 76. In its first year, arrests per man per year in Shropshire

were about 34. In 1842, the average in Hampshire was about 18 per man; in 1869, Lancashire police arrests per man averaged 37.

137. V. A. C. Gatrell, 'The Decline of Theft and Violence in Victorian and Edwardian England', in V. A. C. Gatrell, B. Lenman and G. Parker (eds), *Crime and the Law. The Social History of Crime in Western Europe since 1500* (1980), pp. 238–370, at 261–79, quote at 277. Much of the evidence given to the 1853 Select Committee, from chief constables of county forces, makes this point strongly.

138. *First Report of SC on Police*, test. R. Baker, q. 992, p. 66; cf. evidence of the Essex chief constable, Captain McHardy, who immodestly claimed that 'the establishment of a permanent and perfect police force in Essex has been a great check to sheep-stealing' (*ibid.*, q .795, p. 55); and N. Burnardiston, (*Second Report*, q. 3620, p. 80) regarding the breaking up of local 'gangs' of sheep-stealers.

139. W. Watts Miller, 'Party Politics, Class Interest and Reform of the Police, 1829-56' in R. Reiner (ed.), *Police*, vol. 1 of *International Library of Criminology, Criminal Justice and Penology* (Aldershot, 1966), pp. 99–117, at p. 110.

140. T. A. Critchley, *A History of Police in England and Wales* (2nd edn, 1978), chapter 4; Emsley, *The English Police*, pp. 41–52; J. Hart, 'The County and Borough Police Act, 1856', *Public Administration*, xxxiv, (1956), pp. 405–16 and 'Police' in W. R. Cornish (ed.), *Crime and the Law in Nineteenth Century Britain* (Dublin, 1978), pp. 197–200; L. Radzinowicz, *A History of English Criminal Law and Its Administration from 1750*, vol. 4 (1968), pp. 283–300; S. Palmer, *Police and Protest*, pp. 501–15.

141. See D. Roberts, 'Lord Palmerston at the Home Office', *The Historian*, XXI, 2 (1958), pp. 63–81.

142. Critchley, *History of Police*, p. 102; Hart, 'County and Borough Police Act', p. 406. Hart considers him the driving force behind mid-century police reform (p. 405).

143. Fortescue to Palmerston, 17 January 1853, quoted in Critchley, *History of Police*, pp. 102–5.

144. On Chadwick's influence with Palmerston see Palmer, *Police and Protest*, pp. 503–4.

145. *Ibid.*, p. 503. Chadwick's evidence to the Select Committee of 1853 was curiously dense. He appears to have suggested a national police centred in London, with two separate departments to supervise the Metropolitan and provincial police respectively, and multi-county sub-districts (*Second Report of SC on Police*, qq. 3645–6, pp. 83–4). It is possible that Palmerston even contemplated allowing Chadwick to revive the Royal Commission of 1836-9, a project with which Chadwick had been pestering the Home Secretaries in the 1840s – see UCL Chadwick Papers: 849, draft letter Chadwick to Sir James Graham [n.d., probably January 1845]; 1798, Shaw Lefevre to Chadwick, 30 January 1845; 886, Chadwick to Sir George Grey, 3 October 1848.

146. On the composition of the Select Committee, see Hart, 'Police', p. 198.

147. By this time, there were few counties operating with parish constables alone – Cornwall, Dorset, Somerset and Berkshire seem to have been the only ones left. The Select Committee took indirect swipes at the boroughs, throwing in the occasional witness to testify to the virtues of amalgamating small boroughs

to counties for policing purposes. Compare the testimony of H. Thompson, the mayor of Andover, policed by the Hampshire force, with that of J. Beddome, a senior alderman of Romsey, which had its own borough police force (*First Report of SC on Police*, qq. 421–523, pp. 28–34).

148. The three most important were: Capt. John McHardy of Essex, Capt. William Harris of Hampshire and Capt. John Woodford of Lancashire.

149. E.g. Fielder King who farmed in both West Sussex and Hampshire (*First Report of SC on Police*, qq. 335–42, p. 28). He complained about more vagrants and a greater extent of 'depredations upon the fences and the loss of turnips and poultry' in West Sussex, which was without a county police; also, R. Baker, an Essex farmer, who believed that the police increased the value of land (*ibid.*, qq. 951–1003, pp. 64–7).

150. E.g., Henry Dover, chairman of Norfolk Quarter Sessions (*ibid.*, qq. 1767–91, pp. 106–8).

151. The recommendations (from which the quotations come) are in *Second Report of SC on Police*, pp. iii–iv. There are good accounts of the work of the Select Committee in Critchley, *History of Police*, pp. 105–111; Emsley, *The English Police*, pp. 48–50; Palmer, *Policing and Protest*, pp. 503–4; Radzinowicz, *History*, vol. 4, pp. 289–92.

152. *Second Report of SC on Police*, pp. 143–4, 163–4. Surrey Quarter Sessions in 1850 had done its own sums and concluded that a force would be, if not cheap, at least cost-effective.

153. In 1854, *The Justice of the Peace* reproduced Oakley's data as a serial over a number of issues.

154. *HPD*, 3rd Series, 133, 2 June 1854, cols. 1266–8; 134, 27 June 1854, cols. 750–1.

155. *HPD*, 3rd Series, 134, 3 July 1854, cols. 1073–5.

156. He had been Home Secretary in the Whig government of 1846–52.

157. D. Smith, 'Sir George Grey at the Mid-Victorian Home Office', *Canadian Journal of History/Annales Canadiennes d'Histoire*, XIX (1984), pp. 361–86, at p. 367; see also Radzinowicz, *History*, vol. 4, p. 294.

158. The Act did not lay down any minimum number of constables for the county forces. Instead, the inspectors had the power to recommend withholding the government grant if they did not certify the force as 'efficient' – and efficiency was measured largely by the ratio of police to population.

159. One important change was to compel Quarter Sessions to divide their counties into police districts with a view to differential rating. This had been only optional under the County Police Acts, and had proved a stumbling block to adoption in some counties, notably the West Riding.

160. *HPD*, 3rd Series, 140, cols. 229–46, 690–7 (February 1856), 2113–90 (March 1856); 141, cols. 1564–85 (April 1856), 1928–44 (2 May 1856); 142, cols. 293–309, 605–14, 797 (May 1856).

161. See the analysis of the vote on the 1856 bill in Miller, 'Party Politics', p. 111. Of particular significance for this book is the fact that 75 per cent of gentry MPs and 87 per cent of members with a noble background voted for the bill. The landed class had finally reached a consensus on the subject of county police forces.

162. *HPD*, 3rd Series, 140, 10 March 1856, cols. 2124–36. See the exemplary discussion of the transition to 'local government at parliament's command' in D. Eastwood, *Government and Community in the English Provinces, 1700–1870*

(Basingstoke, 1997), chapter 1, esp. pp. 17–19. In the end, Grey withdrew a provision allowing the Home Secretary to make rules for borough police.

163. This term meant only that all counties had to have a police force – *not* that all the forces had to conform to a precise uniformity in structure and operations. County chief constables, even after the 1856 Act, were still free to mould their forces according to their own particular ideas.

164. For the terms 'national governing class' and 'provincial ruling class' see Chapter 1.

165. J. Styles, 'The Emergence of the Police – Explaining Police Reform in Eighteenth and Nineteenth-Century England', *British Journal of Criminology*, 27, 1 (1987), pp. 15–22, at p. 21. On the growth of what Styles calls a new 'public service' ideal of the magistracy see N. Landau, *The Justices of the Peace, 1679–1760* (Berkeley, 1984), and P. Styles, *The Development of County Administration in the Late Eighteenth and Early Nineteenth Centuries* (Dugdale Society, Occasional Paper 4, Oxford, 1934).

166. R. Vogler, *Reading the Riot Act. The Magistracy, the Police and the Army in Civil Disorder* (Milton Keynes, 1991) p. 45. Vogler correctly points out that, by 1855, the magistracy could afford to dispense with its constitutionalist rhetoric. Local self-government – 'the rock upon which the stability of all the institutions of this country rests' (Charles Wood) – became a catchphrase of the Victorian Liberal Party (J. Parry, *The Rise and Fall of Liberal Government in Victorian Britain* (New Haven, 1994), p. 180).

167. Palmer, *Police and Protest*, p. 501.

168. The roots of this reassessment may be traced to the late eighteenth century. Early glimmers of this may be found in a hardening of attitudes towards petty larceny and assault. Assault was quietly 'transferred ... away from the civil toward the criminal sphere' (P. King, 'Punishing Assault: The Transformation of Attitudes in the English Courts', *Journal of Interdisciplinary History*, XXVII, 1 (1996), pp. 43–74, at p. 72. King emphasizes that this predated the social fears created by the growth of radicalism, and reflected 'new attitudes to the manners and reformability of the poor'.

169. See the speech of William Miles MP of Somerset in *HPD*, 3rd Series, 141, 25 April 1856, col. 1581. Miles refers to himself as 'a convert to the system'; in 1840 he had been the co-sponsor of the Law Hodges' scheme.

170. In 1854, adoption was again proposed in the West Riding and defeated 33–19; in 1855, it was defeated 43–33 (West Yorkshire Archives QS10/58, Quarter Sessions Order Books January 1854 – November 1857; *LM* 17 November 1855; *HPD*, 3rd Series, 141, 25 April 1856, col. 1577, speech of E. Baines). The West Riding finally decided, in October 1856 – after the compulsory 1856 Act had been passed, but two months before it would come into force – to adopt the County Police Acts and establish a county force! (*LM* 2 August, 25 October 1856).

171. *Report of the Committee of Justices, Appointed by the Court of Quarter Sessions On a Plan for Extending the Protection of a Police Force* (1850), copy in PRO HO 45/OS 3308.

172. Surrey Record Office, QS 2/1/66, Quarter Sessions Order Book, Sessions 2 December 1850.

173. The Isle of Ely portion had a police for nearly ten years.

174. In Berkshire, the drive began in autumn 1854, although adoption came in 1855 (*RM*, 21 October 1854, 24 November 1855). For Somerset (Spring

1856), see I. G. Collis, 'The Struggle for Constabulary Reform in Somerset', *Proceedings of Somersetshire Arch. and Nat. Hist. Society*, 99 (1956), pp. 75–104, at pp. 97–8. These had been two bastions of resistance in the 1840s. Neither had used the superintending constable system. The votes in the 1850s for adoption were overwhelming: in Berkshire 44–28; in Somerset 64–1. The East Riding also adopted the 1839–40 Acts in 1856. Since 1849 a small force in one division was maintained under the Acts, and well-paid superintending constables operated in all other divisions. The 1856 decision was to create an embodied force everywhere, and place the whole under a chief officer. Devon's Quarter Sessions was also keen by 1855. In 1856 it was taking steps to adopt (*Western Times*, 6 January 1855, 5 January, 12 April, 1856).

175. *Warwick and Warwickshire Advertiser*, 6 January 1855, 7 April 1855. By this time, more than 50 per cent of the land area of the county was policed by what amounted to the county constabulary.

176. In this table we have used legal counties (e.g. West and East Sussex/Suffolk, the three parts of Lincolnshire, Cambs. County and Ely) in order to tabulate outcomes *wherever* a separate Quarter Sessions had an opportunity to make a decision. Middlesex was excluded because of the spread of the Metropolitan Police; Cheshire because it already possessed a police under the Cheshire Act. Cheshire held a debate but was nonetheless differently situated from other countries.

177. Counties south of the traditional Wash–Severn line.

178. B. Weinberger, 'The Police and the Public in Mid-Nineteenth-Century Warwickshire', in V. Bailey (ed.), *Policing and Punishment in Nineteenth-Century Britain* (1981), pp. 65–93, at p. 66.

179. It had ended to New South Wales in 1840; and ceased to Van Diemen's Land in 1853. It continued to Western Australia until 1868 – but only on a very small scale; effectively, after 1853, most of the people who had been transported for fairly serious offences would have to be dealt with in British prisons. See A. G. L. Shaw, *Convicts and the Colonies* (1966), chapters 13–15.

180. These are the factors advanced by Palmer, *Policing and Protest*, pp. 507–9 in his discussion of the background to the Act of 1856.

181. *HPD*, 3rd Series, 141, 2 May 1856, col. 1938.

182. Some MPs attempted to push Grey into putting 50 to 100 per cent of the cost onto the Consolidated Fund, thus shifting the burden entirely from local ratepayer to national taxpayer. See speeches of R. Palmer and Sir H. Willoughby, *HPD*, 3rd Series, 140, 5 February 1856, cols. 242–3 and 142, 9 May 1856, cols. 298–300.

183. For Denison's role in the West Riding's failure to adopt the County Police Acts, see Chapter 8.

184. *Second Report of SC on Police*, test. E. B. Denison, qq. 2952, 2963–4, 2983, pp. 25–9. He might have reinforced his argument by adding that after the Corn Law repeal, Peel's government relieved the ratepayer of between a quarter and a third of the costs of maintenance of convicts in local prisons, transferring them to the Consolidated Fund, and thus to the national taxpayer (S. McConville, *A History of English Prison Administration*, I (1981), pp. 258–9). After 1846, Tories became increasingly espoused to the idea that local administration should be relieved of costs incumbent on problems that were essentially national (H. C. G. Matthew, *Gladstone 1809–1898* (Oxford, 1997), p. 217).

185. Emsley, *Policing and Its Context*, p. 163, muses about a 'counterfactual history of police'.
186. It is likely that some of the later adoptions which we discussed above proceeded as smoothly as they did precisely because gentlemen began to suspect (and at a certain point learned for certain) that the Exchequer would finally be tapped to support county police establishments.
187. We noted, above, that in Kent under the superintending constable scheme there was a tendency over time for Quarter Sessions to take the system more and more into its own hands.
188. See R. D. Storch, 'The Policeman as Domestic Missionary: Urban Discipline and Popular Culture in Northern England 1850-1880', *Journal of Social History*, IX, no. 4 (1976), pp. 481-509.

INDEX